DOMINICANS AND FRANCISCANS IN MEDIEVAL ROME

MEDIEVAL MONASTIC STUDIES

VOLUME 6

General Editors
Janet Burton, *University of Wales Trinity Saint David*
Karen Stöber, *Universitat de Lleida*

Editorial Board
Frances Andrews, *University of St Andrews*
Edel Bhreathnach, *Discovery Programme, Dublin*
Guido Cariboni, *Università Cattolica del Sacro Cuore di Milano*
Megan Cassidy-Welch, *Australian Catholic University*
James Clark, *University of Exeter*
Albrecht Diem, *Syracuse University*
Marilyn Dunn, *University of Glasgow*
Sarah Foot, *Oxford University, Christ Church*
Paul Freedman, *Yale University*
Alexis Grélois, *Université de Rouen*
Johnny Grandjean Gøgsig Jakobsen, *University of Copenhagen*
Martin Heale, *University of Liverpool*
Emilia Jamroziak, *University of Leeds*
Kurt Villads Jensen, *Stockholms Universitet*
William Chester Jordan, *Princeton University*
József Laszlovszky, *Central European University Budapest*
Julian Luxford, *University of St Andrews*
Colmán Ó Clabaigh, *Glenstal Abbey*
Tadhg O'Keeffe, *University College Dublin*
Antonio Sennis, *University College London*

Dominicans and Franciscans in Medieval Rome

History, Architecture, and Art

by
JOAN BARCLAY LLOYD

BREPOLS

British Library Cataloguing in Publication Data
A catalogue record for this book is available from the British Library.

© 2022, Brepols Publishers n.v., Turnhout, Belgium.

All rights reserved. No part of this publication may be reproduced, stored in a retrieval system, or transmitted, in any form or by any means, electronic, mechanical, photocopying, recording, or otherwise without the prior permission of the publisher.

D/2022/0095/122
ISBN: 978-2-503-57883-5
e-ISBN: 978-2-503-57884-2
DOI: 10.1484/M.MMS-EB.5.114679
ISSN: 2565-8697
e-ISSN: 2565-9758

Printed in the EU on acid-free paper.

Table of Contents

List of Illustrations	6
Preface	17
Abbreviations	20
Colour Plates	21
Introduction	27

Part I
The First Dominican and Franciscan Foundations in Rome

Chapter 1
The Dominican Nunnery at S. Sisto (now S. Sisto Vecchio), founded c. 1218–1221 — 43

Chapter 2
The Dominican Priory at S. Sabina, founded c. 1220–1222 — 95

Chapter 3
The Franciscan Church and Friary of S. Francesco a Ripa, founded in 1229 — 153

Chapter 4
The Franciscan Nunnery of SS. Cosma e Damiano (S. Cosimato), founded in 1234 — 177

Part II
A New Generation of Dominicans and Franciscans
and their Foundations in Rome

Chapter 5
The Friars Minor at S. Maria in Aracoeli, founded c. 1248–1252 — 213

Chapter 6
The Friars Preachers at S. Maria Sopra Minerva, founded c. 1266–1276 — 257

Chapter 7
The Franciscan Nunnery at S. Silvestro in Capite, founded in 1285 — 307

Chapter 8
Medieval Dominican Penitents from c. 1286 and Catherine of Siena (1347–1380) — 341

Conclusion	355
Glossary	363
Bibliography	367
Index	411

List of Illustrations

Colour Plates

Plate 1. Icon of S. Sisto (*Maria Advocata / Hagiosoritissa*), encaustic technique, sixth or early seventh century, Byzantine, now at the Dominican nuns' church of S. Maria del Rosario, Monte Mario, Rome (photo: © Giulio Archinà) — 21

Plate 2. Copy of the icon of S. Sisto with the gold attachments, which were added to the original in the seventh century (photo: © Giulio Archinà) — 21

Plate 3. Unknown artist, a medieval Dominican nun, a member of the Sant'Eustachio family, at the feet of Christ, as patron of the fresco on the upper left wall of the chancel at S. Sisto, *c.* 1400 (photo: Archivio Fotografico, Musei Lazio – under licence from MiBACT) — 22

Plate 4. *The Mother of God holding the Christ Child, surrounded by saints and patrons*, a recently found fresco in the narthex of S. Sabina, painted in 708–15 (photo: author) — 22

Plate 5. Margaritone of Arezzo, *Saint Francis of Assisi, c.* 1260–1272 (photo: author) — 23

Plate 6. Icon of the *Mother of God Hodegetria*, from S. Cosimato, now in the Poor Clare nunnery on the Little Aventine (Photo: Alberto Ferri) — 23

Plate 7. *Maria Advocata*, icon of the late eleventh century, S. Maria in Aracoeli (photo: © Giulio Archinà) — 24

Plate 8. A fragment of a mosaic from the Colonna Chapel at S. Maria in Aracoeli, with St Francis, Giovanni Colonna, St John the Evangelist, the Mother of God and Child, and angels, 1277–1291 (photo: © Galleria Colonna, Rome) — 25

Plate 9. Icon of the *Mandylion*, Byzantine, sixth or seventh century (?) in a seventeenth-century frame, formerly in S. Silvestro in Capite, now at the Vatican in the Sala del Pianto, Papal Treasury (photo: B.N. Marconi – Genoa – <www.bnmarconi.it>; permission to publish granted by the *Ufficio delle Celebrazioni liturgiche del Sommo Pontefice*) — 26

Plate 10. *Saint Francis and the Virtue of Heavenly Love and Saint Dominic and the Virtue of Holy Emulation*, fresco from the 'Aula Gotica' in the palace of Cardinal Stefano Conti, at SS. Quattro Coronati, *c.* 1246 (photo: Archivio Fotografico, Musei Lazio – under licence from MiBACT) — 26

Figures

Introduction

Figure 1. Map of Rome showing thirteenth-century Dominican and Franciscan foundations, 1–7 and two fourteenth-century nunneries, A and B (Pietro Ruga, Pianta della città di Roma [Map of the city of Rome], 1824, detail; BSR Library Collection, Maps, 609.2.82.2, adapted by David R. Marshall). 28

The Dominican Nunnery at S. Sisto (now S. Sisto Vecchio), founded *c.* 1218–1221

Figure 2. Mario Cartaro, *Large Map of Rome*, det. of Antonine Baths and S. Sisto, 1576 (Frutaz, *Piante di Roma*, vol. II, 1962, detail of Tav. 242) 44

Figure 3. Giovanni Battista Nolli, *Map of Rome*, det. of Antonine Baths and S. Sisto, 1748 (Frutaz, *Piante di Roma*, vol. III, 1962, detail of Tav. 403) 45

Figure 4. S. Sisto, church and nunnery buildings, Plan I: Ground floor (survey by Jeremy M. Blake and Joan Barclay Lloyd) 46

Figure 5. Filippo Cicconetti, Plan of the S. Sisto buildings, 1869 (BSR, no. JHP-0220) 47

Figure 6. Remains of S. Maria in Tempulo (photo: author) 48

Figure 7. S. Sisto, view of façade, campanile, and side wall (photo: © David R. Marshall) 49

Figure 8. S. Sisto, interior of the church today looking north-west. (photo: Direzione Regionale Musei Lazio – under licence from MiBACT) 50

Figure 9. S. Sisto, interior of the church, looking towards inner façade (photo: Direzione Regionale Musei Lazio – under licence from MiBACT) 50

Figure 10. S. Sisto, church and nunnery buildings, Plan II: First floor (survey by Jeremy M. Blake and Joan Barclay Lloyd) 51

Figure 11. S. Sisto, side door of Cardinal Pietro Ferrici y Comentano, 1478 (photo: Direzione Regionale Musei Lazio – under licence from MiBACT). 52

Figure 12. S. Sisto, Chapter Room, façade (photo: author) 52

Figure 13. S. Sisto, Section CC1 (survey by Jeremy M. Blake and Joan Barclay Lloyd) 53

Figure 14. S. Sisto, Chapter Room, interior in the twentieth century (photo: Direzione Regionale Musei Lazio – under licence from MiBACT) 54

Figure 15. S. Sisto, interior of Chapter Room in the nineteenth century (photo: Father Peter Paul Mackey, OP, 1890–1901, BSR: ppm_1284) 54

Figure 16. S. Sisto, Refectory in 2019 (photo: author) 55

Figure 17. S. Sisto, column and capital of the early Christian basilica (photo: Direzione Regionale Musei Lazio – under licence from MiBACT) 55

LIST OF ILLUSTRATIONS

Figure 18. Ancient Roman floor mosaic found at S. Sisto, detail with cock (photo: Direzione Regionale Musei Lazio – under licence from MiBACT) — 56

Figure 19. C. Varetti, Plan of the early Christian basilica of S. Sisto (from Geertman, 'Ricerche', (1968–1969)) — 57

Figure 20. Gieronimo Francino, *S. Sisto, View of atrium and façade* (from *Le Cose Meravigliose…*, ed. Fra Santi, 1588, p. 66r – photo: © 2018 BAV, Cicognara.III.3685) — 57

Figure 21. C. Varetti, Reconstruction of the entrance to the early Christian basilica of S. Sisto (from Geertman, 'Ricerche', (1968–1969)) — 58

Figure 22. Sempringham, Priory church, plan of excavations undertaken in 1939 (H. Brown, from R. Graham, 'Excavations…' *Journal of the British Archaeological Association*, NS, 5 (1940)) — 64

Figure 23. Watton Priory, plan of excavations (W. H. St. John Hope and H. Brakspear, from W. H. St. John, 'The Gilbertine Priory of Watton…' *Archaeological Journal*, 58 (1901)) — 65

Figure 24. View of the S. Sisto buildings before 1908–1917 (photo: ICCD – under licence from MiBACT) — 68

Figure 25. Unknown artist, *Crucifix*, c. 1250, from S. Sisto and now in the Chapter Room, University of Saint Thomas, the 'Angelicum' (photo: Direzione Regionale Musei Lazio – under licence from MiBACT) — 72

Figure 26. Frescoes on the wall to the left of the apse, with an image of *Pentecost* below *Scenes from the life of Saint Catherine of Siena, a patron of the work, and Saint Eustachio* (photo: author) — 75

Figure 27. Unknown artist, *Angels in adoration*, late thirteenth- or early fourteenth-century fresco (photo: Direzione Regionale Musei Lazio – under licence from MiBACT) — 76

Figure 28. Unknown artist, *Pentecost*, upper section, late thirteenth- or early fourteenth-century fresco (photo: ICCD – under licence from MiBACT) — 77

Figure 29. Unknown artist, *Presentation of Mary in the Temple*, late thirteenth- or early fourteenth-century fresco (photo: ICCD – under licence from MiBACT) — 79

Figure 30. Unknown artist, *Girls at the Presentation of Mary in the Temple*, late thirteenth- or early fourteenth-century fresco (photo: ICCD – under licence from MiBACT) — 80

Figure 31. Unknown artist, *Presentation of Christ in the Temple*, late thirteenth- or early fourteenth-century fresco (photo: Direzione Regionale Musei Lazio – under licence from MiBACT) — 81

Figure 32. Unknown artist, *Saints Peter Martyr, Dominic, John the Baptist, and Paul*, late fourteenth- or early fifteenth-century fresco (photo: Direzione Regionale Musei Lazio – under licence from MiBACT) 84

Figure 33. Unknown artist, *Saint Catherine of Siena, Saint Eustace and a medieval nun*, late fourteenth- or early fifteenth-century fresco (photo: Direzione Regionale Musei Lazio – under licence from MiBACT) 85

Figure 34. Unknown artist, *Coat of arms of the Sant'Eustachio family*, late fourteenth- or early fifteenth-century fresco (photo: Direzione Regionale Musei Lazio – under licence from MiBACT) 86

The Dominican Priory at S. Sabina, founded *c.* 1220–1222

Figure 35. Giovanni Battista Nolli, *Map of Rome*, 1748, det. of Aventine (Frutaz, *Piante*, vol. II, 1962, detail of Tav. 407) 97

Figure 36. Carlo Fontana, *Plan of the west side of the Aventine Hill*, 1700 (Modena, Biblioteca Estense Universitaria, MS Campori 379, B. 1. 6. f. 54 – photo: Biblioteca Estense Universitaria) 99

Figure 37. Map of the Aventine Hill near S. Sabina (Spencer Corbett, 1962, published in Krautheimer, *Corpus*, vol. IV, 1970, fig. 67 – adapted by the author) 100

Figure 38. S. Sabina, diagram of the site (Jeremy M. Blake and Joan Barclay Lloyd) 101

Figure 39. S. Sabina, exterior view of the basilica (photo: author) 102

Figure 40. S. Sabina, interior of the church towards the apse (photo: ICCD – under licence from MiBACT) 103

Figure 41. S. Sabina, Plan I: Ground floor (survey by Jeremy M. Blake and Joan Barclay Lloyd) 105

Figure 42. S. Sabina, Plan II: First floor (survey by Jeremy M. Blake and Joan Barclay Lloyd) 106

Figure 43. S. Sabina, Plan III: Second floor (survey by Jeremy M. Blake and Joan Barclay Lloyd) 107

Figure 44. S. Sabina, Section AA' (survey by Jeremy M. Blake and Joan Barclay Lloyd) 108

Figure 45. S. Sabina, Section BB' (survey by Jeremy M. Blake and Joan Barclay Lloyd) 108

Figure 46. S. Sabina, Section CC' (survey by Jeremy M. Blake and Joan Barclay Lloyd) 108

Figure 47. S. Sabina, inscription on the inner façade (photo: ICCD – under licence from MiBACT) 110

Figure 48.	S. Sabina, inner façade mosaics in the late seventeenth century (photo: BAV © 2018, from Ciampini, *Vetera Monimenta*, vol. 1, Tab. XLVIII)	111
Figure 49.	S. Sabina, the fifth-century wooden doors (photo: Alinari Archives)	112
Figure 50.	Leonardo Bufalini, *Map of Rome*, 1551, detail of S. Sabina (Frutaz, *Piante*, vol. II, 1962, detail of Tav. 203)	114
Figure 51.	S. Sabina, view of narthex interior looking south-east towards Via Santa Sabina (photo: author)	115
Figure 52.	Giacomo Fontana, narthex interior looking north-west from Fontana, *Raccolta*, vol I, tav. XXIX (photo: Bibliotheca Hertziana – Max-Planck-Institut für Kunstgeschichte, Rome)	115
Figure 53.	S. Sabina, narthex, view from garden D, drawing by Adriano Prandi (photo: Bibliotheca Hertziana – Max-Planck-Institut für Kunstgeschichte, Rome)	116
Figure 54.	S. Sabina, the bell tower, as seen from the left aisle (photo: ICCD – under licence from MiBACT)	118
Figure 55.	S. Sabina, vault in the bell tower (photo: author)	118
Figure 56.	S. Sabina, view of the façade, narthex, bell wall, south-east wall of wing R, and garden D (photo: Father Peter Paul McKey, OP, 1890–1901, BSR, ppm_1274)	119
Figure 57.	SS. Giovanni e Paolo, narthex, built from 1154 to 1180 (photo: author)	120
Figure 58.	S. Saba, thirteenth-century narthex with fifteenth-century loggia above it (photo: Alinari Archives)	121
Figure 59.	S. Sabina, tomb of Perna Savelli, died 1315 (photo: author)	130
Figure 60.	S. Sabina, tomb of Munio of Zamora, died 1300 (photo: author)	130
Figure 61.	Gieronimo Francino, *S. Sabina, View of side portico*, from *Le Cose Meravigliose…*, ed. Fra Santi, 1588, p. 66v (photo: BAV, © 2018, Cicognara.III.3685)	131
Figure 62.	S. Sabina, view of the side portico with the door to the priory on the left and the side entrance to the basilica on the right (photo: author)	131
Figure 63.	S. Sabina, tracery from an apse window now in cloister (photo: author)	132
Figure 64.	Unknown architect, Spada plan of S. Sabina, *c.* 1483 (photo: BAV, © 2018, Vat. lat. 11257, fol. 178)	133
Figure 65.	Francesco Borromini and workshop, plan of S. Sabina, *c.* 1640 (photo: © The Albertina Museum, Vienna – www.albertina.at)	134

Figure 66.	S. Sabina, View of the convent walls with the plaster removed, and showing niches in Wing P (photo: author)	138
Figure 67.	S. Sabina, the cloister between 1982 and 2002 (photo: author)	139
Figure 68.	Reconstruction of the S. Sabina buildings when the Dominicans arrived (drawing by Jeremy M. Blake)	140
Figure 69.	S. Sabina, cloister ambulatory in wing R, showing entrance to the Chapter Room (photo: ICCD – under licence from MiBACT)	140
Figure 70.	S. Sabina, Wing Q, remains of two blocked arches of the loggia (photo: author)	141
Figure 71.	S. Sabina, loggia in Wing Q, reconstruction (drawing: Jeremy M. Blake)	141
Figure 72.	S. Sabina, room in wing PW, on the ground floor of the priory (photo: ICCD – under licence from MiBACT)	144
Figure 73.	S. Sabina, room in wing PW, on first floor of priory (photo: ICCD – under licence from MiBACT)	145
Figure 74.	Savelli castle, wall of enceinte (photo: author)	149

The Franciscan Church and Friary of S. Francesco a Ripa, founded in 1229

Figure 75.	Mario Cartaro, *Map of Rome*, 1576, detail: Trastevere (Frutaz, *Le Piante di Roma*, vol. II, 1962, detail of Tav. 245)	154
Figure 76.	S. Francesco a Ripa, plan of the church and former conventual buildings, 1979 survey by Roberto Marta and Bruno Menichella (1979_DRW_SFrancesco-a-Ripa_Marta-Menichella, ICCROM)	157
Figure 77.	Leonardo Bufalini, *Map of Rome*, detail of S. Francesco a Ripa (Frutaz, *Le Piante di Roma*, vol. II, 1962, detail of Tav. 208)	164
Figure 78.	Gieronimo Francino, S. Francesco a Ripa, façade (*Le Cose Meravigliose…*, ed. Fra Santi, 1588, p. 20v; photo: BAV, © 2021, Cicognara.III.3685)	166
Figure 79.	Baldassarre Peruzzi, drawing of a project for a trefoil burial chapel for Ludovica Albertoni in S. Francesco a Ripa, 1533–1536 (Uffizi, Florence, Prints and Drawings, n. 1643A – under licence from MiBACT)	167
Figure 80.	Giuseppe Sanità, OFM, Reconstruction plan of the thirteenth-century church of S. Francesco a Ripa (1960s – adapted by author)	168
Figure 81.	Antonio da Sangallo the Younger and Giovanni Battista da Sangallo, Monte Cassino, plan for remodelling the choir of the church of Saint Benedict (photo: Florence Uffizi Gallery, Prints and Drawings, U 181 A – under licence from MiBACT)	170

The Franciscan Nunnery of SS. Cosma e Damiano (S. Cosimato), founded in 1234

Figure 82. S. Cosimato, Plan I, Ground Floor (survey by Jeremy M. Blake and Joan Barclay Lloyd) — 179

Figure 83. S. Cosimato, prothyron, viewed from north-west (photo: author) — 180

Figure 84. S. Cosimato, church façade, as rebuilt in 1475 (photo: author) — 180

Figure 85. S. Cosimato, thirteenth-century cloister, west wing B, viewed from east (photo: author) — 181

Figure 86. S. Cosimato, fifteenth-century cloister S, west wing (photo: author) — 182

Figure 87. S. Cosimato, southern wall of thirteenth-century south wing C (photo: author) — 182

Figure 88. S. Cosimato, view towards southern side of Conference Room (photo: author) — 183

Figure 89. S. Cosimato, Plan II, First Floor (survey by Jeremy M. Blake and Joan Barclay Lloyd) — 184

Figure 90. S. Cosimato, Plan III, Second Floor (survey by Jeremy M. Blake and Joan Barclay Lloyd) — 185

Figure 91. S. Cosimato, Section XX' (survey by Jeremy M. Blake and Joan Barclay Lloyd) — 186

Figure 92. S. Cosimato, Section YY' (survey by Jeremy M. Blake and Joan Barclay Lloyd) — 187

Figure 93. S. Cosimato, Plan made in 1875 (ASC, Contratti. Atti privati, 1875, parte seconda) permission to publish granted by the Soprintendenza Capitolina ai Beni Culturali — 187

Figure 94. Ospizio Umberto I, Plan of Ground Floor, *c*. 1892, detail (from photocopy given to Jeremey M. Blake by the former architect at Ospedale Regina Margherita) — 188

Figure 95. S. Cosimato, Plan drawn in 1892, indicating changes planned in the church (ACSR, AABBAA, II, II. Busta 402, All.B.13) — 189

Figure 96. S. Cosimato, continuation of the southern wall of the church (photo: author) — 192

Figure 97. S. Cosimato, church interior looking towards the east (photo: Bibliotheca Hertziana – Max-Planck-Institut für Kunstgeschichte, Rome) — 196

Figure 98. S. Cosimato, Church interior, counter façade (photo: Bibliotheca Hertziana – Max-Planck-Institut für Kunstgeschichte, Rome) — 197

LIST OF ILLUSTRATIONS 13

Figure 99. Antonio del Massaro (attributed to), *Madonna and Child enthroned, with Saint Francis and Saint Clare, c.* 1478–1494 (photo: author) 200

Figure 100. S. Cosimato, side chapel, altar made in 1685 from sculpture from the former tomb of Cardinal Lorenzo Cybo († 1503) (photo: Bibliotheca Hertziana – Max-Planck-Institut für Kunstgeschichte, Rome) 202

Figure 101. S. Cosimato, side chapel, grille opposite the altar (photo: Bibliotheca Hertziana – Max-Planck-Institut für Kunstgeschichte, Rome) 203

Figure 102. S. Cosimato, campanile viewed from the east (photo: author) 205

Figure 103. S. Cosimato, cloister, north colonnade, wing A (photo: author) 207

Figure 104. S. Cosimato, cloister, east wing D, detail, showing the system of piers and arches (photo: author) 207

Figure 105. S. Cosimato, cloister, south wing C, viewed from the north (photo: author) 208

The Friars Minor at S. Maria in Aracoeli, founded *c.* 1248–1252

Figure 106. Antonio Tempesta, *Map of Rome*, 1593, det. the Capitoline Hill, with S. Maria in Aracoeli on the left (Frutaz, *Le Piante di Roma*, vol. II, 1962, detail of Tav. 266) 212

Figure 107. Stefano Dupérac, *Map of Rome*, 1577, det. the Capitoline Hill, with S. Maria in Aracoeli lower right (Frutaz, *Le Piante di Roma*, vol. II, 1962, detail of Tav. 250) 212

Figure 108. Giacomo Fontana, plan of S. Maria in Aracoeli, *c.* 1838, from Fontana, *Raccolta*, vol. II; photo: Bibliotheca Hertziana – Max-Planck-Institut für Kunstgeschichte, Rome) 214

Figure 109. S. Maria in Aracoeli, interior, looking east (photo: ICCD – under licence from MiBACT) 216

Figure 110. S. Maria in Aracoeli, façade and cavetto (Luigi Rossini, *Le Antichità Romane*, 1819–1823, Tav. 58; photo: Bibliotheca Hertziana – Max-Planck-Institut für Kunstgeschichte, Rome) 218

Figure 111. S. Maria in Aracoeli, south transept, side entrance, and chapels (photo: Bibliotheca Hertziana – Max-Planck-Institut für Kunstgeschichte, Rome) 219

Figure 112. Anonymous, plan of S. Maria in Trastevere, 1510–1530 (Rome, Istituto Centrale per la Grafica, Gabinetto Disegni e Stampe, vol. MMDX, No. 32746 [35] – under licence from MiBACT) 228

Figure 113. S. Maria in Aracoeli, 'Cosmatesque' *opus sectile* pavement showing an outline of the medieval apse (photo: ICCD – under licence from MiBACT) 229

Figure 114. S. Maria in Aracoeli, Spada plan, *c.* 1480
(BAV, © 2018, Vat. lat. 11257, pt. A, _0405-fa_0185r) ... 229

Figure 115. Old St Peter's, transept, reconstruction (drawing: Lloyd,
published in Krautheimer, *Corpus*, vol. v, 1977, fig. 229) ... 230

Figure 116. Marten van Heemskerck, view of S. Maria in Aracoeli from the
south (Berlin, Kupferstichkabinett, Inv. Nr. 79 D 2 a, fol. 16[r]) ... 232

Figure 117. S. Maria in Aracoeli, upper part of a clerestory window
(photo: ICCD – under licence from MiBACT) ... 238

Figure 118. Gieronimo Francino, façade of S. Maria in Aracoeli (*Le Cose
Meravigliose…*, ed. Fra Santi, 1588, p. 50 v; photo: Bibliotheca
Hertziana – Max-Planck-Institut für Kunstgeschichte, Rome) ... 242

Figure 119. Anonymous Fabriczy, S. Maria in Aracoeli, side view of the
façade (photo: Bibliotheca Hertziana – Max-Planck-Institut
für Kunstgeschichte, Rome) ... 243

Figure 120. S. Maria in Aracoeli, ribbed vaulting in the former chapel of Saints
Peter and Paul in the bell tower, which since 1564 has been the side
entrance (photo: author) ... 246

Figure 121. Cavallini (attributed to), *Madonna and Child, with Saints John the
Baptist and John the Evangelist*, *c.* 1295–1300 (photo: author) ... 249

Figure 122. S. Maria in Aracoeli, tomb of Matteo da Acquasparta, *c.* 1302 (photo: author) ... 252

Figure 123. View of the cloister with a well at S. Maria in Aracoeli
(photo: ICCD – under licence from MiBACT) ... 253

The Friars Preachers at S. Maria Sopra Minerva, founded *c.* 1266–1276

Figure 124. Alessandro Moschetti, View of Piazza di S. Maria sopra Minerva,
engraving, 1842 (photo: Bibliotheca Hertziana – Max-Planck-
Institut für Kunstgeschichte, Rome) ... 258

Figure 125. S. Maria sopra Minerva, view of interior (photo: Anderson: Alinari Archives) ... 259

Figure 126. Antonio Tempesta, *Map of Rome* (1593), detail of S. Maria sopra
Minerva and the Pantheon (Frutaz, *Piante*, vol. II, 1962, detail of Tav. 265 ... 260

Figure 127. Anthonis van den Wyngaerde, *Panorama of Rome from the Baths
of Constantine on the Quirinal Hill*, detail showing the church of
S. Maria sopra Minerva to the right of the figure in the middle,
with the Pantheon further to the right (Oxford, Ashmolean
Museum, WA.C.L.G.IV.96b; photo: Ashmolean Museum) ... 261

Figure 128. Survey plan of S. Maria sopra Minerva (Palmerio and Villetti, *Storia edilizia*, Rome, 1989, Plate XIV) — 262

Figure 129. Plan of S. Maria sopra Minerva in 1855 (Masetti, *Memorie istoriche*, 1855) — 264

Figure 130. Fra Gieronimo Bianchedi's sections, before (below) and after (above) the nineteenth-century restorations, (Masetti, *Memorie istoriche*, 1855) — 264

Figure 131. S. Maria sopra Minerva, interior view of nave, showing oculi and side aisle (photo: Bibliotheca Hertziana – Max-Planck-Institut für Kunstgeschichte, Rome) — 266

Figure 132. Florence, S. Maria Novella, exterior of nave and aisle from the south (photo: author) — 267

Figure 133. Giovanni di Cosma, Tomb of Durandus, made shortly after 1296, Rome, S. Maria sopra Minerva (photo: author) — 273

Figure 134. Florence, S. Maria Novella, plan (Wood Brown, *The Dominican Church of Santa Maria Novella*, Edinburgh, 1902) — 275

Figure 135. Baldassarre Peruzzi, survey drawing of the apse and a plan to remodel it (Florence Uffizi Gallery, Prints and Drawings, U 527v A – under licence from MiBACT) — 276

Figure 136. Giovanni Battista da Sangallo, survey drawing of the east end of S. Maria sopra Minerva (Florence Uffizi Gallery, Prints and Drawings, U 1661v A – under licence from MiBACT) — 277

Figure 137. Antonio da Sangallo the Younger, plan showing the old apse in outline and projected new choir (Florence Uffizi Gallery, Prints and Drawings, U 1310 A – under licence from MiBACT) — 277

Figure 138. S. Maria sopra Minerva, reconstruction of the east end by Palmerio and Villetti, (Palmerio e Villetti, *Storia edilizia*, Rome, 1989, fig. 25) — 278

Figure 139. Galuzzi, Reconstruction of the medieval church of S. Maria sopra Minerva (Matthiae, 'Gli aspetti diversi di S. Maria sopra Minerva', *Palladio*, NS 4, 1954) — 280

Figure 140. Giovanni Maggi, *Map of Rome*, 1625, edited by Paolo Maupin and Carlo Losi in 1774 (Frutaz, *Piante*, vol. II, 1962, detail of Tav. 315) — 283

Figure 141. Waterspout with 'lion head' in the cloister garden of S. Maria sopra Minerva (photo: author) — 284

Figure 142. S. Maria sopra Minerva, Tomb of Beato Angelico (photo: Beth Hay) — 291

Figure 143. S. Maria sopra Minerva, angel from Raymond's tomb of Catherine of Siena (photo: ICCD – under licence from MiBACT) — 292

Figure 144. S. Maria sopra Minerva, tomb of Saint Catherine of Siena under the high altar today (photo: author) — 294

Figure 145. S. Maria sopra Minerva, the tomb of Saint Catherine of Siena from *c*. 1855 to 2000, under the high altar (photo: Alinari) — 295

Figure 146. Follower of Fra Angelico (?) *Our Lady of the Rosary* (photo: ICCD – under licence from MiBACT) — 296

Figure 147. S. Maria sopra Minerva, unknown artist, crucifix (photo: ICCD – under licence from MiBACT) — 298

The Franciscan Nunnery at S. Silvestro in Capite, founded in 1285

Figure 148. Antonio Tempesta and Giovanni G. de Rossi, *Map of Rome*, 1693, (Frutaz, *Piante*, vol. III, 1962, det. of Tav. 367) — 307

Figure 149. S. Silvestro in Capite, façade and twelfth-century bell tower from south (photo: author) — 312

Figure 150. Spencer Corbett and Richard Krautheimer, Plan of S. Silvestro in Capite (Krautheimer, *Corpus*, vol. IV, 1970, Tav. IX) — 313

Figure 151. S. Silvestro in Capite, crypt, eighth-century wall built of large blocks of tufa (photo: author) — 315

Figure 152. S. Silvestro in Capite, chapel of the Sacred Heart (now parish office), column and capital from the eighth-century church (photo: author) — 316

Figure 153. S. Silvestro in Capite, chapel of the Pietà, column and capital from the eighth-century church (photo: author) — 316

Figure 154. Plan of S. Silvestro in Capite by Antonio Tanghero (Florence, Casa Buonarroti, drawings, nos 114 A and 122 A) — 327

Figure 155. S. Silvestro in Capite, Colonna and Palombara coats of arms (photo: author) — 328

Figure 156. S. Silvestro in Capite, east end of transept, coat of arms of a Colonna cardinal (photo: author) — 328

Figure 157. Francesco da Volterra, plan of S. Silvestro in Capite, 1591 (ASR, Collezione Mappe, cart. 86. no. 531, fol. 1 – under licence from MiBACT) — 331

Figure 158. Francesco da Volterra, Longitudinal Section of proposed remodelling of the church of S. Silvestro in Capite, 1591 (ASR, Collezione Mappe, cart. 86. no. 531, fol. 3 – under licence from MiBACT) — 332

Figure 159. Plan of the church, monastery, and workshops of the nuns of S. Silvestro in Capite, eighteenth century (ASR, Collezione Mappe, 86, no. 531, fol. 2 – under licence from MiBACT) — 334

Preface

The Dominicans recently marked the eighth centenary of the death of Saint Dominic (*c*. 1174–1221), who, on 28 February 1221, opened the first Dominican foundation in Rome. This was the enclosed nunnery of S. Sisto (now called S. Sisto Vecchio), which Saint Dominic began to establish two or three years before. It was almost contemporary with a second Dominican foundation, the priory of the Friars Preachers at S. Sabina, *c*. 1220–1222. Later, from 1266 onwards, the Dominicans were given a small church and convent near the Pantheon, where they later built the huge Gothic church of S. Maria sopra Minerva and their priory next door. Although Saint Francis of Assisi (*c*. 1181–1226) came to Rome several times, he did not establish any permanent friaries or nunneries in the city, but later four houses for Franciscan friars and nuns were set up in thirteenth-century Rome: the church and friary of S. Francesco a Ripa, close to the banks of the River Tiber, in 1229; the nunnery of S. Cosimato in southern Trastevere, in 1234; the church and friary of S. Maria in Aracoeli on the Capitoline Hill, from 1248–1252 onwards; and the nunnery at S. Silvestro in Capite, in 1285. In the fourteenth century, when the popes had left Rome for Avignon, there were two more Dominican and Franciscan foundations: the Poor Clare nunnery of S. Lorenzo in Panisperna and the Dominican nunnery of Sant'Aurea. This book is about the history, architecture, and art of the first seven Dominican and Franciscan foundations in Rome, while the two later convents are briefly mentioned.

An investigation is made of the site of each thirteenth-century Dominican and Franciscan foundation in Rome, its history, buildings, and art, using archaeological, visual, architectural, and literary evidence. In this way, aspects of the early history of the two Mendicant Orders are revealed through the topography, architecture, and decoration of their buildings in medieval Rome. This study also discusses the patrons of the architecture and art of these foundations: popes and cardinals, members of the great Roman families, Franciscan tertiaries, or other lay people.

Many people have helped me to write this book. Inspiration came a long time ago from Richard Krautheimer, for whom I worked as a research assistant for eight years, and who suggested I look not only at medieval churches, but also at the conventual buildings beside them, and the religious way of life of the men and women who lived in them. Julian Gardner's major works on painting, mosaics, tombs, seals, and patronage in thirteenth-century Rome widened my horizons in those fields. I thank architect Jeremy M. Blake for making the survey drawings of S. Sisto, S. Sabina, and S. Cosimato and for giving me advice about the buildings of S. Francesco a Ripa, S. Maria in Aracoeli, and S. Maria sopra Minerva. Beth Hay accompanied me when I visited various sites in Rome, Bologna, Assisi, and Naples and took some photographs for me. Dr Susan Russell, at the British School at Rome and in Melbourne, encouraged me in my endeavours, and read some drafts of my manuscript.

In 1998, Karin Bull-Simonsen Einaudi and I collaborated on a volume, edited by Marco Vendittelli, on SS. Cosma e Damiano in Mica Aurea (S. Cosimato).[1] I look back in pleasure at the time we worked together on that book. More recently, with Gemma Guerrini Ferri, Alberto

1 Barclay Lloyd and Bull-Simonsen Einaudi, *SS. Cosma e Damiano in Mica Aurea*.

Ferri, Anna Maria Velli, and other members of the voluntary association 'Mica Aurea' in Rome, there has been some more 'popular' interest in S. Cosimato, resulting in lectures, conferences, guided visits of the buildings, and two collections of essays.[2] Dale Kinney has often discussed with me the architecture and art of Roman medieval churches. Margaret Manion, at the University of Melbourne, encouraged me to study the history and art of medieval nuns in Rome. I visited S. Sabina with Manuela Gianandrea, examining fascinating features of the church, the priory, and the museum. I have also received encouragement and inspiration from the following scholars: Frances Andrews, Lisa Beaven, Claudia Bolgia, Brenda Bolton, Elizabeth Bradford-Smith, Caroline Bruzelius, Robert Coates-Stephens, Sible de Blaauw, Anne Dunlop, Laura Gigli, Alison Inglis, Carola Jäggi, Lezlie Knox, Kate Lowe, David Marshall, Angela Ndalianis, Alana O'Brien, John Osborne, Alison Perchuk, and Andreas Rehberg.

I began research for this book, when I was teaching Art History at La Trobe University in Australia. I thank my former colleagues and students for their interest and support. I am grateful to the University and the Australian Research Council for funding several trips to Rome to work on this project.

Many other people, named and unnamed, have helped me and I thank them all. I think particularly of the Dominican friars at S. Sabina and S. Maria sopra Minerva, and the modern Dominican Sisters at S. Sisto; the Franciscans at S. Francesco a Ripa and S. Maria in Aracoeli; the Pallottine Fathers at S. Silvestro; and the staff directing the Poliambulatorio (medical centre) at the ex-Ospedale Nuovo Regina Margherita (formerly S. Cosimato). In Rome, I studied at the Biblioteca Apostolica Vaticana and at the Archivio Segreto Vaticano; at Rome's Archivio di Stato, at the Roma Capitale, Archivio Centrale dello Stato di Roma, and at the Archivio Storico Capitolino di Roma. I was made welcome at the Archivio Generale dell'Ordine dei Predicatori at S. Sabina by successive archivists, and at the Archive of S. Maria sopra Minerva by Fabiana Spinelli and Father Luciano Cinelli, OP. Valerie Scott, Librarian of the British School at Rome, and members of her staff gave me invaluable assistance. At the Bibliotheca Hertziana, librarians like Dr Sonja Kobold helped me, as did Marga Sanchez of the library's Fototeca. Other Roman libraries I have worked in are at the American Academy in Rome, the Biblioteca Nazionale Centrale di Roma, and the Centro Internazionale di Studi Cateriniani. In Australia, I studied at the Borchardt Library at La Trobe University, the Baillieu Library at the University of Melbourne, and at the La Trobe State Library of the City of Melbourne.

I am grateful to Janet Burton, Karen Stöber, and Guy Carney of the Editorial Board of Medieval Monastic Studies for accepting this book for publication in this series. The recommendations of the anonymous reviewer were very helpful and inspired me to revise the text extensively. My thanks are due to the staff of Brepols for their expert editing and publishing.

I have enjoyed the friendly support of members of my family: Bernard and Emily, Megan, and Miriam; Alex and Luzcil; and particularly Margaret and Colin, my sister and brother-in-law, who live in France, and who took me to see 'Dominican sites', such as the rebuilt nunnery at Prouilhe, the centre at Fanjeaux, the Houses of Pierre of Seilhan, and the beautiful church and priory of the Jacobins in Toulouse. They also introduced me to the Communauté de l'Agneau, a modern Dominican and Franciscan Congregation. In Australia, the Missionaries of God's Love, too, are inspired by the ideals of Saints Dominic and Francis. I am personally very grateful to the members of la Communauté de l'Emmanuel

2 See Guerrini Ferri and Barclay Lloyd, ed., *San Chosm' e Damiano e 'l suo bel monasterio ...* '; and Velli, ed., *Nuovi Studi su San Cosimato*.

(the Emmanuel Community) in Paris, Rome, Melbourne, Manila, and elsewhere, who have given me moral support and who have encouraged me to complete this project.

I grew up in Zambia, Central Africa. Our parish was run by Conventual Franciscan Friars and my mother became a Franciscan Tertiary in later life. I attended three schools staffed by Dominican Sisters, where I received an excellent education. Little did I imagine that many years later I would write a book about the history, architecture, and art of Dominicans and Franciscans in medieval Rome. I hope that what I have expressed here embodies the Dominican motto 'Veritas' (Truth) as well as the Franciscan greeting 'Pax et Bonum' (Peace and Goodness).

As always, there are sure to be some mistakes, for which I alone am responsible and for which I apologize. As this work nears completion, I think of how the Dominicans end each day solemnly chanting the 'Salve Regina', which addresses the Virgin Mary as 'Advocata' (her title in the icons of S. Sisto and S. Maria in Aracoeli [Plates 1, 2, and 7]), praying, 'illos tuos misericordes oculos ad nos converte' (turn […] your eyes of mercy towards us).

Joan Barclay Lloyd
Rome, 28 February 2021

I dedicate this book
to two friends:

Father Paul Murray, OP
(Dominican priest, poet, and professor)

and

Sister Mary-Louise Slattery, FMM
(Franciscan Missionary of Mary among Aboriginal
and other people in Australia)

Abbreviations

AASS *Acta Sanctorum*

ACSR Archivio Centrale dello Stato di Roma

AFH *Archivum Fratrum Historicum*

AFP *Archivum Fratrum Praedicatorum*

AGOP Archivum Generale Ordinis Fratrum Praedicatorum

AM Archivum Minervitanum

ASC Archivio storico capitolino

ASR Archivio di Stato, Roma

ASV Archivio Segreto Vaticano

BAV Biblioteca Apostolica Vaticana

BF *Bullarium Francescanum*

BOP Bullarium Ordinis Fratrum Praedicatorum

BSR British School at Rome

DBI *Dizionario Biografico degli Italiani*, ed. and directed by Alberto M. Ghisalberti, Massimiliano Pavan, and Fiorella Bartocchi, (Rome: Istituto della Enciclopedia Italiana fondata da Giovanni Trecciani)

FAED *Francis of Assisi: Early Documents*, 4 vols: I. *The Saint*; II. *The Founder*; III. *The Prophet*; IV. *Index*, ed. by Regis Armstrong, J. A. Wayne Hellman, and William J. Short (New York: New City Press, 1999–2001)

ICCD Istituto Centrale per il Catalogo e la Documentazione

ICCROM International Centre for the Study of the Preservation and Restoration of Cultural Property

LP *Le Liber Pontificalis*, ed. by Louis Duchesne. 2 vols (Paris: Editions E. Du Boccard, 1981)

MGH Monumenta Germaniae Historica

MGH SS Monumenta Germaniae Historica, Scriptores

MiBACT Ministero per i Beni e le Attività Culturali e per il Turismo

MOPH Monumenta Ordinis fratrum Praedicatorum Historica

NCE *New Catholic Encyclopedia*

OFM Order of Friars Minor

OP Order of Preachers

PBSR *Papers of the British School at Rome*

PL *Patrologiae Cursus completus. Series Latina*, ed. by Jacques-Paul Migne, 221 vols (Paris: Bibliotecae Cleri Universae, 1844–1864)

RB Rule of Saint Benedict

Colour Plates

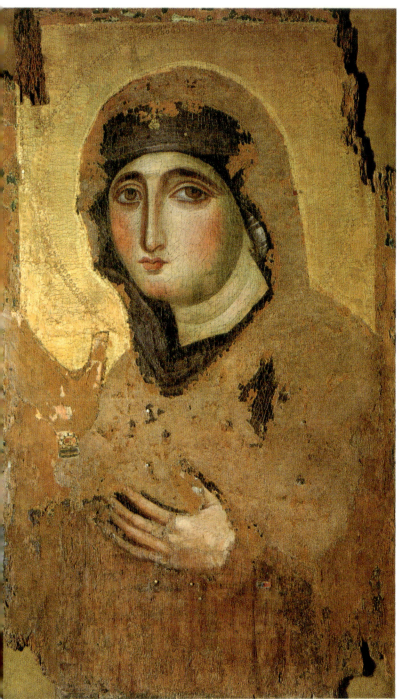

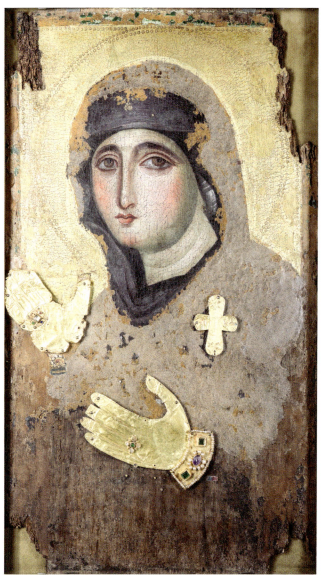

Plate 1. Icon of S. Sisto (*Maria Advocata / Hagiosoritissa*), encaustic technique, sixth or early seventh century, Byzantine, now at the Dominican nuns' church of S. Maria del Rosario, Monte Mario, Rome (photo: © Giulio Archinà)

Plate 2. Copy of the icon of S. Sisto with the gold attachments, which were added to the original in the seventh century (photo: © Giulio Archinà)

22 COLOUR PLATES

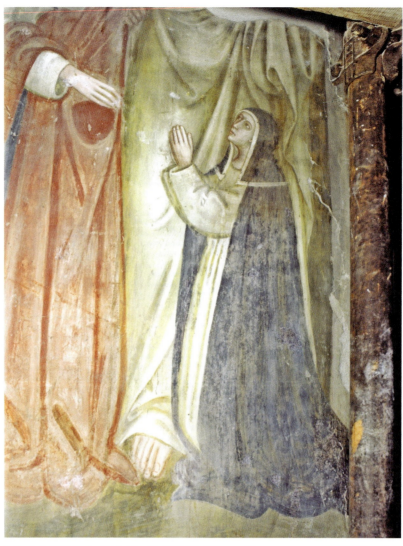

Plate 3. Unknown artist, a medieval Dominican nun, a member of the Sant'Eustachio family, at the feet of Christ, as patron of the fresco on the upper left wall of the chancel at S. Sisto, c. 1400 (photo: Archivio Fotografico, Musei Lazio – under licence from MiBACT)

Plate 4. *The Mother of God holding the Christ Child, surrounded by saints and patrons*, a recently found fresco in the narthex of S. Sabina, painted in 708–15 (photo: author)

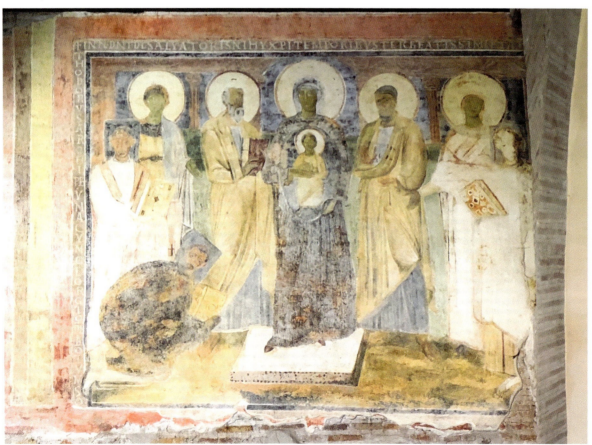

COLOUR PLATES 23

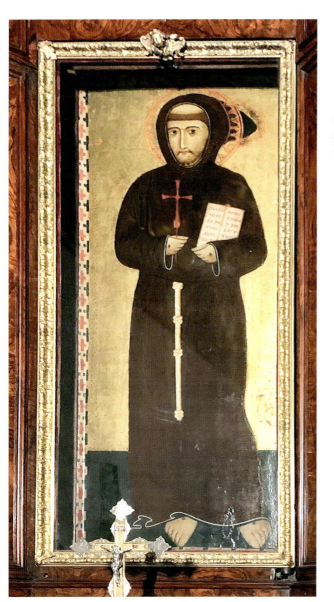

Plate 5. Margaritone of Arezzo, *Saint Francis of Assisi*, c. 1260–1272 (photo: author)

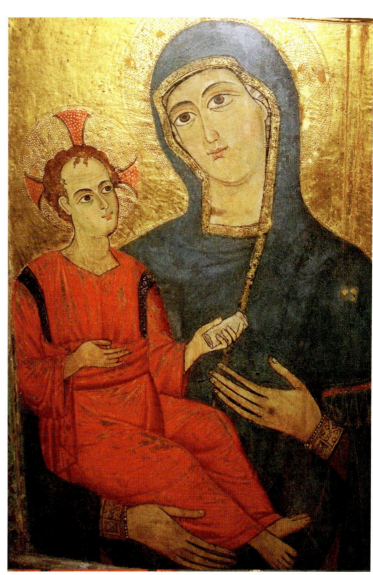

Plate 6. Icon of the *Mother of God Hodegetria*, from S. Cosimato, now in the Poor Clare nunnery on the Little Aventine (Photo: Alberto Ferri)

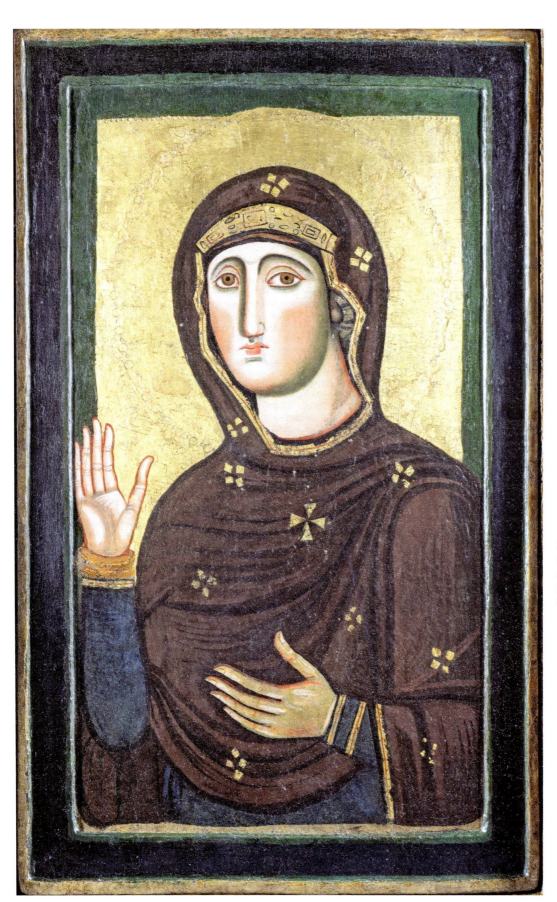

Plate 7. *Maria Advocata*, icon of the late eleventh century, S. Maria in Aracoeli (photo: © Giulio Archinà)

Introduction

There are many venerable churches, monasteries, and shrines in Rome. In the sixteenth and seventeenth centuries, pilgrims were encouraged to visit seven churches in and around the city.[3] These were among Rome's most important sanctuaries: the cathedral of S. Giovanni in Laterano (St. John Lateran), S. Pietro in Vaticano (Old St. Peter's), S. Paolo fuori le Mura, S. Croce in Gerusalemme, S. Maria Maggiore, S. Sebastiano, and S. Lorenzo fuori le Mura. These churches were not only great shrines; they were also significant examples of early Christian architecture, being among the most famous basilicas in Rome, built originally from the fourth to the sixth century.[4] Sometimes, from the end of the sixteenth century onwards, two other holy places, south of the city, were added to this list: S. Maria Annunziata and the sanctuaries at Tre Fontane.[5]

This book is about another group of seven churches in the city, together with their adjacent conventual buildings. They are less well-known than the traditional seven basilicas, yet they are significant because they were the houses where the Dominicans and Franciscans resided in Rome in the later Middle Ages (Fig. 1, 1–7).[6]

In the thirteenth century, these seven churches were ceded to the two Mendicant Orders, and then remodelled or rebuilt. The first Dominican foundations in the city were S. Sisto (called 'S. Sisto Vecchio' from the late sixteenth century onwards), where Saint Dominic founded a nunnery *c.* 1218–1221,[7] and the Dominican priory of S. Sabina, which was established between *c.* 1220 and 1222.[8] The Franciscans took over the church and 'Hospital' (meaning in this case a hostel for pilgrims) of S. Biagio near the Ripa Grande (the main river port in Rome) in 1229 and transformed them into the church and friary of S. Francesco a Ripa.[9] In 1234, SS. Cosma e Damiano in Mica Aurea (called 'S. Cosimato' from 1238 onwards), was transformed into a Franciscan nunnery.[10] These were the first four

3 See, for example, Panvinio, *De praecipuis Urbis Romae sanctioribusque Basilicis* and Severano, *Memorie sacre delle sette Chiese*.
4 Krautheimer, *Corpus*; Brandenburg, *The Ancient Churches of Rome*. Of course, by the sixteenth century, many changes had been made to these early basilicas.
5 See, Baglione, *Le nove chiese*.
6 This map, by Pietro Ruga, was published in 1824. By then, buildings had spread north-west of S. Silvestro in Capite and along the banks of the Tiber. Although this is not an accurate representation of the medieval city in the thirteenth century, it shows the location of the medieval Dominican and Franciscan foundations, before the exponential urban growth that came after 20 September 1870, when the Risorgimento troops took the city and Rome became the capital of Italy.

For an overview of recent studies of Dominican and Franciscan architecture and art, see Bruzelius, 'The Architecture of the Mendicant Orders'. Among such studies, the following stand out: Schenkluhn, *Architektur der Bettelorden* (translated into Italian as *Architettura degli Ordini Mendicanti*); Jäggi, *Frauenklöster*; Cannon, *Religious Poverty, Visual Riches*; and Bruzelius, *Preaching, Building, and Burying*.

7 See the three volumes edited by Raimondo Spiazzi: Spiazzi, *La chiesa e il monastero di San Sisto*; Spiazzi, *Cronache e Fioretti*; and Spiazzi, *San Domenico e il monastero di San Sisto*; Bolton, 'Daughters of Rome'; and Barclay Lloyd, 'The Architectural Planning of Pope Innocent III's Nunnery of S. Sisto'.
8 Barclay Lloyd, 'Medieval Dominican Architecture at Santa Sabina'; and Gianandrea, Annibali, and Bartoni, ed., *Il convento di Santa Sabina*, published in 2016.
9 Menichella, *San Francesco a Ripa*; Del Vasto, *Church of S. Francis of Assisi a Ripa Grande* and, recently, Degni and Porzio, ed., *La Fabbrica del Convento*, published in 2011.
10 Barclay Lloyd and Bull-Simonsen Einaudi, *SS. Cosma e Damiano in Mica Aurea*. Recently, two volumes of essays were published in 2013 and 2017, respectively Guerrini Ferri and Barclay Lloyd, ed., *'San Chosm' e Damiano'* and Velli, ed., *Nuovi Studi su San Cosimato*.

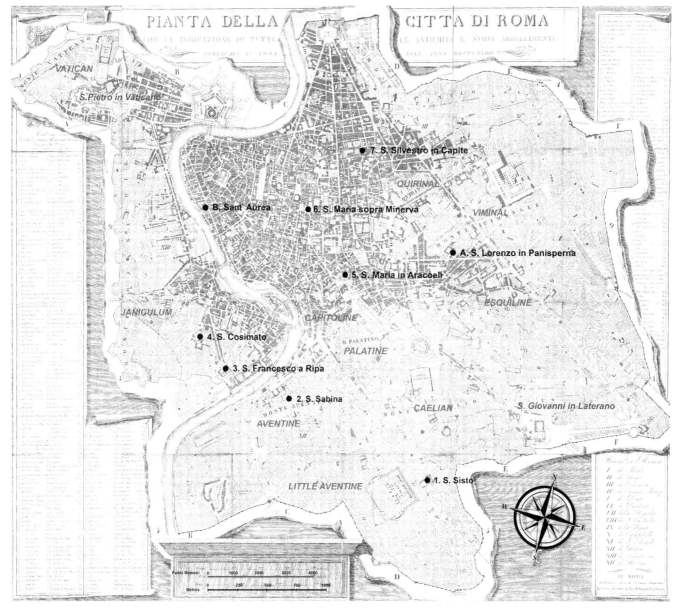

Figure 1. Map of Rome showing thirteenth-century Dominican and Franciscan foundations, 1–7 and two fourteenth-century nunneries, A and B (Pietro Ruga, Pianta della città di Roma [Map of the city of Rome], 1824, detail; BSR Library Collection, Maps, 609.2.82.2, adapted by David R. Marshall).

Dominican and Franciscan foundations in Rome and they are each discussed in a separate chapter in Part I of this book. Part II deals with the next generation of Dominicans and Franciscans, who moved into other quarters in Rome in the second half of the thirteenth century. On the Capitoline Hill, between 1248 and 1252, the Friars Minor were given the Benedictine church and monastery of S. Maria in Capitolio (or S. Maria in Aracoeli), which they replaced with a large new basilica and a friary.[11] S. Maria sopra Minerva, first ceded to the Order of Preachers

11 See, most recently, Bolgia, *Reclaiming the Roman Capitol*, published in 2017. A new study of the church by Daniela Mondini is to appear in *Die Kirchen der Stadt Rom im Mittelalter*, vol. v.

c. 1266, was totally rebuilt by them from about 1280 onwards.[12] The Colonna family established a Franciscan nunnery at S. Silvestro in Capite in 1285.[13] There were also two other medieval Franciscan and Dominican foundations, made in the fourteenth century: the Poor Clare nunnery of S. Lorenzo in Panisperna, founded between 1308 and 1318 by Cardinal Giacomo Colonna, and Sant' Aurea, a Dominican nunnery established in the mid-fourteenth century (Fig. 1: A and B).[14] The history of S. Lorenzo is briefly discussed in Chapter 7 of this book and Sant' Aurea is mentioned in Chapter 1.

This book focuses on the seven major Dominican and Franciscan thirteenth-century building complexes, comparing the earlier ones in Part I with the later ones in Part II. The general aim is to locate each church and convent in the topography of the city; to trace the history of earlier ecclesiastical foundations on the site; to recount how the Dominicans or Franciscans took them over and renewed them; to analyse and reconstruct the medieval architecture, now often obscured by later changes; and to examine the medieval works of art in them that are still accessible, or which are known from written sources. The patrons who paid for these buildings and works of art are also identified, where possible.

All this is done within an overarching perspective of the evolution of the two Mendicant Orders. After an initial phase of foundation by Saint Dominic (*c.* 1174–1221), the Friars Preachers had become known as members of the 'First Order' of Dominicans, while the nuns were accepted officially as members of the 'Second Order' in 1267. Saint Francis (1182–1226) was joined by many friars and helped Saint Clare to establish a female community at San Damiano just outside Assisi; he also welcomed lay men and women as tertiaries, or a Third Order. Cardinal Ugolino, who later became Pope Gregory IX (1227–1241), founded nunneries, which were related to the two Mendicant Orders; one of these was S. Cosimato in Rome. There were also penitents, or 'semi-religious' members of the Franciscan and Dominican Orders, who did not reside in convents.[15] One of them, the 'mantellata' Catherine of Siena, came to Rome in 1378 and stayed in a house near S. Maria sopra Minerva, the Dominican church where she was buried in 1380. After her canonization in 1461, an inscription on her tomb identified her anachronistically as a member of the 'Order of Penitence of Saint Dominic', a Third Order of Dominicans of consecrated life, given papal approval in 1405.

After the Pope had moved to Avignon in France in 1309, an inventory, now known as the 'Catalogue of Turin', was made of all the churches in Rome.[16] This census noted the location of each church and monastery, and the

12 Kleefisch, 'Die römische Dominikanerkirche S. Maria sopra Minerva von 1280 bis 1453'; Palmerio and Villetti, *Storia edilizia*; Kleefisch-Jobst, *Die römische Dominikanerkirche Santa Maria sopra Minerva*; and Villetti and Palmerio, *Santa Maria sopra Minerva in Roma*. Recently, in 2020, Almuth Klein added a short study of the church in Claussen, *Die Kirchen der Stadt Rom im Mittelalter*, vol. IV, pp. 310–36.

13 See the 2015 edition of Kane, *The Church of San Silvestro* and the new English translations of medieval documents published with a historical commentary in *Visions of Sainthood in Medieval Rome*, trans. by Field, ed. by Knox and Field, in 2017.

14 For S. Lorenzo in Panisperna, see Rehberg, 'Nobiltà e monasteri femminili nel Trecento'; Marini, 'Il monastero di San Lorenzo in Panisperna'; Fallica, 'Sviluppo e trasformazione'; Sturm, Canciani, Pastor Altaba, and d'Angelico, 'Dal monastero di S. Lorenzo in Panisperna al palazzo del Viminale'. For Sant' Aurea, see Pecchiai, *La Chiesa dello Spirito Santo dei Napolitani e l'antica chiesa di S. Aurea*; Gardner, 'Nuns and Altarpieces'; Dunlop, '*Advocata Nostra*'; and Dunlop, 'The Dominicans and Cloistered Women'.

15 See Makowski, 'A Pernicious Sort of Woman'; *Dominican Penitent Women*, ed. and trans. by Lehmijoki-Gardner; and Kilgallon, 'Female Sites of Devotion'.

16 Biblioteca Nazionale di Torino, MS lat. A 381, fols 1–16, published in Valentini and Zucchetti, *Codice Topografico*, vol. III, pp. 205–09 and 291–318, and in Huelsen, *Le chiese di Roma*, pp. 26–43.

number of clergy who lived there, with their status as diocesan priests, canons, or members of religious Orders; it also included information about the communities of nuns. This document, which refers to 408 churches spread over the city, is usually dated *c.* 1320.[17] The inventory lists five patriarchal basilicas; twenty-seven tituli of cardinal presbyters and eighteen of cardinal deacons; twenty-eight communities of monks or friars; twenty nunneries; twenty-five hospitals; eleven papal chapels; twenty-one collegiate churches, with from three to six canons; and 261 parish churches with one or two clerics, forty-three with no ministers, and eleven that had been demolished.[18] Within this conspectus, the Catalogue of Turin lists the seven churches that are the subject of this study, assigning them to Dominican and Franciscan friars or nuns. While the friars of the two Mendicant Orders had lived in earlier temporary accommodation at some other places in the city, these seven churches were where the Dominicans and Franciscans had become firmly established in Rome by the early fourteenth century.

In the Catalogue of Turin, the Dominicans are mentioned in three places: at the nunnery of S. Sisto, with seventy nuns and sixteen Friars Preachers; at the church of S. Sabina, with thirty Friars Preachers; and at S. Maria sopra Minerva, with fifty Friars Preachers.[19] The Franciscans are listed at four places: at the church of S. Francesco a Ripa, with fifteen Friars Minor; at S. Maria in Aracoeli, with fifty Friars Minor; and at the two nunneries of S. Cosimato and S. Silvestro in Capite, each with thirty-six nuns of the 'Order of Saint Clare' and two Friars Minor.[20] This makes a total of ninety-six Friars Preachers and seventy Dominican nuns; and sixty-nine Friars Minor and seventy-two Clarissan nuns. The total number of nuns in each Order is almost equal, while, among the friars, there are twenty-seven more Dominicans than Franciscans. S. Maria in Aracoeli and S. Maria sopra Minerva are comparable communities, with fifty friars each, representing the 'main' house of each Order in Rome at that time. The thirty Friars Preachers at S. Sabina form a medium-sized community, while the group of fifteen Friars Minor at S. Francesco a Ripa is similar to the sixteen Friars Preachers at S. Sisto.

At S. Lorenzo in Panisperna the Catalogue of Turin lists eighteen nuns but does not identify the religious Order to which they belonged (Fig. 1, A), perhaps because it was a very new foundation.[21] They were probably of the Order of Saint Clare and would have increased the total number of Franciscan nuns in Rome to ninety. The church was rebuilt in the sixteenth century and still has its nuns' choir from that time.[22] A Dominican nunnery, dedicated to Sant' Aurea, is known to have existed in Rome from at least the mid-fourteenth century onwards (Fig. 1, B).[23]

17 Falco, 'Il catalogo di Torino', pp. 441–43, found from internal evidence that it must have been written after 1313, and he suggested it was completed by 1339; Huelsen, *Le chiese di Roma*, p. 16, dated it *c.* 1320.

18 There is some discrepancy between the number of churches listed and the total number given in the summary at the end of the document — for example, there are 408 churches listed, but the summary refers to 414.

19 Valentini and Zucchetti, *Codice topografico*, vol. III, pp. 309 (S. Sisto); p. 308 (S. Sabina); p. 299 (S. Maria sopra Minerva).

20 Valentini and Zucchetti, *Codice topografico*, vol. III, p. 293 (S. Silvestro in Capite); p. 304 (S. Maria in Aracoeli); p. 306 (S. Francesco a Ripa); and p. 316 (SS. Cosma e Damiano).

21 Valentini and Zucchetti, *Codice topografico*, vol. III, p. 302: 'Monasterium Sancti Laurentii Panispernae habet moniales XVIII' (the monastery of S. Lorenzo in Panisperna has eighteen nuns). For the history of this nunnery, see Rehberg, *Die Kanoniker*, p. 115; Rehberg, 'Nobiltà e monasteri femminili nel Trecento'; Marini, 'Il monastero di San Lorenzo in Panisperna'; and Ait, 'Il Patrimonio delle clarisse di San Lorenzo in Panisperna'.

22 Its history is compared briefly with that of S. Silvestro in Chapter 7.

23 For this convent, see Pecchiai, *La Chiesa dello Spirito Santo dei Napolitani e l'antica chiesa di S. Aurea*; see also,

It is not mentioned in the Catalogue of Turin; and, when the nuns from that convent joined S. Sisto in 1514, the nunnery of Sant' Aurea was closed, and the site was sold. (A fine altarpiece painted by Lippo Vanni shortly after 1368 was, however, taken from there to S. Sisto in the early sixteenth century and is now in the Chapter Room at the Pontifical University of Saint Thomas Aquinas, the 'Angelicum'.[24]) These two fourteenth-century nunneries — S. Lorenzo in Panisperna and Sant' Aurea — are briefly mentioned, but they have not been included in separate chapters in this volume.

It is said that the Benedictines chose to build their abbeys on hilltops and the Cistercians located their monasteries in valleys, whereas the Dominicans and Franciscans lived in towns. The monks left the world to live in their monasteries, most of which were in the countryside;[25] but the friars went into towns and worked among lay people, exercising pastoral care, or 'cure of souls'. Medieval Rome, however, was no ordinary town.[26] It was a very ancient city, in antiquity the capital of the Roman Empire, known in the Middle Ages as 'Caput Mundi' (the head of the world). Situated on its famous seven hills, Rome had been divided into fourteen regions by Augustus (27 BC–AD 14). Later, in the third century, the popes created seven ecclesiastical regions. By the thirteenth century, some of these divisions remained, but notaries would often refer to buildings as located near a well-known landmark or situated in a smaller medieval region.[27] From about 1118, there were twelve important regions, some of which were subdivided into smaller ones; beyond these, there were large areas such as Trastevere, or stretches of almost uninhabited land, like that near the ruins of the Baths of Caracalla or on the Aventine Hill.[28] From 271, Rome was surrounded by the Aurelian Walls with gates located where ancient roads led in and out of the city. Parts of the ancient road network survived, amid the irregular narrow streets and winding lanes of the medieval city. In the thirteenth century, there were still some large ruins from ancient Rome, such as the Colosseum, the Pantheon, and the Baths of Caracalla, as well as remnants of temples, aqueducts, and triumphal arches. Some less clearly defined 'crypts' may have been the large rooms of ancient Roman structures that had been partly buried.

In the thirteenth century, the area within the Aurelian Walls was extensive, but it was not all densely inhabited, most people living in small houses, in clusters near large churches or spread out across the city, along the banks of the River Tiber, or in the inner part of the Campus Martius, the so-called 'Tiber bend'. The city did not have a well-defined centre. Its cathedral was at the Lateran, near the Aurelian Walls to the east, while the greatest pilgrim church was Old St Peter's, officially outside the city's boundaries and across the river in the Leonine City at the Vatican on the north-west. From *c.* 1143, the medieval Roman Senate provided civic government and

Gardner, 'Nuns and Altarpieces'; Dunlop, '*Advocata Nostra*'; and Dunlop, 'The Dominicans and Cloistered Women'.

24 Gardner, 'Nuns and Altarpieces'; Dunlop, '*Advocata Nostra*'; and Dunlop, 'The Dominicans and Cloistered Women'.

25 There were urban monasteries in medieval Rome, however, see Ferrari, *Early Roman Monasteries* and Sansterre, *Les Moines grecs et orientaux à Rome*.

26 See Brentano, *Rome before Avignon*; Krautheimer, *Rome*, esp. Part II: *Forma Urbis Romae Medievalis*, pp. 231–326; and Hubert, *Espace urbain et habitat*. For early medieval Rome, see, for example, Osborne, *Rome in the Eighth Century*; and for the history of the city from 900 to 1150, Wickham, *Medieval Rome*.

27 Hubert, *Espace urbain et habitat*, Chapters 1 and 2. The Catalogue of Turin divides the city into the three ecclesiastical regions governed by the Rectors and Fraternity of the Roman clergy.

28 See, for example, Wickham, *Medieval Rome*, Chapters 4, 6, and 7, who refers to twelve 'super-regiones', divided into lesser 'regiones', such as those at the Colosseum / S. Maria Nova, Pigna, or Colonna.

a tribunal for the city on the Capitoline Hill.[29] Prominent families lived in houses and palaces, with adjoining defensive towers, which were part of the Roman landscape. Because of the complexity of the medieval city and its ancient past, the location of each Mendicant church and convent is discussed. It is clear that the Dominican and Franciscan communities took the place of much older ecclesiastical establishments, whose history is briefly outlined. In this way, the Mendicant Orders renewed the Church in Rome spiritually and in its architecture.

At first, the Dominicans and Franciscans lived on the periphery of the city — the Dominican nuns at S. Sisto in a sparsely inhabited area on the lower slopes of the Caelian Hill near the Via Appia and the friars at S. Sabina on the Aventine Hill, while the Franciscans occupied the edges of Trastevere at S. Francesco a Ripa and S. Cosimato. Later, the Friars Minor moved to S. Maria in Aracoeli on the Capitoline Hill, which had become the centre of civic government after the creation of the Roman Commune, and the Dominicans opened a new house at S. Maria sopra Minerva near the Pantheon in the densely inhabited part of the Tiber bend. At that time, the friars wanted to be closer to the townspeople in order to minister more effectively to the urban population.[30] After being itinerant preachers, speaking to people in public squares, the friars from the mid-thirteenth century onwards began to have their own parish churches, which were often new and large. They also began to establish their own centres of study, with extensive libraries — even though Francis of Assisi had not at first encouraged his friars to be highly educated.

In the thirteenth century, Rome was the centre of the Church. The Pope resided in a palace at the Lateran, near the cathedral, and, when he was not in Rome, he stayed in one of the smaller towns in the region, such as Viterbo, Rieti, Anagni, or Perugia.[31] At the Lateran, there were the offices of the papal Curia.[32] People from many different countries came to negotiate high level ecclesiastical business there, while complex legal cases were decided according to Canon Law at the Church's legal tribunals.

The foundation and development of the Dominican and Franciscan Orders was strongly influenced by the papacy.[33] Consequently, this book takes into account the negotiations between Pope Innocent III (1198–1216) and Dominic and Francis, or the later popes and the Master General of the Dominicans or the Minister General of the Franciscans, as well as the intervention of the papacy in the 'religio' (religious way of life) of Dominican and Franciscan nuns. Innocent III gave Dominic and Francis advice and direction about their nascent religious Orders, sending Dominic to preach to the heretics in France and verbally approving Francis's evangelical way of life and giving him and his companions, as laymen, permission to preach penitence and peace. Honorius III (1216–1227) officially approved the Order of Preachers in 1216 and the Order of Friars Minor in 1223. Gregory IX canonized Francis in 1228 and Dominic in 1234. Innocent IV (1243–1254) rescinded privileges granted to the Mendicant Orders in the face of opposition to the friars from the diocesan clergy, but his successor Alexander IV (1254–1261) intervened on their behalf and not only restored but also extended their privileges.[34] Innocent IV and Urban IV (1261–1264) approved and revised Rules for the Franciscan nuns, who, from 1263,

29 Wickham, *Medieval Rome*, at the end of Chapter 7, gives an account of the formation of the renewed Roman Senate, with further bibliography on the subject.

30 Bruzelius, *Preaching, Building, and Burying*, pp. 107–35.

31 See Gardner, *The Roman Crucible*, pp. 303–28.

32 Gardner, *The Roman Crucible*, pp. 17–34.

33 See, for example, Robson, *The Franciscans*, pp. 69–81, with regard to the Friars Minor.

34 See, for example, Lawrence, *The Friars*, Chapter 8; Brett, *Humbert of Romans*, pp. 12–40; Hinnebusch, *History of the Dominican Order*, vol. I, pp. 319–20; Lambertini, *Apologia e crescita dell'identità Francescana (1255–1279)*.

were called 'Poor Clares' or the 'Order of Saint Clare'. Nicholas III (1277–1280) favoured the Franciscans. Pope Honorius IV (1285–1287) built a palace next door to the Dominican priory of S. Sabina. Towards the end of the thirteenth century, a Franciscan, Girolamo of Ascoli, became Pope Nicholas IV (1288–1292); and a Dominican, Niccolò Boccasini, became Pope Benedict XI (1303–1304).

The popes appointed cardinals to assist the two new Mendicant Orders, another important historical theme. Most cardinals had a titular church and a palace in Rome; for example, Stefano Conti was Cardinal Presbyter of S. Maria in Trastevere and built a palace, which has recently been restored, at SS. Quattro Coronati.[35] Some of the cardinals served on papal 'committees' connected with the new Mendicant foundations — for example, a group of three cardinals assisted Dominic in founding the nunnery of S. Sisto and another group of three cardinals helped to secure S. Maria in Aracoeli for the Franciscan friars. A cardinal also acted as Protector of the Franciscan Order.

Often, the popes and cardinals came from Rome or from nearby towns, and sometimes they were members of prominent local noble families, such as the Savelli (Honorius IV), the Orsini (Nicholas III), or the Caetani (Boniface VIII (1294–1303)). Some cardinals active in promoting the Dominican and Franciscan Orders sponsored the buildings and art of the Mendicant friars and nuns. Eventually, there were also Dominican and Franciscan cardinals, who looked after the interests of their respective Orders.

In the later Middle Ages, the Holy Roman Emperor had to come to Rome to be crowned by the pope, but he often opposed the papacy, as was the case with Frederick II (1220–1250). For this reason, Pope Innocent IV remained outside of Rome from 1245–1251, taking refuge in Lyon in France. He appointed Stefano Conti, Cardinal of S. Maria in Trastevere, to act as 'Vicarius Urbis' (Vicar of Rome) in his absence. The Cardinal, like his relatives, who included his uncle Pope Innocent III, was influential in promoting the new Mendicant Orders. Such 'patrons', who were members of important Roman families, were involved in the establishment, building, and decoration of Dominican and Franciscan churches and convents in Rome. This was very necessary, as the Mendicant Orders were vowed to poverty and did not possess the financial resources to build large churches, friaries, and nunneries.

There was sometimes fierce rivalry among the noble Roman families, which could lead to violence in the city. This can be seen, for example, in the relationship between Pope Boniface VIII Caetani and the Colonna family at the end of the thirteenth century. Since both the Caetani and the Colonna were patrons of the Dominicans and Franciscans, this had an impact on their foundations.

Rome had its own architectural and artistic traditions. From the early fourth century, most churches were colonnaded basilicas, which had a nave, two or more aisles, an apse, and sometimes a transept. One aim of this study is to show how far the Dominicans and Franciscans retained or copied the traditional forms of architecture in Rome and how far they introduced new elements — such as pointed windows filled with tracery, or ribbed vaults (as in S. Maria in Aracoeli) — or a building entirely in the Gothic style, as at S. Maria sopra Minerva. From this it can be seen that the thirteenth-century Dominicans and Franciscans introduced new elements of Gothic architecture to Rome.

A special theme of this book is the architecture of nunneries in the Eternal City. Of course, the Dominican and Franciscan nunneries were

35 For this cardinal see Paravicini Bagliani, *Cardinali di Curia*, p. 15; for his palace, Barelli, *The Monumental Complex of Santi Quattro Coronati*; Draghi, *Gli affreschi dell'Aula Gotica*; Draghi, *Il Palazzo cardinalizio dei Santi Quattro a Roma*; Romano, ed., *Il Duecento e la cultura gotica 1198–1287*, no. 30, pp. 136–79.

not the only ones in Rome in the thirteenth century. The Catalogue of Turin listed twenty women's monasteries, with a total of 468 nuns.[36] At S. Agnese fuori le Mura, at S. Ciriaco (next to S. Maria in Via Lata), and at S. Maria in Iulia, there were forty Benedictine nuns in each community; and at S. Pancrazio, there were thirty-five Cistercian nuns.[37] The remaining female convents had communities of between four and eighteen nuns. The architecture of the Mendicant nunneries in Rome is compared with some other convents in the city, in Lazio, and in Naples.[38] At the early Dominican and Franciscan nunneries, there were also a few friars, accommodated in separate buildings, whose duty was to care for the spiritual and temporal needs of the Sisters. The nuns lived in strict enclosure, which was confirmed by papal legislation, culminating in Boniface VIII's Bull *Periculoso*, issued in 1298.[39] In contrast, the friars moved about freely as preachers and teachers. Members of the Franciscan Third Order and Dominican lay people or consecrated penitents usually lived in their own homes.

In an overview of recent literature on medieval Mendicant architecture, Caroline Bruzelius in 2012 observed that there were broadly three kinds of study.[40] Some scholars concentrated on the buildings of one complex, analysing a particular church or convent, or both.[41] Others, in more synthetic studies, considered a broad range of buildings, including those in a particular geographical region and those constructed over a long period of time.[42] Yet others investigated how the legislation of the two Orders influenced what was built.[43] Beyond this kind of research, some scholars considered building practices and the organization of work; and some concentrated primarily on the decoration of the buildings.

This book combines some of these approaches. It presents a separate study of each of the seven thirteenth-century foundations in chronological order and includes some comments on the adjacent conventual buildings. In this way, the study of each complex is similar to the first category noted by Bruzelius. The fact that the discussion includes seven thirteenth-century Dominican and Franciscan foundations means that the work extends over more than one site within the city and over a long period of time. It also takes a long view of what existed before the mendicants took over and how their buildings changed over time. There is an attempt to show how the seven building complexes relate to one another and to other similar churches and convents in Rome and elsewhere in Central Italy, some similarities and differences being highlighted in passing. In this way, a more 'synthetic' approach is taken, as in Bruzelius's second category. Where possible, Dominican and Franciscan legislation about buildings is taken into account, as in Bruzelius's third category. Finally, attention is paid to methods of construction and the medieval works of art

36 These figures are arrived at by adding up the numbers in the text of the Catalogue of Turin, which, however, in its final summary gives a total of eighteen nuns' monasteries and 470 nuns, see Huelsen, *Le chiese di Roma*, pp. 42–43; Valentini and Zucchetti, *Codice topografico*, vol. III, pp. 317–18.

37 Valentini and Zucchetti, *Codice topografico*, vol. III, p. 293, (S. Agnese fuori le Mura); p. 294 (S. Ciriaco); p. 314 (S. Maria in Iulia); and p. 316 (S. Pancrazio).

38 See Jäggi, *Frauenklöster*, for the architecture of Dominican and Franciscan nunneries in Italy, Switzerland, and Germany, from the thirteenth and fourteenth centuries.

39 Makowski, *Canon Law and Cloistered Women*.

40 Bruzelius, 'The Architecture of the Mendicant Orders in the Middle Ages'.

41 For example, see the recent study of the church of S. Maria in Aracoeli, Bolgia, *Reclaiming the Roman Capitol*; and for a convent, Gianandrea, Annibali, and Bartoni, ed., *Il convento di Santa Sabina*.

42 See, for example, Schenkluhn, *Architektur der Bettelorden* (transl. in Italian as *Architettura degli Ordini Mendicanti*); and Jäggi, *Frauenklöster*.

43 For the Dominicans, see Sundt, '*Mediocres domos et humiles habeant fratres nostri*'; and Sundt, 'The Jacobin Church of Toulouse'.

that have survived or are known from written sources.

With regard to the architectural history of the seven foundations, three of the studies (S. Sisto, S. Sabina, and S. Cosimato) are based on architectural surveys that were made of the churches and monasteries by Jeremy M. Blake and the author. In a way, these represent examples of 'primary' architectural research, which is then connected with the archaeological and historical conclusions of other scholars. For the other four foundations, the groundwork has been done by other scholars and therefore a critical assessment is made of their studies, with the addition of new interpretations and new data.

In 2014, Bruzelius published a fine synthetic study of Italian Mendicant architecture;[44] Joanna Cannon authored a beautiful volume on medieval Dominican art;[45] and Donal Cooper and Janet Robson wrote a penetrating study of the frescoes in the upper church of S. Francesco in Assisi.[46] With a broader perspective, Julian Gardner has made a major contribution to the study of thirteenth-century architecture, art, and patronage in Rome and in some of its surrounding areas.[47] Besides these publications, there are many recent historical discussions of medieval Franciscan and Dominican nuns and semi-religious penitent women.[48] For understanding Saint Dominic, there are the notes of Simon Tugwell, and the biographies of Saint Dominic by Bedouelle and Goergen.[49] André Vauchez's books provide a recent perspective on Saint Francis of Assisi and Saint Catherine of Siena.[50] There are now very useful translations, with historical commentaries, of the medieval sources for Franciscan history published by scholars in the United States of America.[51]

In early 2020, the fourth volume of Claussen's *Die Kirchen der Stadt Rom im Mittelalter 1050–1300* was published, including a section on S. Maria sopra Minerva.[52] This is part of a 'corpus' of medieval churches, that is, a series of architectural studies of all the medieval churches that survive in Rome, arranged in alphabetical order. This book on the Dominican and Franciscan foundations of medieval Rome is a little similar, but it is also different in that it concentrates on a specific group of churches and convents. What makes it distinctive is the fact that these buildings are all connected with the Dominican and Franciscan Orders, and they are discussed in chronological order of their foundation, in the context of the history of those Orders.

New studies have focused on what modern archaeological methods and digital technology can bring to the study of medieval churches and

44 Bruzelius, *Preaching, Building, and Burying*.
45 Cannon, *Religious Poverty, Visual Riches*.
46 Cooper and Robson, *The Making of Assisi*.
47 Gardner, *The Roman Crucible*.
48 See, for example, Smith, 'Prouille, Madrid, Rome'; Smith, '*Clausura Districta*'; Smith, 'Shaping Authority'; Lehmijoki-Gardner, 'Writing Religious Rules'; *Dominican Penitent Women*, ed. and trans. by Lehmijoki-Gardner; Cariboni, 'Domenico e la vita religiosa femminile'; Rusconi, 'The Spread of Womens' Franciscanism in the Thirteenth Century'; Alberzoni, *Clare of Assisi and the Poor Sisters in the Thirteenth Century*; the studies in Zara and Festa, ed., *Il Velo, la Penna e la Parola*; Knox, *Creating Clare of Assisi*; and Mooney, *Clare of Assisi and the Thirteenth-Century Church*.
49 Tugwell, 'Notes', 1995–2004; and Tugwell, 'Schema chronologique de la vie de Saint Dominique'; Bedouelle, *Saint Dominic*; and Goergen, *St Dominic*. See also the standard earlier studies, Vicaire, 'Dominique'; Vicaire, *Saint Dominic*; Koudelka, 'Domenico'; Vicaire, *Dominique et ses prêcheurs*.
50 Vauchez, *Francis of Assisi*; Vauchez, *Catherine of Siena*.
51 *Francis of Assisi: Early Documents* (hereafter *FAED*), ed. by Armstrong, Hellman, and Short, 4 vols; *The Lady, Clare of Assisi*, ed. and trans. by Armstrong; *The Rules of Isabelle of France*, ed. and trans. by Field; *Visions of Sainthood in Medieval Rome*, trans. by Field, ed. by Knox and Field.
52 Claussen, Modini, and others, ed., *Die Kirchen der Stadt Rom im Mittelalter 1050–1300*, vol. IV, entry on S. Maria sopra Minerva by Almuth Klein, pp. 310–36. An entry on S. Maria in Aracoeli is to appear in the next volume in the series.

convents.⁵³ It is now possible to discover traces of buildings that lie below the floor of an edifice through the use of GPR (Ground Penetrating Radar). For example, this has shown the location and form of a choir-screen or 'tramezzo', which was later demolished, at S. Chiara in Naples. With digital 3D modelling, a reconstruction was then made of this feature of the medieval building. For this book, such studies would have been helpful, but unfortunately, they have not been possible. Besides, in Rome, almost all buildings stand above others of varied date, which makes the GPR technique difficult to use accurately. It will most likely be an important area for future investigation.

There is no doubt that the Dominicans and Franciscans were the most important new religious Orders founded in the thirteenth century. Dominic's Order of Preachers and the Dominican nuns began in the Midi, in France, where he and Bishop Diego d'Acabès were sent to preach to heretics; later, his well-educated friars spread all over Europe and beyond on a mission to save souls, and numerous convents of contemplative nuns were founded. Francis began in Assisi and then sent the Friars Minor on missions throughout the known world; he assisted Clare in Assisi to begin establishing a community of nuns, and he welcomed lay people as tertiaries as well.

Both Dominic and Francis visited Rome several times, but the centres of the Dominican and Franciscan Orders were elsewhere. Dominic made the university town of Bologna the headquarters of the Order of Preachers. Francis summoned his friars to the Portiuncula at S. Maria degli Angeli just outside Assisi, which became the Franciscan centre. Pope Gregory IX from 1228 onwards promoted the construction of the church of S. Francesco in Assisi, while the Dominicans rebuilt the church of S. Niccolò in Bologna and re-dedicated it to their founder. Although they were not at first the central houses of their Orders, the Dominican and Franciscan foundations in Rome were significant because of the importance of Rome for the medieval Church, and in later times both Orders had their headquarters in the city.

Dominic and Francis were both famous for their voluntary poverty, their fervent prayer, and their desire to spread the Gospel. Their backgrounds, training, and mission were different, however, and this influenced the evolution of their respective Orders. In his youth, Dominic, who was born in Caleruega in Spain, was educated by his uncle who was a priest, and then studied at the University of Palencia; he joined a community of Regular Canons at Osma and was ordained a priest.⁵⁴ He is famous for his joy, for his desire to speak only to God or about God, and for his ardent intercession for sinners — sometimes all through the night. Francis was the son of a wealthy merchant, who as a young layman went with the local army from Assisi to fight against Perugia, was captured by the enemy, and imprisoned for a year.⁵⁵ After that, he joined another military campaign bound for Puglia, but then withdrew. His life changed dramatically, when he was converted to a more radical faith in Christ, as he began to associate with lepers and to help the poor. After his dramatic opposition to his father, he began to wear a simple tunic and a cord, instead of his previous finery, as he assumed a life of voluntary poverty. He prayed in small churches, like those of San Damiano

53 See, for example, Sturm, Canciani, Pastor Altaba, and d'Angelico, 'Dal monastero di S. Lorenzo in Panisperna al palazzo del Viminale', for a virtual 3D remodelling of the Clarissan convent, as it was just prior to its suppression in 1873; Bruzelius, Giordano, Giles, Repola, de Feo, Basso, and Castagna, 'L'Eco delle Pietre'; Bruzelius and Repola, 'Monuments and Methods in the Age of Digital Technology'.

54 The standard modern biographies of Saint Dominic are Vicaire, 'Dominique'; Vicaire, *Saint Dominic*; Koudelka, 'Domenico'; Vicaire, *Dominique et ses prêcheurs*; Bedouelle, *Saint Dominic*; Tugwell, *Saint Dominic*; and Goergen, *St Dominic*.

55 For Saint Francis, see, for example, Vauchez, *Francis of Assisi*; and Rusconi, *Francis of Assisi*.

and S. Maria degli Angeli outside Assisi, and he restored both those buildings, as well as the local church of S. Pietro. His aim was to follow Christ in humility and poverty and to help others to do the same. For this reason, at Greccio, he constructed the Christmas crib and he often preached about the cross. He conformed his life to that of the Saviour so much that it was later claimed that he was 'alter Christus' (another Christ), especially after he received the wounds of Christ's crucifixion, the stigmata, at La Verna. Although he became a deacon, he was never ordained a priest.

Dominic and Francis were contemporaries, and their ideals were similar. They are said to have met in Rome. There were some differences, however. While Dominic valued education in the training of his priests, who had to preach and lead disputations with heretics, Francis distrusted too much reliance on intellectual pursuits. Dominic was very good at organizing his Order; he was responsible for the first version of its Constitutions and he obtained many papal documents ratifying its mission. Francis was wary of seeking documents from the papal Curia and, in the end, the Franciscans were not as united as the Dominicans.[56] His first Franciscan Rule claimed to be a formula of life based on the Gospel; Cardinal Ugolino, who later became Pope Gregory IX, helped Francis write a new version of the Rule, which was juridically acceptable to the Curia and which was confirmed by Pope Honorius III in 1223.[57] Francis, nonetheless, is famous for his written works, including his Letters, his Prayers, his Testament, and his poems — such as his famous *Canticle of the Creatures*.

Surprisingly, one story is told of both saints: Dominican and Franciscan sources, written in the mid-thirteenth century, say that Pope Innocent III had a dream of a humble man, supporting the cathedral of Rome, St John Lateran, which was threatening to fall down (see the paintings of this by Francesco Traini (1342–1345) and Giotto di Bondone (1297–1308), on the cover of this book).[58] Among the Dominicans, Gerard Frachet claimed the humble man was Saint Dominic, who in 1215 at the time of the Fourth Lateran Council, first asked the Pope to recognize his nascent community of preachers in Toulouse.[59] The Franciscans claimed it was Saint Francis, whom the Pope recognized a few days after his dream, when their founder was introduced to him.[60] At that encounter, an event which modern authorities date to 1209 or 1210, the Pope approved the first version of the Franciscan Rule, which was a simple formula of life, 'written in simple words, using the words of the holy Gospel', and he gave Francis and his followers permission to preach everywhere.[61] Besides reflecting the pontiff's anxieties about the state of the Church at the time, the story showed how Saints Dominic and Francis sustained and renewed the universal Church, which had some serious difficulties, such as heretics spreading false doctrines, the state of the clergy, and strained relations between bishops and secular rulers, which often resulted in violence and war.

56 In 1517, they were officially divided into three groups, the Friars Minor, the Conventuals, and the Capuchins, but differences became apparent long before that.

57 Accrocca, 'Francesco, il Cardinale Ugo di Ostia e la conferma papale della regola'.

58 For the Dominican version of the story, see Constantine of Orvieto, *Legenda*, 21 (dated *c*. 1244–1250), p. 301; and Gerard de Frachet, *Cronica, MCCXV*, in Fracheto, *Vitae Fratrum* (dated 1258), p. 323; and see also, Tugwell, 'Notes on the Life of St Dominic', (1995), pp. 10–11. The Franciscan version of the story is told in the 'Legend of the Three Companions' (dated 1241–1247), in *FAED*, vol. II, *The Founder*, pp. 97–98. It was repeated in the 'Kinship of Saint Francis', by Arnald Sarrant (dated 1365), see *FAED*, vol. III, *The Prophet*, p. 721.

59 Gerard de Frachet, *Cronica, MCCXV*, in Frachet, *Vitae Fratrum*, p. 323.

60 See, the 'Legend of the Three Companions', in *FAED*, vol. II, *The Founder*, pp. 97–98.

61 See, the 'Legend of the Three Companions', in *FAED*, vol. II, *The Founder*, p. 98; for the date, and, *FAED*, vol. I, p. 212, note a.

Images that illustrate the legend of the 'Dream of Pope Innocent III' show the Pope asleep in bed, and Rome's cathedral of St John Lateran falling down, while either Saint Dominic or Saint Francis support the collapsing edifice, as in the two illustrations on the cover of this book. The image on the left is a panel from an altarpiece, dated 1342–1345, that Francesco Traini made for the Dominicans in Pisa, showing *Saint Dominic with scenes from his life*.[62] In this representation, the founder of the Order of Preachers, recognizable in his black and white habit, leans against a pink building of a church that is clearly falling down. The image on the right is a fresco that Giotto painted in 1297 in the upper church of Saint Francis in Assisi, showing Saint Francis supporting on his right shoulder a corner of the colonnaded narthex of the Lateran basilica, with a tall campanile in the background. In contrast to Traini's depiction, in this image, the church looks like a medieval Roman basilica.[63] *The dream of Innocent III* was represented several times in earlier medieval art: for example, Nicola Pisano and his workshop carved a representation of it in relief on the sarcophagus of Saint Dominic's monumental tomb, set up in Bologna in 1264–1267;[64] and the Franciscans portrayed the scene in a mosaic (now in fragments) usually dated 1288–1292, on the cavetto of the Franciscan church of S. Maria in Aracoeli in Rome.[65] The story, common to the hagiography of both founders, affirmed the importance of Saints Dominic and Francis in the renewal of the medieval Church.

Indeed, contemporaries thought both Dominic and Francis brought new light into the Church of their day. Two early legends refer to moments in Dominic's infancy that were seen as prophetic of his future vocation. One relates that when Dominic's mother Juana was pregnant with him, she had a dream in which she saw a dog with a burning torch in its mouth racing through the world, setting it on fire.[66] In hindsight, the dream seemed to foretell Dominic's mission, as a great evangelist who would spread the Gospel by his preaching. A second early legend relates that at Dominic's baptism, a star was seen over the baby's head, or on his forehead, indicating his importance.[67] Pope Gregory IX wrote that Dominic was like a star that projected a very intense light, which could disperse the darkness of those who did not know the Lord, confuse the perverse teachings of heretics, and increase the blessed faith of believers.[68] A famous antiphon that reflects this has been prayed in his honour by the Dominicans since 1240:

62 For the Traini altarpiece, see Cannon, *Religious Poverty, Visual Riches*, pp. 261–73. The panel in question is on the far left of the lower scenes.

63 For Giotto's fresco, see Cooper and Robson, *The Making of Assisi*, pp. 26–27.

64 Cannon, *Religious Poverty, Visual Riches*, p. 2, fig. 2; Moskowitz, 'On the Sources and Meaning of Nicola Pisano's Arca di San Domenico in Bologna'; Moskowitz, *Nicola Pisano's Arca di San Domenico*; Dodsworth, 'Dominican Patronage and the Arca di S. Domenico'; Dodsworth, *The Arca of S. Domenico*.

65 Bolgia, *Reclaiming the Roman Capitol*, pp. 99, 201–03, 396 and Plate 4; see also, Gardner, ''The Louvre Stigmatization'; Andaloro, 'Il sogno di Innocenzio

III all'Aracoeli'; Gardner, 'Päpstliche Träume und Palastmalereien'; Gardner, 'Patterns of Papal Patronage'; Cooper and Robson, *The Making of Assisi*, pp. 26–27.

66 The story is told by Jordan of Saxony, *Libellus*, ed. by Walz, Scheeben, and Laurent, pp. 27–28; Ferrando, *Legenda*, ed. by Walz, Scheeben, and Laurent, pp. 210–11; Constantine of Orvieto, *Legenda*, ed. by Walz, Scheeben, and Laurent, pp. 288–89; Humbert of Romans, *Legenda*, ed. by Walz, Scheeben, and Laurent, p. 371. See also Lippini, *San Domenico*, pp. 71–72; Bedouelle, *Saint Dominic*, pp. 64–65.

67 Ferrando, *Legenda Sancti Dominici*, ed. by Walz, Scheeben, and Laurent, p. 212; Constantine of Orvieto, *Legenda*, ed. by Walz, Scheeben, and Laurent, p. 289; Humbert of Romans, *Legenda*, ed. by Walz, Scheeben, and Laurent, p. 372.

68 Gregory IX wrote this in his Mandate to set up official enquiries in 1233 into the life and virtues of Dominic de Guzman in preparation for his canonization in 1234, see Lippini, *San Domenico*, pp. 431–35, esp. p. 433.

Lumen ecclesiae, doctor veritatis
rosa patientiae, ebur castitatis,
aquam sapientiae propinasti gratis,
predicator gratiae nos iunge beatis.

> (Light of the Church, teacher of truth
> rose of patience, ivory of chastity,
> who freely bestows the water of wisdom,
> preacher of grace, unite us with the blessed).[69]

Similarly, in 1228–1229, Thomas of Celano wrote:

> At that time, through the presence of Saint Francis and through his reputation, it surely seemed a new light had been sent from heaven to earth, driving away all the darkness that had so nearly covered that whole region that hardly anyone knew where to turn […] He gleamed like 'a shining star in the darkness of the night and like the morning spread over the darkness'.[70]

Dominic and Francis seemed to bring new light into the medieval Church, and also into the ancient city of Rome, through their followers, who lived in the Dominican and Franciscan buildings discussed in this volume. The aim of this book is to give an orderly account of the history, architecture, and art of those foundations, taking a closer look at the surviving structures, old written and visual sources, and modern studies, as well as presenting new ideas. It is hoped that it will foster greater understanding of the two great Mendicant Orders and show how they renewed the Church of their day and enhanced the architecture and art of medieval Rome.

69 Evidently, the earliest version of this antiphon began 'O decus Hispaniae' (O glory of Spain), but the rest of the verses were the same; the first three words had been changed to 'O lumen ecclesiae' (O light of the Church) by 1240, with the approval of the Acts of the General Chapter of the Dominicans in that year. See Gleeson, 'Dominican Liturgical Manuscripts', esp. p. 104.

70 Thomas of Celano, *First Life of Saint Francis*, Book 1, chapter XV, in *FAED*, ed. by Armstrong, Hellman, and Short, vol. I, *The Saint*, p. 215. The quotation at the end is from Gregory IX's Bull, *Mira circa nos*, issued at the time of Francis's canonization in 1228.

Part I

The First Dominican and Franciscan Foundations in Rome

CHAPTER 1

The Dominican Nunnery at S. Sisto (now S. Sisto Vecchio), founded c. 1218–1221

Saint Dominic founded the nunnery of S. Sisto (now called 'S. Sisto Vecchio') in Rome *c.* 1218–1221. It was his third convent for women and his first foundation in the Eternal City, where he did not initially intend to establish a nunnery.[1] The first time Dominic came to Rome was in 1206, when he and Diego d'Acabès, Bishop of Osma in Castile, visited the court of Pope Innocent III (1198–1216) on their return from two diplomatic journeys to Scandinavia, to arrange a marriage between a Scandinavian princess and Ferdinand, the Spanish king's son and heir, which in fact did not take place.[2] In Rome, they asked Innocent III for papal approval to go and evangelize some pagans, the 'Cumani', whom they had met in Northern Europe, but the Pope refused their request.[3] Instead, he sent them to the Midi of France to join a preaching mission to the heretics that was led by the Cistercians, an assignment Diego and Dominic obediently accepted.[4]

Bishop Diego and Dominic had already met some of these heretics on their journeys.[5] Jordan of Saxony states that when Dominic perceived that they were heretics, he was disturbed, feeling great compassion for the many souls that were being wretchedly deceived.[6] At Toulouse, Bishop Diego and Dominic lodged at an inn owned by a heretic, and Dominic by arguing into the night managed to persuade him to accept the orthodox teachings of the Church.[7]

During their mission in the Midi, Bishop Diego and Dominic converted some heretic women, who asked them for protection, as they were afraid to return to their homes for fear of reprisals from their relatives. Diego and Dominic therefore established a residential community where these women could live 'religiously' (that is according to a religious way of life) in a church and monastery entrusted to them at Prouilhe (also known as Prouille), near Fanjeaux.[8] This was the first of three nunneries Dominic founded: at Prouilhe, Madrid, and Rome.[9] The French convent

1 The standard modern biographies of Saint Dominic are Jarrett, *Life of Saint Dominic*; Vicaire, 'Dominique'; Vicaire, *Saint Dominic*; Koudelka, 'Domenico'; Hinnebusch, *History of the Dominican Order*, vol. I; Vicaire, *Dominique et ses prêcheurs*; Hill, 'St Dominic'; Bedouelle, *Saint Dominic*; Tugwell, 'Notes on the Life of St Dominic'; Koudelka, *Dominic*; Tugwell, *Saint Dominic*; Tugwell, 'Schéma chronologique'; Lawrence, *The Friars*, pp. 65–88; and Goergen, *St Dominic*.
2 For the identification of the place as Denmark, see Bedouelle, *Saint Dominic*, p. 67.
3 Jordan of Saxony, *Libellus*, 17, p. 35; Tugwell, 'Schéma chronologique', 4, 1205.
4 For the Dominicans and their mission to heretics, see Ames, *Righteous Persecution*, with further bibliography on medieval heresy.

5 Jordan of Saxony, *Libellus*, 14, p. 33.
6 Jordan of Saxony, *Libellus*, 15, p. 33.
7 Jordan of Saxony, *Libellus*, 15, pp. 33–34; Bedouelle, *Saint Dominic*, p. 67.
8 Tugwell, 'Schéma chronologique', p. 6 and n. 18, for documents of 1206 and 1208. Other documents, which illustrate the establishment of the monastery, with donations, gifts, and deeds of sale to provide for it, are published in *Monumenta Diplomatica S. Dominici*, ed. by Koudelka. See also, Tugwell, 'For whom was Prouille founded?', esp. pp. 59–65.
9 Smith, 'Prouille, Madrid, Rome'; Duval, 'Comme les anges sur la terre', pp. 23–27. He also planned but left to others to establish the nunnery of S. Agnese in Bologna.

Figure 2. Mario Cartaro, *Large Map of Rome*, det. of Antonine Baths and S. Sisto, 1576 (Frutaz, *Piante di Roma*, vol. II, 1962, detail of Tav. 242)

was in existence by 1207.[10] In 1218, Dominic founded the nunnery at Madrid and a letter he wrote to the nuns there has survived.[11] His third foundation for nuns was at S. Sisto in Rome, a nunnery which had been begun by Innocent III, but left unfinished. His successor, Honorius III (1216–1227), after negotiating with the Gilbertines from 1218 to 1219, officially asked Dominic in December 1219 to complete the foundation, a task he accepted in obedience to the Pope.[12]

The first group of nuns moved into the convent on 28 February 1221 and by *c.* 1320, S. Sisto had become the largest nunnery in Rome and one of the most important Dominican foundations for women.[13] The nuns stayed there until 1576, when Pope Gregory XIII (1572–1585) transferred them to the new convent of SS. Domenico e Sisto on the Quirinal Hill.[14] From then onwards, the former medieval nunnery became known as 'S. Sisto Vecchio', a name it retains to this day.[15] (In this book, however, it will be given its medieval title, 'S. Sisto').

Location

S. Sisto is situated on the lower slopes of the Caelian Hill, opposite the 'Thermae Antonianae' (the Antonine Baths, or the Baths of Caracalla) (Figs 2 and 3). To the south-west, the buildings originally stood along the ancient Via Appia, as it led from Porta Capena in the Republican 'Servian' Wall of the fourth century BC to the Appian Gate (now known as Porta San Sebastiano) in the Aurelian Wall, built in AD 271.[16] Not far from S. Sisto, the Via Latina branched off the Via Appia in the direction of Porta Latina. To the south-east of the church ran another ancient road, which in the Middle Ages linked the nunnery to the papal quarter at the Lateran. This has been replaced by a modern thoroughfare, called 'Via Druso'.

The road network in this part of Rome was changed considerably in 1908–1917, when a vast archaeological park, called the 'Passeggiata

10 Bedouelle, *Saint Dominic*, p. 72.
11 *Early Dominicans*, ed. and trans. by Tugwell, p. 394; Lippini, *San Domenico*, pp. 315–17; Tugwell, 'St Dominic's Letter to the Nuns in Madrid'.
12 See Berthier, *Chroniques du monastère de San Sisto*, vol. I; Zucchi, *Roma domenicana*, vol. I, pp. 254–342; Koudelka, 'Le "Monasterium Tempuli" et la fondation dominicaine de San Sisto', pp. 4–81; Vicaire, *Saint Dominic*, pp. 345–48; Maccarone, 'Il progetto per un "universale coenobium"'; Bolton, '*Mulieres Sanctae*'; Sterpi, Koudelka, and Crociani, *San Sisto Vecchio*, pp. 77–95; Boyle, *The Community of SS. Sisto e Clemente*, pp. 1–5; *Le più antiche Carte*, ed. by Carbonetti Vendittelli; Spiazzi, *La chiesa e il monastero di San Sisto*; Spiazzi, *Cronache e Fioretti*; Spiazzi, *San Domenico e il monastero di San Sisto*; Bolton, 'Daughters of Rome'; Barclay Lloyd,

'The Architectural Planning of Pope Innocent III's Nunnery of S. Sisto'; Rainini, 'La Fondazione e i primi anni del monastero di San Sisto'.
13 Catalogue of Turin, published in Valentini and Zucchetti, ed., *Codice topografico*, vol. III, p. 309.
14 Bernardino, Draghi, and Verdesi, *SS. Domenico e Sisto*; and Zucchi, 'La Chiesa dei Santi Domenico e Sisto'.
15 Pisano, 'L'ospizio-ospedale di San Sisto'; Cannizzaro, 'La Chiesa di S. Sisto Vecchio'.
16 Barclay Lloyd, 'Memory, Myth and Meaning in the Via Appia'.

Archeologica', was laid out from the Capitoline Hill to the Colosseum, and from there to the Via Appia and the area where S. Sisto is located.[17] As a result, today S. Sisto stands at the corner formed by the modern roads, Via Druso on the south-east and Via di Valle delle Camene, on the south-west, which runs parallel to the course of the ancient Via Appia. These roads meet near Piazzale Numa Pompilio, which is a hub where several modern thoroughfares converge.

The original church on the site has been identified as the early 'basilica Crescentiana', whose name had been changed to 'S. Sisto' by the late sixth century. The sixth-century *Liber Pontificalis* records that Pope Anastasius I (399–401), 'Fecit autem et basilicam, quam dicitur Crescentiana, in regione II, via Mamurtini in urbe Roma' (He also built the basilica that is called Crescentiana, in Region II, on the Via Mamurtini in the city of Rome).[18] 'Region II' could refer either to one of the Fourteen Regions of the city established by Augustus (27 BC–AD 14) or to one of the Seven Ecclesiastical Regions marked out by Pope Fabian (236–250).[19] Herman Geertman believed that the author of the *Liber Pontificalis* referred to the second ecclesiastical subdivision of the city and that the Via Mamurtini was a road leading to the Baths of Mamertinus, which were not far from S. Sisto.[20] Indeed, he suggested that the Via Mamurtini followed the course of Via Druso. Richard Krautheimer thought the author of the *Liber Pontificalis* mistakenly referred to the Augustan Region II, called 'Caeliomontium', after

Figure 3. Giovanni Battista Nolli, *Map of Rome*, det. of Antonine Baths and S. Sisto, 1748 (Frutaz, *Piante di Roma*, vol. III, 1962, detail of Tav. 403)

the Caelian Hill, because S. Sisto was situated on the lower slopes of the hill, whereas in fact the basilica was located in Augustan Region I (called 'Porta Capena').[21]

Flowing through the property of S. Sisto in the Middle Ages was an extension of the River Almo, usually called the 'Mariana' or 'Marrana', or sometimes the 'Crabra' (as on the left of the monastery in Fig. 2).[22] Starting from a source near Grottaferrata in the hills outside Rome, this stream originally joined the River Aniene, but Pope Calixtus II (1119–1124) diverted it towards the Lateran region in Rome, where it provided water for a large settlement near the medieval papal palace.[23] After flowing through the property of S. Sisto, the river ran along the valley between

17 Tomasetti, *Della Campagna Romana*, vol. II, pp. 16–41; Ciancio Rossetto, 'La "Passeggiata archeologica"'; Lanciani, *Notes from Rome*, pp. 425–26; Gallavotti Cavallero, *Rione XXI, San Saba*, pp. 124–34; Genovesi, 'La zona di Porta Capena', pp. 11–40; Coates-Stephens, *Immagini e Memoria*, p. 28; Barclay Lloyd, 'Memory, Myth and Meaning in the Via Appia'.
18 *Le Liber Pontificalis*, ed. by Duchesne (hereafter *LP*), vol. I, p. 218.
19 *LP*, vol. I, p. 148.
20 Geertman, 'Ricerche', p. 226; Geertman and Annis, 'San Sisto Vecchio', pp. 517–19; Geertman, 'Titulus Sancti Sixti'.

21 Krautheimer, *Corpus*, vol. IV, pp. 174–75. For the location of Augustan Region I, see Platner and Ashby, *A Topographical Dictionary*, p. 446.
22 Genovesi, 'La zona di Porta Capena', pp. 17–35, with further bibliography.
23 *LP*, vol. II, p. 379; Platner and Ashby, *A Topographical Dictionary*, pp. 4 and 23–24, who connect the springs with the ancient Aqua Iulia; Koudelka, 'Le "Monasterium Tempuli" et la fondation dominicaine

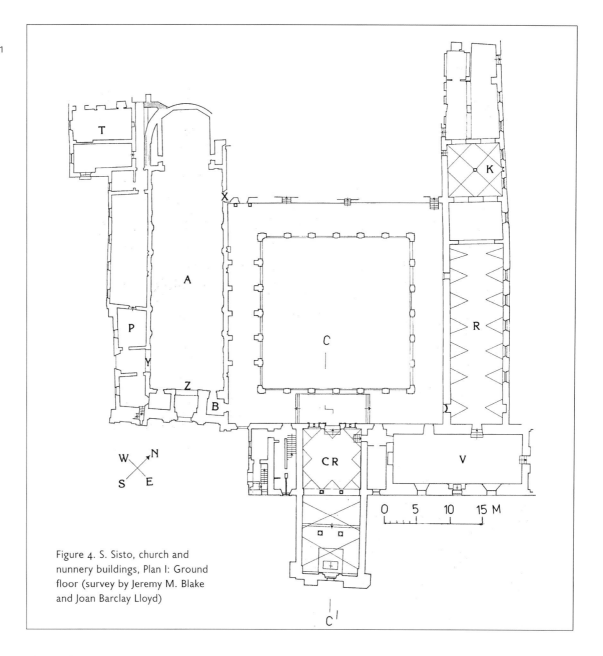

Figure 4. S. Sisto, church and nunnery buildings, Plan I: Ground floor (survey by Jeremy M. Blake and Joan Barclay Lloyd)

the Caelian and Aventine Hills, passed through the Circus Maximus, and emptied into the River Tiber near the great drain of ancient Rome, the Cloaca Maxima.[24] In 1261, the Lateran canons diverted some of the Mariana water, which led to litigation between them and the nuns of S. Sisto.[25] Two other disputes between the nunnery and other parties regarding the Mariana water occurred in 1262 and 1263.[26]

de San Sisto', p. 22; Krautheimer, *Rome*, p. 322; Coates-Stephens, *Immagini e Memoria*, p. 23.

24 Koudelka, 'Le "Monasterium Tempuli" et la fondation dominicaine de San Sisto', p. 22 and map on p. 24.

25 Domenica Salomonia, *Cronache del Monastero di San Sisto*, in Spiazzi, *Cronache e Fioretti*, p. 97. See also *Le più antiche carte del convento di San Sisto*, ed. by Carbonetti Vendittelli, document 132, 2 September 1260, pp. 262–64; and document 147, 29 August 1261–2 October 1264, p. 299, a papal decree of Pope Urban IV (1261–1264), saying that the Lateran Canons should not take the water.

26 *Le più antiche carte del convento di San Sisto*, ed. by Carbonetti Vendittelli, documents 142, 25 October 1262, pp. 287–89; document 143, 1262, p. 289; and document 144, 5 February 1263, pp. 289–92.

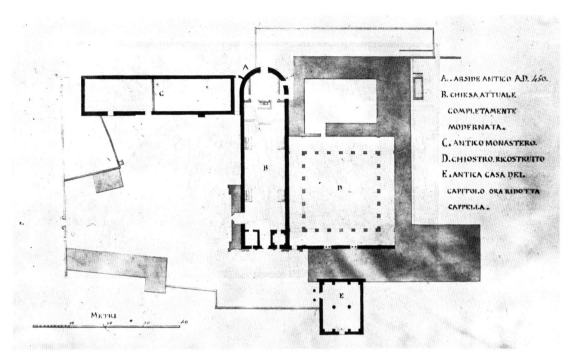

Figure 5. Filippo Cicconetti, Plan of the S. Sisto buildings, 1869 (BSR, no. JHP-0220)

Calixtus II also built mills for grinding corn along the course of the Mariana: two outside the Porta Asinaria at the Lateran, two at S. Sisto (Fig. 2), one in the Circus Maximus, and two near S. Maria in Cosmedin.[27] Three of these mills survive: two are in what is now the municipal garden centre at S. Sisto and one is at the Circus Maximus.[28] In the Middle Ages, the nuns derived some income from the two mills on their property by leasing them to a miller on a temporary basis, and in 1263, they built a third mill.[29] One of the first Dominican nuns at S. Sisto, Sister Cecilia, mentioned the mills as being beside 'canals' in the convent grounds.[30] She records that one day, after Mass, Dominic told the nuns 'ut omnes convenirent ad canales, ubi erant molendini' (that they should all gather at the canals, where the mills were).

When the 'Passeggiata Archeologica' was laid out in the early twentieth century, some people complained that medieval and Renaissance buildings were demolished in the process. As Giuseppe Tomassetti pointed out in 1910, mines had been used to destroy old buildings, and the water of the Mariana had been channelled underground in cast iron pipes.[31] At that time, a block of the medieval S. Sisto convent buildings close to the Via Appia disappeared. This can be seen by comparing the few rooms, labelled T on Plan I (Fig. 4), south-west of the church's apse, with the long block between the church and the road shown in early maps of Rome and in a plan of the church and convent made by Filippo Cicchonetti c. 1869 (see Figs 3, and 5, C).[32]

27 Koudelka, 'Le "Monasterium Tempuli" et la fondation dominicaine de San Sisto', p. 22.

28 Koudelka, 'Le "Monasterium Tempuli" et la fondation dominicaine de San Sisto', pp. 22–23.

29 Le più antiche carte del convento di San Sisto, ed. by Carbonetti Vendittelli, p. xx, and document 145, 1 August 1263, pp. 292–95.

30 Cecilia, Miracula Beati Dominici, 8, pp. 318–19.

31 Tomasetti, Della Campagna Romana, vol. II, pp. 16–24.

32 Frutaz, Piante, vol. II, tav. 267, vol. III, tav. 403. See also, the Tempesta/De Rossi map of 1693, Frutaz, Piante, vol. III, tav. 369. The nineteenth-century plan, Filippo Cicconetti, Plan of S. Sisto, c. 1869, is reproduced as Parker Photograph, BSR Parker 220.

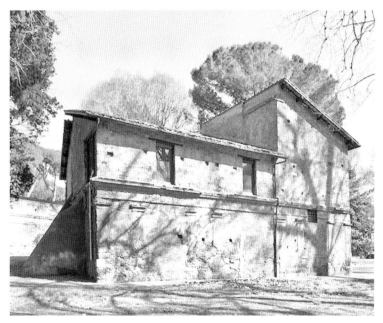

Figure 6. Remains of S. Maria in Tempulo (photo: author)

The remains of this block and some early photographs show that it was built in the late Middle Ages.[33]

The area where S. Sisto is located must have been almost deserted in the early thirteenth century. Only some ancient Roman ruins and a few churches and monasteries stood near the convent, which was surrounded by fields and vineyards.[34] The site was in a virtually uninhabited area of Rome but still within the third-century Aurelian Walls. Still, to the north-east, S. Sisto was within an hour's walking distance of the Lateran, where the papal palace and Curia were located in the Middle Ages.

Towards the Circus Maximus there may have stood the early nunnery of S. Maria in Tempulo (also called 'S. Maria in Tempore', or 'Monasterium Tempuli').[35] Christian Huelsen identified as the remains of that convent a building (which now incorporates some late antique walls, part of a medieval bell tower, and a nineteenth-century hall covered by 'Neo-Gothic' arches) situated between S. Sisto and the Circus Maximus (Fig. 6).[36] Vladimir Koudelka agreed with that identification because in a thirteenth-century deed of sale, he found a reference to a vineyard located in front of the cloister of S. Maria in Tempulo, which was close to the road going to S. Balbina on the Little Aventine Hill, a river bank (possibly of the Mariana), a road going to the 'Antinian' mill (a name that was perhaps derived from the nearby Antonine Baths), and the public road.[37] When Dominic founded S. Sisto, the nuns from S. Maria in Tempulo formed part of the new community, and their monastery was closed down. Hence not much of the S. Maria in Tempulo buildings survives today.

The choice of location for the thirteenth-century monastery of S. Sisto was typical of the times, for medieval nunneries were often situated on the periphery of inhabited areas, or outside town. Saint Clare (1193–1253) and her nuns lived at S. Damiano outside the walls of Assisi, until they were moved c. 1257 to S. Chiara, which was on the edge of the town; when the Friars Preachers chose an urban site for the monastery of S. Agnese for the Dominican nuns of Bologna, the bishop refused to grant permission to build there, because it was too close to the city centre, and an alternative, more isolated location had

33 One can see this from the shape of the windows in the photographs in Spiazzi, *San Domenico e il monastero di San Sisto*, following p. 320, especially the one entitled, 'Dietro l'abside della chiesa'. The masonry in what remains is typical of that dating to the late thirteenth century in Rome.

34 S. Sisto and two other churches nearby — SS. Nereo ed Achilleo and S. Cesareo — are discussed in Matthiae, 'Tre chiese'.

35 The nunnery was also referred to as 'S. Maria qui vocatur tempuli', and sometimes erroneously named 'S. Maria in Turri trans Tiberim', see Koudelka, 'Le "Monasterium Tempuli" et la fondation dominicaine de San Sisto', pp. 19–23 and 28–32; see also Ferrari, *Early Roman Monasteries*, pp. 225–27.

36 Huelsen, *Chiese*, pp. 367–68. For this building, see Krautheimer, *Corpus*, vol. III, pp. 61–64.

37 Koudelka, 'Le "Monasterium Tempuli" et la fondation dominicaine de San Sisto', p. 21.

to be found.[38] S. Sisto, too, was in a sparsely inhabited region.

The Church and the Convent Today

The church of S. Sisto has changed very much over the centuries. A visitor today first sees an elegant eighteenth-century façade fronting Via Druso, or the rooms on the side of the church, Plan I, A and P (Fig. 4) along Via di Valle delle Camene; and the medieval bell tower, Plan I, B (Figs 4 and 7). Both façades are articulated by pilasters and pierced by quatrefoil windows framed in travertine, which are part of a refurbishment undertaken by the architect Filippo Raguzzini in the pontificate of the Dominican Pope, Benedict XIII (1724–1730). After the Dominican nuns left in 1576, the church and convent were entrusted to Pope Gregory XIII's nephew, Cardinal Filippo Buoncompagni, who transformed them into a hospice for the poor. His armorial dragons still appear on either side of the lintel of the church's main door. A wall dividing the nuns' choir from the public part of the church was probably demolished at that time.

Cardinal Buoncompagni's attempts to improve the church and former convent were recorded in 1588 by his contemporary, Pompeo Ugonio, who says that the Cardinal levelled the ground

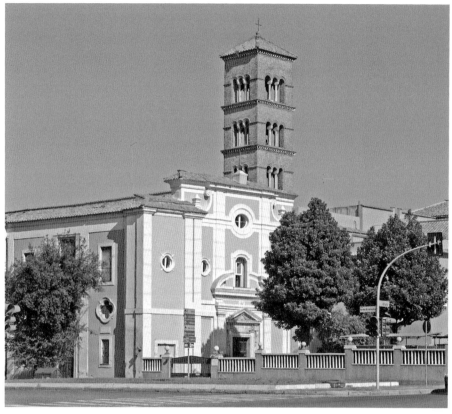

Figure 7. S. Sisto, view of façade, campanile, and side wall (photo: © David R. Marshall)

in front of the church in order to create a 'piazza' there.[39] In addition, the Cardinal provided the church with a fine wooden ceiling, cleaned up the walls, reordered the altars, and placed steps in front of the high altar. Ugonio referred to two other altars, flanking the high altar: one in honour of Saint Blaise; the other dedicated to the Virgin Mary, where, according to Ugonio, there was an icon of the Mother of God honoured by the people of Rome.[40] With regard to the monastery, Ugonio stated that most of the old buildings were still standing, with the dormitories, corridors, loggias, refectory, and various other rooms,

38 For S. Damiano and S. Chiara, Jäggi, *Frauenklöster*, pp. 25–27 and 115–17; Bigaroni, 'San Damiano'; Bigaroni, Meier, and Longhi, *Basilica di S. Chiara in Assisi*; and Wood, *Women, Art and Spirituality*, pp. 38–39 and 45–46; for the Dominican convent of S. Agnese at Bologna, see the excerpts from the Chronicle of the same convent, in *Early Dominicans*, ed. and trans. by Tugwell, p. 396; and Jäggi, *Frauenklöster*, pp. 115–17. For a similar siting of nunneries far from urban centres in England and Wales, see Gilchrist, *Gender and Material Culture*, pp. 63–64.

39 Ugonio, *Historia delle Stationi*, pp. 170ᵛ–171ʳ.
40 The nuns took their famous icon (Plates 1 and 2) with them when they left S. Sisto, as recorded further on in Ugonio, *Historia delle Stationi*, p. 171ᵛ, so this may have been another image, or perhaps the altar was where the nuns' icon had been located before they left.

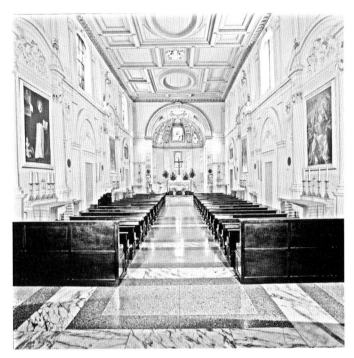

Figure 8. S. Sisto, interior of the church today looking north-west. (photo: Direzione Regionale Musei Lazio – under licence from MiBACT)

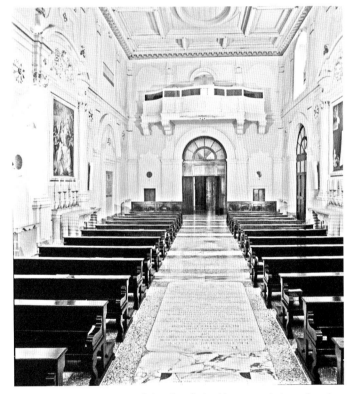

Figure 9. S. Sisto, interior of the church, looking towards inner façade (photo: Direzione Regionale Musei Lazio – under licence from MiBACT)

that were in use when the nuns lived there.[41] These structures were remodelled or refurbished in the early seventeenth century, as indicated by a date '1619' still to be seen in the refectory.

The S. Sisto buildings were returned to the Order of Preachers in 1642 and were entrusted to the Irish Dominican Friars in 1677, with the church and college of S. Clemente.[42] In 1888, the Municipality of Rome expropriated all the buildings of S. Sisto, except for the church, the decorated part of the chapter room, and some rooms above it.[43] The remaining part of the chapter room became a storeroom for hay and the monastic refectory was turned into a stable for the horses used in funeral processions.[44] At the same time, the municipal garden depot, nursery, and workshops were located on the land surrounding the former convent, where some of them remain to this day.

In 1893, a Dominican Sister, Maria Antonia Lalìa (1839–1914) founded a new congregation of teaching Sisters, called the 'Dominican Sisters of S. Sisto', to run a school, a printing press, and a hospice at S. Sisto, which, except for the garden centre, she gradually reacquired and partly rebuilt.[45] These Sisters remain there today, where they continue the work initiated by Mother Lalìa.

The church is not oriented, but its apse is in the north-west, and its façade is in the south-east, Plan I, A (Fig. 4). The interior, which has a single nave, is quite spacious (Fig. 8). Beyond an arch at the north-west end, there is a polygonal sanctuary, laid out in the fifteenth century within what remains of an earlier semi-circular apse. Two windows, one above the other, illuminate the sanctuary, and three others now open along the south-western side of the nave. Light also

41 Ugonio, *Historia delle Stationi*, p. 171ᵛ.
42 Boyle, *The Community of SS. Sisto e Clemente*, pp. 1–58; Fenning, 'SS. Sisto and Clemente'.
43 Genovesi, 'La zona di Porta Capena', p. 42.
44 Boyle, *The Community of SS. Sisto e Clemente*, Plate 4; Genovesi, 'Un nuovo capitolo nella storia di San Sisto', pp. 665–66; and Spiazzi, *San Domenico e il monastero di San Sisto*, photographs following p. 320.
45 This is discussed in detail in Spiazzi, *Madre M. Antonia Lalìa*.

filters into the nave from a window in the façade beyond a narrow balcony at the south eastern end of the church above an arched doorway leading to an entrance vestibule (Fig. 9). The interior decoration of the nave, which was restored in the 1930s and in 2019, reflects the early eighteenth-century remodelling by Raguzzini. Apart from the high altar in the chancel, there are now four altars, two on either side of the nave, each with an altarpiece attributed to Emanuele Alfani and executed *c.* 1727.[46]

At the main entrance to the church, the choir balcony is entered from a narrow room (Figs 9 and 10). The balcony and this room are built above three rooms on the ground floor (Fig. 4): in the centre, a vestibule leads from the main doorway into the church, Plan I, Z; on the north-east, there is a chamber under the bell tower, Plan I, B; and on the south-west, there is another room. The ceiling of the church is made of wood with simple cornices. It bears the arms of Pope Pius XI (1922–1939) and Cardinal Achille Liénart, indicating the restoration carried out in 1930–1935.[47]

Along the south-western side of the church there are some rooms, Plans I, P,

Figure 10. S. Sisto, church and nunnery buildings, Plan II: First floor (survey by Jeremy M. Blake and Joan Barclay Lloyd)

and II, (Figs 4 and 10) that are connected to the partly demolished block, Plan I, T. An elegant fifteenth-century marble doorway opens on this side of the church near its entrance, opposite Y on Plan I; it bears the name and arms of Cardinal Pietro Ferrici y Comentano and the date, 1478 (Fig. 11). This may be contemporary with changes made in the chancel during the pontificate of Pope Sixtus IV (1471–1484).

About a hundred years later, the sanctuary of the church was redecorated by Cardinal Buoncompagni who commissioned a stucco ceiling and paintings, now attributed to Bartolomeo

46 Anonymous, *San Sisto all'Appia*, p. 78; Sterpi, Koudelka and Crociani, *San Sisto Vecchio*, p. 49. From the entrance to the sanctuary, the altarpieces on the left represent *A Miracle of Saint Vincent Ferrer* and *Saint Dominic of Soriano with Saints Mary Magdalene and Catherine of Alexandria*. On the right, the altarpieces depict *The Madonna of the Rosary with Saints Dominic, Filippo Neri, Thomas Aquinas and Agnes of Montepulciano*, and *The Blessed Virgin Mary with Saints Dominic, Thomas Aquinas, Hyacinth, Catherine of Siena, Rose of Lima, and Pius V*.

47 Krautheimer, *Corpus*, vol. IV, p. 165. A new restoration was made in 2019.

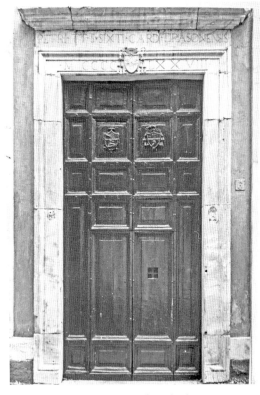

Figure 11. S. Sisto, side door of Cardinal Pietro Ferrici y Comentano, 1478 (photo: Direzione Regionale Musei Lazio – under licence from MiBACT).

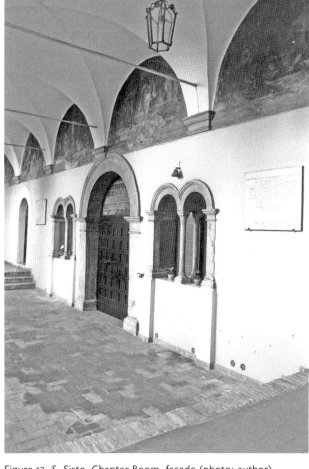

Figure 12. S. Sisto, Chapter Room, façade (photo: author)

Spranger c. 1576–1578.[48] Their iconography relates to the patron saint of the church and the transformation of S. Sisto into a hospice for the poor.[49] The patron saint, Pope Sixtus II (257–258), was martyred with his deacons during the persecution of Valerian on 6 August 258 along the Via Appia, and then buried in the Catacomb of Calixtus.[50] A few days later, another Roman deacon, Lawrence, was put to death by the Roman authorities and then buried in the catacomb along the Via Tiburtina, where the church of S. Lorenzo fuori le Mura was built in the sixth century.[51] Sixtus and Lawrence were among the most popular saints of Rome, on account of their love for the poor. An inscription in the church of S. Sisto written in medieval

48 Anonymous, *San Sisto all'Appia*, p. 78.

49 Anonymous, *San Sisto all'Appia*, pp. 47, 78–82. In the centre there is a representation of the *Trinity, with Angels bringing a crown and palm branches to Pope Saint Sixtus II and two of his deacons*; on the sides of the chancel ceiling are depicted two scenes, showing *Saint Sixtus in prison baptizing the poor*, and *Saint Sixtus in prison instructing Saint Lawrence to give alms to the poor*. A late sixteenth-century painting of the *Assumption of the Blessed Virgin Mary* attributed to Federico Zuccari now hangs on the left wall of the chancel; it was originally the altarpiece of the refurbished church. Its composition resembles that in a fresco by the same artist in the transept of SS. Trinità dei Monti in Rome.

50 Farmer, *Oxford Dictionary of Saints*, pp. 481–82; Saint Cyprian, writing from North Africa at the time, mentioned four deacons. The legendary '*Passio*' of Saint Sixtus says he was martyred near the Temple of Mars, which was just outside the later Porta Appia (now Porta San Sebastiano), and hence quite close to the church of S. Sisto. See also, Kirsch, *Die römischen Titelkirchen*, p. 23.

51 See, Mondini, *San Lorenzo*.

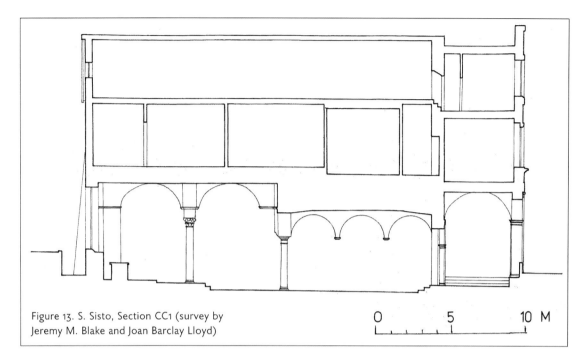

Figure 13. S. Sisto, Section CC1 (survey by Jeremy M. Blake and Joan Barclay Lloyd)

lettering, and to which has been added the coat of arms of Pope Paul V (1605–1611), states that the relics of Pope Saint Sixtus and several other popes and martyrs were located in the basilica.[52] These relics were probably transferred from the catacombs to S. Sisto in the eighth or ninth century.[53] Prudentius c. 400 told of how Saint Lawrence was instructed by the Roman authorities to produce the treasures of the Church, after which he presented a crowd of poor people to them.[54] The subjects of the paintings were therefore appropriate for the function of the buildings, especially when they were transformed into a hospice for the poor after the nuns left in 1576.

North-east of the church (Figs 4 and 10), the convent buildings are located around a central cloister garden. The main wings of the convent were rebuilt or refurbished in the late sixteenth and early seventeenth centuries, but they most probably stand on the site of the earlier medieval structures. The sacristy, to the right of the chancel, opens to the north-west on a smaller courtyard surrounded by twentieth-century buildings connected with the school run by the Dominican Sisters of S. Sisto. (They are not included on Plan I (Fig. 4) but the earlier quadrangle and its surrounding buildings are shown in Figs 3 and 5.)

The medieval chapter room Plan I, CR, (Fig. 4) is preserved on the south-eastern side of the cloister, and it has been remodelled and renovated several times (Figs 12–15). At the south-east end, there is an altar. Three large paintings, executed by Father Hyacinthe Besson, OP between 1852 and 1856, depict miracles from the life of Saint Dominic, as well as an image of Saint Dominic embracing Saint Francis.[55] There are also portraits

52 Forcella, *Iscrizioni*, vol. x, p. 540, no. 904. Forcella notes that the inscription was written in Gothic letters and he recognized the coat of arms of Pope Paul V Borghese (1605–1621). See also, Sigismondi, 'La Questione dell'iscrizione medievale'.
53 Krautheimer, *Corpus*, vol. IV, p. 164.
54 Prudentius, *Peristephanon Liber*, II, trans. by Thomson, pp. 109–43.

55 See, Anonymous, *San Sisto all'Appia*, p. 49. On the left, there is *The resurrection of a child* and *The raising of Napoleone, the nephew of Cardinal Stefano of Fossanova at*

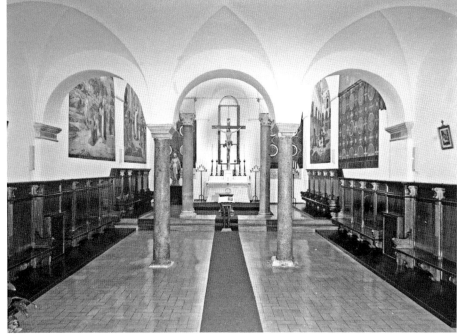

Figure 14. S. Sisto, Chapter Room, interior in the twentieth century (photo: Direzione Regionale Musei Lazio – under licence from MiBACT)

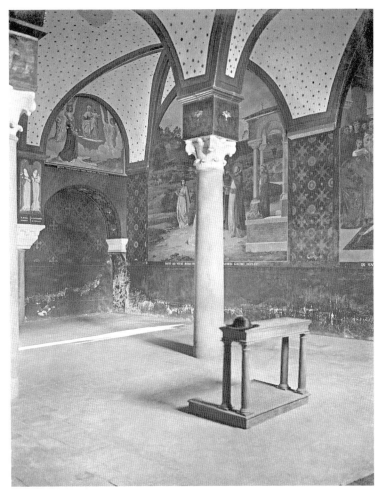

Figure 15. S. Sisto, interior of Chapter Room in the nineteenth century (photo: Father Peter Paul Mackey, OP, 1890–1901, BSR: ppm_1284)

of saints in roundels, of unknown date. On the sides of the chapter room stand the tombs of Mother Maria Antonia Lalìa (died 1914) and of Mother Maria Cecilia Fichera, who was General Prioress from 1920 to 1965.[56]

To the north-east of the chapter room, there is a barrel-vaulted room, Plan I, V (Fig. 4) that functions as a vestibule to the refectory, which is situated on the ground floor of the wing opposite the church, Plan I, R (Fig. 4). The refectory is most likely the medieval structure but it has been renewed and remodelled several times (Fig. 16). At the north-western end, an arch gives access to a smaller chamber, beyond which there are two arches, leading to a rectangular room, Plan I, K, which is medieval, and which has a central column that sustains four cross vaults (Fig. 4).[57] This is next to the modern kitchen.

S. Sisto, pictured as having happened inside the chapter room itself; and on the right, *The resurrection of one of the builders of S. Sisto.*

56 Anonymous, *San Sisto all'Appia*, p. 98.
57 There were rooms of similar plan at S. Clemente, S. Maria in Cosmedin, and S. Lorenzo fuori le Mura in the twelfth century, see Barclay Lloyd, *The Medieval Church and Canonry of S. Clemente*, pp. 182, 198; Barclay Lloyd, 'The Architecture of the Medieval Monastery at S. Lorenzo fuori le Mura, Rome'; and Mondini, *San Lorenzo*, pp. 136–43.

Around the cloister courtyard, there is an ambulatory, with piers surrounding the central garden. Andrea Casali (1705–1784), a student of Sebastiano Conca (1680–1764), painted thirty-two scenes from the life of Saint Dominic in the lunettes of the cloister between 1725 and 1728.[58] On the floor above, narrow modern walls now divide the space into corridors and cells, Plan II (Fig. 10), where the nuns would have had large dormitories in the Middle Ages.

Archaeological Evidence

As often happens in Rome, the buildings at S. Sisto were constructed over earlier structures, which have been revealed in archaeological investigations of the site. In 1869, Father Joseph Mullooly, OP, Prior of SS. Sisto and Clemente, made some preliminary excavations at S. Sisto.[59] Although a marble pavement, two column bases standing on a brick wall, and fragments of inscriptions came to light, Mullooly's excavations at S. Sisto were not continued.[60]

In 1930–1935, the titular cardinal of S. Sisto, Achille Liénart, commissioned the architect, Guglielmo Palombi, to restore the church. During this campaign, arches and four capitals resting on columns were found embedded in the north-eastern wall of the nave (Fig. 17); fragments of the early apse were observed on the exterior of the modern apse; and some medieval murals in the sanctuary, known from the late nineteenth century onwards, were made accessible.

Enrico Josi and Adriano Prandi identified parts of the building as belonging to the early Christian basilica of S. Sisto, which they dated

Figure 16. S. Sisto, Refectory in 2019 (photo: author)

Figure 17. S. Sisto, column and capital of the early Christian basilica (photo: Direzione Regionale Musei Lazio – under licence from MiBACT)

58 Anonymous, *San Sisto all'Appia*, pp. 90–93, gives a list of these scenes.
59 Boyle, *The Community of SS. Sisto e Clemente*, p. 204.
60 BSR, Parker Photographs 220 and 1488 show the finds from this dig. Father Mullooly may not have had time to excavate at S. Sisto, because he was fully occupied in the excavations at S. Clemente.

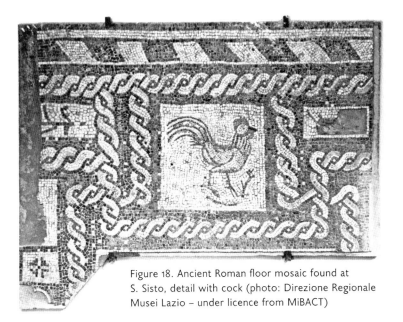

Figure 18. Ancient Roman floor mosaic found at S. Sisto, detail with cock (photo: Direzione Regionale Musei Lazio – under licence from MiBACT)

to the late fourth or early fifth century.[61] Clearly, it was situated below the present church, which rose over only the original nave, the two early side aisles having been demolished in the thirteenth century. The archaeologists noted that parts of the early apse were visible in the present one, which had been totally rebuilt in the middle. Kirsch worked out that the early basilica had had twelve columns on each side supporting thirteen arches between the nave and aisles.[62] Moreover, he reported that the early floor level was c. 3.70 m below the paving of the present church. When Josi and Prandi continued their archaeological investigations in 1936, they found part of the north-eastern aisle wall of the early basilica under the cloister garden. They also dug around one of the columns to a depth of 3.45 m below the present church, where they found the earlier floor, paved in *opus sectile*. In 1957, two more columns were discovered *in situ* in the south-west wall of the present nave.

Geertman made more extensive excavations at the site between 1967 and 1968.[63] His aim was to complete the picture of the early Christian basilica.[64] He and his team excavated in front of the church façade and in the cloister garden; they also examined in detail the walls of the present church, from the entrance to the apse. They discovered that the early Christian basilica was itself built over antecedent ancient Roman structures: three fragments of walls dating from the early second century had been incorporated in the atrium in front of the church; and other structures from the late second to the early fourth century, including a water channel and part of a floor mosaic, came to light under the cloister garden.[65] In the mosaic was an ancient Roman image of a cock (Fig. 18).

Geertman's excavations revealed the main features of the atrium in front of the early Christian basilica (Fig. 19). It was a rectangular courtyard surrounded by an ambulatory, with L-shaped piers at the inner corners. Two red granite columns stood between the piers on each of three sides, while on the fourth side — that opposite the church façade — there was a wall with an arch, leading via a passageway to the perimeter wall of the atrium and thence to the ancient road below Via Druso. Fragments of marble barrier slabs (transennae) were found between some of the piers and the columns. The atrium was paved with a rough mosaic of white marble in the courtyard and with tesserae of different colours in the ambulatory. The excavators reconstructed the outer walls of the atrium, which they calculated was nearly square, 24.25 m long from the church façade to the road, and 24.85 m wide. The inner courtyard measured 12.20 m in length and 11.55 m in width.

61 Josi, 'Relazione', p. 174.
62 Kirsch, 'Anzeige', col. 405; Kirsch, 'Anzeiger für christliche Archäologie', pp. 295–96.

63 Geertman, 'Ricerche'.
64 Geertman, 'Ricerche'; Geertman and Annis, 'San Sisto Vecchio'.
65 Geertman and Annis, 'San Sisto Vecchio', pp. 520–22.

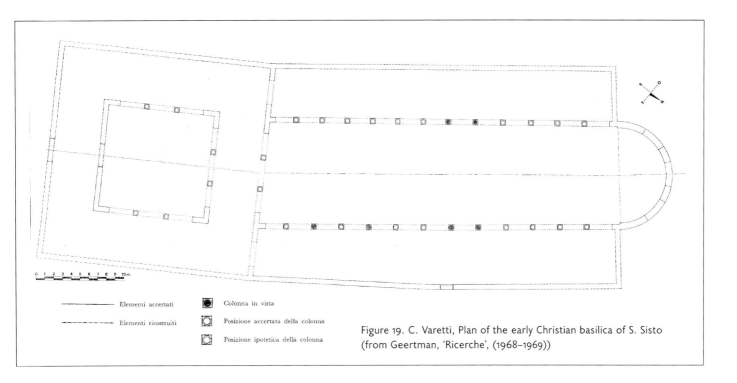

Figure 19. C. Varetti, Plan of the early Christian basilica of S. Sisto (from Geertman, 'Ricerche', (1968–1969))

An 'atrium' in front of the present church is implied in a sixteenth-century woodcut (Fig. 20).[66] Behind two high walls of such a courtyard, the 'TEMPL(UM). S. SYXTI' (the church of S. Sisto) is hardly visible. The central doorway and four windows on either side of the atrium façade all have fifteenth-century frames, perhaps datable to the intervention of Cardinal Pietro Ferrici y Comentano in 1478.[67] This atrium would have replaced, at a higher level, that found in Geertman's archaeological investigations.[68] Today there is no atrium, but only an irregular open space in front of the church, perhaps the 'piazza' laid out by Cardinal Buoncompagni.[69]

Geertman found parts of the façade, nave, two aisles, and the apse of the early basilica, which had been built by Pope Anastasius I

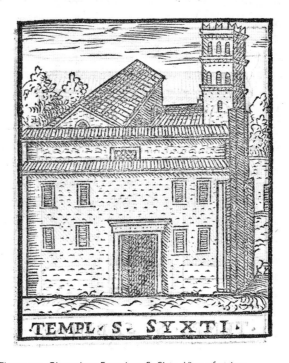

Figure 20. Gieronimo Francino, S. Sisto, View of atrium and façade (from Le Cose Meravigliose..., ed. Fra Santi, 1588, p. 66r – photo: © 2018 BAV, Cicognara.III.3685)

66 The woodcut is in *Le cose maravigliose*, p. 66. See also, Krautheimer, *Corpus*, vol. IV, fig. 149.
67 Krautheimer, *Corpus*, vol. IV, p. 172.
68 See above, and Geertman, 'Ricerche', pp. 225–28; Geertman and Annis, 'San Sisto Vecchio'.
69 Ugonio, *Historia delle Stationi*, pp. 170v–171r.

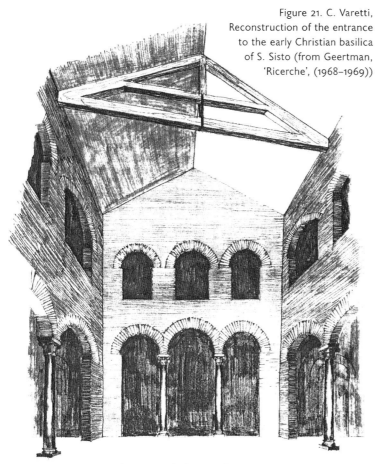

Figure 21. C. Varetti, Reconstruction of the entrance to the early Christian basilica of S. Sisto (from Geertman, 'Ricerche', (1968–1969))

(399–401) (Fig. 19).[70] From an examination of the existing building, he could establish the position and form of the early Christian entrance to the church below that built in the thirteenth century (Fig. 21). The façade opened in a triple arcade, sustained by two columns and two outer piers. (Such entrances are known to have existed in Rome also in the early Christian basilicas of S. Clemente, SS. Giovanni e Paolo, S. Pietro in Vincoli, S. Vitale, and possibly S. Pudenziana.)[71]

70 Geertman and Annis, 'San Sisto Vecchio', pp. 525–29.
71 Matthiae, 'Basiliche paleocristiane con ingresso a poliforo'. See also, Krautheimer, *Corpus*, vol. I, pp. 127, 131, 135 (S. Clemente, with five arches); pp. 289 and 298 (SS. Giovanni e Paolo, with five arches); vol. III, pp. 216–18 (S. Pietro in Vincoli, with five arches); p. 298 (S. Pudenziana, with three arches); vol. IV, pp. 313–20 and 327 (S. Vitale, with five arches). See also, Barresi, Pensabene, and Trucchi, 'Materiali di reimpiego'.

Paolo Barresi, Patrizio Pensabene, and Daniela Trucchi have pointed out that there were notable similarities in the planning and proportions of the early churches of S. Vitale, S. Sisto, and SS. Giovanni e Paolo.[72] The north-eastern arch of the entrance at S. Sisto was partially destroyed during the construction of the medieval bell tower, while the central arch disappeared below the modern doorway. The south-western arch survives, having been blocked up, probably in the eighth century, when Pope Hadrian I (772–795) restored the church. Eighth-century masonry now fills what is visible of it, as well as the space occupied by the column on that side, which is no longer *in situ*.[73] Above this arcade, there were three large round-headed windows, approximately 3 m high and nearly 2 m wide, the middle one being slightly higher and wider than the other two.

On either side of the nave a row of twelve columns and two end piers sustained thirteen arches.[74] In the walls of the present nave there are traces of the early Christian clerestory windows that were blocked up in the thirteenth century. They were 3 m high and 1.80 m wide, and their voussoirs were made with long ancient Roman bricks.

Neither a semi-dome nor an arch was found in the apse. The archaeologists therefore believed that it was originally covered with a wooden roof and not a semi-dome, as is normal in Rome. One could argue, however, that since the medieval apse was on a higher level than its predecessor, its semi-dome would have been demolished in the thirteenth century. The apse opened almost directly into the nave, with only very narrow shoulders.[75] Geertman found traces of two side

72 Barresi, Pensabene and Trucchi, 'Materiali di reimpiego', p. 839.
73 Geertman, 'Ricerche', p. 221.
74 Geertman and Annis, 'San Sisto Vecchio', p. 526.
75 Geertman, 'Ricerche' p. 221; Geertman and Annis, 'San Sisto Vecchio', p. 526.

windows in the apse that measured 2.70 m in width by 4.95 m in height. He suggested that there were originally three windows. (Since the central part of the apse has been rebuilt, Krautheimer cautiously concluded that it was not clear whether there were originally two or three windows.)[76]

Geertman was able to calculate the total length of the church building, including the apse, as 47.24 m.[77] The depth of the apse was 5.40 m. The width of the nave, including the two colonnades, was 10.98 m, while the aisles were 6.05 m and 5.50 m wide. The exterior width of the building was *c*. 24.83 m.[78] Geertman calculated the height of the early Christian basilica's nave walls as 13.25 m. He found that the early Christian walls were built of masonry typically used in the late fourth or early fifth century in Rome.

All the columns that remain *in situ* in the church are made of grey granite, except for one, which is of white marble.[79] Four granite columns were re-used in building the chapter room of the nunnery, Plan I, CR (Figs 4, 13, 14, and 15) and one is in the vaulted room next to the refectory, Plan I, K (Fig. 4). Eight capitals from the early Christian basilica survive. Six are *in situ*, embedded within the remodelled structure of the medieval church (Fig. 17), and two are in the chapter room (Figs 14 and 15). The capitals are all Composite, with plain smooth leaves; they are similar in type to some of those in the early Christian basilicas of S. Paolo fuori le Mura, S. Clemente, and S. Vitale.[80] From his discoveries and from an analysis of the documentary evidence, Geertman dated the early Christian church to the late fourth or early fifth century, identifying it as the 'basilica Crescentiana', built by Pope Anastasius I.[81]

At about the same time as Geertman first published his findings, Krautheimer wrote his study of the church.[82] He added a 'Supplementary Note' referring to Geertman's excavations.[83] Krautheimer remarked on some details of the later history of the building, not mentioned by Geertman. He believed the walls inserted in the sanctuary to give it its present polygonal interior were built in the fifteenth century, because they were constructed of a rubble masonry typical of that time.[84] He also found that the church exterior was overlaid with post-medieval features: the fifteenth-century side door (Fig. 11); the principal doorway in the façade dating from Cardinal Buoncompagni's campaign in 1576–1586; and the quatrefoil windows and pilasters from the restoration of Raguzzini in 1727 (Fig. 7).[85]

Krautheimer pointed out that the side walls of the present church were in fact the former clerestory walls of the earlier basilica, with the windows blocked up.[86] He found part of a wall of late antique *opus listatum* that had crossed the south-west aisle of the early Christian basilica, forming a separate chamber in the bay closest to the apse.[87] He compared this small side room with one in the early Christian basilica of S. Lorenzo in Lucina.[88]

The first basilica on the site of S. Sisto was one of Rome's early 'tituli'. The term was connected

76 Krautheimer, *Corpus*, vol. IV, p. 170. Brandenburg, *The Ancient Churches of Rome*, pp. 167–76, agreed with Geertman, as against Krautheimer.
77 These measurements are given by Geertman and Annis, 'San Sisto Vecchio', p. 525.
78 This corresponds with the width of the atrium, which was also 24.83 m.
79 Geertman, 'Ricerche', p. 224.
80 This type of capital is called in Italian 'a foglie d'acqua' (water-leaf capitals).
81 *LP*, vol. I, p. 218, and Geertman, 'Ricerche', pp. 225–28; Geertman and Annis, 'San Sisto Vecchio', p. 517.
82 Krautheimer, *Corpus*, vol. IV, pp. 163–77.
83 Krautheimer, *Corpus*, vol. IV, p. 177.
84 Krautheimer, *Corpus*, vol. IV, p. 170.
85 Krautheimer, *Corpus*, vol. IV, p. 166.
86 Krautheimer, *Corpus*, vol. IV, p. 169.
87 Krautheimer, *Corpus*, vol. IV, p. 171.
88 Krautheimer, *Corpus*, vol. IV, p. 171; for the similar phenomenon in S. Lorenzo in Lucina, see Krautheimer, *Corpus*, vol. II, pp. 174, 181.

to property endowed by wealthy Romans that functioned as public places of worship, on which churches were built from the fourth or fifth century.[89] At two Roman synods, held in 499 and in 595, the priests who signed documents added the name of the titulus at which they ministered beside their signatures.[90] This evidence shows that there were some changes over time in the names of the tituli. The 'titulus Crescentianae' appears in the 499 list, but not in that of 595, whereas the 'titulus S. Sixti' does not appear in the 499 list, but it is included in the 595 list, when a priest named Felix represented the church.[91] Kirsch, Geertman, and Krautheimer concluded that the 'titulus Sancti Sixti' replaced the 'titulus Crescentianae'.[92] Since the Middle Ages, the church has been assigned to a cardinal priest.

From the pontificate of Pope Gregory the Great (590–604), S. Sisto has also been a 'stational church', that is, a church at which the Pope celebrated Mass once a year on a particular day. The station at S. Sisto was held on the Wednesday after the third Sunday in Lent. In 1303, the Dominican Pope Benedict XI (1303–1304) granted an indulgence of one year and forty days to people visiting the church on that day.[93]

The *Liber Pontificalis* records that late in the eighth century Pope Hadrian I renovated the building of the titulus of S. Sisto.[94] The late eighth- or early ninth-century guidebook to Rome, the *Einsiedeln Itinerary*, mentioned the church twice.[95]

There had been a monastery beside the church of S. Sisto from at least 599.[96] In the mid-ninth century Pope Leo IV (847–855) decided to revive this convent, then called the 'Monasterium Corsarum' (the Monastery of the Corsicans), which had by his time been reduced to a secular dwelling; he established a community of nuns there to sing God's praises every day; he donated gifts to the church; he restored everything that had been taken away; and he personally confirmed the nunnery.[97] Leo IV also established a community of nuns in a nearby convent dedicated to Saints Simetrius and Caesarius, to which he donated a silver paten and a chalice.[98] It is possible that the monastery of Saints Simetrius and Caesarius was joined to the Monasterium Corsarum at this time. In 1192, Cencius Camerarius in the *Liber Censuum* referred only to the monastery of Saint Cesarius, which by then had a community of monks ('monachorum') — rather than of nuns ('monialium'); earlier, however, the place where S. Sisto was located had been a female monastic establishment.[99]

89 Kirsch, *Die römischen Titelkirchen*, pp. 6–8; Guidobaldi, 'L'organizzazione dei *tituli*'; Hillner, 'Families, Patronage, and the Titular Churches'; Bowes, *Private Worship*, pp. 65–71. Krautheimer in 1988 pointed out that 'titulus' and 'ecclesia' were two separate entities: the first was a legal concept attached to the property, the second was the material reality of a church as a building or as a congregation, see Krautheimer, 'Congetture sui mosaici scomparsi di S. Sabina', pp. 172–73. The name of a titulus referred to the owner of the property, while the church was named after a saint, usually a martyr, to whom it was dedicated.

90 Guidobaldi, 'L'organizzazione dei *tituli*'.

91 Kirsch, *Die römischen Titelkirchen*, p. 8. Geertman, 'Ricerche' pp. 225–28, esp. p. 226. Krautheimer, *Corpus*, vol. IV, p. 164.

92 Kirsch, *Die römischen Titelkirchen*, p. 12; Geertman, 'Ricerche', p. 226; Krautheimer, *Corpus*, vol. IV, pp. 164, and 174–75; Geertman and Annis, 'San Sisto Vecchio', p. 517.

93 Koudelka, 'Le "Monasterium Tempuli" et la fondation dominicaine de San Sisto', no. 17, p. 79.

94 *LP*, vol. I, pp. 507–08.

95 Krautheimer, *Corpus*, vol. IV, p. 164, referring to Lanciani, 'L'itinerario di Einsiedeln', cols 440, 444, p. 199.

96 Ferrari, *Early Roman Monasteries*, pp. 96–97.

97 *LP*, vol. II, p. 112; Krautheimer, *Corpus*, vol. IV, p. 164; and Ferrari, *Early Roman Monasteries*, pp. 96–99.

98 Ferrari, *Early Roman Monasteries*, pp. 96–97, referring to *LP*, vol. II, p. 120.

99 Ferrari, *Early Roman Monasteries*, pp. 97 and 99, referring to *Liber Censuum*, ed. by Fabre, Duchesne, and Mollat, vol. I, p. 304, nos 311 and 309.

The Thirteenth-Century Church

At the beginning of the thirteenth century, Pope Innocent III decided to establish a new nunnery at S. Sisto. He may have chosen the site because it was in a fairly isolated place that had earlier been occupied by nuns. In this way, he could revive the tradition of female monasticism in that place. According to the anonymous *Gesta Innocentii*, the Pope spent a large sum of money on the nunnery: 'ad constituendum aedificia Sancti Sixti, ad opus monialium, quingentas uncias auri regis, et mille centum libras proventum' ([the Pope paid] for the construction of the buildings at San Sisto for the nuns' project 500 ounces of the king's gold and 1100 pounds provinois).[100] It is not possible to give an exact modern equivalent for this sum, but it was clearly an expensive building campaign. Martin of Poland wrote that in Rome Innocent III built the hospital of Santo Spirito and he renewed the church of S. Sisto.[101] An anonymous Cistercian writer claimed that the Pope 'instituit etiam universale coenobium monialium Rome, in quo omnes moniales conveniant, nec eis progredi liceat' (he also established a universal convent for the nuns of Rome, in which all the nuns would gather together, and they would not be allowed to go out).[102]

Benedict of Montefiascone, who was the Dominican prior of S. Sisto from 1316 to 1318, wrote about Innocent III's rebuilding of the monastery in an introduction to a collection of documents pertaining to the nunnery.[103] He claimed that the Pope had begun to build S. Sisto with great zeal and with the wealth of the Church, so that the women of Rome and the nuns from other convents, 'per diversa vagantes' (who were wandering around in various places) could live 'sub arcta clausura' (in strict enclosure) under the protection of diligent servants of the Lord.[104] The monastery was left unfinished at Innocent's death, however. His successor, Honorius III, after confirming the Order of Friars Preachers, granted the site and the buildings of S. Sisto to Dominic and his friars.[105] According to Benedict, when Dominic learned that this monastery had been planned for nuns, he did not want the brethren to remain there, so he diligently sought from the Pope the church of S. Sabina, where the friars then went to live.[106]

It has been suggested that Innocent III conceived his project for the nunnery because of several pastoral problems regarding the religious women of Rome. In some women's convents discipline was lax and family members and friends of the Sisters often interfered in the day-to-day running of the community. Besides, the Pope was worried about the many small groups of 'semi-religious' or 'quasi-religious' women, known as 'penitents' or 'bizoke', who were not strictly enclosed.[107] To deal with this, Innocent III conceived the idea of building a new nunnery at S. Sisto, where the nuns would live together in strict enclosure, thereby improving discipline and preventing outside interference.[108]

100 *Innocentii III Papae Gesta*, PL, vol. CCXIV, col. 227.
101 *Martini Chronicon. Pontificum imperatorum*, ed. by Wieland, p. 437; and see Koudelka, 'Le "Monasterium Tempuli" et la fondation dominicaine de San Sisto', p. 43. Other medieval authors mentioned Innocent III's building of S. Sisto; see, for example, *Catalogus Pontificum et imperatorum Romanorum*, p. 362 and *Gilberti Chronicon Pontificum et imperatorum Romanorum*, p. 135.
102 *Chronica Romanorum pontificum et imperatorum ac de rebus in Apulia gestis*, p. 34.
103 Benedict of Montefiascone, *Historical Introduction*.
104 Benedict of Montefiascone, *Historical Introduction*, para. 1, p. 69.
105 Benedict of Montefiascone, *Historical Introduction*, para. 2, p. 69.
106 Benedict of Montefiascone, *Historical Introduction*, para. 3, p. 69. For S. Sabina, see Chapter 2 of this book.
107 For religious women in twelfth- and thirteenth-century Rome, Bolton, '*Mulieres Sanctae*'; and Bolton, 'Daughters of Rome'. For semi-religious women in general, Grundmann, *Religious Movements*, chapters 4 and 5, and Makowski, '*A Pernicious Sort of Woman*'.
108 Many writers have discussed this part of S. Sisto's history, e.g. Berthier, *Chroniques du monastère de San*

Innocent III's rebuilding of the church was also typical of the renewal of Rome, the 'renovatio Romae', of the twelfth and thirteenth centuries, when churches and convents were rebuilt, often on a smaller scale and at a higher level.[109] For example, in 1116, a smaller church replaced the earlier one at SS. Quattro Coronati; and at S. Clemente in the first two decades of the twelfth century a new, narrower church was constructed *c.* 4.37 m above the early Christian basilica.[110] In a similar way, at a level between 3.45 and 3.70 m above the early Christian basilica of S. Sisto, Innocent had a new, smaller, and narrower church laid out, as at Plan I, A (Fig. 4). The two aisles of the early basilica were demolished; the nave arcades were filled in; and the former nave walls were raised about 3 m. The result was a church with a single nave and no aisles, terminated by an apse rising above the original one in the north-west and a narthex in the south-east. The church is as long as the previous one (47.24 m.) and only as wide as the previous nave and colonnades (10.98 m).

Most medieval nuns' churches were relatively simple and plain.[111] Cistercian nuns' churches often had only a nave and a rectangular or apsed sanctuary; sometimes they also included a transept, with subsidiary chapels; rarely were there impressive colonnades, piers, ambulatories, or radiating chapels, as in some monks' churches.[112] In Rome, some later nunnery churches, such as that at the Franciscan nunnery at S. Cosimato founded in 1234 in Trastevere, and the Cistercian nunnery of 1255 at S. Pancrazio had a single nave.[113] These churches may have followed the design of the church at S. Sisto.

Innocent III began to build his new nunnery shortly after he had canonized the Englishman, Gilbert of Sempringham, in January 1202.[114] The Pope wanted Gilbertine Canons to come to Rome to run his nunnery, because he knew Saint Gilbert had founded a religious Order specifically to care for the spiritual and temporal needs of nuns.[115] He had his nuns follow the Rule of Saint Benedict, and he established an Order of Canons, who followed the Rule of Saint Augustine, to give them spiritual direction. Meanwhile, lay brothers oversaw the physical maintenance of the monasteries and ran the farms, and lay Sisters

Sisto; Zucchi, *Roma Domenicana*, vol. I, pp. 254–342; Koudelka, 'Le "Monasterium Tempuli" et la fondation dominicaine de San Sisto', pp. 46–48; Vicaire, *Saint Dominic*, pp. 345–48; Maccarone, 'Il progetto per un "universale coenobium"'; Sterpi, Koudelka, and Crociani, *San Sisto Vecchio*, pp. 21–40; Boyle, *The Community of SS. Sisto e Clemente*, pp. 1–5; Bolton, 'Daughters of Rome'; Spiazzi, *La chiesa e il monastero di San Sisto*; Spiazzi, *Cronache e Fioretti*; and Spiazzi, *San Domenico e il monastero di San Sisto*; Barclay Lloyd, 'The Architectural Planning of Pope Innocent III's Nunnery of S. Sisto'; Jäggi, *Frauenklöster*, pp. 24–25, 27, 212–13.

109 Krautheimer, *Rome*, pp. 161–228; Bloch, 'The New Fascination with Ancient Rome'; Kitzinger, 'The Arts as Aspects of Renaissance'; Claussen, 'Renovatio Romae', and Guidobaldi, 'Un estesissimo intervento urbanistico'.

110 For SS. Quattro Coronati, see Krautheimer, *Corpus*, vol. IV, pp. 3–4, 30–31; for San Clemente, see Barclay Lloyd, 'The Building History [...] of S. Clemente'; and Barclay Lloyd, *The Medieval Church and Canonry of S. Clemente*, pp. 104–09, 117–21.

111 Gilchrist, *Gender and Material Culture*, pp. 95–109; Jäggi, *Frauenklöster*, for the layout of churches in enclosed nunneries of the Mendicant Orders; and Burton and Stöber, ed., *Women in the Medieval Monastic World*, for nuns in England, Ireland, Spain, Germany, and Italy.

112 Aubert, *L'Architecture cistercienne*, vol. II, pp. 173–205; Dimier, *Receuil de plans*, 4 vols, where he refers to forty-eight plans of medieval Cistercian nunnery churches that had a single nave in his first two volumes, and 161 in the third volume; see also, Kinder, *L'Europe cistercienne*, pp. 32–34, 165; and Jäggi and Lobbedey, 'Church and Cloister', p. 120. Jäggi, *Frauenklöster*, illustrates plans of many thirteenth- and fourteenth-century Dominican and Poor Clare nunnery churches, the majority of which had only a single nave.

113 See below, Chapter 4 for S. Cosimato, and for S. Pancrazio, Barclay Lloyd, 'The Church and Monastery of S. Pancrazio', pp. 255–63.

114 *The Book of St Gilbert*, ed. by Foreville and Keir, pp. lxiii–c; 168–85 and 245–53; and see Bolton, 'Daughters of Rome', p. 111.

115 Graham, *St Gilbert*; Knowles, 'Gilbertini e Gilbertine'; Elkins, *Holy Women*, pp. 78–144; Thompson, *Women Religious*, pp. 73–79; Golding, *Gilbert of Sempringham*; and Sykes, *Inventing Sempringham*.

performed domestic duties in the nunneries. The Gilbertines were highly successful in caring for nuns. The monasteries were 'double' in that they accommodated both men and women, in suitably separate spaces. At Gilbert's death in 1189, there were about 1500 enclosed nuns in his houses, which were all in England.

The planned connection between S. Sisto and the Gilbertines led to King John of England being persuaded to donate 150 marks a year towards the project. In addition, the church of Saint Oswald at Nostle in the diocese of York donated an annual sum of 150 marks sterling to S. Sisto in Rome, which was still being paid in 1244.[116]

Although the Pope wanted the Gilbertines to run his new nunnery, he did not follow the Gilbertines' architecture in planning the church of S. Sisto. Most of the English monastic buildings of the Order of Sempringham have disappeared since the suppression of the monasteries in 1536–1540, but some aspects of them are known from excavations.[117] From the excavated foundations of the Gilbertine priory church at Sempringham, the plan of that building has been revealed (Fig. 22). A thick wall, built from the façade to the end of the sanctuary, divided the church lengthwise into two parts: it has been suggested that south of the wall was located the choir of the nuns and lay Sisters, while the canons' choir and seating for the lay brethren were situated on the other side of the central wall to the north. Further north still, there was an additional aisle and transept, allowing space for pilgrims to gather and then go and pray at the tomb of Saint Gilbert, which was located within the central wall dividing the church. The altar of Saint Andrew was in the canons' side of the wall, while the altar of Saint Mary was in the nuns' choir. At Watton Priory, the layout of the church was similar, but it has been suggested that the nuns' choir was to the north of the central wall, whereas the canons' choir was on the south of it and to the west there was space for the lay brothers (Fig. 23). At the east end of the church, there was a double sanctuary, with an altar in both the nuns' choir and in the canons' part of the edifice.

The architecture of Innocent III's church at S. Sisto was not like these Gilbertine buildings. It was preceded by a narthex and had a single nave, which ended in an apse — a plan similar to other churches in Rome, Plan I, A (Fig. 4). Originally there seems to have been a wall, or 'tramezzo', across the nave, rather than a wall lengthwise down the middle of the church. The intermediary wall across the nave would have reached from the floor to the roof, and thus effectively divided the church into two distinct spaces, one for the nuns, the other for the public. In the tramezzo, there seems to have been a large window with a grille. It is likely that there was an altar in front of the window, in the lay part of the church and there may also have been one on the nuns' side, most probably in the apse.

One can deduce some of these details from Sister Cecilia's comments regarding the church's interior layout.[118] In a description of a Mass celebrated in the church on the Second Sunday of Lent, she says 'Beatus vero Dominicus stabat ad fenestram, ita quod sorores poterant eum videre et (sic!) audire, et verbum domini fortiter predicabat' (Blessed Dominic was standing at the window, so that the Sisters could see and hear him, and he was powerfully preaching the

116 *Bullarium Ordinis FF. Praedicatorum*, ed. by Brémond (henceforth *BOP*), vol. I, p. 134; Koudelka, 'Le "Monasterium Tempuli" et la fondation dominicaine de San Sisto', pp. 74–76.

117 See Graham, 'Excavations on the Site of Sempringham Priory'; Knowles, *Monastic Sites from the Air*, pp. 242–45 (Sempringham) and pp. 246–47 (Watton); St John Hope, 'The Gilbertine Priory of Watton'; Barclay Lloyd, 'The Architectural Planning of Pope Innocent III's Nunnery of S. Sisto', pp. 1306–1307; Müller, 'Symbolic Meanings of Space', pp. 313–14.

118 Cecilia, *Miracula Beati Dominici*, 5, pp. 313–14, 318, 320–21. See also, Jäggi, *Frauenklöster*, pp. 24–25, 27, 186–91.

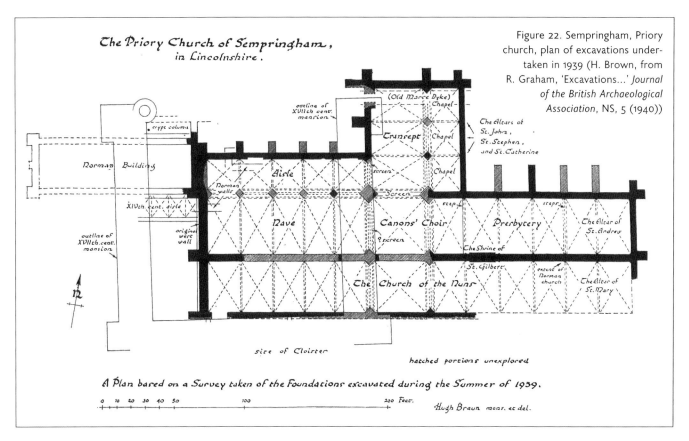

Figure 22. Sempringham, Priory church, plan of excavations undertaken in 1939 (H. Brown, from R. Graham, 'Excavations…' *Journal of the British Archaeological Association*, NS, 5 (1940))

word of God).[119] On this occasion, a woman possessed by demons started to cause a commotion, whereupon Dominic exorcised her with a prayer and the sign of the cross, and the woman was dramatically delivered and totally healed. This event made an impression on Sister Cecilia and the other Sisters, 'videntibus' (seeing) and 'audientibus' (hearing) what was taking place.[120] From this account, one can imagine Dominic in the public part of the church beside an altar, located close to the transverse wall built across the nave. The Sisters in their choir could see and hear what he was doing in the public part of the church through a window in the tramezzo, which was close to the altar. The window would have been fitted with a grille. A document of 1368 concerning the commission of an altarpiece for the Dominican nunnery of Sant'Aurea refers to a similar arrangement, in stipulating that 'per gratam dicta domina priorissa et moniales valeant habiliter et ex aspectu oculorum videre et audire canere missam et celebrare divina officia' (through the grille the said lady prioress and the nuns may easily be able both to see with their eyes, and to hear Mass being sung and the Divine Offices being celebrated).[121] From these sources, it is clear that Dominican nuns could both see

119 Cecilia, *Miracula Beati Dominici*, 5, p. 313.
120 Cecilia, *Miracula Beati Dominici*, 5, p. 313.

121 Pecchiai, *La Chiesa dello Spirito Santo dei Napolitani e l'antica chiesa di S. Aurea*, p. 149; Gardner, 'Nuns and Altarpieces', pp. 30–31. Only fourteen documents from the fourteenth and fifteenth centuries survive from this foundation. They are now in the Dominican Archives at S. Sabina, AGOP XII, 9002, buste 66–81 and 9003, busta 123. The S. Aurea altarpiece is discussed by Gardner, 'Nuns and Altarpieces'; Dunlop, '*Advocata Nostra*', pp. 159–91; Dunlop, 'The Dominicans and Cloistered Women'; Cirulli, 'Lippo Vanni: il trittico di Santa Aurea'.

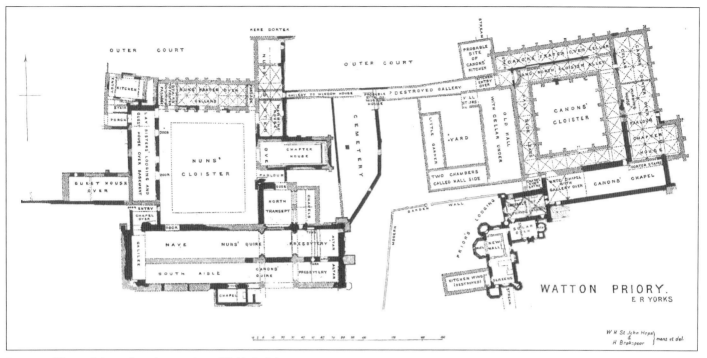

Figure 23. Watton Priory, plan of excavations (W. H. St. John Hope and H. Brakspear, from W. H. St. John, 'The Gilbertine Priory of Watton…' *Archaeological Journal*, 58 (1901))

and hear what was going on in the public part of the church, unlike some Franciscan nuns, who could often only hear but not see, as Caroline Bruzelius has observed.[122]

Sister Cecilia refers to the window and to a 'rota' (a wooden turnstyle for passing things through a nunnery wall) in the tramezzo.[123] She says that Dominic used to come sometimes in the evening to preach to the Sisters in the church.[124] One evening, when the bell rang to announce Dominic's arrival, 'omnes sorores festine venerunt ad ecclesia et aperta fenestra invenerunt eum iam ibi sedentem cum fratribus et expectantem illas' (all the Sisters hurriedly came to the church and, having opened the window, they found him already sitting there with some brothers waiting for them).[125] From this, it appears that the window could be opened so that the nuns could see and hear what was happening in the public part of the church, or it could be closed, when the Sisters wanted to protect their privacy. After Dominic had taught them, he shared some wine with both the friars and the Sisters, first handing it to the brothers.[126] He then placed the container in the rota and told Sister Nubia to take it and give some wine to the Sisters, who all drank from it.[127] On another occasion, Dominic spoke to one of the Sisters at the rota, when he is reported to have healed three nuns who had a fever.[128] Sister Cecilia records that, when Dominic preached to them at night, 'fratres extra et sorores intus accendebant magna luminaria, ita quod bene poterant videre quicquid in ecclesia fiebat' (the friars outside and the Sisters inside lit great lights, so that they

122 Bruzelius, 'Hearing is Believing'.
123 In Rome, there is still a rota at SS. Quattro Coronati opposite the entrance to the chapel of S. Silvestro.
124 Cecilia, *Miracula Beati Dominici*, 6, pp. 313–15.
125 Cecilia, *Miracula Beati Dominici*, 6, p. 314.
126 Murray, *The New Wine*, refers to this story.
127 Cecilia, *Miracula Beati Dominici*, 6, p. 314; see also *Early Dominicans*, ed. and trans. by Tugwell, pp. 391–92.
128 Cecilia, *Miracula Beati Dominici*, 9, p. 319.

could see clearly whatever was happening in the church).¹²⁹ 'Outside', for Sister Cecilia, indicated the public part of the church; 'inside' the nuns' choir; and the 'great lights' may have been large candles or torches. The nuns would have needed some means of receiving Holy Communion and going to Confession, but there is no evidence of how this was organized.

It is not clear exactly where the tramezzo stood in the church of S. Sisto.¹³⁰ Still, there may be a clue in the position of the fifteenth-century door (Fig. 11) on the south-western side of the building, see Plan I, Y (Fig. 4). This and the door in the main façade, Plan I, Z (Fig. 4) gave access to the public part of the church. The fifteenth-century entrance is rather close to the south-eastern end of the building, suggesting that the public area was much smaller than the nuns' choir to the north-west. There are known to have been seventy nuns at S. Sisto *c.* 1320, so they would have required a large space for their choir.¹³¹ A plan made before 1819 of the Dominican nuns' church of S. Agnese in Bologna shows that the public part of that church was much shorter than the nuns' choir.¹³² That church was divided by a tramezzo with an altar on either side of it, one inside the choir, the other in the public part of the church.

The bell tower at S. Sisto is situated in the north-eastern corner of the church, Plan I, B (Figs 4 and 7).¹³³ Ann Priester, who made a detailed study of it, found that it rises approximately 25 m, with the lower 13 or 14 m surrounded by the walls of the church and convent.¹³⁴ A roughly square vaulted chamber about 5 m high is at the lowest level. The next storey is about 4 m high, the third about 5 m.¹³⁵ The uppermost three levels are pierced on all four sides by triple arched openings, each divided by pairs of small marble columns, bases, and pulvins.¹³⁶ Of the colonnettes, eight are ancient spoils, thirteen were made in the Middle Ages, and three are modern replacements. A cornice of bricks and marble brackets separates each of the storeys of the campanile. Brickwork, where it is accessible, is either from the very early fifth century (in the lowest part of the tower, which makes use of the walls of the former early Christian basilica),¹³⁷ or medieval brickwork, of the kind found in the parts of S. Lorenzo fuori le Mura that were built in 1216–1227 and in the Chapel of S. Silvestro at Quattro Coronati, built in 1246.¹³⁸ This suggests a date of construction for the bell tower between 1216 and 1246. Sister Domenica Salomonia stated that a certain Guido Corleone paid for it, but this may refer to his having extended or restored it.¹³⁹

The Monastic Buildings

Monastic buildings were constructed on either side of the church, which presumably separated the friars' quarters from the nuns' residence. On the south-west, some rooms were built beside the nave, Plan I, P (Fig. 4), and in the late thirteenth or early fourteenth century there was added the block that used to stand between the apse and

129 Cecilia, *Miracula Beati Dominici*, 10, p. 321.
130 This is where it would be helpful to go over the floor with GPR (Ground Penetrating Radar), to find its foundations, a technical procedure that has not been possible. See, however, the recent studies by Bruzelius, 'L'Eco delle Pietre' and by Bruzelius and Repola, 'Monuments and Methods in the Age of Digital Technology', which relate how the authors and a team of technicians located the choir-screen or tramezzo in the medieval Clarissan church of S. Chiara in Naples and were able to make a 3D digital model of it.
131 Catalogue of Turin, in Valentini and Zucchetti, ed., *Codice topografico*, p. 309.
132 Jäggi, *Frauenklöster*, pp. 38–39 and fig. 29.
133 Priester, 'The Belltowers', p. 295; see also, Krautheimer,

Corpus, vol. IV, p. 172.
134 Priester, 'The Belltowers', pp. 289–97; and Priester, 'The Bell Towers and Building Workshops in Medieval Rome'.
135 Priester, 'The Belltowers', p. 294.
136 Priester, 'The Belltowers', pp. 291–92.
137 Priester, 'The Belltowers', p. 293.
138 Priester, 'The Belltowers', p. 295.
139 Domenica Salomonia, *Cronache del Monastero di San Sisto*, Book 2, Cap. 1, in Spiazzi, *Cronache e Fioretti*, p. 105.

the Via Appia, of which only a small part remains today, Plan I, T (Fig. 4, and compare Figs 3 and 5). In what remains of the exterior wall of this building there is a fragment of a blocked window, with a rectangular marble frame, surmounted by a small brick relieving arch.[140] This type of window is typical of late medieval construction in Rome.[141] In the exterior of the same wall, there is a type of brickwork typical of Roman medieval construction in the late thirteenth and fourteenth centuries.[142] On the interior, the masonry displays a combination of brickwork interspersed with rows of tufelli (medieval *opus listatum*).[143] These constructional techniques were used in Rome in the thirteenth and fourteenth centuries, when the building south-west of the apse was presumably erected. An old photograph shows this wing from behind the apse of the church.[144] The block is tall, with two rectangular windows of post-medieval date and four blocked medieval stone-framed windows clearly visible on the first floor. Along this façade there appear to have been three buttresses and an arched entrance on the ground floor. The sixteen friars mentioned in the Catalogue of Turin *c.* 1320 may have lived in this block.[145]

North-east of the church, monastic buildings were constructed for the nuns around a cloister garden. These structures were rebuilt in the late sixteenth and early seventeenth century, but Krautheimer has suggested plausibly that the later builders preserved 'the outline of the medieval cloister as well as some of its salient features'.[146] In particular, the location of the medieval chapter room and refectory remained unchanged, Plan I, CR and R (Fig. 4), although both of them were later remodelled.

The chapter room, Plan I, CR (Fig. 4) retains its medieval façade, opening towards the cloister garden with an early thirteenth-century semi-circular arched doorway framed with marble (Fig. 12). This is flanked by double-light windows, each separated by two small marble columns with medieval bases and smooth-leaf medieval capitals. The floor level in the cloister ambulatory in front of the chapter room is lower than that in the remainder of the cloister walks. This may reflect the original floor level of the medieval cloister and, indeed, of the medieval church. In the interior of the chapter room, four ancient granite columns now divide the space. Two of the capitals they support are like those found on the columns embedded in the church walls (Figs 14, 15 and 17). It is likely that these columns and capitals came from the early Christian basilica. Old photographs show some of the original medieval vaults of the chapter room. A different form of vaulting now covers the part of the room close to the cloister, which may date from after Mother Lalía took over the convent in 1893. The nineteenth-century plan by Filippo Cicconetti

140 The marble pieces are 10–12 cm wide and the window opening was originally 42 cm high.
141 Barclay Lloyd, *The Medieval Church and Canonry of S. Clemente*, p. 27, 'f' and fig. 22, 4.
142 The length of the bricks is varied: 11.1, 11.2, 17.5, 20, 23.5, or 27 cm long, with many short brick fragments. The mortar is crumbly and full of black, white, and red granules. The height of the mortar beds is only 15, 20, or 25 mm and there is no 'stilatura' (*falsa cortina* pointing). A modulus of five alternating rows of bricks and mortar measures 23, 23.5, 24, 24.5, or occasionally 25 cm. For this type of masonry, see Barclay Lloyd, 'Masonry Techniques', pp. 238–39, 272–73.
143 The brickwork has a modulus of five alternating rows of bricks and mortar measured 24, 24.5, 25 cm. For this kind of masonry, see Barclay Lloyd, 'Masonry Techniques', pp. 238–39, 272–73, while the stretches of tufelli are made up of blocks of tufa 12.5, 14.5, or 17 cm long and 4, 4.5, 5, or 6 cm high. Mortar beds are 15 or 20 mm high, and five courses of tufelli and mortar measure 32 cm. For this type of masonry, see Barclay Lloyd, 'Masonry Techniques', pp. 241–42, 244, 275–76; for such tufa masonry, called 'opus saracinescum', see Daniela Esposito, *Techniche costruttive*.
144 The photograph is illustrated in Spiazzi, *San Domenico e il monastero di San Sisto*, unnumbered fig. after p. 320, entitled, 'Dietro l'abside della chiesa'.
145 Valentini and Zucchetti, *Codice topografico*, vol. III, p. 309.
146 Krautheimer, *Corpus*, vol. IV, p. 172.

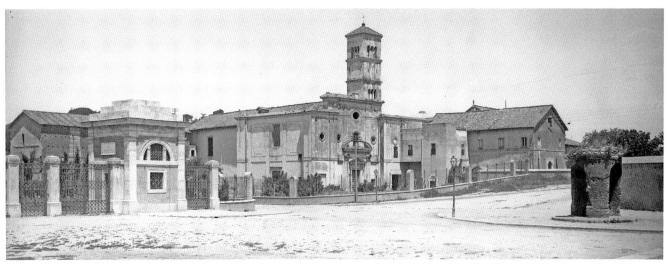

Figure 24. View of the S. Sisto buildings before 1908–1917 (photo: ICCD – under licence from MiBACT)

(Fig. 5) shows a wall, dividing the room into two parts. This wall appears to have been erected in the late eighteenth or nineteenth century. The two columns in its place are more likely to show the medieval disposition of the room. Koudelka, Sterpi, and Crociani believed that Cardinal Giovanni Boccamazza was responsible for an enlargement of the chapter room in 1285–1309, which is possible.[147] Other remodellings have also been recorded: for example, Father Mullooly is said to have had work done in the chapter room in the nineteenth century, which may have included the transverse wall. Between 1852 and 1856, Father Hyacinthe Besson, OP decorated the chapter room with paintings.[148]

Old photographs show a small porch and a square medieval tower south-west of the chapter room.[149] The porch, which resembled several medieval entrance gates, or 'prothyra', that survive in Rome,[150] had two columns sustaining a barrel vault and a semi-circular arch.[151] It was dismantled in the 1940s and the columns are now in front of the door leading into the sacristy from the cloister, but the capitals have disappeared. The nineteenth-century plan by Cicconetti shows the porch standing in front of a room with two columns in the interior, now part of the chapter room (Fig. 5). It is not clear where the columns in the small porch came from. The capitals, seen in the photographs, are unlike any others in the S. Sisto buildings, which makes one suspect that the porch was a later, possibly nineteenth-century, addition to the convent.

A tower was located between the church and the entrance to the nunnery. It contained a guard room and was obviously built to protect the entrance. It may be the tower mentioned by Sister Domenica Salomonia in the mid-seventeenth century as having had that function.[152] It is still visible, as a two-storey edifice close to the chapter room and to the right of the church in an old photograph of the S. Sisto buildings (Fig. 24).

147 Sterpi, Koudelka, and Crociani, *San Sisto Vecchio*, p. 61.

148 These show scenes from the life of Saint Dominic and some Dominican saints, as pointed out above.

149 See Spiazzi, *San Domenico e il monastero di San Sisto*, unnumbered fig after p. 320, entitled 'L'ingresso di San Sisto alla fine del secolo scorso' (the entrance of S. Sisto at the end of the last century). For the porch and its ancient columns and capitals, see Coates-Stephens, *Immagini e Memoria*, no. 46, pp. 138–39.

150 Barclay Lloyd, 'Il protiro medievale a Roma'.

151 See Coates-Stephens, *Immagini e Memoria*, no. 46, 138–39.

152 Domenica Salomonia, *Cronache del Monastero di San Sisto*, Book 2, cap. 2, in Spiazzi, *Cronache e Fioretti*, p. 118.

Early maps of Rome show the chapter room and what stood north-east of it, where the present refectory vestibule, Plan I, V, is located (Fig. 4). In 1618, M. Greuter's *Map of Rome* showed no building between the chapter room and the refectory, although a single wall marked the outer limit of the present refectory vestibule.[153] In Nolli's *Map of Rome*, printed in 1748 (Fig. 3), a long monastic block, which continues beyond the refectory wing, includes the chapter room, and the vestibule.[154]

The refectory (Fig. 16) and the vaulted room north-west of it, Plan I, R and K (Fig. 4) appear to be in the location of their medieval predecessors, although they have been modified over the centuries. It is clear that the refectory vaulting is not medieval, but part of a restoration made in 1619, as attested by an inscription near a coat of arms at one end. The room is in the traditional place for a monastic refectory — on the side of the cloister opposite the church — and its outer walls, now covered in plaster, are probably medieval. On the west, there is a now a lectern for reading during meals, which may replace a medieval one. In the late nineteenth century, the refectory was turned into a stable, as is recorded in a photograph of 1893, which shows the room divided into stalls for the animals, with feeding troughs along the walls.[155]

The refectory at S. Sisto was famous for a miracle, reported by Sister Cecilia.[156] When Dominic and the Friars Preachers were living at S. Sisto, before the nuns moved in, two of the brethren went to beg for food but received only one loaf of bread. When, further on, a man begged from them, they gave it to him. On returning to S. Sisto, they had no food for the community. Dominic, however, ordered tables to be prepared for the midday meal, although there was no food or drink. When he prayed, two youths appeared and distributed bread to each brother. Wine was also provided, and in this way the brethren learned from Dominic to trust in divine providence. This miracle reputedly occurred in the refectory of S. Sisto.[157]

The Dominican Foundation of S. Sisto

Innocent III did not live to see his project for a nunnery at S. Sisto completed, and the Gilbertines did not come to Rome to make the foundation. Innocent's successor, Honorius III entrusted the convent to Dominic and his friars after protracted negotiations with the Gilbertines. In August 1218, Honorius wrote to the Gilbertines complaining that the church of S. Sisto stood empty and 'viduata' (as though widowed), because they had not come to take up their position there; he commanded them to send four canons to Rome by Christmas, if they wished to retain their legal rights to the nunnery; otherwise, it would be transferred to another religious Order, a remark that suggests that by then the Pope had already planned to transfer it to Dominic.[158] The Gilbertines declined to come to Rome. (Brenda Bolton put it neatly, when she summarised their reasons for not coming: 'Rome was too far, too expensive, and too hot!')[159] Accordingly, on 4 December 1219, Honorius wrote to them, officially absolving them from their responsibilities for the nunnery.[160] A fortnight later, he sent a letter to the Dominican nuns in France, at Prouilhe,

153 Frutaz, *Piante*, vol. II, tav. 288.
154 Frutaz, *Piante*, vol. III, tav. 392 (autograph drawing) and tav. 403, printed map.
155 Boyle, *The Community of SS. Sisto e Clemente*, Plate 4; and Genovesi, 'Un nuovo capitolo nella storia di San Sisto', pp. 665–66.
156 Cecilia, *Miracula Beati Dominici*, 3, pp. 309–11.

157 There was a similar miracle reported at S. Maria della Mascarella in Bologna.
158 *Historia Diplomatica S. Dominici*, ed. by Laurent, no. 88, p. 103.
159 Bolton, 'Daughters of Rome', p. 111, referring to *The Book of St Gilbert*, p. 171.
160 *Historia Diplomatica S. Dominici*, ed. by Laurent, no. 100, p. 120.

saying that he had transferred the convent of S. Sisto to Dominic, and he commanded them to be ready to come to Rome when he sent for them.[161] He then officially ceded the church and convent to Dominic and his friars.[162]

Sister Cecilia and Benedict of Montefiascone describe how Dominic transferred nuns from the two existing Roman Benedictine convents of S. Maria in Tempulo and S. Bibiana to S. Sisto.[163] These writers claimed there were then about forty nuns and Sister Domenica Salomonia, writing in the seventeenth century, gave the names of over fifty nuns who were at S. Sisto in its first years as a Dominican convent, but these could include some who arrived after the initial foundation of the nunnery on 28 February 1221.[164] (Modern historians give a much smaller number: they claim that in 1221 five Sisters came from S. Maria in Tempulo, four from S. Bibiana, and soon after that, eight from Prouilhe, a total of seventeen.[165]) In order to smooth over the transition in the early foundation of the nunnery, Dominic had Sister Blanche and seven nuns come to Rome from Prouilhe, four of whom later returned to France.[166] Their experience made it possible for them to teach the Roman Sisters by word and example what needed to be done. Dominic appointed Blanche prioress and Fra Tancredi prior of S. Sisto, committing to him the internal and external care of the convent. Friars John of Calabria and Albert, who were both priests, were also to reside at S. Sisto and to celebrate Mass there. Fra Roger, a lay brother from Spain, was assigned to guard the rota.

S. Sisto was Saint Dominic's first foundation in Rome and one of three nunneries that he established, the others being at Sainte Marie de Prouilhe near Fanjeaux, where they also received the church of Saint Martin at Limoux in 1207, and Madrid in 1218.[167] With Diana D'Andalò he also planned, but left others to establish, in 1223, the Dominican nunnery of S. Agnese at Bologna.[168]

Sister Cecilia says that she made her profession to Dominic three times.[169] She did this first at S. Maria in Tempulo, when the nuns there agreed after protracted negotiations with Dominic to join the new nunnery of S. Sisto. Then their relatives and friends began to meddle in the nuns' affairs, and they persuaded the Sisters to go back on their word and refuse to comply with what Dominic had proposed. After another round of negotiations, Cecilia made her second profession there. Finally, her third profession was made at the door of S. Sisto, when the nuns moved to the nunnery definitively.

Honorius III appointed three cardinals to assist Dominic in the foundation of S. Sisto — Ugolino, Cardinal Bishop of Ostia; Stefano of Fossanova, Cardinal Bishop of Tusculo; and Nicola, Cardinal Priest of Dodici Apostoli.[170] On the day the nuns from S. Maria in Tempulo and S. Bibiana were supposed to move into S. Sisto, on 25 February 1221, which was Ash Wednesday, they were escorted by Dominic and the three cardinals to the new nunnery. On this occasion Napoleone,

161 *Historia Diplomatica S. Dominici*, ed. by Laurent, no. 104, p. 124.
162 *BOP*, vol. I, XI, p. 8. Papal influence on the foundation is discussed in Alberzoni, 'Papato e nuovi Ordini religiosi femminili', pp. 221–39; and Smith, 'Prouille, Madrid, Rome', pp. 342–47; and Smith, '*Clausura Districta*'.
163 Cecilia, *Miracula Beati Dominici*, 14, pp. 323–25; Benedict of Montefiascone, *Historical Introduction*, 5, p. 70.
164 Spiazzi, *Cronache e Fioretti*, pp. 76–77.
165 Koudelka, 'Le "Monasterium Tempuli" et la fondation dominicaine de San Sisto', pp. 59–60.
166 Benedict of Montefiascone, *Historical Introduction*, 7, p. 70.
167 Smith, 'Prouille, Madrid, Rome'. See also, Scheeben, 'Die Anfänge des zweiten Ordens'; Grundmann, *Religious Movements*, pp. 92–93; Lawrence, *The Friars*, pp. 75–79; Tugwell, 'For Whom was Prouille Founded?'
168 Roncelli, 'Domenico, Diana, Giordano', pp. 77–82; Grundmann, *Religious Movements*, pp. 94–96; Jäggi, *Frauenklöster*, pp. 38–39.
169 Cecilia, *Miracula Beati Dominici*, 14, pp. 323–25.
170 Cariboni, 'Domenico e la vita religiosa femminile', p. 341, but Sterpi, Koudelka, and Crociani, *San Sisto Vecchio*, pp. 35–36, say Nicola was bishop of Frascati. Both Cardinals Stefano and Nicola were Cistercians.

Cardinal Stefano's nephew, fell from his horse and died.[171] After Mass had been celebrated in the church of S. Sisto, Dominic went and prayed beside the dead lad and made the sign of the cross over him, whereupon Napoleone came back to life and Dominic gave him some food and drink. This miracle was considered one of the saint's greatest marvels, and it was often represented in Dominican art: for example, it was carved in 1264–1267 by Nicola Pisano on the front of Dominic's sarcophagus in Bologna. Because of this event, however, the solemn profession of the nuns was postponed, and they were installed in S. Sisto on 28 February 1221, which was the first Sunday in Lent.[172]

Maria 'Advocata': The Icon of S. Maria in Tempulo, later called the Icon of S. Sisto

According to Sister Cecilia, the nuns from S. Maria in Tempulo agreed to join the community at S. Sisto, on condition that their icon came with them and stayed with them there.[173] Dominic, accompanied by Cardinals Stefano and Nicola and many other people, carried the icon on his shoulders from S. Maria in Tempulo to the church of S. Sisto at night in a candlelight procession shortly after the nuns had been installed in the new monastery. Everyone was barefoot, including the nuns, who waited at S. Sisto to receive the precious image and place it in their choir.[174] When the Dominican nuns moved to SS. Domenico e Sisto in 1576, the icon went with them, conveyed in a separate coach;[175] and, when they moved again to the church of S. Maria del Rosario in Monte Mario in the 1930s it was located in the nuns' choir there.

In the icon (Plate 1), the Mother of God is depicted, unusually, without the Christ Child and with her hands raised in intercession. This icon is one of the most beautiful in Rome. Mary has big brown eyes, a long straight nose, a small red mouth, and an exquisitely modelled face. The upper part of her brow is covered, first with a striped veil, which is only visible on the right, and then by a dark purple mantle. There are traces of a gold cross on her forehead and the figure stands out against a gold background. Later, hands of gold metal were attached to the image (Plate 2), as if to indicate the powerful effect of Mary's intercession.[176] There was also a gold metal cross attached to her right shoulder. Except for the head, one hand, and part of the gold background, the icon shows damage, where the paint has fallen from the surface.

The icon is painted on a rectangular wooden panel, 42.5 cm wide and 71.5 cm high. It is executed in the ancient encaustic technique, in which the artist used wax as the medium for the paint. This technique was employed in pre-iconoclastic icons, which is why experts usually date this image to the sixth or early seventh century.[177]

171 Cecilia, *Miracula Beati Dominici*, 2, pp. 307–09. It is incorrect to say that Napoleone was a member of the Orsini family, as is frequently asserted.
172 Sterpi, Koudelka, and Crociani, *San Sisto Vecchio*, p. 36.
173 Cecilia, *Miracula Beati Dominici*, 14, pp. 323–25. See Bertelli, 'L'immagine del "Monasterium Tempuli"'; Belting, *Likeness and Presence*, pp. 72, 314–16; Andaloro, 'Le icone a Roma in età preiconoclastico'; Wolf, *Salus Populi Romani*, pp. 161–170, 318–320; Andaloro and Romano ed., *Arte e Iconografia a Roma*, pp. 40, 47, 51; and Leone, *Icone di Roma e del Lazio*, no. 9, pp. 60–62.
174 Cecilia, *Miracula Beati Dominici*, 14, pp. 323–25, but the exact location of the icon is not clear from her account. Perhaps it was placed on the side altar mentioned in the sixteenth century by Ugonio, *Historia delle Stationi*, p. 171ᵛ.
175 Nicoletti, *The Church of Saints Dominic and Sixtus*, p. 10.
176 Similarly, in the early seventh-century icon in the Pantheon, Mary has her hands painted gold, see Wolf, 'Icon and Sites: Cult Images of the Virgin', p. 29; and Bertelli, 'La Madonna del Pantheon'.
177 Bertelli, 'L'immagine del "Monasterium Tempuli"', gives a date in the seventh century; Andaloro and Romano ed., in *Arte e Iconografia a Roma*, pp. 40, 47, 51, date it in the sixth century; Belting *Likeness and Presence*, also gives a sixth-century date; Leone, *Icone di Roma e del Lazio*,

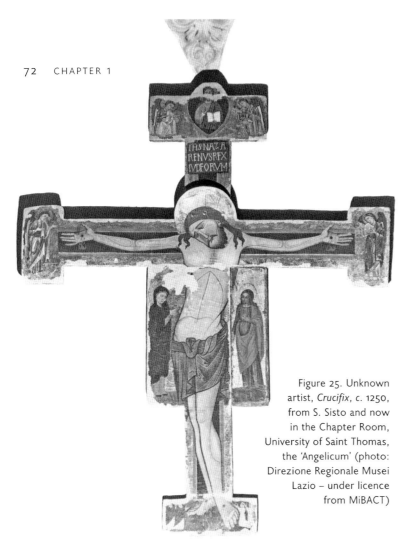

Figure 25. Unknown artist, *Crucifix*, c. 1250, from S. Sisto and now in the Chapter Room, University of Saint Thomas, the 'Angelicum' (photo: Direzione Regionale Musei Lazio – under licence from MiBACT)

Moreover, Mary does not look straight out at the viewer, but she has an indirect gaze, which is not typical of medieval Roman art. When Carlo Bertelli restored the image, he concluded that the icon was not made in the Eternal City because of the technique and the unusual gaze of the Mother of God.[178]

In Rome this type of icon is named *Maria Advocata* (Mary as Advocate), stressing her role as intercessor — a role that would have been significant to the Dominican nuns, who were called to intercede for their Order. In Constantinople the prototype of the icon was called *Hagiosoritissa*, a name derived from the holy reliquary urn (Hagia Soros) in the sanctuary where the original image was kept. The urn contained relics of the Mother of God: her belt, her dress, and, from 473 onwards, her mantle.[179] In Constantinople, the icon and the Marian relics were kept in the Chalkopratia, an imperial church built in 452. In 573–574, Emperor Justin II and Empress Sophia constructed a shrine adjoining the Chalkopratia specifically to house the Marian relics and the original icon. From 584 onwards, the Byzantine Emperor would go on 15 August each year and pray before the icon and the relics, as he entrusted the protection of Constantinople to the Mother of God.

There are three legends associated with the Roman icon.[180] The first attributed the icon to the evangelist Luke, who is said to have painted it when the Apostles remained at Jerusalem in prayer with the Mother of Jesus, the women, and the brethren just before the feast of Pentecost (Acts 1. 14).[181] The second legend tells the story of how the icon came to be at S. Maria in Tempulo in Rome.[182] According to this, three brothers, named Tempulus, Servulus, and Cervulus, came from Constantinople to Rome, where Tempulus was guided by God to seek out a pilgrim, who had brought the icon to Rome from Jerusalem,

no. 9, pp. 60–62, gives a date of the first third of the seventh century, and provides further bibliography.

178 Bertelli, 'L'immagine del "Monasterium Tempuli"'.

179 Baynes, *Byzantine Studies and Other Essays*, pp. 240–47 ('The Finding of the Virgin's Robe') and pp. 248–60 ('The Supernatural Defenders of Constantinople'); Cameron, 'The Theotokos in Sixth-Century Constantinople'; Cameron, 'The Virgin's Robe', pp. 42–46.

180 They survive in manuscripts from the medieval archive of the early nunnery of S. Maria in Tempulo, see Koudelka, 'Le "Monasterium Tempuli" et la fondation dominicaine de San Sisto', pp. 5–81, esp. 13–19. They were repeated in the seventeenth century, for example, in Martinelli, *Imago B. Mariae Virginis*, pp. i–x; and Torrigio, *Historia della veneranda Immagine di Maria Vergine*.

181 Torrigio, *Historia della veneranda Immagine di Maria Vergine*, p. 1; Koudelka, 'Le "Monasterium Tempuli" et la fondation dominicaine de San Sisto', p. 14.

182 Torrigio, *Historia della veneranda Immagine di Maria Vergine*, pp. 2–3; Koudelka, 'Le "Monasterium Tempuli" et la fondation dominicaine de San Sisto', p. 14.

and to place it in the church of S. Agata in Torre. After this, the name of the church was changed to S. Maria, and many miracles occurred there. By some transposition of names, the convent that owned the icon was called S. Maria in Tempulo. (This nunnery was first mentioned in the *Liber Pontificalis*, when Pope Leo III (795–816) gave a silver basket to the oratory of Saint Agata within that monastery, the name of the oratory being that of the church, where the icon had been placed.[183]) The third legend relates how Pope Sergius and some of his clergy took the icon away from the nunnery of S. Maria in Tempulo.[184] After carrying the image in procession through the streets, the pope placed it in his palace at the Lateran, next to the icon of the Saviour, the famous 'acheiropoietos' ([the icon] not made by human hands). The next day, when the Pope went to pray before the two icons, the nuns' image was missing. He returned to S. Maria in Tempulo to inform the abbess, but she was not perturbed, for she claimed that in the middle of the night, the icon of the holy Mother of God had of its own accord returned to the nunnery. Pope Sergius recognized this as a miracle, celebrated a special Mass at the monastery, and he decreed that the bishop of Rome should pay for lamps to be kept burning continuously before the sacred image. In fact, Pope Sergius III (904–911), who was famous for his devotion to the Mother of God, drew up charters in favour of the nunnery and he and later popes did pay for lamps to burn before the icon. (The third legend may also account for the condition the nuns of S. Maria in Tempulo insisted upon, when they went to live at S. Sisto, that their move was contingent upon their icon going with them and staying there.)[185]

Bernard Hamilton suggested that S. Maria in Tempulo was one of the early Roman nunneries reformed by the House of Theophylact in the tenth century, the others being S. Maria in Campo Marzio and S. Ciriaco, which had similar but much later icons.[186] The type of icon, *Maria Advocata*, became one of the most frequently represented in Rome. Among these icons, a particularly close copy of the S. Sisto icon, dating from the late eleventh century, is to be seen at the Franciscan church of S. Maria in Aracoeli (Plate 7).[187]

The S. Sisto Crucifix

When the nuns of S. Sisto went to live at SS. Domenico e Sisto in 1576, they also took with them their crucifix (Fig. 25), a triptych by Lippo Vanni that had come from the convent of Sant' Aurea, and a painting executed in 1527 called *La Vergine delle Grotte* (Our Lady of the Grottoes). These works of art are now in the Chapter Room at the Pontifical University of Saint Thomas Aquinas (the 'Angelicum').[188]

When Gianluigi Colalucci restored the painted crucifix in 1970–1971, under the direction of Luisa Mortari,[189] he noted that the cross is 2.06 m high and 1.59 m wide. It is made of eight pieces of chestnut wood, a material sometimes used in Roman panel paintings of the thirteenth century. These panels are held together at the back of the crucifix by bands of metal. One piece of wood, with the figure of Saint John, to the right of

183 *LP*, vol. II, p. 24; Koudelka, 'Le "Monasterium Tempuli" et la fondation dominicaine de San Sisto', p. 17.
184 Torrigio, *Historia della veneranda Immagine di Maria Vergine*, pp. 3–7; Koudelka, 'Le "Monasterium Tempuli" et la fondation dominicaine de San Sisto', p. 14.
185 Cecilia, *Miracula Beati Dominici*, 14: 6–10, p. 324.

186 Hamilton, *Monastic Reform, Catharism and the Crusades*, IV, pp. 195–217 ('The House of Theophylact').
187 See below, Chapter 5. Grassi, 'La Madonna di Aracoeli e le tradizioni romane', pp. 65–94; Bolgia, *Reclaiming the Roman Capitol*, pp. 360–64; Wolf, *Salus Populi Romani*, pp. 228–235; Leone, *Icone di Roma e del Lazio*, vol. I, no. 12, pp. 63–65.
188 Bernardini, Draghi, and Verdesi, *SS. Domenico e Sisto*, pp. 104–09; Nicoletti, *The Church of Saints Dominic and Sixtus*, pp. 37–38. The Rector of the Angelicum kindly allowed me to examine these paintings.
189 Mortari, 'L'antica croce dipinta'.

Christ, is not medieval but a later replacement. The entire wooden cross was first covered with cloth and then an undercoat was added of rough grey material, over which paint was applied. The minor figures now stand out against a gold background. Before the restoration, the painting was dark because it was covered with layers of varnish. Except for a few 'lacunae' in the painted surface, what survives of the original is now in fairly good condition. The crucifix of S. Sisto is believed to date to *c.* 1250 and Mortari asserts that it was certainly made in Rome, given the artistic techniques employed.[190]

The composition shows a full-length figure of Christ on the cross, his face expressing his sufferings.[191] Mary and the later figure of Saint John stand on either side of the vertical section of the cross, while a full-length angel is at the end of each arm. At the top of the cross, above the figure of the dead Christ is the 'INRI' inscription and another much smaller image of the Redeemer in an oval mandorla, blessing with one hand and holding in the other an open book (with no writing discernible on it). Two three-quarter length figures of angels flank this image. At the feet of the crucified Christ, there are on the left two kneeling figures of Dominican friars, wearing their white habits, scapulars, and black mantles. On the right there are two girls, dressed in long white robes and white veils. (They are not in the full habit of the Dominican nuns, so they may be postulants or novices.) It has been suggested that the crucifix was commissioned by the prioress but, in the light of these two female figures, one wonders whether it was donated to the nunnery by the relatives of two young nuns, when they first joined the convent.[192] Having such figures at the feet of the crucified Christ seems to stem from a lost crucifix that Giunta Pisano made for the church of S. Francesco in Assisi in 1236, where Fra Elia was depicted in that position.[193] Giunta Pisano also made a magnificent painted crucifix for the Dominican friars in Bologna, which still hangs in a side chapel of the church of S. Domenico.

As Joanna Cannon has indicated, most Dominican churches had a large crucifix and a painting of Mary, the Mother of God, which were often placed on top of the tramezzo, facing the public part of the church.[194] The medieval nuns at S. Sisto had their crucifix and the famous icon of *Maria Advocata*. The tramezzo in a nuns' church would have stood between the floor and the roof, so no works of art could have been placed on top of it. It is therefore likely the crucifix and the icon were located inside the choir, facing the nuns.

The Medieval Frescoes

In the late nineteenth century, medieval frescoes were discovered in what remains of the medieval apse and on the side walls of the sanctuary.[195] These paintings are located to the left and right of the high altar in spaces that were hidden by

190 Mortari, 'L'antica croce dipinta'.
191 Gardner, 'Nuns and Altarpieces', pp. 31–32; Gardner, *The Roman Crucible*, pp. 241–42 and fig. 260; Quadri, 'La croce dipinta'.
192 Gardner, 'Nuns and Altarpieces', p. 31.
193 Gardner, 'Nuns and Altarpieces', pp. 31–32.
194 Cannon, *Religious Poverty, Visual Riches*, Chapters 2 and 3, pp. 71–89.
195 The murals were mentioned briefly in Crowe and Cavalcaselle, *A History of Painting in Italy*, vol. II, p. 157; Tomasetti, *Della Campagna Romana*, vol. II, p. 27; van Marle, *The Development of the Italian Schools of Painting*, vol. V, p. 362; Toesca, *Il trecento*, p. 684 and n. 207; Kaftal, *Iconography of the Saints in Central and South Italian Painting*, col. 269; Matthiae, *Pittura romana*, vol. II, p. 238; Matthiae, *Pittura romana*, updated by Gandolfo, vol. II, p. 350. More recently, see Romano, *Eclissi di Roma*, pp. 133–37 and 411; Jäggi, *Frauenklöster*, pp. 264–65; and Sgherri, 'La decorazione ad affresco nell'antica abside e nella navata di San Sisto Vecchio'. Three longer studies specifically about the frescoes at S. Sisto, are Ronci, 'Antichi affreschi in S. Sisto Vecchio', pp. 15–26; Vitali, 'Gli affreschi medioevali di S. Sisto Vecchio'; and Barclay Lloyd, 'Paintings for Dominican Nuns', pp. 189–232.

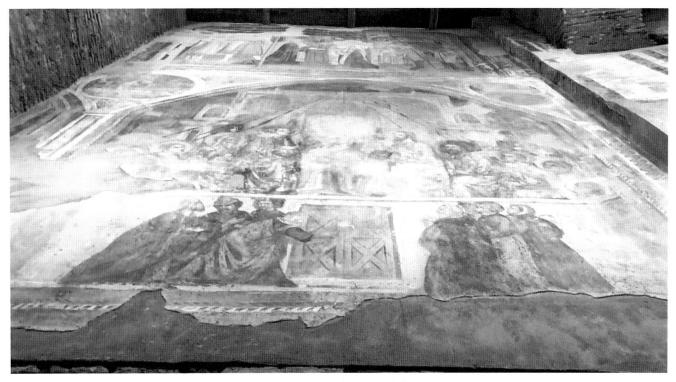

Figure 26. Frescoes on the wall to the left of the apse, with an image of *Pentecost* below *Scenes from the life of Saint Catherine of Siena, a patron of the work, and Saint Eustachio* (photo: author)

the fifteenth-century polygonal reordering of the chancel. Since the restoration of the church in 2019, however, they have been made more visible from the sanctuary; besides, a later division between the floor and the roof has been removed. While the whole apse and the nave may have been painted in the Middle Ages, only these fragments survive.[196] Originally, the frescoes would have been designed to be seen by the Dominican nuns in their choir. They were painted in two distinct phases: first, there are paintings lower down, which are attributed to artists connected with Pietro Cavallini, dating from the late thirteenth to early fourteenth century; and second, there is a band of frescoes higher up, attributed to an unknown Sienese artist, from the years between Catherine of Siena's death in 1380 and her canonization in 1461 (Fig. 26).[197]

The frescoes are not in good condition, even though Silvana Franchini restored them in 1990–1992.[198] During that campaign, later

196 Following Zucchi, *Roma domenicana*, vol. I, p. 17, the anonymous author of *San Sisto all'Appia*, pp. 46, 55, suggests that the whole of the medieval church was covered with frescoes. See the same opinion in Romano, *Eclissi di Roma*, p. 136. On the left of the Pentecost scene, it looks as though the decoration continued along the nave.

197 Ronci, 'Antichi affreschi in S. Sisto Vecchio', pp. 15–26; Sgherri, 'La decorazione ad affresco nell'antica abside e nella navata di San Sisto Vecchio'; and Cirulli, 'Gli affreschi nella navata di San Sisto Vecchio'.

198 Reports and photographs of the restoration campaigns are in the archives of the Soprintendenza Speciale per il Patrimonio Storico, MiBACT, at Palazzo Venezia. There are two very brief accounts of the restoration campaign in Anonymous, *San Sisto all'Appia*, p. 55, and in Genovesi, 'Un nuovo capitolo nella storia di San Sisto', pp. 676–77. Romano, *Eclissi di Roma*, p. 136 mentioned one scene discovered during the restoration, the *Presentation of Christ in the Temple*; see also Sgherri, 'La decorazione ad affresco nell'antica abside e nella navata di San Sisto Vecchio'. The murals do not seem to

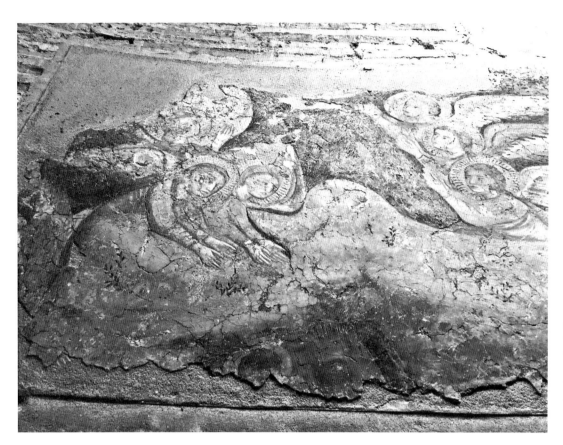

Figure 27. Unknown artist, *Angels in adoration*, late thirteenth- or early fourteenth-century fresco (photo: Direzione Regionale Musei Lazio – under licence from MiBACT)

over-painting was also removed from a wall to the right of the present chancel to reveal a depiction of the *Presentation of Christ in the Temple*, and fragments of the *Adoration of the Magi*, which were part of the first cycle.

The murals portray scenes from the New Testament, the Apocryphal *Protoevangelium of James*, and figures of prophets and saints, including Catherine of Siena. It is likely that rich patrons paid for this decoration. Such donors may have been relatives of the nuns of S. Sisto and they, the convent prior, and some of the nuns may have planned the paintings.[199]

The Medieval Frescoes: Phase 1

Among the murals of the first phase, which covered the lower parts of the walls, one can distinguish on the left, three unidentified standing saints, who appear to be apostles from the way they are dressed; a rectangular panel with *Angels in adoration* (Fig. 27), that was part of a *Nativity* scene;[200] and a large image of *Pentecost* (Figs 26

have been improved much in the restoration campaign of 2019, although they are now more visible to visitors to the church.

199 For convent art and convent visual culture, see, for example, Wood, *Women, Art and Spirituality*; Hamburger, *Nuns as Artists*; Thomas, *Art and Piety in the Female Religious Communities of Renaissance Italy*; Lowe,

Nuns' Chronicles and Convent Culture; and Hamburger, Schlotheuber, Marti, and Fassler, *Liturgical Life and Latin Learning at Paradies bei Soest, 1300–1425*.

200 This image is on a panel 1.35 m long and 0.80 m high, which seems to have been taken off the wall in another place and then inserted in its present position. Whereas Ronci and Vitali believed that the angels belonged to a scene of the *Assumption*, see Ronci, 'Antichi affreschi in S. Sisto Vecchio', p. 17; Vitali, 'Gli affreschi medioevali di S. Sisto Vecchio', p. 437; and Romano identified the scene as perhaps the *Dormition of the Virgin*, Romano,

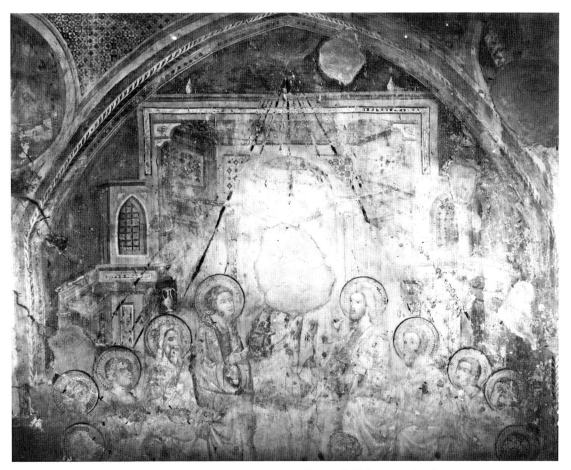

Figure 28. Unknown artist, *Pentecost*, upper section, late thirteenth- or early fourteenth-century fresco (photo: ICCD – under licence from MiBACT)

and 28). The fresco of *Pentecost*, which takes up most of the left wall of the sanctuary (Figs 26 and 28), would have been very meaningful to the Dominican nuns. At its base, the painting is rectangular, but it rises into a pointed arch at the top between two roundels, which contained portraits of prophets. The image is 3.40 m wide at the bottom and rises 3.40 m to the apex of the arch. At the apex of the *Pentecost* scene (Fig. 28) is the dove of the Holy Spirit, from which spread rays of light, falling on the haloes of the apostles. In the centre is seated Mary, the Mother of God, who is slightly raised above the apostles, but whose head has been destroyed.[201] She was represented in artistic depictions of this scene from at least the sixth century onwards, although she and the other women present at Pentecost were often not included, as in the twelfth-century mosaic representation of *Pentecost* in the monastery for Greek monks at Grottaferrata.[202] Her presence here at S. Sisto was no doubt significant for the nuns. The scene appears to take place in a

Eclissi di Roma, p. 133; in my opinion they seem to have been part of a *Nativity*, Barclay Lloyd, 'Paintings for Dominican Nuns', pp. 217–18, a conclusion now supported by Sgherri, 'La decorazione ad affresco nell'antica abside e nella navata di San Sisto Vecchio'.

201 Ronci, 'Antichi affreschi in S. Sisto Vecchio', p. 18.
202 Pace, *Arte e Roma nel medioevo*, pp. 416–19 (in his chapter 'La Chiesa abbaziale di Grottaferrata e la sua decorazione').

medieval church building, perhaps to remind the viewer that Pentecost was connected with the birth or foundation of the Church.[203] Below the interior view of the room, there is an exterior representation of the same building (Fig. 26), with a central doorway.[204] In the low 'outside' view of the building, eight people distinguished by different forms of headdress come forward to find out what is happening: they represent the 'gentes' (peoples) of the earth present in Jerusalem on the feast of Pentecost (Acts 2. 5–13). They were sometimes depicted in Byzantine art, for example in the Pentecost domes at Hosios Lukas (early eleventh century) in Greece, and in San Marco (*c.* 1200) in Venice.[205] The peoples also appear in some Trecento Italian paintings.[206]

The sermon Peter gave at Pentecost (Acts 2. 14–42) underlines the relevance of this scene for the Order of Preachers, as it was a famous example of effective preaching, when about three thousand people were converted. (Peter is not shown preaching at S. Sisto, as he is in some later Italian works, such as Andrea di Buonaiuto's fresco of *Pentecost* of 1365–1368 in the vault of the Dominican Chapter House in S. Maria Novella in Florence, where he is standing up preaching to the crowd gathered outside the cenacle.[207]) Perhaps for that reason, among others, the Dominican friars held their General Chapter every year on the feast of Pentecost. Perhaps Saint Peter is not shown preaching at S. Sisto, because this painting was in the nuns' choir. Dominican nuns, however, expected to be filled with the Holy Spirit in order to accomplish their vocation of supporting the mission of the friars through their life of prayer. The affectionate letters of Jordan of Saxony, second Master General of the Order of Preachers, to Diana of Andalò, the foundress of the Dominican nunnery of S. Agnese in Bologna, indicate that he valued the prayers of the Sisters in support of his ministry.[208] Often Jordan asks Diana and her community to pray for him personally and for his mission, as well as for peace in the Church and for good priests.[209] It is clear from his letters to Diana that although the Sisters lived an enclosed, contemplative life, they were open to the Holy Spirit, and they played a valuable role in the mission and growth of the Order of Preachers through their intercessory

203 See for the iconography of Pentecost and this point in particular, Schiller, *Ikonographie der christlichen Kunst*, vol. IV. 1, pp. 11–37, esp. p. 11; and Gardner von Teuffel, 'Ikonographie und Archäologie', pp. 16–40, esp. p. 20.

204 Other instances of the interior and exterior of a building being shown together in the same composition are known in medieval and early Renaissance art. See, for example, the *Presentation of Christ in the Temple*, in the eleventh-century Golden Evangelistary of Henry III, Gotha, Landsbibliothek, MS 1, 19, in Shorr, 'The Iconographic Development of the Presentation in the Temple', pp. 22–23 and fig. 6; and the *Ordination of Saint Stephen* in the Chapel of Saint Nicholas in the Vatican Palace, 1447–1451, where Fra Angelico shows the interior of St Peter's in the lower part of the painting, with the exterior of the clerestory above it, as pointed out in Krautheimer, 'Fra Angelico and – perhaps – Alberti', pp. 290–96, esp. pp. 291 and 293.

205 For Hosios Lukas, see Diez and Demus, *Byzantine Mosaics in Greece*, pp. 44, 72–73; for the Pentecost dome in San Marco, see Demus, *The Mosaics of San Marco*, vol. I, pp. 148–59.

206 For example, in a panel by Giotto and his workshop, now in the National Gallery London, the people stand outside the building, as pointed out by Gordon, 'A Dossal by Giotto', pp. 524–31, and fig. 13.

207 For the fresco of *Pentecost* in the vault of the Dominican Chapter House in S. Maria Novella in Florence, see Gardner von Teuffel, 'Ikonographie und Archäologie', pp. 30–31, fig. 14 and Gardner, 'Andrea di Bonaiuto'.

208 The Letters of Jordan of Saxony are published in *Beati Iordani de Saxonia Epistulae*, ed. by Walz. His letters to Diana are translated into English in Pond, trans. and ed., *Love among the Saints*, and Vann, *To Heaven with Diana*. The practice of male members of religious Orders writing affectionate letters to their nuns seems to have originated in Cistercian correspondence, according to Maguire, 'Cistercian Nuns', p. 176. See also Schreiner, 'Pastoral Care in Female Monasteries', pp. 237–38. For the early Dominican nunnery of S. Agnese in Bologna, see Grundmann, *Religous Movements*, pp. 94–96; Roncelli, 'Domenico, Diana, Giordano', esp. pp. 83–86; and Jäggi, *Frauenklöster*, pp. 38–39.

209 *Beati Iordani de Saxonia Epistulae*, ed. by Walz, pp. 5–52.

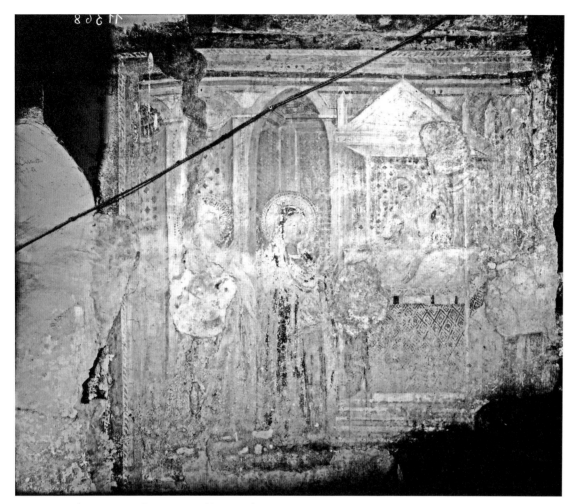

Figure 29. Unknown artist, *Presentation of Mary in the Temple*, late thirteenth- or early fourteenth-century fresco (photo: ICCD – under licence from MiBACT)

prayer. All this makes the image of Pentecost, with the mission 'ad gentes' (to the peoples) in S. Sisto significant for the vocation of the Dominican nuns.

On the right of the sanctuary, there is a three-quarter-length image of an unidentified martyr, who is perhaps the patron of the church, Pope Saint Sixtus II, and the *Presentation of Mary in the Temple* (Fig. 29), a fresco that is in very bad condition, a part of it having disappeared (Fig. 30). The surviving part of the fresco is 1.90 m wide and 1.70 m high, about half the size of the image of *Pentecost* on the other side of the sanctuary.[210] Below these images, there are the two scenes revealed in the 1990s: fragments of a scene, which has been identified as the *Adoration of the Magi*, and *The Presentation of Christ in the Temple* (Fig. 31).[211] The *Presentation of Mary in the Temple* (Fig. 29) takes place in a painted Gothic architectural interior, representing the Temple in Jerusalem, in which stands an altar with a Roman medieval altar canopy.[212] The child Mary — her

210 Vitali, 'Gli affreschi medioevali di S. Sisto Vecchio', p. 435.
211 Barclay Lloyd, 'Paintings for Dominican Nuns', pp. 216–17.
212 Vitali, 'Gli affreschi medioevali di S. Sisto Vecchio', p. 437. Versions of this type of altar canopy (with Gothic arches and no small columns) are to be found in the Roman churches of S. Maria in Cosmedin, S. Paolo fuori le Mura (1285) and S. Cecilia (1293), the latter two by Arnolfio di

80 CHAPTER 1

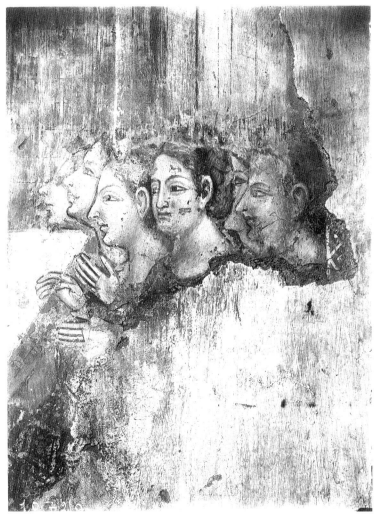

Figure 30. Unknown artist, *Girls at the Presentation of Mary in the Temple*, late thirteenth- or early fourteenth-century fresco (photo: ICCD – under licence from MiBACT)

head is missing — is seen to the left of the altar. Behind her stand her parents, Joachim and Anna. The High Priest leans forward to welcome the little girl. In an early report by the Soprintendenza dei Monumenti, there is also a reference to some other girls with exquisite profiles and dressed in white (Fig. 30).[213] These figures have since disappeared, but the profiles of six girls can be seen in a photograph in the Istituto Centrale per il Catalogo e la Documentazione in Rome.[214] They represent the other young girls present at the event, as recounted in the *Protoevangelium of James*, 7.[215] The scene of *The Presentation of Mary in the Temple* is also found in Byzantine mosaics, like those in the narthex of the church at Daphni near Athens in the early twelfth century, and in the nunnery church of the Chora in Constantinople c. 1320.[216] The scene would have reminded the nuns at S. Sisto that they, too, had been presented to the Lord by their parents, as candidates in the Dominican nunnery, for a life of prayer in the enclosed community.

The scene of the *Presentation of Christ in the Temple* (Fig. 31) based on Luke 2. 22–38, was situated below the image of the *Presentation of Mary in the Temple*. It was a subject often depicted in medieval art.[217] In Rome in the late thirteenth century, Pietro Cavallini included it in the apse mosaics of S. Maria in Trastevere, as did Jacopo Torriti in the apse of S. Maria Maggiore in 1295.[218] At S. Sisto, the meeting of

Cambio, see Romanini, 'Arnolfo e gli "Arnolfo" apocrifi', pp. 27–52, esp. pp. 48–52; Pace, *Arte a Roma nel medioevo*, pp. 132, 137–50, and 347–97; de Blaauw, 'Arnolfo's High Altar Ciboria', pp. 123–41.

213 Ronci, 'Antichi affreschi in S. Sisto Vecchio', p. 26, says the report was by Sergio Ortolani.
214 Photograph E 10720. This was originally printed the wrong way round but here it has been turned to the correct side.
215 'The Book of James or the Protoevangelium', 7, in *Apocryphal New Testament*, trans. and ed. by James, pp. 41–42. The Apocryphal *Protoevangelium of James* gives many details of the early life of the Virgin Mary not found in the canonical gospels. These events, however, were often depicted in medieval art.
216 For the scene at Daphni, see Diez and Demus, *Byzantine Mosaics in Greece*, p. 75. For the scene in the narthex of the Chora in Constantinople, see Underwood, *The Kariye Djami*, vol. i, pp. 72–74. He notes that the image is very close to the main entrance to the nave, highlighting its importance in that nuns' church.
217 Shorr, 'The Iconographic Development of the Presentation in the Temple'; and Maguire, 'The Iconography of Symeon with the Christ Child'.
218 For Pietro Cavallini's mosaics in S. Maria in Trastevere, see

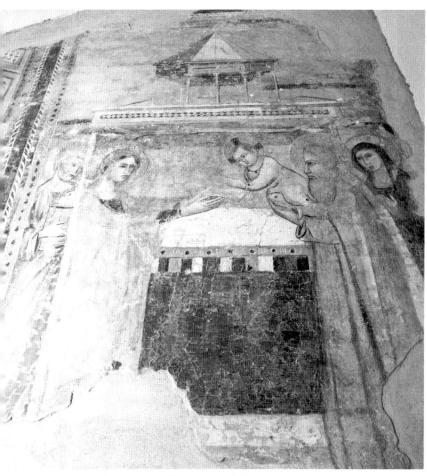

Figure 31. Unknown artist, *Presentation of Christ in the Temple*, late thirteenth- or early fourteenth-century fresco (photo: Direzione Regionale Musei Lazio – under licence from MiBACT)

Simeon and Anna with the Holy Family takes place beside an altar under a medieval canopy of a different style from the one in the *Presentation of Mary in the Temple*.[219] On the right of the composition Simeon holds an animated baby Jesus, who reaches towards his mother, as he was said to do in the *Meditations on the Life of Christ*, a devotional work written in the late thirteenth century for Franciscan nuns: 'Then the boy Jesus stretched his arms towards his mother and returned to her'.[220] Mary and Joseph stand to the left of the altar. Mary wears a red tunic and what now looks like a yellow cloak (but there are traces of blue, which was most probably its original colour).[221] She stretches out her arms to receive the baby, while Joseph stands behind her, holding two turtledoves in a square brown basket. Behind Simeon is Anna, who is said to have spent many years fasting and praying in the Temple; she could have been seen as a model for the medieval nuns. The faces of the figures, especially those of Mary, Joseph, and Anna, resemble the faces of the angels on the other side of the apse in shape and modelling, and their hands have similarly long fingers (compare Figs 27 and 31).

It is notable that almost all the early scenes painted in the apse include the Virgin Mary. Her presence would have been particularly relevant to the nuns of S. Sisto, because, since the time of Saint Ambrose, women consecrated to God had been advised to imitate the Mother of God.[222] The Sisters at S. Sisto probably saw themselves as having been presented to the Lord, when they

Hetherington, 'The Mosaics of Pietro Cavallini in Santa Maria in Trastevere'; Hetherington, *Pietro Cavallini*, pp. 13–36; Tiberia, *I mosaici*, pp. 123–76; Tomei, *Pietro Cavallini*, pp. 23, 38–44. For Iacopo Torriti's mosaics in S. Maria Maggiore, see Gardner, 'Pope Nicholas IV'; Righetti Tosti-Croce, 'La Basilica tra due e trecento'; and Tomei, *Iacobus Torriti Pictor*, pp. 99–125, esp. 114–17. See also Matthiae, *Mosaici*, vol. I, pp. 355–78; and Oakeshott, *The Mosaics of Rome*, pp. 318–28.

219 This type of medieval altar canopy can still be seen at S. Lorenzo fuori le Mura and at S. Giorgio in Velabro in Rome. Both have been dated in the early thirteenth century.

220 *Meditations on the Life of Christ*, trans. and ed. by Ragusa and Green, p. 58.

221 This scene was covered by whitewash and when that was removed in the 1990–1992 restoration, the medieval layer of blue may have come off.

222 Graef, *Mary*, pp. 67–69.

joined the nunnery, and persevering in prayer, like Mary and the other women, for the coming of the Holy Spirit at Pentecost. In the nuns' choir there was also the famous icon of Mary as intercessor, *Maria Advocata*. All this points to the strong devotion the nuns had to the Mother of God, who was considered the protectress of the Dominican Order.

It remains to ask who paid for these frescoes. Federica Vitali noted that Cardinal Giovanni Boccamazza endowed the convent with significant funds in the years that he was its protector (*c.* 1285–1309) and that he bequeathed a third of his estate to S. Sisto, when he died in 1309, money which continued to accrue until 1314. After that, another source of income came in the form of 500 scudi donated for repairs to the roof by Giovanni di Polo, the Dominican Archbishop of Nicosia, a little before 1320.[223]

Regarding Cardinal Boccamazza's generosity to the nuns of S. Sisto, Benedetto of Montefiascone, in about 1316–1318, said that the Cardinal gave the nunnery the farmhouse of S. Clemente along the Via Appia and its surrounding land, valued at 3000 florins, as well as a property at Cirsuli near Tivoli, worth 600 florins, which was sold to Matteo Colonna in 1316 for 1000 florins.[224] In 1641 Torrigio transcribed a codicil to Cardinal Boccamazza's will:[225] he bequeathed one third of a large sum of money to his nephews and nieces and he left the rest to be equally divided between the Dominican houses of S. Maria sopra Minerva and S. Sisto in Rome.[226] Cardinal Boccamazza was indeed a generous benefactor. Archbishop Giovanni di Polo's 500 scudi seem to be rather a small gift in comparison, but it was apparently enough to repair the church roof, renovate the altar, and provide a chalice, a cross, candlesticks, altar cloths, and a new set of red vestments; he may have given these things to the nunnery because he was a Dominican friar, who in 1290 had been the head of the Roman Province.[227] There is no reference, however, to the frescoes.

Clearly, Cardinal Boccamazza — who was not a Dominican — gave generously because he had relatives among the nuns at S. Sisto. Vitali noted that Sister Angelica Boccamazza was prioress of the convent in the late thirteenth century. In Sister Domenica Salomonia's history of S. Sisto, she recorded that, apart from Sister Angelica Boccamazza, there were nineteen or twenty other nuns of the Boccamazza family at S. Sisto, in the period between 1221 and *c.* 1400.[228] It is not surprising therefore to find the wealthy Cardinal giving generous donations to the nunnery, where women of his family were nuns. Other rich families who had a female relative in the convent were also willing to support S. Sisto, by paying for buildings and works of art. For example, Cardinal Pietro Colonna, who also had relatives at S. Sisto, donated a magnificent

223 Vitali, 'Gli affreschi medioevali di S. Sisto Vecchio', pp. 435–36.

224 Koudelka, 'Le "Monasterium Tempuli" et la fondation dominicaine de San Sisto', p. 72, no. 14; Spiazzi, *Cronache e Fioretti*, p. 115. The values are from Torrigio, *Historia della veneranda Immagine di Maria Vergine*, p. 57.

225 Torrigio, *Historia della veneranda Immagine di Maria Vergine*, pp. 54–57, esp. pp. 54–55; see also Koudelka, 'Le "Monasterium Tempuli" et la fondation dominicaine de San Sisto', p. 72, no. 13. The codicil is not mentioned in the version of Cardinal Boccamazza's will published by Paravicini Bagliani, *I testamenti dei cardinali*, pp. 353–82, but see p. 78 n. 1, where the author suggests it existed.

226 Koudelka, 'Le "Monasterium Tempuli" et la fondation dominicaine de San Sisto', p. 72, no. 13; Berthier, *Chroniques du monastère de San Sisto*, vol. I, pp. 87, 115, and Torrigio, *Historia della veneranda Immagine di Maria Vergine*, p. 55.

227 Berthier, *Chroniques du monastère de San Sisto*, vol. I, p. 95, where his gifts are listed; Zucchi, *Roma domenicana*, vol. I, pp. 273–74 on Giovanni di Polo.

228 Spiazzi, *Cronache e Fioretti*; and Berthier, *Chroniques du monastère de San Sisto*, vol. I. For further information about the documents of the S. Sisto archive, see *Le più antiche Carte del Convento di San Sisto*, ed. by Carbonetti Vendittelli, pp. xxvii–xxxiv; Carbonetti Vendittelli, 'Il monastero romano di San Sisto', pp. 375–77; see also Berthier, *Chroniques du monastère de San Sisto*, vol. I, p. 97.

silver lamp to hang in front of the icon and an olive grove in Tivoli to provide oil for the lamp to be kept alight.[229]

Sister Domenica claimed that Sister Angelica Boccamazza was a niece of Pope Honorius IV (1285–1287) Savelli.[230] Giovanni Boccamazza was the only cardinal Honorius IV created, and he, too, was a relative of the pontiff, perhaps his nephew.[231] One wonders, therefore, whether they were brother and sister, or cousins, although Sister Domenica thought Sister Angelica Boccamazza might have been the Cardinal's aunt.[232] Clearly, he was related to Sister Angelica on his father's side of the family and to Honorius IV on his mother's side.

Sister Angelica Boccamazza was prioress of S. Sisto in 1290. She raised significant funds for the convent, and she persuaded the Cardinal to make large donations to the nunnery.[233] From such benefactions, the number of choir nuns was increased from 60, the number stipulated by Pope Alexander IV in 1259,[234] to 75 or 76.[235] Sister Angelica Boccamazza also improved the buildings and the prestige of the monastery, by persuading Cardinal Boccamazza to provide 1000 florins in cash, part of which financed an extension to the nuns' dormitory, but it burned down a few years later, according to Benedetto of Montefiascone.[236] Following that disaster, Cardinal Boccamazza immediately provided further large sums of money, and he persuaded other Roman benefactors to do the same.[237] The dormitory was rebuilt, enlarged, and improved, and Sister Domenica suggests that other buildings were constructed, including a well-fortified room in the tower beside the church (Fig. 24), where a guard could be stationed all the time, and two wells.[238] Cardinal Boccamazza may well have financed the first phase of the murals in the apse. The prioress, the prior of S. Sisto, and perhaps the nun related to the benefactor (Sister Angelica Boccamazza?), may have worked out the iconography of the murals.

229 Berthier, *Chroniques du monastère de San Sisto*, vol. I, pp. 95 and 104; and Spiazzi, *Cronache e Fioretti*, pp. 111–12, where seven nuns of the Colonna family were found in the records of the convent by Sister Domenica Salomonia. Relatives acting as patrons of convents can be found elsewhere: Hamburger suggests the parents of Friar Heinrich Susa were the patrons of 'his chapel' in the Dominican Friars' church at Constance, see Hamburger, 'The Use of Images in the Pastoral Care of Nuns', pp. 20–46, esp. pp. 39–41; and relatives of the Dominican nuns at Katharinenthal in Switzerland in 1305 donated funds for a new choir, see Jäggi and Lobbedey, 'Church and Cloister', pp. 124–25. The principal patrons of the Franciscan nunneries at S. Silvestro in Capite and S. Lorenzo in Panisperna came from the Colonna family, see below, Chapter 7.

230 Spiazzi, *Cronache e Fioretti*, p. 115; Berthier, *Chroniques du monastère de San Sisto*, vol. I, p. 114. Cecchelli, *I Crescenzi, i Savelli, i Cenci*, says very little about the female members of the family.

231 Eubel, *Hierarchia*, vol. I, pp. 10–11, refers to him as 'consanguineus' (a blood relative). Gardner says that 'Alfaranus mentioned that the tomb (of Honorius IV) was erected by the pope's wealthy nephew Cardinal Boccamazzi', Gardner, *The Tomb and the Tiara*, p. 103.

232 Spiazzi, *Cronache e Fioretti*, p. 118.

233 Spiazzi, *Cronache e Fioretti*, p. 115; Berthier, *Chroniques du monastère de San Sisto*, vol. I, pp. 114–19, esp. pp. 114–15;

see also Torrigio, *Historia della veneranda Immagine di Maria Vergine*, p. 59.

234 Koudelka, 'Le "Monasterium Templi" et la fondation dominicaine de San Sisto', p. 67; *Le più antiche carte del convento di San Sisto*, ed. by Carbonetti Vendittelli, p. 252, no. 127.

235 Torrigio, *Historia della veneranda Immagine di Maria Vergine*, p. 59 refers to fifteen extra nuns; Benedetto of Monefiascone says that Cardinal Boccamazza's donations allowed for sixteen more nuns than usual, see Koudelka, 'Le "Monasterium Templi" et la fondation dominicaine de San Sisto', p. 72, no. 14. The highest number was 80.

236 Koudelka, 'Le "Monasterium Templi" et la fondation dominicaine de San Sisto', p. 72, no. 14: '[…] Item donavit idem dominus mille florenos in pecunia, de quarum parte facta fuit additio in dormitorio quod postea fuit combustum' (The same lord donated one thousand florins in cash, with part of which an addition was made to the dormitory, which later burned down).

237 Spiazzi, *Cronache e Fioretti*, p. 118; Torrigio, *Historia della veneranda Immagine di Maria Vergine*, p. 62.

238 Spiazzi, *Cronache e Fioretti*, pp. 118–19. For the tower, see Fig. 24.

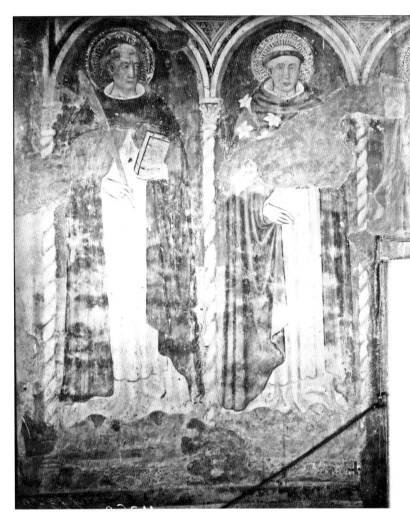

Figure 32. Unknown artist, *Saints Peter Martyr, Dominic, John the Baptist, and Paul*, late fourteenth- or early fifteenth-century fresco (photo: Direzione Regionale Musei Lazio – under licence from MiBACT)

The Medieval Frescoes: Phase 2

The frescoes of the second phase are situated above the earlier works in a band about 2.50 m high: on the right, four saints stand under a painted colonnade of twisted medieval columns sustaining pointed arches, while further scenes can be seen on the left, above the representation of Pentecost (Fig. 26). The four saints are Peter Martyr, holding a book and a palm; Dominic, holding a spray of lilies; John the Baptist, holding and pointing to an image of the Lamb of God (cf. John 1. 29 and 36); and Paul, holding a sword (cf. Ephesians 6. 17) (Fig. 32). The Dominican General Chapters held in 1254–1256 had recommended that images of Saints Dominic and Peter Martyr be located in Dominican churches, as they were in the nuns' choir at S. Sisto.[239]

On the left, there are two scenes from the life of Catherine of Siena, an image of the patron of the work, and Saint Eustace with his two young sons (Fig. 33). An inscription, '*B(ea)TA KATHERINA DE SENIS*', (Blessed Catherine of Siena), identifies the principal protagonist in two fragmentary scenes.[240] It is noteworthy that Catherine is identified as 'Beata' (Blessed) not 'Sancta' (Saint), and the painter shows her with rays of light around her head, rather than a round halo.[241] One may conclude, therefore,

239 See *Acta capitulorum generalium*, ed. by Reichert, vol. I, pp. 70, l. 34 and 81, ll. 13–14; and Cannon, *Religious Poverty, Visual Riches*, p. 93.

240 Ronci, 'Antichi affreschi in S. Sisto Vecchio', pp. 19–24; Kaftal, *Iconography of the Saints in Central and South Italian Painting*), col. 269; Romano, *Eclissi di Roma*, p. 411; Barclay Lloyd, 'Paintings for Dominican Nuns', pp. 223–28.

241 Rays around the head are used in images of Blessed Catherine in manuscripts of the first half of the fifteenth century, as shown in Bianchi and Giunta, *Iconografia*

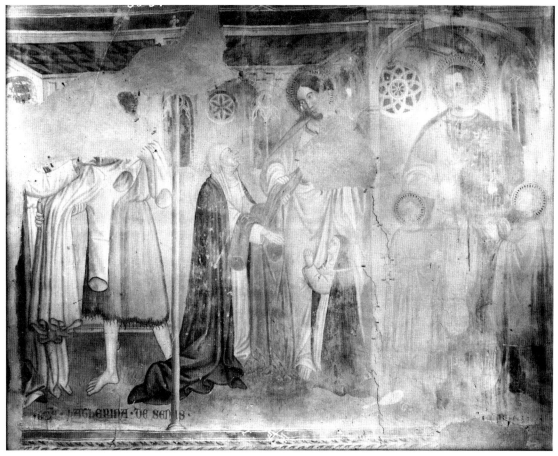

Figure 33. Unknown artist, *Saint Catherine of Siena, Saint Eustace and a medieval nun*, late fourteenth- or early fifteenth-century fresco (photo: Direzione Regionale Musei Lazio – under licence from MiBACT)

that the fresco was painted between Catherine's death in 1380 and her canonization in 1461; the date was probably before 1411, when there was a diocesan enquiry in Venice into how the Dominicans were venerating Catherine before she was canonized.[242]

The first scene takes place in a medieval church interior, where Catherine is handing a long-sleeved white tunic to a poor man, who has bare feet and is dressed in rags. The upper parts of both figures are fragmentary, but one can still see that the poor man had a halo marked with the arms of a cross, which would reveal him to be Christ, who is to be seen in the poor. This refers to Christ's identification with the hungry, the thirsty, the stranger, the naked, the sick, and those in prison, and his statement that he counted works of mercy done to these people as done to himself (Matt. 25. 31–46). A thin column divides this scene from the next, in which Catherine kneels before a tall figure, with a halo containing the red arms of the cross, that clearly does represent Christ. He looks lovingly at her, as he draws a red robe from the wound in his side to give her

di S. Caterina da Siena, pp. 250, 275–77, and tav. II, fig. 4; tav. IV, figs 1 and 2; tav. V, figs 2 and 3. See also the drawings discussed by Moerer, 'The Visual Hagiography', pp. 89–102, esp. p. 98.

242 Ronci, 'Antichi affreschi in S. Sisto Vecchio'), pp. 20–21. The enquiry in Venice is reported in *Il Processo Castellano*. Cirulli, 'Gli affreschi [...] di San Sisto Vecchio', gives a date of 1385–1395 for the frescoes.

in exchange for the tunic she gave to the beggar. The story depicted comes from the *Life of Saint Catherine*, or *Legenda Maior*, by Raymond of Capua (*c.* 1330–1399), which was written between 1385 and 1395.[243] According to Raymond, one day when Catherine was absorbed in prayer in the basilica of S. Domenico in Siena, a poor pilgrim asked her for some clothes. Telling him to wait, Catherine withdrew upstairs into a chapel, where she took off a sleeveless woollen tunic, which she wore under her outer long-sleeved robe, and then gave it to the man. (The Rule for the 'Vestitae' [Dominican penitents] of 1286, refers to their wearing two tunics, one over the other.[244]) The beggar also wanted a linen garment, so she took him home, and gave him some other clothing. The man thanked her, but added that he had a friend, who also needed clothes. Since the only robe that was still available was the outer tunic she was wearing, Catherine declined to give him anymore. The following night the Saviour appeared to her, as the poor pilgrim, holding the tunic she had given him, which was now adorned with pearls and other gems, and he praised her for her charity to the poor beggar.[245] He then drew from the wound in his side a garment the colour of blood that radiated light and fitted her perfectly. Raymond commented that Catherine 'in propriarum vestium dono glorioso assimiliata Martino' (in giving away her own clothes, was like glorious [Saint] Martin [of Tours]).[246]

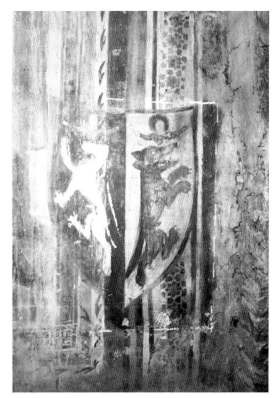

Figure 34. Unknown artist, *Coat of arms of the Sant'Eustachio family*, late fourteenth- or early fifteenth-century fresco (photo: Direzione Regionale Musei Lazio – under licence from MiBACT)

In these scenes Catherine wears a white robe, a black mantle, and a white veil — the dress of a Dominican 'mantellata', or 'vestita'. At the feet of the Saviour kneels a much smaller Dominican nun, with her hands joined in prayer, contemplating the events (Plate 3). This is a portrait of one of the medieval nuns of S. Sisto, showing her as a typical 'patron' figure. It indicates that this Sister was connected with the patronage and planning of the upper band of frescoes, although her relatives probably paid for them. She wears the black veil of a Dominican nun, in contrast to the white veil of Catherine, who was a 'mantellata'.

To the right of the two scenes of Blessed Catherine stands a male saint dressed in ancient

243 A Latin edition of Raymond of Capua's *Legenda Maior*, is published in *Acta Sanctorum*, ed. by Henschenius and Papebrochius, and others (hereafter *AASS*), aprilis, III, pp. 851–978; for this scene, see esp. Part II, paras 135–38, pp. 887–88. For an Italian translation of Catherine's life, see Raimondo da Capua, *Legenda maior*, trans. by Tinaglio, pp. 153–56; and for an English translation, see Raymond, *Life*, trans. by Lamb.

244 *Dominican Penitent Women*, ed. and trans. by Lehmijoki-Gardner, p. 41.

245 Christ's identification with the pilgrim would account for the fragmentary halo containing the arms of a cross in the image of the man in the mural.

246 *AASS*, aprilis, III; Raymond of Capua, *Legenda Maior*,

ed. by Henschenius and Papebrochius, Part II, para. 138, p. 888.

Roman armour, with a green breastplate and a red cloak; he holds a staff in his hand, and he is flanked by two young boys (Fig. 33). Gilberto Ronci identified this figure as Saint Eustace ('Sant' Eustachio' in Italian), who is shown with his sons, because he and his children were martyred in the arena in the reign of Emperor Hadrian (117–138).[247] In the border on the right of this painting is a coat of arms (Fig. 34), with a rampant white lion on a red background and a rampant red bear on a white background, each animal holding in its maw a very young nimbed child with arms outstretched. Ronci identified this coat of arms as that of the Roman Sant' Eustachio family, which may explain why Saint Eustace is shown here with his sons, focusing on his family.[248] It also identifies the Dominican nun at the feet of Christ, as a member of the Sant' Eustachio family.[249] In the seventeenth century, Sister Domenica found two Dominican Sisters at S. Sisto named 'Andrea di Sant' Eustachio': one entered the convent *c.* 1280 and was prioress in the early fourteenth century, and the other was there towards the end of the fourteenth century.[250] On a document dated 1386 in the Archives of Tivoli, there is also a reference to another nun from S. Sisto, named 'Sopphia de Sancto Heustachio', who signed her name as a witness and was a member of the same family.[251] The date is six years after the death of Catherine in 1380. Either this Sister, or the second Sister Andrea di Sant' Eustachio, could be the nun represented in the apse. She is shown close to the family saint and coat of arms, which indicate that she and her relatives commissioned the later frescoes.

Robert Brentano has shown that from the eleventh century onwards the Sant' Eustachio family lived in the Roman Regione of that name near the Pantheon, where they owned a lot of property.[252] Catherine of Siena, when she came to live in Rome, did not stay at S. Sisto with the Dominican nuns, but in lodgings, first in Regione Colonna, and then near Via del Papa not far from the Dominican priory at S. Maria sopra Minerva, near the Pantheon.[253] While she was in Rome, Catherine went to St Peter's every day, and she may have passed the church of S. Eustachio as she walked through Regione Sant' Eustachio on her way to the Vatican.[254] If the people who commissioned the fresco were members of the Sant' Eustachio family, they may well have seen her, or come to know Catherine personally. Perhaps the Sister depicted in the fresco proudly alluded to that fact.

S. Sisto as a 'papal' Nunnery

Guido Cariboni has characterized S. Sisto as a 'papal' nunnery.[255] Its foundation was a project of Innocent III, and Honorius III selected Dominic to establish the convent after the Gilbertines refused to come to Rome for that purpose. Moreover, Maria Pia Alberzoni has noted that Popes Innocent III and Honorius III were keen to solve problems regarding the way of life of

247 Ronci, 'Antichi affreschi in S. Sisto Vecchio', pp. 21–23.
248 Ronci, 'Antichi affreschi in S. Sisto Vecchio', p. 21. The children in the coat of arms refer to the sons of Saint Eustace.
249 For this family, see Carocci, *Baroni di Roma*, pp. 405–13 and Paravicini Bagliani, *I testamenti dei cardinali*, p. 78. Wickham, *Medieval Rome*, points out that this family rose to prominence in the eleventh century and remained important thereafter.
250 Spiazzi, *Cronache e Fioretti*, pp. 110 and 177.
251 *Le più antiche carte del convento di San Sisto*, ed. by Carbonetti Vendittelli, p. xi.

252 Brentano, *Rome before Avignon*, p. 199 and Krautheimer, *Rome*, pp. 252, 309, both refer to this family and their possessions in Rome. See also Carocci, *Baroni di Roma*, pp. 405–13; Paravicini Bagliani, *I testamenti dei cardinali*, p. 78; and Wickham, *Medieval Rome*.
253 Cavallini and Giunta, *Luoghi cateriniani di Roma*, pp. 17–18.
254 Bianchi and Giunta, *Iconografia di S. Caterina da Siena*, p. 54; see also Gatto, 'La Roma di Caterina', especially pp. 26, 27, 29 and 33.
255 Cariboni, 'Domenico e la vita religiosa femminile', pp. 356–60.

religious women by stressing strict enclosure and, to enforce this, Cardinal Ugolino (from 1227 to 1241 Pope Gregory IX) played an important part in codifying the religious way of life of Dominican and Franciscan nuns.[256] After the Fourth Lateran Council, the Popes were keen that all religious Orders should have an established Rule and juridically approved Constitutions. This was arranged for the nuns of S. Sisto, who, like the Dominican friars, followed the Rule of Saint Augustine and had their own 'Institutiones' (Constitutions). Julie Ann Smith has argued convincingly that the 'religio' of the nuns at S. Sisto in Rome was stricter than that at the earlier Dominican convents at Prouilhe and Madrid on account of this papal influence.[257]

The details of the religious way of life of the nuns at Prouilhe are not clearly spelled out. In a letter Dominic wrote to the nuns at Madrid, which has survived, he recommended that they should earnestly fast and pray in their fight against the devil; that they keep silence in the refectory, dormitory, and oratory; that they should not allow unauthorized coming into or going out of the convent; that they should be obedient to their prioress in all things; that they should not waste time chatting to each other; and that they should allow one of the friars to take care of the administration of the nunnery.[258] In contrast, the 'religio' or way of life of the Roman nunnery was prescribed in detail in the 'Institutiones' of S. Sisto and, after some time, these regulations were applied to other nunneries. The papal insistence on strict enclosure for nuns reached its climax when Pope Boniface VIII (1294–1303) issued his Bull *Periculoso* in 1298.[259]

Dominic gave the nuns committed to his care at S. Sisto the habit of his Order, composed of a white tunic, a white scapular, a black mantle, and a black veil over a white one. Like the friars, they were to live according to the Rule of Saint Augustine. The Institutiones of S. Sisto gave practical instructions on life in the nunnery. Dominic himself is said to have written a first version of these Institutiones.[260] They were modified later by Dominic's successors, until Humbert of Romans, Master General of the Order of Preachers from 1254 to 1263, made a definitive revision, which was approved by the Dominican General Chapter in 1259 and lasted until 1930.[261]

The earliest text begins by exhorting the nuns to be of one heart and mind and to hold all things in common, as in the early Church (Acts 4. 32).[262] New Sisters were to promise obedience and stability to the convent and to the Order; they were to possess nothing of their own, to live a chaste life, and they were not to go out, even to another convent. From the Feast of the Holy Cross (14 September) until Easter, excepting on specified feast days, they were to have one meal a day; after Easter until the feast of the Holy Cross, they were to have two. During meals, which consisted of two cooked dishes

256 Alberzoni, 'Papato e nuovi Ordini religosi femminili', especially pp. 221–39. See also, Barone, 'Alle origini del Secondo Ordine Domenicano'.
257 Smith, 'Prouille, Madrid, Rome', pp. 342–47; Smith, '*Clausura Districta*'.
258 Tugwell, 'St Dominic's Letter to the Nuns in Madrid'; *Early Dominicans*, ed. and trans. by Tugwell, p. 394.
259 Makowski, *Canon Law and Cloistered Women*, pp. 1–42, with a copy of the Bull in Latin, and an English translation, pp. 133–36.
260 Benedict of Montefiascone, *Historical Introduction*, 6, p. 70.
261 Berthier, *Chroniques du monastère de San Sisto*, vol. I, pp. xii–xxx; Creytens, 'Les Constitutions Primitives des Soeurs Dominicaines de Montargis', pp. 54–60; for Humbert of Romans, see Brett, 'Humbert of Romans and the Dominican Second Order' and Brett, *Humbert of Romans*, esp. pp. 57–79; Smith, '"The Hours That They Ought to Direct to the Study of Letters"'.
262 Prologus, in Simon, *L'Ordre des Pénitentes de Ste Marie Madeleine*, p. 143. Berthier, *Chroniques du monastère de San Sisto*, vol. I, pp. xiv–xxviii, gives a French translation of the text and makes a few comments. The summary that follows is based on the text of the *Institutiones* in Simon, *L'Ordre des Pénitentes de Ste Marie Madeleine*, pp. 142–53; and Berthier, *Chroniques du monastère de San Sisto*, vol. I, pp. xx–xxv.

(without meat), they were to listen to a reading. Only Sisters who were ill in the infirmary could eat a little meat. After Vespers each day, the nuns could listen to a reading, a 'collation', as was customary in Cistercian houses. Girls could come and live at the convent from the age of fourteen onwards. Silence was to be kept in all places in the nunnery as much as possible but talking was allowed in the chapter room during the chapter and in the parlour, with the Prioress's permission. The nuns could also talk about their work in the work-room, with permission from the Prioress. They were to be given two of each of the main garments of the Dominican habit and they were to be modest about their clothes. They each had a bed covered with straw and wool and they wore a woollen nightgown with a belt. Eight times a year on specific days their hair was cut.

There is a long section in the Institutiones on various faults that might be committed and should be confessed by the Sisters in Chapter; for these, there were corresponding punishments to be given by the Prioress.[263] The faults were divided into light, medium, and serious matters, and appropriate punishments were specified.

With permission, the nuns were allowed to speak to people from outside the nunnery at the parlour window, in the presence of three more mature members of the community.[264] Enclosure was strict. No friars were allowed into the nunnery, except when the Provincial Prior made his visitation once a year; or when a priest came to anoint a sick nun. Only the Prioress was free to speak to outsiders, about the management of the house.[265] In fact, she could in the presence of three trusted witnesses talk to the cellarer and other lay brothers about repairs or other aspects of the administration of the convent.[266] There were instructions on how to receive visiting nuns, the work the Sisters were required to do, about reading, and prayer.[267] (Not all prospective nuns knew how to read, however. If they were twenty-four years of age, or older, when they entered the convent, they were not expected to learn to do so. If they were younger, they were given lessons.) Those who could not read said other prayers, like the Creed and the Our Father. There were also specified times for meditation.

For each house four friars were to be appointed to manage the administration of the nunnery and its relations with the outside world; it was stipulated that there should also be four nuns who assisted the Prioress and the Prior in their duties.[268] The Prioress was to be elected by the community and her election had to be confirmed by the Procurator General.[269] The Prior was to be elected by the male members of the community, of whom there should be at least four, three being priests.

This text of the Institutiones of S. Sisto is found in a Bull of Nicholas IV, dated 1291, in which the Pope quotes from a much earlier Bull of Gregory IX, dated 1232, which does not survive, but which goes back to within eleven years from the time of Dominic and the official opening of S. Sisto on 28 February 1221.[270] It is a surprising fact that the two papal Bulls were not written for Dominican nuns, but for the

263 *Institutiones*, 11–15, in Simon, *L'Ordre des Pénitentes de Ste Marie Madeleine*, pp. 146–50; Berthier, *Chroniques du monastère de San Sisto*, vol. I, pp. xx–xxv.
264 *Institutiones*, 16, in Simon, *L'Ordre des Pénitentes de Ste Marie Madeleine*, p. 150.
265 *Institutiones*, 17, in Simon, *L'Ordre des Pénitentes de Ste Marie Madeleine*, pp. 150–51.
266 *Institutiones*, 18, in Simon, *L'Ordre des Pénitentes de Ste Marie Madeleine*, pp. 150–51.
267 *Institutiones*, 19–21, in Simon, *L'Ordre des Pénitentes de Ste Marie Madeleine*, p. 152, and see Smith, '"The Hours That They Ought to Direct to the Study of Letters"'.
268 *Institutiones*, 23, in Simon, *L'Ordre des Pénitentes de Ste Marie Madeleine*, p. 153.
269 *Institutiones*, 24, in Simon, *L'Ordre des Pénitentes de Ste Marie Madeleine*, p. 153.
270 *Bullarium Ordinis FF. Praedicatorum*, ed. by Brémond (hereafter *BOP*), VII, pp. 410–13; Berthier, *Chroniques du monastère de San Sisto*, vol. I, pp. xiv–xxx, 8–30, with slight variations; Simon, *L'Ordre des Pénitentes de Ste Marie Madeleine*, pp. 142–53.

Order of Penitents of Saint Mary Magdalene in Germany, who received the Institutiones of S. Sisto as their religious way of life from Pope Gregory IX.[271] Later, in 1286–1288, the papal legate in Germany — no other than Cardinal Giovanni Boccamazza — tried to place the Order of Penitents of Saint Mary Magdalene, who by then had about forty convents, under the direct care of the German Dominican friars.[272] It is possible that the Cardinal adopted this policy because of his personal knowledge of S. Sisto in Rome. His measure was not accepted by all the German nuns, however, nor by all the German Dominican friars, so Pope Nicholas IV reiterated the Institutiones of S. Sisto as the religious way of life of the Order of Penitents, without specifying the need for Dominican friars to assist them.[273]

Gregory IX gave the Rule of Saint Augustine and the Institutiones of S. Sisto to numerous other convents — mostly in Germany and Switzerland.[274] The Pope called the women's houses that followed these Institutiones, the 'Ordo sancti Sixti de Urbe' (the Order of S. Sisto in Rome), whether they were linked to the Order of Preachers or not. (Gregory IX also wrote a Rule for 'Franciscan' nuns, whom he called the 'Order of San Damiano', although they had little connection with Saint Francis and Saint Clare.)

The original Institutiones of S. Sisto were not preserved by the Dominicans because they were replaced in 1259 by the Institutiones of Humbert of Romans. This revision came after a period in which the friars objected strongly to taking pastoral care of nuns, beginning in 1228, when the Cistercian monks made a similar move in their Order.[275] In the struggles that resulted, the four early nunneries at Prouilhe, Madrid, Rome, and Bologna argued that they had special rights because they had been founded or planned (in the case of Bologna) by Saint Dominic himself. They also petitioned the popes to defend them, and, indeed, the popes insisted that the Dominican friars continue to look after the nuns of S. Sisto, as Dominic and his successor, Jordan of Saxony, had done.[276] For this reason, Cariboni has argued that in this controversy S. Sisto held a special position because it was a 'papal' nunnery.[277]

Meanwhile, Amicie, one of Simon de Montfort's daughters, founded a new nunnery at Montargis in France.[278] This was affiliated to the Dominicans in 1245, although it was not one of the original four nunneries. Almost immediately, other convents followed suit and by 1246 about thirty-six nunneries had been affiliated to the Order of Preachers.[279] The number of these convents rose steadily until 1252, when opposition from the friars intensified and Pope Innocent IV (1243–1254) was persuaded to issue his Bull *Evangelice predicationis officium*, which absolved the friars from all pastoral care of nuns, except for those of Prouilhe and S. Sisto.[280] At that time, he appointed the Dominican Cardinal Hugh of St Cher, who was sympathetic to the friars' work among nuns and beguines, to provide a solution to the problem of the Order's pastoral care of religious women.[281]

271 Simon, *L'Ordre des Pénitentes de Ste Marie Madeleine*, pp. 18–33.
272 Simon, *L'Ordre des Pénitentes de Ste Marie Madeleine*, pp. 33 and 85–94.
273 Simon, *L'Ordre des Pénitentes de Ste Marie Madeleine*, pp. 95–97.
274 Grundmann, *Religious Movements*, pp. 98–100.
275 Vicaire, *Dominique et ses prêcheurs*, pp. 393–95; Grundmann, *Religious Movements*, pp. 96–109; 124–34; Brett, 'Humbert of Romans and the Dominican Second Order', pp. 1–25, esp p. 4; Brett, *Humbert of Romans*, pp. 57–79; Cariboni, 'Domenico e la vita religiosa femminile', 348–58.
276 *BOP*, vol. I, p. 131; Brett, 'Humbert of Romans and the Dominican Second Order', p. 7.
277 Cariboni, 'Domenico e la vita religiosa femminile', pp. 356–60.
278 Creytens, 'Les Constitutions Primitives des Soeurs Dominicaines de Montargis', pp. 41–84, esp. 46.
279 Grundmann, *Religious Movements*, pp. 108–09.
280 *BOP*, vol. I, p. 217; Brett, 'Humbert of Romans and the Dominican Second Order', p. 8.
281 *BOP*, vol. I, p. 33; see Brett, 'Humbert of Romans and the Dominican Second Order', p. 9.

At the Dominican General Chapters of 1255, 1256, and 1257, steps were taken to clarify the constitutional process of incorporating nunneries into the Order of Preachers. Each convent had to make an application to the General Chapter, which then had to be accepted at three successive annual meetings.[282] Humbert of Romans was Master General at the time, and he issued new Institutiones for all the Dominican nuns c. 1256, which were officially approved in 1257–1259.[283] Eventually, the Friars Preachers officially approved the second Order (of nuns) in 1267, and Pope Clement IV (1265–1268) published guidelines for the friars who served as nuns' chaplains.[284] The Pope established that the friars should act as spiritual directors and administer the sacraments to the nuns. When making official visitations, they could correct problems or initiate reforms in the female communities. They could install or remove a prioress, although it remained normal for the nuns to elect their superior, who then had to be confirmed by the Provincial Prior and the Master General. The friars had to oversee the nuns' temporal needs and reside at the nunneries at Prouilhe, Madrid, and S. Sisto, where this had been the practice since Dominic's time, but not at the other convents.

Humbert of Romans' Institutiones of 1259 were meant to take the place of all earlier versions of the nuns' constitutions.[285] His work was clearly based on the Institutiones of Montargis, which he himself may have formulated when he was Provincial in France, and which were based on the Constitutions of the friars. There were, however, several differences between the nuns' and the friars' Constitutions.[286] The nuns' Institutiones did not mention the government of the Order, the Provincial and General Chapters, or teachers and preachers, matters not considered relevant to them. While the friars' Constitutiones stressed the mobility of the male members of the Order, the nuns' Institutiones reflected the stability of life in the female communities. There were a few other variations: prospective nuns were examined with regard to their moral character, bodily vigour, and spiritual understanding, whereas male aspirants were questioned more broadly on moral matters and specifically on their knowledge. The women did not need to be as highly educated as the men. In describing the teaching of novices, Humbert's Institutiones say that the novice mistress should teach them about the Order, about humility, devotion, poverty, and modesty, in contrast to the programme of theology that was designed for the men.

While the friars were itinerant preachers with a mission in the world, the Sisters pursued a vocation of prayer in seclusion, apart from the world.[287] There was an emphasis on silence. When they did speak, the nuns were to be careful about how they communicated with others, because light and negative talk could have a bad effect on the community. The nunnery was a place set apart, where the nuns could grow in holiness, in steadfastness, and in imitation of contemplative Mary at the feet of Jesus listening to his word, rather than active Martha, busy about many things.

282 *Acta capitulorum generalium*, ed. by Reichert, vol. I, p. 75; see also Brett, 'Humbert of Romans and the Dominican Second Order', p. 15.

283 Brett, 'Humbert of Romans and the Dominican Second Order', pp. 20–25, discusses these Institutiones in detail. They are sometimes called the 'Constitutions of Valenciennes', as that is where Humbert wrote them. They are published in *Liber Constitutionum Sororum Ordinis Praedicatorum*, ed. by an Anonymous Dominican Friar, AOP, III (1897).

284 *BOP*, vol. I, p. 481; see also, Berthier, *Chroniques du monastère de San Sisto*, p. 18; and Brett, 'Humbert of Romans and the Dominican Second Order', pp. 18–19.

285 Creytens, 'Les Constitutions Primitives des Soeurs Dominicaines de Montargis', pp. 61–64; Brett, *Humbert of Romans*, pp. 78–79.

286 Brett, *Humbert of Romans*, pp. 78–79.

287 Smith, '*Clausura Districta*', pp. 23–28. The place of reading and learning in the lives of Dominican nuns and a comparison of their Constitutions and those of the friars are given in Smith, '"The Hours that They Ought to Direct to the Study of Letters"'.

It became easier for women's houses to be affiliated to the Dominican Order after Humbert's Institutiones had been approved by the General Chapter of 1259 and the nuns had been recognized as the Dominican Second Order in 1267. After that, the number of Dominican nunneries rose significantly. Among them, S. Sisto retained an important position, as the nunnery founded by Saint Dominic in Rome, with its significant Institutiones.

The Property and Income of S. Sisto

Whereas the medieval friars in the Order of Preachers pursued voluntary poverty and an itinerant and mendicant lifestyle, the nuns had to possess landed property and income from endowments in order to survive. S. Sisto's property was located in and around Rome, Tivoli, and Tusculo.[288] This was managed by the priests and brothers, who administered the nuns' temporal affairs. Usually the prior of S. Sisto, the procurator, or the bursar put their names to documents of lease and sale, while occasionally the names of one or two lay brothers appear, often as witnesses. From the mid-thirteenth century, the Prioress and sometimes some of the nuns also signed documents, in the chapter room or in the choir. When a girl entered the convent, she brought with her a dowry, usually of 50 or 60 scudi. Some of the nuns also donated their inheritance to S. Sisto. For example, Sister Maria Rosa and Sister Agata from Trastevere gave the income they each inherited to the nunnery,[289] and Sister Paolo dei Grassi in 1340 brought a palace as her dowry.[290]

An account book from 1369–1381 survives, in which the friar who was bursar of S. Sisto recorded the income and expenses of the monastery.[291] Most of the convent's properties were leased on a temporary basis. Lay tenants ran the mills at S. Sisto, and they paid the convent a percentage of their income. Various bakers in Rome, like a man named Petruccio from Campo de' Fiori, bought their flour from the nunnery, while other merchants — like 'Guglielmo the Jew', who sold wine at Ponte S. Maria — acquired their stock from the convent estates.[292] Sometimes S. Sisto made money by allowing people to pasture their animals on their country properties in return for a rent in kind.[293] Such rents were collected on important feast days, such as Christmas, Easter, or the Assumption of the Virgin Mary on 15 August.

As to the expenses of the monastery, these were of different kinds. Sums were given to the friars for clothes, in winter and in summer.[294] For the nuns, a monthly sum was dispensed, which they used independently, keeping no records. Other expenses were for coal in the sacristy, a lamp for the dormitory, and for medicines. Large sums were paid for building repairs.[295] When, in 1379, S. Sisto had to pay off some debts, a silver image of Saint Paul and some silver vessels were pawned.[296] Often loans were taken out in spring; and then, in summer or autumn, the money was paid back, when the harvest had brought in some income.

288 For the property and income of the nunnery, see Koudelka, 'Il convento di S. Sisto a Roma negli anni 1369–1381'; *Le più antiche carte del convento di San Sisto*, ed. by Carbonetti Vendittelli; Carbonetti Vendittelli, 'Il registro di entrate e uscite'; and Carbonetti Vendittelli, 'Il monastero romano di San Sisto'.
289 Spiazzi, *Cronache e Fioretti*, pp. 139, 142.
290 Spiazzi, *Cronache e Fioretti*, pp. 148, 182.
291 Carbonetti Vendittelli, 'Il registro di entrate e uscite del convento', pp. 83–121; Carbonetti Vendittelli, 'Il monastero romano di San Sisto' pp. 371–401.
292 Carbonetti Vendittelli, 'Il registro di entrate e uscite del convento', p. 102.
293 Carbonetti Vendittelli, 'Il registro di entrate e uscite del convento', p. 104.
294 Carbonetti Vendittelli, 'Il registro di entrate e uscite del convento'', p. 110.
295 Carbonetti Vendittelli, 'Il registro di entrate e uscite del convento', pp. 111–13.
296 Carbonetti Vendittelli, 'Il registro di entrate e uscite del convento', pp. 113–15.

Some Fifteenth- and Sixteenth-Century Developments

Two other Roman nunneries were united to S. Sisto in the fifteenth and sixteenth centuries. In 1439 the nuns from a Benedictine convent called SS. Cosma e Damiano in the Sant' Eustachio Regione near the Pantheon, joined the nunnery.[297] When the fourteenth-century Dominican convent of Sant' Aurea was closed down in 1514, the nuns who lived there joined S. Sisto.[298]

From the fourteenth century onwards, religious communities in Rome began to suffer the effects of plague and other epidemics. Sister Domenica recorded that Sister Caterina Boccamazza died of malaria in 1372, after only one year at S. Sisto.[299] This was an early case of the disease that was to decimate many communities in and around Rome. Many Sisters also died from diseases such as cholera, in the later years of the fourteenth century, usually in the summer months.[300] When plague and famine struck Rome in 1409, S. Sisto may have been affected. Finally, on account of these diseases, and particularly malaria, the nuns moved from S. Sisto to the new convent of SS. Domenico e Sisto at Largo Magnanapoli, on the Quirinal Hill, in 1576.[301] Although the Dominican Pope, Pius V, may have prepared the move, it was his successor, Pope Gregory XIII (1572–1585) who actually transferred the nuns to their new home in 1576. They were escorted in a procession of coaches to the new convent, their icon being conveyed in a separate coach. On arrival at the new nunnery, the nuns alighted and then the youngest member of the community carried the icon of *Maria Advocata* into the new church, which was Baroque in style and is now one of the buildings of the Pontifical University of Saint Thomas Aquinas, the 'Angelicum'. It has a single nave, divided into two parts: the exterior church for the laity in the liturgical west and in the liturgical east, the nuns' choir (now the sacristy) behind an intermediary wall, or 'tramezzo', across the width of the building. A central window allowed the nuns in their choir to see the high altar and hear Mass and other Offices celebrated in the church. In the exterior church, the nave was flanked by side chapels.

S. Sisto was Dominic's third convent for women and his first foundation in Rome. It was one of the most important of all Dominican nunneries. In 1576, the nuns moved to SS. Domenico and Sisto on the Quirinal Hill. Later, in the 1930s they were transferred from there to the nunnery of S. Maria del Rosario on Monte Mario, where Dominican nuns still lead a cloistered, contemplative life, with their icon of *Maria Advocata* in their choir, which is on the side of the church, and has a large window through which the Sisters have a clear view of the sanctuary. If the nunnery of S. Sisto was important, the priory at S. Sabina, also associated with Saint Dominic, is significant for being the first stable home of the friars of the Order of Preachers in Rome.

297 Spiazzi, *Cronache e Fioretti*, pp. 204–05; this was not SS. Cosma e Damian in Mica Aurea in Trastevere, which was a Franciscan nunnery, see below, Chapter 4.
298 Spiazzi, *Cronache e Fioretti*, pp. 241–42.
299 Spiazzi, *Cronache e Fioretti*, p. 160.
300 Spiazzi, *Cronache e Fioretti*, pp. 163–68.
301 Koudelka, 'Il convento di S. Sisto a Roma negli anni 1369–1381', pp. 23–24, refers to some records of the community suffering from malaria. For the move, see Berthier, *Chroniques du monastère de San Sisto*, pp. 4–14.

CHAPTER 2

The Dominican Priory at S. Sabina, founded c. 1220–1222

In 1215, Saint Dominic came to Rome to attend the Fourth Lateran Council with Bishop Foulques of Toulouse. At that time, they sought Innocent III's approval of a diocesan community of sixteen friars who had joined Dominic's mission in France. Before granting his approval, Innocent demanded that Dominic and his friars choose an existing religious Rule, in accordance with Canon 13 of the Fourth Lateran Council. Dominic then returned to Toulouse, where the friars chose the Rule of Saint Augustine, to which he added an adapted form of the Constitutions of Prémontré. The Rule was that followed by contemporary canons, who lived in a community beside a particular church where they had pastoral care of the laity, or 'cure of souls'. As a Canon of the cathedral of Osma, Dominic himself would have lived by this Rule, which was comparatively flexible. His friars needed flexibility if they were to go as itinerant preachers to evangelize and to hold disputations with the aim of saving souls.[1] The ministry of preaching, according to Canon 10 of the Fourth Lateran Council, belonged officially to the bishop of each diocese, but the Council also recommended that bishops appoint suitable men to assist them so as to build up the Church through their word and example; these priests could then collaborate with the bishop not only by preaching, but also by hearing confessions, imposing penances, and assisting in other matters that pertain to the salvation of souls.[2] All this was significant in the mission of Dominic's new Order. The Lateran Council's Canon 11, which dealt with diocesan teaching arrangements for future priests, may have shown him the importance of education; and Canon 12, which recommended General Chapters and visitations for all religious Orders, may have influenced his organization of his Order.[3]

Honorius III (1216–1227) in the Bull *Religiosam Vitam* officially approved the Dominican Order on 22 December 1216.[4] On the same day, the Pope issued a very short Bull in which he called Dominic and his friars, 'Pugiles Fidei, et vera mundi lumina' (Fighters for the Faith and true lights of the world).[5] Later, on 21 January 1217, the Bull, *Gratiarum omnium*, recognized them as 'praedicatoribus in partibus Tolosanis' (preachers in the region of Toulouse), stressing their mission to preach in that diocese.[6] In the

1 The introduction to the Dominican Constitutions declares, 'It is known that our Order was especially founded from the beginning for preaching and the salvation of souls', see Hinnebusch, *History of the Dominican Order*, vol. I, p. 56. For the development of the Dominican Constitution, from 1216 to 1360, see Galbraith, *The Constitution of the Dominican Order, 1216–1360*.

2 Mansi, *Sacrorum Conciliorum*, vol. XXII, cols 997–1000; Tanner *Decrees of the Ecumenical Councils*, vol. I, pp. 239–*240.

3 Mansi, *Sacrorum Conciliorum*, vol. XXII, cols 999–1000; Tanner, *Decrees of the Ecumenical Councils*, vol. I, pp. 240–*240.

4 *BOP*, vol. I, no. 1, pp. 2–3; *Monumenta Diplomatica S. Dominici*, ed. by Koudelka, no. 77, pp. 71–76. See also Hinnebusch, *History of the Dominican Order*, vol. I, p. 48.

5 *BOP*, vol. I, no. 2, p. 4.

6 *BOP*, vol. I, no. 3, pp. 4–5; *Monumenta Diplomatica S. Dominici*, ed. by Koudelka, no. 79, pp. 78–79. See also, Hinnebusch, *History of the Dominican Order*, vol. I, pp. 48–19; Koudelka, 'Notes sur le Cartulaire

second half of 1217, however, Dominic became convinced that the mission of his Order was not local but universal, that the friars were called to go beyond the confines of the diocese of Toulouse. Therefore, on 15 August 1217, he sent them to Paris, to Spain, and to Italy. Honorius III recognized the universal character of the Order on 11 February 1218, and on 8 December 1219 he recommended the friars to bishops all over the world, this being the first time they were called 'fratres ordinis predicatorum' (friars of the Order of Preachers).[7] In some of his visits to Rome, Dominic carefully obtained documents from the papal Curia, recommending his friars to particular bishops and ratifying arrangements that had been made verbally.

While in Rome, Dominic is said to have had a spiritual experience at Old St Peter's, when the Apostles Peter and Paul appeared to him.[8] Saint Peter gave him a staff and Saint Paul gave him a book, as they said, 'Vade, predica, quoniam a Deo ad hoc ministerium es electus' (Go and preach, because you have been chosen by God for this ministry).[9] In about 1258, Gérald de Frachet claimed that this apparition took place in 1215, during Dominic's negotiations with Pope Innocent III for papal approval of his early community in Toulouse.[10] Constantine of Orvieto gave a different interpretation of the circumstances and claimed that the vision happened while Dominic was praying about the preservation and spread of the Order, when in a flash he saw in his imagination his sons going two by two throughout the world to preach the Word of God, as he sent them out in 1217.[11] This implicitly transferred Dominic's experience and his ministry to the Friars Preachers. These two interpretations of the apparition show first how Dominic was confirmed in his own vocation as an itinerant preacher, walking from place to place to preach the Gospel; secondly, when the medieval friars reflected on Dominic's life and miracles, they applied what they had read to their own experience, seeing their Order as one of apostolic life dedicated to itinerant preaching by word and example. Saints Peter and Paul, the Apostles of Rome, had confirmed Dominic's mission. In applying this to the Order of Preachers, the friars could show that they had not only papal approval, but also apostolic authority for their mission.

Dominic and his friars resided at S. Sisto in 1220, but before the arrival of the nuns on 28 February 1221, they went to live at S. Sabina, between 1220 and 1221.[12] Honorius III officially ratified their residence there only on 5 June 1222

du S. Dominique', pp. 92–100; Koudelka, *Dominic*, pp. 142–43; Tugwell, 'Notes on the Life of St Dominic', (1995), pp. 35–37, and 143.

7 *BOP*, vol. I, nos 8 and 10, pp. 7–8; *Monumenta Historica S.P.N. Dominici*, ed. by Laurent, no. 86, p. 98; *Monumenta Diplomatica S. Dominici*, ed. by Koudelka, no. 86, pp. 86–87; Hinnebusch, *History of the Dominican Order*, vol. I, p. 53; Tugwell, 'Schéma chronologique', 1218, p. 15.

8 In about 1250, this was recorded by Constantine of Orvieto, *Legenda*, ed. by Walz, Scheeben, and Laurent, p. 304; in 1258, it was recorded in Fracheto, *Vitae Fratrum*, ed. by Reichert, p. 323; see also Galvagno della Fiamma in Fratris Galvagni de la Flamma, *Cronica*, ed. by Reichert, p. 14.

9 Constantine of Orvieto, *Legenda*, ed. by Walz, Scheeben, and Laurent, p. 304.

10 Gérald de Frachet, *Cronica*, Anno Domini MCCXV, in Fracheto, *Vitae Fratrum*, ed. by Reichert, p. 323.

11 Constantine of Orvieto, *Legenda*, ed. by Walz, Scheeben, and Laurent, p. 304. See also, Hinnebusch, *History of the Dominican Order*, vol. I, p. 49.

12 Major works on S. Sabina include Berthier, *L'Eglise de Sainte-Sabine*; Muñoz, 'Indagini sulla Chiesa di Santa Sabina'; Muñoz, 'Studi sulle basiliche romane di Santa Sabina e di Santa Prassede', pp. 119–28; Muñoz, *La basilica di Santa Sabina in Roma*; Muñoz, *L'Église de Sainte Sabine*; Taurisano, *Santa Sabina*; Darsy, *Santa Sabina*; Krautheimer, *Corpus*, vol. IV, pp. 72–98; Krautheimer, *Rome*, pp. 44–45; Krautheimer, with Curcic, *Early Christian and Byzantine Architecture*, pp. 171–74; Brandenburg, *The Ancient Churches of Rome*, pp. 167–76; Barclay Lloyd, 'Medieval Dominican Architecture at Santa Sabina'; Foletti and Gianandrea, *Zona liminare*; and Gianandrea, Annibali and Bartoni, *Il convento di Santa Sabina*. See also, Le Pogam, 'Otton III sur le Palatin ou sur l'Aventin?'; Le Pogam, 'Cantieri e

(almost a year after Dominic had died in August 1221).[13] The Dominicans remained there until 1874, when the Italian government expropriated the priory buildings and transformed them into a 'lazzaretto', or infectious diseases hospice. After the Lateran Pacts and Concordat of 1929, however, the Dominicans returned to S. Sabina, where they located the international General Curia of the Order (the Dominican Family), with the Master General and his team.

Location

S. Sabina is situated on one of the Seven Hills of Rome, the Aventine.[14] The hill is divided into two parts, the 'Greater' and the 'Little' Aventine.[15] Between them ran an ancient road, the Vicus Portae Raudusculanae, along the route of the present Viale Aventino (formerly called 'Viale di Porta S. Paolo').[16] S. Sabina is situated at the top of the Greater Aventine, where the hill rises abruptly 46 m above sea level from the banks of the River Tiber (Figs 35 and 36). Not far away, to the north-east, are the church and monastery of SS. Bonifacio ed Alessio; S. Maria del Priorato,

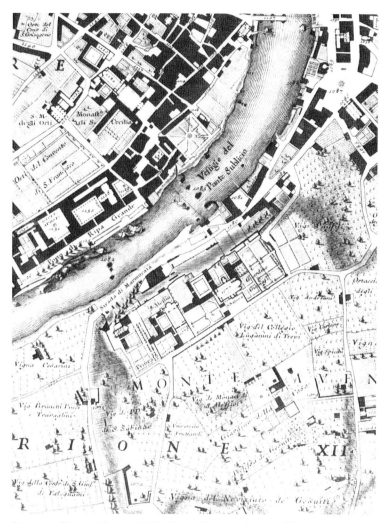

Figure 35. Giovanni Battista Nolli, *Map of Rome*, 1748, det. of Aventine (Frutaz, *Piante*, vol. II, 1962, detail of Tav. 407)

belonging to the Knights of Malta; and S. Anselmo, a Benedictine monastery built at the end of the nineteenth century and now attached to the Pontifical Athenaeum and Collegio di Sant' Anselmo. Some distance to the south-west of S. Sabina is the church of S. Prisca.

In antiquity, the Aventine Hill was associated with the legend of Romulus and Remus and the foundation of the city of Rome.[17] In the contest between the twins, Romulus chose the Palatine

residenza dei papi'; and Le Pogam, *De la 'Cité de Dieu' au 'Palais de Pape'*.
13 *BOP*, vol. I, XXIX, p. 15. See also, Benedict of Montefiascone, *Historical Introduction*, published in Koudelka, 'Le "Monasterium Templi" et la fondation dominicaine de San Sisto', no. 3, p. 69.
14 Merlin, *L'Aventin*; Ashby, *Topographical Study*, pp. 87–88; Platner and Ashby, *A Topographical Dictionary*, pp. 65–67; Trinci Cecchelli, *Corpus della Scultura altomedioevale, VII*, pp. 27–49; Castagnoli, *Topografia*, pp. 114–17; Di Gioia, 'Il quartiere moderno dell'Aventino', pp. 303–12. *Lexicon topograficum*, ed. by Steinby, pp. 147–50.
15 In antiquity the two parts of the hill were named 'maior' and 'minor', as explained in Platner and Ashby, *A Topographical Dictionary*, p. 65. Today the 'greater' Aventine is referred to simply as the 'Aventine'.
16 Trinci Cecchelli, *Corpus della Scultura altomedioevale, VII*, pp. 27, 30, and Platner and Ashby, *A Topographical Dictionary*, p. 65.

17 Merlin, *L'Aventin*, p. 2.

98 CHAPTER 2

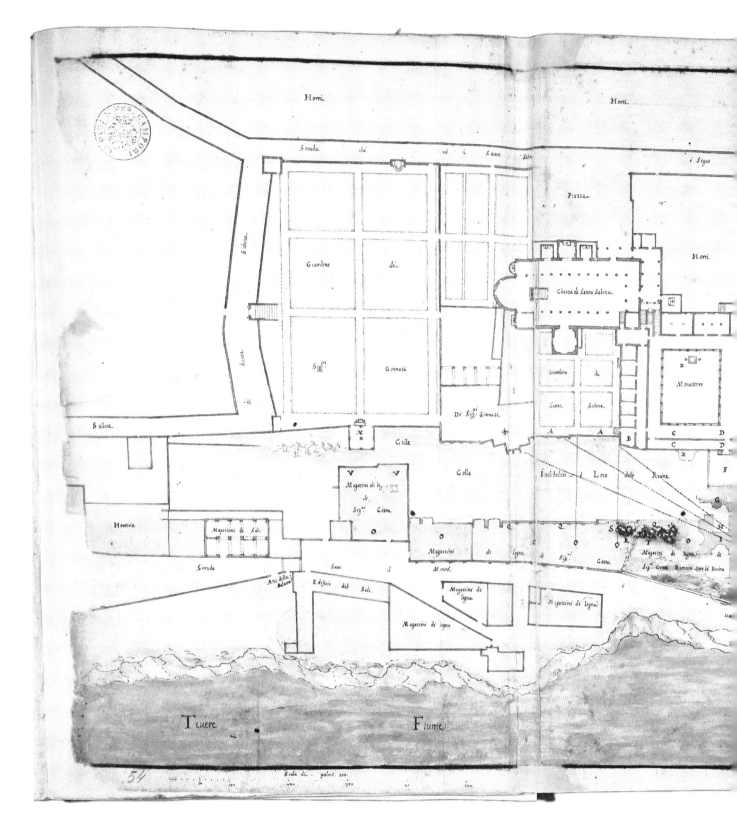

THE DOMINICAN PRIORY AT S. SABINA, FOUNDED c. 1220–1222 99

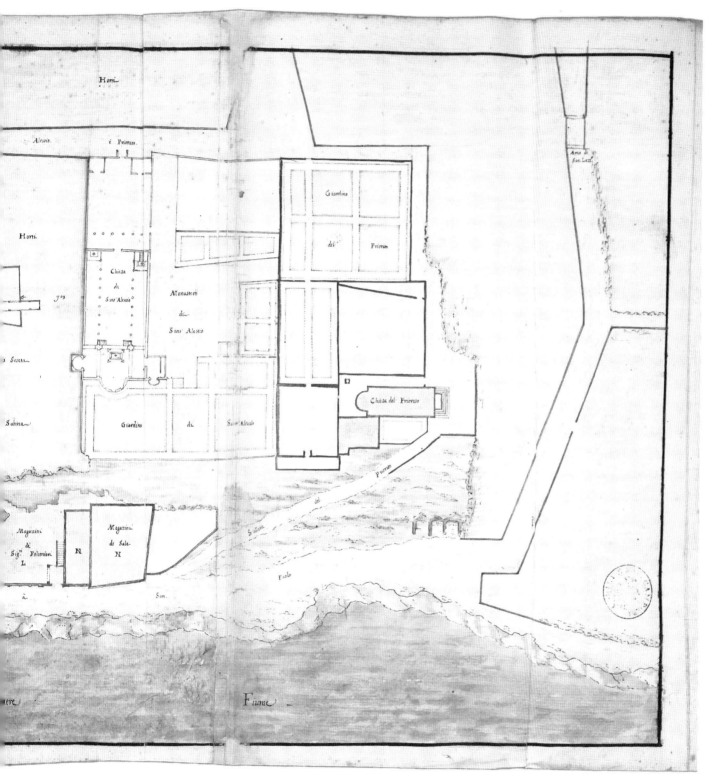

Figure 36. Carlo Fontana, *Plan of the west side of the Aventine Hill*, 1700 (Modena, Biblioteca Estense Universitaria, MS Campori 379, B. 1. 6. f. 54 – photo: Biblioteca Estense Universitaria)

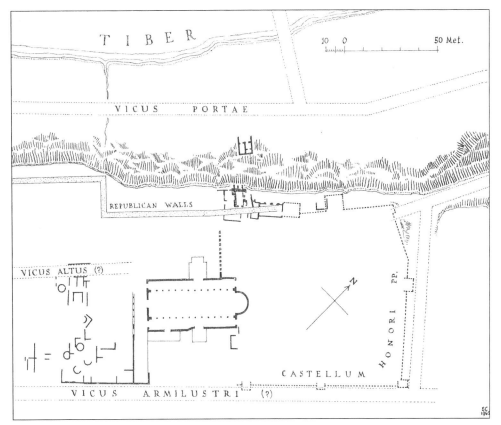

Figure 37. Map of the Aventine Hill near S. Sabina (Spencer Corbett, 1962, published in Krautheimer, *Corpus*, vol. IV, 1970, fig. 67 – adapted by the author)

Hill and Remus the Aventine. From these vantage points, Romulus sighted a flock of twelve birds, while Remus saw only six. Subsequently, after Romulus founded Rome on the Palatine Hill, the Aventine was considered an inauspicious place.[18]

The Republican 'Servian' Wall encircled both the Greater and the Little Aventine.[19] North of the Aventine and near the Forum Boarium there was a gateway in the 'Servian' wall, known as the 'Porta Trigemina'. The Aventine Hill was within the city walls but officially excluded from the 'Pomerium', the sacred boundary of ancient Rome, until the reign of the Emperor Claudius (AD 41–54).[20] In AD 7, Augustus made the Greater Aventine the thirteenth Region of Rome, called 'Aventinus', while the Little Aventine became part of the twelfth Region, named 'Piscina Publica'.[21] At the foot of the Aventine, along the River Tiber, runs the present Lungotevere Aventino, more or less following the route of an ancient road, the 'Vicus Portae', later called the 'Strada Marmorata' (Figs 35 and 37). Branching off the thoroughfare along the Tiber, a pathway called the Clivo di Rocca Savelli climbs the hill to meet a major street, Via Santa Sabina, which links the Via del Circo Massimo to the Piazza dei Cavalieri di Malta. Via Santa Sabina follows the course of an ancient road, called the Vicus Armilustri, which traversed the hill from south-west to north-east, ending in Armilustri Square, according to the fourth-century *Curiosum Urbis Romae Regionum XIV*.[22] Parallel to the Vicus Armilustri there was in antiquity another street, which ran very close to the north-western side of the basilica of S. Sabina and under one of the wings of the priory (Fig. 37). It came to light in Father Felix Darsy, OP's excavations in the convent in 1936–1939, and the Dominican archaeologist called it the 'Vicus Altus'.[23] There were also some

18 Vout, *The Hills of Rome*, p. 227.
19 Merlin, *L'Aventin*, pp. 114–39; Trinci Cecchelli, *Corpus della Scultura altomedioevale, VII*, p. 30.
20 Merlin, *L'Aventin*, p. 53; Vout, *The Hills of Rome*, p. 23.
21 Merlin, *L'Aventin*, pp. 289–90; Platner and Ashby, *A topographical Dictionary*, pp. 66 and 447.
22 Darsy, *Recherches*. pp. 24, 72–73; Trinci Cecchelli, *Corpus della Scultura altomedioevale, VII*, p. 30; for the *Curiosum Urbis Romae*, see *Il Catalogo delle Regioni di Roma, Regio XIII*, in Valentini and Zucchetti, *Codice topografico*, vol. I, 1940, p. 143.
23 Darsy, 'Les Portes de Sainte Sabine'; Darsy, *Recherches*,

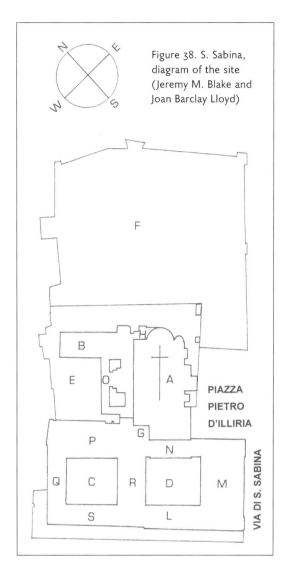

Figure 38. S. Sabina, diagram of the site (Jeremy M. Blake and Joan Barclay Lloyd)

stairs, the 'Scale Cassi' that ascended the hill from the riverbank, the 'scala usque in Aventinum' (stairs up to the Aventine) mentioned in the Einsiedeln Itinerary in the late eighth or early ninth century.[24]

pp. 72–74; Trinci Cecchelli, *Corpus della Scultura altomedioevale*, VII, p. 31; Prandi, 'Per Santa Sabina', p. 308.

24 Trinci Cecchelli, *Corpus della Scultura altomedioevale*, VII, p. 34; the reference to the stairs in the Einsiedeln Itinerary is given in Valentini and Zucchetti, *Codice topografico*, vol. I, 1940, p. 143 n. 2 and p. 181.

From the second century BC, the Aqua Marcia Aqueduct brought water to the Aventine Hill.[25] Before that, there was an earlier, underground aqueduct, the 'Aqua Appia', which, like the Via Appia, was named after Appius Claudius Caecus, who was Roman censor in 312 BC; this was the oldest aqueduct to bring water to Rome, and in the nineteenth century, archaeologists identified part of it in one of two conduits found under the gardens of S. Sabina.[26] Water from the aqueducts on the Aventine flowed into the large public Baths of Decius, located between the later churches of S. Prisca and SS. Bonifacio ed Alessio, and the smaller public Baths of Surae, which Adriano Prandi suggested were located close to S. Sabina.[27] There were also three monumental fountains on the hill, the 'Nymphea tria', recorded in the Regionary Catalogues.[28] In excavations north-west of the S. Sabina Archives (Fig. 38, B) some ancient cisterns for storing water were also found.[29]

In antiquity, not far from S. Sabina, there were temples dedicated to Juno Regina, Jupiter Dolichenus, Minerva, and Luna, as well as a sanctuary of Isis, dating from the second century AD.[30] Further to the south-east was a temple of Diana. There was also a Mythraeum on the site of S. Prisca. At the foot of the hill, some way along the Tiber, was the 'Emporium', built in 193 BC by the aediles M. Aemilius Lepidus and M. Aemilius Paulus, and later filled with many commercial offices, shops, and warehouses — the Roman 'horrea'.[31] The neighbourhood was also a centre

25 Merlin, *L'Aventin*, pp. 248–49; 308–09.
26 Descemet, *Mémoire sur les fouilles*, pp. 17–25.
27 Trinci Cecchelli, *Corpus della Scultura altomedioevale*, VII, p. 35; Prandi, 'Per Santa Sabina', p. 308.
28 Valentini and Zucchetti, *Codice topografico*, vol. I, 1940, p. 140 and n. 6, referring to a monumental fountain built by Diocletian.
29 Descemet, *Mémoire sur les fouilles*, pp. 17–25.
30 Trinci Cecchelli, *Corpus della Scultura altomedioevale*, VII, p. 37; Darsy, *Santa Sabina*, pp. 11 and 57; Darsy, *Recherches*, pp. 30–41, 54.
31 Castagnoli, *Topografia*, p. 115.

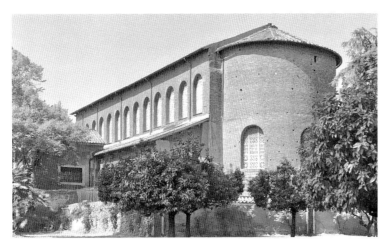

Figure 39. S. Sabina, exterior view of the basilica (photo: author)

for the marble trade and for marble workshops, hence the name 'Marmorata' given to a stretch of land between the Aventine Hill and the river and commemorated in a later road (Fig. 35).[32]

In the fifth century BC, the Aventine Hill was inhabited by refugees and plebeian Romans.[33] By the fourth and fifth centuries AD, the neighbourhood had become a place where aristocrats built their homes. At S. Anselmo, excavations in the 1890s and in 2007 uncovered a Roman 'domus' with a peristyle and floor mosaics.[34] Traces of an early Roman mansion have also been found under the church of S. Sabina. Rodolfo Lanciani suggested that the house of Saint Jerome's friend, Marcella, was on the site of S. Sabina or close by, but there is no firm evidence for this.[35] Marcella lived on the Aventine, but the exact location of her house is unknown. It was close to the homes of other like-minded women, who were trying to live a new type of monastic life, inspired by the Desert Fathers.[36] When Jerome came to Rome in 382, he was very impressed with them. After he went to Bethlehem to set up monasteries with Paula and others in 385, Marcella remained in Rome. When the city fell to the Goths under Alaric in 410, she was still living on the Aventine. In a letter written in 412, Jerome mentioned that the barbarian soldiers, who had hoped to find money and treasure in Marcella's house, beat her up violently, when she told them that she had given everything to the poor.[37] She persuaded the soldiers to take her and Principia, who was staying with her, to S. Paolo fuori le Mura, which Alaric had designated as a place of refuge during the sack of the city.[38] Marcella died soon afterwards, but Principia survived.[39]

The sack of Rome in 410 seriously affected the Aventine, although perhaps not as much as earlier historians maintained.[40] Recent excavations on the hill have shown that there was a huge fire near the Temple of Diana, while in some residential buildings, excavators found treasure troves of money, with coins dating until the early fifth century AD.[41] Besides this, archaeologists suggest that not every building on the Aventine was destroyed by the Goths, but that many may have gradually fallen into decay.

Shortly after the sack of Rome in 410, the basilica of S. Sabina was constructed between 422 and 440, when many of the city's churches were restored or rebuilt. The early Christian basilica and the adjacent Dominican priory now stand on the site of several earlier buildings, including an ancient Roman 'domus', part of

32 Castagnoli, *Topografia*, p. 115.
33 Platner and Ashby, *A Topographical Dictionary*, p. 67.
34 Merlin, *L'Aventin*, p. 454; Quaranta, Pardi, Ciarrocchi, and Capodiferro, 'Il "giorno dopo" all'Aventino', pp. 185–88.
35 Lanciani, *The Destruction*, p. 58. Most modern authorities do not accept this theory.
36 Merlin, *L'Aventin* pp. 418–29; McNamara, *Sisters in Arms*, pp. 19, 47. 49; Caruso, *Santa Marcella*.
37 Jerome's Letter 127, addressed to Principia, is published with an English translation in *St Jerome, Select Letters*, trans. by Wright, pp. 438–67. See also, Brenk, 'L'anno 410'.
38 See Grig, 'Deconstructing the Symbolic City: Jerome as Guide to Late Antique Rome', pp. 130–32.
39 *St Jerome, Select Letters*, trans. by Wright, pp. 462 and 463.
40 Compare Lanciani, *The Destruction*, pp. 56–76; and Merlin, *L'Aventin*, pp. 430–40 with Quaranta, Pardi, Ciarrocchi, and Capodiferro, 'Il "giorno dopo" all'Aventino'.
41 Quaranta, Pardi, Ciarrocchi and Capodiferro, 'Il "giorno dopo" all'Aventino', pp. 188–96.

which was incorporated in the south-eastern wall of the basilica.[42] The patron saint of the church, Sabina, has been identified as a Roman matron who was converted to Christianity by her Syrian slave girl, Seraphia, towards the end of the first century AD. When Seraphia was martyred c. 119 during the reign of the Emperor Hadrian (117–138), Sabina buried her body, after which she herself was also martyred.[43] In the thirteenth century, the location would have seemed a fairly isolated place, on the periphery of the medieval city, close to the ruins of the Circus Maximus, the Palatine, and then the Forum, but far from Old St Peter's, the papal centre at the Lateran, and the more densely populated areas of Rome.

The Buildings of S. Sabina Today

The fifth-century church of S. Sabina (Figs 39 and 40) looms over the top of the Aventine Hill. It is a basilica, with a nave, two aisles, and an apse. The narthex has two storeys and next to it is an unfinished medieval campanile. In 1913–1918, Antonio Muñoz restored the basilica to what he believed was its original fifth-century appearance; then, in 1932–1933, he undertook further restoration work, as well as building a new sacristy and Archive (Fig. 38, B and O) in 1932–1937.[44] The narthex was restored in 2010. West of the church there are medieval conventual buildings, which were later extended (Fig. 38, Q, P, R, S). In 1935–1937, Tullio Passarelli constructed

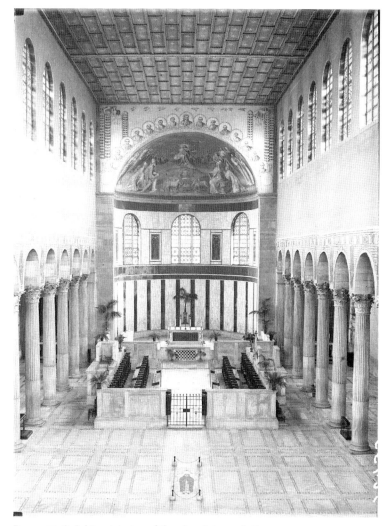

Figure 40. S. Sabina, interior of the church towards the apse (photo: ICCD – under licence from MiBACT)

a large new L-shaped residential wing (Fig. 38, L and M).[45] Close to the apse of the church, there is a small medieval house (Fig. 38, H).

Apart from the priory cloister garth (Fig. 38, C), there are three gardens around the church and priory. Pierre-Yves Le Pogam identified the space north-west of the basilica (Fig. 38, E) near the chapel of Saint Catherine, as the 'orto della cantina' (the kitchen garden near the cellar) or

42 Krautheimer, *Corpus*, vol. IV, pp. 72–98; Brandenburg, *The Ancient Churches of Rome*, pp. 167–76.

43 Delaney, *Dictionary of Saints*, p. 544.

44 For the restoration campaigns, see: Muñoz, 'Indagini sulla Chiesa di Santa Sabina'; Muñoz, 'Studi sulle basiliche romane di Santa Sabina e di Santa Prassede'; Berthier, 'La Restauration de l'église de Sainte-Sabine'; Muñoz, *La basilica di Santa Sabina in Roma*; Muñoz, *L'église de Sainte Sabine*; Muñoz, *Il restauro della basilica di Santa Sabina*; Muñoz, 'A Santa Sabina'; Bellanca, *La Basilica di Santa Sabina e gli Interventi di Antonio Muñoz*; Setti and Broggi, 'Dal Lazzaretto', pp. 135–39.

45 Di Gioia, 'Il quartiere moderno dell'Aventino', pp. 303–04; Le Pogam, *De la 'Cité de Dieu' au 'Palais de Pape'*, pp. 295–97; Setti and Broggi, 'Dal Lazzaretto', pp. 139–42.

'the garden of S. Caterina'.[46] The garden south-west of the basilica (Fig. 38, D) is famous for an orange tree, which Saint Dominic is said to have planted when he returned from Spain in 1218.[47] The large public garden to the north-east of the church (Fig. 38, F) is enclosed in medieval walls built of *opus saracinescum* that formed part of the medieval Savelli fortress, the 'Rocca Savelli'; orange trees were planted there, too, in the 1930s in memory of Dominic's orange tree in garden D. From the north-western side of this garden, there is a fine view along the Tiber, Tiber Island, Trastevere, and St Peter's.

Because S. Sabina is located on a hill, one has constantly to take into account the various levels, on which the structures were built. Therefore, taking the pavement of the basilica as datum, 0.00 m, the levels are indicated on the plans and sections of the survey made by Jeremy M. Blake and the author (Figs 41–46).

Archaeological Evidence

On the site of S. Sabina, excavations have revealed part of an ancient road and the ruins of several structures which existed before the fifth-century basilica was erected and before the Dominicans came to live there, in 1220–1221. These discoveries hint at what lies beneath the church, the convent, and the gardens of S. Sabina, but there are many features that remain unclear.

In 1855–1857, Charles Descemet, Father Hyacinth Besson, OP, and some French Dominican friars excavated north of the present Archive (Figs 37 and 38, B).[48] There they found part of the Republican 'Servian' Wall and the remains of fourteen rooms. Of these chambers, twelve had walls constructed in the ancient masonry techniques of *opus incertum* and *opus reticulatum*, while two, built of medieval *opus saracinescum*, were probably erected in the thirteenth century. Two of the rooms were obviously used as cisterns for storing water, in antiquity and in the Middle Ages. When the excavations took place, the rooms were filled with earth and with fragments of objects made of ceramic, metal, glass, and marble. Amid this debris, the excavators found some inscriptions and the lead seal from a Bull of Pope Innocent III. In two rooms, they uncovered ancient mosaic floors. Under the garden north-west of the church (Fig. 38, E), at a depth of 5.50 m, the channel of an underground aqueduct was discovered, with some steps leading to another channel, 22 m lower down. This lower conduit was explored for about 385 m and Descemet suggested it was part of the Aqua Appia, the oldest aqueduct in Rome, whose water 'castle' was located at the Porta Trigemina north of the Aventine.[49]

In 1936–1939, Darsy re-examined the early excavations near the Archive, studying more precisely the inscriptions and paintings discovered in them.[50] From this material, he concluded that there was in antiquity a sanctuary of Isis on the site. He also thought that the water conduits were later than Descemet had suggested.[51] Darsy uncovered under the convent wing 'R' part of an ancient Roman road that ran parallel to Via Santa Sabina, which he called the 'Vicus Altus'. In the area south-west of the church and south-east of the 'Vicus Altus', (Figs 37 and 38, D, L, and M), he found what he thought were the remains of ancient Roman bath buildings and other structures, at a variety of levels.[52]

46 Le Pogam, *De la 'Cité de Dieu' au 'Palais de Pape'*, p. 289.
47 Since the Dominicans are now believed to have come to S. Sabina only in 1220, this date may not be correct.
48 Descemet, *Mémoire des fouilles*; Buchowiecki, *Handbuch der Kirchen Roms*, vol. III, p. 778.

49 Descemet, *Mémoire des fouilles*, p. 25, who takes the historical information from Julius Frontinus, *De Aqueductu Urbis Romae*, V: 1–9, in Frontinus, *The Stratagems and The Aquedects of Rome*, trans. by Bennett, ed. by McElwain.
50 Darsy *Recherches*, pp. 30–45 (inscriptions), pp. 45–50 (paintings).
51 Darsy, *Recherches*, p. 17.
52 Darsy, *Recherches*, pp. 56–78.

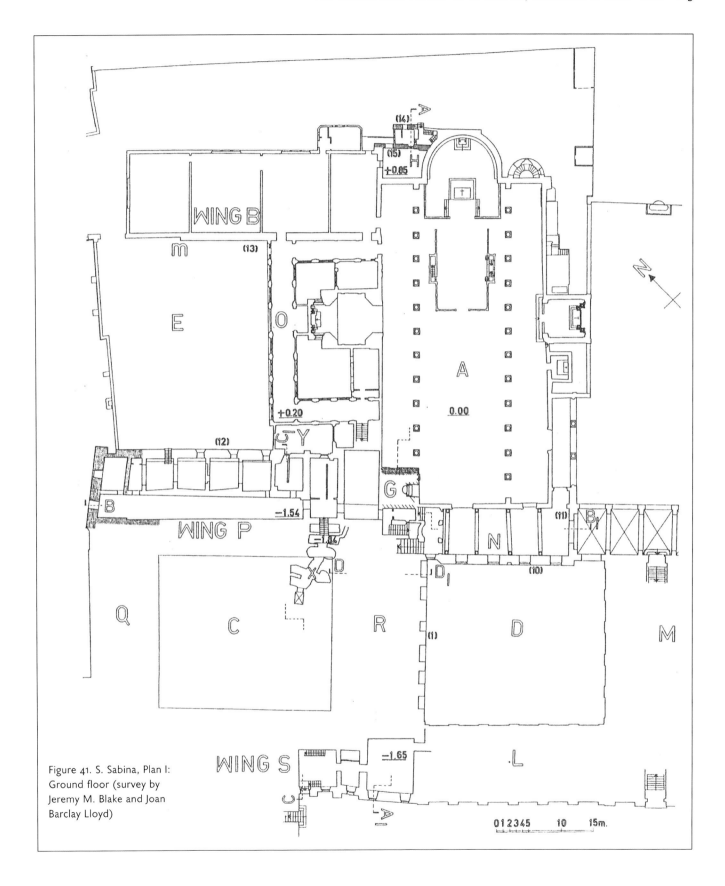

Figure 41. S. Sabina, Plan I: Ground floor (survey by Jeremy M. Blake and Joan Barclay Lloyd)

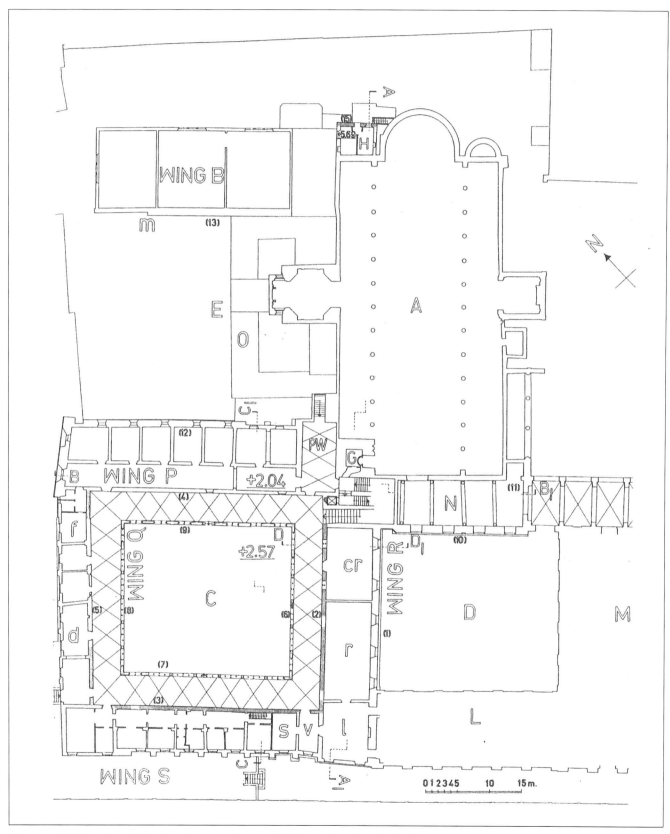

Figure 42. S. Sabina, Plan II: First floor (survey by Jeremy M. Blake and Joan Barclay Lloyd)

Figure 43. S. Sabina, Plan III: Second floor (survey by Jeremy M. Blake and Joan Barclay Lloyd)

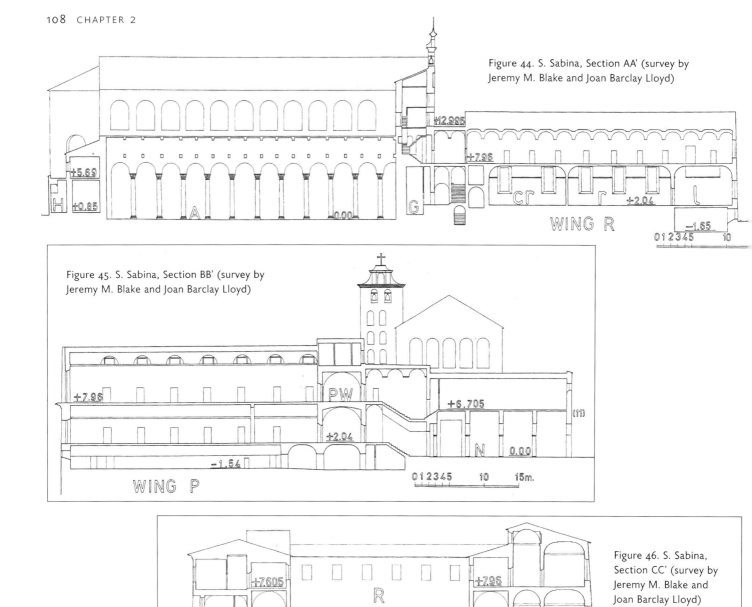

Figure 44. S. Sabina, Section AA' (survey by Jeremy M. Blake and Joan Barclay Lloyd)

Figure 45. S. Sabina, Section BB' (survey by Jeremy M. Blake and Joan Barclay Lloyd)

Figure 46. S. Sabina, Section CC' (survey by Jeremy M. Blake and Joan Barclay Lloyd)

Among these was the base of a wall that ran from the Vicus Altus to Via Santa Sabina, passing under the south-western wall of the narthex (Figs 37 and 38, N). From these discoveries, he suggested that there was an atrium in front of the early Christian church, with an unusual extension as far as Via Santa Sabina. He also found graves in this zone, dating as far back as the sixth century AD.[53]

Beneath the basilica, a mosaic of the third century AD was found 1.76 m below the first two bays in the nave from the façade. Beside the

53 Darsy, 'Zone di sepolture', p. 199.

mosaic pavement, there were pieces of marble with rectangular holes for fixing small posts to connect marble 'transennae', flanking what appeared to be a stepped walkway. Richard Krautheimer in 1970 called this a 'dromos',[54] and he referred to the structures at that level, as 'the dromos building'. Darsy found another floor, made of *opus sectile*, under the floor of the narthex at about the same level as the mosaic under the nave.[55] He also found evidence of an archaic sanctuary under the north-western side of the church.[56] Along the right (south-eastern) aisle of the basilica, a wall of an ancient Roman house was revealed, which had been incorporated into the aisle wall of the church. Where the wall changes direction slightly, a column of that building was found in the interior of the church but standing at a lower level than the basilica's pavement.[57]

When in 1977 a group of archaeologists examined a thick wall built against the south-eastern side of wing R of the priory in the eighteenth century (see Fig. 41), they uncovered six arches outlined with blocks of tufa, placed at uneven distances from each other in front of a medieval wall of *opus saracinescum*. Under the arches, there were fragments of a plinth, some bases, and part of a column, standing on an earlier, ancient Roman wall, which was aligned with the left (north-western) colonnade of the early Christian church.[58] The archaeologists believed that they had found part of a colonnade in front of the early Christian basilica. Manuela Gianandrea has pointed out that the columns were in line with those in the church because they all stood on the same Roman wall.[59] Although several excavations have been undertaken and many items have been found, the disposition of earlier buildings on the site, especially to the south-west of the church, is still rather unclear.

The Fifth-Century Basilica of S. Sabina

After the sack of Rome in 410, many of the city's churches, like S. Sabina, were restored or rebuilt, and paid for by popes, priests, and wealthy lay men and women. The mosaic inscription on the counter façade of the nave (Figs 47 and 48) says the priest, Peter of Illyria (Dalmatia), constructed the basilica in the pontificate of Pope Celestine I (422–432):

CULMEN APOSTOLICUM CAELESTINUS HABERET / PRIMUS ET IN TOTO FULGERET EPISCOPUS ORBE / HAEC QUAE MIRARIS FUNDAVIT PRESBYTER URBIS / ILLYRICA DE GENTE PETRUS VIR NOMINE TANTO / DIGNUS AB EXORTU CHRISTI NUTRITUS IN AULA / PAUPERIBUS LOCUPLES SIBI PAUPER QUI BONA VITAE / PRAESENTIS FUGIENS MERUIT SPERARE FUTURAM

> (When Celestine possessed the Apostolic pre-eminence and shone forth as the first bishop of the world, this at which you marvel was founded by a presbyter of the City of Illyrian family — Peter, a man worthy of so great a name — raised from birth in Christ's Church, rich towards the poor, poor towards himself, who shunning the good things of the present life deserved to hope for that yet to be).[60]

A slightly different account of the church's foundation is given in the Life of Pope Sixtus III (432–440) in the *Liber Pontificalis*, which says: 'Et huius temporibus fecit Petrus episcopus

54 Krautheimer, *Corpus*, vol. IV, pp. 84–85.
55 Darsy, *Recherches*, pp. 79–88.
56 Darsy, *Santa Sabina*, pp. 88–89.
57 Brandenburg, *The Ancient Churches of Rome*, p. 167.
58 Pani Ermini and Giordano, 'Recenti ritrovamenti', pp. 49–51.
59 Gianandrea, 'Il nartece e il cortile dell'arancio', pp. 66–68; Gianandrea, 'Il giardino dell'Arancio di san Domenico', pp. 101–04.

60 Translation taken from Lansford, *The Latin Inscriptions of Rome*, 5.4, pp. 168–69.

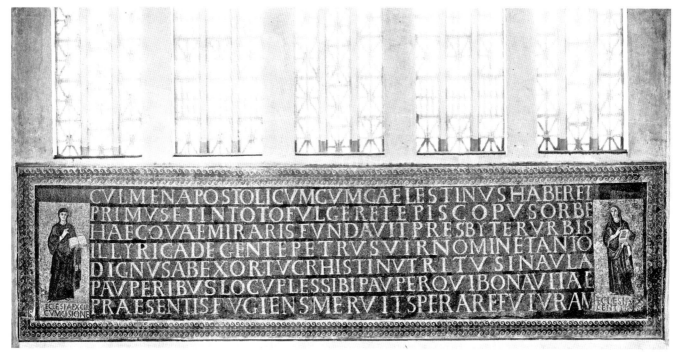

Figure 47. S. Sabina, inscription on the inner façade (photo: ICCD – under licence from MiBACT)

basilicam in urbe Roma sanctae Savinae, ubi et fontem construxit' (At this time Bishop Peter built in the city of Rome the basilica of S. Sabina, where he constructed a fountain).[61] One notes that by this time Peter had become a bishop and 'constructing a fountain' was a way of saying he built a baptistery. These sources together seem to indicate that, as a priest, Peter of Illyria began building S. Sabina in the pontificate of Celestine I (422–432) and completed the basilica and the baptistery, when he was a bishop, in the pontificate of Pope Sixtus III (432–440). While the church still stands today, the baptistery has not survived.[62]

Like S. Sisto, S. Sabina was a Roman titulus.[63] Among the priests who signed documents at the Roman synod of 499, Abundantius, Victorinus, and Valens signed as presbyters of this titulus.[64] Placitus, priest of the titulus of S. Sabina, attended the Roman synod in 595, and in 600, Pope Gregory the Great mentioned a certain Felix, who was a priest of S. Sabina.[65] In the later Middle Ages, S. Sabina was assigned to a titular cardinal and sometimes, after the Dominicans took up residence there, he was a member of the Order of Preachers, the first being the Frenchman, Hugh of Saint Cher, OP, created Cardinal of S. Sabina in 1244.[66]

S. Sabina, like S. Sisto, was also a Station church. Gregory the Great decreed that the first Station of Lent (on Ash Wednesday) should be held there. On that day, the Pope, his entourage, and the people of Rome began the ceremonies

61 *LP*, vol. I, p. 235.
62 Krautheimer, *Corpus*, vol. IV, 1970, pp. 72–98; Brandenburg, *The Ancient Churches of Rome*, pp. 167–75.
63 Guidobaldi, 'L'organizzazione dei *tituli*'; Hillner, 'Families, Patronage, and the Titular Churches'; Bowes, *Private Worship*, pp. 65–71.

64 Krautheimer, *Corpus*, vol. IV, p. 75, referring to 'Acta Synodorum habitarum Romae', in *Cassiodorus Senatoris Variae*, ed. by Mommsen, p. 411.
65 Letter XI.15, in *Gregorius I Papa, Registrum, Epistolae*, ed. by Ewald and Hartman, vol. I, p. 367 and vol. II, pp. 275–76; see also, Krautheimer, *Corpus*, vol. IV, p. 75.
66 Ciacconius, *Vitae et Gesta*, vol. I, p. 569.

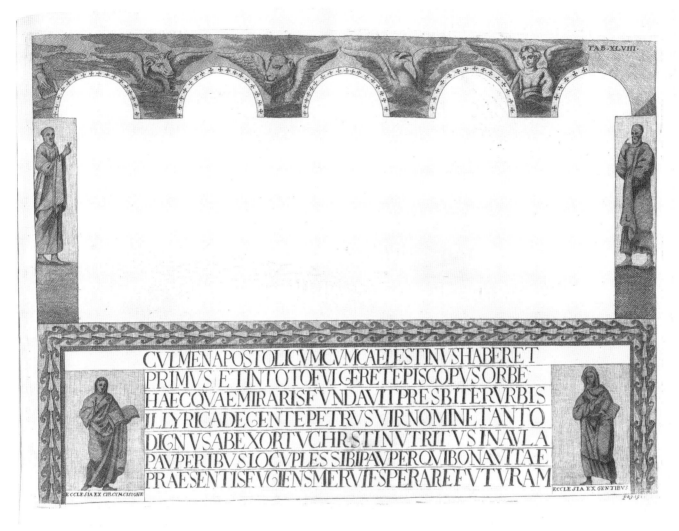

Figure 48. S. Sabina, inner façade mosaics in the late seventeenth century (photo: BAV © 2018, from Ciampini, *Vetera Monimenta*, vol. 1, Tab. XLVIII)

at the church of S. Anastasia at the foot of the Palatine Hill, and then walked in procession up the Aventine Hill to S. Sabina. This custom fell into disuse in the fourteenth century but in the late sixteenth century Pope Sixtus V (1585–1590) revived it.[67]

S. Sabina is one of the most beautiful early Christian basilicas to survive in Rome (Figs 39, 40, 41, 42, and 44). Its nave is flanked by two aisles. The colonnades separating the nave and aisles consist of a set of twenty-four ancient fluted columns of white marble with corresponding bases and Corinthian capitals. Above the columns is an arcade whose spandrels are covered with designs in *opus sectile*. The apse is in the north-east, while the entrance, preceded by a narthex, is in the south-west. The nave is 46.80 m long, while the radius of the apse is 7.20 m and the depth of the narthex is 7.05 m. The width of the nave and aisles combined is 24.80 m.[68] The height of

67 Today the Pope goes in procession to S. Sabina from S. Anselmo.

68 Dimensions taken from Krautheimer, *Corpus*, vol. IV, pp. 87–88.

112 CHAPTER 2

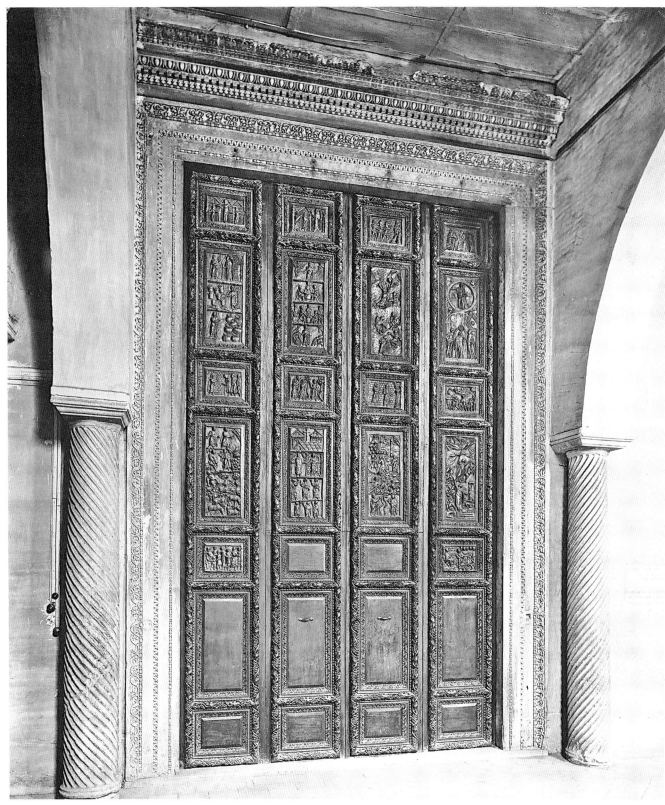

Figure 49. S. Sabina, the fifth-century wooden doors (photo: Alinari Archives)

the nave is 18.89 m.[69] Light enters the lofty nave through twenty-six large round-arched windows, three in the apse, and five in the façade. Unlike S. Sisto, the façade wall of the church originally opened, not in a colonnaded arcade, but in three doorways (cf. Figs 19, 21, and 41). Today, one can still see the largely intact fifth-century wooden doors, which were in the centre of the façade (Fig. 49), with their famous early Christian reliefs.[70] These display scenes from the Old and New Testaments — including a rare early image of Christ's death on the cross — and two allegorical representations of the 'Triumph of the Church' and the 'Second Coming'. On either side of the central entrance, there were two minor doors: today, the south-eastern doorway is still accessible, but the north-western one is hidden by the medieval bell tower and other structures of later date (Fig. 41).[71]

The fifth-century church was decorated with mosaics, of which only a small part survives, while others are known from early illustrations and some written sources. The mosaic inscription on the inner façade (Figs 47 and 48) is flanked by images of two matrons who personify the Church, labelled 'ECCLESIA EX CIRCUMCISIONE' (the Church from circumcision) and 'ECCLESIA EX GENTIBUS' (the Church from the peoples), alluding to the Church's Jewish and Gentile origins.[72] In the late seventeenth century, one could still see mosaic figures of the Apostles Peter and Paul higher up, on either side of five round-arched windows that opened in the façade, while the hand of God and the symbols of the four evangelists in mosaic were visible above the windows (Fig. 48).[73]

There were originally mosaics in the apse, but by the sixteenth century they were in a ruinous state, and Cardinal Otto Truchses arranged for Taddeo Zuccari to replace them with a fresco (Fig. 40).[74] It shows Christ seated in the centre surrounded by the apostles. In the foreground there are some sheep drinking from a stream, while other figures kneel on either side. It is not clear how far this reflects the earlier composition.

Pompeo Ugonio in the sixteenth century observed two mosaic friezes on the apsidal arch;[75] Giovanni Battista Ciampini illustrated them.[76] In the early twentieth-century restorations, Ciampini's illustration was followed in the painted roundels containing portraits of Christ, the Apostles, and the Evangelists, as well as images of the holy cities of Jerusalem and Bethlehem now on the apsidal arch (Fig. 40). Krautheimer noted that while only the apostles Peter and Paul were pictured with the symbols of the Evangelists on the inner façade, around the apsidal arch there were at least fifteen roundels (and possibly more), with the head of Christ in the centre amid other figures.[77] Krautheimer suggested that this was an extended group of the apostles. He compared

The early Christian basilica at S. Sisto was 47.24 m long and about 24.83 m wide, the apse being 5.40 m deep, see Geertman and Annis, 'San Sisto Vecchio', p. 526; and see above, Chapter 1, Archaeological Evidence.

69 Darsy, *Recherches*, p. 92. Geertman and Annis, 'San Sisto Vecchio', p. 526, calculated the height of the early Christian nave at S. Sisto as 13.25 m.

70 Among the many studies of the doors at S. Sabina, see Jeremias, *Die Holztür*; and Foletti, 'La porta di Santa Sabina'.

71 The double-storeyed narthex will be discussed in detail further on.

72 See, Oakeshott, *The Mosaics of Rome*, pp. 89–90; Matthiae, *Mosaici*, pp. 77–80; James, *Mosaics*, pp. 189–91; and *Mosaici medievali di Roma attraverso il Restauro*, ed. by Andaloro and D'Angelo, pp. 21–55.

73 These images are known from Ciampini, *Vetera Monimenta*, vol. I, Tab. XLVIII.

74 *Una Cronaca*, ed. by Rodocanachi, p. 24; Berthier, *L´Eglise de Sainte-Sabine*, p. 87; Darsy, *Santa Sabina*, p. 100.

75 Ugonio, *Historia delle Stationi*, p. 9ʳ: 'Si vede anco nell'arco della Tribuna in due fregi che vi sono rimasti, segno del Musaico antico, che pur è verosimile fusse da principio' (One can see, too, on the arch of the apse in two friezes that have remained, a sign of the ancient Mosaics, which most likely were there from the beginning).

76 Ciampini, *Vetera Monimenta*, vol. I, Tab. XLVII.

77 Krautheimer, 'Congetture sui mosaici scomparsi di S. Sabina'.

Figure 50. Leonardo Bufalini, *Map of Rome*, 1551, detail of S. Sabina (Frutaz, *Piante*, vol. II, 1962, detail of Tav. 203)

this composition with the way Pope Celestine I included other apostles and evangelists in the preparatory documents of the Church of Rome for the Council of Ephesus in 431, which was summoned to resolve some of the Nestorian and Arian heresies regarding the nature of Christ. This would have made the mosaic decoration of S. Sabina in the fifth century relevant to the theological controversies of its time.

Atrium and Narthex

Leonardo Bufalini's *Map of Rome* (Fig. 50), printed in 1551, shows a colonnade along the south-western side of the narthex and an open space in front of the church. Darsy believed that there was an atrium in front of the fifth-century basilica that extended beyond the church all the way to the Vicus Armilustri (now Via Santa Sabina) on the south-eastern side (see Fig. 37).[78] Krautheimer found no evidence for an atrium.[79] Letizia Pani Ermini and Roberto Giordano thought some fragments of a colonnade beneath the refectory and chapter room in wing R of the priory may have been part of an atrium (Figs 41 and 42, wing R).[80] Gianandrea thought an atrium was unlikely but she found it hard to account for the columns along the side of the priory.[81] The existence of an atrium remains an open question.

The disposition of the narthex is clearer. It does not extend neatly across the basilica's façade (Figs 41, 45, 51, and 52). On the north-western side, it ends in a niche, which contains a statue of Saint Rose of Lima, dating from the pontificate of Clement IX (1667–1669) (Fig. 52). On either side of the niche is a doorway: to the right, a staircase built in 1567 goes up to the priory; to

78 Darsy, *Santa Sabina*, p. 32.

79 Krautheimer, *Corpus*, vol. IV, p. 86.
80 Pani Ermini and Giordano, 'Recenti ritrovamenti', pp. 49–51.
81 Foletti and Gianandrea, 'Il nartece, la sua funzione e le sue decorazioni', pp. 66–68.

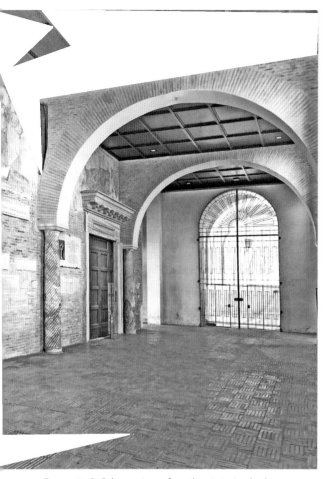

Figure 51. S. Sabina, view of narthex interior looking south-east towards Via Santa Sabina (photo: author)

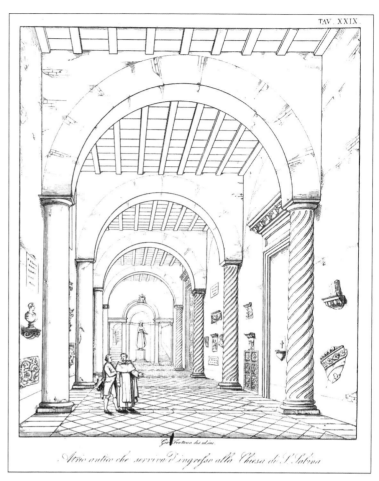

Figure 52. Giacomo Fontana, narthex interior looking north-west from Fontana, *Raccolta*, vol I, tav. XXIX (photo: Bibliotheca Hertziana – Max-Planck-Institut für Kunstgeschichte, Rome)

the left, there is a ramp, built in 1599 to replace an earlier staircase, ascending to the cloister (Figs 41 and 42), which is 2.04 m above the level of the narthex and church.[82] On the south-eastern side, the narthex now extends beyond the church as far as Via Santa Sabina along Passarelli's vaulted walkway, built in the 1930s (Figs 42, M, and 51).[83]

It has long been assumed that the present narthex incorporates the fifth-century entrance porch to the basilica.[84] Krautheimer suggested that the narthex could not have been entered from the front, or south-western, side.[85] He related the arcade above it to the 'dromos building' and considered the arched openings to be windows high up in its south-western wall, which was later incorporated into the narthex of the church. Today, the original layout of the narthex and its upper storey is complicated by additions made in the sixteenth and seventeenth centuries.[86] These include a monumental staircase, going up

82 Darsy, *Santa Sabina*, p. 64, gives the dates for both the staircase and the ramp. See also, Roberto, 'I "teatri sacri" del Barocco', pp. 81–82, who gives more details.

83 Foletti and Gianandrea, 'Il nartece, la sua funzione e le sue decorazioni', pp. 40–50.

84 Prandi, 'Per Santa Sabina'.

85 Krautheimer, *Corpus*, vol. IV, p. 86.

86 Roberto, 'I "teatri sacri" del Barocco'; Roberto and

Figure 53. S. Sabina, narthex, view from garden D, drawing by Adriano Prandi (photo: Bibliotheca Hertziana – Max-Planck-Institut für Kunstgeschichte, Rome)

to the cell of Saint Dominic, and the chapel of Saint Pius V (Figs 42 and 52). In the vestibule of Saint Dominic's cell, which was restructured in 1645–1647 (Fig. 43, inset, SD, 1, 2, and 3), there is a stretch of fifth-century masonry. One can also see the voussoirs of three arches in the south-west wall in the museum above the present narthex. Lower down, further to the south-east, there is a column embedded in the south-western wall of the narthex, which can be aligned with these arches (Fig. 53). It stands on a thick wall, 2.34 m high, which has been built over the ancient Roman wall that went from the Vicus Altus to Via Santa Sabina. Gianandrea has reconstructed how this evidence implies an open arcade built above a high ledge.[87] She believes the narthex was originally 30 m long and 7.05 m deep, open at the north-western and south-eastern ends, towards the former Vicus Altus on one side, and a short distance from the present Via Santa Sabina on the other. The five arched openings would have formed a kind of 'loggia', bringing light and air to this space. Giannandrea dated this to the fifth century.[88]

Ugonio recorded in 1588 that he had observed marble incrustations (*opus sectile*?) on the north-eastern wall of the narthex, like that above the nave colonnades and in the apse:

[…] così nel Portico maggiore, come per i muri della nave di mezzo sopra le colonne si veggono incrostature di varie pietre artificiosamente conteste, di qual lavoro habbiamo visto rovinosi vestigij nella Tribuna ancora, prima che fusse rinovata

([…] thus, in the greater Portico [the Narthex], as in the walls of the nave above the columns, incrustations are to be seen of various stones artfully arranged, [and] we saw damaged vestiges of such work still in the Apse before it was renovated).[89]

Bartoni, 'La Cappella di San Domenico'; Borsoi, 'La Cappella di Pio V'.

87 Gianandrea in Foletti and Gianandrea, 'Il nartece, la sua funzione e le sue decorazioni', pp. 40–50 and Dis. 4.

88 Gianandrea in Foletti and Gianandrea, 'Il nartece, la sua funzione e le sue decorazioni', p. 65.

89 Ugonio, *Historia delle Stationi*, pp. 8r–v.

When the interior of the narthex was restored in 2010, later layers of plaster and paint were removed from the façade of the church, uncovering the original masonry and some early painted decoration inside the portico. Gianandrea has noted that the narthex was covered with painting imitating coloured blocks of marble.[90] One wonders whether this painting was the undercoat of the vestiges of *opus sectile* decoration seen by Ugonio.

The 2010 restoration revealed a hitherto unknown fresco (Plate 4) painted during the pontificate of Pope Constantine (708–715) on the north-eastern wall of the narthex interior.[91] In the centre is a majestic figure of the Mother of God, holding the Christ Child in front of her, in a mandorla, which signifies that he is the divine Logos, whereas the fact that he is depicted as a baby with his mother shows that he is also human.[92] Mary as Theotokos had since the Council of Ephesus in 431 stood for orthodox teaching on the two natures of Christ, fully human and fully divine, which was clearly defined in the Council of Chalcedon in 451. At S. Sabina, the Mother of God and the Child are flanked by two male saints (recognizably the Apostles Peter and Paul as represented in Rome) and two female saints (who are most likely those associated with the church, Sabina and Seraphia). These figures are depicted in front of a colonnade. Mary and the Child are raised on a footrest, or 'suppedaneum'. On either side of the central figures, stand two donors, with a third kneeling on the left. They all have rectangular haloes to show that the paintings are portraits of people who are not yet canonized saints. An inscription in a red border frames the painting and includes the names of the three patrons: Pope Constantine, Archpriest Theodore, and the priest George.[93] Pope Constantine's pontificate lasted from 708 to 715, which indicates the date of the painting. Besides, Gianandrea and Osborne have argued convincingly that these three men were among the four delegates of the Church of Rome, who attended the Sixth Ecumenical Council held in Constantinople in 680–681. The fourth, John, became Pope in 685 and died a year later. The Council condemned the heresy of Monothelitism, which claimed that Christ had only one will, which appeared to deny his two natures, human and divine. Theodore, Archbishop of Canterbury (668–690) also condemned this heresy at the Synod of Hatfield in England in 680.[94] This early medieval mural at S. Sabina seems to celebrate the triumph of orthodoxy over heresy in the late seventh and early eighth centuries. As such, it anticipated the work of the Order of Preachers, who were engaged in combatting other heresies from the thirteenth century onwards. Hence, it was an appropriate image for the medieval Dominican church.

The Church in the Eighth and Ninth Centuries

According to the *Liber Pontificalis*, Pope Leo III (795–816) diligently renewed the titulus of S. Sabina.[95] While this may indicate a restoration of the building, it is not clear precisely what was entailed. He also gave gifts to the church, consisting of five large and two smaller silver crowns, and other lighting fixtures, as well as textiles, one with a picture of the Resurrection, and a large curtain to hang in the centre of the basilica.[96]

90 Gianandrea, 'Nel lusso della tradizione'.
91 Tempesta, ed., *L'icona murale di Santa Sabina*; Gianandrea, 'Un'inedita committenza', pp. 21–26; Osborne, 'Rome and Constantinople'; Gianandrea, 'Il nartece nei secoli altomedioevali', pp. 201–16; Osborne, *Rome in the Eighth Century*, pp. 67–72.
92 Osborne, *Rome in the Eighth Century*, p. 72, described the Child as being depicted on a shield, but it seems to be a mandorla of light.
93 Osborne, *Rome in the Eighth Century*, p. 68 and n. 5.
94 Gianandrea, 'Un'inedita committenza', pp. 404–05.
95 *LP*, vol. II, p. 2.
96 *LP*, vol. II, pp. 9, 11, 12, 20, 25, 27, and 31. See also Krautheimer, *Corpus*, vol. IV, p. 75.

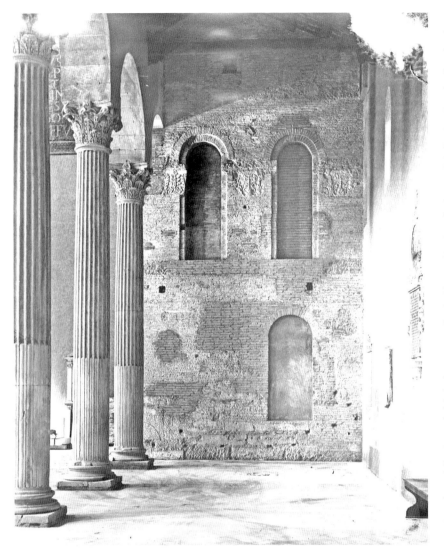

Figure 54. S. Sabina, the bell tower, as seen from the left aisle (photo: ICCD – under licence from MiBACT)

Figure 55. S. Sabina, vault in the bell tower (photo: author)

Pope Eugenius II (824–827), who had been presbyter of the titulus of S. Sabina before his election to the papacy, remodelled the liturgical arrangements, decorated the walls with paintings, and placed a silver canopy, weighing 102 pounds, over the high altar.[97] Ugonio still saw remnants of these elements in the late sixteenth century.[98] In the apse was the ninth-century high altar, but Ugonio noted that the silver canopy had not survived. He described the space around the altar, where the Pope sat with the Cardinals, as surrounded with marble transennae; nearby, there were six columns, which sustained a high stone frieze.[99] To enter the sanctuary, one had to walk through a bronze gate, on which was inscribed 'EUGENIUS SECUNDUS. PAPA. ROMANUS' (Eugenius II, Pope and Roman).[100] A later inscription, of the tenth or eleventh century, commemorated how Pope Eugenius II had placed under the high altar next to the relics of Saints Sabina and Seraphia, those of Saints Alexander, Theodolus, and Eventius, from the Via Nomentana.[101]

When Antonio Muñoz restored the basilica in the early twentieth century, he reconstructed the decoration in the apse and built a 'medieval' choir enclosure that is still in the church, imitating what was known from these written sources. Two modern studies have identified what little actually survives of the liturgical furniture from the Middle Ages.[102]

97 *LP*, vol. II, p. 69. See also, Biblioteca Casanatense, Anonymous, *Notizie*, MS 3209, fol. 347ᵛ–348ʳ.
98 Ugonio, *Historia delle Stationi*, p. 9ᵛ.
99 Ugonio, *Historia delle Stationi*, 9ᵛ.
100 Ugonio, *Historia delle Stationi*, p. 10ʳ.
101 Berthier, *L'Eglise de Sainte-Sabine*, p. 289; Darsy, *Santa Sabina*, pp. 112–13; Krautheimer, *Corpus*, vol. IV, p. 75.
102 Gianandrea, 'Note sul perduto arredo liturgico di

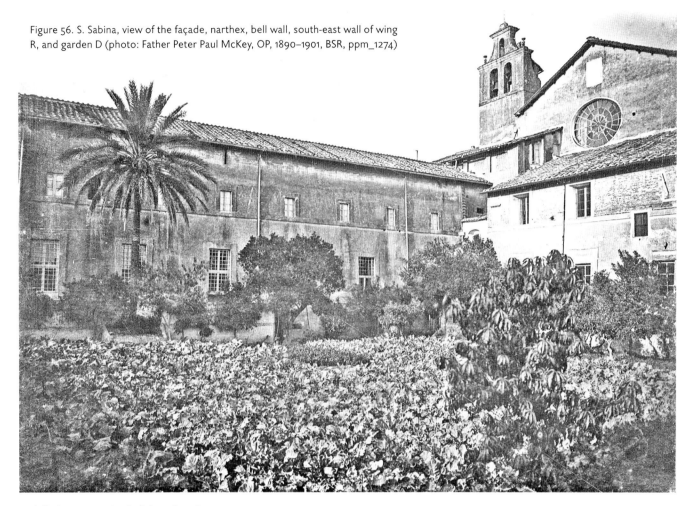

Figure 56. S. Sabina, view of the façade, narthex, bell wall, south-east wall of wing R, and garden D (photo: Father Peter Paul McKey, OP, 1890–1901, BSR, ppm_1274)

Additions to S. Sabina in the Eleventh and Twelfth Centuries

In the late eleventh and twelfth centuries, a bell tower was added to the church of S. Sabina and changes were made to the narthex. When the Dominicans came to S. Sabina in 1220–1221, they would have found a campanile on the left of the entrance to the basilica (Fig. 54; see also Figs 41–45, G). Although this campanile has been dated to the tenth century,[103] its structure is characteristic of Roman bell towers of the late eleventh to the fourteenth century and its masonry is typical of that used in Rome in the eleventh and twelfth centuries.[104] One can also see that its vaults were constructed over woven matting, a constructional technique typical of that time (Fig. 55).[105] At the top, it was left unfinished, and a 'bell wall'

Santa Sabina'; and Betti, 'L'arredo liturgico della basilica di S. Sabina al tempo del papa Eugenio II'.

103 Darsy, *Santa Sabina*, pp. 25, 30, and 115, who follows Serafini, *Torri campanarie*, pp. 94–96.

104 For medieval Roman bell towers, see Priester, 'The Belltowers'. The bell tower at S. Sabina is constructed on a foundation of large travertine blocks and built of brickwork with the mortar beds clearly marked with *falsa cortina* pointing ('*stilatura*') and with a modulus, for five rows of bricks and five courses of mortar, of 28, 28.5, or 29.5 cm. All this is typical of masonry of the eleventh or twelfth centuries, see Barclay Lloyd, 'Masonry Techniques', pp. 233, 267–71.

105 Barclay Lloyd, *The Medieval Church and Canonry of S. Clemente*, pp. 22–24.

Figure 57. SS. Giovanni e Paolo, narthex, built from 1154 to 1180 (photo: author)

was added in the late sixteenth century on the south-western side, in which bells were secured in 1612 (Figs 45 and 56).[106] In its position, date, and structure, the campanile is similar to the unfinished bell tower at S. Maria in Aracoeli.[107]

In the Middle Ages, the narthex was restructured. Four semi-circular arches each supported by two columns span the interior from northeast to south-west (Figs 51 and 52). The four columns standing against the church façade are of pavonazzetto marble and have spiral fluting, while the four columns placed against the outer wall of the narthex are smooth and of plain grey granite.[108] All the shafts are ancient Roman spoils.

Although the columns stand on attic bases, they carry no capitals, but support low impost blocks. Semi-circular 'diaphragm arches' spring from these impost blocks. The use of diaphragm arches was a typical way of reinforcing buildings in Rome in the twelfth and early thirteenth centuries, a technique that was used in a wall built across the centre of S. Stefano Rotondo, attributed to Pope Innocent II (1130–1143); in a wall built across the transept of S. Paolo fuori le Mura at about the same time; and in three arches spanning the nave of S. Prassede, that have been dated to the early thirteenth century.[109] At the abbey of SS. Vincenzo ed Anastasio at Tre Fontane,

106 *Una Cronaca*, ed. by Rodocanachi, pp. 38–39 and 45.
107 See below, Chapter 5.
108 The columns near the façade are said to be of giallo antico, but they look more like pavonazzetto as they are not yellow, but white and streaked with purplish patterns.

109 See Krautheimer, *Corpus*, vol. IV, pp. 202, 209, 238 (S. Stefano Rotondo); vol. V, p. 101 (S. Paolo fuori le Mura) and vol. III, pp. 245–49 (S. Prassede), for which see also Caperna, *La basilica di S. Prassede*, p. 31 with a date in the early thirteenth century.

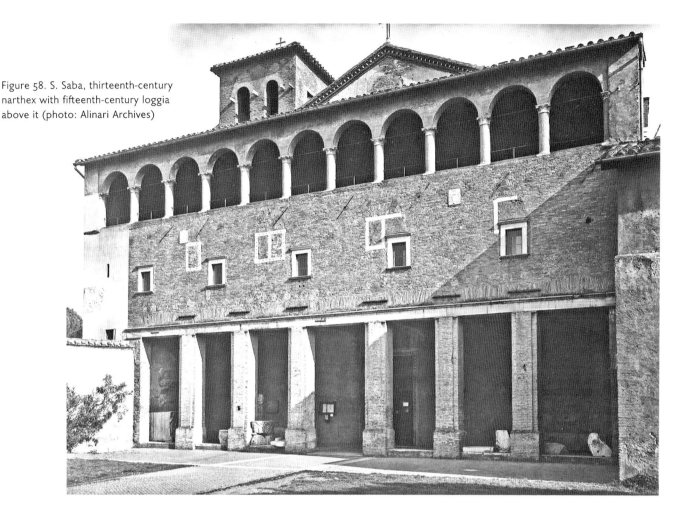

Figure 58. S. Saba, thirteenth-century narthex with fifteenth-century loggia above it (photo: Alinari Archives)

Pope Innocent II provided the Cistercians with monastic buildings between 1138 and 1143. Later in the twelfth century, perhaps during the pontificate of Pope Eugenius III (1145–1153), who had previously been the founding abbot of the monastery, the cloister colonnade in the monks' wing was reinforced with diaphragm arches across the cloister ambulatory, sustained by piers rather than columns.[110] These arches look similar to those in the narthex at S. Sabina, and they have the same function — to strengthen the outer colonnade of the cloister, which stands on a ledge.

The restoration of the narthex at S. Sabina in 2010 revealed the masonry of the walls and arches above the eight columns that sustain the diaphragm arches (Fig. 51). It looks characteristic of twelfth-century construction, with neatly laid bricks and regular voussoirs of reused Roman bricks. The mortar beds are covered with 'latte di malta', a white film.[111] Muñoz dated the insertion of the columns and arches in the narthex at S. Sabina to the thirteenth century, and Darsy believed they were set up after the Dominicans arrived.[112] Since the restoration of 2010, it appears, however, that this reinforcement was made earlier, in the twelfth century. When the Dominicans came to

110 Barclay Lloyd, *SS. Vincenzo e Anastasio*, pp. 154, 202–03.

111 While this masonry is visible, it has not been possible to measure it.

112 Muñoz, *Il restauro della basilica di Santa Sabina*, p. 41; Darsy, *Santa Sabina*, p. 63.

S. Sabina, the columns and arches would have been in place.

The arches provide extra support for a room above the narthex, where the Museum of S. Sabina is now located (Figs 43 and 45). This room may have been built in the twelfth century too. Formerly, as Gianandrea has pointed out, the narthex had a sloping roof above that room (see Fig. 56), but Muñoz covered it with a flat terrace (cf. Figs 44 and 45). It was quite common to have a double-storeyed narthex in medieval Rome. Such upper rooms still exist above the narthex at S. Maria in Cosmedin, remodelled early in the twelfth century and consecrated in 1123; at SS. Giovanni e Paolo, where the narthex was built from 1154 to 1180 (Fig. 57); and at S. Saba, where columns have been replaced by piers and in the fifteenth century another loggia was built above the medieval upper room (Fig. 58).[113] There is today an upper storey divided into three rooms over the narthex at S. Sisto and at S. Silvestro in Capite, a nuns' choir was added in that place and extended over part of the nave in the sixteenth century.[114] The room at S. Sabina could have been used as an alternative choir space, as a passageway between one side of the church to the other, or for other purposes.

The Installation of the Dominicans at S. Sabina in the Thirteenth Century

In December 1219, Honorius III ceded to Dominic the unfinished nunnery at S. Sisto.[115] When the nuns moved into that nunnery on 28 February 1221, a few friars stayed there in a separate building to assist them, but this was not the priory Dominic needed for his friars in Rome. Instead, S. Sabina became their Roman residence, where, it is believed, Dominic and some companions went to live *c.* 1220–1221.[116] According to the Dominican Prior of S. Sisto, Benedict of Montefiascone, writing *c.* 1316–1318, Dominic asked for and obtained the church of S. Sabina from Pope Honorius III, when he learned that S. Sisto was to become a nunnery:

> Beatus Dominicus processu temporis audiens dictum monasterium (scilicet S. Sixti) ad usum monialium aedificatum fuisset, ductus teneritudine conscientiae noluit quod fratres sui ordinis ulterius ibi manerent, sed cum multa solicitudine multoque labore ecclesiam S. Sabinae a summo pontifice sibi et suo ordini impetravit.

> (When in the course of time, blessed Dominic heard that the said monastery [that is, of S. Sisto] had been built for the use of nuns, guided by the tenderness of his conscience, he did not wish the friars of his Order to remain there any longer, but with great solicitude and much labour he obtained the church of S. Sabina from the Pope for himself and for his Order).[117]

Honorius III's donation of S. Sabina to the Dominicans was legally ratified on 5 June 1222, nearly a year after Dominic's death at Bologna on 6 August 1221.[118] The papal Bull was addressed

113 Krautheimer, *Corpus*, vol. II, pp. 277–307 (S. Maria in Cosmedin); vol. I, pp. 273, 275 (SS. Giovanni e Paolo), vol. IV, pp. 53, 69 (S. Saba); for SS. Giovanni e Paolo, see also, Riccioni, 'From Shadow to Light' pp. 217–44; and for S. Saba, see also, Cutarelli, *Il complesso di San Saba*, pp. 27–30; 35; 77–90.

114 See Chapter 1 for S. Sisto and Chapter 7 for S. Silvestro in Capite.

115 See above, Chapter 1.

116 Berthier, *Le Couvent de Sainte-Sabine*; Darsy, *Santa Sabina*, pp. 32–34, 115, 139–40.

117 From the Benedict of Montefiascone, *Historical Introduction*, published in Koudelka, 'Le "Monasterium Tempuli" et la fondation dominicaine de San Sisto', no. 3, p. 69.

118 *BOP*, vol. I, XXIX, p. 15; in *Una Cronaca*, ed. by Rodocanachi, p. 1, the author claimed that the Bull was issued at Alatri, in the sixth year of Honorius III's pontificate, which he calculated as June 1221 — shortly before Dominic died — but this is not followed by other authorities.

to the Master of the Dominican Order, who, by 1222, was Jordan of Saxony. Despite the date of the Bull, the friars are believed to have moved to S. Sabina before then. It was there, according to tradition, that in April 1220, Dominic received into the Order some famous early Friars Preachers from outside Rome — Hyacinth and Ceslaus from Poland, Henry from Moravia, and Hermann the German.[119] Later, Hyacinth evangelized parts of Poland, and his tomb is now in the church of Saint Dominic in Cracow. Ceslaus went to preach in Bohemia. Hermann returned to Germany, where, with other German friars, Henry and Leo, he established the Order in Cologne.

Sister Cecilia, one of the original nuns at S. Sisto, described Dominic dividing his time between S. Sisto and S. Sabina.[120] He is said to have prayed all night in the basilica and there is a tradition that this so enraged the devil that he hurled a black basalt stone weight at Dominic, which missed him, but caused considerable damage to a slab of marble on the floor of the church with an inscription listing saints' relics.[121]

Honorius III not only ceded the church and convent to the Order of Preachers, but he also clarified which parts of the S. Sabina buildings they were to occupy, and which parts were to be reserved for two priests in charge of the parish, under the authority of the titular cardinal.[122] This may indicate that the document was written to clarify the division of space at S. Sabina between the Roman priests and the Dominicans, a problem that may have emerged after the friars moved in. The document may also reflect Dominic's custom of ensuring that grants to his Order were later ratified in writing. For these reasons, it is plausible that the friars moved to S. Sabina before the Bull was issued, and that Dominic himself resided there.[123]

In order to understand more clearly what was originally ceded to the Dominicans at S. Sabina, it is important to consider the terms of Pope Honorius III's Bull. The document states:

Cum igitur certum hospitium non haberetis in Urbe, ubi eo forsan plus prodesse potestis, quo ibi tam indigene quam extranei congregantur Nos tam vobis, quam multorum utilitate consulere cupientes, Ecclesiam S. Sabinae, ad celebrandum, et domos ad inhabitandum, sicut Seculares Clerici habuerunt, de consensus Fratrum nostrorum, et specialiter dilecti filii nostri tituli ejusdem Ecclesie Presbyter Cardinalis, vobis duximus concedendam, domo ubi est Baptisterium cum horto proximo et reclusorio pro duobus Clericis reservato, qui de Parochia, et possessionibus ipsius Ecclesiae, prout expediet, curam gerent, jure Cardinalis in omnibus integre conservato.

(Therefore, since you have not had a fixed abode in Rome, in which you could perhaps accomplish more and gather together there both natives and foreigners, We, desiring to take measures that are as useful to you as to many other people, have decided to concede to you the church of S. Sabina, in which to celebrate, and a house in which to live. As secular clergy have these, we make this concession with the consent of our brothers and especially of our beloved son, the Cardinal Presbyter

119 Berthier, *Le Couvent de Sainte-Sabine*, pp. 162–70; Muñoz, *La basilica di Santa Sabina in Roma*, p. 25; Darsy, *Santa Sabina*, p. 123; Jarrett, *Life of Saint Dominic*, p. 84.

120 Cecilia, *Miracula Beati Dominici*, pp. 293–326.

121 This stone and the slab of marble are on display in the basilica, and see Darsy, *Santa Sabina*, p. 112 and fig. 29. See also, Panciroli, *Tesori nascosti*, p. 739.

122 One notes that the Dominicans at this time did not expect to run a parish. In fact, there was considerable opposition to the Mendicant Orders from parish priests in the first half of the thirteenth century, because they were seen as rivals in the pastoral care of parishioners.

123 Something similar seems to have happened at S. Maria sopra Minerva. The friars 'acquired' the existing church and convent in 1266, but their presence there was only fully ratified legally in 1276, after their parish rights in the church had been clarified; see below, Chapter 6.

of the church, having reserved a house where the Baptistery is, with the garden next to it, and a hermitage, for two priests who will administer the Parish and the possessions of this church, as may be necessary, maintaining the right of the Cardinal in all matters in its entirety.)[124]

From this text, it is clear that the Dominicans could use the church for celebrating Mass and the Divine Office, but they were not expected to run the parish, nor usurp any of the normal roles of the two diocesan priests. The titular Cardinal of S. Sabina at the time was Thomas, Bishop of Capua, who was created cardinal by Innocent III in 1216 and who died in 1243.[125] The friars could live in some existing residential buildings, where they could study and equip themselves for preaching missions; and they could return to S. Sabina, as their base, when those missions were over. They could also prepare novices — whether Romans or foreigners (like Hyacinth, Ceslaus, Henry, and Hermann) — to join the Order. The text of Honorius III's Bull speaks of several buildings. Apart from the church of S. Sabina, there is a large house for the Friars Preachers, and another house near the baptistery, with its adjacent garden, and a hermitage for the two priests of the parish. As Joanna Cannon has explained, in the early days of the Order of Preachers, the friars were often entrusted with an existing church and convent buildings.[126] This was the case at S. Sabina, the friars' first church in Rome. They could use the existing fifth-century basilica, the interior of which they modified, and they lived in some conventual buildings, which they later extended.

The Church of S. Sabina in the Thirteenth Century: the Choir-Screen or 'Tramezzo'

Shortly after the Dominicans came to live at S. Sabina, the space in the church was divided into two parts: a place for the parishioners and the secular clergy in the south-west and another place for the Dominican choir in the north-east. This can be seen in Bufalini's *Map of Rome* of 1551 (Fig. 50), where the basilica is shown with a thick wall crossing the nave and aisles in the fourth bay from the apse.[127] (Since Bufalini shows only eight of the twelve columns in each colonnade, his depiction cannot be taken as a precise record of the wall's location, but he evidently wanted to indicate the presence of the 'tramezzo').[128]

Ugonio revealed more about this wall in his description of S. Sabina, in 1588.[129]

> […] si può […] ogni huomo ch'è stato à questa età in Roma ricordare, che insino all'anno 1586 da molto tempo indietro questa chiesa di Santa Sabina era per il mezzo divisa in due parti, con un muro alto circa 12. palmi che attraversava tutte tre le nave per il largo, sì che la vista del lungo della chiesa non si poteva commodamente godere et dalle bande del detto muro vi erano due porticelle per passare da una parte nell'altra.
>
> ([…] everyone who has been in Rome at this time […] can remember that, until 1586, and for many years before, this church of Santa Sabina was divided in the middle into two parts by a wall *c.* 12 palmi high, which stood across the width of the nave and aisles so that one could

124 Val van Putten kindly helped with this translation.
125 Eubel, *Hierarchia*, vol. I, pp. 4, 46 and 359. Berthier says Thomas of Capua was cardinal of S. Sabina from 1216–1239; Berthier, *L'Église de Sainte Sabine*, p. 515.
126 Cannon, *Religious Poverty, Visual Riches*, pp. 35–36.
127 Frutaz, *Piante*, vol. II, tav. 203; see also Barclay Lloyd, 'Medieval Dominican Architecture at Santa Sabina', pp. 251–59, and fig. 9.
128 As at S. Sisto, it would be helpful to have a GPR examination made, which might locate the choir-screen.
129 Ugonio, *Historia delle Stationi*, pp. 10[r–v].

not easily enjoy a view of the length of the church; and there were on the sides of this wall two small doors to pass from one side of it to the other.)[130]

The height of the wall, *c.* 12 palmi, was *c.* 2.68 m.[131] This meant that even tall men could not be seen above it, but it did not reach up to the roof, as one presumes was the case with the transverse wall in the nuns' church of S. Sisto. There is no mention of a doorway in the middle of the wall, only two small doors, one at either end of the wall, presumably in the aisles of the church. Ugonio suggested that the Dominicans built the wall shortly after they came to S. Sabina and that its purpose was to allow them to withdraw behind it in a choir enclosure where they chanted the Divine Office.[132] He was delighted when Pope Sixtus V (1585–1590) removed this 'ingombramento' (encumbrance) in 1586. At that time, it was considered an anachronism, and quite inappropriate for the Counter Reformation liturgy.

Ugonio noted that in the pontificate of Pope Gregory IX (1227–1241) a new high altar and four other altars were erected on the south-western or public side of the transverse wall. The new high altar was placed against the middle of the transverse wall:

> Quindi è, che al tempo di Gregorio Nono […] successore di Honorio Terzo, furono fatti cinque altari nuovi nella parte anteriore, per commodità del popolo: de quali il maggiore che vedevamo appoggiato al sudetto muro nel mezzo.
>
> (Therefore, it happened that at the time of Gregory IX […] Honorius III's successor, five new altars were set up in the front part of the church for the convenience of the people; of these, the high altar could be seen placed against the aforementioned wall in the middle.)[133]

Ugonio also mentioned that Pope Gregory IX, three cardinals, and a bishop consecrated the five new altars. An inscription, still in the right aisle of the church, says this event took place on the day before the Octave of the feast of Saint Martin in November 1238.[134] (It is likely that the whole arrangement — the choir-screen and the altars — all date from that time.) In the presence of the Pope, four altars were consecrated by the Cardinals of Palestrina, Ostia, and Alatri, and the Bishop of Cefalu, with the Archbishops of Besançon and Messina and other prelates in attendance. Gregory IX consecrated the high altar, 'PROPRIIS MANIBUS' (with his own hands). An indulgence of one year and 40 days was granted to everyone who visited the church once a year on the day of its dedication or in the octave of that feast.

In this way, Gregory IX endorsed the 'privacy' needed by the friars. Lay people coming to S. Sabina could attend the parish Mass in the south-western part of the church, where the new high altar and four other altars were located. To the north-east, the Dominican choir and the ninth-century altar of Pope Eugene II, which Ugonio still saw before 1586, were located behind the intermediary wall.[135] In their secluded part of the church, the friars could celebrate the Hours of the Divine Office and their conventual Mass.[136] The building of the 'tramezzo' also emphasized that the Dominicans were originally not there for parish ministry, but to prepare for their mission

130 Ugonio, *Historia delle Stationi*, p. 10ʳ. He must have examined the wall before Pope Sixtus V demolished it in 1586.
131 One *palmo Romano* is equivalent to 0.2234 m.
132 Ugonio, *Historia delle Stationi*, p. 10ʳ.
133 Ugonio, *Historia delle Stationi*, pp. 10ʳ⁻ᵛ.
134 Berthier, *L'Église de Sainte Sabine*, pp. 282–83 n. 2; and Forcella, *Iscrizioni*, vol. VII, no. 590, p. 294.
135 Ugonio, *Historia delle Stationi*, p. 9ᵛ.
136 See Cannon, *Religious Poverty, Visual Riches*, pp. 25–45 for the public part of the church of the laity; and pp. 109–17 for the friars' choir.

of saving souls through study, preaching, and hearing confessions.

What seems to have begun as a clear way of creating a boundary between the Dominicans' choir and the parish run by the secular clergy at S. Sabina soon became typical of all the early churches of the Order of Friars Preachers.[137] In 1239, the Provincial Chapter met at S. Eustorgio in Milan, where a new choir was built and a transverse wall was erected across the church in preparation for that event, one year after the tramezzo was set up at S. Sabina. Galvano Fiamma described it *c.* 1340:

> Item factus est murus isto tempore per trasversum ecclesie, in medioque muri factus est hostium ubi depicti sunt fratres quos beatus Dominicus Mediolanum misit ad habitandum. In muro etiam ex utraque parte facte sunt due fenestre per quas videri poterat corpus Christi interius. Super murum autem factum est pulpitum, ubi cantatur evangelium et in processu temporis facta sunt tria altaria, sicut nunc apparet.

> (At that time, a wall was built across the church and in the middle of the wall an entrance was made, where there were depicted the brothers Saint Dominic sent to live in Milan. In the wall itself on either side two windows were made through which could be seen the Body of Christ in the interior. Furthermore, above the wall there was constructed the pulpit where the Gospel was sung; and in the course of time, three other altars were set up, as can be seen now.)[138]

One notes a significant difference in this 'tramezzo': at S. Sabina there was a high altar in the church of the laity, placed against the middle of the screen wall, which had a small door at either end, whereas in Milan the entrance to the choir was in the middle of the wall, and windows were opened on either side of it so that the congregation could see the elevation of the Host at the high altar, which was inside the part of the church containing the choir.[139] It is also interesting to note that a pulpit was placed above the transverse wall, which became a common feature of mendicant churches, so that the friars could read the Gospel and preach to the people from that position, where they could be seen and heard. The three other altars, added later, are reminiscent of the four other altars in the church of the laity at S. Sabina, but their precise locations are not given.

Dominican architecture gradually evolved to suit the needs of the friars and their mission. At first, the brethren needed places for prayer and study, to prepare for an apostolate beyond the priory. The priory was a base from which to launch preaching missions elsewhere and a place to return to after such missions. Often the friars preached in public squares, or in churches not their own.[140] Later on, as Dominican communities increased in size, and the Mendicant Orders, in the face of fierce opposition from the diocesan clergy, began to attract the public to their own churches and to run parishes, their buildings were considerably enlarged to cater for the greater number of brethren and to provide more space for the laity. Gilles Mersseman, OP divided thirteenth-century Dominican architecture into three phases: an early period, *c.* 1216–1240, when

137 Berthier, *L'Église de Sainte-Sabine*, p. 282.
138 Fiamma, *Chronicon Maior*, published and ed. by Gundisalvo Odetto, 'La Cronaca maggiore dell'Ordine domenicano di Galvano Fiamma', 324, written *c.* 1340. Meersseman, 'L'Architecture dominicaine', p. 152, quotes this passage. See also, Berthier, *L'Église de Sainte Sabine*, p. 377; Schenkluhn, *Architettura*, pp. 81–84; Jäggi, *Frauenklöster*, pp. 18–19; Cannon, *Religious Poverty,* *Visual Riches*, pp. 34–37; and Bruzelius, *Preaching, Building, and Burying*, p. 31.
139 For the wider significance of choir screens for the laity, see Knipping, 'Die Chorschranke'; Jung, 'Peasant Meal or Lord's Feast?'.
140 Bruzelius, *Preaching, Building, and Burying*, pp. 124–35.

priories were centres of preparation for itinerant preaching; a second phase, 1240–1263, when existing buildings were enlarged, although the Constitutions regulated the height of both church and priory; and a third period, 1264–1300, when proscriptions on size were abolished, and further extensions were made, or new large buildings were acquired or erected.[141] At this last stage, in cities where a Dominican priory was not in the centre of town, an alternative church and priory were obtained in such a location, as happened in Rome, when the Dominicans were given S. Maria sopra Minerva between 1266 and 1276.[142]

Dominic wanted the Friars Preachers to live in university towns and he selected Bologna as the central location of the Order. Regarding the building phases of the Dominican church at Bologna, documents show that the Friars Preachers first obtained the church of S. Nicolò delle Vigne, which was later rededicated to Saint Dominic, and then they acquired some land surrounding it.[143] The original edifice was apparently demolished in 1228 or 1229 and a new church was begun, which could have been in use by 1233–1234.[144] Various changes were made before Pope Innocent IV (1243–1254) consecrated the building on 17 October 1251.[145] In design, the east end resembled the so-called 'Bernardine' plan in Cistercian architecture, in that the sanctuary was rectangular with two smaller rectangular chapels on either side.[146] The western part of the church had a wooden roof and round piers, whereas the eastern half, housing the choir, was vaulted and had multiple piers. This was in accordance with Dominican legislation about church architecture, which stipulated that only the choir and sacristy might be vaulted.[147] This part of the building was also more Gothic in style. The edifice has changed considerably since Carlo Dotti remodelled it in 1727–1733. It is clear, however, that the thirteenth-century church had a public area in the west, which was different and separated from the Dominican choir in the east.[148] Most probably, at Bologna there was a transverse wall between the 'internal' and 'external' church, but it has not survived and there is no evidence regarding its characteristics. In 1243 the Chapter at Bologna divided the choir itself into spaces for clerics and lay brothers (*conversi*).[149] Since the church was the burial place of Saint Dominic, the architectural planning also took into account the need people had to venerate the tomb of the saint, who was canonized on 3 July 1234. The tomb was first moved from under the floor of the chancel to a stone sarcophagus

141 Meersseman, 'L'Architecture dominicaine', p. 142. One can compare this development with that outlined in Bruzelius, *Preaching, Building, and Burying*, pp. 25–51, who gives a slightly different chronology, for both the Franciscans and the Dominicans, with stages from the 1230s, late 1230s and 1240s, 1240s and 1250s, and after 1256.

142 See Chapter 6 for S. Maria sopra Minerva, and Bruzelius, *Preaching, Building, and Burying*, pp. 107–30 for the phenomenon in general.

143 Alce, 'Documenti', pp. 5–45.

144 Alce, 'Documenti', document 26.

145 For various interpretations, see Meersseman, 'L'Architecture dominicaine', pp. 153–57; Wagner-Rieger, 'Zur Typologie italienischer Bettelordenskirchen', esp. p. 272; Cannon, 'Dominican Patronage', pp. 169–75; Schenkluhn, *Ordines Studentes*, pp. 86–92; Alce, *La basilica di San Domenico*, p. 9; Schenkluhn, *Architettura*, pp. 34–37.

146 For Cistercian influences on mendicant church design, see Wagner-Rieger, 'Zur Typologie italienischer Bettelordenskirchen', pp. 266–98. For the design of S. Domenico in Bologna, Schenkluhn, *Architettura*, pp. 34–35 with a plan and elevation in fig. 6.

147 For legislation on Dominican architecture, see Meersseman, 'L'Architecture dominicaine'; and Sundt, '*Mediocres domos*', pp. 394–407.

148 In some ways this differentiation resembled the architecture of several Dominican churches north of the Alps, which had a wooden-roofed nave in the west, and a long, vaulted choir in the east. For such churches see Krautheimer, *Die Kirchen der Bettelorden*; Donin, *Die Bettelordenskirchen*; Schenkluhn, *Ordines Studentes*, pp. 204–30; and Schenkluhn, *Architettura*.

149 Berthier, *L'Église de Sainte Sabine*, p. 376. This could have followed Cistercian practice. The new choir at S. Eustrogio in Milan in 1239 was also divided this way.

located in the south aisle.¹⁵⁰ By 1267, the stone coffin was replaced by the marble '*arca*' carved by Nicola Pisano and others.¹⁵¹ The completed building was clearly divided into two separate spaces, with the vaulted choir separated from the crowds coming to venerate Saint Dominic's tomb and to attend Mass in the western part of the church.

At the Jacobin church in Toulouse, which was begun in 1229 and completed in the late fourteenth century, there was a separation of different design.¹⁵² The church had two parallel naves, one on the north for the Dominican choir, the other on the south for the public.¹⁵³ A similar plan was followed in Paris in the church of Saint Jacques, *c.* 1240–1263.¹⁵⁴

After these solutions had already been tried for setting the friars' choir apart from the laity, in 1249 the General Chapter of the Order of Preachers decreed that a screen wall should be erected in all Dominican churches to separate the community choir from the public section of the church.

> Intermedia que sunt in ecclesiis nostris inter seculares et fratres, sic disponantur ubique per priores. Quod fratres egredientes et ingredientes de choro non possint videri a secularibus vel videre eosdem. Poterunt tamen alique fenestre ibidem aptari ut tempore elevationis corporis dominici possint aperiri […].

> (The intermediary walls that are in our churches between the lay people and the friars should be set up everywhere by the priors, so that friars leaving or entering the choir cannot be seen by the laity, nor see them. Some windows, however, can be made there in such a way that they can be opened at the time of the elevation of the Body of the Lord […].)¹⁵⁵

This decree followed the disposition at Sant' Eustorgio in Milan, rather than that of S. Sabina in Rome, but both these early 'tramezzi' preceded the Dominican legislation. Such barriers continued to be built in Dominican churches in the thirteenth century. For example, at S. Maria Novella in Florence in 1279, an elaborate vaulted 'ponte' was constructed across the church.¹⁵⁶

150 Meersseman, 'L'Architecture dominicaine', pp. 153–57; Cannon, 'Dominican Patronage', pp. 169–75; and Alce, *The basilica*, pp. 5–11.

151 Alce, *La basilica*, p. 9; Moskowitz, 'On the Sources and Meaning of Nicola Pisano's Arca'; Dodsworth, 'Dominican Patronage and the Arca di S. Domenico'; Moskowitz, *Nicola Pisano's Arca*; Dodsworth, *The Arca di San Domenico*; Romano, 'The Arca of St Dominic at Bologna'; Cannon, *Religious Poverty, Visual Riches*, pp. 99, 132–35.

152 Lambert, 'L'Église et le couvent des Jacobins de Toulouse', pp. 141–86; Schenkluhn, *Ordines Studentes*, pp. 72–76; Sundt, 'The Jacobin Church of Toulouse', pp. 185–207; Schenkluhn, *Architettura*, pp. 165, and 194–96.

153 William Pelhisson, procurator of the Jacobin priory at Toulouse from 1245 to 1260, noted 'est divisa ecclesia fratrum et ecclesia laicorum' (it is divided into the church of the friars and the church of the laity), quoted from Prin, 'L'Église des Jacobins di Toulouse', pp. 185–208, esp. p. 187 by Sundt, 'The Jacobin Church of Toulouse', p. 187.

154 Meersseman, 'L'Architecture dominicaine', p. 161. This church, which was demolished in 1849, is briefly mentioned by Lambert, 'L'Église et le couvent des Jacobins de Toulouse', pp. 179–81; Schenkluhn, *Ordines Studentes*, pp. 55–71; Sundt, 'The Jacobin Church of Toulouse', pp. 203–04; Schenkluhn, *Architettura*, pp. 29–30, 45.

155 *Acta capitulorum generalium*, ed. by Reichert, vol. I, p. 47; Sundt, '*Mediocres domos*', p. 406, appendix C, AD 1249; Sundt pointed out that the legislation of 1249 does not so much prescribe the transverse wall, as define details of its disposition.

156 Meersseman, 'L'Architecture dominicaine', p. 179; Hall, 'The Ponte in S. Maria Novella'. The Franciscan church of S. Croce in Florence had a comparable screen, see Hall, 'The Tramezzo in Santa Croce'; Hall, 'The Italian Rood Screen'; Hall, 'The "Tramezzo" in the Italian Renaissance'; Bacci, *Lo spazio dell'anima*, pp. 79–85; Cooper, 'Franciscan Choir Enclosures'; Cooper, 'Access all Areas?'; and Cannon, *Religious Poverty, Visual Riches*, Parts I and II, pp. 23–163.

The 'tramezzo' at S. Sabina is significant because it appears to be the earliest screen wall built in a Dominican friars' church.[157] It is likely that its initial purpose was to separate the choir of the Friars Preachers from the distractions of the parish run by the secular clergy. It is not known when the separate parish arrangement ceased.[158] The Catalogue of Turin c. 1320 speaks only of thirty Friars Preachers at S. Sabina and makes no mention of any other clergy.[159] The transverse wall remained until 1586, when Pope Sixtus V had it removed.

Besides the four extra altars consecrated in 1238, other side chapels were added to the church of S. Sabina in the thirteenth century. As recorded in an inscription now located in the right aisle of S. Sabina, in 1248, during the pontificate of Pope Innocent IV (1243–1254) the Chapel of the Holy Angels was consecrated by the Pope's delegate, Rainaldo dei Conti di Segni, Cardinal Bishop of Ostia.[160] It was located along the south-eastern aisle. In 1643–1647, a chapel dedicated to Saint Dominic replaced it,[161] which Muñoz demolished in the early twentieth century. Another inscription, now in the south-eastern aisle of S. Sabina, records that during the pontificate of Pope Urban IV (1261–1264) Giovanni Colonna, OP, Archbishop of Messina, dedicated an altar in S. Sabina to the Dominican Saint Peter Martyr in 1263, ten years after his canonization. The location of this altar (or chapel) is unknown.[162]

Thirteenth- and Early Fourteenth-Century Tombs at S. Sabina

Julian Gardner has pointed out that there is a rich collection of medieval incised marble slabs from floor tombs at S. Sabina, commemorating clerics and lay people, as well as some Dominican friars.[163] Among the women, Giovanna, Matteo Rosso Orsini's wife, who died in 1272, had such a tomb, with her coat of arms rendered in mosaic, although not many of the tesserae have survived.[164] Likewise, on the tomb slab of Perna Savelli, who was the wife of Luca Savelli and who died in 1315, there are two coats of arms prominently displayed in mosaic on either side of her head (Fig. 59).[165] A Dominican penitent, Stefania from Tiber Island, who died in 1313, was shown holding an open book.[166]

Among tombs for men, there was one for the Dominican Friar Hildebrandino who died in 1309 and who had been penitentiary to the Pope.[167] The tomb slab of Abbot Egidius of Varnspernach, who died in Rome in 1312, shows him in fine vestments, with a mitre and an abbot's pastoral staff.[168] Munio of Zamora has the finest tomb of all (Fig. 60). His tomb is now in the centre of the nave and shows him in his Dominican habit, under a Gothic canopy. Mosaic has been used to render his hair, beard, and face, his white

[157] Sundt, 'The Jacobin Church of Toulouse', p. 191 n. 25, claims that the earliest was at S. Eustorgio in Milan, but it was built after that at S. Sabina.

[158] The Mendicant Orders began to have their own parishes in the mid-thirteenth century.

[159] Valentini and Zucchetti, *Codice topografico*, vol. III, p. 308.

[160] The wording of the inscription is given in Berthier, *L'Église de Sainte-Sabine*, p. 312 n. 1, and Forcella, *Iscrizioni*, vol. VII, no. 591, p. 294; Barclay Lloyd, 'Medieval Dominican Architecture at Santa Sabina', p. 235 n. 12. For the chapel, see Darsy, *Santa Sabina*, p. 34.

[161] Berthier, *L'Église de Sainte-Sabine*, p. 311.

[162] The wording of the inscription is given in Berthier, *L'Église de Sainte-Sabine*, p. 310; Forcella, *Iscrizioni* vol. VII,

no. 592, p. 295; and Barclay Lloyd, 'Medieval Dominican Architecture at Santa Sabina', p. 236 n. 14.

[163] Gardner, *The Tomb and the Tiara*, p. 88.

[164] Garms and others, ed., *Die mittelalterlichen Grabmäler in Rom*, vol. I, LVII, 1, pp. 275–76.

[165] Garms and others, ed., *Die mittelalterlichen Grabmäler in Rom*, vol. I, LVII, 9, pp. 283–84; Darsy, *Santa Sabina*, fig. 39.

[166] Garms and others, ed., *Die mittelalterlichen Grabmäler in Rom*, vol. I, LVII, 8, pp. 282–83; Darsy, *Santa Sabina*, fig. 40.

[167] Garms and others, ed., *Die mittelalterlichen Grabmäler in Rom*, vol. I, LVII, 4, p. 279.

[168] Garms and others, ed., *Die mittelalterlichen Grabmäler in Rom*, vol. I, LVII, 5, pp. 279–80; Darsy, *Santa Sabina*, fig. 41.

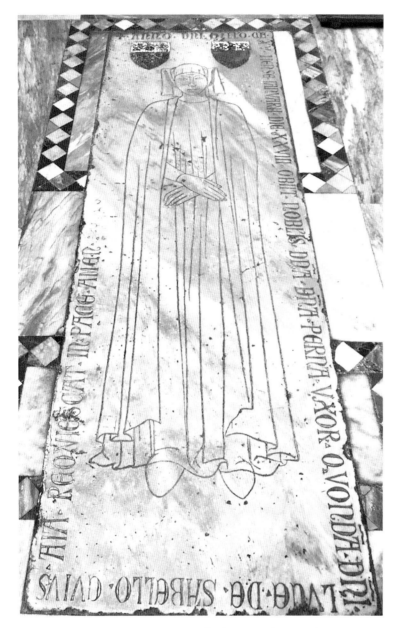

Figure 59. S. Sabina, tomb of Perna Savelli, died 1315 (photo: author)

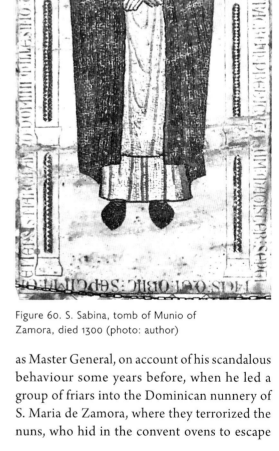

Figure 60. S. Sabina, tomb of Munio of Zamora, died 1300 (photo: author)

robes and black mantle, and the decoration of the arched canopy. The inscription recalls that he came from Zamora in Spain, had been the seventh Master General of the Order of Friars Preachers, and died in 1300.[169] What it does not say, is that Munio was made to resign his position as Master General, on account of his scandalous behaviour some years before, when he led a group of friars into the Dominican nunnery of S. Maria de Zamora, where they terrorized the nuns, who hid in the convent ovens to escape

169 Garms and others, ed., *Die mittelalterlichen Grabmäler in*

Rom, vol. I, LVII, 3, pp. 277–78; Darsy, *Santa Sabina*, fig. 42; Gardner, *The Tomb and the Tiara*, pp. 88–89.

Figure 61. Gieronimo Francino, *S. Sabina, View of side portico*, from *Le Cose Meravigliose…*, ed. Fra Santi, 1588, p. 66v (photo: BAV, © 2018, Cicognara.III.3685)

abuse.[170] Despite this, after his time as Master General, Munio became a bishop in Spain, but he died in Rome, hence his tomb is in S. Sabina.[171]

The Church of S. Sabina from the Fifteenth Century Onwards

There is some evidence of changes to the basilica in the fifteenth century. Ugonio recorded an inscription in a corner of the apse, saying: 'Anno D. 1441 reparata est ecclesia ista per reverendum dominum Julianum de Caesarinis cardinalem hujus ecclesie' (In the year of the Lord 1441, this church was repaired by the reverend Lord Giuliano Cesarini, Cardinal of this church).[172]

Figure 62. S. Sabina, view of the side portico with the door to the priory on the left and the side entrance to the basilica on the right (photo: author)

Before the Muñoz restorations, Cardinal Cesarini's coat of arms was to be seen in various places in the basilica, including a rather damaged example over the side door in the south-eastern aisle, according to Berthier.[173] This would indicate that Cardinal Cesarini opened the side door in the right aisle in 1441 (Figs 41, 61, and 62). The Cardinal also renewed the roof of the church and

170 Linehan, *The Ladies of Zamora*, pp. 224–29.
171 Its present position is due to the restorations of Muñoz in the twentieth century, when all the tomb slabs were removed from their original positions and placed in their present locations.
172 Ugonio, *Historia delle Stationi*, p. 12r; and Ugonio, *Schedario*, BAV, Barb. Lat. 1993, fol. 44; see also Krautheimer, *Corpus*, vol. IV, p. 76.
173 Berthier, *L'Eglise de Sainte-Sabine*, p. 101; see also Krautheimer, *Corpus*, vol. IV, p. 76.

narthex. Further changes are shown in a plan drawn in the late fifteenth century (Fig. 64).[175] There are detailed measurements written on the south-eastern side of the church, to the right of the main apse, near a small side apse, which was obviously projected at the time. This is where Valentine d'Auxio de Podio (from Xativa, near Tarragona in Spain), Cardinal of S. Sabina from 1477 to 1483, sponsored a chapel dedicated to Our Lady of the Holy Rosary, which was built in 1484.[176] The chapel also contained a monumental tomb for Cardinal d'Auxia, which has been attributed to the workshop of Andrea Bregno (1420–1506).[177]

The fifteenth-century plan exhibits many other features that existed or were planned at S. Sabina (Fig. 64). It shows a side apse, to the left of the main one, which was never built. Along the south-eastern aisle wall, the side entrance opened by Cardinal Cesarini is visible. Two steps are drawn beside it in the interior, showing that the floor of the basilica at that time must have

Figure 63. S. Sabina, tracery from an apse window now in cloister (photo: author)

he inserted Gothic tracery (Fig. 63) in two of the apse windows, which were reduced in size.[174] The third one seems to have been blocked.

The side door at S. Sabina is like that provided by Cardinal Pietro Ferrici y Comentano at S. Sisto in 1478 (Fig. 11). Opening such a door was a way of granting the laity access to the public part of the church, without going through the

174 Muñoz placed the fifteenth-century tracery in the cloister, when he restored the apse windows to their early Christian size and form.

175 Krautheimer, 'Some Drawings of Early Christian Basilicas in Rome', esp. p. 213; Krautheimer, *Corpus*, vol. IV, p. 80 and fig. 70. The drawing is in the first volume of architectural drawings collected by Virgilio Spada (1595–1662), BAV, Vat. lat. 11257, fol. 178.

176 *Una Cronaca*, ed. by Rodocanachi, p. 9; Darsy, *Santa Sabina*, p. 37; Krautheimer, *Corpus*, vol. IV, p. 76. In the chapel, there was a painting by Raphael of Urbino, which the Dominicans donated to Cardinal Antonio Barberini in 1629 in the hope of receiving a reward in return for their gift, see *Una Cronaca*, ed. by Rodocanachi, pp. 44, 50–51. In fact, the Cardinal graciously accepted the painting but gave them nothing in return. In 1643, a painting of *Our Lady of the Rosary* by Giovanni Battista Salvi, known as Sassoferrato, was placed in the chapel and it was surrounded later by small images of the mysteries of the Rosary painted by other unknown artists, according to *Una Cronaca*, ed. by Rodocanachi, p. 53.

177 Darsy, *Santa Sabina*, pp. 136–37. Muñoz destroyed the contents of the chapel and moved the tomb into the south-eastern aisle, see, Michele Nicolaci, in Gianandrea, Annibali and Bartoni, *Il convento di Santa Sabina*, pp. 191–93. Sassoferrato's painting, which was in the chapel, was then placed in the chapel of Saint Catherine of Siena, and it is now in the S. Sabina Museum.

been lower than the level outside. The drawing indicates a door into the priory (Fig. 62) near the side entrance to the church, but there is no trace of the side portico itself, which is often referred to as having been built in the fifteenth century.[178] It seems to have been built later, after the plan was drawn, and by the late sixteenth century.[179] The fifteenth-century plan also indicates projected changes to the disposition of the narthex, with the addition of thick walls on the north-western and south-eastern sides, each with three niches, and three doors leading south-west from the narthex into garden D (see Figs 42, D and 56).

By 1588, a colonnaded porch stood in front of the south-eastern side door (Fig. 61). Two very tall columns sustain an arcade, which is connected to vaulting.[180] Next to the porch stood a small medieval tower erected beside the narthex at an unknown time and a wall that projects from the south-eastern aisle of the church (Fig. 42). Information about this tower was revealed in the 2010 restoration of the narthex. It stands beside the south-eastern end of the narthex and may have been built in the thirteenth century 'to guard the church', like the one at S. Sisto.[181] The tower can be seen in a view of S. Sabina by Giuseppe Vasi, made in 1756.[182] The restorations in 2010 uncovered a narrow staircase in the tower leading up to the room above the narthex (now the museum).

An arched doorway framed with blocks of tufa (Fig. 62), which was probably built in the sixteenth or seventeenth century, served as the main entrance to the narthex (and beyond

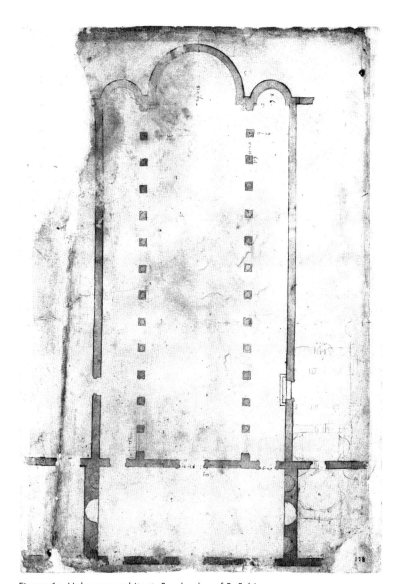

Figure 64. Unknown architect, Spada plan of S. Sabina, c. 1483 (photo: BAV, © 2018, Vat. lat. 11257, fol. 178)

that to the priory) and also to the tower (and beyond that, to the room above the narthex). The doorway is very similar in form to the one at the entrance of the chapter room at S. Sisto (Fig. 12), but whereas the arch at the nunnery was made of marble, that at the priory was made of tufa. Above the door at S. Sabina (Fig. 62), there is a Baroque painting by an unknown artist, in which Saint Dominic and two companions come to the door at night, accompanied by a young man, who is dressed in red and holding

178 For example, by Krautheimer, *Corpus*, vol. IV, p. 97.
179 See below, and Ugonio, *Historia delle Stationi*, p. 8ʳ; *Le cose maravigliose*, 1588, 66ᵛ.
180 Ugonio, *Historia delle Stationi*, 8ʳ, claimed these columns were black, but they have now been substituted by white ones.
181 Above, Chapter 1.
182 Vasi, *Delle Magnificenze di Roma*, Lib. 7; see also, Foletti and Gianandrea, *Zona liminare*, Figs 7 and 8; and Darsy, *Santa Sabina*, p. 142.

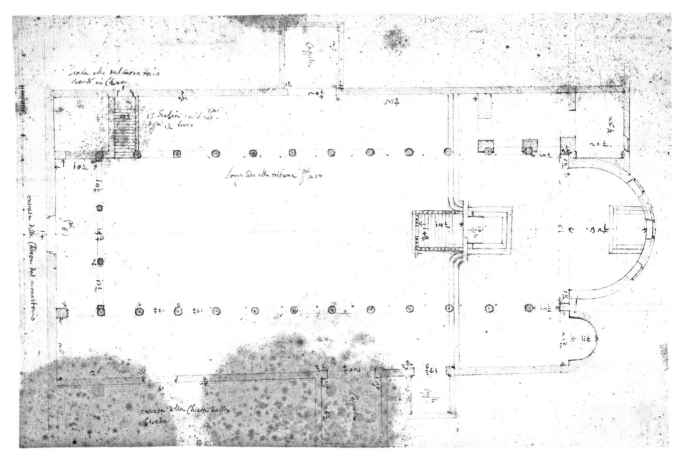

Figure 65. Francesco Borromini and workshop, plan of S. Sabina, c. 1640 (photo: © The Albertina Museum, Vienna – www.albertina.at)

a burning torch. The painting illustrates a story told by Sister Cecilia.[183] She says Dominic was at S. Sisto one evening, when he was inspired to return in haste to S. Sabina, although other friars protested that it was dark, and the door of S. Sabina would be locked. As he set out with the priors of S. Sabina and S. Sisto, a young man joined them, and, when they came to the door of S. Sabina, it was indeed locked, but when the young man touched it, it opened immediately. Once Dominic and his two companions were inside the building, the young man left them, and the door was firmly closed. Dominic explained to the others that the young man was an angel who had been sent to help them. At S. Sabina, Dominic found a young Roman novice, who was tempted to leave the Order, which he planned to do, as soon as the door opened in the morning. Dominic counselled him and then prayed for him in the church. After that, the young friar decided to persevere as a Dominican. The next morning Dominic returned to S. Sisto and told the tale to the sisters.

Gianandrea has pointed out that the narthex by the sixteenth century had become an enclosed space, not open to the public.[184] Ugonio confirmed this in 1588, when he wrote that, although it would have been normal in a basilica like S. Sabina to have the principal entrance opposite the apse,

183 Cecilia, *Miracula Beati Dominici*, 6, pp. 315–16. She calls the door in question 'portam ecclesiae' (the door of the church), rather than of the convent.

184 Gianandrea, 'Archeologia del monumento', p. 40.

in his day the only door in use was that on the side ('per traverso').[185] The woodcut, published at about the same date, by Gieronimo Francino (Fig. 61), shows the side portico with its colonnade in front of the side door to the basilica.[186] Above the portico, there are five round-arched windows. They are not those in the façade of the church, but those of the nave above the side porch. The Dominicans could enter the priory through the arched door to the south-west of the side portico, but the public could not, without permission. The friars could then walk across the enclosed narthex to the stairs leading to the cloister, but the public could only enter the church through the side door in the south-eastern aisle. Therefore, the side portico is shown in the woodcut as the main entrance to the basilica.

Pope Pius V (1566–1572) renewed the roof of the church. This Dominican Pope often stayed at S. Sabina, where he extended the convent buildings and, after a fire, renewed the library.[187] In 1586, Pope Sixtus V (1585–1590) made significant changes to the church interior, when he revived the practice of 'Station Liturgies'. S. Sabina was traditionally the venue for the first Station, on Ash Wednesday. The people first assembled at the basilica of S. Anastasia at the foot of the Palatine Hill and then walked in procession with the pontiff and his entourage to S. Sabina. In order to revive this practice, Sixtus V had the road that mounted the Aventine Hill partly levelled, and he remodelled the liturgical arrangements in the interior of the church.[188] The Pope had his architect, Domenico Fontana, redesign the sanctuary for the liturgy of his day. He demolished the intermediary wall (the 'tramezzo'); he removed the medieval high altar in the centre of the outer church, and he built a new high altar in the apse. He translated the relics of Saints Sabina, Serafia, Alexander, Theodulus, and Eventius to a 'confessio' below the new high altar. In that location, he also built a small crypt chapel dedicated to Saint Dominic.[189] He removed what remained of the ninth-century chancel screens and dismantled the medieval pulpits and lecterns, which stood along the side walls of the choir.[190] Sixtus V closed almost all the clerestory windows in the church, leaving only three open on each side. At the same time, he blocked up the windows in the apse. In the façade he substituted three circular windows for the original five round-arched ones. He restored the roof and repaired the floor of the basilica.[191] All this was commemorated in an inscription.[192]

Between 1589 and 1601, a choir loft was built against the inner façade of the church. Two columns in the nave, which supported it, and other changes to the church at the time are shown on a plan by Francesco Borromini or his workshop drawn c. 1640 and now in Vienna (Fig. 65).[193] The choir loft would have been similar to the one built in the same place in the church of S. Silvestro in Capite in the late sixteenth century (see Figs 150 and 158 in chapter 7 of this volume).[194] Borromini's plan depicts the layout of Sixtus V's liturgical arrangements. It also indicates the side door on the south-east and in the north-west aisle fourteen steps next to the bell tower leading up to the choir loft.

Projecting from the south-eastern aisle was a rectangular chapel, dedicated to the Holy Angels.

185 Ugonio, *Historia delle Stationi*, p. 8ʳ.
186 *Le cose maravigliose*, p. 66ᵛ.
187 Darsy, *Santa Sabina*, pp. 37–38.
188 Several aspects of this work at S. Sabina are listed by Sistus V's architect, Domenico Fontana, in a manuscript, ASV, *Libro di tutta la Spesa*.
189 Ugonio, *Historia delle Stationi*, 10ᵛ–11ʳ.
190 ASV, *Libro di tutta la Spesa*, fol. 13ʳ.
191 Ugonio, *Historia delle Stationi*, p. 11ʳ.
192 It is recorded in Ugonio, *Historia delle Stationi*, p. 11ᵛ. See also Forcella, *Iscrizioni*, vol. VII, no. 621, p. 306.
193 The drawing by Francesco Borromini or his workshop is in The Albertina Museum in Vienna, with the call number Vienna, Albertina, IT. AZ. Rom 250. The Choir loft is also mentioned in *Una Cronaca*, ed. by Rodocanachi, pp. 35 and 41.
194 See below, Chapter 7.

Next to it was a larger rectangular chapel, which was built by Cardinal Girolamo Bernerio, OP in 1599–1600, shortly after the canonization in 1594 of the great apostle of Poland, Saint Hyacinth Odrowatz, OP (1185–1257), who had been received into the Order of Preachers by Saint Dominic at S. Sabina.[195] Federico Zuccari decorated the chapel with frescoes showing Saint Dominic in 1220 clothing Hyacinth with the Dominican habit, in the presence of Ceslaus and Hermann. The female Roman artist, Lavinia Fontana, painted the altarpiece, which shows an apparition of the Virgin Mary to the new saint.[196] In 1643–1647, a new chapel dedicated to Saint Dominic replaced the Chapel of the Holy Angels,[197] but Muñoz subsequently demolished it. On the north-western side of the church there was a rectangular chapel, projecting from the left aisle, shown in Fig. 65, perhaps the chapel of Santa Lucia. In 1671, this was replaced by the larger domed chapel of Saint Catherine of Siena, with paintings by Giovanni Odazzi (1663–1731) of scenes from the saint's life.[198]

Traces of the early mosaics and also of the paintings done in the pontificate of Eugenius II were found above the colonnades of the nave and in the upper corners of the inner façade in 1625 and again in 1683, when the titular cardinal, Thomas Howard of Norfolk, had the façade mosaic repaired.[199] The Dominican pope, Benedict XIII (1724–1730), who had been received into the Order of Preachers at S. Sabina, contributed 1000 of a total 2000 scudi, to pay for a thorough restoration of the church in 1729.[200] This involved extensive repairs to the roof of the church, the chapels, the choir, the aisle walls, and parts of the convent. At that time, the apsidal arch and the wall above it were strengthened; the façade wall above the mosaic inscription was renewed; the three round windows then in the façade were replaced with one large oculus (Fig. 56); and the *opus sectile* designs above the colonnades were restored.

Further repairs were made in the years 1829–1830, before the S. Sabina buildings were taken over by the Government of Italy in 1874. In the twentieth century, Muñoz carried out his restorations in 1914–1919, in 1932–1933, and in 1935–1937.[201] The apsidal arch was strengthened again in 1955, and in 1959 traces of painted decoration were found during the laying of electric wires in the aisles.[202] The latest restoration campaign was in the narthex, which was renovated in 2010.[203]

Residential Buildings

Darsy believed that the convent buildings had been part of Alberic's fortress in the tenth century, but there is no evidence of this.[204] Pope Honorius III's Bull of 1222 divided the dwelling places at S. Sabina between the clergy administering the parish and the Friars Preachers: a house near the baptistery ('domo ubi est baptisterium') with a garden nearby ('horto proximo') and a hermitage ('reclusorio') were reserved for the two priests of the parish; and other large houses ('domos') for the Dominicans. It is difficult to locate the baptistery, house, and garden reserved for the two priests who were in charge of the parish in 1222. The baptistery was as old as the basilica, constructed by Peter of Illyria

195 Darsy, *Santa Sabina*, p. 123. His tomb is in the church of Saint Dominic in Cracow.
196 Darsy, *Santa Sabina*, p. 127 and fig. 136.
197 *Una Cronaca*, ed. by Rodocanachi, pp. 53–54.
198 Darsy, *Santa Sabina*, pp. 116–19.
199 Krautheimer, *Corpus*, vol. IV, p. 77; see also, *Una Cronaca*, ed. by Rodocanachi, p. 49, and Ciampini, *Vetera Monimenta*, vol. I, p. 188.
200 *Una Cronaca*, ed. by Rodocanachi, pp. 56–57.

201 Muñoz, *La basilica di Santa Sabina in Roma*; Muñoz, *Il restauro della basilica di Santa Sabina*; Bellanca, *La Basilica di Santa Sabina e gli Interventi di Antonio Muñoz*.
202 Darsy, *Santa Sabina*, pp. 48 and 104; Krautheimer, *Corpus*, vol. IV, p. 77.
203 Tempesta, ed., *L'icona murale di Santa Sabina*, esp. pp. 33–46.
204 Darsy, *Santa Sabina*, pp. 31–32.

in the pontificate of Pope Sixtus III. Like others of that time in Rome, it was probably a separate building, and, from Honorius III's Bull, one can presume it still existed in 1222, but it has since disappeared, and it is not known where it was situated. Various ideas have been put forward regarding its location, but there is no agreement. Berthier thought it stood beyond the narthex and near the campanile (Figs 38 and 41, E).[205] Trinci Cecchelli believed it was in the centre of the present Piazza Pietro d'Illiria (Fig. 38).[206] It could have been located north-west of the apse of the church, near the Archive (Fig. 38, B).[207] Le Pogam pointed out that Darsy claimed to have discovered bath buildings in his excavations in the garden south-west of the basilica (Fig. 38, D), which suggests that the baptistery may have been situated there.[208] (At Porec cathedral in Croatia the early Christian baptistery was located in front of the basilica in a similar place.[209]) Recently, Gianandrea has suggested that the baptistery stood at the junction of the southern end of the narthex and the portico in front of Cardinal Cesarini's side door on the south-eastern flank of the basilica.[210] She thought it might have been near the right-hand side of the basilica, with an earlier side door and a passageway connecting it to the church, as was the case with the early baptisteries that have been excavated in Rome at S. Clemente, S. Lorenzo in Lucina, S. Marcello, SS. Quattro Coronati, and S. Cecilia.[211] In the end, however, one has to admit that its site is still unknown.

The two diocesan priests were also assigned a 'reclusorium', or hermitage. A hermitage, called a 'romitorio' in Italian, is mentioned as part of the property belonging to S. Sabina in 1487; its location was given as 'sotto la vigna di S. Sabina' (below the vineyard of S. Sabina) on the steep slopes of the Aventine towards the Marmorata.[212] That is in the direction of the River Tiber on Nolli's *Map of Rome* (Fig. 35), which also shows on the south-west of the churches and convents on the Aventine a 'Vig(na) dei PP. di S. Sabina' (a vineyard of the Fathers of S. Sabina), with a few small buildings within it. Perhaps one of these was the hermitage. Again, the location is not clear.

The Medieval Priory Buildings

Honorius III officially provided the Dominicans with somewhere to live at S. Sabina. There is now a large priory, with a cloister, refectory, chapter room, and other rooms on the ground floor, and with cells opening on to central corridors in the floors above (Figs 41–46). When the friars arrived at S. Sabina, they moved into some existing domestic buildings, which they later transformed into an extensive complex around a medieval cloister (Fig. 38, C, S, P, Q, and R), to which were added two wings in 1935–1937 (Fig. 38, L and M). Le Pogam pointed out that the location of the claustral buildings at S. Sabina is very unusual, in that they are disposed around a quadrangle that is not next to the church, where it was traditional for monastic structures to stand.[213]

205 Berthier, *L'Église de Sainte Sabine*, p. 49.
206 Trinci Cecchelli, *Corpus VII*, p. 194.
207 Barclay Lloyd, 'Medieval Dominican Architecture at Santa Sabina', p. 287.
208 Le Pogam, *De la 'Cité de Dieu' au 'Palais de Pape'*. p. 285, n. 47.
209 Krautheimer, *Early Christian and Byzantine Architecture*, pp. 278–80 and fig. 24.2.
210 Gianandrea, 'Il nartece e il cortile dell'arancio', pp. 68–73.
211 See Cosentino, 'Il battesimo a Roma'; for the baptistery at S. Clemente, see Guidobaldi, 'Gli scavi del 1993–1995'; for S. Lorenzo in Lucina, Brandt, 'Sul battistero paleocristiano', and Brandt, 'The Excavations in the Baptistery'; for S. Marcello, Gigli, *San Marcello*,

pp. 165–67 and Episcopo, 'Il battistero della basilica di S. Marcello', pp. 235–306; for SS. Quattro Coronati, Barelli, *The Monumental Complex of Santi Quattro Coronati*, pp. 66–67; and for S. Cecilia, Parmegiani and Pronti, 'Il battistero di S. Cecilia', pp. 391–98.
212 *Una Cronaca*, ed. by Rodocanachi, p. 10.
213 Le Pogam, *De la 'Cité de Dieu' au 'Palais de Pape'*, p. 285.

Figure 66. S. Sabina, View of the convent walls with the plaster removed, and showing niches in Wing P (photo: author)

Those at S. Sabina are located beyond the basilica, to the west and south, and they are at a level more than 2 m above the floor of the basilica. (If an atrium stood in front of the early Christian church, the wing of the refectory and chapter room would have stood above and beside it on the north-west.)[214] It is also possible that the priory could not be located beside the church because there was something else there — such as the baptistery and its adjoining house, if Berthier was right, or some other edifice.[215]

214 Although Darsy thought there was an atrium in front of the early church, other writers, such as Krautheimer and Gianandrea, have doubted this, as is noted above.
215 Berthier, *L'Église de Sainte Sabine*, p. 49.

No clear archaeological evidence for such buildings has yet been revealed, however.

It is interesting to note that on Bufalini's *Map of Rome*, there are claustral buildings in the traditional place, to the left of the nave and narthex of the basilica, as well as those that still exist (Fig. 50). Indeed, Bufalini shows two cloisters, surrounded by further conventual buildings, perhaps indicating that that was where he imagined the priory should have been located. (Since there is no other evidence for this disposition, he may have imagined it.)

Many facets of the building history of the medieval structures at S. Sabina were revealed, and several blocked doors and windows were made visible, when plaster was removed from the

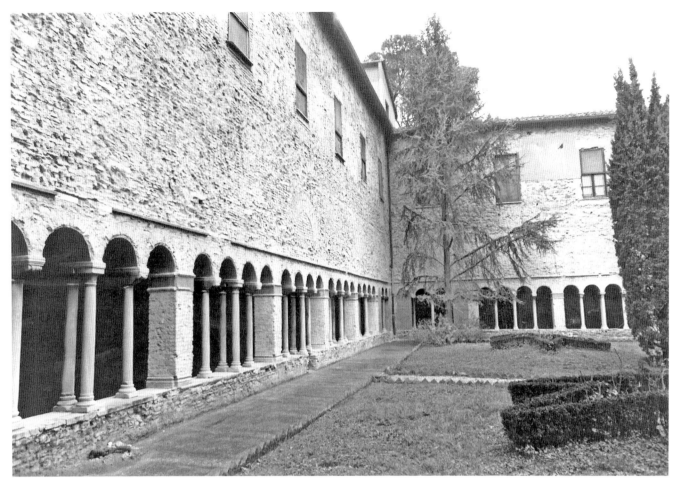

Figure 67. S. Sabina, the cloister between 1982 and 2002 (photo: author)

walls around the cloister in 1982 (Figs 66 and 67); the walls remained open to inspection until they were covered with plaster again in 2002.[216] From an analysis of the walls surrounding the cloister, one could identify what structures stood there when the Dominicans came to live at S. Sabina and how they extended the buildings later.[217]

The double-storeyed wing with the refectory and chapter room (wing R) was already standing, with a portico along its north-western side where the cloister colonnade now stands (Figs 42, and 68).[218] Originally, the chapter room and the refectory could both be entered from the portico. The main door into the chapter room is flanked by a double window on either side (Fig. 69). These windows, which resemble those in the chapter room at S. Sisto, still exist, and they are separated by twin colonnettes. There were two doorways leading from the portico into the refectory, and two windows on that side lit that room, but one door and one window were

216 An analysis of the medieval walls at S. Sabina and their masonry in detail is published in Barclay Lloyd, 'Medieval Dominican Architecture at Santa Sabina', pp. 288–92.

217 Barclay Lloyd, 'Medieval Dominican Architecture at Santa Sabina', pp. 268–78.

218 This is demonstrated by the type of masonry in the plinth and piers of the cloister colonnade in wing R.

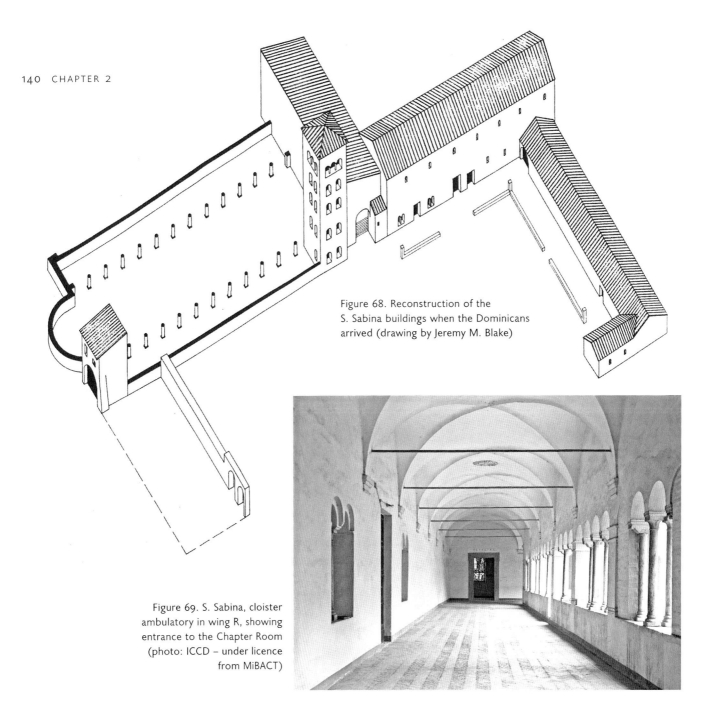

Figure 68. Reconstruction of the S. Sabina buildings when the Dominicans arrived (drawing by Jeremy M. Blake)

Figure 69. S. Sabina, cloister ambulatory in wing R, showing entrance to the Chapter Room (photo: ICCD – under licence from MiBACT)

blocked in the thirteenth or fourteenth century. The room is now entered from the south-west. The chapter room and refectory were remodelled in the late sixteenth century, when the cloister was renovated.[219] Beyond the refectory there is a vaulted room (Fig. 42, l), with a basin for the friars to wash their hands. This room is connected with the cloister ambulatory by a vestibule in the south-western wing (Fig. 42, v, in wing S). On its north-western side this vestibule now opens on a storeroom (Fig. 42, s).

The lowest part of wing S (Figs 41 and 46, and 68) was built in the twelfth century and it was already standing when the Dominicans came to S. Sabina. There was an arched entrance in the first bay from wing R and a doorway near the south-western end. A portico already existed along its north-eastern side. The rooms in wing S are now accessible only from the western end

219 *Una Cronaca*, ed. by Rodocanachi, p. 24.

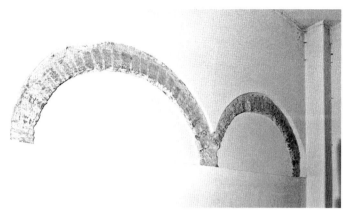

Figure 70. S. Sabina, Wing Q, remains of two blocked arches of the loggia (photo: author)

Figure 71. S. Sabina, loggia in Wing Q, reconstruction (drawing: Jeremy M. Blake)

of the cloister ambulatory. In the first half of the thirteenth century, this block was raised one storey. Six round-arched windows opened at the south-western end of wing S. Along the exterior of its south-western wall there are huge arches, which were probably built later, to serve as buttressing to the floor above.

At the south-western end of wing Q (Figs 42 and 68) there was a short, low block, which was in existence when the Dominicans came to S. Sabina. This was raised, perhaps in the first half of the thirteenth century. The Dominicans extended wing Q (Fig. 42), probably in the first half of the thirteenth century, when they also built the cellar and ground floor of wing P (Figs 41, 45, and 46). Four rooms in wing Q are accessible from the cloister. Three medieval columns have been found embedded in the cloister wall in wing Q beyond the early part of the building. They are 1.83 m high and 0.23 m diameter, and they carry simple cushion capitals. They are not aligned but must have stood in two rows. Blocked arches made of *opus saracinescum* have also been uncovered (Fig. 70), which stood above the twin columns, which alternated with piers, in an arcade of at least ten bays (Fig. 71).[220] This arcade formed an airy loggia, looking out over the River Tiber and the city of Rome. Written sources refer to such a loggia. For example, in 1568, it is recorded,

'Il generale Giustiniani fa lastricare la loggia verso il Tevere' (Master General Giustiniani had the loggia towards the Tiber paved).[221] It is possible that this loggia was also called the 'Belvedere', since it opened on a magnificent view of the River Tiber. There is, for example, a reference to the 'romitorio sotto Belvedere' (the hermitage below the Belvedere) in 1487.[222]

All of wing P (Figs 41–46) was built after the Dominicans came to S. Sabina. The lower part of this wing was constructed in the first half of the thirteenth century, as can be seen from the *opus saracinescum*, found in the cellar and also visible from garden E, along the north-eastern exterior wall of the building. This is below later sixteenth-century masonry that testifies to the construction of the upper floors at that time.

220 Gianandrea, 'Archeologia del monunento', esp. pp. 28–30, gives recent additional discoveries in this wall.

221 *Una Cronaca*, ed. by Rodocanachi, p. 27.

222 *Una Cronaca*, ed. by Rodocanachi, p. 10. There were, however, other loggias constructed in the sixteenth century at S. Sabina.

After wing Q was extended and wing P was built, the Dominicans completed a rectangular cloister, which was in existence by the late thirteenth century. The piers and colonnettes of the cloister are grouped in a regular sequence of a pier, a single colonnette, a pair of twin colonnettes, and a single colonnette (Figs 42, 46, and 67), repeated six times along the north-western and south-eastern sides, and seven times along the other two sides. Occasionally the spaces between the piers and colonnettes have been filled by later brickwork reinforcements. In the middle of the ambulatory in wing P, the normal sequence of piers and colonnettes is interrupted by an entrance to the cloister garth flanked by twin colonnettes on either side. There are two other entrances, the width of one intercolumniation in the south-eastern and in the south-western sides of the cloister. The single colonnettes support 'impost blocks' and the twin colonnettes sustain medieval leaf capitals (Fig. 67). The combined height of bases, colonnettes, and capitals (or impost blocks) is 1.56 m. Gianandrea has identified some stylistic variations in the carving of the impost blocks and capitals.[223] Some of the impost blocks are decorated only with incised lines on their leaves, but others are more rounded, and have a sphere below the outer edge of the leaves. There are three different types of capitals. Some are decorated with four separate flat leaves, which are carved with almost no ornament, while others have incised outlines, and a third variant has an elongated shape with sharply pointed leaves.

In the wall along the cloister ambulatory in wing P, there were eleven arched niches, about 34 cm wide and 42 cm high (Fig. 66). The niches had a marble shelf and a tiled back. They may have been constructed to contain lamps to light that part of the cloister during nocturnal processions. From its masonry, this wall, with its niches, appears to date from the first half of the thirteenth century, probably shortly after the Dominicans arrived at S. Sabina.

The cloister ambulatories are now vaulted, the vaults springing from the piers in the colonnades and from corbels on the ambulatory walls (Figs 42, 46, and 69). Some of the vaults covering the cloister ambulatory in wing R bear the coat of arms of Bandinello Sauli who was titular cardinal of S. Sabina from 1511 to 1516.[224] To his patronage were also ascribed some paintings in the cloister illustrating the life and miracles of Saint Dominic, which have not survived.[225] The wall on the first floor above the cloister colonnettes is constructed of brickwork and the 'rubble' masonry that is typical of fifteenth-century and early sixteenth-century construction in Rome. This shows that vaulting the cloister ambulatories was done at that time in order to expand the space of the convent by building cells above the ambulatories. When the plaster was removed from the walls of the cloister in 1982–2002, beam-holes were uncovered directly above some of the colonnettes and along the ambulatory walls of the cloister. Moreover, an investigation under the floor of one of the rooms overlooking the cloister in wing R revealed a medieval beam above the sixteenth-century vaulting. Below the beam there were traces of fresco decoration, which would once have covered the ambulatory wall.[226] One may therefore conclude that, before the vaults were constructed, a lean-to roof originally covered the cloister walks, the walls of which were decorated with murals.[227]

223 Gianandrea, 'Un'apparente arcaicità', esp. pp. 76–78.

224 Darsy, *Santa Sabina*, pp. 37 and 139; Annibali, 'Il Rinascimento privato del convento di Santa Sabina', esp. pp. 43–44.

225 Annibali, 'Il Rinascimento privato del convento di Santa Sabina', p. 44.

226 Information obtained in the late 1980s.

227 Muñoz, *Il restauro della basilica di Santa Sabina*, pp. 42–43, believed the vaults were built in the fifteenth century. He also claimed to have 'liberated' the cloister from later additions and to have consolidated it.

One of the great patrons of S. Sabina in the sixteenth century was Fra Vincenzo Giustiniani, OP (1519–1582), who was Master General of the Order from 1558 to 1570 and then titular cardinal of S. Sabina from 1579 to 1582.[228] He completed the work of Cardinal Sauli in wing R, built a library, paved the loggia overlooking the Tiber, and built another loggia.[229]

The Dominican pope, Pius V (1566–1572), often stayed at S. Sabina. He enlarged the priory by building part of the upper floor of wing P (Figs 42, 43, and 45).[230] This floor was completed by Cardinal Girolamo Bernerio (1540–1611), who was prior of S. Sabina in 1585, and a cardinal benefactor thereafter.[231] He is also said to have organized the construction of the choir over the narthex; refurbished the old dormitory over the chapter room, the refectory, and its vestibule; and constructed new rooms and loggias over the cloister ambulatories, although work is known to have been done there also by other patrons. Sixteenth-century masonry in the additions to wing P is visible from garden E.

A glance at plans I, II and III and Section BB1 (Figs 41–43 and 45) shows that, where wing P adjoins the church and the medieval bell tower, G, a distinctive block, PW, which is wider than the rest of the wing, was built with a cellar and three floors, rather like a broad 'tower'. In the cellar in PW there are thick foundations of *opus saracinescum*, indicating a date in the thirteenth century. At cloister and first floor levels there are vaulted rooms, one above the other (Figs 72 and 73). The vaults are medieval. Over these vaulted rooms is a third floor, shown in an inset, on plan III and in Section BB' (Figs 43 and 45). The block, PW, is different from the rest of wing P. It seems to be a separate construction, which the Dominicans built not long after their arrival. The ground floor was where the sacristy was located until it was moved to the first floor in 1685.[232] This block was, then, important to both the church and the priory.

Poverty in buildings was an ideal of the Order of Preachers. Although in 1215 Peter of Seilhan of Toulouse gave Dominic the Order's first two houses, which were described as 'sublimes et nobiles' (high and noble), they were not the norm.[233] At Saint Dominic's insistence, the first General Chapter of the Order, held in Bologna in 1220, decreed:

> Mediocres domos et humiles habeant fratres nostri, ita quod ne ipsi expensis graventur, nec alii seculares vel religiosi in nostris sumptuosis edificiis scandalizentur.
>
> (Our brothers have houses that are moderate in size and humble, so that they are not burdened by expenses, and nor are other people, whether secular or religious, scandalized by our sumptuous buildings.)[234]

Later, from *c.* 1228 to 1263, the Dominican General Chapters retained this early injunction and even stipulated a maximum height of 12 feet (3.55 m) for single-storey and 20 feet (5.9 m) for double-storey

228 Annibali, 'Il Rinascimento privato del convento di Santa Sabina', pp. 47–48.

229 Annibali, 'Il Rinascimento privato del convento di Santa Sabina', p. 47.

230 In the pontificate of Pius V, it is recorded that work was done in the cloister in 1566, and 'le camere del dormitorio sopra l'ala del chiostro' (the rooms of the dormitory above the wing of the cloister) were built in 1567, see *Una Cronaca*, ed. by Rodocanachi, p. 26; Bartoni, 'Dalle "delitie" del cardinal Bernerio', pp. 55–62; see also, Le Pogam, *De la 'Cité de Dieu' au 'Palais de Pape'*, p. 294.

231 Bartoni, 'Dalle "delitie" del cardinal Bernerio', p. 56, quoting from the eighteenth-century Anonymous, *Notizie*, MS 3209, fol. 275ᵛ.

232 Annibali, 'Il Rinascimento privato del convento di Santa Sabina', p. 51.

233 Jordan of Saxony, *Libellus*, 44, pp. 46–47; Bedouelle, *Saint Dominic*, p. 75.

234 Meersseman, 'L'Architecture dominicaine', pp. 136–90; Sundt, '*Mediocres domos*', pp. 394–407; Cannon, *Dominican Patronage*, pp. 74–108.

Figure 72. S. Sabina, room in wing PW, on the ground floor of the priory (photo: ICCD – under licence from MiBACT)

priory buildings, along with 30 feet (8.88 m) for churches.[235] Moreover, stone vaults were proscribed, except above the choir and in the sacristy.[236] Anyone who disobeyed these rules would receive a moderately heavy penalty.[237]

From c. 1235 to 1241, in each convent three friars from among those with greater discretion were to be elected as a kind of building committee, and no edifice was to be constructed without their advice.[238] Between 1263 and 1300, no curiosities or notable superfluities in sculpture, painting, pavements, and so on, were allowed, since they contravened the principle of poverty of the Order.[239] After 1300, the clauses regarding specific heights and vaults were deleted from this legislation.[240]

235 Meersseman, 'L'Architecture dominicaine', p. 147, with dimensions in metres of 4.20–4.56 m for the height of the ground floor, 7–7.20 m for the two storeys, and 10.50–11.40 m for the height of the church, based on a variety of measures for one foot (instead of a Roman foot equal to 29.56 cm used here); see also, Sundt, 'Mediocres domos', p. 405, who dates this legislation as early as 1228.
236 Meersseman, 'L'Architecture dominicaine', pp. 147–48; Sundt, 'Mediocres domos', p. 405.
237 Meersseman, 'L'Architecture dominicaine', p. 148; Sundt, 'Mediocres domos', p. 405.

238 Meersseman, 'L'Architecture dominicaine', pp. 148–49; Sundt, 'Mediocres domos', p. 405.
239 Meersseman, 'L'Architecture dominicaine', p. 176; Sundt, 'Mediocres domos', p. 405.
240 Meersseman, 'L'Architecture dominicaine', p. 176; Sundt,

Figure 73. S. Sabina, room in wing PW, on first floor of priory (photo: ICCD – under licence from MiBACT)

At S. Sabina, the height of the church was determined in the fifth century, long before the Dominicans took over the building. On the ground level in all the wings of the priory, the height is approximately 5–6 m, which is above that stipulated. The present height, however, is higher than it was in the Middle Ages, because in the sixteenth and seventeenth centuries, the ceilings of the priory rooms were raised. In the tower-like structure, built by the Dominicans, and designated 'PW' on Plans I, II, and III and Section BB' (Figs 41–43, 45, 71, and 72), there is vaulting, which was justified, since the ground floor of this building functioned as a sacristy in the Middle Ages, until the sacristy was transferred upstairs in the seventeenth century. Such vaulting therefore accords with Dominican building legislation.

One part of the medieval complex, which has the prescribed height, is the so-called cell of Saint Dominic, where in 1645–1647, the Dominicans set apart three rooms to the north-west of the room above the narthex, as seen in SD1, SD2 and SD3 in an inset in Plan III (Fig. 43, inset SD).[241]

'Mediocres domos', p. 405.

241 *Una Cronaca*, ed. by Rodocanachi, pp. 54–55. The cell's location was agreed upon in the seventeenth century. Yet it must be noted that there was a tradition in the

The floor level of SD1, SD2 and SD3 is 1.79 m below that in the room over the narthex, and 3.04 m below the present height of wing R. Berthier suggested that, when the chapter room, refectory, and refectory vestibule were raised in height and vaulted in the seventeenth-century, rooms SD1, SD2 and SD3 remained at the original level of the dormitory.[242] Muñoz noted that the medieval roof beams remained in place and he found the original door and its architrave.[243] Yet the position of the three rooms is also extraneous to the main part of wing R. It is possible that they stood on the level of the medieval dormitory, or on a slightly lower level, on the landing of the original stairs going from the dormitory in wing R to the cloister and the church.

In 1645–1646, a new monumental stone staircase was constructed to give access to Saint Dominic's cell.[244] In SD1, there is now a seventeenth-century window, and the remains of a medieval blocked opening. SD2 and SD3 were decorated with marble revetment and Baroque frescoes in 1645,[245] but SD1, which contains an altar, has been left with plain grey walls and a wooden ceiling. It is conceivable that Dominic would have chosen just such a place for his cell, since it was his custom to spend long vigils praying in the church. From a location at the north-eastern end of the dormitory, he could go to the church or return, without disturbing the brethren. (Already in the twelfth century, the Cistercians sometimes had a cell close to the stairs leading to the church: usually the abbot, or sometimes the sacristan, occupied this cell.[246])

It is possible that a room like this was part of the S. Sabina buildings when the Dominicans arrived. Although the present 'cell of Saint Dominic' was laid out long after the founder had died, it is conceivable that he spent some time there.

Later, after the canonization of Pius V in 1712, another chapel was built in his honour high up in wing P. Tommaso Maria Ferrari, OP (1647–1716), Cardinal of San Clemente at the time, dedicated it to Saint Pius V (Fig. 43).[247] The Bolognese painter, Domenico Maria Muratori (1661–1742) decorated it with stucco and paintings. One scene shows the Pope gazing at a Crucifix, while the other depicts him receiving an intuition about the victory at Lepanto in 1571. Sebastiano Roberto points out that, shortly after the canonization of Rose of Lima, the first saint from America, in 1671, a statue of her was installed in the narthex of S. Sabina (Fig. 52), and a 'pilgrim path' was constructed, with the grand staircase leading from her statue on the ground floor, to Saint Dominic's cell on the first level, and, at a later date, to the chapel of Saint Pius V higher up.

There were other saints who were associated with S. Sabina. Thomas Aquinas taught philosophy there.[248] He is said to have been inspired to begin his *Summa Theologiae* at S. Sabina. A plaque, set up on 1 March 1726 in the portico between the side door into the church and the door that led to the priory, recalls some of the saints associated with this foundation (Fig. 62): Dominic, Raymond of Peñafort, Thomas Aquinas, Hyacinth, Ceslaus, and Pope Pius V. The plaque also mentions that Pope Clement IX used to make his annual retreat at S. Sabina, and Pope Benedict XIII made his solemn profession as a Dominican friar there on the 13 February 1669.

Dominican Order that Saint Dominic never had a cell of his own, as he spent his nights in the church, Bedouelle, *Saint Dominic*, p. 99.

242 Berthier, *L'Église de Sainte-Sabine*, p. 484.
243 Muñoz, *Il restauro della basilica di Santa Sabina*, p. 6.
244 *Una Cronaca*, ed. by Rodocanachi, pp. 54–55.
245 Darsy, *Santa Sabina*, pp. 40–41; see also Roberto and Bartoni, 'La Cappella di San Domenico'.
246 The room that later became the 'Prison' at the Cistercian Abbey of SS. Vincenzo e Anastasio at Tre Fontane near Rome may originally have been such a cell, see Barclay Lloyd, *SS. Vincenzo e Anastasio*, pp. 156–57.
247 See Guerrieri Borsoi, 'La Cappella di San Pio V'.
248 Mulchahey, 'First the Bow is Bent in Study…', p. 293.

The Savelli Palace and the Dominicans

Darsy believed that the narthex, the bell tower, and the early conventual buildings at S. Sabina were part of a large medieval fortress built by the Crescenzi family on the Aventine, but this theory is no longer accepted.[249] From the sixteenth century onwards, various sources claimed that Pope Honorius III's donation of S. Sabina to the Dominicans included a palace that his family, the Savelli, owned on the Aventine. In one account, the anonymous author states:

> Honorio III. Di Casa Savelli, che haveva il Palazzo unito a questa Chiesa (scilicet S. Sabina) diede una parte di esso à San Domenico per fabricarvi il Convento
>
> (Honorius III. Of the house of Savelli, who had a palace joined to this church [that is, of S. Sabina] gave a part of it to Saint Dominic to build the convent there).[250]

The same facts were reported in another Chronicle, in *Le cose maravigliose dell'alma città di Roma* in 1588, in Ugonio's *Historia delle Stationi di Roma*, of the same year, and in Ottavio Panciroli's *Tesori nascosti dell'alma città di Roma* in 1625.[251]

In spite of these repeated assertions, this tradition has been shown to be false. To begin with, there is no evidence that Honorius III was a member of the Savelli family. Hélène Tillman pointed out that, before he was raised to the papacy, Honorius III identified himself merely as a canon of S. Maria Maggiore, whose father was called Aimeric.[252] Before he became Pope, Honorius III's name was Cencius, and he acted as papal chamberlain (camerarius) under Pope Clement III (1187–1191); hence he became known as 'Cencius Camerarius' and he is famous for being the author of the *Liber Censuum*, written in the late twelfth century.[253] In 1553–1557, Onofrio Panvinio seems to have been the first to connect him with the Savelli family.[254] Panvinio probably conflated information about Honorius III (1216–1227) with data about Honorius IV (1285–1287), who was a genuine Savelli.

The Aventine was a place where several famous early medieval palaces were located.[255] The 'Palace of Euphimianus', associated with Saint Alessio, stood close to the monastery of SS. Bonifacio e Alessio.[256] At S. Sabina, an inscription reused in the tomb of Antonio Ferracuti (who died in 1497), mentioned the 'domus' (mansion) of Theodora, who was the wife of Theophylact (who died in 927) and the grandmother of Alberic, who ruled Rome from 932 to 954.[257] The inscription is thought to have come from the architrave of a doorway in her palace on the Aventine, which was where the monastery of S. Maria in Aventino was later founded, close to S. Maria del Priorato, where the Knights of Malta are now located. Darsy assumed, without any supporting evidence, that it was found at S. Sabina.[258] Another palace

249 For his theory, see Darsy, *Santa Sabina*, pp. 31–34, 139.
250 Anonymous, *Notizie*, Biblioteca Casanatense, MS 3209, fol. 348ʳ. This chronicle starts in the fifteenth century with material which may have been copied from a fifteenth-century source, and it goes on till the late seventeenth century; it was completed in 1700–1721.
251 *Una Cronaca*, ed. by Rodocanachi, p. 1; *Le cose maravigliose*, 1588, p. 66ᵛ; Ugonio, *Historia delle Stationi*, p. 12ʳ; and Panciroli, *Tesori nascosti*, p. 640.
252 Tillman, 'Ricerche', esp. pp. 391–92; see also, *Liber Censuum*, ed. by Fabre, Duchesne, and Mollat, p. 1.
253 Tillman, 'Ricerche', esp. pp. 391–92; Carocci, *Baroni di Roma*, pp. 415–16; Thumser, 'Die ältesten Statuten', esp. p. 307; Barclay Lloyd, 'Medieval Dominican Architecture at Santa Sabina', p. 245.
254 Panvinio, *Epitome pontificum Romanorum*, pp. 146 and 151; Tillman, 'Ricerche', p. 392.
255 Krautheimer, *Rome*, p. 255.
256 Duschesne, 'Notes sur la topographie de Rome'; Hamilton, *Monastic Reform, Catharism and the Crusades*, II, 35–68 ('The Monastic Revival in Tenth Century Rome') and III, pp. 266–310 ('The Monastery of S. Alessio and the Religious and Intellectual Renaissance in Tenth Century Rome'); and Krautheimer, *Rome*, p. 255.
257 Le Pogam, 'Otton III sur le Palatin ou sur l'Aventin?', pp. 596–601.
258 Darsy, *Santa Sabina*, pp. 31–32; Le Pogam, 'Otton III sur le Palatin ou sur l'Aventin?', p. 601.

on the Aventine was that of Emperor Otto III (980–1002), who came to Rome twice in the late tenth century.[259] He is reported to have lived 'in antiquo palacio, quod est in monte Aventino' (in an ancient palace which is on the Aventine Hill). Carlrichard Brühl commented that the Emperor would surely have stayed in the imperial palace on the Palatine instead,[260] but Le Pogam has argued convincingly that this assumption was incorrect, and he has given cogent reasons why it is more likely that Otto III did in fact reside on the Aventine.[261]

Jacopo Savelli, who was elected Pope Honorius IV in 1285, did construct a palace next to S. Sabina. A contemporary Dominican, Ptolemy of Lucca (1236–1327), who would have been well informed about such building activities, records that

> Hic Honorius, statim creatus (scil. papa) ad Urbem se transfert, et in monte Aventino juxta Sanctam Sabinam magna fabricat palatia, et ibidem sedem Pontificalem constituit, totusque ille mons renovatur in aedificiis
>
> (Honorius, immediately after he was made [Pope], moved to Rome and on the Aventine Hill, he built a large palace next to S. Sabina, where he established his pontifical residence and he renewed all of that hill with buildings).[262]

Martinus Polonus also referred to this papal palace.[263]

Jacopo Savelli had been Cardinal of S. Maria in Cosmedin from 1261 to 1285.[264] When he became Pope, taking the name Honorius IV, he signed many papal documents in his palace on the Aventine, where he died in April 1287.[265] He owned property on the Aventine, which is mentioned in two wills.[266] His first will, drawn up in 1279, refers to Savelli possessions along the River Tiber at the Marmorata, and on the Aventine Hill:

> omnes domos, turres seu ruinas turrium quas habemus ab ecclesia S. Mariae de Grandellis [sic] supra versus Marmoratam et in Marmorata et munitionem montis qui supra Marmoratam [est], sive patrimoniales sive fuerint per nos acquisite
>
> (all the houses, towers, or ruins of towers, which we have from the church of S. Maria ad Grandellis [sic] above [and] towards the Marmorata and in the Marmorata, and the fortifications of the hill, which is above the Marmorata, [that is, the Aventine] whether they were inherited or acquired by us).[267]

It also mentions other houses and towers or ruins of towers from the same church of S. Maria further on towards the Ripa, in the whole of the Ripa region, and the fortress of Mons Fabiorum, or Monte Sasso (the Theatre of Marcellus).[268]

259 Le Pogam, 'Cantieri e residenza dei papi'; Le Pogam, 'Otton III sur le Palatin ou sur l'Aventin?'; Le Pogam, *De la 'Cité de Dieu' au 'Palais de Pape'*, 284–85.

260 Brühl, 'Die Kaiserpfalz'.

261 Le Pogam, 'Otton III sur le Palatin ou sur l'Aventin?', pp. 602–09.

262 Tolomeo da Lucca, *Historia Ecclesiastica* Lib. XXIV, cap. 13, c. 1191. See also, *Die Annalen des Tholomeus von Lucca, 1284 (1285)*, ed. by Schmeidler, p. 204; and Le Pogam, *De la 'Cité de Dieu' au 'Palais de Pape'*, p. 287.

263 'Hic in monte Aventino iuxta beate Sabine papale palatium, muros et portas in circuitu platea fecit suo tempore' (In his time, he [Pope Honorius IV] built a papal palace next to S. Sabina, with walls and gates around a square), *Martini Chronicon Pontificum*, ed. by Wieland, p. 482. See also Le Pogam, *De la 'Cité de Dieu' au 'Palais de Pape'*, p. 287.

264 Patroni, *Serie cronologica dei cardinali*, p. 19.

265 There are 286 documents, of which six are disputed, recorded in the index of *Les Régistres d'Honorius IV*.

266 Printed in *Les Régistres d'Honorius IV*, ed. by Prou, cols 576–82 (will of Jacobus Savelli, Rome, 24 February 1279) and cols 588–94 (second will of Jacobus Savelli, 5 July 1285). Eubel, *Hierarchia*, vol. I, no. VII, pp. 6, 8, 10, 11; XV, p. 51; and Ciacconius, *Vitae et Res Gestae*, vol. II, cols 245–54.

267 *Les Régistres d'Honorius IV*, ed. by Prou, col. 580.

268 *Les Régistres d'Honorius IV*, ed. by Prou, col. 580. 'Mons

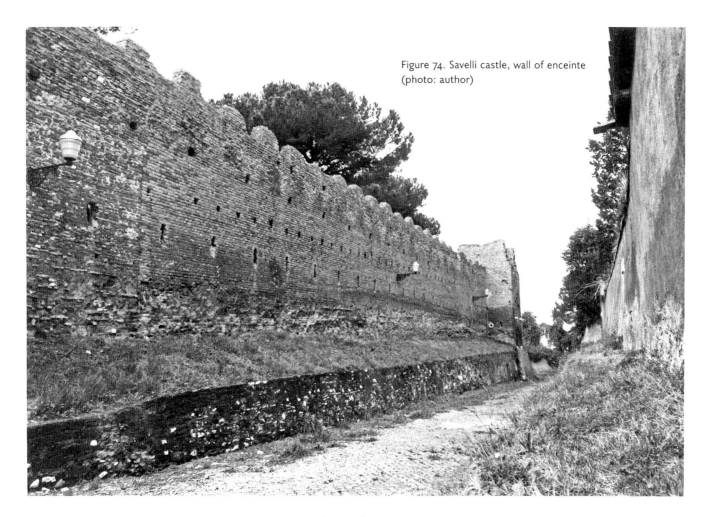

Figure 74. Savelli castle, wall of enceinte (photo: author)

When Jacopo Savelli was elected Pope in 1285, he made a second will, in which he listed, among other property, his possessions in Rome, including Monte Sasso (the Theatre of Marcellus) and buildings on the hill located above the Marmorata (the Aventine), as well as houses, towers, and other buildings located in the city.[269]

On the Aventine, some medieval walls, built of *opus saracinescum*, and ruins of towers still surround the orange-tree public park north-east of S. Sabina (Fig. 38, F); these remains clearly formed part of the perimeter wall of his property on the Aventine mentioned in the two wills (Fig. 74).[270] After Honorius IV died in his palace in April 1287, the Conclave that followed was held there, during which the cardinals eventually elected Pope Nicholas IV (1288–1292).[271]

Honorius IV did not share his palace with the Dominicans; nor did he leave it to them. He bequeathed all his property to his nephews, Leone and Giovanni — who was Cardinal Giovanni Boccamazza, who assisted the nuns of S. Sisto because he was also related to Sister Angelica Boccamazza.[272] When the Cardinal died in 1309, he left his property to his relatives and to the Dominicans at S. Sisto and at S. Maria

Fabiorum', and 'Monte Sasso' are medieval names for the fortified Theatre of Marcellus.

269 *Les Régistres d'Honorius IV*, ed. by Prou, col. 588.

270 Marchetti Longhi, *L'Aventino*, p. 27.

271 *LP*, vol. II, p. 466.

272 See above, Chapter 1.

sopra Minerva, where he chose to be buried. At that point there may have been a connection between the Dominicans at S. Sabina and the Savelli buildings on the Aventine, but none is mentioned in the historical records.

Honorius III was not a member of the Savelli family and he did not have a palace on the Aventine. Pope Honorius IV Savelli built a palace there long after the Dominicans had moved to S. Sabina. Le Pogam suggests a date of construction between 1280 and 1287, which is plausible.[273] When he became Pope, Honorius IV made his palace on the Aventine his normal residence, where he was a close neighbour of the Dominicans, but they did not stay at nor own his palace.

That would have been unthinkable, especially when Dominic and his friars arrived at S. Sabina *c.* 1220–1221. Early Dominican sources attest that Dominic valued and lived a life of strict poverty.[274] Several witnesses at the process for his canonization, held in 1233, stressed Dominic's attitudes towards poverty in all things, including buildings. A story was told of how Dominic, in tears, confronted the friars at Bologna, who were building a spacious new dormitory, and asked whether they wanted to relinquish poverty to such an extent that they would build 'a large palace' (*magna palatia*).[275] It seems highly unlikely that Dominic would have requested or accepted a papal palace on the Aventine as a Dominican friary.

The palace next to S. Sabina did in the course of time become a source of income for the Friars Preachers. It is recorded that in 1483 Pope Sixtus IV ceded to Cardinal d'Auxia, titular of S. Sabina, the palace and garden adjoining the church, for which he was to pay four barrels of wine annually to the Friars Preachers in rent.[276] After that, the Dominicans seem to have let the palace to various rich individuals.

Where was it located? The discovery in 1483 of a treasure trove gives some indication.

> In palatio horti iste cardinalis (d'Auxia) invenit in pariete proximo tribunae maiori [...] magnam summam auri et pecuniarum in argento et auro.
>
> (In the palace of the garden the same Cardinal [d'Auxia] found in the wall next to the main apse [...] a large amount of gold and of gold and silver coins.)[277]

This 'treasure' is similar to the hordes of coins found by archaeologists in 2007 in various places on the Aventine and may show that the sack of Rome in 410 directly affected the site of S. Sabina.[278] The description also shows that the palace was situated at the north-eastern end of the basilica, near a garden beside the apse of the church (Figs 36 and 38, F), adjacent to the 'orange-tree' public park, which is still encircled by the medieval walls, with the gates and towers, of the Savelli fortress (Fig. 74).[279] These walls are constructed of *opus saracinescum*, a type of masonry used in Rome in the thirteenth and fourteenth centuries. The surviving walls give the impression of a fortified enceinte. Other parts of the Savelli palace were incorporated in the present library/archive building (Fig. 38, B). It was close to the north-eastern end of the church, where a window opened to give a view of the basilica's interior. It is clear that originally

273 Le Pogam, *De la 'Cité de Dieu' au 'Palais de Pape'*, p. 288.
274 *Acta Canonizationis S. Dominici*, ed. by Walz, Scheeben, and Laurent, pp. 89–187; Anonymous, *Saint Dominique*, pp. 83–84, 96; Jarrett, *Life of Saint Dominic*, p. 104.
275 *Acta Canonizationis S. Dominici*, ed. by Walz, Scheeben, and Laurent, 38, p. 157.
276 *Una Cronaca*, ed. by Rodocanachi, p. 7; *Memorie*, AGOP, XIII, fol. 1ʳ. For this and the following references to renting out the palace until 1548, see also Le Pogam, *De la 'Cité de Dieu' au 'Palais de Pape'*, p. 289.
277 *Una Cronaca*, ed. by Rodocanachi, p. 7; *Memorie* AGOP, XIII, fol. 1ʳ.
278 Quaranta, Pardi, Ciarrocchi, and Capodiferro, 'Il "giorno dopo" all'Aventino'.
279 See especially, Le Pogam, *De la 'Cité de Dieu' au 'Palais de Pape'*, pp. 298–311.

the Savelli palace was in no way connected with the medieval claustral buildings, which stand beyond the south-western end of the church.

In 1588, Ugonio said that the palace was not in good repair.[280] Parts of it were demolished in 1613 and in 1627, but it seems to have been restored by Cardinal Ginnasi, to whom it was sold and who lived there until 1637.[281] His heir, Alessandro Ginnasi, invited the Academy of the Arcadians to meet there; and the architect Gianbattista Contini built them an amphitheatre, which is clearly visible in Nolli's *Map of Rome* in 1748 (Fig. 35).[282] The separate buildings of the Dominican priory and the palace, as it existed in 1700, are moreover clearly illustrated in the plan drawn by Carlo Fontana in 1700 (Fig. 36).[283]

Le Pogam suggests convincingly that the rooms excavated beyond the library by Descemet and Darsy lay beneath and formed part of the Savelli palace, as did two cisterns, which seem to have been constructed in antiquity, but which continued to be used in the Middle Ages.[284] There were two very large rooms, which could have been audience halls in the palace. One wall of the Archive building (Fig. 38, B) includes sections of twelfth- and thirteenth-century masonry.[285] It was close to the north-eastern end of the basilica and to the medieval house, H, part of which was built in the twelfth century.[286] The house may have served as a porter's residence or gatehouse to the palace. These structures were separated from the Dominican priory by a garden (Figs 38, E and 42, E). The walls around the present public orange-tree park are all that survives of the Savelli fortress shown on Carlo Fontana's plan (Fig. 36).

When the Dominicans came to S. Sabina *c.* 1220–1221, they shared the property with two priests who ran the parish. The friars modified the interior of the fifth-century basilica to suit their needs and they extended the residential buildings entrusted to them. At an unknown date they took over the whole complex, which, except for the years 1874–*c.* 1930 remained their oldest priory in Rome. It is now the home of the Master General of the Order of Preachers and the headquarters of the worldwide 'Dominican Family'.

280 Ugonio, *Historia delle Stationi*, p. 13ᵛ; see also Le Pogam, *De la 'Cité de Dieu' au 'Palais de Pape'*, p. 291.
281 Le Pogam, *De la 'Cité de Dieu' au 'Palais de Pape'*, p. 291.
282 Le Pogam, *De la 'Cité de Dieu' au 'Palais de Pape'*, p. 292.
283 Manuela Ginandrea kindly pointed out this plan.
284 Le Pogam, *De la 'Cité de Dieu' au 'Palais de Pape'*, p. 315. For the excavations of Descemet and Darsy, see section above, 'Archaeological evidence'.
285 Barclay Lloyd, 'Medieval Dominican Architecture at Santa Sabina', pp. 278–79, 291–92.
286 Barclay Lloyd, 'Medieval Dominican Architecture at Santa Sabina', pp. 279 and 292.

CHAPTER 3

The Franciscan Church and Friary of S. Francesco a Ripa, founded in 1229

Francis of Assisi, who did not want his friars to own property, wrote in his Testament, 'Let the brothers be careful not to receive in any way churches or poor dwellings or anything else built for them unless they are according to the holy poverty we have promised in the rule'.[1] He himself rebuilt or restored some church buildings.[2] In *The Life of Saint Francis*, written in 1228–1229, Thomas of Celano described how, after his conversion, Francis set about repairing the church of S. Damiano on the outskirts of Assisi: 'The first work that blessed Francis undertook after he had gained his freedom from the hands of his carnally-minded father, was to build a house of God. He did not try to build a new one, but he repaired an old one, restored an ancient one'.[3] In 1245–1247, the same author recorded that it was there that the image of Christ, painted on the crucifix, spoke to him, saying 'Francis, go rebuild my house; as you see, it is all being destroyed', meaning not just the physical building, but the living universal Church.[4] Francis also restored the small churches of S. Pietro and S. Maria degli Angeli (the Portiuncula), which belonged to the Benedictines of Monte Subasio and which became one of the most important centres for the Friars Minor.[5] Later, the friars of his Order restored or rebuilt other churches that were given to them, including two in Rome — S. Francesco a Ripa and S. Maria in Aracoeli. As the Franciscan Order began to spread, local bishops ceded churches and hospice buildings to the friars: for example, in 1224, the bishop of Verona arranged for them to have the hospice of S. Croce degli Infermi; in Siena, they received the Hospital of the Maddalena and its church in the early 1220s; and in Bergamo, in 1233, they obtained the hospice of S. Maria.[6]

Francis visited Rome several times, but he did not establish any friaries there.[7] It was Pope Gregory IX (1227–1241), who as Cardinal Ugolino had been the Protector of the Franciscan Order, arranged for the Friars Minor to take over the 'Ospedale di S. Biagio' (the pilgrim hospice of S. Biagio) in Trastevere in 1229, which had belonged to the early medieval Benedictine monastery of SS. Cosma e Damiano 'in Mica Aurea'. The friars rebuilt the church, which they named 'S. Francesco a Ripa', and they erected their friary beside it. (From 1234 onwards, the same Pope also established the Franciscan nunnery

1 Francis of Assisi, 'The Testament', in *FAED*, vol. I: *The Saint*, p. 126.
2 See the commentary, referring to his restoration of San Damiano, S. Maria of the Angels (the Portiuncula), and the church of S. Pietro, all near Assisi in *FAED*, vol. I: *The Saint*, p. 175.
3 Thomas of Celano, *The Life of Saint Francis* (1228–1229) Book 1, Chapter 8, in *FAED*, vol. I: *The Saint*, pp. 196–97; see also, the *Legend of the three companions*, Chapter VII, in *FAED*, vol. II: *The Founder*, pp. 81–83.
4 Thomas of Celano, *The remembrance of the desire of the soul, or The second Life of Saint Francis* (1245–1247), Book 1, Chapter VI, in *FAED*, vol. II: *The Founder*, pp. 249–50.

5 Thomas of Celano, *The Life of Saint Francis* (1228–1229). book 1, Chapter 9, in *FAED*, vol. I: *The Saint*, p. 201, who says, 'The restoration of the church (the Portiuncula) took place in the third year of his conversion'.
6 These three early churches and houses are mentioned by Udina, 'Dallo xenodocchio benedettino al convento francescano', pp. 21–22.
7 See Oliger, 'S. Francesco a Roma'.

Figure 75. Mario Cartaro, *Map of Rome*, 1576, detail: Trastevere (Frutaz, *Le Piante di Roma*, vol. II, 1962, detail of Tav. 245)

of San Cosimato in the main buildings of the Benedictine abbey of SS. Cosma e Damiano.)[8]

Location

The first two Franciscan houses in Rome, the friary of S. Francesco a Ripa and the nunnery of San Cosimato, were located across the River Tiber, in Trastevere (Fig. 75). The Tiber separates this region from the rest of the city, and it has always had a distinctive character. Trastevere is south of the Vatican, which is on the same side of the river, and which, until the sixteenth century, was officially outside the city of Rome. In the Middle Ages, the inhabitants of Trastevere included many poor people, foreigners, artisans, fishermen, ceramic workers, policemen, and firemen. From ancient times, there was also a notable Jewish community and there was a synagogue located in the region, until it burned down in 1268.[9] In the twelfth century, Benjamin Tudela mentioned a Rabbi Yehiel as resident in Trastevere.[10] The early Christian community was served by three titular churches: the basilicas of S. Cecilia, S. Crisogono, and S. Maria in Trastevere. In the Middle Ages, Tiber Island and Trastevere were governed by the Cardinal Bishop of Porto, who was next in rank to the Cardinal Bishop of Ostia.[11]

Trastevere extends from the foot of the Janiculum Hill to the river.[12] The gardens of Julius Caesar were located in the southern part of this area. Augustus made Trastevere Region XIV of ancient Rome and he brought water there through the 'Aqua Alsietina' aqueduct.[13] This was to feed fountains and public baths; to drive water mills on the Janiculum;[14] and to enable the production of naval shows at the Naumachia of Augustus — a huge stadium equipped for staging mock sea battles. About one hundred years later, the Emperor Trajan (98–117) restored the Aqua Alsietina, extending it in new directions, and he brought water to Trastevere through a new aqueduct, the 'Aqua Traiana'.[15]

The main river port of medieval and early modern Rome, the 'Ripa Grande', was on the Trastevere side of the Tiber (Figs 35 and 75). Fishermen, dockworkers, sailors, and shipbuilders, as well as millers and merchants, lived close to the river. The church and friary of S. Francesco were not far from the river port. In 271, Region XIV was enclosed within the Aurelian Walls, with major gates at the Porta Portuensis (some distance from the present 'Porta Portese', which opens in the later, seventeenth-century Walls of Pope Urban VIII) on the south near the riverbank, and the Porta Aurelia (from the sixth century onwards known as 'Porta S. Pancrazio', after the martyr Saint Pancratius, whose tomb and basilica were nearby) on the Janiculum Hill (Fig. 75).

Trastevere was linked to Tiber Island and from there to the other side of the river by two ancient bridges, the 'pons Cestius' and the 'pons Fabritius'. Further south, another bridge, the

8 Wadding, *Annales Minorum*, vol. I, pp. 254–55 (S. Francesco a Ripa) and pp. 406–08 (SS. Cosma e Damiano); the latter, also known as 'San Cosimato', is discussed below, in Chapter 4.
9 Robbins, 'A Case Study of Medieval Urban Process', p. 276.
10 Referred to by Wickham, *Medieval Rome*, Chapter 5.
11 Kehr, *Italia Pontificia*, vol. I, p. 17.
12 For this part of Rome in Antiquity and the Middle Ages, see, Maischberger, 'Transtiberim' and De Spirito, 'Transtiberim (età Tardo Antica)', in *Lexicon Topographicum*, ed. by Steinby, vol. IV, pp. 77–83, and 83–85; Staccioli, 'Trastevere nell'antichità'; Bull-Simonsen Einaudi, 'Il monastero di S. Cosimato in Mica Aurea. Appunti di storia e di topografia', in Barclay Lloyd and Bull-Simonsen Einaudi, *SS. Cosma e Damiano in Mica Aurea*, pp. 34–50; Robbins, 'A Case Study of Medieval Urban Process'; Gigli, *Rione XII. Trastevere*; for a recent account of the area around S. Francesco a Ripa, see Porzio, 'Il convento di San Francesco a Ripa e il quartiere di Trastevere', and Wickham, *Medieval Rome*, Chapter 5.
13 Mazzei, '"*Aquae in Transtiberim*"'; Claridge, *Rome*, pp. 58–59.
14 See Wilson, 'The Water Mills on the Janiculum', pp. 219–46, with further bibliography.
15 Mazzei, '"*Aquae in Transtiberim*"'.

'pons Aemilius', later renamed 'Ponte S. Maria', connected Trastevere with the area close to the Forum Boarium, below the Palatine Hill. There were two main Roman roads: the via Aurelia that came into Trastevere from the Janiculum Hill, and the 'Via Campana', also known as the 'Via Portuensis', which came from the countryside south of the city, through the 'Porta Portuensis', and led to the Aemilian Bridge. Other streets were further inland from the Tiber.

Mario Cartaro's *Map of Rome*, printed in 1576 (Fig. 75), shows Trastevere in the late sixteenth century, bordered by the Aurelian Walls and the Tiber.[16] Along the riverbank, ships are docked at the port, labelled the 'Ripa magna'. Parallel to the riverbank and a short distance from it, runs an unnamed street (the medieval equivalent of the Roman Via Campana-Portuensis?) that leads from Porta Portuensis in the Aurelian Wall to a bridge, labelled 'Pons S. Mariae Palatinus' (the Palatine bridge of S. Maria), formerly the Pons Aemilius.[17] An unnamed street, in the Middle Ages known as 'Via Anicia' or 'Via Frangipana', runs more or less parallel to the Via Campana / Portuensis, but further inland, ending in the square in front of the church of 'S. Francisci' (S. Francesco a Ripa).[18] Tiber Island (at the upper left of Fig. 75) is connected to Trastevere by the 'Pons Cestius' and to the other side of the river by the 'Pons Quattuor Capitum Fabritius' (the Four Heads Fabritius Bridge), adding the four ancient marble busts that stand upon the bridge to its ancient name. In Trastevere, Cartaro shows rows of buildings on either side of a wide straight road named 'Via Transtiberina', and now called 'Via della Lungaretta', which leads from the 'Pons S. Maria Palatinus' to the square in front of S. Maria in Trastevere. There are three or four other streets to the right and left of the Via Tanstiberina, which are lined with houses. Beyond them, on the right, a few isolated buildings stand in the midst of fields, in an area that is mostly uninhabited ('disabitato'). Cartaro's *Map* indicates the Janiculum Hill (drawn diagonally from the lower left to the lower right corner of Fig. 75); there are hardly any buildings on the hill, except for the church and monastery of S. Pietro in Montorio and a gate in the Aurelian Wall labelled 'P(orta) S. Pancratii'. Among the fields below the hill, some distance from the built-up area of Trastevere, the two Franciscan churches and convents are clearly marked 'S. Cosmati' and 'S. Francisci'. There is an open space in front of each of these buildings, the one in front of S. Cosimato being particularly large. (This is the forerunner of today's Piazza San Cosimato.) To the right of 'S. Francisci', next to the Aurelian Wall and not far from the Porta Portuensis is a place named 'Campus Iudeorum' (the Jewish cemetery).[19]

S. Francesco a Ripa Today

S. Francesco a Ripa is now a Baroque church, rebuilt in the late seventeenth century, with a nave and aisles, separated by piers and flanked by three chapels on either side, leading to a transept, which has a chapel at either end; behind the high altar, there is a large rectangular choir (the plan is shown in the middle of the lower part of Fig. 76). The church is not oriented but has its sanctuary in the south-east and its entrance to the north-west. The decoration of the building is typical of the late sixteenth and seventeenth

16 For this detail of the Cartaro Map, see Frutaz, *Le piante di Roma*, vol. II, tav. 245.

17 See Claridge, *Rome*, pp. 227, 253–54. After part of that bridge fell down, it was renamed 'Ponte Rotto' (the Broken Bridge).

18 Ghilardi, 'L'aria meridionale della Regio XIV', pp. 3–14, esp. 7–8. The medieval Frangipane family claimed to be descendants of the Ancient Roman Anicii clan, so the road was clearly named after them.

19 Cristofaro, Di Mento, and Rossi, 'Coraria Septimiana et Campus Iudeorum', pp. 3–39, report on excavations made near modern Palazzo Leonori of part of the late medieval and early modern Jewish cemetery.

THE FRANCISCAN CHURCH AND FRIARY OF S. FRANCESCO A RIPA, FOUNDED IN 1229 157

Figure 76. S. Francesco a Ripa, plan of the church and former conventual buildings, 1979 survey by Roberto Marta and Bruno Menichella (1979_DRW_SFrancesco-a-Ripa_Marta-Menichella, ICCROM)

centuries in Rome. Beyond the chapels flanking the north-east aisle is a long rectangular sacristy; to the south-west of this, one can enter a room filled with relics and then go up some stairs to the 'cell of Saint Francis', a small chapel, where there is an image of the saint by Margaritone of Arezzo (Plate 5).[20] On three sides of the church, there were extensive friary buildings. Those to the north-east of the church became the barracks of the Bersaglieri troops in 1873 and are now occupied by the Carabinieri; the rest of the residential buildings belong to the parish of S. Francesco a Ripa run by the Franciscans. A few books refer to the history of the church, including an analytical study of its architecture by Anna Menichella; recently, the buildings of the former friary were restored and discussed in a volume published in 2011.[21]

Archaeological Evidence

There has been no overall archaeological investigation of the site. In 2009–2010, some excavations were made in the fifteenth-century cloister of S. Francesco a Ripa, which is situated to the south-west of the transept and one of the chapels flanking the nave (Fig. 76).[22] Some burials were uncovered, dating from the ninth and tenth centuries. A few objects of similar date also came to light in that area, showing that the site was inhabited at that time. In the cloister, the archaeologists also examined the remains of a cistern and a circular well, which seem to have replaced an earlier channel of water connected to a rectangular vessel. The well was constructed of *opus saracinescum*, and hence it was probably built in the thirteenth century. It stands over the remains of earlier structures. Apart from this, not much is known about the very early features of this site, which, like most places in Trastevere, stands over ancient Roman remains.

The Early Benedictine Monastery of SS. Cosma e Damiano in 'Mica Aurea' in Trastevere

S. Francesco a Ripa is on the site of the 'Ospedale di S. Biagio', the medieval pilgrim hospice which belonged to the Benedictine monastery of SS. Cosma e Damiano 'in Mica Aurea'. While archaeological evidence is scarce, many historical documents refer to the medieval monastery, which preceded the two Franciscan houses in Trastevere.[23] The name refers to two saints, who were brothers and doctors martyred in Asia Minor (modern Turkey), who were famous for treating their patients for the love of God and for free; they later became the patrons of the medical profession.[24] In Rome, a famous sixth-century church dedicated to them is located beside the Roman Forum. The expression 'Mica Aurea' may derive either from the 'golden sand' in Trastevere, or it may refer to the golden grains

20 Falcucci, Leone, and Scarperia, 'Sulla tavola medievale di San Francesco d'Assisi a Ripa Grande in Roma', pp. 277–342, with further bibliography; see also, Bolgia, *Reclaiming the Roman Capitol*, pp. 105–06; and Bolgia, 'Patrons and Artists on the Move', pp. 196–99. The cell of Saint Francis is discussed more fully below.

21 Pesci, *San Francesco a Ripa*; Anonimo, *S. Francesco a Ripa: Guida storico-artistico*; Menichella, *San Francesco a Ripa*; Kuhn-Forte, 'S. Francesco a Ripa', in Buchowiecki, *Handbuch der Kirchen Roms*, vol. IV, pp. 441–81; Del Vasto, *Church of Saint Francis of Assisi of Ripa Grande*; and Degni and Porzio, ed., *La Fabbrica del Convento*.

22 Degni and Porzio, ed., *La Fabbrica del Convento*, pp. 7, 22, 26.

23 See Fedele, 'Carte' (1898 and 1899); Ferrari, *Early Roman Monasteries*, pp. 103–06; Caraffa and Lotti, *S. Cosimato*; Barclay Lloyd, 'The Medieval Benedictine Monastery of SS. Cosma e Damiano'; Barclay Lloyd and Bull-Simonsen Einaudi, *SS. Cosma e Damiano in Mica Aurea*; Lowe, 'Franciscan and Papal Patronage'; Lowe, 'Artistic Patronage'; Lowe, *Nuns' Chronicles and Convent Culture*, pp. 123–41; Guerrini Ferri and Barclay Lloyd, ed., with Velli, '*San Chosm' e Damiano e 'l suo bel monasterio …*'; and Velli, ed., *Nuovi Studi su San Cosimato e Trastevere*. The early history of the monastery is discussed in further detail below, in Chapter 4 of this book.

24 Farmer, *Oxford Dictionary of Saints*, p. 122.

of corn ground in the mills on the Janiculum Hill.[25] The term was used in inscriptions from the sixth century onwards, and also in the Einsiedeln *Itinerarium*, dating from the late eighth or early ninth century.[26]

Most of the documents that survive from the Benedictine monastery of SS. Cosma e Damiano in Mica Aurea are now in the Archivio di Stato in Rome, but, after 1873, when the nunnery of S. Cosimato was suppressed by the Italian Government, some were taken by the Poor Clare nuns to their new convent, which is now located on the Little Aventine Hill.[27] The early manuscripts were discovered and carefully preserved by Sister Orsola Formicini (*c.* 1548–1615), a Poor Clare nun and abbess of S. Cosimato in the late sixteenth and early seventeenth centuries, who discussed them in a history she wrote of the nunnery, which survives in three manuscripts.[28]

(This history is in some ways similar to the work of Sister Domenica Salomonia on S. Sisto.[29]) It provides an account of the history of S. Cosimato, up to the early seventeenth century, based on medieval documents and the author's inside knowledge of the convent.

Founded in the tenth century, perhaps on an earlier ecclesiastical site, the Benedictine monastery of SS. Cosma e Damiano in Mica Aurea was by the twelfth century one of the twenty most important monasteries in Rome, which meant that the abbot had the privilege of attending on the Pope at solemn High Mass in the city.[30] In 1066, the abbey church was enlarged by Odemundus, abbot from 1066 to 1075, and whose epitaph is now in the thirteenth-century cloister of S. Cosimato. Another inscription, now in that church, refers to a consecration of the monastic basilica by Pope Alexander II (1061–1073) in November 1066. The consecration took place shortly after Pope Nicholas II (1059–1061) had consecrated a remodelled church at the abbey of Farfa in 1060 and five years before Alexander II in 1071 consecrated the new abbey church, built by Abbot Desiderius, at Monte Cassino in the style of Rome's early Christian basilicas.[31] Clearly, the

25 See Gatti, 'Della mica aurea in Trastevere', for the first meaning, where he says the name of S. Pietro in 'Montorio' refers to a 'golden mountain' perhaps for the same reason. For the second etymology, which relates the word 'mica' (grain) to corn ground in the mills on the Janiculum and in Trastevere, see Bull-Simonsen Einaudi, 'Il monastero di S. Cosimato in Mica Aurea', pp. 42–43, with further bibliography. See also, Mazzei, 'Mica Aurea in Trastevere', pp. 183–204.

26 Valentini and Zucchetti, *Codice topografico*, vol. II, p. 190. See also, Barclay Lloyd and Bull-Simonsen Einaudi, 'Cronologia', p. 129.

27 The early documents are now in *ASR*, fondo *Clarisse in SS. Cosma e Damiano in Mica Aurea* and were published by Fedele, 'Carte', (1898) and Fedele, 'Carte' (1899). See also Bull-Simonsen Einaudi, 'Il monastero di S. Cosimato', pp. 28–34; Lowe, 'Franciscan and Papal Patronage', pp. 219–20; Mantegna, 'Le carte dei SS. Cosma e Damiano in Mica Aurea'; and Voltaggio, '... et stavan confusamente'. Gemma Guerrini Ferri has made a Catalogue of the manuscripts now at the Poor Clare convent on the Little Aventine.

28 Rome, Biblioteca Nazionale Centrale, Varia 5 and Varia 6; and BAV, Vat. Lat. 7847. See also, Quondam, 'Lanzichenecchi in convento'; Bull-Simonsen Einaudi, 'Il monastero di S. Cosimato in Mica Aurea', pp. 28–34, and 139; Lowe, *Nuns' Chronicles and Convent Culture*, pp. 126–41, 173–79, 184–89, 202–03, 218–19, 257–62, 318–25, 328–33, 365–71, 383–94; Bull-Simonsen Einaudi,

'Perché studiare San Cosimato?', pp. 21–22; Guerrini Ferri, 'I libri di suor Orsolina Formicini'; Guerrini Ferri, Il *Liber monialium* ed il *Libro de l'antiquità* di suor Orsola Formicini'; Guerrini Ferri, 'Storia, contabilita ed approvvigionamenti nel monastero di San Cosimato' pp. 19–61.

29 See above, Chapter 1 and Domenica Salomonia, *Cronache del Monastero di San Sisto*, in Spiazzi, *Cronache e Fioretti*.

30 The extent of the monastery's property and some of its buildings are described in a Bull of John XVIII in 1005, which is discussed below, Chapter 4. There is a list of the twenty most important Roman abbeys in John the Deacon, *Descriptio Lateranensis Ecclesiae*, written in the pontificate of Pope Alexander III (1159–1181) and in Petrus Mallius, *Descriptio Basilicae Vaticanae*, published in Valentini and Zucchetti, *Codice topografico*, vol. III, pp. 361–62; and 438–39.

31 For Farfa, see McClendon, *The Imperial Abbey of Farfa*; for the rebuilding of the church at Monte Cassino in the eleventh century, see Bloch, 'Monte Cassino, Byzantium

abbey of SS. Cosma e Damiano in Mica Aurea was an important Benedictine monastery in eleventh- and twelfth-century Rome.

In the early thirteenth century, the monastery ran a hospice for poor pilgrims and foreigners, the 'Ospedale di S. Biagio', not far from the Ripa Grande, near the road coming from South of Rome into Trastevere through the Porta Portuensis in the Aurelian Wall, and near the Via Anicia /Frangipana. The hospice provided accommodation for travellers and, like all such monastic institutions, it must have had its own small church or chapel. One of the people who stayed there was Francis of Assisi, when he came to Rome to see the Pope in 1212 or, more likely, in 1219.[32] According to tradition, his friend, Jacopa de' Settesoli (c. 1190–1239), widow of Graziano Frangipane, arranged this accommodation for him and his companions.[33]

The Church of S. Francesco a Ripa (from 1229 onwards)

Two years after Francis died at S. Maria degli Angeli on 3 October 1226, Pope Gregory IX canonized him on 16 July 1228, and issued the Bull, *Mira circa nos*, on 19 July 1228.[34] Almost immediately, work began on building the church dedicated to Saint Francis in Assisi, where his remains were translated.[35] Only one year after the canonization of Saint Francis, in 1229, Gregory IX established the first Franciscan church and friary in Rome, which was the first church dedicated to the saint after that in Assisi. Probably because Francis had stayed at the Ospedale di S. Biagio, the Pope commanded the monks of SS. Cosma e Damiano in Mica Aurea to cede this building to the Franciscans. The papal Bull *Cum deceat vos*, dated 23 July 1229 and sent from Perugia, ratified this arrangement.[36] The Pope claimed that the transfer could be done 'sine detrimento' (without detriment) to the monks and he referred to the church of S. Biagio as 'quasi derelictam' (almost abandoned); he commanded the monks to give this church 'cum omnibus sibi adiacentibus per circuitum […] fratribus et eorum ordini' (with everything adjoining it and around it […] to the friars and to their Order).[37] From this document, it seems the church was in poor condition and the gift included the adjacent hospice and some land surrounding it.

Anna Menichella has argued that, because the church of S. Biagio was semi-abandoned ('quasi derelictam') in 1229, the Franciscans immediately began rebuilding it, perhaps as early as 1230–1231.[38] They rededicated it to their founder, with a reference to its location near the port, as 'S. Francesco a Ripa'. They also established a friary in the buildings beside and around it, which they refurbished and extended to suit their needs — as the Dominicans had done at S. Sabina. The medieval church of S. Francesco a Ripa was completely restructured in the late seventeenth century and is now totally Baroque in style.[39] Still, there are some written records, drawings, and prints, which record the history of the Franciscan foundation and indicate some

and the West'; Pantoni, 'La basilica di Montecassino e quella di Salerno'; Pantoni, 'Descrizioni della basilica di Montecassino'; and Pantoni, *Le vicende della basilica di Montecassino*; Carbonara, *Iussu Desiderii*; Bloch, 'The new fascination with Ancient Rome'; Bloch, *Monte Cassino*.

32 For 1212, *Bullarium Francescanum*, ed. by Baptistae (hereafter *BF*), vol. I, p. 51, (a), but for a more likely date of 1219, see Oliger, 'S. Francesco a Roma', p. 87.

33 This claim is made in Anonimo, *S. Francesco a Ripa*, p. 12. See Oliger, 'S. Francesco a Roma', and Terzi, *San Francesco d'Assisi a Roma*.

34 For this Bull, promulgated in Perugia, *Mira circa nos* of Gregory IX (1228), see *FAED*, vol. I: *The Saint*, pp. 565–69.

35 Schenkluhn, *Architettura degli Ordini Mendicanti*,

pp. 37–43; Cooper and Robson, *The Making of Assisi*; and Gardner, *The Roman Crucible*, pp. 61–70.

36 *BF*, vol. I, pp. 50–51.

37 *BF*, vol. I, p. 51.

38 Menichella, *San Francesco a Ripa*, p. 14.

39 Golzio and Zander, *Le chiese di Roma*, p. 83.

features of the medieval buildings. Moreover, a recent restoration campaign has revealed some remains of medieval date, which show that parts of the Franciscan church and friary still exist, incorporated in the later remodellings.[40]

In 1518, the Franciscan, Fra Mariano from Florence, mentioned the church in his itinerary of Rome:

> Non longe ripam [...] templum est divi Francisci, olim hospitale sancti Blasii, in quo sanctus ipse se recipiebat ad Urbem veniens. Haec est prima ecclesia, auctoritate Gregorii noni, a fundamentis erecta praefato sanctoque dicata, post illam Assisii, impensis illustrissimae dominae Iacobae de Septem zonis [...].
>
> (Not far from the riverbank [...] is the church of Saint Francis, formerly the Hospital of S. Biagio, in which the saint himself was welcomed when he came to Rome. This is the first church, which was built from the foundations and dedicated to the saint, after the one in Assisi, on the authority of Gregory IX, with funds from that most illustrious lady, Jacopa de' Settesoli [...]).[41]

Fra Mariano was correct in attributing the foundation of the church to Gregory IX, as the Bull of 1229 attests, and it is likely that he was also correct in saying that Jacopa de' Settesoli provided the funds needed for rebuilding it. Jacopa was the widow of Graziano Frangipane (of the Gradellis branch of that family).[42] When her husband died in 1217, she took over the administration of the family estates. Her other name, 'de' Settesoli', indicates that she resided near the Septizonium, a monumental ancient fountain with a magnificent display of columns, built by Septimius Severus (193–211) near the beginning of the Via Appia in Rome.[43] She was a personal friend of Francis of Assisi and one of the earliest Franciscan Tertiaries — lay people who followed a Franciscan formula of life. She is mentioned in some of the medieval biographies of the saint. According to Bonaventure,

> Once in Rome he (Francis) had with him a little lamb out of reverence for the most gentle Lamb of God. At his departure he left it in the care of the noble matron, Lady Jacopa of Settesoli. Now the lamb went with the lady to church, standing reverently by her side as her inseparable companion, as if it had been trained in spiritual matters by the saint. If the lady was late in rising in the morning, the lamb rose and nudged her with its horns and woke her with its bleating, urging her with its nods and gestures to hurry to the church. On account of this, the lamb, which was Francis's disciple and had now become a master of devotion, was held by the lady as an object of wonder and love.[44]

This practical Roman lady was present at S. Maria degli Angeli when Francis died. He had just dictated a letter asking her to come to Assisi, and requesting her to bring various items, when she arrived with two of her sons and an escort of companions mounted on horseback.[45] According to Thomas of Celano,

40 See, Degni and Porzio, ed., *La Fabbrica del Convento*.

41 Mariano da Firenze, *Itinerarium Urbis Romae di Fra Mariano*, ed. by Bulletti, p. 100. The spellings 'Jacoba' or 'Jacopa' were interchangeable.

42 Wickham, *Medieval Rome*, refers to the Frangipane family as important from the eleventh century onwards; the main area where they lived was from the Circus Maximus and Palatine to the Colosseum and S. Maria Nova. In this zone, they resided in the Septizonium. The 'Gradellis' branch of the family may have had property near S. Maria ad Gradellis, not far from S. Maria in Cosmedin and on the other bank of the River.

43 Coarelli, *Rome and Environs*, p. 155.

44 Bonaventure, *The Major Legend of Saint Francis*, Chapter 8: 7, *FAED*, vol. II: *The Founder*, pp. 591–92. See also, Oliger, 'S. Francesco a Roma', pp. 79–83.

45 *The Assisi Compilation*, [8], *FAED*, vol. II: *The Founder*, pp. 121–23; see also Thomas of Celano, *The Treatise on the*

Unable to restrain himself for joy, (one of the friars) said, 'I have good news for you, father'. Without a pause the saint immediately replied, 'Blessed be God, who has brought our Brother Lady Jacoba to us! Open the doors and bring her in. The decree about women is not to be observed for Brother Jacoba'.[46]

Calling her 'Brother Jacoba' meant Francis allowed her to enter the cloistered part of the building, where women were normally not permitted by the Franciscan Rule. She thereafter became known in Franciscan literature as 'Brother Jacoba (or Jacopa)'. She came to Assisi with some clean grey cloth to be made into a new habit and shroud for Francis, a napkin for his face, a pillow for his head, lots of wax to make candles, and a quantity of incense; she also brought the ingredients for 'mostacciolo', a marzipan speciality of Rome that he particularly liked.[47] She made it for him, but he was too ill to take more than a tiny taste before he died.

Because Jacopa was an early Franciscan Tertiary, she gave generously to the Friars Minor. On her seal, she defined herself as 'Ancilla Jesu Christi' (Handmaid of Jesus Christ).[48] It seems likely that she did pay for the first phase of rebuilding S. Francesco a Ripa, which stood at the end of the street in Trastevere called 'Via Anicia/ Frangipana', named after her husband's family. Towards the end of her life, she lived in Assisi, where she died, in 1239.[49] She is buried in the crypt of the basilica of Saint Francis, near the saint's tomb. The inscription, 'Hic requiescat Jacopa sancta nobilisque Romana' (Here lies Jacopa, a holy and noble Roman lady) is on her funerary urn and another, 'Hic requiescat Jacopa de Septemsoli' (Here lies Jacopa of Settesoli) is on her grave.

Jacopa de' Settesoli was connected to two noble Trastevere families — her own, the Normanni, and that of her husband, the Frangipane.[50] Following Oliger, Menichella noted that the Normanni coat of arms was to be seen in the church of S. Francesco a Ripa before its late seventeenth-century Baroque transformation, as indicated by a drawing of those arms by Francesco Gualdi in 1657 with the statement, 'vedesi al presente quell'arma nella chiesa di S. Francesco in Trastevere dipinta' (at present these arms are to be seen painted in the church of S. Francesco in Trastevere).[51] It is not known when such a depiction was made; nor is there any other mention of the Frangipane coat of arms.

Other sources refer to another lay patron of the building. The Franciscan friar, Fra Ludovico da Modena (1637–1722), who spent a year in Rome in 1660–1661, wrote in his *Cronaca della Riforma e Fondazione dei conventi dal 1519 al 1722*, that the church of S. Francesco a Ripa and the adjacent convent were built by Pandolfo, Count of Anguillara, whose coat of arms was visible in

Miracles of Saint Francis, Chapter 6, FAED, vol. II: *The Founder*, pp. 417–19; and Ugolino di Boniscambi of Montegiorgio, *The Deeds of Blessed Francis and his Companions*, XVIII, FAED, vol. III: *The Prophet*, pp. 471–74.

46 Thomas of Celano, *The Treatise on the Miracles of Saint Francis*, FAED, vol. II: *The Founder*, pp. 417–18.

47 This was made of 'almonds, sugar or honey, and other ingredients', according to Thomas of Celano, *The Treatise on the Miracles of Saint Francis*, FAED, vol. II: *The Founder*, p. 418, note a.

48 See Rehberg, 'Nobiltà e monasteri femminili nel Trecento', fig. 1, for an illustration of her seal from Rome, Museo Nazionale del Palazzo di Venezia, and his discussion of it on p. 405.

49 Oliger, 'S. Francesco a Roma', p. 83, says that she died in 1239, but Sabatier suggested a date of 1273, as noted in FAED, vol. III: *The Prophet*, p. 474, note a. The first date of 1239 is the one that is usually accepted.

50 Pointed out by Bulletti, in Mariano da Firenze, *Itinerarium Urbis Romae*, ed. by Bulletti, p. 100 n. 4. See also, Pesci, *San Francesco a Ripa*, p. 24. According to Wickham, *Medieval Rome*, the Normanni family rose to prominence in the early twelfth century and was contemporary with the Frangipane, being rivals to begin with.

51 Oliger, 'S. Francesco a Roma', p. 88; Menichella, *San Francesco a Ripa*, p. 21 and n. 33, referring to BAV, Vat. lat. 8353, pt. 2, fol. 329ʳ. The Normanni arms show two confronted gold serpents on a red background.

various places in the church; and there were also paintings showing the same Count, dressed as a Franciscan Tertiary, presenting an image of the church to Saint Francis.

> Fu poi questa chiesa dopo la morte del Santo ridotta in miglior forma e grandezza insieme con il convento da Pandolfo Conte dell'Anguillara, come chiaramente appariva dalle armi di detto illustrissima casa dipinta in diversi luoghi della chiesa, nelle pareti della quale era anco dipinto l'istesso conte, vestito da Terziario francescano in atto di offrire la rinnovata chiesa a san Francesco, come anch'hoggi se ne vedono in buoni quadri in tela.

> (This church was, then, after the death of the Saint, rendered in better form and size, together with the convent, by Pandolfo Count of Anguillara, as clearly appears from the arms of that most illustrious house painted in various places in the church, on the walls of which there is also painted the same count, dressed as a Franciscan Tertiary, in the act of offering the renovated church to Saint Francis, as one can also see today in good pictures on canvas.)[52]

Another early seventeenth-century document in the S. Francesco a Ripa Archive claimed that the church was first built by Jacopa de' Settesoli and then the Count of Anguillara enlarged and decorated it:

> Ecclesiam hanc seraphico Patriarchae P. Francisco anno Domini 1229, quarto ab eius obitu a pia Heroina Domina Jacoba de septem soliis dicatam primitusque instructam deinde ab illis comitibus de Anguillaria auctam et picturis decoratam [...]

> (This church, dedicated to the seraphic Patriarch Father Francis in the year of the Lord 1229, the fourth after his death, and first constructed by the pious Heroine Jacopa dei Settesoli, was then enlarged and decorated with paintings by those counts of Anguillara).[53]

This suggests two phases in the rebuilding of the church, one attributed to Jacopa, and the other to the Count(s) of Anguillara. An anonymous modern author (said to be Fra Giuseppe Sanità, OFM) suggested another sequence of events: that there was first merely a restoration of the old Benedictine church, sponsored by Jacopa de' Settesoli, after which the church was totally rebuilt by Pandolfo of Anguillara.[54] If the church was very small and not in good condition in 1229, as seems likely from the description in Gregory IX's Bull, there was probably an immediate rebuilding by Jacopa, followed by a new campaign involving the extension of the edifice and the decoration of the interior by Count Pandolfo. There would have been two phases of construction, but it is not clear which parts of the building belonged to each phase. Usually, medieval churches were built from the liturgical east end to the façade, which may have happened in this edifice. Whichever came first, one notes that both Jacopa and Pandolfo were lay Franciscan Tertiaries, who donated funds for this purpose.

Menichella found that there were two Counts of Anguillara called Pandolfo in the thirteenth century: one, who was mentioned between c. 1230 and 1240, was a Ghibelline follower of

52 Ludovico da Modena, *Cronaca*, cited by Pesci, *San Francesco a Ripa*, p. 10. Some sources, such as Panciroli, *Tesori nascosti*, p. 316, refer to the Count of Anguillara as 'Ridolfo' rather than 'Pandolfo', although the latter name is most frequently given in the modern accounts of the building. The Anguillara were connected through marriage with the Orsini family in Rome.

53 Ludovico da Modena, *Cronaca*, quoting from the convent's *Libro degli Atti*, carta 47, as cited by Pesci, *San Francesco a Ripa*, p. 29 n. 67.

54 Anonimo, *S. Francesco a Ripa: Guida storico-artistico*, p. 13. The anonymous author is identified by Del Vasto, *Church of S. Francis of Assisi*, p. 7.

the Holy Roman Emperor Frederick II and she assumed that he would not therefore have been interested in sponsoring the building of the church; the other, who seems more likely to have been involved in this project, was recorded between 1260 and 1293 or 1294.[55] Menichella argued convincingly that it was this second Count Pandolfo of Anguillara whose arms were represented in the building, and who was shown as the donor of a cycle of frescoes, painted in the later years of the thirteenth century.[56]

The murals in the church were mentioned by Lorenzo Ghiberti, Giorgio Vasari, and Pompeo Ugonio as having been painted by the Roman artist, Pietro Cavallini (c. 1250–c. 1330).[57] The painter also decorated the church of S. Cecilia, not far away, and he designed the late thirteenth-century mosaic cycle below the twelfth-century images in the apse of S. Maria in Trastevere. Ghiberti mentioned that Cavallini had painted the whole church of S. Francesco.[58] Vasari recorded that Cavallini, after painting almost the whole of S. Cecilia in Trastevere, 'poi lavorò nella chiesa di S. Francesco appresso Ripa molte altre cose' (then worked on many other things in the church of S. Francesco near Ripa).[59] Ugonio described Cavallini's murals as covering all of the nave and aisle walls 'usque ad summum' (right up to the top) and showing 'multa ex miracula S. Francisci' (many of the miracles of Saint Francis).[60] Cavallini probably painted them in the late 1280s.[61] Unfortunately, nothing survives of

Figure 77. Leonardo Bufalini, *Map of Rome*, detail of S. Francesco a Ripa (Frutaz, *Le Piante di Roma*, vol. II, 1962, detail of Tav. 208)

these paintings — it would have been interesting to compare them with the medieval frescoes in the church of S. Francesco in Assisi.[62]

Fra Ludovico da Modena gave a written description of the nave and aisles of the medieval Franciscan church, as they existed at his time:[63]

Era fatta all'antica, coperta con semplice tetto et a tre navi, sostenute di divisorie muraglie da colonne di pietra. Erano le mure di bellissime et antiche pitture adornate, le quali molti miracoli del nostro S. Padre rappresentarono.

(It was built in the ancient manner, covered with a simple roof and it had three naves [i.e. a nave and two aisles], the dividing walls supported by stone columns. The walls were adorned with very beautiful and ancient paintings, representing many miracles of our Holy Father [Saint Francis].)

The description indicates that the church was a traditional basilica with a nave and two aisles separated by colonnades and that there was a timber roof.

55 Menichella, *San Francesco a Ripa*, p. 22.
56 Menichella, *San Francesco a Ripa*, p. 22. There is also a tomb slab of a figure of the Anguillara family in the room near the steps leading up to the cell of Saint Francis, behind the church.
57 Ghiberti, *I Commentarii*, vol. II, p. 39; Vasari, *Le Vite*, ed. by Milanesi, Book 1, Pietro Cavallini, pp. 537–43; and Ugonio, cited in Menichella, *San Francesco a Ripa*, p. 22.
58 Ghiberti, *I Commentarii*, vol. II, p. 39.
59 Vasari, *Le Vite*, ed. by Milanesi, Book 1, Pietro Cavallini, pp. 537–43.
60 Cited in Menichella, *San Francesco a Ripa*, p. 22.
61 Menichella, *San Francesco a Ripa*, p. 22, notes that Ugonio

mentions a Pope Honorius, who would have been Pope Honorius IV (1285–1287) Savelli.
62 For these, see Cooper and Robson, *The Making of Assisi*.
63 Rome, Archivum S. Francisci a Ripa, MS 12, Ludovico da Modena, *Cronaca*, p. 12.

Leonardo Bufalini's *Map of Rome* dated 1551 (Fig. 77), shows the church this way, with an apse, a nave, and two aisles, separated by eight columns, with four on either side. The altar is quite far forward in front of the apse. To the right of the church there is a long convent building, while further conventual structures stand behind and to the left of the church. This vignette is not a detailed plan of the building, but it does give a general idea of the church and friary.

In his *Theatrum Urbis Romae*, Ugonio described the architecture of the church c. 1588 in more detail, before it was rebuilt in Baroque style.[64] In the nave he saw ten (rather than Bufalini's eight) re-used ancient columns of different types, without bases but sustaining capitals. He noted that 'quinque ex una et quinque ex altera parte columnae [...] regunt sex arcus' (five columns on one side and five on the other side [...] support six arches). The nave was covered with a simple timber roof. Beyond the nave there was a transept (not shown clearly by Bufalini), where Ugonio found one column in each of its four corners; at the crossing, two columns stood beside the piers of the triumphal arch, opposite two others on the other side of the transept. These four columns suggest two arches across the transept. It is likely that the eight columns in the transept sustained three cross vaults (without ribs). In addition, Ugonio noted two columns of 'Numidian' granite, which supported the triumphal arch itself, between the nave and the transept. The altar stood under a ciborium supported by four columns. Two more columns sustained the minor arch which rose higher than the high altar and divided the crossing from the choir. Inside the choir there were old wooden seats and there were two more columns in the corners. These four columns (at the 'minor arch' and in the corners of the choir) suggest a cross vault over a rectangular choir.

By the late sixteenth century, an iconostasis of marble, 'a veteri forma et structura' (of an old form and structure) was noted by Ugonio at the triumphal arch.[65] This marble partition may have divided the friars' area in the transept and choir from the public part of the church (as the 'tramezzo' did at S. Sabina), but the evidence is rather vague as to its form and date.[66] An eighteenth-century document claimed on the basis of an existing marble 'tabella' (a diagram on a marble plaque?) that there was a large room or dormitory, where Francis and his companions stayed, behind the apse of the church; in it, Francis was said to have set up a partition of wickerwork and clay, which served as a tramezzo between the living quarters of the friars and a small oratory where they prayed.[67] It was in the floor above this area, that the friars later indicated what had been the cell of Saint Francis. In 1603–1608, behind the high altar, the architect Onorio Longhi built a large new choir, which still exists today.[68] It is of interest, that the architect wanted to demolish the structures behind the church, associated with Saint Francis, but was prevented from doing so by the friars and their supporters, among whom was Cardinal Alessandro Peretti Montalto. As a result, the new choir took up part of the area in question, but the 'cell' of the saint was preserved in a narrower form.[69]

The medieval façade was rather plain, with a monumental doorway, in front of which stood four columns (perhaps indicating a monumental entrance or prothyron). Five steps led up to the door, whose frame was decorated with mosaic, according to Ugonio, perhaps meaning a design

64 BAV, Barb. lat. 1994, fols 550, 556–57. See also, Menichella, *San Francesco a Ripa*, p. 19.

65 Cited by Menichella, *San Francesco a Ripa*, p. 19.
66 For the tramezzo at S. Sabina, see above, Chapter 2.
67 Rome, Archivum S. Francisci a Ripa, Busta I; Menichella, *San Francesco a Ripa*, p. 15. Righetti Tosti-Croce, 'Gli esordi', sought to work out the disposition of this large room.
68 There is an inscription in the choir commemorating this work.
69 The cell of Saint Francis is discussed more fully below.

Figure 78. Gieronimo Francino, S. Francesco a Ripa, façade (*Le Cose Meravigliose...*, ed. Fra Santi, 1588, p. 20v; photo: BAV, © 2021, Cicognara.III.3685)

in 'Cosmatesque' *opus sectile*, like that to be seen in several other medieval door frames in Rome, for example at S. Saba and at SS. Bonifacio ed Alessio. In a woodcut by Gieronimo Francino, published by Fra Santi in 1588, one sees the church façade with the main doorway, and above it, two round-headed windows, flanking a niche (Fig. 78).[70] There is clearly an aisle on the left of the central part of the façade and a lower wall with a trilobate Gothic window, perhaps pertaining to a side chapel. A campanile is visible further back on the left. On the right of the central part of the façade, there is another doorway, with a small window on the left and a much larger opening above the door. This structure is surmounted by a small belfry. This part of the image appears to incorporate both a separate entrance and the right aisle.

Baldassarre Peruzzi (1481–1536) made a plan of the church (Fig. 79) shortly after the death in 1533 of the Franciscan Tertiary, Ludovica Albertoni, who was famous for her sanctity and for her charitable work among the poor of Trastevere.[71] The architect was evidently preparing designs to remodel the nave and aisles, and to build a chapel of trefoil plan, extending from the north-eastern end of the transept, to accommodate her tomb, but he never completed this project. Instead, Blessed Ludovica Albertoni was buried in a smaller chapel of a different shape, in which, after she was beatified in 1671, the famous statue of her in ecstasy by Gian Lorenzo Bernini was located in 1675.

Peruzzi's plan shows a new and asymmetrical disposition of the nave and aisles, as part of his projected changes. He placed twelve columns in six pairs sustaining arches between the nave and the left aisle. (He drew part of this double colonnade in elevation to the right of his plan, which is now not very clearly visible.) Between the right aisle and the nave he indicated piers rather than columns. It seems his double colonnade was part of a plan to create a monumental pathway for pilgrims to visit his new chapel in honour of Blessed Ludovica and, beyond that perhaps, to go to the rooms of the former hospice, where Saint Francis had stayed. (This was in some ways like the later pilgrim path at S. Sabina that led past the statue of Saint Rose of Lima at the end of the narthex and then up the stairs to the room of Saint Dominic, and the chapel of Pius V above that. At S. Maria in Aracoeli, there was also a pathway through the left aisle of the church to the icon of *Maria Advocata*, the footprints of Saint

70 *Le Cose Maravigliose*, p. 20 v.

71 The plan survives at the Uffizi, Florence, Disegni, n. 1643A.

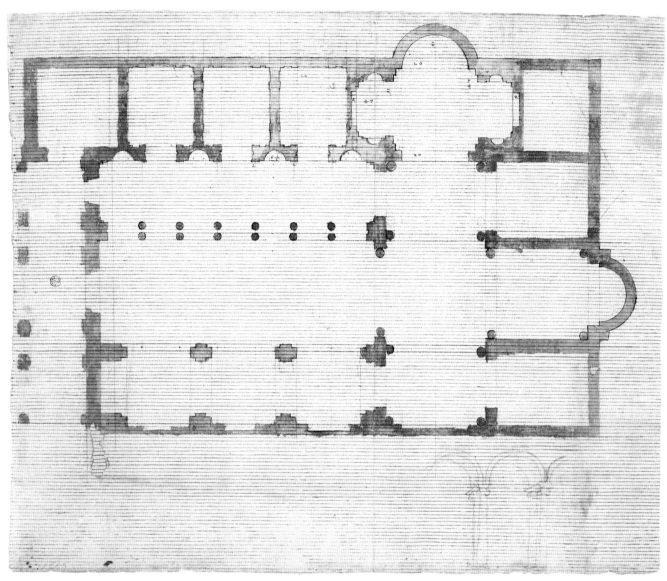

Figure 79. Baldassarre Peruzzi, drawing of a project for a trefoil burial chapel for Ludovica Albertoni in S. Francesco a Ripa, 1533–1536 (Uffizi, Florence, Prints and Drawings, n. 1643A – under licence from MiBACT)

Michael, and the 'altar of heaven', or Aracoeli, in the shrine of Saint Helena.[72])

In Peruzzi's plan, there are no side chapels on the right of the church because convent buildings then occupied that space. (A late seventeenth-century document published by Menichella refers to twelve cells of the friary adjacent to that side of the church that later had to be demolished to make way for side chapels.[73]) The side chapels on the left at S. Francesco a Ripa were evidently planned and begun in the sixteenth century.[74] Peruzzi also projected a new

72 See above, Chapter 2, with regard to S. Sabina; and below, Chapter 5, with regard to S. Maria in Aracoeli.

73 *Memoriale di Matthia De' Rossi*, 20 settembre 1685, in Menichella, *San Francesco a Ripa*, pp. 99–100.

74 Menichella, *San Francesco a Ripa*, p. 36.

narthex in front of the church, which was never built, but is visible on his plan.

Peruzzi's project for the nave and aisles at S. Francesco a Ripa was new, but he showed the transept in a way that confirmed the description given by Ugonio: there is one column in each of the far corners, and two supporting arches on either side of the crossing. The columns divide the transept into three parts. It is likely that the columns also supported cross vaults, but Peruzzi does not indicate them.[75] He shows two columns supporting the triumphal arch between the nave and transept, as Ugonio pointed out when he referred to two columns of 'Numidian' granite in that place. Beyond the transept there is a 'choir' with a rectangular plan which ends in a small apse. Again, as Ugonio noted, Peruzzi shows two columns at the entrance to this space, which would have supported an arch framing the high altar, which Ugonio described as standing under a canopy in the transept. There are also two columns in the inner corners of the choir, close to the apse. Pesci suggested convincingly that there was first an apse, and then, about the middle of the sixteenth century, that was transformed into a rectangular choir.[76] Since Peruzzi's plan is dated 1533–1536, this arrangement must have existed by then. Later, in 1603–1608, the rectangular choir was considerably enlarged, and the earlier choir and its small apse were demolished in the process. Peruzzi indicates that the choir in his day was flanked by a rectangular chapel on either side, of the same depth as the choir, which suggests that the chapels were contemporary with it.

A tripartite vaulted transept is typical of early Franciscan architecture — as, for example, in the upper and lower churches of S. Francesco and in the church of S. Chiara in Assisi, or at S. Francesco

Figure 80. Giuseppe Sanità, OFM, Reconstruction plan of the thirteenth-century church of S. Francesco a Ripa (1960s – adapted by author)

al Prato in Perugia.[77] Having rectangular chapels on either side of the sanctuary is to be seen in such Franciscan churches as San Francesco in Cortona, San Francesco in Udine, San Francesco in Cagliari, and San Francesco in Pescia.[78] The apse at the end of the choir at S. Francesco a Ripa is unusual, which perhaps confirms that the disposition of the choir and apse shown in Peruzzi's plan was a post-medieval addition and there was originally only an apse opening off the transept.

75 Udina, 'Dallo xenodocchio benedettino al convento francescano', p. 27, suggests there were probably cross vaults in the transept.

76 Pesci, *S. Francesco a Ripa*, p. 26 n. 43.

77 Schenkluhn, *Architettura degli Ordini Mendicanti*, p. 57, tav. II, 1, 2, and 3; Gardner, *The Roman Crucible*, pp. 63–70, figs 31 and 32.

78 Schenkluhn, *Architettura degli Ordini Mendicanti*, p. 64, tav. III, 1, 2, 4, and 7.

The design of the transept and sanctuary of the Trastevere church resembles early Franciscan architecture rather than the early Christian and medieval basilicas of Rome. Marina Righetti Tosti-Croce pointed out that the design of the transept of S. Francesco a Ripa was foreign to Rome, whereas the nave and aisles, and the altar under a ciborium, resembled the architecture of most medieval churches in the city.[79] It seems that this first church dedicated to Saint Francis after the one in Assisi may have taken the overall plan of the transept from the Umbrian building and the rectangular sanctuary flanked by side chapels was added later and may have imitated other Franciscan churches in the early sixteenth century. If there were two building phases at S. Francesco a Ripa in the Middle Ages, one may have consisted of the 'Franciscan' transept with an apse, while the second may have added the 'Roman' nave and aisles. In a much later third campaign, the liturgical east end of the church was remodelled with a rectangular choir, apse, and side chapels.

Fra Giuseppe Sanità, OFM included a reconstruction plan of the medieval church in his anonymous publication (Fig. 80), which includes an apse (but no rectangular choir attached to it) a tripartite vaulted transept, a nave separated from the aisles by five columns on either side, and no side chapels.[80] While he showed columns in the apse, he did not include those at the triumphal arch which have been added to his plan here. He also drew four columns at the entrance to the church, as Ugonio had mentioned in his description.

The two columns at the triumphal arch, between the nave and the transept, were a local feature, being like those in the twelfth-century churches of S. Crisogono and S. Maria in Trastevere, not far from S. Francesco a Ripa. Ultimately, the design goes back to the columns erected to strengthen the triumphal arch in S. Paolo fuori le Mura by Pope Leo I (440–461). The two columns behind the altar are similar to those at the entrance to the apse in the church of S. Maria in Domnica in Rome, built by Pope Paschal I (817–824). Claudia Bolgia has pointed out that columns at both the triumphal arch and on either side of the apse, were features of the abbey church at Monte Cassino, as rebuilt by Abbot Desiderius in the eleventh century and as shown in a plan of that church made in the 1530s by Antonio Sangallo the Younger and Battista da Sangallo (our Fig. 81).[81] She thought this was a distinctively Benedictine feature and related it to the church of S. Maria in Capitolio, which the Franciscans rebuilt as the church of S. Maria in Aracoeli after *c.* 1248–1252.[82] (One should note that the church of S. Paolo fuori le Mura has since the early Middle Ages been served by a community of Benedictine monks.) S. Francesco a Ripa took the place of the Benedictine church of S. Biagio, but it is unlikely that that small, almost abandoned building would have been like the monastery church of Monte Cassino, whereas the main church of the monastery of SS. Cosma e Damiano, on the site of San Cosimato, may well have had such a design, especially as it was enlarged by Abbot Odemundo and consecrated by Pope Alexander II in 1066, just five years before the consecration of the abbey church at Monte Cassino in 1071. (Unfortunately, however, very little is known about the plan and elevation of the Benedictine church of SS. Cosma e Damiano.)

Bolgia thought a vaulted transept at S. Francesco a Ripa was unlikely in the years 1230–1240, a date ascribed to it by the restorer,

79 Righetti Tosti-Croce, 'Gli esordi', p. 29.
80 Anonimo, *S. Francesco a Ripa: Guida storico-artistico*; and reproduced in Del Vasto, *The Church of Saint Francis of Assisi a Ripa Grande*, p. 10.
81 Bolgia, *Reclaiming the Roman Capitol*, pp. 61–63; she illustrates the Sangallo plan, Uffizi, Gabinetto dei Disegni, no. 182.
82 See below, Chapter 5.

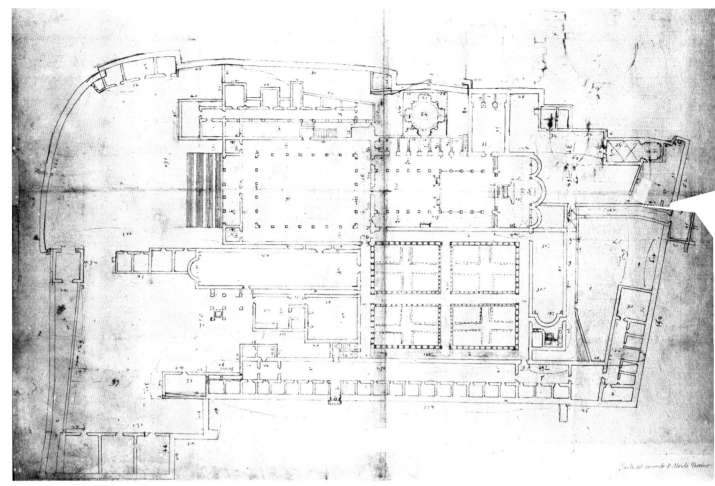

Figure 81. Antonio da Sangallo the Younger and Giovanni Battista da Sangallo, Monte Cassino, plan for remodelling the choir of the church of Saint Benedict (photo: Florence Uffizi Gallery, Prints and Drawings, U 181 A – under licence from MiBACT)

Cristina Udina.[83] Bolgia's argument is not totally convincing. If Jacopa de' Settesoli was involved in the first building phase of S. Francesco a Ripa, she and the first friars there may well have called on builders from Assisi to help design the Roman church. In any case, cross vaults (without ribs) are known in Roman church and conventual buildings of the twelfth and early thirteenth centuries — for example, in the ambulatories of the cloister at S. Lorenzo fuori le Mura, in the aisles of the twelfth-century Cistercian church of SS. Vincenzo e Anastasio alle Tre Fontane, and in the monastic buildings there.[84] At S. Clemente, S. Maria in Cosmedin, S. Lorenzo fuori le Mura, and at S. Sisto there are rooms where cross vaults are sustained by a central column and brackets on the walls.[85] The architect of the Trastevere

83 Bolgia, *Reclaiming the Roman Capitol*, p. 102, n. 88, referring to Udina, 'Dallo xenodocchio benedettino al convento francescano', p. 26.

84 Barclay Lloyd, 'The Architecture of the Medieval Monastery at S. Lorenzo fuori le Mura ', pp. 99–102; and Barclay Lloyd, *SS. Vincenzo e Anastasio*, for the cross vaults in the aisles of the church, pp. 76, 139 and in the chapter room, pp. 154–55.

85 For S. Clemente and S. Maria in Cosmedin, Barclay Lloyd, *The Medieval Church and Canonry of S. Clemente*, pp. 187,

church used ancient columns to strengthen the walls and sustain the vaulting. The columns are characteristic of the examples of monastic structures given above. They are also a feature of the ambulatories of the cloister constructed by the Vassalletti at the Lateran between 1227 and 1237.[86] This was during the pontificate of Gregory IX (1227–1241), when the first phase of the new church of S. Francesco a Ripa may well have been built. In the north-eastern 'extra' aisle in the church of San Saba, there are four large cross vaults that are sustained by columns on one side and by brick pilasters on the other side of the aisle.[87] This part of the church was an external lateral portico in the twelfth century and was then restructured as an additional aisle of the church, probably in the last quarter of the thirteenth century. Cross vaults supported by columns seem to have been a feature of twelfth- and thirteenth-century Roman architecture and they could have been used in the first phase of S. Francesco a Ripa. In the late thirteenth century, ribbed vaulting was constructed in Rome, as was the case in the Sancta Sanctorum chapel at the Lateran, in some chapels at S. Maria in Aracoeli, in the Colonna chapel at S. Silvestro in Capite, and in the present sacristy of SS. Vincenzo e Anastasio.[88] These ribbed vaults were distinctively Gothic and a new development in Rome in the late thirteenth century.

Menichella found that Peruzzi indicated measurements on his plan of S. Francesco a Ripa in Roman palmi, which concur with the dimensions of the Baroque church given by Giuseppe Brusati Arcucci in 1685.[89] She was therefore able to superimpose the plan of the seventeenth-century church on Peruzzi's plan (Figs 76 and 79), which showed that the transept, nave and aisles of the Baroque church kept the same overall dimensions as the medieval building, but the enlarged choir of 1603–1608, the side chapels, and the Baroque façade were all added to the perimeter of the original edifice.[90] Claims had been made that the columns of the medieval nave were hidden within its later piers, but Menichella's documentation demonstrates that during the Baroque remodelling by Matthia de' Rossi, the chief Master Builder — Giacomo Bertioli — took away the medieval columns and capitals and sold them.[91]

A restoration campaign, which began in 2000–2001, has revealed that some walls have survived from the medieval church and the adjacent conventual buildings.[92] For example, one can see a medieval wall above the Paluzzi-Albertoni chapel, in which Bernini's statue of Ludovica Albertoni is installed.[93] The exterior of the wall is built of brickwork characteristic of the thirteenth century and the wall is crowned with a typical medieval frieze of bricks and

198; for S. Lorenzo, Barclay Lloyd, 'The Architecture of the Medieval Monastery at S. Lorenzo fuori le Mura', pp. 99–102; for S. Sisto, above, Chapter 1.

86 De Blaauw, 'A Mediaeval Portico', pp. 299–314, esp. p. 309; Claussen, *Magistri Doctissimi Romani*, pp. 126–32, esp. 127 for the date, p. 128 for the columns and vaulting; Claussen, Modini and others, ed., *Die Kirchen der Stadt Rom*, vol. II, pp. 115–314, esp. 154–55 (date) and 265–68 (columns and vaulting in the ambulatories).

87 Cutarelli, *Il complesso di San Saba*, pp. 32–33.

88 The ribbed vault in the Sancta Sanctorum must date to the pontificate of Pope Nicholas III (1277–1280), who built the chapel, see Gardner, 'L'architettura del Sancta Sanctorum', pp. 19–37; for the Colonna chapel in S. Maria in Aracoeli, built between 1279 and 1291, see Bolgia, *Reclaiming the Roman Capitol*, pp. 303–04; for the Colonna chapel in S. Silvestro, built after 1290, see Toesca in Gaynor and Toesca, *S. Silvestro in Capite*,

p. 40 and n. 9; for the sacristy at Tre Fontane, dated between c. 1284 and 1306, see Barclay Lloyd, *SS. Vincenzo e Anastasio*, p. 192.

89 Menichella, *San Francesco a Ripa*, p. 19.

90 Menichella, *San Francesco a Ripa*, plate XX.

91 *Memoriale di Matthia De'Rossi*, 20 settembre 1685 and *Replica del Padre Guardiano alla Risposta di Matthia De' Rossi*, in Menichella, *San Francesco a Ripa*, pp. 69, 99–102 and 103–06.

92 The results were published in 2011 in Degni and Porzio, ed., *La fabbrica del Convento*.

93 Udina, 'Dallo xenodocchio benedettino al convento francescano', pp. 22–23 and fig. 21.

marble brackets.[94] This would have been part of the north wall of the north-eastern arm of the medieval transept. Under the roof of the transept, some *opus saracinescum* masonry is accessible: it has a modulus of 36–42 cm for five rows of tufelli and five mortar beds and it is a building technique often used from the early thirteenth to the fourteenth century in Roman construction.[95] The masonry shows that the transept was built in the thirteenth century and then remodelled in the late seventeenth century.

From 1675 onwards, the whole church of S. Francesco a Ripa was transformed in the Baroque style with a new façade, designed by Mattia de Rossi and paid for with a bequest from Cardinal Lazzaro Pallavicini. What can be seen today is fundamentally the Baroque church, which was reconsecrated in 1701 by Cardinal Sperello Sperelli (1639–1710), who came from Assisi for the ceremony. Later in the eighteenth century, the high altar was rebuilt.

The medieval church of S. Francesco a Ripa was probably built in two medieval phases in *c.* 1230–1240 and in the 1280s. In 1290, the Franciscan Pope Nicolas IV granted indulgences to visitors to the church, perhaps at the end of the second campaign, which would have included the decoration with paintings by Pietro Cavallini.[96] It seems likely that the first phase was sponsored by Jacopa de' Settesoli, the second by Pandolfo II, Count of Anguillara. In the Catalogue of Turin, *c.* 1320, there were fifteen friars in residence, as opposed to fifty at S. Maria in Aracoeli.[97] Although it was a relatively small community, this was an important Franciscan church and friary because of its early foundation and because Saint Francis himself had stayed there.

The Friary

Gregory IX's Bull *Cum deceat vos*, dated 23 July 1229, ordered the monks of SS. Cosma e Damiano in Mica Aurea to transfer to the Franciscans not only the church, but also the adjacent residential buildings of the Ospedale di S. Biagio.[98] The friars then lived next to S. Francesco a Ripa. In the fifteenth century, the friary was home to Franciscan friars of the Observance (a reform instituted in 1368) as is evident from a document of 8 January 1444, in which Pope Eugenius IV referred to them as such.[99] Indeed, from 1579 to 1887, S. Francesco a Ripa was the headquarters of the Roman Province of the Franciscans of the Observance.

In 1472, Pope Sixtus IV issued a Bull, *Inter ceteros*, noting that the buildings of S. Francesco needed repair, and offering indulgences to people who donated money for that purpose.[100] In fact, in the fifteenth century, a new cloister was built south-west of the church (Fig. 76). In the 1580s, the convent was enlarged with funds provided by Vittoria Frangipane della Tolfa, wife of Pardo Orsini.[101] On the north-east of the church, a huge infirmary, 110 m long, was begun in 1603–1608. In the eighteenth century, the conventual buildings were extended further. In 1873, when the convent was suppressed by the Italian Government, the infirmary building was transferred to the Bersaglieri troops as their barracks, and only a small part of the original friary was reserved as a residence for the priests of the parish.

94 For the masonry, no dimensions are given of a modulus of five rows of bricks and five courses of mortar, which is a pity, as that would have indicated whether it was constructed in the first or second half of the thirteenth century.
95 Udina, 'Dallo xenodocchio benedettino al convento francescano', p. 28 and n. 7.
96 Anonimo, *S. Francesco a Ripa: Guida storico-artistico*, p. 113, mentioned a copy of a Bull, *Una perennis gloria*, of Nicholas IV issued on 10 August 1290 granting indulgences, in the Archive of S. Francesco a Ripa.
97 Valentini and Zucchetti, *Codice topografico*, vol. III, pp. 304 (S. Maria in Aracoeli) and 306 (S. Francesco a Ripa).

98 *BF*, vol. I, pp. 50–51.
99 Kuhn-Forte, 'S. Francesco a Ripa', p. 445.
100 Anonimo, *S. Francesco a Ripa: Guida storico-artistico*, p. 114.
101 Kuhn-Forte, 'S. Francesco a Ripa', p. 446.

In 2003, the former infirmary wing was ceded to the police who track down the illicit removal of artworks from Italy.[102]

Since the mid-twentieth century, parts of the medieval structures of the friary have come to light, revealed in successive restoration campaigns. In 1956, Arduino Terzi uncovered some medieval walls in the refectory and kitchen.[103] About twenty years later, Righetti Tosti-Croce wrote that parts of the early medieval buildings were still recognizable in the structures behind and to the left of the church.[104] In particular, there were remains of a long rectangular room, which she thought may have been where Saint Francis and his companions had stayed in 1219.

In the restoration of the convent buildings in 2000–2001, some stretches of thirteenth-century or early fourteenth-century masonry were uncovered, indicating that parts of the medieval friary survive, incorporated in the structures of later times.[105] For example, Fra Ludovico da Modena had referred to an enlargement of the refectory *c.* 1700, a fact now confirmed by the restorers: in part of that room, the masonry uncovered was found to be *opus saracinescum*, dating from the thirteenth century, whereas beyond that the masonry was different, indicating the eighteenth-century extension.[106] In the fifteenth-century cloister to the right of the church, *opus saracinescum* masonry was found on the ground floor and on the first floor, showing that parts of that building were based on earlier medieval structures.[107] Before columns were erected in the cloister ambulatories, there seem to have been wooden posts. Moreover, there was a disused circular cistern in the cloister courtyard built of *opus saracinescum*.[108] More stretches of the same masonry came to light in 'il cortile del lavatoio' (the courtyard of the washhouse) beyond the refectory. All these stretches of *opus saracinescum* indicate walls built in the thirteenth or early fourteenth century, which survive from the medieval Franciscan friary built around and beside the church of S. Francesco a Ripa. As with S. Sabina, the friary buildings were extended at later times — for example the addition of the long infirmary building to the north-east of the church in 1603–1608, and the enlargement of the refectory in the eighteenth century.

The Cell of Saint Francis

When, in 1603–1608, the architect Onorio Longhi built the new, enlarged choir, he wanted to destroy some structures behind the apse, which had been part of the early Ospedale di S. Biagio and were associated with Saint Francis's stay there, but Cardinal Alessandro Peretti Montalto, nephew of Pope Sixtus V, stopped this.[109] Instead, a new plan was made to retain parts of the old building and to allow access to a small room on the first floor now known as the 'cell of Saint Francis'. The medieval layout of the rooms behind the apse is not very clear, but it has been conjectured that there was a large dormitory — the 'dormitorio vecchio' — an oratory, and a small sacristy, which could be reached only from the convent, and not the church.[110]

102 Porzio, 'Il convento di San Francesco a Ripa e il quartiere di Trastevere', in Degni and Porzio, ed., *La fabbrica del Convento*, pp. 18–19.

103 Terzi, *S. Francesco a Roma*, pp. ix–xii.

104 Righetti Tosti-Croce, 'Gli esordi', pp. 29–30.

105 Udina, 'Dallo xenodocchio benedettino al convento francescano', pp. 21–53.

106 Udina, 'Dallo xenodocchio benedettino al convento francescano', p. 25.

107 Udina, 'Dallo xenodocchio benedettino al convento francescano', p. 25.

108 Udina, 'Dallo xenodocchio benedettino al convento francescano', p. 25; see also above, in the section 'Archaeological evidence'.

109 Pesci, *S. Francesco a Ripa*, p. 15.

110 Udina suggests that Francis and his companions may also have been accommodated in a large room like a dormitory where the present sacristy is located, see Udina, 'Dallo xenodocchio benedettino al convento

The cell of Saint Francis is on the first floor of the building and it is now reached from stairs located beyond a room behind and north-east of the choir. (The concept is rather like that of the cell of Saint Dominic in S. Sabina, which was remodelled in 1645–1647.) The cell of Saint Francis was made narrower in 1603–1608 and transformed into a chapel. Some plaster has been removed recently from the walls on either side of the cell, so one can examine the masonry. The wall on the right, looking towards the altar, is built of thirteenth-century *opus saracinescum*, with a modulus of 38–40 cm for five rows of tufelli and the intervening mortar beds, while the masonry of the wall on the left is completely different, consisting of a kind of very late *opus listatum* with alternating bands of one row of bricks to several uneven rows of stone. This wall was probably built in the early seventeenth century, when the room was made narrower. In the area behind and around the choir of 1603–1608, there are further traces of thirteenth-century masonry (*opus saracinescum*) accessible in the walls of the ground floor, which survive from the early thirteenth century.

In 1698, a new altar, filled with relics, was erected in the cell. It was designed by Fra Bernardino of Jesi, and made with funds from Cardinal Ranuccio Pallavicini. Three paintings are incorporated in the altar — one of Saint Francis in the centre, flanked by two others, of Saints Anthony of Padua and Louis of Toulouse.

In the cell, the painting of Saint Francis (Plate 5), which since the early twentieth century has been attributed to Margaritone d'Arezzo (active from *c.* 1240–1290) or one of his assistants, is said to have been executed sometime between 1250–1272.[111] The image is painted on wood and measures 129.5 cm in height and 52 cm in width. It is not known when exactly it came to S. Francesco a Ripa. Fra Mariano in 1518 mentioned that there was in the church a painting of the saint, which he identified with an image that had belonged to a devout medieval Roman lady, who had noticed that the artist had left out the wounds of the stigmata, which then mysteriously appeared, only to disappear again when she doubted this amazing occurrence — a story told by both Thomas of Celano, in 1250–1252, and Bonaventure, in 1260–1263.[112] This painting may have been transferred to S. Francesco a Ripa, as Fra Mariano believed, or the image in the cell may be a different representation of the saint. Today, one sees Saint Francis wearing a brown habit, with a pointed hood (cappuccio) over his head and to the right. He also has a halo outlined in red. His tonsure is revealed under the hood. Around his waist is his cord, with the traditional three knots, signifying poverty, chastity, and obedience. The marks of the stigmata are evident on his hands and feet, but there is no wound in his side.[113] Francis holds a red cross in his right hand against his chest and an open book in his left hand, inscribed with the text, 'Qui vult venire post me abneget semetipsum et tollat + suam' (He who would come after me let him deny himself and take up his cross [Matthew 16. 24]). Giovanni Colonna's *Life* of his sister Margherita Colonna, who died in 1280, may hint at this painting: he recounts how Margherita associated the words

francescano', p. 23. See also, Righetti Tosti-Croce, 'Gli esordi'.

111 See Falcucci, Leone, and Scarperia, 'Sulla tavola medievale di San Francesco d'Assisi a Ripa Grande in Roma',

pp. 277–342, with further bibliography, and Bolgia, *Reclaiming the Roman Capitol*, pp. 105–06.

112 For Fra Mariano, *Itinerarium Urbis Romae di Fra Mariano*, pp. 100–01; for the story of the painting, Thomas of Celano, 'The treatise on the miracles of Saint Francis, (1250-1252)', Chapter II, 8–9, FAED, vol. 2: *The Founder*, pp. 405–06; Bonaventure, 'The Major Legend of Saint Francis (1260-1263): The Miracles shown after his death', Chapter I, 4, FAED: *The Founder*, vol. 2, p. 652.

113 The wounds in the hands appear to have been repainted in a restoration made in the twentieth century. Those in his feet may be older since they indicate the nails, according to Falcucci, Leone, and Scarperia, 'Sulla tavola medievale di San Francesco d'Assisi a Ripa Grande in Roma'.

of the same text spoken in a vision by a preacher with a painting of Saint Francis that she had seen.[114] At that time she was also given a cross, which was red, and which became attached to her chest, more or less where the cross is located in the Trastevere image of Saint Francis.

A new study of the painting in Trastevere, published in 2014, documents various legends, historical references, and early photographs taken of it, as well as scholarly criticism, and a scientific examination of the panel, which included X-rays.[115] In the early seventeenth century, it was said to have been commissioned by Jacopa de' Settesoli before or just after Francis died. Luke Wadding, who mentioned but doubted that story in 1628, recorded that the image was in his time kept in the sacristy covered with a veil.[116] (It is possible that earlier it was on display in the church.[117]) Beside it, in the seventeenth century, there were the two other paintings, of Saint Anthony of Padua and Saint Louis of Toulouse, which are now also in the cell of Saint Francis. They seem from their style to have been painted later, in the first quarter of the fourteenth century.

The image of Francis has been repainted several times. This is evident, for example, with regard to the hood (cappuccio) of the saint, which has been shown as pointed or rounded at various times.[118] The halo has also been repainted. Early photographs indicate that the stigmata side wound was formerly shown, but it is not apparent today. It seems to have disappeared in a restoration of the panel undertaken in the 1940s by Emilio Lavagnino; and it was not replaced in another restoration in 1997.[119]

A photograph taken between 1892 and 1920, shows ex-votos attached, evidently with nails, to the lower sections of the panel, as well as a piece of paper glued to the painting, to the left of the saint's feet, which recounted the life and death of Saint Francis and perhaps told the story of Jacopa arranging for an image to be made of him.[120] These objects were removed in the 1950s and one could then see the feet of the saint with the stigmata and a broad strip of green paint across the lower part of the panel.[121]

When the painting was X-rayed in the early years of the twenty-first century, some vertical rows of small, blocked holes became visible, which have been explained as repairs to the image, made after the removal of the ex-votos.[122] Surprisingly, an inscription was found under the green paint at the level of the saint's feet, on both the right and left of the figure. It reads: 'MARGARITUS DE ARITIUS ME FECIT' (Margaritone of Arezzo made me). If genuine, this would confirm the attribution of the panel.[123] The words were later covered with paint and hence the inscription was hidden from view, only to come to light in the early twenty-first century.

114 *Visions of Sainthood in Medieval Rome*, p. 90. This is discussed more fully below, in Chapter 7.

115 Falcucci, Leone, and Scarperia, 'Sulla tavola medievale di San Francesco d'Assisi a Ripa Grande in Roma'.

116 Wadding, *Annales Minorum*, vol. II, pp. 254–55 (published originally in 1628).

117 A theory that images of a single standing saint were designed to be attached to piers in churches is mentioned by Falcucci, Leone, and Scarperia, 'Sulla tavola medievale di San Francesco d'Assisi a Ripa Grande in Roma', p. 282; see also Bolgia, 'Patrons and Artists on the Move', esp. pp. 196–98.

118 This is evident in early photographs.

119 Falcucci, Leone, and Scarperia, 'Sulla tavola medievale di San Francesco d'Assisi a Ripa Grande in Roma', p. 299.

120 This photo is in the Anderson-Alinari Collection. For a discussion of the paper attached to the painting, see, Falcucci, Leone, and Scarperia, 'Sulla tavola medievale di San Francesco d'Assisi a Ripa Grande in Roma', pp. 284–85.

121 Falcucci, Leone, and Scarperia, 'Sulla tavola medievale di San Francesco d'Assisi a Ripa Grande in Roma', p. 288.

122 Falcucci, Leone, and Scarperia, 'Sulla tavola medievale di San Francesco d'Assisi a Ripa Grande in Roma', pp. 319–20.

123 This discovery needs to be set beside other 'signed' images by Margaritone and his followers.

Conclusion

At this site, the Friars Minor were entrusted with the existing Benedictine Ospedale di S. Biagio, together with its church, which was probably small, and not in good condition. They rebuilt it with a tripartite transept rather like those in other early Franciscan churches and a nave and aisles separated by colonnades in the style of a Roman basilica. In the late thirteenth century, the church was decorated with scenes of the miracles of Saint Francis by Pietro Cavallini, which, unfortunately, no longer survive.

Parts of the medieval friary at S. Francesco survive under later restructuring. There were rooms on the north-east and behind the church, which may have been part of the hospice where Francis of Assisi and his companions stayed, when they came to Rome. There was also a medieval wing of the friary adjacent to the south-west aisle of the church, with a row of twelve cells. In the place occupied by the fifteenth-century cloister, there were other medieval structures and a round cistern in the courtyard. The medieval refectory was smaller than the one which survives today, which was extended *c.* 1700. Further medieval structures were found in the area which later became a courtyard with a washhouse. In the early seventeenth century, a large rectangular choir was added to the church and a long infirmary building was constructed to the north-east of it. At that time the cell of Saint Francis was made narrower. Although what one sees today at S. Francesco a Ripa is Baroque in style, aspects of the medieval buildings can be deduced from early descriptions and drawings, while architectural analysis and restoration campaigns have demonstrated that medieval parts of the building complex underly what remains today.

CHAPTER 4

The Franciscan Nunnery of SS. Cosma e Damiano (S. Cosimato), founded in 1234

After the Friars Minor had taken over the Ospedale di S. Biagio in 1229, Pope Gregory IX (1227–1241) persuaded the monks of SS. Cosma e Damiano in Mica Aurea to surrender the medieval Benedictine monastery itself in 1233.[1] The Pope planned to place a Camaldolese community there, but when that project failed, he founded a Franciscan nunnery instead, in 1234.[2] It was the first one in Rome. To accommodate the nuns, the Benedictine church was rebuilt, and a new cloister and convent were provided. It was known as 'S. Cosimato' from at least 1238 onwards and that is what it will be called here.[3] Later, Pope Sixtus IV (1471–1484) restored the nuns' church and added a new colonnaded courtyard, a second cloister. Subsequently, the convent buildings were extended.

S. Cosimato remained a nunnery until 1873, when it was suppressed by the Italian government. The Poor Clares then left and eventually settled on the Little Aventine Hill in a new convent, which still exists. On 9 May 1875, the buildings of S. Cosimato were officially expropriated by the Italian state for public utility and service.[4]

They were given to the Roman Commune and then transferred to the Confraternità di Carità. From 1892 to 1896, parts of the former convent buildings were demolished or remodelled to form a hospice for elderly residents, called the 'Ospizio Umberto I', after the king of Italy at the time.[5] New buildings were added from 1960 to 1970, when the complex was transformed into a hospital, the 'Ospedale Nuovo Regina Margherita', named in memory of Umberto I's wife. In the early twenty-first century, the status of this hospital was downgraded to a 'Poliambulatorio' (a diversified medical centre). Part of the nuns' church and extensive conventual buildings survive from the nunnery.

Location

Like S. Francesco a Ripa, S. Cosimato is situated in Trastevere, where the early Benedictine monastery of SS. Cosma e Damiano in Mica Aurea, which preceded the thirteenth-century Franciscan nunnery, was located at the foot of the Janiculum Hill (Fig. 75).[6] In 1005, Pope John XVIII (1004–1009) issued a Privilege, confirming the possessions of this abbey.[7] Besides noting its lands in and outside of Rome, this document

1 For the transfer of the Ospedale di S. Biagio, see above, Chapter 3.
2 Wadding, *Annales Minorum*, vol. II, pp. 406–07; *Vita ... Gregorii Papae IX, Rerum Italicarum Scriptores*, ed. by Muratori, vol. III, p. 575; *BF*, vol. I, no. 113, pp. 112–13; see also, Barclay Lloyd and Bull-Simonsen Einaudi, 'Cronologia', pp. 134–35.
3 A record of this name survives in a document of that date, see Fedele, 'Carte' (1898), p. 469. Wickham, *Medieval Rome*, Chapter 5, found an earlier reference to 'S. Cosimato' in 1078.
4 Bull-Simonsen Einaudi, 'Il monastero di S. Cosimato in Mica Aurea', p. 52, document 2.

5 This has been documented by Bull-Simonsen Einaudi 'Il monastero di S. Cosimato in Mica Aurea', Appendice I, pp. 51–71. Umberto I of the House of Savoy reigned as King of Italy from 1878 to 1900.
6 See above, Chapter 3. See also, Wickham, *Medieval Rome*, Chapter 5.
7 Pflugk-Hartung, *Acta pontificum Romanorum*, vol. II, no. 93, pp. 57–68.

gives a valuable description of the monastery itself and its property in Trastevere at that time. The description begins by calling it:

> ipsum [...] monasterium, quod est edificatum in honore beatissimorum martirum Cosme et Damiani, una cum ecclesia maiore sancti confessoris Benedicti, cum diversis mansionibus et caminatis atque cellis et hortuis, seu et oratorio sancti confessoris Nicolai cum cellis et porticulis suis [...]
>
> ([...] the monastery itself, which is built in honour of the most blessed martyrs Cosmas and Damian, together with the major church of the holy confessor Benedict, with various living quarters and heated rooms, as well as cells and gardens; and also the oratory of the holy confessor Nicholas with its cells and little porticoes [...])[8]

(The 'little porticoes' may have been a cloister.) Beyond these buildings, there were vineyards. In front of the monastery, there were stables and 'pens' (?) for animals.[9] (This is reminiscent of the *Plan of St Gall*, where there are stables for horses, brood mares, foals, oxen, and cows, as well as pens for sheep, goats, and pigs in front of the main monastic buildings.[10]) On one side of the Roman monastery stood some dwellings, with gardens and orchards. There were also some ancient ruins: part of a Roman aqueduct and some ancient rooms, in which there had formerly been three mills driven by water ('aquimoles tres'). There was another oratory, dedicated to Saint Lawrence, next to a seeding ground. The monastery also owned part of the riverbank, with a fishing pool in the Tiber called 'Solarulus' and a site for constructing a water mill. SS. Cosma e Damiano's main property in Rome was located in Region XIV (Trastevere) in the place called 'Mica Aurea'.[11] The main property was within these borders: on one side, there was the road that came down the Janiculum Hill from Porta San Pancrazio; on the second side, there was another road, leading straight past the apse of the basilica of S. Cecilia, going towards land that belonged to the monastery of S. Maria in Capitolio, with the land of the monastery of S. Bonifacio behind it, and then straight on to the river; on the third side, there was the Tiber, up to half its width, as far as the Porta Portuensis; and on the fourth side, there stood the Roman city walls. From this evidence, it is clear that almost all the sparsely inhabited area shown in Trastevere on the Cartaro Map (Fig. 75) belonged to the monastery, from the foot of the Janiculum Hill to halfway across the Tiber, and from the last rows of houses in the built-up area of Trastevere to the Aurelian Wall. (One place that was not mentioned was the Ospedale di S. Biagio, which was to become S. Francesco a Ripa. This may indicate that the hospice was established after 1005.)[12]

The monastery also possessed property elsewhere in Rome. It owned a watermill in the river near Tiber Island, with all its equipment and some land on the bank nearby, and another water mill, near the public pool of Saint Gregory. There was an oratory of S. Angelo, whose location

8 Excerpts given here are from, Pflugk-Hartnung, *Acta Pontificum Romanorum*, vol. II, no. 93, pp. 57–68. See also, Barclay Lloyd and Bull-Simonsen Einaudi, 'Cronologia', pp. 130–32; Barclay Lloyd, 'The Medieval Benedictine Monastery of SS. Cosma e Damiano', pp. 25–26; and Bull-Simonsen Einaudi, 'Perché studiare San Cosimato?', pp. 15–16.

9 The text refers to 'bovarica et manarica': 'bovarica' is a word used for 'stables', but the meaning of 'manarica' is unknown. Given the context, the term 'pens' (for other farm animals) is suggested.

10 For the monastery at San Gall, see Horn and Born, *The Plan of St Gall*.

11 The name is discussed above, in Chapter 3, pp. 158–59.

12 Excavations at S. Francesco a Ripa made in 2009–2010 brought to light evidence of habitation and burials in the ninth and tenth centuries, however; see above, Chapter 3, and Degni and Porzio, ed., *La Fabbrica del Convento*, pp. 7, 22, 26.

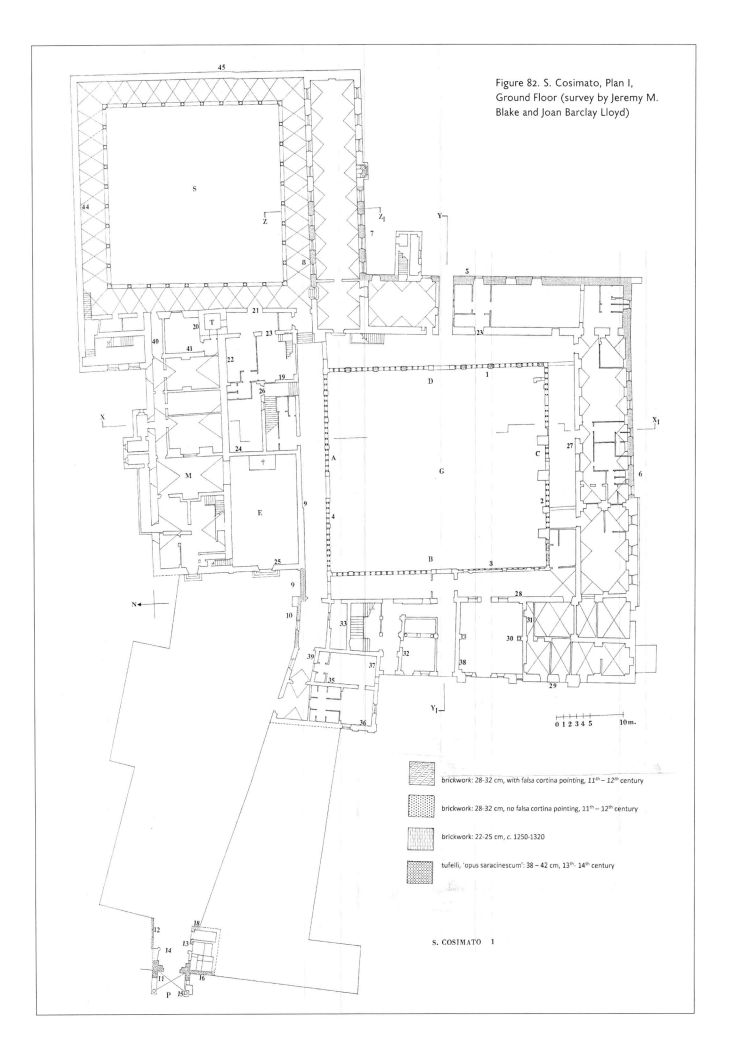

Figure 82. S. Cosimato, Plan I, Ground Floor (survey by Jeremy M. Blake and Joan Barclay Lloyd)

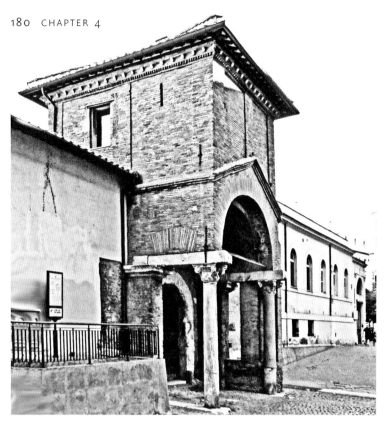

Figure 83. S. Cosimato, prothyron, viewed from north-west (photo: author)

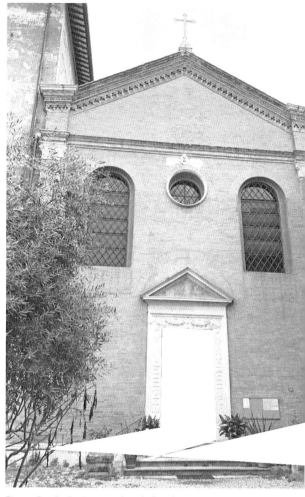

Figure 84. S. Cosimato, church façade, as rebuilt in 1475 (photo: author)

was not specified. There was also a small church of S. Maria, with some monastic cells, which stood on the stone bridge (the Pons Aemilius, later named Ponte S. Maria, after that building).[13] On the Janiculum Hill, the monastery owned some arable land, around some 'crypts', which were probably ruins of ancient Roman buildings. There were also possessions outside some of the city gates (Porta Appia, Porta S. Pancrazio, and Porta Portuensis); and there was property a long way from Rome. The document included S. Maria in Minione, which the abbey claimed to possess from the mid-tenth century until it was definitively established legally in 1072 that it belonged to the monastery of Farfa.[14]

When the nuns took over S. Cosimato, they were not given all the former possessions of the Benedictine abbey. Instead, they were provided with a new church beside new convent buildings constructed around a cloister, some land around the nunnery, and some other property outside Rome.

13 In the Middle Ages, the bridge was called S. Maria, and 'Ponte Rotto' (the broken bridge) later, after it collapsed in 1557.
14 Until that time, there was litigation between the abbeys of Farfa and SS. Cosma and Damiano over the possession of this monastery. For this dispute, see Kehr, *Italia*

Pontificia, vol. I, p. 130, nos 1–3, 5, 8, p. 131, no. 8; *Il Regesto di Farfa*, ed. by Giorgi and Balzani, vol. III, pp. 149–51, doc. 437, p. 153, doc. 439; vol. IV, p. 217; vol. V, pp. 9–11, doc. 1006; Fedele, 'Carte' (1898), pp. 474–76; p. 478; *Chronicon Farfense*, ed. by Balzani, vol. II, pp. 10–19 and 157–58.

S. Cosimato Today

A piazza opens in front of both the church of S. Francesco and in front of S. Cosimato. Since 1608–1611, a road named 'Via di S. Francesco a Ripa', has connected that Franciscan church and friary with S. Callisto, which is not far from S. Cosimato. Another very broad road, Viale di Trastevere (formerly named 'Via del Re'), now cuts Trastevere into two parts.[15] This major thoroughfare was constructed in the nineteenth century, to link a new bridge across the Tiber (Ponte Garibaldi) to the railway station in southern Trastevere. S. Cosimato and S. Francesco a Ripa now stand on opposite sides of Viale Trastevere, which has totally changed the morphology of this part of Rome.

S. Cosimato, now the Poliambulatorio of the former Ospedale Nuovo Regina Margherita, can be entered on the west, from Piazza S. Cosimato or from Via Roma Libera; and, on the south, from Via Emilio Morosini. Approaching the site from Piazza S. Cosimato, one comes to the medieval gatehouse or 'prothyron' of the former Benedictine monastery (Figs 82, P, and 83), which is reminiscent of other medieval entrance porches and monastic gates, such as those at S. Clemente, S. Maria in Cosmedin, and SS. Vincenzo e Anastasio alle Tre Fontane.[16] If one

Figure 85. S. Cosimato, thirteenth-century cloister, west wing B, viewed from east (photo: author)

enters the complex through this gateway, one comes into an irregular open space, with a garden and a fountain, and the church of S. Cosimato (Fig. 82, E) to the east. The church today is L-shaped, with a single rectangular nave and one large chapel, M, to the north. Its brick façade is pierced by two large round-headed windows, an oculus, and a wooden door surrounded by a carved marble frame (Fig. 84).

If one enters the complex further south, from Via Roma Libera, one walks east past some modern buildings to an L-shaped block, whose ground floor is strengthened by heavy buttresses, and which incorporates the western wing B of the medieval nunnery. Crossing this wing, one comes to the thirteenth-century cloister, with its arcaded porticoes of twin colonnettes surrounding a spacious garth (Figs 82, G, and 85). From there, most visitors step up to the fifteenth-century courtyard, to the north-east (Figs 82, S, and 86).

On the south, the Via Morosini entrance, formerly used by ambulances, is next to the 1960s

15 See Carlotti, 'Ripensare Trastevere disegnando San Cosimato', pp. 117–39, and see esp. his fig. 6.
16 See Barclay Lloyd, 'Il protiro medievale a Roma'.

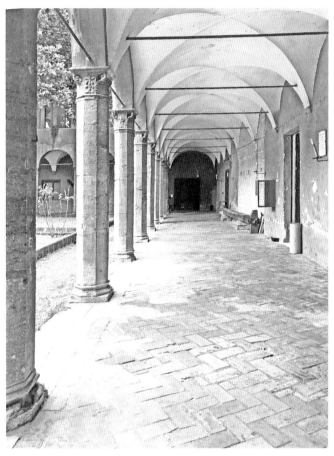

Figure 86. S. Cosimato, fifteenth-century cloister S, west wing (photo: author)'

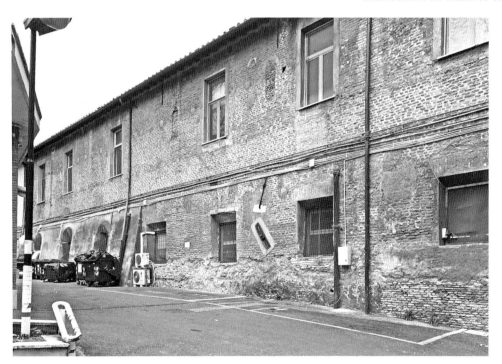

Figure 87. S. Cosimato, southern wall of thirteenth-century south wing C (photo: author)

buildings of the Ospedale Nuovo Regina Margherita. From this side, one sees the southern wall of the eastern wing C, of the medieval nunnery (Fig. 82, C and Fig. 87), constructed of thirteenth-century brickwork and *opus saracinescum*, in which some small, blocked round-headed medieval windows are still visible among larger rectangular openings of later date. Going further north from the entrance, one comes to a car park, where the eastern wall of wing D of the medieval nunnery (Fig. 82, D) is visible on the left; it is also built of *opus saracinescum* and has some slightly larger blocked round-headed medieval windows. Straight ahead, to the north, there is a Conference Room, now divided by a narrow wall into a vestibule and a long hall. The masonry on the southern side of the Conference Room shows that these rooms were built in two phases, one in the Middle Ages and the other much later (Figs 82 and 88).

The way the buildings appear today does not accurately reflect their form and function in the Middle Ages. They have changed over the years and the medieval parts of the complex are in a bad state of repair. To understand and reconstruct the medieval church and monastic buildings at S. Cosimato requires a more profound investigation of the documents related to the history of the monastery, drawings and prints that portray its former layout, and the plan, elevation, and structural details of the buildings themselves. In order to study the buildings carefully, an architectural survey was made of the medieval and early modern structures at S. Cosimato by the architect, Jeremy M. Blake and the author, leaving out what were clearly much later additions (see Plans I, II, and III, and Sections XX1 and YY1 – Figs 82, and 89–92). From the different kinds of historical and material evidence, it has been possible to identify and reconstruct several medieval building phases in a relative chronology. All this was included in a book on S. Cosimato co-authored

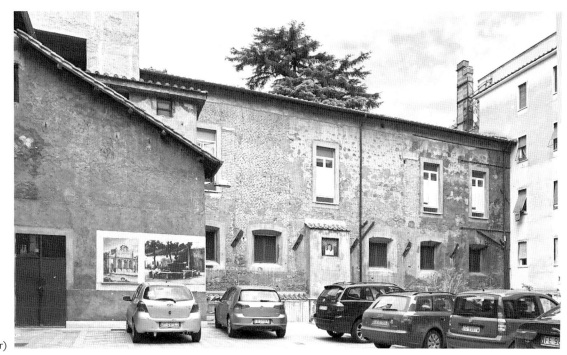

Figure 88.
S. Cosimato, view towards southern side of Conference Room (photo: author)

with Karin Bull-Simonsen Einaudi and published in Italian in 1998.[17] It is the aim of this study to take a new look at the history and architecture of the Franciscan nunnery of S. Cosimato, in the light of this and of more recent publications.[18]

Archaeological Evidence

In the late nineteenth century, some medieval and ancient remains came to light on the site of S. Cosimato during building programmes undertaken in 1892 and 1894, rather than through systematic scientific archaeological excavations.[19] In 1892, when the nunnery was being restructured to form the Ospizio Umberto I, changes were made in wing A to the north of the cloister (Fig. 82, A). Plans drawn in 1875 and just before 1892 (Figs 93, 94, and 95) show the disposition of this wing before that transformation, and indicate what was projected and then built.[20] The church, which had been divided by a transverse north–south wall into two parts — one to the east of the wall with a single nave and an apse, the other a rectangular space to the west of the dividing wall and a chapel on the north — was to be reduced to only the western part, as it is today (Fig. 82, E and M). The eastern section, which had been the nuns' choir, was transformed: the apse was demolished, and the remaining space was filled with a staircase and three rooms on the ground floor (compare Figs 82, 93, 94, and

17 Barclay Lloyd and Bull-Simonsen Einaudi, *SS. Cosma e Damiano in Mica Aurea*.
18 Since 1998, new publications have included Lowe, 'Franciscan and Papal Patronage'; Lowe, 'Artistic Patronage'; Lowe, *Nuns' Chronicles and Convent Culture*, pp. 123–41; Jäggi, *Frauenklöster*, pp. 27–28, 191; Guerrini Ferri and Barclay Lloyd, ed., with Velli, 'San Chosm' e Damiano e 'l suo bel monasterio'; and Velli, ed., *Nuovi Studi su San Cosimato e Trastevere*.
19 These are discussed by Bull-Simonsen Einaudi, 'Il

monastero di S. Cosimato in Mica Aurea', pp. 24–41, relying on archival documents in Rome.
20 A photocopy of the *c*. 1892 plan (Fig. 94) was given to Jeremy Blake at the time of the survey by the architect in charge of the buildings at S. Cosimato. This plan was not included in Barclay Lloyd and Bull-Simonsen Einaudi, *SS. Cosma e Damiano in Mica Aurea*.

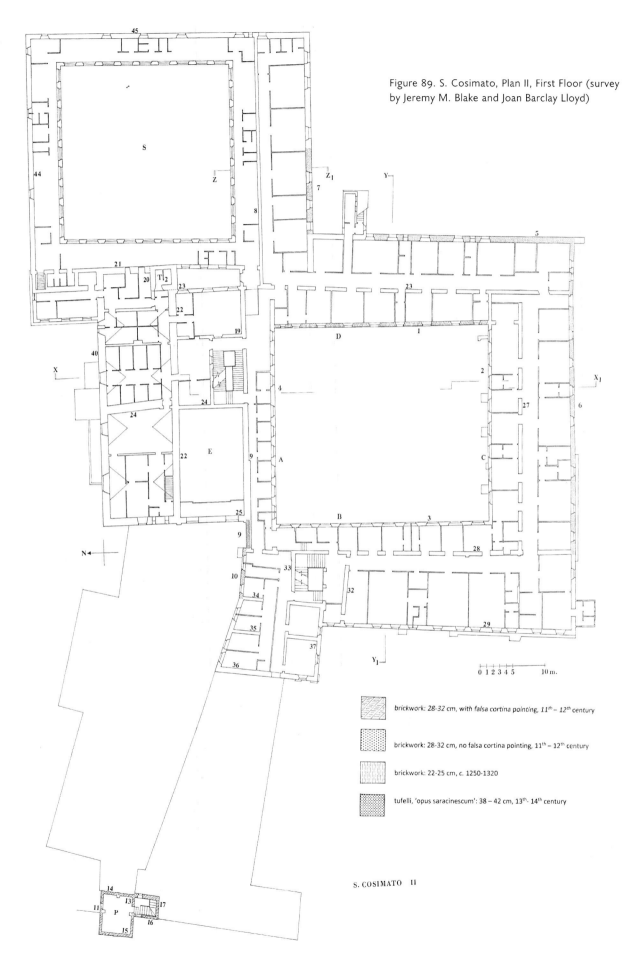

Figure 89. S. Cosimato, Plan II, First Floor (survey by Jeremy M. Blake and Joan Barclay Lloyd)

95), and more rooms were inserted above these on the floor above (Figs 89 and 91).

When these changes were begun in 1892, the apse was found to be decorated with more than one layer of murals, described as 'pitture votive le quali sembrano sopra altre più antiche' (votive paintings, which seem to be over older ones) but none of these were deemed to be of sufficient artistic value to merit the expense of their being removed from the wall and preserved.[21] In a report by Giuseppe Bonfanti, dated 18 July 1892, some of the builders' other discoveries were listed.[22] In the apse there was an altar, which was removed. (It is significant that there was an altar in the nuns' choir and another in the outer church.)[23] At a level 1.50 m below the altar were found two glass urns containing relics of holy martyrs; a pectoral cross, made of bronze and perhaps also containing a relic; an ivory box; and a smaller wooden container, which contained sacred objects that were unrecognizable. Attached to the altar was an eleventh-century inscription recording the consecration of the Benedictine church by Pope Alexander II in 1066.[24] To the right of the altar, in the pavement, was the tombstone of Francheta della Rovere, Pope Sixtus IV's sister.[25] On the left, about 1.00 m below the floor, an earlier pavement was found, with mosaic in black and white, 'ornato dei consueti simboli cristiani' (decorated with the usual Christian

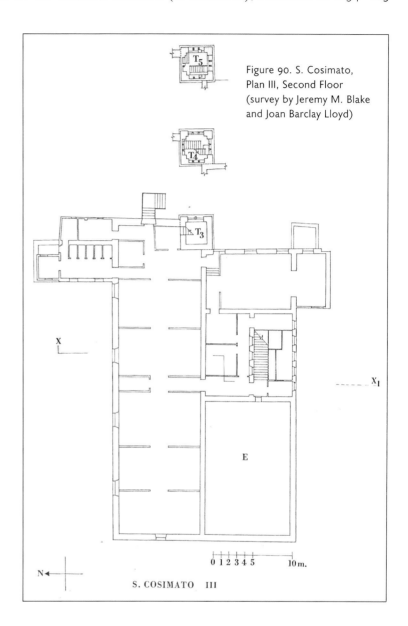

Figure 90. S. Cosimato, Plan III, Second Floor (survey by Jeremy M. Blake and Joan Barclay Lloyd)

symbols). Later, this was described in more detail as a mosaic divided into squares, in which were represented a transenna, a fish, and two eagles.[26] These finds were later displayed on the north wall of the thirteenth-century cloister in a collection of over 200 ancient Roman and early medieval pieces from under the floor of

21 This information is taken from two letters and a report, dated 9, 18, and 22 August 1892, See Bull-Simonsen Einaudi, 'Il monastero di S. Cosimato in Mica Aurea', Appendice I, documents 13, 14, and 15, pp. 59–60; and see comments by Bull-Simonsen Einaudi, on pp. 24–28.

22 Published in Barclay Lloyd and Bull-Simonsen Einaudi, *SS. Cosma e Damiano in Mica Aurea*, Appendice I, document 7, pp. 54–55.

23 For this sort of disposition, see Jäggi, *Frauenklöster*, pp. 207–16.

24 Orsola Formicini described the inscription as forming the first step in front of the altar, see Formicini, *Istoria*, BAV, Vat. Lat. 7847, fols 12r–12v. It is now in the present church.

25 Discussed in greater detail below.

26 Gatti, in *Notizie degli Scavi*, 1892, p. 325, quoted by Bull-Simonsen Einaudi, 'Il monastero di S. Cosimato in Mica Aurea', pp. 25–26, and partly illustrated in fig. 51.

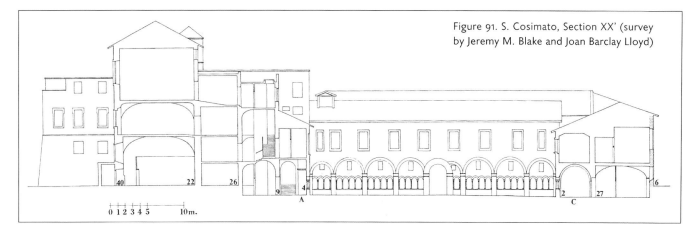

Figure 91. S. Cosimato, Section XX' (survey by Jeremy M. Blake and Joan Barclay Lloyd)

the nuns' choir found in 1892, and from other locations at S. Cosimato found in 1894.[27] Among these fragments, there are some pieces of marble decorated with the interlace designs typical of Carolingian ecclesiastical furnishings in Rome. Such items were found in the nuns' choir and in the thirteenth-century cloister. Details of their provenance are unknown. They may have been in the earlier Benedictine church; they may have belonged to an earlier ecclesiastical building on the site; or they may have come from elsewhere and been reused at S. Cosimato. The finds in the nuns' choir suggest that it was constructed within an earlier building, which had itself been restructured, perhaps more than once. It was not built totally *ex novo* by Pope Sixtus IV in 1475, as has sometimes been stated, but it was restored or remodelled in the fifteenth century.[28]

In 1892 and in 1894, some significant ancient Roman remains came to light in other places at S. Cosimato.[29] A mosaic typical of Roman floors of the second century BC was found at a depth of 5.60 m in one of the internal gardens of the Ospizio in 1892.[30] Other fragments of later ancient Roman floor mosaics were found under the kitchen garden of the Ospizio in 1894.[31] In one room, at a depth of 1.60 m, there was a mosaic image of a head surrounded by dolphins and, in a smaller room nearby, a mosaic with designs in black and white tesserae. These pieces are thought to survive from an ancient Roman bath building on the site.

In the garden in front of the church, there is a fountain, which incorporates an ancient Roman bath 'tub' of grey granite.[32] Its provenance is not known, but an inscription states it was incorporated in the fountain in 1731. It may have been part of the Roman bath building with mosaic floors. Laura Gigli and Marco Setti suggest plausibly that the fountain was designed by Giovanni Pietro Minelli, who was the architect in charge of the convent buildings from 1715 to 1749.[33]

27 These pieces will be discussed in part of a book on medieval sculpture in Trastevere by Karin Bull-Simonsen Einaudi. They were recently catalogued by members of the Associazione Mica Aurea. Some of the original fragments have disappeared, presumed lost or stolen.

28 Bull-Simonsen Einaudi, 'Il monastero di S. Cosimato in Mica Aurea', p. 28.

29 Bull-Simonsen Einaudi, 'Il monastero di S. Cosimato in Mica Aurea', pp. 34–41.

30 Gatti, Report in *Notizie degli Scavi* (1892), p. 265; Bull-Simonsen Einaudi, 'Il monastero di S. Cosimato in Mica Aurea', pp. 35–36 n. 60 and fig. 47.

31 Gatti, Report in *Notizie degli Scavi* (1894), p. 279; Bull-Simonsen Einaudi, 'Il monastero di S. Cosimato in Mica Aurea', pp. 36–37 n. 62 and fig. 49.

32 Bull-Simonsen Einaudi, 'Il monastero di S. Cosimato in Mica Aurea', p. 38 and fig. 50; the fountain was restored in 2009, see Gigli and Setti, 'Il restauro della fontana', pp. 199–208.

33 Gigli and Setti, 'Il restauro della fontana', p. 202.

THE FRANCISCAN NUNNERY OF SS. COSMA E DAMIANO (S. COSIMATO), FOUNDED IN 1234 187

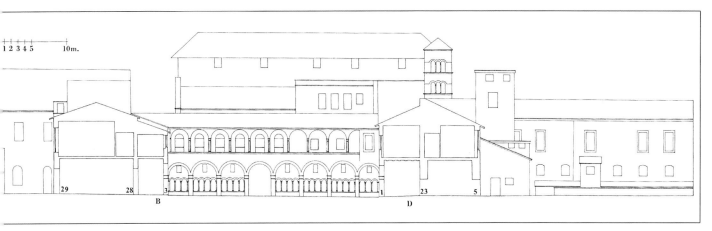

Figure 92. S. Cosimato, Section YY' (survey by Jeremy M. Blake and Joan Barclay Lloyd)

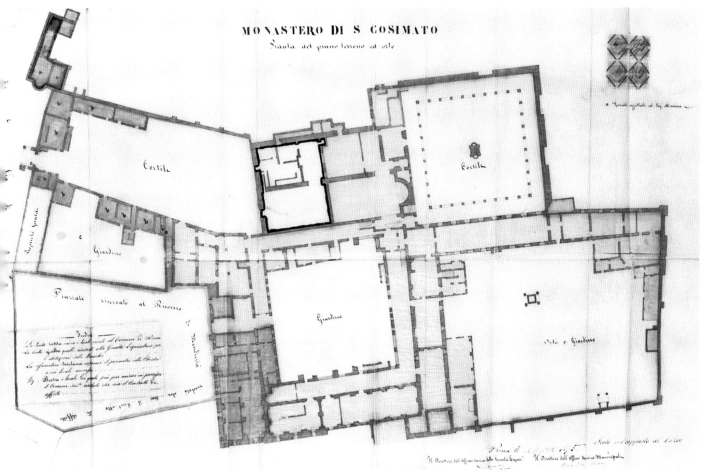

Figure 93. S. Cosimato, Plan made in 1875 (ASC, Contratti. Atti privati, 1875, parte seconda) permission to publish granted by the Soprintendenza Capitolina ai Beni Culturali

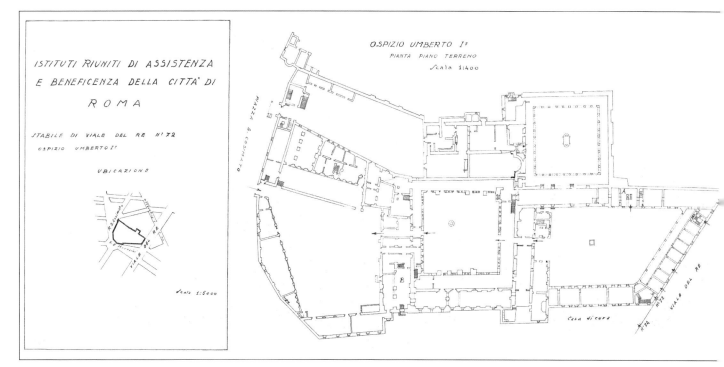

Figure 94. Ospizio Umberto I, Plan of Ground Floor, c. 1892, detail (from photocopy given to Jeremey M. Blake by the former architect at Ospedale Regina Margherita)

There is a marble portrait bust of a man, of unknown provenance, which seems to date from the Roman Republican era.[34] It used to be part of a fountain in the medieval cloister and is now in the vestibule in front of the Conference Room.

When the prothyron at S. Cosimato was restored in the 1990s, some small excavations at its base revealed that it stands above an earlier building.[35] From its masonry, one can date the prothyron to the eleventh or twelfth century. Not much is known of the previous structure, which may have been the gatehouse of the monastery in the tenth century.

The Benedictine Abbey of SS. Cosma e Damiano in Mica Aurea

A very early ecclesiastical or monastic establishment may have existed at 'Mica Aurea' in Trastevere, dating from before the tenth century.[36] This is suggested by the early fragments of mosaic and liturgical sculpture found in 1892 in the nuns' choir and cloister. In addition, Sister Orsola Formicini, a Poor Clare nun at S. Cosimato from 1556 to 1615, wrote in her history of the monastery that she had discovered some early documents, which she used as sources for her work.[37]

34 Bull-Simonsen Einaudi, 'Il monastero di S. Cosimato in Mica Aurea', p. 36 and fig. 48.

35 Sacchi, 'Santi Cosma e Damiano in Mica Aurea (S. Cosimato): restauri nel protiro', pp. 83–100.

36 See Bull-Simonsen Einaudi, 'Il monastero di S. Cosimato in Mica Aurea', pp. 28–34, for possible evidence of such an early establishment.

37 For Orsola Formicini, see above, Chapter 3. Manuscripts of her history are in Rome, Biblioteca Nazionale Centrale, Varia 5 and Varia 6; and BAV, Vat. Lat. 7847. See also, Bull-Simonsen Einaudi, 'Il monastero di S. Cosimato in Mica Aurea'; Barclay Lloyd and Bull-Simonsen Einaudi, *SS. Cosma e Damiano in Mica Aurea*, pp. 28–34, and 139; Lowe, *Nuns' Chronicles and Convent Culture*; Bull-Simonsen Einaudi, 'Perché

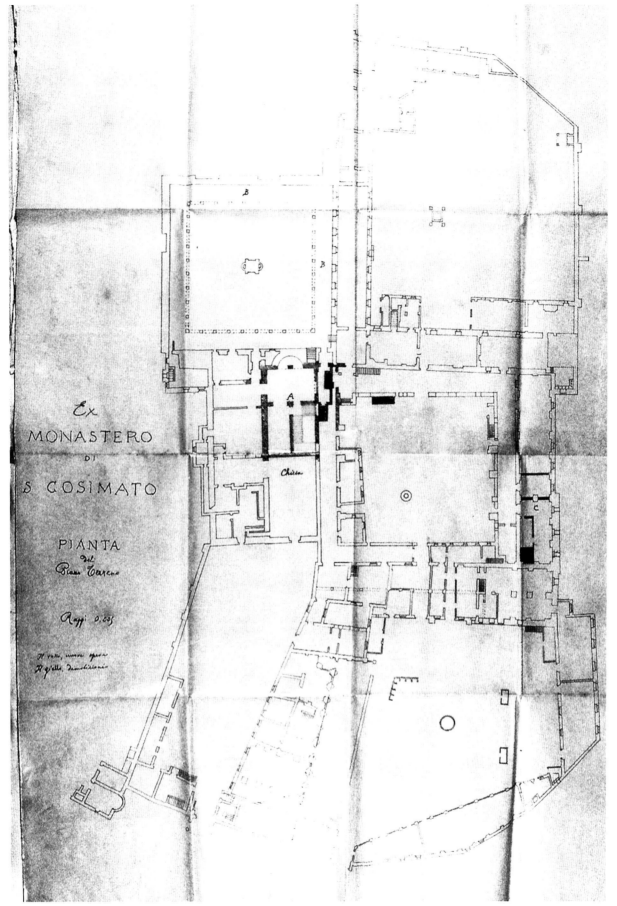

Figure 95. S. Cosimato, Plan drawn in 1892, indicating changes planned in the church (ACSR, AABBAA, II, II. Busta 402, All.B.13)

Among these, there were ten documents that she dated between 685 and 930, but they are now lost, and they are not mentioned in the nineteenth-century studies on the subject.[38]

Instead, the extant medieval documents refer to the history of the monastery from the tenth century onwards.[39] They state that, between 936 and 948, the noble Benedictus Campaninus founded the monastery of SS. Cosma e Damiano in Mica Aurea on his own property in Trastevere.[40] (The name 'Campaninus' in the tenth century evidently indicated that he came from the territory around Frosinone; he clearly owned extensive land in Rome too.[41]) Benedictus Campaninus was mentioned as being present at a legal case held in 942 with other Roman nobles in the entourage of Alberic, Prince of the Romans from 932 to 954.[42] Alberic had invited Abbot Odo of Cluny to come to Rome in 936 to reform some of the existing monastic institutions in the city and to found new ones, such as S. Maria in Aventino in the house where Alberic was born.[43] This monastic reform occurred at the same time as Benedictus Campaninus founded the early monastery of SS. Cosma e Damiano, and one suspects that the Trastevere foundation may have been influenced by the Cluniac reforms in Rome.[44]

The new foundation was closely associated with the imperial abbey of S. Maria at Farfa in Sabina, which had been razed to the ground by the Saracens in 882 and was then revived in the early tenth century.[45] Campo, Abbot of the monastery at Farfa from *c.* 936 to 962, assisted Benedictus Campaninus in establishing the monastery in Trastevere. Its first abbot was Venerandus, formerly prior of the Farfa cell of S. Maria in Minione.[46] When Venerandus came to Rome, he retained his rights over S. Maria in Minione and its dependencies. Later abbots of SS. Cosma e Damiano in Mica Aurea made the same claims, which were contested by the monks of Farfa. The matter remained fluid until Hildebrand in 1072 decided in Farfa's favour.[47]

In 1066, the main church at SS. Cosma e Damiano in Mica Aurea was enlarged by Abbot Odemundus, whose epitaph is now in the medieval cloister of San Cosimato.[48] He had begun his monastic life at Farfa, and, while he was there,

studiare San Cosimato?', pp. 21–22; Guerrini Ferri, 'I libri di suor Orsolina Formicini', pp. 89–99; Guerrini Ferri, 'Il *Liber monialium* ed il *Libro de l'antiquità* di suor Orsola Formicini'; Guerrini Ferri, 'Storia, contabilita ed approvvigionamenti nel monastero di San Cosimato' pp. 19–61.

38 Pointed out by Bull-Simonsen Einaudi, 'Il monastero di S. Cosimato in Mica Aurea', p. 33.

39 See Fedele, 'Carte' (1898 and 1899). New assessments of the collection of early documents, which are in the Archivio di Stato in Rome, were published in 2013: Mantegna, 'Le carte di SS. Cosma e Damiano in Mica Aurea', pp. 53–60; Voltaggio, '*et stavan confusamente*', pp. 61–87.

40 *Il Regesto di Farfa*, ed. by Giorgi and Balzani, vol. III, doc. 439, p. 153; Fedele, 'Carte' (1899), pp. 18–21; and Bull-Simonsen Einaudi, 'Perché studiare San Cosimato?', pp. 15–18.

41 Wickham, *Medieval Rome*, pp. 563, 566–68.

42 *Il Regesto sublacense*, ed. by Allodi and Levi, pp. 202–04. See also, Barclay Lloyd, 'The Medieval Benedictine Monastery of SS. Cosma e Damiano', p. 25; and Wickham, *Medieval Rome*, pp. 95 and 563.

43 *Chronicon farfense*, ed. by Balzani, vol. I, 1903, pp. 39–40. This reform is discussed by Hamilton, *Monastic Reform,*

Catharism and the Crusades, II, pp. 35–68 ('The Monastic Revival in Tenth Century Rome'). See also Fedele, 'Carte' (1898), p. 479. S. Maria in Aventino was on the site of S. Maria in Priorato, where the Knights of Malta now have their headquarters in Rome.

44 Ferrari, *Early Roman Monasteries*, p. 104, commented, 'Benedictus Campaninus could not have escaped the notice of both Alberic and St Odo of Cluny, both interested in the reform of Roman monasteries of the time'.

45 For the history of the monastery at Farfa, see Schuster, *L'imperiale abbazia di Farfa*, and for the architecture of the abbey church, McClendon, *The Imperial Abbey of Farfa*.

46 *Il Regesto di Farfa*, ed. by Giorgi and Balzani, vol. III, doc. 439, p. 153.

47 Fedele, 'Carte' (1898), pp. 474–78. The Privilege of Pope John XVIII in 1005 included S. Maria in Minione in the list of SS. Cosma e Damiano's possessions, however.

48 See above, Chapter 3.

the church of that monastery was extended by Abbot Berardus I and consecrated by Pope Nicholas II on 6 July 1060.[49] Another inscription, found in the nuns' choir in 1892 and now in the church of S. Cosimato, commemorates the consecration of the renewed Roman church by Pope Alexander II (1061–1073) in November 1066. In this inscription, the church is called a 'basilica', which probably means that it had an apse, a nave, separated by colonnades from two aisles, and possibly a transept, but details of its layout are now unknown. The church was dedicated to the Blessed Virgin Mary, the martyrs Cosmas and Damian, Saint Benedict, and Saint Emerentiana. It was probably a later version of the church of Saint Benedict, mentioned in the 1005 Privilege of Pope John XVIII.[50] The eleventh-century renewal of the church at SS. Cosma e Damiano in Mica Aurea appears to have been part of a Benedictine revival of ecclesiastical buildings in Central Italy, when other churches were rebuilt and consecrated, such as those at Farfa in 1060 and at Monte Cassino in 1071.[51]

Not much survives of the Benedictine monastic buildings at SS. Cosma e Damiano in Mica Aurea. The most striking feature that is preserved is the monastery's gatehouse, or prothyron (Fig. 82, P, and Fig. 83).[52] It was not built on the same axis as the medieval monastic church, as was the case with other monastic gatehouses in Rome, such as that at SS. Vincenzo e Anastasio alle Tre Fontane. In the front, two ancient Roman columns, supporting Composite Severan capitals and a semi-circular arch, flank the entrance to the gateway. The column on the north is of white marble and fluted. That on the south has been damaged and repaired, as a result of an incident in 1849; it now consists of two pieces, one of white marble and fluted at the bottom that is joined to part of a plain grey granite shaft on top.[53] Above the columns on either side is a marble entablature, sustained near the entrance by ornate ancient Roman marble brackets. The entablature on the south has been damaged and a brick pier now supports it. The space in front of the doorway is covered with a segmented vault. The doorway itself is framed by a semi-circular arch of rough blocks of tufa, as remodelled in the seventeenth century. (The material is similar to that in the arch leading into the narthex and from there into the convent at S. Sabina (Fig. 62), but the Dominican doorway is more finely constructed.) The internal side of the prothyron was originally similar to the exterior, but the southern column has been replaced by a brick pier. The capital above that is a medieval copy of the ancient Roman Composite capital on the northern interior column. The inner part of the gatehouse is covered with a barrel vault and its façade rises in a semi-circular arch. The gatehouse has an upper storey, consisting of a single room (Fig. 89, P). There is now a window in the northern wall and formerly a window also opened in the west wall, as can be seen in early photographs. Externally, the walls are each

49 For Odemundus, see *Il regesto di Farfa*, ed. by Giorgi and Balzani, vol. IV, pp. 229–31, docs. 829–31, all dated 1052; vol. V, pp. 291–96, esp. 294–95, doc. 1307, which is signed by 'Odemundus praesbiter et monachus'. See also, Schuster, *L'imperiale abbazia di Farfa*, p. 129.

50 Pflugk-Hartnung, *Acta pontificum Romanorum*, vol. II, no. 93, pp. 57–68.

51 Barclay Lloyd, 'The Medieval Benedictine Monastery of SS. Cosma e Damiano', p. 27; Barclay Lloyd and Bull-Simonsen Einaudi, 'Cronologia', p. 134. For the rebuilding of the church at Monte Cassino, see Bloch, 'Monte Casino, Byzantium and the West', and Bloch, *Monte Cassino in the Middle Ages*.

52 See Barclay Lloyd, 'The Medieval Benedictine Monastery of SS. Cosma e Damiano', pp. 28–29; Barclay Lloyd, 'L'architettura medievale di S. Cosimato', in Barclay Lloyd and Bull-Simonsen Einaudi, *SS. Cosma e Damiano in Mica Aurea*, pp. 98–101 and 114; Barclay Lloyd, 'Il protiro medievale a Roma', pp. 79–84 and 93–98.

53 An inscription in the fifteenth-century courtyard records that in 1849, a projectile fired by French troops damaged the southern side of the gatehouse, see Barclay Lloyd and Bull-Simonsen Einaudi, 'Cronologia', p. 142.

articulated by three brick pilasters. The roof of the gatehouse has been restored, but it rests on a typical medieval cornice of bricks and small marble brackets. Adjacent to the prothyron is a small medieval house, with a staircase leading up to the room above the gateway (Figs 82, and 89, P). On the landing, looking towards the monastery, there are traces of a medieval double-light window; below its sill is the front of an ancient Roman sarcophagus, embedded in the wall. It is likely that this house was built for the gatekeeper or 'porter', whose duty was to welcome visitors to the monastery 'as Christ' (*Rule of Saint Benedict* (hereafter *RB*), 53, 1–2) and to see to their needs with fervent charity (*RB*, 66, 1–5).

The walls of the prothyron and the adjacent house are built of masonry that is typical of late eleventh or twelfth century construction in Rome, that is brickwork with a modulus in the range of 27.5–30 cm for five rows of bricks and mortar and marked by 'falsa cortina' pointing, or *stilatura*. Masonry with a similar modulus, but not always with *stilatura*, is to be found in a few other places at S. Cosimato: in the lower part of a wall that extends westwards from the southern side of the church (Fig. 96), and in the eastern wall of the former nuns' choir. It is also found in some of the ledges of the western, northern, and eastern colonnades of the medieval cloister. These ledges probably date from the late eleventh or twelfth century and they survive from the Benedictine monastery, but the overall plan of the Benedictine church and monastery is unknown.

The Transfer of SS. Cosma e Damiano in Mica Aurea to the Franciscan Nuns

According to the Irish Franciscan historian, Luke Wadding (1588–1657), Pope Gregory IX in 1233–1234 gave the monastery of SS. Cosma e Damiano in Mica Aurea to the women 'Recluses of San Damiano', as recorded in a Privilege of

Figure 96. S. Cosimato, continuation of the southern wall of the church (photo: author)

the same Pope.[54] Unfortunately, the document of that Privilege has been lost. In an anonymous *Vita* of Gregory IX, the Pope's foundation of the nunnery is mentioned.[55]

> Domnabus eisdem in urbe Monasterium unum, scilicet monasterium Sancti Cosmae, in Lombardia […] in Tuscia […] expensis innumeris, et ministerii sui subventione construxit, providendo postmodum necessitatibus singulorum.
>
> (For those Ladies, he had constructed through the subvention of his office and at incalculable expense a monastery in Rome, that of Saint Cosmas, [and others] in Lombardy and in Tuscany, afterwards providing for the necessities of each one.)[56]

The first of the monasteries mentioned is clearly S. Cosimato in Rome. The monasteries in Lombardy and Tuscany, which are not named in the text, were most likely some earlier foundations for Franciscan nuns established by Cardinal Ugolino, before he became Pope.[57] This text not only confirms that Gregory IX arranged for the monastery of SS. Cosma e Damiano to be ceded to the Franciscan nuns, but it also indicates that the Pope spent a lot of money on constructing the new nunnery and that he continued to provide for the needs of the Sisters. From this, one may conclude that S. Cosimato, like S. Sisto, was a 'papal' nunnery, in that it was sponsored by the Pope. As happened at S. Sisto, the former church on the site was adapted and rebuilt for the use of the nuns and new conventual buildings were constructed beside it by the Pope 'at incalculable expense'. It is quite likely that in this Gregory IX was following the example of Pope Innocent III.[58]

In September 1234, Gregory IX approved the appointment of a certain Fra Giacomo as bursar 'in Monasterio Sancti Cosmae in Transtyberim de Urbe' (in the monastery of S. Cosmas in Trastevere in Rome').[59] Having a friar to administer the property of the nunnery was similar to the arrangement set up by Dominic at S. Sisto, where at least four friars were to look after the spiritual and temporal needs of the nuns. The nunnery of S. Cosimato owned property to pay for its running expenses.[60] A document of 1238, referring to its property, survives in the Archivio di Stato in Rome.[61] A bell, made by Bartolomeo Pisano and with the date 1238, is now in the vestibule to the Conference Room; it was no doubt part of the equipment provided for the new foundation.[62]

54 Wadding, *Annales Minorum*, vol. II, n. 357, pp. 406–07. The Privilege is not among the documents from the monastery now in the Archivio di Stato in Rome. For Pope Gregory IX and the development of the 'Religio' of the Damianites, see Andenna, 'Dalla Religio pauperum Dominarum'.

55 *Vita […] Gregorii Papae IX*, published in *Rerum Italicarum Scriptores*, ed. by Muratori, vol. III, p. 575; and also in Alberzoni, *Clare of Assisi*, pp. 169–78, and Appendix 1, pp. 209–10. This text is mentioned by Oliger, 'De Origine', p. 415. It was unfortunately overlooked in Barclay Lloyd and Bull-Simonsen Einaudi, *SS. Cosma e Damiano in Mica Aurea*.

56 The translation is taken from Alberzoni, *Clare of Assisi*, pp. 209–10. Today, Tuscia is a region of Italy near Viterbo. Earlier, the term included all of Tuscany and part of Umbria. For medieval Franciscan nuns in that part of Italy, see, Precorini, 'Fondazioni femminili nella Provincia Tusciae'.

57 Sant'Apollinare in or near Milan was one of the monasteries he established in Lombardy. In documents written in 1219, Ugolino referred to nunneries he had established at S. Maria di Gattaiola in the diocese of Lucca, at Monteluce in Perugia, S. Maria fuori Porta Camollia in Siena, and at Monticelli near Florence, see Alberzoni, *Clare of Assisi*, pp. 39 and 94.

58 The layout of the buildings of the church and nunnery will be considered below.

59 Wadding, *Annales Minorum*, vol. II, pp. 406–07; *BF*, vol. I, no. 143, pp. 137–38.

60 Sicari, 'Monastero dei SS. Cosma e Damiano', pp. 30–44.

61 ASR, *Fondo Clarisse in SS. Cosma e Damiano in Mica Aurea*, cassetta 17, n. 246. See also, *BF*, vol. I, no. 274, pp. 249–52. It did not include the vast estates of the former Benedictine abbey.

62 Caraffa and Lotti, *S. Cosimato*, p. 111; de Blaauw, 'Klocken supra urbem', pp. 111–42, esp. 114 n. 9.

Cardinal Ugolino influenced the foundation of S. Sisto,[63] where the Dominicans gave the nuns *Institutiones* based on the *Constitutiones* of the male Order of Preachers (whose Rule was that of Saint Augustine). After the Cardinal became Pope Gregory IX, he sometimes gave the Rule of Saint Augustine and the *Institutiones* of S. Sisto to other nuns, who were not necessarily under the direction of the Dominicans, and he referred to these convents as being of the 'Order of S. Sisto'.[64] What happened with the Franciscan nuns was in some ways similar. Clare of Assisi (1194–1253), wanting to be part of the new Franciscan movement, dedicated herself to God in absolute poverty, chastity, obedience, and humility, under the direction of Francis.[65] At first, she lived for a few months in a Benedictine convent, but she had no interest in becoming a Benedictine nun. When she moved to San Damiano on the outskirts of Assisi, she and the Sisters who joined her there at first followed a simple 'formula of life', which Francis had given her.[66] Later, Clare herself wrote a Rule, expressing the ideals of Francis and including his 'formula of life', for the nuns at San Damiano.[67] Clare's Rule was approved by Pope Innocent IV in 1253 just before she died.[68] Other Rules were also written for Franciscan nuns, notably one composed in 1219 by Cardinal Ugolino, who was evidently trying to take into account Canon 13 of the Fourth Lateran Council, which stipulated that new religious communities should take one of the established Rules; he was also intent on providing an approved Rule of life for the many groups of penitent or 'semi-religious' women in Italy.[69] As a result, his Rule was based on that of Saint Benedict, and it made no reference at all to Francis of Assisi, the male Franciscans, or to absolute poverty; it imposed strict enclosure and admitted the possession of property, two conditions that medieval popes considered essential for religious women. Clare and her companions did not accept it. Ugolino, however, had independently begun to establish 'Franciscan' houses for women, who were to live according to his Rule, and it appears that there were in Central Italy many groups of women willing to abide by it.[70] Some were new communities, and some were existing houses of penitents. Ugolino in 1219 mentioned womens' houses at Monteluce in Perugia, S. Maria della Porta Camollia in Siena, S. Maria di Gattaiola near Lucca, and S. Maria di Monticelli in Florence; of these, only the house in Florence was connected to Clare's community at San Damiano in Assisi.[71] After that, several other houses were brought under Ugolino's influence, and, by 1228, they numbered twenty-four.[72] In that year, which was after he had become Pope, Gregory IX visited Clare and he confirmed her way of life for the Sisters at San Damiano in Assisi, extending to them a 'Privilege of Poverty', but he did not extend it to the other Franciscan nunneries he had founded, except for the one at Monteluce in Perugia, which later

63 See above, Chapter 1; Alberzoni, 'Papato e nuovi Ordini religosi femminili', pp. 221–39; Smith, 'Prouille, Madrid, Rome', pp. 342–47; and Cariboni, 'Domenico e la vita religiosa femmile'.

64 Grundmann, *Religious Movements*, pp. 98–100, 102–04; Cariboni, 'Domenico e la vita religiosa femmile', esp. pp. 352–60. See above, Chapter 1.

65 Oliger, 'De Origine', pp. 185–209; 424–38.

66 See, *The Lady: Clare of Assisi*, ed. and trans. by Armstrong, p. 109.

67 *The Lady: Clare of Assisi*, ed. and trans. by Armstrong, pp. 106–26.

68 Oliger, 'De origine'; Oliger, 'Documenta originis Clarissarum'; *The Lady: Clare of Assisi*, ed. and trans. by Armstrong, with an English translation of the Rule of Saint Clare (1253) on pp. 106–26.

69 *The Lady: Clare of Assisi*, ed. and trans. by Armstrong, pp. 73–85; Alberzoni, 'Papato e nuovi Ordini religosi femminili'; Alberzoni, 'Intra in gaudium Domini…'; and Rusconi, 'The Spread of Womens' Franciscanism', p. 46; Alberzoni, *Clare of Assisi*, pp. 87–96; Alberzoni, 'I nuovi Ordini, il IV concilio laternense e i Mendicanti'.

70 Rusconi, 'The Spread of Women's Franciscanism', pp. 45–46.

71 Rusconi, 'The Spread of Women's Franciscanism', p. 47.

72 Rusconi, 'The Spread of Women's Franciscanism', p. 53.

accepted ownership of property.[73] Perhaps as a result of consulting with Clare, or because other religious Orders, such as the Cistercians, were then unwilling to expand their care for nuns, Gregory IX modified his Rule in 1228, insisting that Franciscan friars care for the spiritual and economic needs of these Sisters. From about 1230, the nuns who followed his Rule became known as the 'Order of San Damiano', obviously an allusion to the house of Saint Clare. (The nuns seem, however, to have had as little direct connection with Clare and her community, as those of his 'Order of S. Sisto' had with the nuns of S. Sisto in Rome.)[74]

The Roman nunnery Gregory IX established at SS. Cosma e Damiano in 1233–1234 was part of his Order of San Damiano and the nuns, called 'the Recluses of San Damiano', would have followed his Rule rather than the 'formula of life' of Francis and the Rule of Clare. In fact, when he wrote to the nuns in 1238 regarding some property they were to have instead of the former holdings of the monks at SS. Cosma e Damiano, he addressed the letter, 'Dilectis in Christo filiabus Abbatissae, et Sororibus inclusis Monasterii Sancti Cosmae Transtyberim de Urbe Ordinis Sancti Damiani […]' (To the beloved daughters in Christ, the Abbess, and the Enclosed Sisters of the Monastery of Saint Cosmas in Trastevere in Rome of the Order of San Damiano […]).[75] At S. Cosimato, in accordance with the modifications he had made to his Rule in 1228, Gregory IX appointed a Franciscan friar as the nunnery's first bursar, who took care of the property owned by the nunnery. Later, there were always at least two Friars Minor at S. Cosimato, who looked after the nuns' spiritual and temporal needs, as one finds in the Catalogue of Turin *c.* 1320, which stated that there were thirty-six nuns, of the Order of Saint Clare, and two Friars Minor.[76]

As is well-known, there were other Rules for Franciscan nuns. Pope Innocent IV (1243–1254) wrote a new Rule in 1247. Another Rule was that of Isabelle of France (1225–1270), which Pope Alexander IV (1254–1261) authorized in 1259, and which was revised in 1263 and approved by Pope Urban IV (1261–1264).[77] Urban IV wrote a new Rule for Franciscan nuns in 1263. From then on, the Franciscan nuns began to be called 'Poor Clares', or of the 'Order of Saint Clare', whatever their origin or the Rule they lived by.[78] The General Chapter of the Friars Minor, held in Naples in 1316, reported that there were then 372 Franciscan women's houses.[79] Obviously, the Franciscan Order of enclosed nuns was very popular. The nuns lived according to one or other of the various Rules, but only very few nunneries followed that of Clare herself.

From 1447 to 1457, the nunnery of San Cosimato was reformed by the Poor Clares of S. Lucia of Foligno and S. Maria di Monteluce in Perugia, when they adopted the Rule of Urban IV.[80] By the early seventeenth century, Orsola Formicini referred to the nuns of S. Cosimato as belonging to the observant reform.

73 For Gregory IX's 'Privilege of Poverty', see *The Lady: Clare of Assisi*, ed. and trans. by Armstrong, pp. 86–88.

74 Alberzoni, *Clare of Assisi*, p. 17; Rusconi, 'The Spread of Women's Franciscanism', pp. 52–56.

75 *BF*, vol. I, no. 274, p. 249. Formicini, *Istoria*, BAV, Vat. Lat., 7847, fol. 82ᵛ–83ʳ, was amazed that Saint Clare never wrote any letters to the nuns of San Cosimato, not understanding that Clare would have had nothing to do with the Roman foundation. It is interesting to see that Pope Gregory IX referred to the monastery as dedicated to Saint Cosmas, while the nuns were of the Order of Saint Damian.

76 Valentini and Zucchetti, *Codice topografico*, vol. III, p. 316.

77 *The Rules of Isabelle of France*, ed. and trans. by Field, pp. 9–13.

78 For the Rule of Urban IV, see Oliger, 'De origine regularum Ordinis S. Clarae'; Barone, 'La Regola di Urbano IV'; Horowski, 'La legislazione per le Clarisse del 1263; la Regola di Urbano IV…', pp. 80–99; and Alberzoni, *Clare of Assisi*, pp. 63–64.

79 Rusconi, 'The Spread of Women's Franciscanism', p. 39.

80 Alveri, *Della Roma in ogni stato*, pt. 2, p. 347, wrote erroneously that there were at first Benedictine nuns at S. Cosimato, who moved to S. Sisto in 1349, and that the Poor Clares then came in 1451.

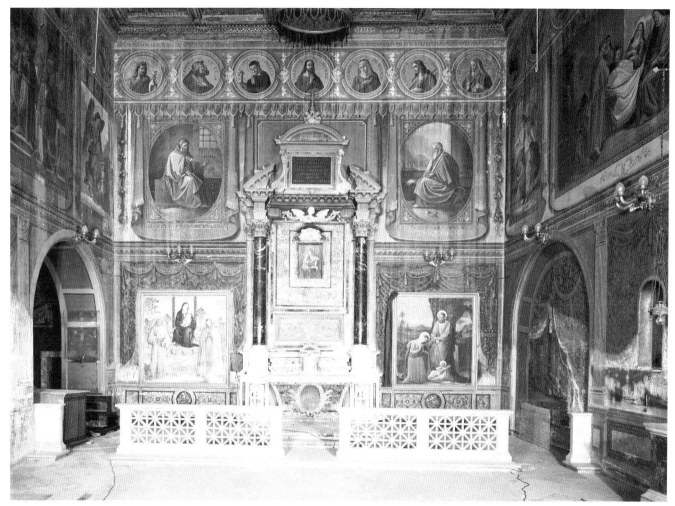

Figure 97. S. Cosimato, church interior looking towards the east (photo: Bibliotheca Hertziana – Max-Planck-Institut für Kunstgeschichte, Rome)

The Church

Sister Orsola Formicini stated that the first Abbess, Iacopa Cenci, rebuilt the medieval Benedictine church and monastery of S. Cosimato.[81] It is now more accurate to say that Pope Gregory IX planned, financed, and began to have the church and monastery rebuilt, but he died in 1241, perhaps before this work was completed. When Jacopa Cenci was Abbess, the church was finished and consecrated. She belonged to a prominent Roman family, who may have helped pay for the completion of the buildings. (There may be some similarity here with the sequence of patronage and rebuilding of S. Sisto, where Innocent III began to rebuild the church and convent, which Dominic completed after that Pope's death.) In 1246, Bishop Teodino of Ascoli consecrated the church of S. Cosimato, at the behest of Cardinal Stefano Conti, then Vicar of Rome for Pope Innocent IV (1243–1254).[82]

81 Formicini, *Istoria*, BAV, Vat. Lat., 7847, fol. 76.

82 Barclay Lloyd and Bull-Simonsen Einaudi, 'Cronologia', p. 135, quoting from a modern copy of a medieval manuscript in Rome, ASR, *Fondo Clarisse in SS. Cosma e Damiano in Mica Aurea*, cassetta 17 bis, n. 261. The Pope

THE FRANCISCAN NUNNERY OF SS. COSMA E DAMIANO (S. COSIMATO), FOUNDED IN 1234 197

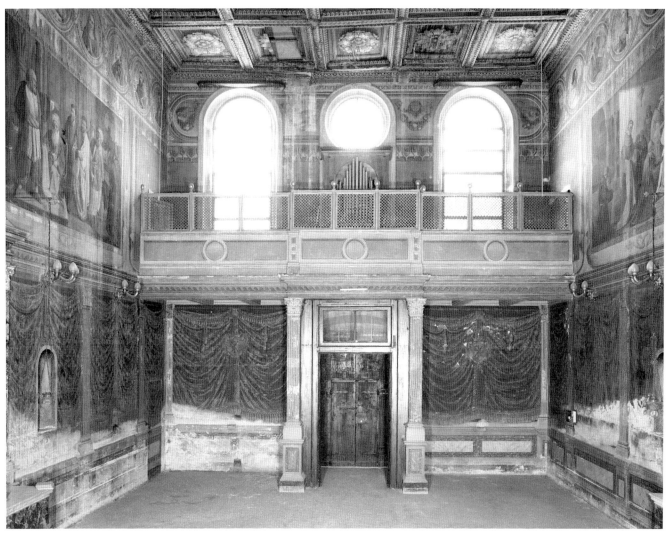

Figure 98. S. Cosimato, Church interior, counter façade (photo: Bibliotheca Hertziana – Max-Planck-Institut für Kunstgeschichte, Rome)

Only part of the medieval church of S. Cosimato survives. There is a single nave, 16.10 m. long, 10 m. wide, and 10 m. high, and the altar is set against a straight wall in the east (Fig. 82, E, and Fig. 97). At the eastern end of the church, a chapel opens to the north, to the west of which there are a few other rooms, including a sacristy and a staircase going up to a narrow balcony along the inner façade of the nave (Fig. 98). (This is rather like the narrow balcony at the liturgical west of S. Sisto (Fig. 9)).[83] To the east of the chapel, there is a passageway flanking

is given mistakenly as 'Innocent III'; his vicar in Rome, 'Cardinal Stefano' must have been Stefano Conti, who was Innocent III's nephew, and who laid out the Aula Gotica at SS. Quattro Coronati; and he was also involved in obtaining S. Maria in Aracoeli for the Friars Minor. See below, Chapter 5.

83 See above, Chapter 1. Jäggi, *Frauenklöster*, pp. 207–16, found a narrow balcony at the liturgical west of several nuns' churches, which had a choir in the liturgical east. In 1998, it seemed possible that the balcony was part of a raised choir in the west of the church, see Barclay Lloyd, 'L'architettura medieval di S. Cosimato', pp. 95–96, but that idea was clearly erroneous.

four rooms, three of which are divided by narrow partitions, showing that they originally formed only one large room (Fig. 82, east of M).

The church, as it is seen today, is less than half of the medieval structure, and it is almost all covered with nineteenth-century paintings provided by Pope Pius IX in 1871 and painted by Father Bonaventure Loffredo, with decorative work by Andrea Fiorani (Figs 97 and 98).[84] What was left of the nuns' church, up until the late nineteenth century, can be seen in three nineteenth-century plans (Figs 93, 94, and 95). Two of the plans (Figs 93 and 94) indicate that the church formerly had a single nave, with a transverse wall across it, which separated the public section in the west (which survives today), from a nuns' choir in the east, with an apse, which has been demolished. The third plan (Fig. 95) shows the projected changes, with no apse; the space formerly occupied by the nuns' choir is divided into other rooms and a staircase leading to the floor above. In the early seventeenth century, Sister Orsolo Formicini confirmed the earlier arrangement, when she stated that the choir of the nuns was separated from the rest of the church by a wall.[85] This would have been the transverse wall, which most likely opened in a window with a grille, and with a 'turn', to permit communication between the nuns in the east and the priest in the west of the church. The wall still exists, but one cannot see the earlier openings.

The full plan of the nuns' church can be reconstructed with the aid of the nineteenth-century drawings and the twentieth-century survey (Figs 82, and 93–95). Beyond the existing church and the transverse wall, there was a continuation of the single nave, 16.70 m. long and 10 m. wide. The full length of the nave, including the transverse wall, was *c.* 33.50 m internally and *c.* 35.20 m externally, as scaled from survey Plan I (Fig. 82).

This ended in an apse, which had a diameter of 5.30 m., or a radius of 2.65 m, and was destroyed in 1892.

In 1475, the Franciscan Pope Sixtus IV thoroughly restored the church of S. Cosimato. Some documents, inscriptions, and copies of the Pope's coat of arms at S. Cosimato record the work sponsored by the pontiff.[86] On the lintel of the door of the church today, there is the inscription: 'SYXTUS IIII PON MAX FUNDAVIT ANNO IUBILEI MCCCCLXXV' (Sixtus IV, the greatest pontiff, founded this in the Jubilee year 1475).[87] This has led some historians and architectural historians to assert that the entire fabric of the church at S. Cosimato was rebuilt from the foundations by Pope Sixtus IV in the fifteenth century; and even that he founded the nunnery.[88] A fifteenth-century document states that Sixtus IV, 'noviter hanc eccelsiam sanctorum martirum Cosme et Damiani a fundamentis eius integre *restauravit*' ([Sixtus] *restored* anew the whole church of the holy martyrs Cosmas and Damian from its foundations) — author's italics.[89] This text speaks of a restoration rather

84 Caraffa and Lotti, *S. Cosimato*, pp. 71–72; Barclay Lloyd and Bull-Simonsen Einaudi, 'Cronologia', p. 143.

85 Formicini, *Istoria*, BAV, Vat. Lat, 7847, fol. 76 v.

86 See Lowe, 'Franciscan and Papal Patronage', pp. 226–30 and Formicini, *Istoria*, BAV, Vat. Lat., 7847, fol. 134[r] and [v].

87 The wording of this inscription is repeated in two others at the convent: one is in the threefold doorway leading from the garden in front of the church to the medieval cloister; the other is on a piece of marble of unknown provenance in the cloister. See Lowe, 'Franciscan and Papal Patronage', p. 228.

88 In 1664, Alveri claimed that only in 1451 were the Franciscan Poor Clares installed in Trastevere, see Alveri, *Della Roma in ogni stato*, pt. 2, p. 347. Tomei, *L'architettura*, p. 161, believed Sixtus IV rebuilt the church from the foundations; Gunther Urban made the same claim, Urban, 'Die Kirchenbaukunst des Quattrocento in Rom', pp. 214 and 271; and Caraffa and Lotti, *S. Cosimato*, pp. 34–35, were of the same opinion. Lowe writes of almost all the early buildings and their decoration at San Cosimato as dating from the fifteenth century, not clearly distinguishing between the medieval and later parts of the building, Lowe, 'Franciscan and Papal Patronage'; Lowe, 'Artistic Patronage'; Lowe, *Nuns' Chronicles and Convent Culture*, pp. 123–41.

89 Lowe, 'Franciscan and Papal Patronage', p. 227, and n. 41;

than a rebuilding of the church, which a careful analysis of the architecture confirms.

Sixtus IV made some changes to the church. He provided a new façade (Fig. 84) and he had the interior of the church adorned with paintings. Nonetheless, there is evidence of earlier phases of construction and decoration. In demolishing the apse in 1892, murals were found in it, below others of later date. An altar stood in the apse, with the inscription referring to the consecration of the Benedictine church in 1066 by Pope Alexander II.[90] In addition, traces of early medieval floor mosaics and many fragments of liturgical furniture were found about 1.50 m below the floor of the former nuns' choir. These may have been remnants of one or more earlier phases of the church building. Besides these finds, an examination of the eastern wall of the former nuns' choir shows it was constructed of brickwork dating from the late eleventh or twelfth century, and masonry visible in the church's south wall, which still stands and continues west of the fifteenth-century façade, reveals a low band of eleventh or twelfth-century brickwork over which is another band of thirteenth-century *opus saracinescum*, and a much later addition, possibly of seventeenth-century masonry, at the top (Fig. 96). Two blocked round-headed windows, 85 cm high and 31 cm wide, are clearly visible in the earliest part of this wall, and their size and shape also suggest an eleventh or twelfth-century date. They are fairly low down, which may indicate that the thirteenth-century church was at a higher level than the Benedictine building. (This is reminiscent of S. Sisto, where the nuns' church was about 3.45–3.70 m higher than the early Christian basilica that preceded it, but at San Cosimato, the difference in level is not known.) This archaeological and architectural evidence therefore shows that the church was built in three or more phases: as part of the early medieval Benedictine monastery; in the Franciscan rebuilding of 1234–1246; as part of a thorough restoration by Sixtus IV, who certainly retained at least the eastern and southern walls of the earlier church, which he seems to have restored rather than completely rebuilt; and then later additions in the seventeenth and eighteenth centuries. When the work of the third phase was completed, the altar was reconsecrated on 21 April 1476.[91] Formicini recorded that Pope Sixtus IV visited the nunnery on the day of the church's consecration, that he stayed for Vespers with the nuns, and that he wept during the service.[92]

Sixtus IV provided a completely new façade for the church, which he may have shortened, and he decorated the interior with frescoes.[93] The façade wall is faced with pale bricks and has brick pilasters sustaining travertine capitals of fifteenth-century design at either end (Fig. 84). The pilaster on the south has clearly been built against the pre-existing wall that is an extension of the southern wall of the church.[94] At the top of the façade, there is a horizontal cornice of travertine and a tympanum decorated with a terracotta corbel-table frieze, like the one on the exterior walls of the fifteenth-century chapel of Saint Bernardino at S. Maria in Aracoeli. Two large round-headed windows and an oculus open in the upper part of the façade. Below, the marble doorframe is carved in the style of Andrea Bregno.[95] Inside the present church, to the left of

see, ASR, *Fondo Clarisse di SS. Cosma e Damiano in Mica Aurea*, cassetta 19, n. 382.

90 For this and the fragments of liturgical furniture, see above, in the section 'Archaeological Evidence'.

91 ASR, *Collezione Pergamene, Clarisse di SS. Cosma e Damiano in Mica Aurea*, cassetta 19, n. 382.

92 Formicini, *Istoria*, BAV, Vat. Lat., 7847, fol. 134[r] and [v].

93 The façade of Sixtus IV is built against the earlier south wall of the church, which continues westwards, as seen in Fig. 96.

94 This part of the south wall now rises to just below the pilaster capital, but it would have been much lower in 1475, the top part of the wall having been added long after the façade was built, perhaps in the seventeenth century.

95 Gigli, *Rione XII. Trastevere*, pp. 36–37; Gigli and Setti, 'Il

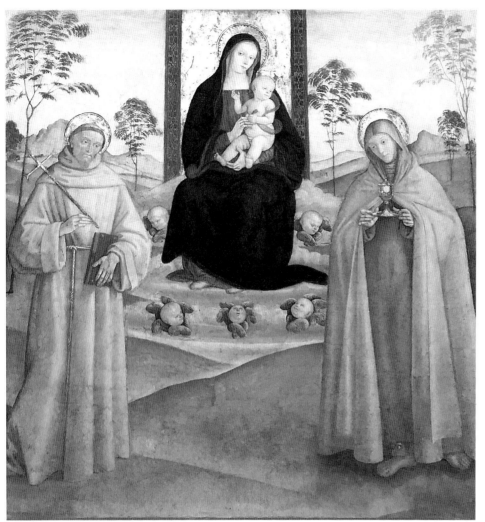

Figure 99. Antonio del Massaro (attributed to), *Madonna and Child enthroned, with Saint Francis and Saint Clare*, c. 1478–1494 (photo: author)

The internal plan of the church, as known from the nineteenth-century plans, was in two parts (Figs 93 and 94): the public section, which survives, and the nuns' choir, now rebuilt behind a transverse wall. Some fifteenth-century frescoes are preserved in the rooms constructed within the former nuns' choir: they represent the figures of Saints Cosmas and Damian, Saint Sebastian, and an unknown female martyr, perhaps Saint Emerentiana, which can still be seen in the present pharmacy on the first floor of the medical centre.[97] Sixtus IV presumably sponsored them.

The disposition of the nuns' church seems to have been similar to that at S. Sisto in the early thirteenth century, where there was a single nave and there seems to have been a transverse wall across the building with a window through which the nuns could see and hear what was happening in the public part of the church. Another nuns' church in Rome, S. Pancrazio, had a similar plan in the thirteenth century.[98] There, the seventh-century basilica originally had a nave and two aisles, which were reduced to a single nave, with a marble screen dividing the church into two parts in a remodelling made for Cistercian nuns by the Cistercian John of Toledo, Cardinal of S. Lorenzo in Lucina in

the high altar, there is a fresco of the *Madonna and Child enthroned, with Saint Francis and Saint Clare*, attributed to Antonio del Massaro, an artist from Viterbo, who was active in Rome from 1478 to 1494, when he could have painted this work (Fig. 99).[96] There is a nineteenth-century painting of the *Holy Family* by an unknown artist on the right of the altar (Fig. 97).

restauro del portale di San Cosimato'.
96 Lowe, 'Artistic Patronage', pp. 288–90; Milazzi, 'Un dipinto di Antonio del Massaro'.

97 The female martyr, Saint Emerentiana, was one of the patrons of the church at the time of Abbot Odemundus. For these works, see Lowe, 'Artistic Patronage', pp. 273–97, but she does not mention the female martyr.
98 Barclay Lloyd, 'The Church and Monastery of S. Pancrazio', pp. 255–63.

1255–1257.[99] This arrangement was noted in the late sixteenth century by Pompeo Ugonio, who made further observations about the church and its furnishings, at a time when the building was in the care of the Friars of Saint Ambrose ad Nemus, who took it over from the Cistercian nuns in the fifteenth century.[100] He described the basilica as very spacious and said one could see that it formerly had had a nave and two aisles, but the side aisles had been suppressed and only the central nave was in use. In the middle of the church was an altar, which was adorned with porphyry and other precious stones, while the ciborium above it was made of marble and stood on four columns of porphyry, two fluted and two smooth. Behind this altar, there was a screen wall that divided the church in half, also made of plaques of porphyry and other decorative stones. Ugonio sketched this feature in his notebook, showing that the transverse screen had a central doorway and must have been over two metres high. There was an altar in the apse behind the screen. The transformation of this church from a basilica with a nave and two aisles to a single nave was most likely carried out for the nuns, following the example of what Innocent III had done at S. Sisto. One would expect that in the thirteenth century the transverse wall reached the full height of the church. The screen seen by Ugonio in the late sixteenth century would have taken its place, after the Cistercian nuns had moved to S. Pietro in Montorio in 1438 and the Friars of Saint Ambrose ad Nemus took over their church and convent at S. Pancrazio. (The arrangement of the screen and the two altars are reminiscent of that at S. Sabina.[101])

The church built by Pope Gregory IX at S. Cosimato had a similar plan: a single nave, with a transverse wall (up to the ceiling) and an apse. There was an altar in the apse and another west of the transverse wall. These features were evidently typical of nuns' churches in thirteenth-century Rome. (Jäggi has shown that in Germany and Switzerland, and at S. Maria Donnaregina in Naples, there was another arrangement, in which the nuns' choir was raised on a gallery in the western half of the nave and there was only one altar, in the east of the church.)[102]

In the apse of the former nuns' choir at S. Cosimato, the builders in 1892 found an altar, attached to which was the inscription, referring to the consecration of the church in 1066; there was also an inscription commemorating the re-consecration of the church by Sixtus IV on 21 April 1476.[103] This clearly shows that there was an altar in both parts of the church — in the nuns' choir and in the western, public part of the building.[104] (The high altar in the present church, set against the transverse wall, was provided by Sister Constantina Androsilla in 1639, as commemorated in an inscription.)

Not far from the altar in the nuns' choir, to the right and near a pulpit, the nineteenth-century builders found the tomb of Pope Sixtus IV's sister, Francheta della Rovere, who died in 1480.[105] It was dismantled in 1892 and her tombstone

99 The Catalogue of Turin mentioned thirty-five nuns there, c. 1320, see, Valentini and Zucchetti, *Codice topografico*. vol. III, p. 316. The Cistercian nuns stayed at S. Pancrazio until 1438, when they moved to S. Pietro in Montorio, see Barclay Lloyd, 'The Church and Monastery of S. Pancrazio', p. 261.

100 Ugonio described this church in BAV, Barb. lat. 2160, fols 135^r–v; and in Ugonio, *Historia delle Stationi*, pp. 317–24; see also, Barclay Lloyd, 'The Church and Monastery of S. Pancrazio', pp. 261–63.

101 See above, Chapter 2.

102 Jäggi, *Frauenklöster*, pp. 192–207.

103 Bull-Simonsen Einaudi, 'Il monastero di S. Cosimato in Mica Aurea' pp. 51–71 and 137.

104 See Jäggi, *Frauenklöster*, pp. 207–16, for other examples of this arrangement.

105 1892, 18 luglio, *Relazione dell'Ispettore archeologico Giuseppe Bonfanti*, in Bull-Simonsen Einaudi, 'Il monastero di S. Cosimato in Mica Aurea', p. 54. Pierluigi Galletti saw this tomb in the eighteenth century in the floor near the pulpit, see Vat. lat. 7921A, 33v, n. 94, as pointed out by Lowe, 'Franciscan and Papal Patronage', p. 232.

202 CHAPTER 4

Figure 100. S. Cosimato, side chapel, altar made in 1685 from sculpture from the former tomb of Cardinal Lorenzo Cybo († 1503) (photo: Bibliotheca Hertziana – Max-Planck-Institut für Kunstgeschichte, Rome)

is now in the thirteenth-century cloister. The inscription on it reads:

> GENEROSE / FRANCHETE / DE RUERE /
> SIXTI IIII PONT / MAX. SECUNDUM /
> CARNEM SORORIS / DULCISSIME /
> MULIERIS RELIGIO- / SISSIME CORPUS /
> SUB HOC LAPIDE IACET

(Under this stone lies the body of generous Francheta della Rovere, the sister of Pope Sixtus IV according to the flesh, a very sweet and most religious woman).[106]

Lowe explained that Francheta della Rovere married Bartolomeo Armoino de Cella and had three daughters. She came to Rome c. 1472 and in June 1475, Sixtus IV gave her permission to visit any convent of her choice and even to stay overnight.[107] (Staying at a nunnery was a privilege that was sometimes given to lay women patrons of convents in the thirteenth and fourteenth centuries.[108]) Francheta evidently became a bountiful patron of the nunnery of San Cosimato, hence the epithet 'generose' on her tombstone, and she had the privilege of being buried in the nuns' choir.[109] It is likely that she persuaded her brother to restore the nunnery. She probably encouraged him to sponsor the extensive work done at San Cosimato in the church and also in the convent, where he built the second courtyard / cloister (Figs 82, S, and 86). (The patronage of Sixtus IV at S. Cosimato in a way resembles that of Cardinal Giovanni Boccamazza at S. Sisto, where

106 Forcella, *Iscrizioni*, vol. X, p. 323 n. 544. Lowe has written about her and other wealthy women who supported the convent, for example, Margherita Maleti, who died in 1538 and whose incised tomb slab is now also in the medieval cloister, see Lowe, 'Artistic Patronage', p. 295 and fig. 10.

107 Lowe, 'Franciscan and Papal Patronage', p. 232. Gigli, *Rione XII. Trastevere*, p. 32, erroneously says she was a nun at San Cosimato.

108 For example, Isabelle of France stayed at the nunnery at Longchamp near Paris which she founded, without becoming a member of the community, see Field, 'Douceline of Digne and Isabelle of France', pp. 91–98; and Sancia, Queen of Naples, not only spent some time in the nunneries she founded, but she had papal permission for some of the nuns to come and stay at her court, see Andenna, 'Sancia, Queen of Naples', pp. 115–32. For Sancia's patronage, see also Gaglione, 'Sancia d'Aragona-Maiorca', pp. 931–85.

109 See Bruzelius, 'The Dead Come to Town', and Bruzelius, *Preaching, Building, and Burying*, pp. 150–66, for the burial of lay people in Mendicant churches and convents.

the Cardinal generously supported the nunnery and contributed money for its buildings because one of his female relatives was not only a friend of the Sisters, but a nun and prioress there.[110])

There is a side chapel to the north of the present church, which is covered with a low vault (Fig. 82, M).[111] Against its western wall stands an altar framed by carved marble plaques (Fig. 100), which were formerly part of the tomb of Cardinal Lorenzo Cybo, who died in 1503, and who was buried in S. Maria del Popolo. In 1685, Cardinal Alderano Cybo donated the marble plaques to the nunnery and they were used to decorate the altar in the chapel, as recorded in an inscription.[112] Relics of saints were installed in two caskets in separate niches, one below and the other, above the altar. Before the sculpture was placed in the chapel, there had been a painting over the altar of the *Crucifixion with Saint Francis and Saint Clare*, by Girolamo Siciolante da Sermoneta (1521–1575), which is now in the Clarissan convent on the Little Aventine.[113] In 1664, Gasparo Alveri described the arrangement of the chapel and the altarpiece:

> Nel secondo altare dentro una cappella, dove per una grata di ferro le Monache sentono messa, si adora l'imagine di Cristo crocefisso.
>
> (At the second altar, in a chapel, where the nuns hear Mass through an iron grille, the image of Christ crucified is adored.)[114]

Apart from the information about the location of the painting, this observation records interesting evidence about the function of the chapel. One can still see a large iron grille in the east wall opposite the altar (Fig. 101); and nearby there appears to have been another window, which has been blocked up. Besides this, the

Figure 101. S. Cosimato, side chapel, grille opposite the altar (photo: Bibliotheca Hertziana – Max-Planck-Institut für Kunstgeschichte, Rome)

nineteenth-century plans (Figs 93–95) show an opening at the north-western end of the chapel that communicates with a small room, perhaps a place where the nuns could have gone to confession or spoken to a priest through another grille. In 1755–1756, Abbess Ermengilda Acquaroni rebuilt the residence of the abbess from the foundations including within it a large room adjacent to and east of the chapel.[115] This large room appears to have been an oratory, parallel to the earlier medieval nuns' choir, with a window (protected by a metal grille), facing the altar in the chapel (Fig. 82, M). This arrangement is a late addition, but it shows how the nuns of that day, and, possibly before that, in the seventeenth century, could attend Mass celebrated at the chapel's altar, with a view through the large window of the priest, who could give

110 See above, Chapter 1.
111 Lowe, 'Artistic Patronage', pp. 292–94 and Fig. 9.
112 Barclay Lloyd and Bull-Simonsen Einaudi, 'Cronologia', p. 141.
113 Lowe, 'Artistic Patronage', pp. 290–92 and fig. 8.
114 Alveri, *Della Roma in ogni stato*, p. 348.

115 An inscription records this, see Barclay Lloyd and Bull-Simonsen Einaudi, 'Cronologia', p. 141.

them Holy Communion through a small 'door' in the middle of the grille.

It is not clear exactly when the side chapel was built. It is shown by Antonio Tempesta in his Map of Rome in 1593 and the *Crucifixion* was painted before 1575. The arrangement helps to clarify a strange phenomenon in Clarissan architecture pointed out by Caroline Bruzelius: from their choir the nuns could often hear but not see the ceremonies in the church.[116] (On the contrary, documents show that the Dominican nuns were able both to see and hear them.[117]) The new, second choir at San Cosimato demonstrates how the Poor Clares in that convent later resolved this problem and arranged to follow the Mass visually as well as aurally.

The Icon

Like the Dominican nuns at S. Sisto, the Franciscan nuns possessed an icon, a Roman version of the Byzantine *Hodegetria* (Plate 6).[118] When this painting was restored in 1951, the wood on which the image was painted had curved, so it had to be flattened and at least two levels of repainting, as well as later layers of varnish, had to be removed.[119] The style of the painting is typical of work done in medieval Rome: the Virgin Mary, portrayed in three-quarter view, looks directly at the viewer, while her left hand with elegantly long fingers points to the Christ Child, who is seated on her right arm. She wears a blue cloak, or '*maphorion*', with a thin gold border and a gold cross on her left shoulder. Christ is portrayed not as a tiny baby but as quite a large 'grown-up' child — a medieval way of showing that he is both human (a child) and divine (in the pose of an adult). He wears a bright red tunic with back '*clavi*', and he holds a scroll in his left hand, while giving the Byzantine gesture of blessing with his right hand. His halo contains three arms of the cross, painted in red against a gold background. This and the Virgin's halo are lightly etched into the gold background of the panel.

In the late sixteenth and early seventeenth century, Orsola Formicini wrote that this icon, which she said was in the nuns' choir, was painted by angels and given to the abbot of the monastery of SS. Cosma e Damiano in Mica Aurea, as recorded in an ancient codex and in a later account written by some of the nuns; she also referred to Ottavio Panciroli, who had declared that the image was 'veramente miracolosa [...] per (essere) fatta da Dio per mano degli Angeli' (truly miraculous [...] having been made by God through the hand of Angels), which would make it 'acheiropoietos', not made by human hands.[120] Orsola Formicini believed it had been in a chapel of Old St Peter's at the time of a certain Pope Leo, when some thieves, who stole it from the Vatican basilica, took the jewels that then adorned it, and threw the painting into the Tiber. They tied it to a rock so that it would sink, but it floated along the river as far as a bridge. The Madonna then appeared to Pope Leo in a dream and ordered him to take her picture out of the water. When he had arranged this, it was placed in a chapel dedicated to the Virgin on the bridge beside which it was found. (The bridge was the ancient Pons Aemilius, which became known as 'Ponte S. Maria' from the eleventh century onwards; it was later renamed 'Ponte Rotto', after part of it fell down in the late sixteenth

116 Bruzelius, 'Hearing is Believing', 83–91.

117 As explained in Chapter 1.

118 For this icon, Lowe, 'Artistic Patronage', pp. 273–77; Leone, *Icone di Roma e del Lazio*, vol. I, no. 26, pp. 76–77, with further bibliography; and Guerrini Ferri, 'La "Madonna del coro"'. The icon is 61 cm wide and 81 cm high, according to Urbani, 'Anonimo fine secolo XIII'.

119 Urbani, 'Anonimo fine secolo XIII'.

120 Guerrini Ferri, 'La "Madonna del coro"', pp. 228–32, who refers to Orsola Formicini, *Cronaca* – in BNC Roma, MS Varia 6, c. 212r and Varia 5, cc. 54v–66r, and Panciroli, *Tesori Nascosti* (1600 edition), p. 289. Some early icons have the reputation of having been made miraculously and not by human hands.

The archpriest therefore tied it to a beam in his church, which displeased the abbot, who sent a young monk to S. Sebastiano, who 'per esser romano sapeva molto ben negociare fra le gente' (being Roman knew very well how to negotiate with people) and who, eventually, with the help of the Madonna, worked out a way of untying the icon, and brought it to the monastery of SS. Cosma e Damiano in Mica Aurea.[122]

This image looks as though it was made specifically for the nuns of S. Cosimato in the thirteenth century, from the style of the painting. The restorer, who examined the icon carefully with X-rays, however, was of the opinion that what is seen today may have been painted over another older image, of which only minimal traces remain, which were visible at its borders.[123] The legend of the icon and its origins remains something of a mystery. Like the nuns of S. Maria in Tempuli and those of S. Sisto, when the Poor Clares of S. Cosimato had to leave their nunnery in 1873, they carefully took their icon with them, and it is now in their convent on the Little Aventine.

The Campanile

North of where the early apse once stood, there is a bell tower, which superficially resembles those built in Rome in the twelfth or thirteenth century (Figs 82 [T], 89 [T2], 90 [T3, T4, T5], 92, and 102).[124] There is a bell made in 1238 at S. Cosimato, which suggests that there may have been a bell tower at that date. Yet documentary evidence indicates that the tower was built (or perhaps rebuilt) from funds paid to Abbess

Figure 102. S. Cosimato, campanile viewed from the east (photo: author)

century. The bridge and its chapel belonged to the monastery of SS. Cosma e Damiano in Mica Aurea.) Later, the icon was moved to the church of S. Sebastiano, which was close to the bank of the Tiber, but during a fight between some Romans and some people from Trastevere, the archpriest of S. Sebastiano and the abbot of SS. Cosma e Damiano were afraid the icon would be stolen.[121]

121 One notes that in this account that the people of Trastevere are distinct from the Romans.

122 Orsola Formicini, *Cronaca*, BNC Roma, MS Varia 5, cc. 57ᵛ–62ᵛ. Guerrini Ferri, 'La "Madonna del coro"', pp. 231–32.

123 Urbani, 'Anonimo fine secolo XIII', p. 58.

124 Barclay Lloyd, 'L'architettura medievale di S. Cosimato', pp. 96–97. For campanili of that date, see Priester, 'The Belltowers of Medieval Rome'.

Theodora of S. Cosimato in 1481.[125] The coat of arms of Pope Sixtus IV della Rovere is attached to the tower, and it has been argued convincingly that the campanile, as it is now, was erected shortly after 1482.[126]

If one takes a closer look at the bell tower, it becomes clear that there are some unusual features in its fabric. Instead of having friezes of bricks and small marble brackets between the different floors of the campanile, as one sees in medieval Roman bell towers, such as those of S. Sisto and S. Silvestro in Capite (Figs 7 and 149), there are moulded bands of travertine between the floors (Fig. 102). On the first floor, there are double-arched openings (now blocked), while on all sides of the two top levels, there are triple arcades, each sustained by two colonnettes, which stand on bases and support pulvins made of travertine rather than marble. Around the arches there is only one splay of bricks, the voussoirs being framed on the exterior with a single row of narrow bricks, which continue as a string course around the corners of the campanile. In the interior of the tower, large tufa quoins reinforce the corners, and a relieving arch strengthens the wall above the triple openings. Rubble masonry, of a type often used in fifteenth-century Rome, fills the space between the large and small arches in the interior of the tower, but on the exterior, the wall is faced only with bricks. The building techniques of the interior, therefore, are typical of fifteenth-century construction in Rome, but the tower appears superficially to be a simple medieval belfry from outside. Moreover, if one compares this tower with the fifteenth-century campanile of Santo Spirito in Sassia, also built in the pontificate of Sixtus IV, one sees the same fifteenth-century building techniques — such as travertine cornices between the floors and, on the exterior rather than the interior, a relieving arch over the arcaded openings. The campanile at S. Cosimato is a Renaissance 'copy' of a medieval bell tower. It is unusual to find an example of such a 'medieval revival' in fifteenth-century Rome.

The bell tower at S. Cosimato is in the east, close to where the apse and the nuns' choir are known to have stood. Perhaps this was because it was in the interior of the nunnery complex, whereas the façade of the church, where bell towers are often located, was in an area open to the public.

The Conventual Buildings

With funds from Pope Gregory IX, the Benedictine monastic buildings were rebuilt shortly after 1234. The medieval cloister survives from the thirteenth century, with ambulatories, arranged around a rectangular garth, providing covered access to the various parts of the monastic buildings (Figs 82, G; 85, 103, 104, and 105). The cloister is one of the largest in Rome — 34.10 m from north to south and 30.50 m from east to west.

The colonnettes of the cloister are varied in style, indicating that many of them were recycled from older buildings, including presumably the former Benedictine monastery on the site. Some of them bear the marks of medieval masons, (a cross or the letter 'D', 'T', or 'V'), which may indicate their intended position.[127] Some colonnettes are made in one piece with their bases; others are in separate sections and of slightly varied heights. Some of the capitals are plain, while leaves are carved in outline on others. In the northern ambulatory, one column has disappeared, and a piece of wood has been put in its place, a rather primitive repair in this building, which badly needs restoration. The

125 ASR, *Camerale I*, busta 847, fol. 227ᵛ; see also, Serafini, *Torri campanarie di Roma*, pp. 181–82; Cecchelli, 'Note e documenti'; Urban, 'Die Kirchenbaukunst des Quattrocento in Rom', p. 271; Priester, 'The Belltowers of Medieval Rome', p. 82.

126 Cecchelli, 'Note e documenti'.

127 Claussen, *Magistri doctissimi romani*, p. 79.

colonnettes are not arranged in a sequence of one then two then one, as at S. Sabina, but they are simply in pairs (Fig. 103). Above the colonnettes, there are brick arches framed with one arch of small voussoirs (Figs 104 and 105). As is usual in cloisters, there are wider arched openings connecting the ambulatories to the cloister garden; the very wide ones on the north, east, and west are surely modern. The corner piers are built of bricks and were faced originally with plaques of marble, a few with eighth- or ninth-century designs carved on them. (Most of these were removed — and some were sold — in the late nineteenth century.[128])

There is evidence that the cloister replaced an earlier and smaller one of the Benedictine monastery. In the ledge that supports the colonnettes on the western side of the cloister, wing B (Fig. 85), there are traces of early medieval masonry, perhaps of the tenth century. In the ledge and above some of the colonnettes to a height of 2.80–3.12 m above the ambulatory floor in the same wall, there is some masonry identifiable as dating to the eleventh or twelfth century, from the northern corner of the colonnade to the large arch leading into the garth. There is a corresponding stretch of eleventh- or twelfth-century brickwork in the colonnade in wing D, from its northern end to the last arch before the modern entrance to the garth. The ledge below the colonnade in wing C was all built in the thirteenth century. This means that the cloister of the monks, which preceded that of the nuns, may have been narrower, only about half its later width from north to south.

Careful inspection of the east range of the cloister, wing D (Fig. 104), shows that, in the second half of the thirteenth century, to judge by the masonry, piers were built between some of the pairs of colonnettes to form a strong support for a wall with wide relieving arches going up to

[128] Pointed out by Bull-Simonsen Einaudi, 'Il monastero di S. Cosimato in Mica Aurea', pp. 62–71.

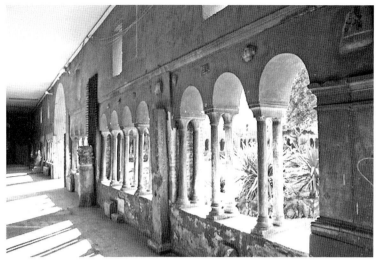

Figure 103. S. Cosimato, cloister, north colonnade, wing A (photo: author)

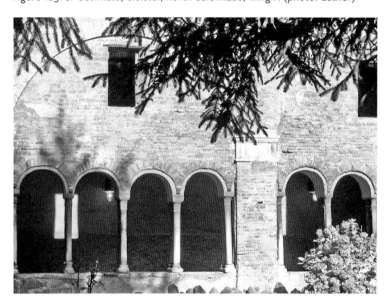

Figure 104. S. Cosimato, cloister, east wing D, detail, showing the system of piers and arches (photo: author)

an upper floor. The masonry under about half of each relieving arch is *opus saracinescum*, showing that the wall was raised, in the thirteenth century. (A date written on this side of the cloister, '1680', seems to indicate a restoration rather than this structural change.) This wall would have made possible the building of a long room, which is now separated by narrow partitions into small chambers, above the cloister walk (Fig. 89, D). The east wall of wing D is constructed of

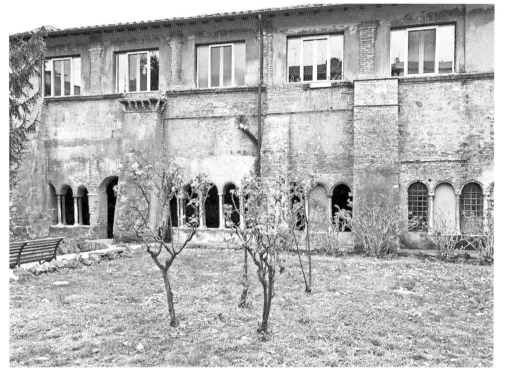

Figure 105. S. Cosimato, cloister, south wing C, viewed from the north (photo: author)

opus saracinescum and on the first floor, small round-headed windows, that are now blocked, are visible along its eastern side.

The walls directly above the colonnades on the north, west, and south of the cloister in wings A, B, and C, are all built of much later masonry, dating from the sixteenth century onwards (see, for example the righthand section of the wall in Fig. 105; this wall was also strengthened with buttresses). The very late masonry implies that the porticoes of the cloister on the north, west, and south were originally single-storeyed, with a lean-to roof connecting them to the buildings behind them. Later, walls were raised above the colonnades on those sides of the cloister, providing more space on the upper floor, as had been done in the late thirteenth century in wing D (Fig. 89). The long rooms above the cloister ambulatories are now divided by narrow partitions, as in wing D. (At S. Sabina, the cloister was also a lean-to structure at first, until walls and vaulting were constructed over the colonnades to enable the extension of the space upstairs above the cloister walks in the sixteenth century.[129])

In wing C, one can examine the southern exterior wall of the building (Fig. 87). It is built of thirteenth-century *opus saracinescum*, and some small, round-headed, blocked windows of medieval date are clearly visible in the upper floor. Leaving aside numerous thin modern partitions (Fig. 89), it is clear that upstairs in the eastern, southern and western wings of the convent, there were large rooms, which were no doubt used as dormitories, for the nuns, the novices, and the infirm. Orsola Formicini refers to several such dormitories, including two that were in her time painted with images of various saints: in particular, there were representations of Saints Cosmas and Damian, and Saint Michael in the 'Dormitorio di mezo' (the middle dormitory).[130] In the sixteenth century, there was a long room above the cloister ambulatory running alongside the church in wing A.

At the northern corner of the eastern wing, D, near the church, there is the entrance to a medium-sized room and then a long 'Conference Room', which is adjacent to the southern side of the fifteenth-century courtyard, S (Fig. 82). The two rooms are divided by a narrow modern wall, indicating that, formerly, there was just one long room. Inside, both rooms are covered with sixteenth-century vaulting. Above the two rooms there is now an upper storey (Fig. 89). On the exterior of the southern wall of the long room, one can see two stretches of different masonry with a fissure between them (Fig. 88).

129 See above, Chapter 2.
130 Formicini, *Istoria*, BAV, Vat. Lat., 7847, fols 120ᵛ–121ʳ.

The wall starts from the cloister ambulatory and is built of *opus saracinescum* for about half its length on both floors; after a clear break, the wall continues in a kind of mixed masonry with large stones. This indicates that the long room and its upper floor were originally only about half their present length, that is, 21.80 m long and 8.40 m wide, in the thirteenth century. Being close to the nuns' choir, the room on the ground floor may have been the chapter room of the nunnery. Later, in the sixteenth or early seventeenth century, it was extended to an exterior length of *c.* 40 m, and the room was vaulted as it is now. Just east of the join in the two phases, a small staircase and a reading desk were added, which can still be seen behind wooden seating in the interior and jutting out to the south on the exterior (Figs 82 and 88). This indicates that the new, longer room was turned into a refectory, where the nuns during meals would have listened to someone reading at a built-in lectern. (At S. Sisto, there is a raised reading desk in the refectory, as shown on the left in Fig. 16.) Probably, before the change, the nuns' refectory was on the ground floor of the south wing, C, opposite the church, in the traditional place for a monastic dining room. Upstairs, above the 'Conference Room', there was until recently only one long room, which is now crossed by narrow partitions, to form a corridor, and smaller rooms (Fig. 89).

The church and the monastic buildings at S. Cosimato show the intervention of Pope Sixtus IV, reflecting his renewal of the nunnery. The Pope built a new courtyard, or cloister, behind the church, which still exists (Figs 82, S, and 86). Around the ambulatories, tall octagonal piers of travertine stand on low bases and sustain fifteenth-century capitals, which support arches and cross vaults. In the nineteenth century, an upper floor was added above the three ambulatories, on the east, north, and west, with windows opening on the central garden (Fig. 89).

To the west of the thirteenth-century cloister (Fig. 82, B), there is a row of re-used ancient columns, which were later enclosed in other structures. They may originally have formed an arched portico at the entrance to the cloister from the west, which was then extended further in that direction, when wing B was enlarged, possibly in the fifteenth century.

Between the garden in front of the church and the medieval cloister, another entrance that was vaulted and had three doorways was inserted between 1657 and 1661. Inscriptions record the names of Sister Maria Belardina Caetana, head porter, and Sister Dionora Teti, head sacristan, who sponsored this project.[131] There was a parlour south-west of the church in the early nineteenth century, which is shown in a painting of S. Cosimato by Bartolomeo Pinelli (1781–1835), but it was demolished in the late nineteenth century. It may have served as a place where the nuns could communicate with people from outside the nunnery, probably through a grated window and a turn.

Comparisons

It is interesting to compare S. Cosimato with San Sebastiano at Alatri in Lazio.[132] This provincial monastery was built over previous ancient Roman structures, where inscriptions suggest that a certain deacon, called Servandus, set up a monastery for Liberius in the sixth century. About twenty or thirty monks may have inhabited two parallel buildings on the site, parts of which survive.[133] These were restructured in the eleventh and twelfth centuries. In 1233, a community of Franciscan nuns, of the Order of San Damiano,

131 See Barclay Lloyd and Bull-Simonsen Einaudi, 'Cronologia', p. 140.
132 Fentress, Goodson, Laid, and Leonie ed., *Walls and Memory*.
133 Fentress, Goodson, Laid, and Leonie ed., *Walls and Memory*, pp. 43–72.

was installed in this monastery, modifications being made at the time to accommodate them.[134] Additions on the ground floor may have constituted a chapter room, a refectory, and a rectangular room with a central column supporting a high vaulted ceiling. On the floor above, there was a large room, probably a dormitory. The monastic buildings were ranged around a cloister, of which two sides survive, with triple and double groups of colonnettes. The cloister ambulatories were covered with a simple lean-to roof. Traces of a kitchen were found close to a water channel. As the community grew, vaulted rooms were added to the conventual buildings. Above one such space was a room decorated with frescoes whose iconography suggests that it was originally an upstairs oratory with the floor raised at one end. The paintings have been dated by their style *c.* 1260–1300, but most probably they were executed in the 1280s.[135] This oratory may have served as the nuns' choir. At a later time, the church was rebuilt, on a smaller scale than its predecessor, with two bays covered with groin vaults. There seems to have been little communication between the church and the oratory. Where there is now a door, there may originally have been a window with a grille, allowing the sound of the Mass being celebrated in the church to be heard by the nuns. Other buildings were added to the complex at later times for the use of people who assisted the nuns, including the clergy who administered the sacraments and celebrated the Mass for them. In 1442, the nunnery was dissolved, and the buildings were changed into a Renaissance villa.

In some ways, the disposition at San Sebastiano is similar to the situation at the Franciscan nunnery of S. Pietro in Vineis at Anagni, in Lazio, where the nuns' oratory was above the north aisle of the church, and was also decorated with frescoes.[136] There, some small slit windows may have given the nuns a partial view of the nave of the church and allowed them to listen to the celebration of the Mass.

Conclusion

S. Cosimato was a significant medieval Franciscan nunnery, the first in Rome. Like S. Sisto, it was a papal foundation. It survived in Trastevere until the late nineteenth century and, indeed, there are Poor Clare nuns on the Little Aventine Hill today, who trace the origin of their community to S. Cosimato. The plan of the medieval church can be reconstructed from surviving documents and architectural remains. Pope Sixtus IV restored rather than rebuilt the church and he added a second cloister. The campanile was constructed at about the same time. In the late sixteenth century, a side chapel was added to the public part of the church and in the eighteenth century an oratory adjacent to the nuns' choir was built with a view through a large grille of the altar in the side chapel. In the nineteenth and twentieth centuries, the buildings were modified for new functions, as a hospice, then a hospital, and finally the present medical centre.

134 Bruzelius and Goodson, 'The Buildings', pp. 73–113.

135 Iazeolla, 'Gli affreschi di S. Sebastiano ad Alatri'; Pace, 'Pitture del Duecento', esp. 437.

136 Bianchi, Alessandro, 'Affreschi duecenteschi nel S. Pietro in Vineis', pp. 379–84; Romano, 'Gli affreschi di San Pietro in Vineis'; Böhm, *Wandmalerei […] im Klarissenkloster S. Pietro in Vineis*.

PART II

A New Generation of Dominicans and Franciscans and their Foundations in Rome

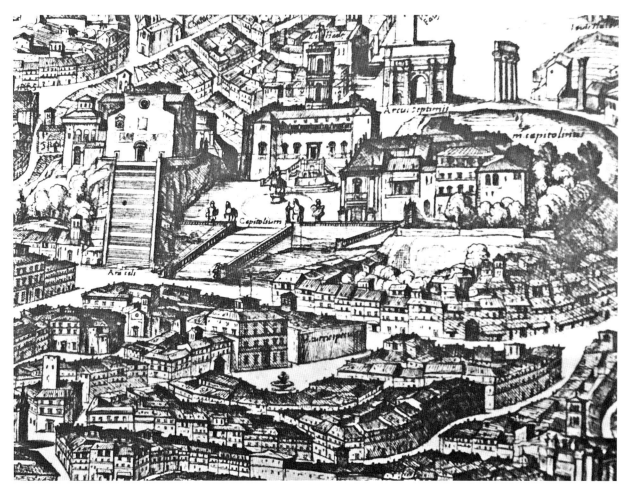

Figure 106. Antonio Tempesta, *Map of Rome*, 1593, det. the Capitoline Hill, with S. Maria in Aracoeli on the left (Frutaz, *Le Piante di Roma*, vol. II, 1962, detail of Tav. 266)

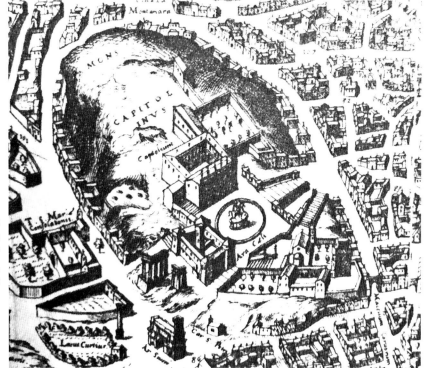

Figure 107. Stefano Dupérac, *Map of Rome*, 1577, det. the Capitoline Hill, with S. Maria in Aracoeli lower right (Frutaz, *Le Piante di Roma*, vol. II, 1962, detail of Tav. 250)

CHAPTER 5

The Friars Minor at S. Maria in Aracoeli, founded c. 1248–1252

The imposing Franciscan medieval church of S. Maria in Aracoeli still stands on the Capitoline Hill (Figs 106 and 107), but the friary next to it was almost completely demolished in 1892, when the Victor Emmanuel Monument was erected in its place. In this chapter, therefore, particular attention is paid to the history and architecture of the church, noting only briefly what is known of the friary.[1]

In the early Middle Ages, there was a monastery on the Capitoline Hill known as 'S. Maria in Capitolio', which, from the mid-twelfth century onwards, was also called 'S. Maria in Aracoeli', a name which became more common in the thirteenth century.[2] The second name refers to a legend in the *Mirabilia Urbis Romae* (*The Marvels of the City of Rome*), written c. 1140–1143.[3] This related that, when the Senators of ancient Rome wanted to worship the Emperor Augustus by setting up a statue in his honour, he asked the Tiburtine Sybil for advice and, while they discussed the problem in his palace on the Capitoline Hill, the heavens opened and a beautiful virgin appeared, standing above an altar and holding a boy in her arms, while Augustus heard a voice saying, 'This is the altar of the son of God'. The author of the *Mirabilia* explained that this was an apparition of the Madonna and Child, which occurred, 'ubi nunc est ecclesia Sanctae Mariae in Capitolio. Idcirco dicta est Sancta Maria Ara Celi' (where there is now the church of S. Maria in Capitolio. Therefore, it is called S. Maria Ara Celi [the Altar of Heaven]).[4]

Location

The Capitoline Hill, which overlooks the Roman Forum (Figs 106 and 107), is one of the seven hills of ancient Rome.[5] On the north, there is a crest of the hill called the 'Arx' (citadel) and on

1 There are many studies of the church, including Cellini, 'Di Fra Guglielmo'; Pietrangeli, 'Recenti restauri nella chiesa di S. Maria in Aracoeli'; Cellini, 'L'opera di Arnolfo all'Aracoeli'; Pietrangeli, 'Storia e architettura dell'Aracoeli'; Pietrangeli, 'Storia ed istituzioni capitoline'; D'Onofrio, *Renovatio Romae*, pp. 11–128; Malmstrom, 'S. Maria in Aracoeli at Rome'; Romanini, 'L'architettura degli ordini mendicanti'; Romanini, *Arnolfo di Cambio*; Romanini, 'L'architettura dei primi insediamenti francescani'; Carta and Russo, *Santa Maria in Aracoeli*; Romanini, 'Arnolfo architectus'; Cellini, *Tra Roma e Umbria*; Brancia di Apricena, *Il complesso dell'Aracoeli*; Strinati, Tommaso, *Aracoeli: gli affreschi ritrovati*; Russo, *Santa Maria in Aracoeli*; and Bolgia, *Reclaiming the Roman Capitol*. Here, particular attention is paid to the works of Malmstrom, 'S. Maria in Aracoeli at Rome'; and Bolgia, *Reclaiming the Roman Capitol*.
2 Bolgia, *Reclaiming the Roman Capitol*, pp. 13–14, 35–33; see also Kinney, 'Fact and Fiction'.
3 The text of the *Mirabilia* is published in Valentini and Zucchetti, *Codice Topografico*, vol. III, pp. 17–65. An earlier, rather different version of the story was told in Greek in *The Chronicle of John Malalas*, in the late sixth century, and that text was translated into Latin by an anonymous author in 740, see D'Onofrio, *Renovatio Romae*, p. 50.
4 Valentini and Zucchetti, *Codice Topografico*, vol. III, pp. 28–29; and see Bolgia, *Reclaiming the Roman Capitol*, p. 14, and n. 25.
5 See Giannelli, 'Arx', Tagliamonte, 'Capitolium (fino alla prima età repubblicana)', and Reusser, 'Capitolium (Republik und Kaiserzeit)' in *Lexicon Topographicum Urbis Rome*, ed. by Steinby, vol. I, pp. 127–29, 226–31, and 232–33.

214 CHAPTER 5

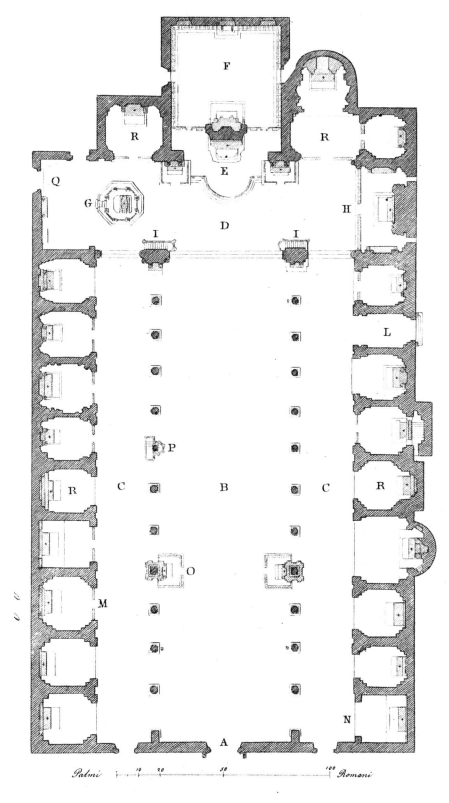

Figure 108. Giacomo Fontana, plan of S. Maria in Aracoeli, c. 1838, from Fontana, *Raccolta*, vol. II; photo: Bibliotheca Hertziana – Max-Planck-Institut für Kunstgeschichte, Rome)

the south, another crest called the 'Capitolium' (the Capitol).[6] In the middle, there is a lower stretch of land, where Michelangelo in the sixteenth century designed the Piazza del Campidoglio with the equestrian statue of Marcus Aurelius in the centre.[7] The Capitoline Hill was a defensive and religious place in Antiquity, rich in history and legend. In the earliest wars between Rome and her neighbours, Romulus vowed to build the city's first temple on the Capitol and he dedicated it to 'Jupiter Feretrius', to commemorate the god's assistance in war.[8] In 509 BC, another, larger temple was built, dedicated to 'Jupiter Optimus Maximus Juno et Minerva' (Jupiter the Best and Greatest, Juno, and Minerva).[9] Roman armies used to bring the spoils of war in triumphal procession to the Capitol, to present them to Jupiter in thanksgiving for their victories.

After the Romans had taken the Sabine women, the Sabine General, Titus Tatius, came to Rome with an army, seeking revenge. At the time, Spurius Tarpeius was in charge of the Roman forces on the Arx, and the Sabines secretly persuaded his daughter, the Vestal Virgin Tarpeia, to allow them into the citadel in return for what they wore on their left arms — she thought this was a promise of

6 Claridge, *Rome*, p. 229.
7 In Antiquity, this place was called the 'Asylum', because Romulus assigned it to refugees who came to Rome, see Claridge, *Rome*, p. 229.
8 Livy I. x. 6–7; see, *Livy, Books I and II*, trans. by Foster, pp. 40–41.
9 Remains of its walls can still be seen in the Capitoline Museum.

gold bracelets and rings, but, instead, she was crushed to death by the enemy's shields and the Romans, as a punishment for her treachery, flung her body from the escarpment on the south of the Capitoline Hill, which became known as the 'Tarpeian Rock'.[10] Later, this site became a place where criminals were executed.

A temple dedicated to Juno 'Moneta' (she who warns) was located on the hill close to the Roman mint.[11] When, in 390 BC, the Gauls scaled the Arx at night, intending to attack the soldiers on the Capitol who were guarding the city, the geese that were sacred to Juno alerted the Romans of their approach and thus saved Rome. Other temples on the hill were dedicated to Janus Custos (the guardian) and to the Egyptian goddess, Isis. Indeed, an obelisk that used to stand near the Franciscan friary was probably connected with that ancient Egyptian cult.[12] Nearby, there was the 'Auguraculum', a place where ancient Roman augurs predicted the future by observing the flights of birds from the top of the hill.

On the south-eastern side of the Capitol was the ancient Roman Tabularium (Archive), a building erected by Sulla in 78 BC to house the city offices, including the archives, hence the name. From this building one looks out over the Roman Forum, which was the centre of government, law, and business in the ancient city, with its Senate House, basilicas, temples, triumphal arches, and honorary columns. Augustus made the Capitoline Hill and the Roman Forum Region VIII of Ancient Rome.

The medieval Roman commune, founded in 1143–1145, had its headquarters on the Capitoline Hill.[13] A 'Palazzo del Senatore' was first set up there in the twelfth century and by 1257 a new palace had been built over the Tabularium to house the medieval Senate and its president, the Senator of Rome.[14] In the later Middle Ages, it was the Capitol that was the centre of civic government, justice, and commerce, rather than the Forum. The medieval Senate held its meetings in the Palazzo del Senatore. A tribunal was established on the hill, and justice was meted out near an ancient sculpture of a lion killing its prey, located near the seat of civic government.[15] A market was held regularly on and around the hill from the fifth century until 1477, when it was transferred to Piazza Navona.[16]

S. Maria in Aracoeli Today

The church of S. Maria in Aracoeli is a large basilica with a nave, two aisles, a transept, and a rectangular choir behind the high altar (Fig. 108). The nave and aisles are separated on either side by colonnades of eleven re-used Roman columns, which support twelve arches (Fig. 109). In the sixteenth century, the rectangular choir behind the high altar (Fig. 108, F) replaced a medieval apse. Beside the choir, there are now three chapels, the one on the north in honour of Saint Gregory the Great; the first on the south dedicated to the Blessed Sacrament; and the second named after Saint Rose of Viterbo. The chapels on the south are inter-connecting. Beside the chapel on the north, there is a passage leading to a shrine of the Holy Infant Jesus and to the sacristy. From the late

10 The story is recounted in Livy, I, xi. 5–9, see *Livy, Books I and II*, trans. by Foster, pp. 42–45.
11 For this reason, the Italian word for a coin, 'moneta', and the English word 'money' stem from the name of the temple; see Bolgia, *Reclaiming the Roman Capitol*, p. 12 n. 11, with regard to the Italian word.
12 For the obelisk, see Bolgia, *Reclaiming the Roman Capitol*, pp. 82–83. An obelisk was also found in the gardens of the Dominican convent at S. Maria sopra Minerva, see below, Chapter 6.

13 Krautheimer, *Rome*, pp. 152–54, 197–99, 206-07; O'Daly, 'An Assessment', pp. [100] 512 – [121] 533, esp. [1–2] 514 – [105] 517. See also, Wickham, *Medieval Rome*, especially the last part of Chapter 7.
14 For the palace, see Pietrangeli, 'Il palazzo del Senatore', and Krautheimer, *Rome*, pp. 206–07.
15 Bolgia, *Reclaiming the Roman Capitol*, pp. 16–18.
16 Casimiro, *Memorie*, p. 432; Krautheimer, *Rome*, p. 251.

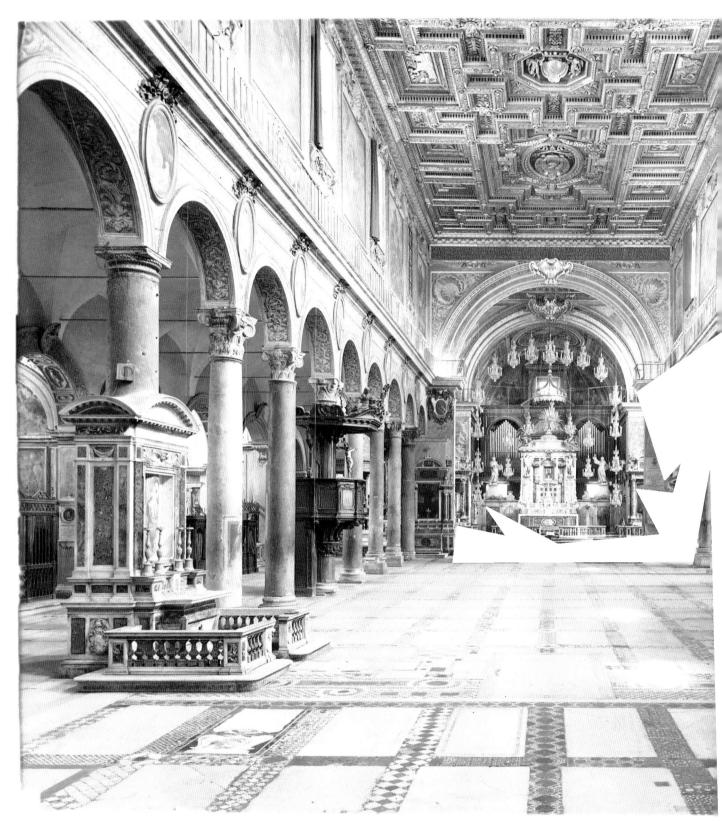

Figure 109. S. Maria in Aracoeli, interior, looking east (photo: ICCD – under licence from MiBACT)

thirteenth century onwards, chapels were added to the southern end of the transept and flanking both aisles (Fig. 108).[17] The nave and transept are now covered by sixteenth-century gilded ceilings, while there are fifteenth-century groin vaults over the aisles. Six large rectangular windows on either side of the clerestory illuminate the nave, with one over every second intercolumniation. The interior decoration of the church and the chapels is now almost all Baroque, with some painting and sculpture surviving from the Middle Ages and the Renaissance.[18] There are three entrances in the west and one on the south of the church. The tall façade, with a cavetto, overlooks a staircase with 125 marble steps, built in 1348–1349 (Figs 106 and 110).

The church is impressive in size. According to Ronald Malmstrom, the nave is 51.23 m long and 14.37 m wide; the aisles are 5.71 and 5.72 m wide, making a total width for the nave and aisles of c. 26.80 m.[19] The nave is approximately 19 m high, and the height of the aisles is c. 9.80 m. The transept is 9.43 m deep and 40.38 m long, projecting 6.50 m beyond the north aisle, and c. 6.25 m beyond the south aisle. The choir arch is 11.24 m wide, whereas the choir itself is 12.30 m wide and 13.38 m long. The triumphal arch rises to a height of 15.68 m above the nave pavement. The full length of the building from east to west is 74.04 m. It is clear that the nave pavement slopes upwards slightly from west to east and there are three steps leading from the nave to the transept.

Archaeological Evidence

S. Maria in Aracoeli is built over the remains of ancient Roman buildings, but little is known precisely about what lies immediately under the church. In 1963, some American archaeologists

17 See Heideman, *The Cinquecento Chapel Decorations*, for the sixteenth-century decoration of the chapels.
18 Only the medieval works will be discussed below.
19 Malmstrom, 'S. Maria Aracoeli at Rome', pp. 135–36.

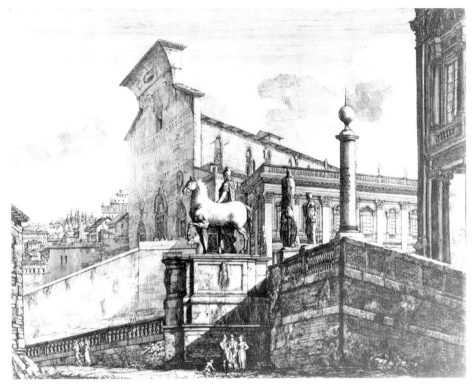

Figure 110. S. Maria in Aracoeli, façade and cavetto (Luigi Rossini, *Le Antichità Romane*, 1819–1823, Tav. 58; photo: Bibliotheca Hertziana – Max-Planck-Institut für Kunstgeschichte, Rome)

Malmstrom examined the foundations of the former medieval bell tower and areas adjacent to it (Fig. 108, L, and Fig. 111).[21] The subterranean areas around the bell tower, under the nave, and under some of the chapels were also explored by Claudia Bolgia.[22] She found some early medieval walls under the eastern and southern walls of the Blessed Sacrament chapel, to the south of the present Franciscan choir (Fig. 108, R). Two walls running at right angles to each other at that level were constructed with large irregular blocks of tufa, in masonry that was typical of medieval Roman foundations of the eighth and ninth centuries. She suggested that they were remnants of the early medieval monastic church that preceded the Franciscan building. Directly above these stone blocks, she found medieval brickwork with mortar beds streaked with 'falsa cortina' pointing and the bricks laid in a modulus of five rows of bricks and mortar of 28–32 cm, a type of masonry used in Rome from the eleventh to the late twelfth century.[23] This indicates a remodelling of the Benedictine church at that time, possibly by Anaclete II (1130–1138). In addition, Bolgia discovered in other areas below S. Maria in Aracoeli that the foundations of the nave, aisles, and façade of the Franciscan church were all constructed in thirteenth-century *opus saracinescum*, from which she deduced that the church was planned, and its foundations built, in one campaign.[24]

excavated an area about 3 m square and 4 m deep, under the present shrine of the Ara Coeli, also known as the chapel of Saint Helena, in the north transept (Fig. 108, G).[20] At a level 3 m below the pavement of the transept, they found some slabs of travertine, which may have formed a base or foundation of unknown date. About 1 m lower down, there was some red earth, which they suggested could date from the time of Augustus (27 BC–AD 14). Most of the area uncovered was filled with earth, containing debris dating from the second to the sixth century AD. Across this area along an east–west axis, was a brick wall, built during the reign of the Emperor Hadrian (117–138). A sculpted plaque, which now forms part of the medieval shrine was fixed on top of the Hadrianic wall, but it was not part of a shrine or a medieval 'confessio' or crypt.

20 D'Onofrio, *Renovatio Romae*, pp. 67–68.

21 Malmstrom, 'S. Maria in Aracoeli at Rome', pp. 23–26.
22 Bolgia, *Reclaiming the Roman Capitol*, pp. 54–57.
23 Barclay Lloyd, 'Masonry Techniques' pp. 233, 237–38, 245–46, 269–71, for this type of masonry.
24 Bolgia, *Reclaiming the Roman Capitol*, pp. 147–50.

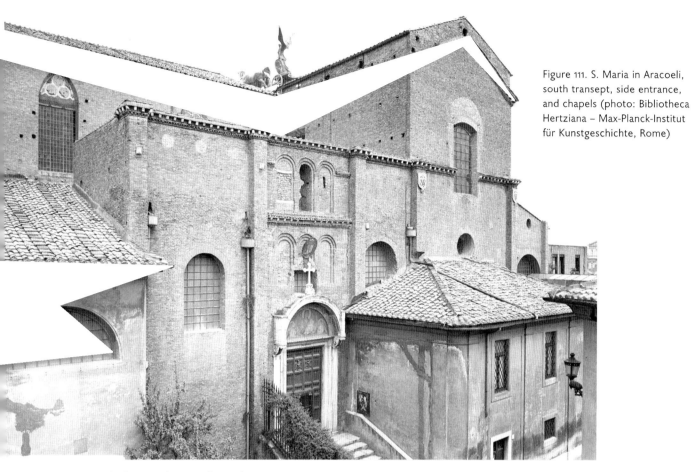

Figure 111. S. Maria in Aracoeli, south transept, side entrance, and chapels (photo: Bibliotheca Hertziana – Max-Planck-Institut für Kunstgeschichte, Rome)

History of the Early Medieval Benedictine Monastery of S. Maria in Capitolio

Unfortunately, the early history of the church and monastery of S. Maria in Capitolio is obscure.[25] An inventory written in the pontificate of Gregory III (731–741) lists a monastery, in a place called 'Camellaria', dedicated to the Holy Mother of God, Saint John the Evangelist, and Saint John the Baptist.[26] The *Mirabilia* located the 'Camellaria' next to the temple of Janus Custos on the Capitol.[27] Not all scholars have accepted this location, however, or its identification with the monastery of S. Maria in Capitolio.[28] Cesare D'Onofrio suggested that the name 'Camellaria' was a corruption of 'Cancellaria' (chancery) and hence the monastery may have been located near the Tabularium.[29]

25 Ferrari, *Early Roman Monasteries*, pp. 210–13 and Bolgia, *Reclaiming the Roman Capitol*, pp. 26–28.
26 See Bolgia, *Reclaiming the Roman Capitol*, pp. 26–27.
27 Bolgia, *Reclaiming the Roman Capitol*, p. 27; citing the *Mirabilia* in Valentini and Zucchetti, *Codice topografico*, vol. III, p. 53.
28 Ferrari, *Early Roman Monasteries*, pp. 210–13, did not mention it; Malmstrom, 'S. Maria in Aracoeli at Rome', pp. 6 and 16 rejected this as a reference to S. Maria in Capitolio, whereas Krautheimer, *Corpus*, vol. II, p. 270 and Brancia di Apricena, *Il complesso dell'Aracoeli*, p. 29, accepted the identification and location.
29 D'Onofrio, *Renovatio Romae*, pp. 44–52, esp. 50. He also associated the 'Camellaria' with two porticoes, which formed part of the Tabularium building. Bolgia gives good reasons for accepting this theory and hence identifies that eighth-century monastery with S. Maria

The discovery of a stone inscribed with the word 'hegoumenos' during the demolition of buildings near S. Maria in Aracoeli in 1892 suggested that the early medieval monastery was Greek, but there is no supporting evidence for this and it is more likely that it was always a Latin foundation.[30] S. Maria in Capitolio was not mentioned in the list of Roman monasteries that received gifts from Pope Leo III (795–816), but there are texts referring to it from the tenth century onwards, most of which refer to its property.[31] In 944, the abbot of the monastery of the Holy Mother of God, which was situated on the Capitol, sold a vineyard in Ariccia.[32] In 955, a Bull of Pope Agapitus II, confirming the possessions of the monastery of S. Silvestro in Capite, mentioned a mill, beside another water-mill belonging to the monastery of S. Maria in Capitolio.[33] The same mill was mentioned in a Bull of Pope John XII, dated 962, also for S. Silvestro in Capite.[34] Three years later, Abbot George of Subiaco rented land in Albano next to a vineyard belonging to the Capitoline monastery.[35] Negotiations between Abbot Peter of S. Maria in Capitolio and Abbot Martin of SS. Cosma e Damiano in Mica Aurea were held in 986.[36] The following year, Abbot Peter of S. Maria in Capitolio sold some land in 'Aqua Tuzia'.[37] John XVIII's Bull, confirming the possessions of the monastery of SS. Cosma e Damiano in Mica Aurea in 1005, mentioned land belonging to S. Maria in Capitolio in Trastevere.[38] By the twelfth century, the Benedictine abbey of S. Maria in Capitolio was listed as one of the twenty most important monasteries in Rome.[39]

Anacletus II, who ruled as Pope in Rome from 1130 to 1138, before he was demoted to the status of antipope, issued a privilege *c.* 1130–1134, in favour of S. Maria in Capitolio, which defined the site and property of the monastery.[40] He ceded to John, Abbot of the monastery of the Holy Mary Mother of God and Saint John the Baptist on the Capitol, 'totum montem Capitolii in integrum' (the whole Capitoline Hill in its entirety), with its houses, ruins, storerooms, courtyards, gardens, and trees.[41] The terms of the Bull recall the dedication of the monastery and its location, as given in the eighth century.[42] There was land in front of the church, with its walls, columns, and stones; and also the market, with everything belonging to it. The site was delimited by a public road below the eastern side of the hill, running towards and then along the

in Capitolio, see Bolgia, *Reclaiming the Roman Capitol*, pp. 27–28.

30 Ferrari, *Early Roman Monasteries*, pp. 210–11, with further bibliography.

31 There are six such documents referred to in Ferrari, *Early Roman Monasteries*, pp. 210–13.

32 Ferrari, *Early Roman Monasteries*, p. 210, citing *Il Regesto Sublacense*, ed. by Allodi and Levi, p. 94, no. 54.

33 Ferrari, *Early Roman Monasteries*, p. 210, citing Federici, 'Regesto del monastero di S. Silvestro de Capite', (1899), p. 208.

34 Ferrari, *Early Roman Monasteries*, p. 210, citing Federici, 'Regesto del monastero di S. Silvestro de Capite', (1899), p. 208.

35 Ferrari, *Early Roman Monasteries*, p. 210, citing *Il Regesto Sublacense*, ed. by Allodi and Levi, p. 181, no. 130.

36 Ferrari, *Early Roman Monasteries*, p. 210, citing Fedele, 'Carte del monastero dei SS. Cosma e Damiano', (1898), pp. 514–16.

37 Ferrari, *Early Roman Monasteries*, p. 210, citing Fedele, 'Tabularium S. Praxedis', (1904), pp. 38–40, no. 1.

38 Ferrari, *Early Roman Monasteries s*, p. 211, citing Pflugk-Hartnung, *Acta Pontificum Romanorum*, vol. II, p. 57, no. 93. For this Bull, see above, Chapter 4.

39 Valentini and Zucchetti, *Codice Topografico*, vol. III, pp. 361–62, 438–39.

40 The Bull was published by Wadding, *Annales Minorum*, vol. II, p. 255; it was quoted in the Bulls of Innocent IV of 5 July 1252, and of Alexander IV of 26 September 1259 in favour of the Franciscans taking over the monastery, see Casimiro, *Memorie*, pp. 15–22 and 431–36. Palumbo, *Lo Scismo*, p. 678, no. 65, notes that Anaclete's Bull was addressed to Abbot John of the monastery of S. Maria and S. Giovanni Battista on the Capitol. See also, Kehr, *Italia Pontificia*, vol. I, p. 101.

41 A detailed analysis and an English translation of parts of the Bull are to be found in Bolgia, *Reclaiming the Roman Capitol*, p. 28 and n. 26, and pp. 31–34.

42 It leaves out the name of Saint John the Evangelist, however.

Clivus Argentarius; then, turning left, by another road, going around the hill to the north-west; on the third side, continuing in an anti-clockwise direction, by a road along the banks of the River Tiber, which went past the meat market, to S. Teodoro;[43] and on the fourth side, by a road that led back to the area below the Cancellaria and then up 100 steps to the monastery.[44] Malmstrom commented astutely that the location of the monastery on the Capitoline Hill would have resembled the elevated sites of the abbey of Saint Benedict at Monte Cassino and the monastery of Sant'Andrea, founded by Pope Gregory the Great on the Caelian Hill in Rome.[45]

The Transfer of S. Maria in Capitolio to the Franciscans

The new, grandiose church of the Friars Minor on the Capitoline Hill reflects how the Franciscan Order had evolved by the mid-thirteenth century, with new attitudes towards property, learning, and parish work. Although Francis of Assisi had wanted his friars to live an itinerant lifestyle and to have simple churches and humble and small houses, the friars were given more freedom to accept larger churches and friary buildings after Pope Gregory IX promoted the building of the basilica of Saint Francis in Assisi, from 1228 onwards, and after he authorized in 1229 the Franciscan takeover in Rome of the Ospedale di S. Biagio, which became the church of S. Francesco a Ripa.[46] In 1230, Gregory IX's Bull, *Quo elongati*, stated that

> […] property may be possessed neither individually nor in common. However, the brotherhood may have the use of equipment or books and such other moveable property as is permitted, and the individual brothers may use these things at the discretion of the general and provincial ministers. Dominion over places or houses is excepted; this is the right of those to whom you know they belong.[47]

In fact, the church and convent buildings might legally belong to another entity (from 1245, that could be the Holy See) rather than to the friars, who had normal use of them; and a 'nuntius' or agent from outside the Order could be appointed to administer property on behalf of the Franciscans. Bonaventure (*c*. 1218–1274) as Minister General in 1257 recommended large and tall buildings constructed in stone and brick, as being efficient, safe, and durable; in his opinion, large churches in city centres were suitable for Franciscan missions to the urban populace and big friaries ensured a more stable form of life for the friars.[48] In 1260, the Franciscan General Chapter at Narbonne commented on aspects of poverty and mentioned architecture in recommendations that recall Cistercian and Dominican guidelines on this matter.[49] Church buildings were to keep within the limits imposed by poverty, by having a simple design with a plain sanctuary instead of an elaborate east end; there should be no vaulting except in the major chapel (the sanctuary) and there was to be no separate tower for bells. The friars were to avoid curiosities and superfluities in paintings, windows, and columns, and have no exaggerations in the length, width, and height of

43 In the later Middle Ages, meat was sold at the Theatre of Marcellus and near S. Teodoro, see Krautheimer, *Rome*, p. 251 and fig. 195.

44 This is an abbreviated summary. See Bolgia, *Reclaiming the Roman Capitol*, p. 31, for further details.

45 Malmstrom, 'S. Maria in Aracoeli at Rome', p. 15.

46 See above, Chapter 3.

47 *BF*, vol. I, pp. 68–70. The quotation is from *FAED*, vol. I: *The Saint*, p. 573. On the questions of poverty and property, see Bordua, *The Franciscans and Art Patronage*, pp. 18–25.

48 For Innocent IV's Bull, *Ordinem vestrum*, 6, in *FAED*, vol. II: *The Founder*, p. 777. For Bonaventure, see Little, *Religious Poverty*, p. 206.

49 General Chapter of Narbonne, Rubric III, in Bihl, 'Documenta', pp. 45–54. See also Moorman, *A History of the Franciscan Order*, pp. 148–50, esp. p. 149.

their buildings. Historiated stained-glass windows were forbidden, except for one behind the high altar; and there could be some paintings only in the choir (of the Crucifixion, the Virgin Mary, Saint John, Saint Francis, and Saint Anthony). Plain vestments and altar furnishings were to be used. Later, from 1285 onwards, the rules about buildings were relaxed and in 1322, Pope John XXII's Bull *Ad conditorem canonum* did away with the distinction between 'use' and 'ownership' of property.[50]

In the 1230s, the friars became more clerical, that is, there were more priests, who were well educated, and they exercised the pastoral 'cura animarum' or the pastoral care of souls through preaching and hearing confessions. By c. 1250, both the Dominicans and Franciscans had become famous for their learning and teaching at the University of Paris, which aroused some rivalry among other teachers.[51] The diocesan clergy were also alarmed because the friars seemed to be encroaching on their parochial prerogatives. In addition, many people wanted to be buried in Franciscan or Dominican churches, but the parish clergy resented this because it was likely to deprive them of bequests and the burial fees normally given to the parish.[52] All this came to a head in the early 1250s, when the Masters of the University of Paris and the diocesan clergy combined forces against the Mendicant Orders. They sent delegates to Rome in 1253, led by the Parisian priest, William of Saint-Amour (1200–1272), to argue their case at the papal court. Learned Franciscans, like Bonaventure (c. 1218–1274) and John Peckham (1230–1292), and Dominican scholars, like Albert the Great (1200–1280) and Thomas Aquinas (c. 1225–1274) wrote in defence of the Mendicant Orders. Pope Innocent IV (1243–1254), however, issued a Bull, *Etsi animarum*, in November 1254, in which he revoked all the privileges his predecessors had granted to the Mendicant Orders and made stringent conditions regarding their relations with the parish clergy. Only one month later, in December 1254, Innocent IV died and was succeeded by Pope Alexander IV (1254–1261), formerly Cardinal Rainaldo dei Conti di Segni, who had been Protector of the Franciscan Order before he became Pope. He rescinded Innocent IV's Bull and on 14 April 1255, he issued another Bull, *Quasi lignum vitae*, by which he restored all the papal privileges granted to the Mendicants.

Although the Mendicant Orders enjoyed papal support from 1255 onwards, the opposition did not die out until the Second Council of Lyons in May 1274 reaffirmed the Franciscans and Dominicans, while curtailing some of their privileges, and suppressed some smaller Mendicant Orders, like the Friars of the Sack.[53] To try and solve the problem once and for all, Pope Boniface VIII (1294–1303) issued a Bull, *Super Cathedra*, in 1300 that permitted the friars to preach in parishes, with the consent of the parish priest; insisted that the heads of mendicant Provinces should recommend to bishops those priests who could preach and hear confessions; and stipulated that a quarter of all income derived from burials and bequests should be given to the parish priest of the deceased. This measure seems to have brought peace between the diocesan clergy and the Mendicant Orders. In the mid-thirteenth century, however, the Franciscans and Dominicans began to deal with the problem in another way, by running their own parishes, with large churches to accommodate the crowds of people who came to them for pastoral care and to hear them preach. In Rome, this was the case at S. Maria in Aracoeli and at S. Maria sopra Minerva.

50 Bruzelius, *Preaching, Building, and Burying*, p. 47; Bourdua, *The Franciscans and Art Patronage*, pp. 21–22.

51 Lawrence, *The Friars*, Chapter 8; Brett, *Humbert of Romans*, pp. 12–40.

52 Bruzelius, *Preaching, Building, and Burying*, pp. 150–71; Bruzelius, 'The Dead Come to Town'.

53 Andrews, *The Other Friars*, pp. 173–230.

The transfer of the Benedictine church and monastery of S. Maria in Capitolio to the Friars Minor took place in this context. The Franciscan takeover is recorded in six Bulls of Pope Innocent IV.[54] On 23 July 1248, a Bull, *Quanto dilecti filii Fratres Ordinis Minorum*, was addressed to Rainaldo, Cardinal Bishop of Ostia and Velletri; Stefano, Cardinal Priest of S. Maria in Trastevere; and Riccardo, Cardinal Deacon of S. Angelo in Pescheria.[55] They were to form a small 'committee' to assist the Friars Minor to find a new residence in Rome. Cardinal Rainaldo di Jenne, also known as Rainaldo dei Conti di Segni, was born in Anagni in the late twelfth century, and was a nephew of Pope Gregory IX, the son of the Pope's brother Filippo.[56] He became a Canon at the cathedral of Anagni where he served until Gregory IX made him Cardinal Deacon of S. Eustachio in 1227, and then promoted him to the position of Cardinal Bishop of Ostia and Velletri in 1231.[57] Cardinal Rainaldo was close to the Franciscan Order, in which his sister was a nun and his nephew a friar, known as Andrea da Anagni.[58] Rainaldo was the second Protector of the Friars Minor, after his uncle Cardinal Ugolino (later Gregory IX). In 1254, he was elected Pope, taking the name Alexander IV, after which he continued to defend the Mendicant Orders, especially the Franciscans, for whom he continued to act as Protector until he died in 1261. He was praised by the Friars Minor for his generosity, goodness, affability, holiness, and honesty and in October 1255, he confirmed the authenticity of the stigmata of Saint Francis.[59] Cardinal Stefano Conti, also known as 'Stephanus de Normandis' (late twelfth century–December 1254) was a nephew of Pope Innocent III, the son of the Pope's brother Riccardo.[60] Before taking up a clerical career, he had been married and then widowed, and he had a son, Filippo, who joined the Friars Minor, which may account for Cardinal Stefano's affection for the Franciscans.[61] (As a friar, Stefano Conti's son was also 'familiaris' [a close associate] of Cardinal Rainaldo, later Pope Alexander IV.) Innocent III made Stefano Cardinal Deacon of S. Adriano in 1216, after which he served as Cardinal Presbyter of S. Maria in Trastevere, from 1228 to 1254. Cardinal Stefano was Papal Vicar of Rome from September 1245 to February 1251, during the absence of Pope Innocent IV in Lyon; he built a residence at SS. Quattro Coronati, with a new chapel dedicated to S. Silvestro and a hall now known as the 'Aula Gotica', which modern art historians believe was painted by artists who either came from Anagni or who were influenced by the murals in Anagni cathedral, especially those by the so-called third Master of Anagni.[62]

54 *BF*, vol. I, no. 288, pp. 521–22; no. 304, pp. 530–31; no. 330, p. 545; no. 346, pp. 556–58; no. 397, p. 599; and no. 418, pp. 616–18; and see Bolgia, *Reclaiming the Roman Capitol*, pp. 3, 22, 112.

55 *BF*, vol. I, no. 288, pp. 521–22.

56 Paravicini Bagliani, *Cardinali di Curia*, pp. 41–53. An ancient tradition claims that both Cardinal Rainaldo and Pope Gregory IX were members of the Conti family and hence related, albeit distantly, to Pope Innocent III, but Carocci, *Baroni di Roma*, p. 373, says this is false.

57 These were the positions Ugolino had occupied before he became Pope Gregory IX. The Cardinal Bishop of Ostia and Velletri was the highest ranking of all the cardinals.

58 Paravicini Bagliani, *Cardinali di Curia*, p. 44, who relies on Salimbene regarding these relatives. The name of Rainaldo's sister is not given.

59 See Paravicini Bagliani, *Cardinali di Curia*, pp. 44–45, who takes information from Salimbene.

60 He is called 'Stephanus de Normandis' ('Stefano Normanni' in Italian) in Eubel, *Hierarchia catholica*, vol. I, p. 4 (30). See also Ciacconius, *Vitae et res gestae* (ed. 1677), col. 78; Maleczek, 'Conti Stefano', in *DBI*, vol. XXVIII, pp. 475–78; and Carocci, *Baroni di Roma*, pp. 371–80.

61 Ciacconius, *Vitae et res gestae* (ed. 1677), col. 78, says, '... ex legitimo matrimonio ante Cardinalatum in filium habuisse Philippum, qui divino se famulatui devovens in sacro Minorum ordine' (... from a legitimate marriage before the Cardinalate, he had a son, Filippo, who consecrated himself to divine service in the sacred Order of Minors).

62 For SS. Quattro Coronati and its decoration, see Draghi, *Gli affreschi dell'Aula Gotica*; Draghi, *Il Palazzo cardinalizio dei Santi Quattro a Roma*; Barelli, *The Monumental*

An inscription records the dedication of the chapel of S. Silvestro on the Friday before Palm Sunday in 1246; the bishop who consecrated the chapel was Cardinal Rainaldo, at the behest of Cardinal Stefano Conti, who is said to have built the chapel and the large house ('domos') on the site.[63] The third cardinal on the 'committee' was Riccardo Annibaldi (1200/1210–1276), who had met Francis of Assisi; he became Cardinal Deacon of Sant'Angelo in Pescheria in 1238; his titular church stood at the foot of the Capitoline Hill, fairly close to S. Maria in Capitolio. After Innocent IV's first Bull of 23 July 1248, he was no longer mentioned in the documents concerned with the transfer of S. Maria in Capitolio to the Franciscans.

On account of the political crisis between the papacy and the Holy Roman Emperor Frederick II (born December 1194 and died December 1250), Pope Innocent IV left Rome and went to live in Lyon, France, from June 1244 until early 1251. The three cardinals named in the Bull were among those who remained in the city at that time, to support papal interests and to protect Rome and the Patrimony of St Peter from Frederick II.[64] In his Bull of 23 July 1248, the Pope instructed them to provide the Friars Minor with a new home because the Franciscans were living in two places in the city where they suffered great discomfort — one place was too remote for them to obtain provisions easily and in the other their health was being compromised by 'pestilential' air.[65] (The remote place may have been S. Maria del Popolo, while S. Francesco a Ripa, in a valley near the docks and the river, could have been the unhealthy and polluted location.[66]) The Pope declared that he wanted the friars to reside in a place where they would be able to live humbly and at peace, praising God.

A second Bull, *Dilecti filii Fratres Minores Urbis*, sent from Lyon a year later, on 12 July 1249, declared that the Friars Minor had humbly petitioned the Pope to procure for them the church and monastery of S. Maria on the Capitoline Hill, 'propter aeris corruptionem' (because of pollution of the air) and various other negative features of the places where they were then living.[67] Bolgia stresses that the

Complex of Santi Quattro Coronati. See also, Hauknes, 'The Painting of Knowledge'.

63 The inscription begins: '+AD LAUD[EM] D[E]I O[MN]I[POTENT]IS ET HONOR[EM] B[EAT]I SILV[EST]RI / P[A]P[E] ET CON[FESSOR]IS. DEDICATA E[S]T HEC CAPELLA P[ER] D[OMI]N[U]M / RAYNALD[UM] OSTIEN[SEM] EP[ISCOPU]M AD P[RE]CES D[OMI]NI / STEPH[AN]I T[I]T[ULI] S[AN]C[T]E M[ARI]E T[RA]NSTIB[ER]IM P[RES]B[YTE]RI CARD[INALIS] / Q[UI] CAPELLAM ET DOMOS EDIFICARI FECI[T] / + IN NO[MIN]E D[OMI]NI AM[EN]. ANNO D[OMI]NI MCC / XLVI INDICTIO[N]E IIII FERIA VI ANTE / PALMAS T[EM]P[OR]E D[OMI]NI INNOCE[N]TII QUA / RTI P[AP]E ANNO IIII. ...' (This chapel was dedicated to the praise of Almighty God and to the honour of saint Silvester Pope and Confessor by Rainaldo [Cardinal] Bishop of Ostia at the prayers of Stefano, Cardinal Priest of S. Maria in Trastevere, who had this chapel and house built. + In the name of God, Amen. The year of the Lord 1246, Indiction IV, on the Friday before Palm Sunday, in the fourth year of the pontificate of Innocent IV ...) See Barelli, *The Monumental Complex of Santi Quattro Coronati*, p. 73, with some changes in the English translation. Some authorities point out that the year may have been 1247, given medieval variations of the calendar.

64 Maleczek, 'Conti Stefano', in *DBI*, vol. XXVIII, pp. 475–78.
65 *BF*, vol. I, pp. 521–22, no. 288. The 'other places' where the friars were living are given by the editor of *BF* as S. Francesco a Ripa, formerly called 'S. Thoma' (surely mistaken for S. Biagio) and SS. Crispino and Crispiano on the other side of the river, which Wadding described as 'destructa' (destroyed) in 1251. The friars were also said to have lived at S. Maria in Cosmedin and S. Maria del Popolo. The Catalogue of Turin, c. 1320, mentioned only ten clergy of no religious order at S. Maria in Cosmedin and twelve hermits (of Saint Augustine) at S. Maria del Popolo, see, Valentini and Zucchetti, *Codice Topografico*, vol. III, pp. 307 and 294.
66 For the Franciscans at S. Maria del Popolo, see Bolgia, *Reclaiming the Roman Capitol*, p. 97, and Oliger, 'De fratribus'. For S. Francesco a Ripa, see above, Chapter 3.
67 *BF*, vol. I, pp. 530–31, no. 304; Casimiro, *Memorie*, pp. 18–19; Wadding, *Annales Minorum*, vol. II, p. 16, no. 36.

initiative came from the friars.[68] It is likely that they first complained to their Cardinal Protector, Rainaldo, who then discussed the problem with the Vicar of Rome, Cardinal Stefano, and from there it was taken to the Pope.[69] Innocent IV ordered the Benedictine monks to transfer to the Friars Minor their monastery of S. Maria in Capitolio, including all its appurtenances, with the gardens around the monastery, the living quarters, the books, and all the ecclesiastical furnishings. The monks were to be re-located in other monasteries. It is noteworthy that both the books and the furnishings in the church were to be left for the friars, to use in their intellectual pursuits and in their liturgical celebrations. A third Bull, *Lampas insignis caelestium*, signed the following year in Lyon on 26 June 1250, was addressed to Cardinals Rainaldo and Stefano, about specific arrangements for the transfer of the Capitoline monastery to the Friars Minor, making it clear that the Benedictines were to be moved from there to other monasteries of their Order.[70] It would have been inappropriate for the Franciscans to have owned all the property of the rich Benedictine monastery, but they needed to 'use' the church, the monastic buildings, and the land surrounding them. Since the Pope was in France, it is likely that the transfer of the Benedictine monastery to the Franciscans was in fact planned and executed by Cardinals Rainaldo and Stefano, who were in close touch with the Friars Minor, rather than by the Pope, whose Bulls ratified the actions taken by his representatives in Rome. The fact that Cardinal Rainaldo had a sister and a nephew, and Cardinal Stefano had a son who had joined the Franciscans, may account for their patronage of this project (just as Cardinal Giovanni Boccamazza had assisted the Dominican nuns at S. Sisto because one of them was his relative).

In a fourth Bull, dated 1 October 1250, *Cum divinis deputati*, Innocent transferred to the Schola Cantorum of Rome all the property of the Capitoline monastery (churches, chapels, as well as various other possessions, houses, income, tithes, and pensions), making it clear that the church and monastery of S. Maria in Capitolio, with its gardens and other adjacent areas on the slopes of the Capitoline Hill, were reserved for the use of the Friars Minor.[71] It would have been inappropriate for the Franciscans to have kept all the property of the rich Benedictine monastery, but they did need the church, the monastic buildings, and the land surrounding them.

After Pope Innocent IV returned to Italy, he issued a fifth Bull, *Quoniam, ut ait Apostolus*, from Perugia on 20 March 1252, addressed to all the Christian faithful, urging lay people to help the Friars Minor, 'Ecclesiam cum aliis aedificibus suis usibus opportunis coeperunt aedificare' (who have begun to build their church as well as other buildings suitable for their customs); in return for this assistance, the Pope offered an indulgence of 40 days.[72] This Bull implies that the Franciscans had already begun rebuilding by 1252, but Bolgia downplays that possibility by pointing out that the Bull repeated a formula used in many other similar documents.[73] Nonetheless, the statement may have been a correct assessment of the situation on the Capitol, and, in any case, it clearly reflected the friars' intention to rebuild the church and other structures.[74]

68 Bolgia, *Reclaiming the Roman Capitol*, pp. 96–199.
69 One wonders whether Cardinal Stefano's son and Cardinal Rainaldo's nephew were involved in formulating the Franciscan petition; and whether Cardinal Annibaldi of Sant'Angelo in Pescheria had suggested the monastery on the Capitol, since he lived close by.
70 *BF*, vol. I, p. 545, no. 330. It stated that monks who opposed this and rebelled were to be dealt with according to ecclesiastical discipline.

71 *BF*, vol. I, pp. 556–58, no. 346; see Oliger, 'De fratribus', p. 293; and Malmstrom, 'S. Maria in Aracoeli at Rome', pp. 50–51.
72 *BF*, vol. I, p. 599, no. 397.
73 Bolgia, *Reclaiming the Roman Capitol*, p. 111.
74 D'Onofrio, *Renovatio Romae*, p. 94.

On 5 July 1252, Innocent IV, in a sixth Bull, *Iis, quae auctoritate*, sent from Perugia, provided the Minister General and the Order of Friars Minor with an official, written confirmation of the grant to them of the church and monastery of S. Maria in Capitolio, with all its appurtenances, as arranged by Rainaldo, Cardinal Bishop of Ostia and Velletri, and Stefano, Cardinal of S. Maria in Trastevere.[75] Innocent noted that the friars had moved into the buildings; he quoted from the Privilege of Anaclete II, which had defined the site of S. Maria in Capitolio; and he stated that S. Maria in Capitolio was a parish church.[76] The last provision eliminated problems from the local clergy about parish ministry. (Later, the Dominicans at S. Maria sopra Minerva did not begin to rebuild that church until parish rights there had been legally clarified in 1276.[77]) On 26 September 1259, Pope Alexander IV (formerly Cardinal Rainaldo) confirmed this Privilege.[78]

Hypothetical Reconstructions of the Benedictine Church of S. Maria in Capitolio

Several hypothetical reconstructions have been made of the Benedictine church, which the Franciscans rebuilt. When S. Maria in Aracoeli was restored in the 1950s, Pico Cellini produced a highly imaginative reconstruction of the earlier building, which was followed by several scholars.[79] He suggested that the Benedictine church was erected in the ninth century along the same axis as the later Franciscan one; that there were originally three apses at the eastern end of this building; and that it had no transept. The Franciscans, according to Cellini, kept the main structure of the earlier church, but removed four columns from the eastern end of its colonnades, to make way for their transept, placing the four columns at the eastern ends of the two side aisles. Cellini proposed that in the late thirteenth century, Arnolfo di Cambio added two structures to the sides of the transept and the eastern ends of the aisles. Further, he proposed that the structures on the south became a tribunal hall for the judges of the Roman commune, this development being patronized by Charles of Anjou, whose statue was placed at the entrance.[80] These proposals are now considered incorrect. Bolgia, in particular, has clearly and convincingly refuted Cellini's claims about Arnolfo, Charles of Anjou, and the tribunal, which are not supported by archaeological, architectural, or documentary evidence.[81] For all that, it is worth noting that Cellini recognized that the structures, now identified as medieval family chapels, at the eastern end of the church to the south of the transept and south aisle, and the Colonna chapel beside the eastern end of the north aisle, were late thirteenth-century additions to the main structure of the edifice. He also noted their pronounced Gothic features, such as ribbed vaults, pointed windows, and stained glass.

In 1973, Malmstrom produced a very different hypothetical reconstruction of the Benedictine church, which has partly been followed by Marianna Brancia de Apricena and Bolgia.[82] He

75 *BF*, vol. I, pp. 616–18, no. 418.
76 Bolgia, *Reclaiming the Roman Capitol*, p. 110. It is unlikely that the Benedictine church had been a parish.
77 See below, Chapter 6.
78 *BF*, vol. II, p. 365, no. 513.
79 Cellini, 'Di Fra Guglielmo e di Arnolfo'; Cellini, 'Ricordi Normanni e Federiciani a Roma'; and Cellini, 'L'opera di Arnolfo all'Aracoeli'. His reconstruction was accepted and followed by scholars, such as Pietrangeli, 'Recenti restauri nella chiesa di S. Maria in Aracoeli'; Pietrangeli, 'Storia e architettura dell'Aracoeli'; Romanini, *Arnolfo di Cambio*; and Romanini, 'Arnolfus architectus'.

80 Cellini, 'Di Fra Guglielmo e di Arnolfo'; Cellini, 'Ricordi Normanni e Federiciani a Roma'; and Cellini, 'L'opera di Arnolfo all'Aracoeli'.
81 Bolgia, 'The So-Called Tribunal of Arnolfo di Cambio'; Bolgia, 'Santa Maria in Aracoeli and Santa Croce: The Problem of Arnolfo's Contribution'; and Bolgia, *Reclaiming the Roman Capitol*, pp. 291–94.
82 Malmstrom, 'S. Maria in Aracoeli at Rome', pp. 21 and

believed that when the Franciscans built their church, they demolished the earlier edifice, which had been erected from the ninth to the twelfth century. He suggested that the Benedictine church stood roughly where the transept is today and that it had a north–south axis, with its façade facing the area that is now Piazza del Campidoglio.[83] He envisaged two rows of columns separating its nave and aisles. He examined the remains of the medieval bell tower, which can still be seen where the present side entrance to the church is located (Fig. 111) and he concluded that it was built *c.* 1200, but it was not finished, as it rises in only two storeys.[84] The campanile can be identified by its arched openings on two levels, its medieval friezes with small marble brackets and bricks laid in sawtooth fashion, and its twelfth-century brickwork streaked with 'falsa cortina' pointing. (In many ways the bell tower is like the unfinished campanile of S. Sabina.[85]) Malmstrom found that the tower had an exterior width of 5.42 m and an interior width of 3.645 m.

Brancia de Apricena followed Malmstrom in proposing that the Benedictine church was located on the site of the present transept and had a north–south axis. Bolgia agreed with the location and axis, and she worked out a detailed hypothetical reconstruction of the earlier church, facing south towards Piazza del Campidoglio.[86] She envisaged the Benedictine building with an apse to the north of the present transept, an earlier transept, and the nave and aisles separated by eight columns on either side. She suggested that the shrine of Saint Helena with the 'ara coeli' (altar of heaven) was located in its present position, which was then in the transept of the Benedictine church, near its triumphal arch. She argued convincingly, on the evidence of earlier walls, that, south of the Benedictine façade, there was a narthex, and that the unfinished bell tower stood to the west of that porch.

The Franciscan Church of S. Maria in Aracoeli

The Franciscan church of S. Maria in Aracoeli, instead of facing south towards the square in front of Palazzo del Senatore on the Capitoline Hill, looked towards the densely inhabited area of Rome in the bend of the River Tiber and, beyond that, towards Old St Peter's at the Vatican. The friars thus oriented the church and turned away from the centre of ancient Rome in the Forum, and towards Old St Peter's, a basilica with which S. Maria in Aracoeli has certain similarities, as it has with other early Christian and medieval churches in Rome. In plan, the Franciscan church (Fig. 108) is a basilica with a nave, two aisles, a transept, and formerly an apse; the nave and aisles (Fig. 109) are separated by eleven columns on either side, which support arcades. (The rectangular choir replaced the apse in the sixteenth century.) As at S. Francesco a Ripa, columns originally sustained the triumphal arch and columns framed the apse, beside which there were side chapels. The façade rose in a cavetto.

In many ways, the plan was similar to that of the great twelfth-century Marian basilica, S. Maria in Trastevere (Fig. 112), as depicted in an anonymous early sixteenth-century drawing, which shows the church with an apse, transept, nave, and two aisles, separated by eleven columns on either side — the rooms beside the basilica in this plan were not part of the medieval church.[87]

32–37; Brancia di Apricena, *Il complesso dell'Aracoeli*, p. xi endorsed this reconstruction; and see Bolgia, *Reclaiming the Roman Capitol*, pp. 39–67 and her fig. 1.12.

83 Malmstrom, 'S. Maria in Aracoeli at Rome', pp. 32–37.
84 See Malmstrom, 'S. Maria in Aracoeli at Rome', pp. 23–26, for his analysis.
85 See above, Chapter 2.
86 Bolgia, *Reclaiming the Roman Capitol*, pp. 39–67 and her fig. 1.12.

87 Rome, Istituto Centrale per la Grafica, Gabinetto Disegni e Stampe, vol. 2510, No. 32746 (35) with the inscription, 'S(anta) maria in tr(aste)vere i(n) Roma'. The drawing is

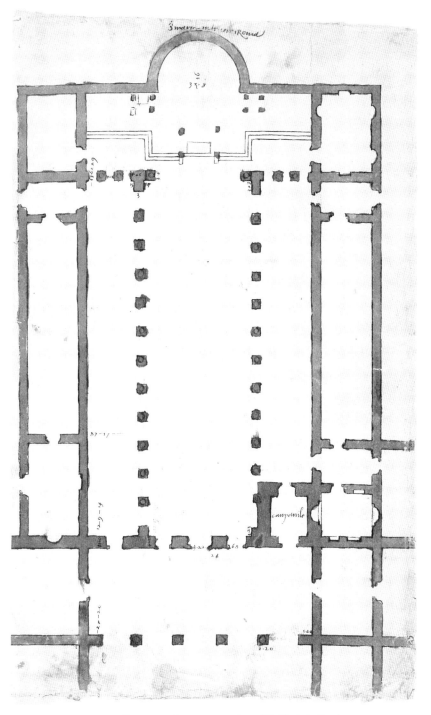

Figure 112. Anonymous, plan of S. Maria in Trastevere, 1510–1530 (Rome, Istituto Centrale per la Grafica, Gabinetto Disegni e Stampe, vol. MMDX, No. 32746 [35] – under licence from MiBACT)

At the triumphal arch, there were two large columns, and between each aisle and the transept there were two more columns, as there were originally in the Capitoline church. Instead of arcades over the colonnades, there were straight entablatures in the Trastevere church. The façade rose in a cavetto, over which was later added a triangular tympanum. There was a narthex in front of the church, and a campanile in the last bay of the 'south' aisle. At S. Maria in Aracoeli, there were in addition some features of the elevation that were different and Gothic in style — the clerestory and transept windows were pointed and filled with tracery; there were rose windows at either end of the transept and in the façade. In the medieval side chapels — rightly identified by Cellini as later additions to the main structure — there were ribbed vaults and tall lancets.

The Thirteenth-Century Apse

The original thirteenth-century apse of S. Maria in Aracoeli is known only from descriptions and drawings, since it was demolished and then replaced by the present choir (Fig. 108, F) in the pontificate of Pope Pius IV (1559–1565).[88] A medieval *opus sectile* pavement still in situ behind the high altar shows an outline of the original curve of the apse (Fig. 113). Drawings analysed by Bolgia contain further information.[89] These include

in ink and brown wash, and measures 27.5 × 44 cm. Dale Kinney kindly provided information about this anonymous drawing. She very kindly also allowed me to read her contribution on S. Maria in Trastevere in Claussen's *Die Kirchen der Stadt Rom im Mittelalter*, vol. v, which had not yet been published.

88 Casimiro, *Memorie*, p. 32.
89 Bolgia, 'Il coro medievale', pp. 233–36; Bolgia, 'Santa

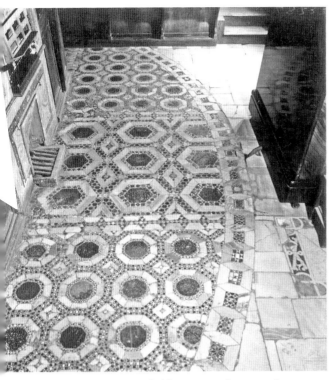

Figure 113. S. Maria in Aracoeli, 'Cosmatesque' *opus sectile* pavement showing an outline of the medieval apse (photo: ICCD – under licence from MiBACT)

a plan, dated *c.* 1480, in the Spada volumes at the Vatican Library[90] (Fig. 114), which shows that the medieval apse had a semi-circular interior and a polygonal (five-sided) exterior, with pilasters at the exterior angles. The interior was like the apses of other Roman basilicas, but the angular exterior with pilasters was unusual — although the apse of S. Maria in Trastevere had external pilasters, articulating a semi-circular surface. Bolgia pointed out that the five sides of the Aracoeli apse exterior recalled the apse of the upper church of S. Francesco in Assisi. Furthermore, in a view of the Forum drawn *c.* 1560, Giovanni Antonio Dosio showed above the walls of the apse of S. Maria in Aracoeli some triangular features,

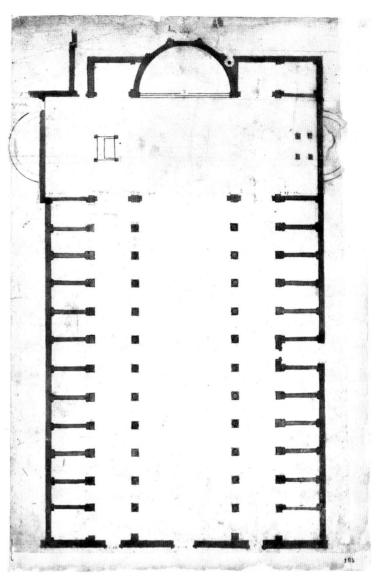

Figure 114. S. Maria in Aracoeli, Spada plan, c. 1480 (BAV, © 2018, Vat. lat. 11257, pt. A, _0405-fa_0185r)

topped by decorative pieces of sculpture.[91] A view of the Forum and Capitol, drawn by Marten van Heemskerck in 1532–1536, confirms this detail, by indicating similar outlines above the apse.[92]

Maria in Aracoeli and Santa Croce: The Problem of Arnolfo's Contribution'.

90 BAV, Vat. Lat. 11257, fol. 185ʳ.

91 Bolgia, 'Il coro medievale', p. 234, fig. 2 (Florence, Uffizi, Gabinetto dei disegni e delle stampe, nr. 2572A). See similar drawings in Bolgia, 'Santa Maria in Aracoeli and Santa Croce: The Problem of Arnolfo's Contribution'.

92 Bolgia, 'Il coro medievale', p. 235, fig. 3 (Berlin,

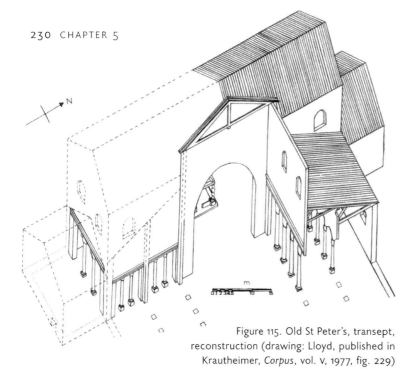

Figure 115. Old St Peter's, transept, reconstruction (drawing: Lloyd, published in Krautheimer, *Corpus*, vol. V, 1977, fig. 229)

These decorative features can be compared with those on the apses of the Franciscan churches of S. Croce in Florence (c. 1295–1310) and S. Fermo Maggiore in Verona (c. 1312–1318). Hence, Bolgia considered them typically Franciscan and she argued that the apse was built in the 1280s.[93] It may have been newly built, re-decorated, or remodelled, at that time.[94]

Pietro Cavallini painted a fresco on the vault of the medieval apse's semi-dome. It no longer exists, but Giorgio Vasari considered it his best work in Rome:

> Ma la migliore opera che in quella città facesse fu nella detta chiesa d'Araceli sul Campidoglio, dove dipinse in fresco nella volta della tribuna maggiore la Nostra Donna col Figliuolo in braccio circondata da un cerchio di sole, e a basso Ottaviano imperador, al quale la sibilla Tiburtina mostrando Gesù Cristo, egli l'adora.

(But the best work he did in that city was in the aforesaid Church of the Aracoeli on the Capitol, where he painted in fresco in the vault of the main apse Our Lady with her little Son in her arms, surrounded by a circle of the sun: and below, the Emperor Octavian, to whom the Tiburtine Sybil shows Jesus Christ, whom he adores.)[95]

The medieval high altar was where the present altar stands, and it would originally have been in the apse.[96] The sacred precinct around the modern altar is demarcated in the pavement by a border of intricate designs in *opus sectile* in an area 4.85 m wide and 4.20 m deep.[97] Incorporated in the sixteenth-century altar are some marble plaques with 'Cosmatesque' *opus sectile* designs.

The church is believed to have been consecrated on 23 July 1291, by the Franciscan Pope Nicholas IV (1288–1292), but it was most likely in use many years before that.[98] In Rome, the consecration of churches often took place long after the edifice was built. At S. Clemente, the upper church was in use by 1118–1119, when indulgences were granted to visitors, but it was officially consecrated only in 1295.[99] At SS. Vincenzo e Anastasio at Tre Fontane, the monastery church was built in 1140–1150, but only consecrated in 1221.[100] S. Maria in Trastevere was

Staatliche Museen Preussischer Kulturbesitz, berliner Skizzenbuch II., fol. 12ʳ).

93 Bolgia, *Reclaiming the Roman Capitol*, pp. 180–85 and figs 3.33 and 3.34.

94 The decorative features could have been added to the Aracoeli apse after the apse was built. At S. Maria sopra Minerva, the apse was rebuilt more than once.

95 Vasari, *Le Vite*, vol. I, p. 539. See also Casimiro, *Memorie*, p. 23. Bolgia, *Reclaiming the Roman Capitol*, pp. 210–22, discusses possible iconographic sources for this image and later works derived from it.

96 Bolgia, *Reclaiming the Roman Capitol*, pp. 185–87.

97 For the modern altar, see Noreen, 'The High Altar of S. Maria in Aracoeli'.

98 Nicholas IV issued a Bull, *Vitae perennis gloria*, on 23 July 1291, which granted indulgences to people visiting S. Maria in Aracoeli on certain days, including the anniversary of the dedication of the church, see Malmstrom, 'S. Maria in Aracoeli', p. 63 and his document 43.

99 Barclay Lloyd, 'The Building History [...] of San Clemente'; Barclay Lloyd, *The Medieval Church and Canonry*, pp. 66, 69–70, and 121.

100 Barclay Lloyd, *SS. Vincenzo e Anastasio at Tre Fontane*, pp. 185–87.

built in 1130–1143 and consecrated by Innocent III in 1215.[101] S. Maria in Aracoeli would surely have been in use long before the official consecration of the church took place in 1291.

The Transept

Malmstrom pointed out that the transept of S. Maria in Aracoeli showed the influence of the transept of Old St Peter's, which was a model for many later churches (Fig. 115).[102] Until the upper walls of the Capitoline transept were raised in the sixteenth century (as can be seen on the exterior of the building from a change of masonry between a typical medieval frieze of bricks and small marble brackets and the roof), the covering of the transept was c. 80 cm lower than that of the nave (Fig. 111), a feature similar to the transept of Old St Peter's. The floor of the transept is raised three steps above that of the nave and aisles at S. Maria in Arcoeli.[103] On either side of the Capitoline church, the transept extends beyond the width of the nave, which is a feature reminiscent of the exedrae that extended beyond the transept of Old St Peter's. (The east and west walls of the transept are c. 90 cm wide, except for where they extend beyond the nave and aisles, where they are only 62–65 cm wide.)[104] At the junction of the transept and the aisles, there are two pairs of columns, now standing close to the northern and southern ends of the openings. Evidently, they originally formed a columnar screen between the transept and aisles. This was also a feature of the space between the transept and aisles at Old St Peter's (Fig. 115) and at S. Maria in Trastevere, as known from the sixteenth-century plan (Fig. 112), until the columns there were pushed towards the edges of those spaces by Cardinal Altemps (1533–1595).[105]

There were two columns at the triumphal arch of S. Maria in Aracoeli, which are now hidden in piers that were part of a remodelling of the church interior in 1577.[106] The columns supporting the triumphal arch were not copied from Old St Peter's but from S. Paolo fuori le Mura. There is a similar feature at S. Maria in Trastevere. There are also columns at the apsidal arch of S. Maria in Aracoeli, which are now hidden. They are similar to those at S. Maria in Domnica. Although Bolgia sees these columns as typical of 'Benedictine' architecture, because they were a feature of the abbey church of Saint Benedict in Monte Cassino (see Fig. 81), they were also part of Rome's architectural heritage, which Abbot Desiderius of Monte Cassino was clearly imitating in his rebuilding of St Benedict's church. In Trastevere, at the Franciscan church of S. Francesco a Ripa, there were also columns at the triumphal arch and framing the apse.[107]

The Aracoeli transept originally had a simple timber roof, but it is now covered with a ceiling 'a cassettoni', dating from 1571, when it was constructed to commemorate the victory at Lepanto.[108] High up in the southern wall of the transept, Cellini found the remains of fresco decoration, with the Lamb of God in a roundel at the apex of the gable, and fragments of the symbols of the Evangelists John and Matthew lower down; he also discovered a frieze of brackets painted in perspective, similar to those in the

101 Kinney, 'The Image of a Building', esp. pp. 19–31; *Leggenda per la Consacrazione*, ed. and transcr. by Bartoli, trans. by Mallo, pp. 1–67, esp. 53–67.
102 Malmstrom, 'S. Maria in Aracoeli', pp. viii, and 164–74.
103 Bolgia, *Reclaiming the Roman Capitol*, pp. 159–63.
104 Malmstrom, 'S. Maria in Aracoeli', p. 167, who also explains how the different parts of each wall were joined; Bolgia, *Reclaiming the Roman Capitol*, p. 162. These narrower walls may indicate that they are later additions.

105 Malmstrom, 'S. Maria in Aracoeli', p. 220. Dale Kinney kindly provided information on Cardinal Altemps's moving the columns at S. Maria in Trastevere.
106 Bolgia, *Reclaiming the Roman Capitol*, p. 160 gives details of the evidence for this campaign.
107 See above, Chapter 3.
108 Carta and Russo, *Santa Maria in Aracoeli*, pp. 101–03; Bolgia, *Reclaiming the Roman Capitol*, p. 162.

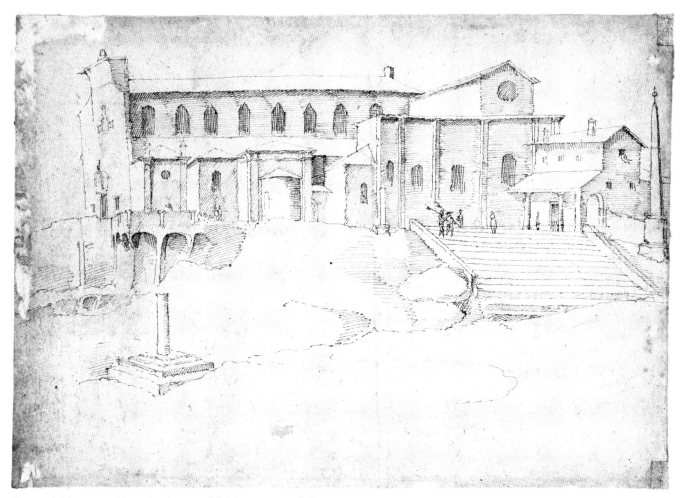

Figure 116. Marten van Heemskerck, view of S. Maria in Aracoeli from the south (Berlin, Kupferstichkabinett, Inv. Nr. 79 D 2 a, fol. 16ʳ)

transept of S. Maria Maggiore.[109] In the roof space, Malmstrom also saw traces of painting on the medieval rafters of the transept roof.[110] Although some of this decoration was lost in a later restoration campaign, Bolgia observed flowers painted on the rafters, as well as fictive brackets, star motifs, and vegetal designs.[111]

In the roof space, Bolgia perceived that the apsidal arch was slightly pointed — a Gothic feature — and she proposed that the triumphal arch was similar.[112] Another Gothic feature, a rose window, opened at either end of the transept. Malmstrom noted that the one on the north was located high up in the gable and would have been partly hidden by the medieval rafters; from this, he surmised that there was a pre-existing double-storeyed monastic building on that side of the church, which made it necessary to locate the window so high up in the north wall.[113] Bolgia found an old photograph, which showed a monastic building abutting the northern end of the transept,[114] but she claimed that the apse

109 Cellini, 'Di Fra Guglielmo e di Arnolfo', pp. 224–28.
110 Malmstrom, 'S. Maria in Aracoeli', pp. 96–98; 191–92.
111 Bolgia, *Reclaiming the Roman Capitol*, pp. 162–63.
112 Bolgia, *Reclaiming the Roman Capitol*, p. 158 and her fig. 3.14.
113 Malmstrom, 'S. Maria in Aracoeli', pp. 39–40.
114 Bolgia, *Reclaiming the Roman Capitol*, p. 162, her fig. 3.16.

of the Benedictine church had been in that location and the wall in question must have been built in the 1270s, when the apse of the earlier edifice was demolished and the new church was begun.[115] The masonry of the northern wall of the transept is constructed of *opus saracinescum*, which led Malmstrom to believe that it was probably built at the end of the twelfth or in the early thirteenth century by the Benedictines, but that kind of masonry was used throughout the thirteenth century and can be attributed to the Franciscans. Bolgia thought the wall belonged to an early sacristy, a theory that seems to be confirmed by the word 'sagrestia' in that place on the Spada plan (Fig. 114).[116] Casimiro also mentioned in the eighteenth century that the northern rose window was 'sopra della Sagrestia' (above the Sacristy).[117] The Franciscans probably constructed the sacristy north of the transept, but if so, it is strange that they built it to a height that interfered with the rose window in their new transept unless that wall of the transept was raised later.

The rose window in the southern wall of the transept was lower and not in the gable, but it no longer exists, being known only from an outline in the masonry above a later rectangular window (Fig. 111) and from views of the building, such as that by Marten Van Heemskerck of *c.* 1532–1536 (Fig. 116).[118] From a small garden east of the church, one can also see a blocked window, with a pointed arch and marble tracery, in the eastern wall of the south transept. Evidently, there was a similar window in the corresponding east wall of the northern arm of the transept.[119] These two transept windows are similar in their position to those in the transept of Old St Peter's (Fig. 115).

In S. Maria in Trastevere, windows (now blocked) on either side of the apse were outlined in mosaic. It is interesting to see that the designer of the transept of S. Maria in Aracoeli was inspired by the two great early Christian basilicas, Old St Peter's and S. Paolo fuori le Mura, as well as the medieval churches of S. Maria in Domnica and S. Maria in Trastevere.[120]

The Spada plan indicates that there were important features at either end of the transept. On the north (Fig. 114), there was, and still is, the 'chapel of Saint Helena', which incorporates the 'Ara coeli' (the altar of heaven), earlier called the 'ara filii Dei' (altar of the son of God). This is not an ancient Roman altar, despite the legend of Augustus and the Sybil. The very beautifully carved plaque in front of the altar looks like part of a medieval 'confessio', with an arched fenestella in the centre, as a focus for pilgrims approaching the sacred site.[121] Yet, there is no tomb or reliquary below this plaque. The 'confessio' and fenestella did not mark the tomb of a saint, nor a holy place, but a legendary event.[122] Hence, Bolgia aptly defines the arrangement as a 'pseudo-confessio'.[123] Above it, there is a porphyry 'sarcophagus' (in fact an ancient Roman trough), said to have served for the burial of the Empress Helena, Constantine's mother, and which is now part of an altar.[124] Inside this vessel were found the relics of Saint Helena in a sandalwood box, carved with birds and other designs, probably in the twelfth

115 Bolgia, *Reclaiming the Roman Capitol*, pp. 160–62 and her fig. 3.16.
116 Bolgia, *Reclaiming the Roman Capitol*, p. 162.
117 Casimiro, *Memorie*, p. 109.
118 Bolgia, *Reclaiming the Roman Capitol*, p. 160 and her fig. 1.6.
119 Bolgia, 'An Engraved Architectural Drawing', pp. 441–42.

120 It was common for churches in medieval Rome to follow features of St Peter's, as pointed out by de Blaauw, 'Origins and Early Developments of the Choir', pp. 25–32; de Blaauw, 'The Lateran and Vatican Altar Dispositions', pp. 201–17; and de Blaauw, 'Liturgical Features of Roman Churches', pp. 321–37.
121 Bolgia, *Reclaiming the Roman Capitol*, pp. 22–24, 116–41.
122 The excavations in 1963 did not uncover a special location, only a Hadrianic wall running east–west.
123 Bolgia, *Reclaiming the Roman Capitol*, p. 139.
124 Saint Helena is more credibly believed to have been buried in the fourth-century porphyry battle sarcophagus now in the Vatican Museums, see Bolgia, *Reclaiming the Roman Capitol*, pp. 127–32.

century. The relics of Saints Artemio, Abbondio, and Abbondanzio were also in the 'sarcophagus', in a small zinc box of unknown date.[125] It is possible that this arrangement dates from the time of Anaclete II (1130–1138), and that the translation of Saint Helena's relics was completed by his rival Pope Innocent II (1130–1143).[126] An inscription, formerly on one side of the altar, claimed that the original church on the Capitol had been consecrated by Pope Anacletus I (79–92), which suggests Anaclete II may have been the builder of the shrine.

Around the shrine's altar, there are now eight columns, which support a dome. This arrangement dates from the seventeenth century and was restored and perhaps restructured in 1833, when the altar was re-consecrated.[127] Earlier, there had been an altar canopy supported by four columns, as shown on the Spada plan (Fig. 114). The columns were of precious marble, according to Fra Mariano in 1518, who considered two of them particularly valuable and beautiful.[128] About seventy years later, Pompeo Ugonio described the altar as a porphyry vessel with a slab of marble on top and raised on two steps; over this was a ciborium supported by four columns of speckled green 'verde antico' marble, while iron grilles surrounded the shrine on all sides.[129]

On one side of the white marble 'confessio' plaque, there is an early medieval carving of the 'Tree of life' that probably dates from the ninth century and is now hidden from view.[130] On the other side, which is accessible, there is a carving in relief of the Lamb of God, with a halo, a cross on a disk, and blood flowing from his heart into a chalice. These were all symbols referring to the Eucharist, redemption, the remission of sins, the passion, and the resurrection of Christ. They were themes that were particularly dear to Saint Francis and to the Friars Minor. Parts of the 'confessio' slab are decorated with complex *opus sectile* patterns. In the spandrels of the outer arch, the Emperor Augustus is portrayed kneeling on the left, before an image on the right of the Mother of God holding the Child Jesus in an oval 'mandorla', filled with rays of light. These figures clearly refer to the legend of the 'Ara coeli', which is confirmed by an inscription along the top edge of the 'confessio'.

> Luminis hanc almam matris qui scandis ad aulam / cunctarum prima quae fuit orbe sita / noscas quod Cesar tunc struxit Octavianus / hanc ara[m] celi sacra proles cum patet ei.
>
> (You who ascend to the holy church of the Mother of Light, / the first of all that were established in the world, / should know that Octavian Caesar then built this altar / when the holy offspring of heaven was revealed to him.)[131]

The inscription stresses that this church is the earliest one in the world; it refers to the legendary revelation to Augustus of the Son of God; and it claims that the emperor built this altar. Mary holds Jesus, the light of the world.

From her analysis of the iconography and style of the carving of the 'confessio' plaque, Bolgia convincingly suggests a date c. 1250–1252, that is, at about the time the Friars Minor acquired and moved into their new friary.[132] This date came after a time of theological reflection on the real presence of Christ in the Eucharist, following the declaration on transubstantiation at the Fourth Lateran Council in 1215. The image of the Roman emperor on his knees before the

125 Bolgia, *Reclaiming the Roman Capitol*, pp. 128–29.
126 Bolgia, *Reclaiming the Roman Capitol*, pp. 128–32.
127 Carta and Russo, *S. Maria in Aracoeli*, pp. 148–52.
128 Mariano da Firenze, *Itinerarium Urbis Romae*, pp. 41–43.
129 BAV, Barb. lat. 1994, fol. 404ᵛ, and also quoted in Bolgia, *Reclaiming the Roman Capitol*, p. 118.
130 Bolgia, *Reclaiming the Roman Capitol*, pp. 120–26; see also, pp. 134–41.
131 Text and translation taken from Bolgia, *Reclaiming the Roman Capitol*, p. 22.
132 Bolgia, *Reclaiming the Roman Capitol*, pp. 135–39; the date is given on p. 139.

Virgin and Child can be seen in the political context of the crisis between Pope Innocent IV and the Holy Roman Emperor Frederick II. It also recalls similar iconography in the frescoes in the chapel of San Silvestro at SS. Quattro Coronati, commissioned by Cardinal Stefano Conti in 1246, which show images of the legend of the 'Donation of Constantine', culminating in the fourth-century Roman emperor acting as the subservient squire of Pope Silvester. These frescoes are located, moreover, opposite images depicting the story of Saint Helena finding the True Cross. The connection with Constantine's mother was also evident at the Aracoeli in the dedication of the shrine to Saint Helena with her relics, and there was evidently a relic of the True Cross in the Franciscan church.[133] Through the link with the chapel at SS. Quattro Coronati, the shrine in the transept points to Cardinal Stefano Conti as well as to the Franciscans.

The style of the carving on the 'confessio' plaque is very similar to that seen on a few items of liturgical furniture — namely, two pulpits and remnants of the medieval High Altar. Bolgia suggests that the Franciscans set up a new choir enclosure (which could at this stage have included a 'tramezzo') in the old Benedictine church very soon after they arrived at the site in 1250–1252.[134] If the Franciscans intended to rebuild the church, which they clearly did, it seems odd that they did not use the old Benedictine choir enclosure until the new building was completed and then build a new enclosure in the new church.

At the southern end of the transept there was a chapel dedicated to Saint Francis, which would have balanced that of Saint Helena. It was later overlaid by the Savelli family chapel.[135] Until the early eighteenth century, there was in the chapel an altar, surrounded by four columns of pavonazzetto marble, as shown in the Spada plan (Fig. 114).[136] Above these rose a ciborium with 'mosaic decoration'.[137] Saint Francis's altar was obviously an important focus in the Franciscan church. There was also a wooden statue of the saint of unknown date, showing him receiving the stigmata; this was moved to the sacristy in the early eighteenth century. Images of the saint's life are known to have been depicted on the walls of the transept and some also shone in stained glass in the two windows in the south wall.[138]

Two of the saint's early companions, Friars Sabatino and Juniper, were buried in the Aracoeli, but the location of their tombs is unknown.[139] Sabatino came to Rome with Francis and died in 1251. Juniper lived in the Eternal City and, when he died in 1257, he was buried in S. Maria in Aracoeli. It is possible that their tombs were close to Saint Francis's altar. A monument, said to contain the bones of Juniper, was erected in 1958 on the east wall of the south transept.

The Nave and Aisles

The nave is separated from the two aisles by colonnades of eleven columns each sustaining arcades (Fig. 109). From the late thirteenth century onwards, chapels were added to the north and south of the side aisles, many of them in the sixteenth century (Fig. 108).[140] The church walls are built of *opus saracinescum* and brickwork. Both Malmstrom and Bolgia made a careful examination of the masonry accessible in sections of the rising walls of the nave and of the façade of the church — but not in the walls of the aisles, which are hidden by plaster or were demolished during the erection of the

133 Bolgia, *Reclaiming the Roman Capitol*, pp. 144–45.
134 Bolgia, *Reclaiming the Roman Capitol*, p. 139.
135 The Savelli chapel is discussed below.
136 See also, Casimiro, *Memorie*, pp. 109–10.
137 Perhaps the 'mosaic decoration' was 'Cosmatesque' decoration in *opus sectile*.
138 These will be discussed below in conjunction with other imagery in the Savelli family chapel.
139 Bolgia, *Reclaiming the Roman Capitol*, pp. 142–43.
140 Heideman, *The Cinquecento Chapel Decorations*.

Shafts, Capitals, and Bases in the nave of S. Maria in Aracoeli, from the transept to the façade

	North Colonnade	South Colonnade
1.	*Shaft:* grey Elba granite *Capital:* ancient Composite *Base:* Ionic	*Shaft:* grey Elba granite *Capital:* ancient Composite *Base:* Attic
2.	*Shaft:* grey Elba granite *Capital:* ancient Corinthian with added volutes *Base:* Ionic on a plinth	*Shaft:* grey Elba granite *Capital:* ancient Corinthian with added volutes *Base:* Ionic on a plinth
3.	*Shaft:* grey Elba granite *Capital:* Composite *Base:* Attic	*Shaft:* grey Elba granite *Capital:* Composite *Base:* Attic on a plinth
4.	*Shaft:* grey Elba granite *Capital:* Composite *Base:* Attic	*Shaft:* grey Elba granite *Capital:* cut-down Composite *Base:* Attic
5.	*Shaft:* not visible, covered *Capital:* Augustan capital with 'imagines clipeatae' *Base:* not visible	*Shaft:* grey granite *Capital:* medieval copy of left capital with 'imagines clipeatae' *Base:* Attic attached to a plinth
6.	*Shaft:* grey Forum granite *Capital:* Severan Composite *Base:* Attic	*Shaft:* grey Elba granite *Capital:* Corinthian recut to look Composite *Base:* Attic attached to a plinth
7.	*Shaft:* pavonazzetto *Capital:* Severan Composite *Base:* round medieval plinth	*Shaft:* cipollino *Capital:* late Antique Corinthian *Base:* Attic on a moulded plinth
8.	*Shaft:* grey Elba granite *Capital:* a base used as a capital *Base:* not visible	*Shaft:* red granite (Aswan?) *Capital:* low medieval capital with leaves *Base:* not visible
9.	*Shaft:* red Aswan granite inscribed 'a cubiculo Augustorum' *Capital:* Composite *Base:* Ionic	*South shaft:* grey Elba granite *Capital:* Corinthian *Base:* Ionic
10.	*Shaft:* fluted white Proconnesian marble *Capital:* medieval Ionic *Base:* low plinth	*Shaft:* fluted white Proconnesian marble *Capital:* medieval Ionic *Base:* round stone
11.	*Shaft:* red Aswan granite *Capital:* late Antique Ionic *Base:* lacking	*Shaft:* red Aswan granite *Capital:* ancient Ionic *Base:* lacking

later chapels.[141] From their observations, it is clear that the northern and southern clerestory walls were built in bond with the walls of the transept and the part of the façade connected to the nave.[142] On either side of the church, a little over 20 m from the transept, in each of the clerestory walls there was a broad pilaster, 72 cm wide on the north and 68 cm wide on the south, remnants of which are visible in the roof space. (There are similar pilasters in the clerestory walls of S. Clemente, built in 1099–1119, and of S. Maria in Trastevere, built in 1130–1143.[143])

In the brickwork masonry of the north clerestory wall, which is 78 cm thick, there is clearly a join, which Bolgia interpreted as evidence that two teams of builders, working from either end of the nave, met at that point, which is about 24.80 m distant from the west wall of the transept. In the roof space of the southern clerestory wall, which is 74–75 cm thick, no break was visible in the interior, but a join could be seen on the exterior of the wall above the eastern jamb of the fourth window from the front of the building. Bolgia suggested that this showed that the upper part of that wall, from that point to the façade, was built a little later than the rest. Perhaps there was a more complete break on the south, which was effectively hidden by the builders when the window was constructed. If that were so, it is possible that the nave was built in two phases, one from the transept to the breaks on the north and on the south, the second from the breaks to the façade. (At S. Maria sopra Minerva, there are clear breaks in the masonry in similar places, on both sides of the nave, with two different types of masonry on either side of the breaks, which indicates that the nave was constructed in separate phases.[144])

The colonnades of S. Maria in Aracoeli each have eleven columns which sustain arcades composed of twelve semi-circular arches (Fig. 109).[145] The twelve intercolumniations vary in length, from 3.99 m to 4.61 m, perhaps because of the varied diameters of the re-used Roman columns.[146] (At Old St Peter's, there were four aisles and two rows of twenty-two columns on either side of the nave. Several medieval churches in Rome had half that number of aisles, namely two, and half that number of columns, namely eleven. Examples of this can be seen at S. Prassede in 817–824, at S. Crisogono in 1124–1130, S. Maria in Trastevere in 1130–1143, and in the nave of S. Lorenzo fuori le Mura in 1217–1227. These churches have a trabeation over the columns, whereas S. Maria in Aracoeli has arcades.)

All the columns, and most of the capitals and bases in S. Maria in Aracoeli, are reused *spolia* (see the table opposite).[147] The piers at the east end of the colonnades differ from those in the west, in that they have an upper decoration with string courses, while those near the façade have an ancient Corinthian pilaster capital on the north and a piece of foliate relief used as a capital on the south.[148] Most of the columns are arranged in pairs that more or less match each other across the nave. This is particularly noticeable in the six pairs closest to the transept,

141 Malmstrom, 'S. Maria in Aracoeli', pp. 149–64; Bolgia, *Reclaiming the Roman Capitol*, pp. 153–58.

142 Malmstrom noted, however, that part of the southern clerestory wall seemed to abut the façade wall, see Malmstrom, 'S. Maria in Aracoeli', p. 150.

143 For S. Clemente, see Barclay Lloyd, *The Medieval Church and Canonry*, pp. 107 and 120; for S. Maria in Trastevere, Kinney, 'S. Maria in Trastevere from its Founding to 1215', p. 252.

144 See below, Chapter 6.

145 See Malmstrom, 'S. Maria Aracoeli at Rome', pp. 144–49; Malmstrom, 'The Colonnades', pp. 39–40; Bolgia, *Reclaiming the Roman Capitol*, pp. 263–83, for a discussion of the shafts, bases, and capitals. Bolgia suggested that the arches above the columns may have been pointed originally — 'in tune with the pointed windows' in the clerestory, see Bolgia, *Reclaiming the Roman Capitol*, p. 158, but there is no evidence for this.

146 Bolgia, *Reclaiming the Roman Capitol*, pp. 146–47.

147 Kinney, 'Making Mute Stones Speak', pp. 85–86.

148 This is pointed out by Bolgia, *Reclaiming the Roman Capitol*, pp. 263–64.

Figure 117. S. Maria in Aracoeli, upper part of a clerestory window (photo: ICCD – under licence from MiBACT)

grey granite columns, extends as far as the sixth columns from the triumphal arch; the second, with columns of varied materials, is located from there to the façade. Like the joins in the clerestory walls, the two divergent groups of columns may indicate two different building campaigns.

Each aisle originally had a simple timber roof, but the aisles are now vaulted, a change dating from the 1460s, when vaulting was commissioned by Cardinal Oliviero Carafa (1430–1511).[150] The columns between the aisles and the transept were perhaps moved to their present positions at that time. The six clerestory windows on either side of the nave are now rectangular, but van Heemskerck indicated eight pointed windows (Fig. 116); it is clear that they did have pointed arches (Figs 111 and 117), but there is no evidence that there were eight rather than six openings. (Six windows indicate that there was one above every second intercolumniation, a feature of the fenestration of the nave of Old St Peter's.) From the exterior, one can still see that the clerestory windows were filled with Gothic tracery, fragments of which remain.[151]

The Medieval Choir

Casimiro mentioned in his history of the church that the choir of the friars was 'nel mezzo della nave maggiore' (in the middle of the main nave), quoting the biography of Pope Paul II (1464–1471)

which have shafts of grey granite, whereas the rest have shafts of varied kinds of granite or marble. The columns, capitals, and bases therefore seem to be in two different groups — one with grey granite columns, perhaps taken from the earlier Benedictine church, the other a more varied selection of shafts.[149] The first group, with the

149 Malmstrom, 'S. Maria Aracoeli at Rome', p. 146, notes that 'the twelve columns at the west end of the church [...]

form a less coherent group' than the remaining columns in the east of the nave.

150 Casimiro, *Memorie*, p. 28, attributes to Cardinal Oliviero Caraffa the vaults in the aisles, where he saw his coat of arms. See also, Malmstrom, 'S. Maria Aracoeli at Rome', pp. 107–10; and Bolgia, *Reclaiming the Roman Capitol*, pp. 150–53.

151 Bolgia, 'An Engraved Architectural Drawing'; Bolgia, *Reclaiming the Roman Capitol*, pp. 222–39. Brancia di Apricena, *Il complesso dell'Aracoeli*, pp. 71–78, suggested there were at first only very low clerestory windows, which were replaced by tall pointed ones in a reconstruction, which Bolgia rightly refutes.

by Michele Cannesio of Viterbo (1420–1482),[152] which was written long before the new choir was constructed behind the high altar in the pontificate of Paul IV (1555–1559).[153] According to Malmstrom, special or unusual capitals in the colonnades sometimes marked the division of the nave into a space for the clergy and a space for the laity.[154] Of all the capitals in S. Maria in Aracoeli, the most unusual are the two supported by the fifth columns west of the transept, which bear 'imagines clipeatae' (portraits on shields) and leaves. Hence, Malmstrom believed that these capitals marked the western limit of the original choir enclosure of the Friars Minor, which was situated in the eastern half of the nave.[155] A side door in the south aisle wall shown in the Spada plan (Fig. 114) was located between the fifth and sixth columns west of the transept and would have granted access to the public part of the nave beyond the choir. Malmstrom's theory about the western limit of the choir enclosure has been overturned by Bolgia, who found archaeological and documentary evidence that an ornate marble tabernacle-chapel, commissioned by Francesco Felici to house the icon of *Maria Advocata* in S. Maria in Aracoeli, was erected in 1372 against the choir enclosure close to its entrance; and the tabernacle-chapel had its western edge in line with the fourth pair of columns from the transept.[156] This shows that the choir would have been shorter than Malmstrom proposed, ending between the third and fourth bays of the nave from the east. Besides, the location of the tabernacle against the choir enclosure indicated that there was no wall, or 'tramezzo', between the choir enclosure and the rest of the nave, as at S. Sabina.[157]

The position of the choir enclosure in front of the transept was similar to the location of the choir at the abbey of Monte Cassino (Fig. 81). In S. Maria in Aracoeli, the part of the church west of the choir was accessible to the public, who, when the building was completed, could enter through the three doors in the façade or through the side entrance shown in the Spada plan (Fig. 114).[158] The two re-assembled pulpits or lecterns now in the transept, decorated with 'Cosmatesque' designs of inlaid coloured marble may have stood on either side of the choir enclosure, in an arrangement like that at S. Clemente, which dates from the early twelfth century.[159] It seems likely that this liturgical furniture was made expressly for the Franciscan church, rather than installed in the earlier Benedictine edifice and then reassembled in the thirteenth-century church.

A Pilgrim Pathway to the Aracoeli Shrine and the Icon of the Madonna Advocata

As was the case at S. Sabina, there was a 'pilgrim pathway' for people to visit the shrines in the church.[160] For example, they could go to the famous 'Ara coeli' and chapel of Saint Helena in the north transept.[161] High up on the third column from the façade on the north, there was an inscription, 'A cubiculo Augustorum', which

152 Casimiro, *Memorie*, p. 23.
153 Bolgia, *Reclaiming the Roman Capitol*, pp. 177–78.
154 Malmstrom, 'The Colonnades'.
155 For early Franciscan choirs in Central Italy, see Cooper, 'Franciscan Choir Enclosures'; and Cooper, 'Access all Areas?'.
156 Bolgia, *Reclaiming the Roman Capitol*, pp. 124, 137–38 for the icon, and 348–88 for the Felici chapel. For the location of the choir and tabernacle chapel, see her fig. 4.25. See also her article on the Felici tabernacle, Bolgia, 'The Felici Icon Tabernacle'. Casimiro, *Memorie*, p. 24, referred to the icon being in the Tabernacle.

157 Bolgia, *Reclaiming the Roman Capitol*, pp. 284–86. For the tramezzo in S. Sabina, see Chapter 3.
158 The present side entrance dates from 1564. In the sixteenth century, the earlier side entrance was demolished, when chapels were added to that side of the building.
159 Barclay Lloyd, *The Medieval Church and Canonry of S. Clement*, pp. 38–40.
160 See above, Chapter 2 and Bolgia, *Reclaiming the Roman Capitol*, pp. 283–89.
161 Discussed above in the section on the transept.

can be taken to mean 'from the bedroom of the Augusti (or of the Emperors)', or it can be interpreted as a reference to the 'cubicularius' (chamberlain) of the Emperor.[162] In the Middle Ages, it was probably given the first meaning and it was understood to refer to the legend of the Aracoeli, since Augustus's revelation was said to have taken place in the emperor's palace. It could therefore have been a signpost to the shrine in the north transept. Pilgrims would have walked past the column and along the north aisle to visit the shrine at the northern end of the transept.

Above the Aracoeli shrine, there was also, early on, the icon of *Maria Advocata* (Plate 7) until, in 1372, it was moved to the Felici tabernacle set against the north-western side of the choir enclosure in the middle of the nave. (Today it is above the high altar, which was remade in the late sixteenth century and then refurbished by Benedict XIII in 1723.[163]) The icon was first mentioned as being at S. Maria in Aracoeli in 1257.[164] This was the year when the General Chapter of the Friars Minor was held on the Capitol and Bonaventure was elected Minister General of the Order. From the late fourteenth century onwards, pilgrims coming to S. Maria in Aracoeli could have approached the Gothic tabernacle of the Felici chapel, where the icon of the Virgin was kept above the altar in a wooden cabinet that could be opened or closed.[165] All this was sheltered in a magnificent, intricately carved Gothic canopy.

The image (Plate 7) was attributed to Saint Luke and is a copy of the *Hagiosoritissa* icon, known in Rome as *Maria Advocata* (Plate 1), that was taken by Saint Dominic from S. Maria in Tempuli to S. Sisto in 1221, then transferred from there to SS. Domenico e Sisto in the late sixteenth century, and, in the 1930s, moved to the Dominican nunnery of the Madonna del Rosario at Monte Mario, where it is today.[166] The artistic techniques of the Aracoeli icon differ from that at S. Sisto — the image is not painted in encaustic — with wax as a medium for the paint — and there are no golden metal hands (see Plate 2). Yet, it is clear that the artist has tried to copy the prototype in the shape of the eyebrows, the long nose, the small mouth, and the modelling of the chin. In Roman fashion, in the Aracoeli icon, the Mother of God looks directly at the viewer, which is not true of the S. Sisto image. Today, the Franciscan icon is more complete than the Dominican one. One sees the Virgin's purple *maphorion* decorated with gold crosses, her blue tunic edged with gold stripes at the cuffs, a painted diadem on her head. The Aracoeli image has been dated from the tenth to the twelfth century, or, more recently, to the third quarter of the eleventh century, and ascribed to a Roman artist.[167] The S. Sisto icon has been dated to the sixth century and attributed to an artist from Constantinople, or elsewhere in the Byzantine Empire.

The type of icon — known in Rome as the *Maria Advocata* (Mary as Advocate or Intercessor) — was very popular in the city. Several medieval examples survive and some of them have

162 Kinney, 'Making Mute Stones Speak', pp. 83–86.
163 Carta and Russo, *Santa Maria in Aracoeli*, p. 158; Casimiro, *Memorie*, p. 129. For the later arrangement, see Noreen, 'The High Altar of S. Maria in Aracoeli'.
164 Malmstrom, 'S. Maria Aracoeli at Rome', p. 53, refers to a text written *c.* 1385–1390, which recorded a miracle that occurred in 1257 'ante imaginem, quam pinxit sanctus Lucas de Domina nostra' (before the image which Saint Luke painted of Our Lady'). See Pesci, 'Il problema cronologico della Madonna di Aracoeli', p. 57.
165 For the icon, Grassi, Luigi, 'La Madonna dell'Aracoeli'; Andaloro, 'Note', pp. 127–29; Wolf, *Salus populi Romani*, pp. 228–35, 307 n. 98; and Leone, *Icone*, vol. 1, no. 12, pp. 63–65, fig. 12 (with further bibliography). For the Felici tabernacle-chapel, Bolgia, 'The Felici

Icon Tabernacle'; and Bolgia, *Reclaiming the Roman Capitol*, pp. 349–53 and Fig. 4.26, where she gives a reconstruction of the Felici altar and icon tabernacle.
166 See above, Chapter 1 for the icon of S. Maria in Tempuli / S. Sisto.
167 Bolgia, *Reclaiming the Roman Capitol*, p. 124, for the latest theories about its date.

inscriptions giving them special titles: 'Fons lucis stella maris' (Fount of light and star of the sea) at S. Maria in Via Lata; the 'Virgin of Edessa' at SS. Bonifacio ed Alessio;[168] 'Virgo virginum' (Virgin of virgins) on one of two such icons at the nunnery of S. Maria in Campo Marzio.[169] The Cistercian nuns of S. Susanna possessed two similar icons in the early eighteenth century.[170] These icons belonged to communities of nuns, monks, or friars, except for one at S. Lorenzo in Damaso, which has a list of relics rather than a title, and came from a chapel at Campo de' Fiori.[171]

The icon at S. Maria in Aracoeli was considered miraculous and it was reputed to have been the image carried by Pope Gregory the Great (590–604) during an outbreak of the plague, when he led a penitential procession through the streets of Rome, chanting a litany and begging for the epidemic to cease.[172] On that occasion, Saint Michael the Archangel is said to have appeared above the Mausoleum of Hadrian, replacing his sword in its scabbard, as a sign that the pestilence had ended. From that time on, the name of the ancient Mausoleum of Hadrian was changed to 'Castel Sant' Angelo' and a bronze statue of Saint Michael was placed at the top of the monument, where there was also a chapel dedicated to him.[173]

According to Fra Mariano, when Gregory heard the angels singing, 'Regina coeli laetare, alleluia' (Queen of heaven rejoice, alleluia), he responded, 'Ora pro nobis, alleluia' (Pray for us, alleluia), and then the plague ceased; in later times, the Friars Minor joined the penitential Litany held on the feast of Saint Mark (25 April) every year, and, in memory of that event, they would sing the 'Regina coeli' antiphon when the procession reached Ponte Sant'Angelo.[174] The words, 'Regina coeli laetare, Alle', were written above the icon, when it was transferred to its present position above the high altar in the church and can still be seen today. The Franciscans at S. Maria in Aracoeli also showed pilgrims a stone with the imprint of two feet, which they claimed were the Archangel Michael's footprints as he stood on the top of Castel Sant'Angelo sheathing his sword.[175]

Of course, if the icon at S. Maria in Aracoeli were painted in the eleventh century, it could not have been the image Gregory the Great carried in the sixth-century procession. According to Fra Mariano, some people said that that was an icon from S. Maria Maggiore, while some Dominican friars claimed it was the one from S. Sisto; so, he concluded, 'Sed qualis sit, Deus scit' (But God knows which one it was).[176] Still, the Aracoeli icon was a copy of the original image. When the Black Death struck in the summer of 1348, the people of Rome imitated Gregory the Great by carrying the Aracoeli icon of *Maria Advocata* in procession while praying to the Virgin to stop the plague; and, when the pestilence ceased, they attributed this to Mary's intercession.[177]

168 For the 'Fons Lucis Stella Maris', and the 'Virgin of Edessa', see Leone, *Icone*, vol. I, no. 18 and no. 31, pp. 70–71 and 79–81 and vol. I, fig. 27 and vol. II, tav. on p. 21.
169 Leone, *Icone*, vol. I, no. 14, pp. 66–67; and fig. 14 and vol. II, figures on p. 13. This icon is now in Rome, Galleria Nazionale d'Arte Antica di Palazzo Barberini. The other icon of this type from Campo Marzio is discussed in Leone, *Icone*, vol. I, no. 32, p. 81 and illustrated in fig. 35 and in Caracciolo, 'Il monastero di Santa Maria e San Gregorio' pp. 12–13 and 18–20.
170 Casimiro, *Memorie*, p. 130, refers to one at S. Susanna on an altar close to the sacristy and another within the monastery. An icon of this type is still accessible in the main part of the church.
171 For the icon at S. Lorenzo in Damaso, see Poós, *San Lorenzo in Damaso*, pp. 20–22; Leone, *Icone*, vol. I, no. 45, pp. 91–92, and fig. 50.
172 Casimiro, *Memorie*, pp. 134, 136.
173 Mariano da Firenze, *Itinerarium Urbis Romae*, p. 42.
174 Casimiro, *Memorie*, pp. 136–38.
175 Panciroli, *Tesori nascosti*, p. 70. Lisa Beaven kindly told me about the archangel's footprints. In the church pavement there is also a single footprint, reputedly of Christ, like those associated with his Ascension in Jerusalem, see Bolgia, *Reclaiming the Roman Capitol*, p. 191 and fig. 3.39.
176 Mariano da Firenze, *Itinerarium Urbis Romae*, p. 42; see also, Wolf, *Salus Populi Romani*, pp. 102–106.
177 Casimiro, *Memorie*, p. 135, who first attributes the miracle to 1388, but then clarifies that it was in 1348.

In thanksgiving, people donated money to the church, which was used to build the monumental marble staircase in front of the façade.[178]

The Façade

The brick façade of S. Maria in Aracoeli rises high and majestic, with a cavetto over the centre (Figs 110, 118, and 119). It has been given a date of 1268 or 1320.[179] Its foundations were built contemporaneously with the foundations of the nave and aisles, which shows it was planned and possibly built at the same time — in the 1280s and 1290s, according to Bolgia.[180] The façade now opens in three doorways, leading into the nave and aisles. The central door is flanked by marble jambs and a lintel, which is supported by brackets held up by finely carved marble hands.[181] Above the lintel is a semi-circular arch that dates from the fifteenth century. Above the side doors, there are pointed arches, and, higher up, two circular blocked windows with carved marble tracery. In the wall above the main doorway, there is now a rectangular opening, but earlier drawings and prints show that there was originally a

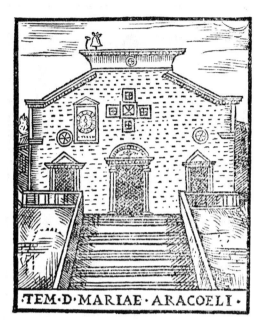

Figure 118. Gieronimo Francino, façade of S. Maria in Aracoeli (*Le Cose Meravigliose…*, ed. Fra Santi, 1588, p. 50 v; photo: Bibliotheca Hertziana – Max-Planck-Institut für Kunstgeschichte, Rome)

cross-shaped window, containing one large and four smaller rose windows (Figs 118 and 119).[182] This window symbolized Franciscan devotion to the cross of Christ.

On the southern face of the Aracoeli cavetto, fragments survive of a mosaic representation of the *Dream of Innocent III*, showing Saint Francis holding up the tottering cathedral of St. John Lateran.[183] Given this iconography, the most appropriate time for this mosaic to have been made was in the pontificate of the first Franciscan pope, Nicholas IV (1288–1292), who restored the Lateran church and in so doing imitated Saint Francis.[184]

178 This is discussed below.

179 Malmstrom, 'S. Maria Aracoeli at Rome', p. 55, gave a date of 1268. D'Onofrio, *Renovatio Romae*, pp. 105–06; Carta and Russo, *Santa Maria in Aracoeli*, p. 61; and Brancia di Apricena, *Il complesso dell'Aracoeli*, pp. 74–75 all dated it *c.* 1320.

180 Bolgia found its foundations in *opus saracinescum* were connected to those of the nave and aisles, Bolgia, *Reclaiming the Roman Capitol*, pp. 202–03. The brickwork of the façade has a modulus of 25 cm for five rows of bricks and mortar, which was common in Roman masonry from the second half of the thirteenth to the early fourteenth century. If there were two phases in building the nave and aisles, as suggested above, the western part of the church would have been built after the transept and the eastern half of the nave and aisles.

181 Malmstrom, 'S. Maria Aracoeli at Rome', p. 131, dates the brackets to *c.* 1350; Bolgia, *Reclaiming the Roman Capitol*, pp. 203–04, suggests a date of 1349, following a severe earthquake in Rome.

182 Malmstrom, 'S. Maria Aracoeli at Rome', pp. 129–32; Bolgia, *Reclaiming the Roman Capitol*, pp. 204–06. In the images, from the sixteenth century onwards, there is a clock.

183 For a fresco of this scene, painted in 1297–1308 by Giotto, see the righthand image on the cover of this book.

184 Bolgia, *Reclaiming the Roman Capitol*, pp. 99, 178,

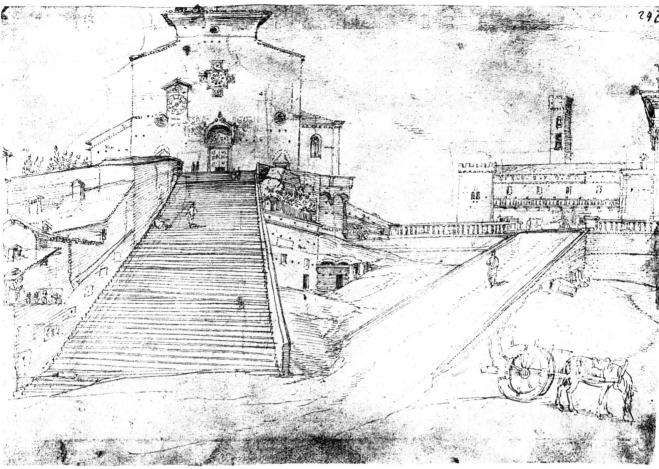

Figure 119. Anonymous Fabriczy, S. Maria in Aracoeli, side view of the façade (photo: Bibliotheca Hertziana – Max-Planck-Institut für Kunstgeschichte, Rome)

The Staircase

In 1348, a monumental staircase was built, leading up the Capitoline Hill to the façade of the church (Figs 106, 118 and 119).[185] A marble plaque on the façade gives the name of the man who designed the stairs, Lorenzo Simeone Andreozzo 'fabricator de Roma de Regione Columnae' (architect of Rome from the Colonna Region) who was the principal Master of the work of the stairs.[186] Construction began on 25 October 1348. On either side of the 125 steps, marble plaques with ancient Roman reliefs were placed.[187] The stairs completed the friars' plan to turn the church around and face a new direction. They facilitated the ascent of the Capitoline Hill from the west, rather than from the Forum. The steps were often depicted

201–03, 396 and Plate 4; see also, Gardner, 'The Louvre Stigmatization'; Andaloro, 'Il sogno di Innocenzio III all'Aracoeli'; Gardner, 'Päpstliche Träume und Palastmalereien'; Gardner, 'Patterns of Papal Patronage'; Cooper and Robson, *The Making of Assisi*, pp. 26–27.

185 Carta and Russo, *S. Maria in Aracoeli*, pp. 77–80. Malmstrom, 'S. Maria Aracoeli at Rome', p. 130, notes the number of steps, which has changed over the centuries, but has been 125 since a restoration in 1888.

186 See Casimiro, *Memorie*, pp. 26–27, who gives the whole text. A 'fabricator' was an architect or designer, who had overall supervision of buildings, see Du Cange, *Glossarium mediae et infimae Latinitatis*, 'fabricator': 'cui aedificiorum cura demandata' (of whom is demanded the overall oversight of buildings).

187 The reliefs have since disappeared.

on early maps of Rome and help to identify the Franciscan church (Fig. 106). Built at the time of Cola da Rienzo, they are often associated with his plans for the renewal of Rome. Before the stairs were constructed, visitors to the church had to enter it from the west via a built-up platform surrounded by a low wall, as seen in the Heemskerck view (Fig. 116).

Medieval Chapels

The Franciscans were close to lay people and they encouraged prominent Roman families to establish private chapels at S. Maria in Aracoeli — as the Dominicans did at S. Maria sopra Minerva.[188] Caroline Bruzelius has observed that this was a way of funding the construction and maintenance of church buildings belonging to the Mendicant Orders, as the patrons of these chapels took care of them and provided a regular income to the friars in return for the right to have family members buried and commemorated in the chapels, and Masses to be said for the repose of their souls.[189] The families who established chapels at S. Maria in Aracoeli were often members of the Roman Senate, because of the church's proximity to the offices of civic government on the Capitol. Among them were the Capocci, the Savelli, and the Colonna. When the members of a family could no longer maintain their chapel, it would pass to another family and sometimes the dedication of the chapel was changed. (There are records of this happening at S. Maria in Aracoeli and at S. Maria sopra Minerva.[190])

It was typical of early Franciscan churches to have one or more chapels on either side of the apse. The Spada plan of c. 1480 shows this disposition, before the apse was replaced by the present choir in the sixteenth century (Fig. 114);[191] the chapel on the left is more or less rectangular, that on the right has two interconnecting bays, with a wall separating the southern bay from the transept.[192] The east wall of these side chapels probably rose above the eastern aisle wall of the former Benedictine church.[193] These were the oldest chapels at S. Maria in Aracoeli, which were later remodelled.

Sixteenth-century drawings, such as that by Marten van Heemskerck, *S. Maria in Aracoeli from Piazza del Campidoglio*, c. 1532–1536 (Fig. 116); and Anonymous, *View of the South flank of S. Maria in Aracoeli*, c. 1561,[194] show on the south-eastern side of the church a high wall, which survives and is articulated by six narrow pilasters. The wall appears to have been added to the south of the transept (Fig. 111). Above the pilasters is a crowning medieval frieze of bricks and small marble brackets, which also runs across the transept.[195] The wall began east of the transept, where the chapel of Saint Rose of Viterbo is now located, and where the wall has now been lowered; then, there are two pilasters at each corner of the transept itself, whose southern wall rises higher than the frieze; there follow three more pilasters to the west of the transept,

188 Casimiro, *Memorie*, pp. 36–129, 150–56, 182–237. For the later history and decoration of the chapels, see Heideman, *The Cinquecento Chapel Decorations*. For the chapels at S. Maria sopra Minerva, see Chapter 6.
189 Bruzelius, *Preaching, Building, and Burying*, pp. 166–71.
190 Casimiro, *Memorie*, pp. 36–129, 150–56, 182–237, gives information on the dedication and patronage of chapels at S. Maria in Aracoeli. For S. Maria sopra Minerva, see below, Chapter 6.

191 Most of the chapels shown in the fifteenth-century Spada plan beside the aisles are not accurately drawn, whereas the ones beside the apse may be more precise.
192 Brancia di Apricena, *Il complesso dell'Aracoeli*, figs 1 and 16, reconstructs the side chapels north and south of the apse, as in the Spada plan.
193 Bolgia, *Reclaiming the Roman Capitol*, fig. 1.12.
194 Bolgia, *Reclaiming the Roman Capitol*, fig. 1.9.
195 The fact that it crosses the transept makes one suspect that the southern wall of the transept was built at the same time as the rest of the wall, which includes the earlier southern façade of the bell tower. In other words, the transept was extended southwards, as proposed by Cellini, 'Di Fra Guglielmo e di Arnolfo', figs 9 and 11–13, who does not include the easternmost chapel, however.

two of which are on either side of the former bell tower; and one more at the western end of this wall. The pilasters stand at varied distances from one another. The height of the wall (except for where it crosses the transept) originally may have been related to the height of the unfinished campanile. In 1260, at the General Chapter of Narbonne, the Franciscans decreed that in order not to exceed the bounds of poverty in their buildings they should not have bell towers.[196] Hence, the existing, unfinished campanile at the Aracoeli was left incomplete and incorporated in the new block added to the south transept. Today the situation shown by van Heemskerck has changed, in that east of the transept the wall rises to a lower level; a large modern window also interrupts the frieze across the transept (compare Figs 111 and 116).

The two pilasters at the corners of the transept bear marble shields with the Savelli coat of arms depicted in mosaic, indicating the location of their family chapel, in the transept.[197] The space between the transept and the next pilaster to the west is occupied by the chapel now dedicated to Saint Paschal Baylon (but it was formerly the Capodiferro chapel of Saint John the Evangelist). The next compartment is taken up by the remains of the former bell tower (Fig. 108, L), in which there was the chapel of Saints Peter and Paul until 1564, when the present side entrance to the church was opened. The final section of this 'block' is taken up by the chapel of Saints Lawrence and Diego, formerly dedicated only to Saint Lawrence, and belonging to the Cenci family. Heemskerck's drawing (Fig. 116) shows a lower structure to the west of that chapel and then indicates the earlier side entrance to the church, which is also drawn on the Spada plan, although that drawing does not clearly distinguish the southern block from the rest of the edifice (Fig. 114).

Pilasters, like the ones that articulate this southern wall, are a feature of the church of S. Maria sopra Minerva, built by the Dominicans from the 1280s onwards, where they incorporated a means of draining water off the roof.[198] At S. Maria in Aracoeli, the pilasters do not support the roof over this section of the building. Seen from above, or from the south aisle roof, the wall with the pilasters appears to have been added to the church as a distinctive façade, or what Malmstrom calls a 'false front', that now rises higher than the roof of the three chapels west of the transept.[199] It is possible that the pilasters also helped to drain rainwater from the building.

From an architectural point of view, these southern chapels form interesting additions to the thirteenth-century church and incorporate the eleventh- or twelfth-century remnants of the bell tower. In the Anonymous drawing, there seems to be a vertical line some way along the west wall of the transept. One can also see this in a modern photograph (Fig. 111). There appears to be a fissure at a point in the west wall of the south transept. To the north of this, there is a row of gargoyles, but none on the other side. This suggests that the transept, south of the fissure, is an addition to the original structure of the Franciscan church, and Malmstrom and Bolgia noted that the thickness of the walls of the transept beyond the aisles differed from the rest.[200] (In fact, Cellini drew this part of the transept as an addition.[201]) Taking note of Bolgia's hypothetical reconstruction of the Benedictine church,[202] one can suggest that the builders of the chapels erected the wall with the pilasters over the southern end of the Benedictine narthex, from its east wall to the west wall abutting the former

196 Bihl, 'Documenta', nos 14–22, pp. 47–48.
197 Bolgia, 'Ostentation, Power, and Family Competition', p. 95 and fig. 22.

198 See below, Chapter 6.
199 Malmstrom, 'S. Maria Aracoeli at Rome', pp. 143–44.
200 This was discussed above and see n. 104.
201 Cellini, 'Di Fra Guglielmo e di Arnolfo', figs 9, 11–14.
202 Bolgia, *Reclaiming the Roman Capitol*, fig. 1.12.

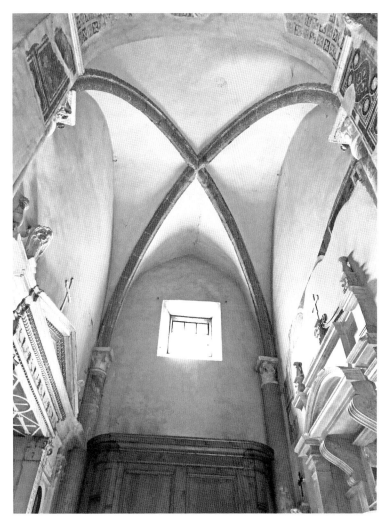

Figure 120. S. Maria in Aracoeli, ribbed vaulting in the former chapel of Saints Peter and Paul in the bell tower, which since 1564 has been the side entrance (photo: author)

These elements were typical of late thirteenth-century building in Rome, as seen in the Sancta Sanctorum chapel at the Lateran, built in the pontificate of Nicholas III (1277–1280); in the present sacristy, but perhaps formerly the abbot's chapel, at SS. Vincenzo e Anastasio at Tre Fontane, c. 1284–1306; and at S. Maria sopra Minerva, after c. 1280. This section of the building appears to be a late addition in Gothic style to the main body of the thirteenth-century Franciscan church. It was probably built between 1277 and c. 1306.

(a) The Capocci Chapel and the Chapel of Saint Rose of Viterbo

On the southern side of the sixteenth-century choir, there are two interleading chapels that originally belonged to the Capocci family (Fig. 108, R).[204] The chapel closest to the choir is now dedicated to the Blessed Sacrament and has been remodelled and extended eastwards. The chapel beside it, which can now only be entered from the Blessed Sacrament Chapel, was dedicated to Saint Rose of Viterbo (1233–1251), after she was canonized in 1457.[205] This chapel was previously dedicated to Saint Nicholas and the Capocci family were its patrons in 1317.[206]

bell tower, and then continued it westwards to take in the tower and the westernmost chapel.

All five chapels along the south-eastern side of the church have clearly Gothic features: there is a Gothic piscina in the chapel of Saint Rose of Viterbo; a pointed lancet and a rose window are known to have illuminated the Savelli chapel in the transept; and tall ribbed vaults are still to be seen in two of the three western chapels (Fig. 120).[203]

203 See Bolgia, *Reclaiming the Roman Capitol*, figs 4.11 and 4.12, for the ribbed vaults. The other chapels have been remodelled and their ceilings are now more Baroque in nature.

204 This was transferred to the Margani family, until it was ceded to the Astalli family in 1588, who changed the dedication to S. Francesca Romana. In 1675, it was re-dedicated to Saint Francesco Solano. The paintings and decoration are all Baroque, except for a medieval mosaic panel. There were two branches of the Capocci family. The Cistercian Cardinal Raniero Capocci of Viterbo was one of the prelates who remained in Italy in 1241–1250, when the Pope was in Lyon, see Norbert Kamp, in *DBI*, vol. XVIII, pp. 608–16. Pietro Capocci (c. 1200–1259), a member of the Roman branch of the family, was created cardinal by Pope Innocent IV in 1244 and also supported the Pope against Frederick II, see Agostino Paravicini Bagliani, *DBI*, vol. XVIII, pp. 604–08.

205 Carta and Russo, *S. Maria in Aracoeli*, pp. 162–67; Bolgia, 'Ostentation, Power, and Family Competition', pp. 98–105; Bolgia, *Reclaiming the Roman Capitol*, pp. 246, 325–28.

206 Carta and Russo, *S. Maria in Aracoeli*, p. 164. Later, in the seventeenth century, Vincenzo Capocci ceded the chapel to Giacomo Velli and his family.

The Capocci chapel may have originally opened into the Savelli chapel, which is located at the southern end of the transept. Bolgia found a medieval 'piscina' in the west wall of the chapel built against the marble tomb of Luca Savelli in the Savelli chapel, but the tomb may have been moved there in the eighteenth century. The former dedication of the chapel to Saint Nicholas suggests it was built in the pontificate of Pope Nicholas III (1277–1280) or Pope Nicholas IV (1288–1292), but the date is not certain.

In the chapel of Saint Rose of Viterbo, there is now on the east wall a late thirteenth-century mosaic of the Virgin and Child enthroned, with Saint John the Baptist on the right, and Saint Francis introducing a kneeling man in civic robes on the left.[207] Oliger identified the latter as Giacomo di Giovanni Capocci, who was Senator of Rome in 1254, or Angelo Capocci, who was Captain of the People in 1267.[208] The presence of Saint John the Baptist in the mosaic suggests instead that the kneeling man was called Giovanni. He may represent Giovanni Capocci, father of Giacomo — a famous ancestor; or the husband of Luciana Capocci, whose tomb was in the chapel from 1317 onwards — this later Giovanni died in 1333. The mosaic has been attributed to the Franciscan friar and mosaicist Jacopo Torriti and dated in the late thirteenth or early fourteenth century.[209]

(b) The Chapel of Saint Francis and of the Savelli Family in the South Transept

When Casimiro published his book on the history of S. Maria in Aracoeli in 1736,[210] he described how the chapel of Saint Francis in the south transept was transformed in 1727–1728 by Father Giuseppe Maria da Evora, who disliked the 'deformity' of its walls, the roughness of its paintings, and, above all, the narrowness of its altar for ecclesiastical ceremonies.[211] Casimiro's book was published only eight years after the eighteenth-century remodelling, which means he would have been well-informed about the previous layout of the chapel and he gives some interesting insights into its earlier appearance.[212]

The dedication to Saint Francis was overshadowed by the commemoration of the Savelli family, whose sepulchral monuments are in the chapel.[213] On the left, there is the tomb of Luca Savelli and on the right, the tomb of his wife, Vanna née Aldobrandeschi, which has been very much changed. At the base of Luca's monument there is an ancient Roman sarcophagus, with winged genii holding garlands of fruit, above which a stone coffin displays the Savelli coat of arms three times, and a niche at the top contains a statue of the Madonna and Child. The sections above the ancient sarcophagus are decorated with 'Cosmatesque' *opus sectile* designs. The inscription mentions that Luca was the father of Pope Honorius IV (1285–1287), as well as of Giovanni and Pandolfo Savelli, and that he died when he was Senator of Rome in 1266.[214] Clearly the tomb was made after that date and possibly during or after the pontificate of Honorius IV. The tomb of Vanna is also on three levels and decorated with *opus sectile* designs. There are three armorial shields: one, in the centre, displays the Aldobrandeschi coat of arms, and the outer two those of the Savelli. In the sixteenth century, an effigy of Pope Honorius IV, Luca and Vanna's son,

207 The panel is 1.25 m high and 1.04–1.09 m wide, see Oliger, 'Due musaici con S. Francesco', pp. 215–51.
208 Oliger, 'Due musaici con S. Francesco', pp. 250–51.
209 Bolgia *Reclaiming the Roman Capitol*, pp. 325–27.
210 Casimiro, *Memorie*.
211 Casimiro, *Memorie*, p. 109, for Father Evora's opinions.
212 Casimiro, *Memorie*, pp. 109–12, for his general comments on the chapel.
213 By the early eighteenth century, the family was extinct. For this chapel, see Casimiro, *Memorie*, p. 109; and Herklotz, 'I Savelli e le loro cappelle di famiglia'.
214 Casimiro, *Memorie*, p. 111, and pp. 111–12, for inscriptions on the tombs in the chapel. See also Bolgia, *Reclaiming the Roman Capitol*, pp. 312–15, who quotes from Casimiro and from Giovanni Antonio Bruzio, *Opera* (BAV, Vat lat. 11871, fols 233ᵛ–234ʳ).

was brought from the Vatican and placed on the tomb of Vanna, which retains an inscription giving her name, 'Domina Vana de Sabellis'. These two tombs were moved, possibly in 1727. They now face each other on the east and west sides of the chapel and stand under canopies each supported by two slender columns. The four columns employed to support the canopies may have been those used previously in the baldacchino over the altar in the chapel, as indicated c. 1480 in the Spada plan (Fig. 114). The present arrangement stems from the renovation of the chapel by Filippo Raguzzini in 1727–1728.[215]

Before that restoration, some 'Savelli' popes, including Honorius IV, and some patron saints of the family were commemorated in the chapel.[216] Honorius IV's brother, Pandolfo, who died in 1306, was also buried there. The tombs include those of Pandolfo's daughter, Andrea; Mabilia Savelli, the wife of Agapito Colonna; Antonio Savelli; and another Luca Savelli. Pandolfo Savelli is believed to have been the patron.[217]

The chapel was lit by two windows, a Gothic lancet located behind the altar and a much bigger rose window higher up, both in what is now the south wall of the transept. Casimiro described the two windows as filled with stained glass images of the life of Saint Francis.[218] The chapel was closed by an iron grille supported by two large pieces of marble encrusted on the outside with mosaic, in the middle of which was the Savelli coat of arms. The step at the entrance to the chapel was made of pink 'porta santa'

marble. On the southern wall, some saints and cherubim were depicted paying homage to the Saviour, whose image appeared between the two windows. Above this composition, in the apex of the gable (and still partly visible in the roof space) there was a painting of the Lamb of God, with blood flowing from a wound in his heart into a chalice; and below this were the symbols of the Evangelists.[219] (The iconography of the Lamb was similar to that on the 'confessio' plaque in the chapel of Saint Helena.) The highest part of the gable was framed by a frieze of fictive brackets, like those in the transept of S. Maria Maggiore.[220] On the side walls of the Savelli chapel were depicted images of Saint Francis, which have not survived. All these paintings were attributed to Pietro Cavallini, or to members of his workshop.

(c) The Three Chapels West of the South Transept

West of the Savelli chapel, there were three more medieval family chapels.[221] The first was a chapel dedicated to Saint John the Evangelist, which is 4.50 m wide and 5.40 m deep.[222] A restoration campaign in the year 2000 fully revealed some medieval frescoes,[223] which originally covered three walls of the chapel. On the south wall, there is a mural of the Madonna and Child in front of a gold brocade cloth of honour between

215 Carta and Russo, *S. Maria in Aracoeli*, pp. 168–76.
216 Bolgia, *Reclaiming the Roman Capitol*, p. 314, quoting from Bruzio, *Opera* (BAV, Vat lat. 11871, fols 233ᵛ–234ʳ).
217 Bolgia, *Reclaiming the Roman Capitol*, pp. 314–15, n. 124.
218 Casimiro, *Memorie*, pp. 109–10. The Franciscan Statutes from the General Chapter of Narbonne in 1260 stated that there should be no windows with historiated pictures, except in the main chapel behind the high altar. For the sanction in the Statutes, see Bihl, 'Documenta', no. 18, p. 48. This policy was changed by Jerome of Ascoli, who was Minister General from 1274 and who became Pope Nicholas IV in 1288.
219 Bolgia, *Reclaiming the Roman Capitol*, pp. 313–14, and Plate 29. Cellini discovered these paintings in the 1950s, see Cellini, 'Di Fra Guglielmo e di Arnolfo', pp. 224–28; Cellini, 'L'opera di Arnolfo', p. 181.
220 See Bolgia, *Reclaiming the Roman Capitol*, plate 28.
221 Casimiro, *Memorie*, pp. 87–108.
222 In 1570, the patrons of the chapel were members of the Capodiferro family after which it passed from them to the Grimaldi, the Buzi, and then the Ceva families. It was dedicated to Saint Paschal Baylon from the seventeenth century onwards.
223 Strinati, *Aracoeli. Gli affreschi ritrovati*. Carta and Russo, *S. Maria in Aracoeli*, pp. 179–81, and Bolgia, *Reclaiming the Roman Capitol*, p. 325, mention that these paintings were already known to exist in the 1950s, but they were not fully uncovered and investigated until 2000.

Saints John the Baptist on the left and John the Evangelist on the right (Fig. 121). This iconography recalls the earliest dedication of the Capitoline monastery, 'of the holy Mother of God [...] as well as of the blessed John the Evangelist and John the Baptist'.[224] The Christ Child is seated frontally and is blessing the viewer, as he does in the icon of the *Hodegetria*, but Mary's right hand, which in the icon normally points to the Saviour, is in fact gently placed on his thigh. Not much survives of the frescoes on the side walls of the chapel — there are only a few traces in sinopia and painting. Tommaso Strinati suggested that scenes from the lives of Saints John the Baptist and John the Evangelist were depicted there, but the iconography is not clear.[225] Fragments on the side walls show three painted medieval twisted columns and some classicizing motifs above the space which would have been filled with narrative scenes. On the left, the decoration resembles the upper parts of Giotto's *Banquet of Herod* in the Peruzzi Chapel in S. Croce in Florence, while on the right there are elements which are reminiscent of Filippo Rusuti's mosaics on the façade of S. Maria Maggiore. The frescoes have been dated between 1295 and 1300,[226] and the paintings have been attributed to Pietro Cavallini and his associates, or to Giotto.[227]

The next chapel was dedicated to Saints Peter and Paul.[228] Fragments were found in the 1950s of the head of Saint Peter, attributed to Pietro Cavallini and his workshop and dated to the early fourteenth century.[229] The space is in the unfinished medieval bell tower, which in 1564

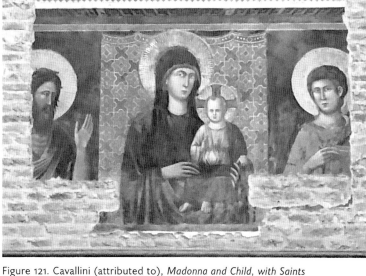

Figure 121. Cavallini (attributed to), *Madonna and Child, with Saints John the Baptist and John the Evangelist*, c. 1295–1300 (photo: author)

became the side entrance to the church. It is covered with a ribbed vault with the ribs resting on 'columns', built of brick and stucco, and Corinthian capitals of varied designs (Fig. 120).

The chapel furthest to the west was also covered by a ribbed vault supported by columns. (The ribs of the vault and the columns were later covered with stucco and raised gilded designs.) It belonged to the Cenci family from the nearby Campitelli region in the early fifteenth century.[230] It was originally dedicated to S. Lorenzo,[231] and S. Diego was added to the dedication in 1610. Fragments have been found of an early fourteenth-century painting, attributed to the school of Pietro Cavallini, of Saint Lawrence being brought to judgment.[232]

(d) The Colonna Chapel

The Colonna family built their chapel west of the northern arm of the transept, very close to the shrine of the Aracoeli. The chapel was

224 See Bolgia, *Reclaiming the Roman Capitol*, pp. 26–27.
225 Strinati, *Aracoeli. Gli affreschi ritrovati*, pp. 24–30.
226 Strinati, *Aracoeli. Gli affreschi ritrovati*, p. 30.
227 Strinati, *Aracoeli. Gli affreschi ritrovati*, p. 325 and note 165.
228 Bolgia, *Reclaiming the Roman Capitol*, pp. 319–22.
229 Bolgia, *Reclaiming the Roman Capitol*, pp. 320–21, suggests that the scene showed Saint Peter and the fall of Simon Magus, an event said to have taken place on the Capitol, but the image is too fragmentary for the iconography to be clear.

230 Bolgia, *Reclaiming the Roman Capitol*, pp. 323–25.
231 Casimiro, *Memorie*, p. 87.
232 Bolgia, *Reclaiming the Roman Capitol*, pp. 323–25.

restructured and redecorated in the late sixteenth and early seventeenth century, being re-dedicated to the Madonna di Loreto in 1613.[233] Before that, its patron was Saint Sebastian, and a terracotta statue of the saint from the chapel was placed in a niche above the entrance to the sacristy *c.* 1700, where it remains today.[234]

An analysis made by Bolgia of the area north and east of the chapel has clarified the medieval remains of the chapel itself.[235] On the western side of the north arm of the transept, two large buttresses were built at the same time as the transept, obviously to strengthen that part of the church. They were later employed as the two 'legs' of the sixteenth-century bell wall that rises above them. Bolgia proposed that there was a spiral staircase in this area leading to the cornice of the transept and perhaps connected with a walkway above the north colonnade. Descending into a subterranean area 4.00 m below the transept pavement, she found that the foundations of the central transept buttresses were built of *opus saracinescum*. This was the same technique as that used in the transept foundations. The type of masonry and the fact that the two buttresses bond with the west wall of the transept show that they were built at the same time, in the thirteenth century.

The medieval chapel of the Colonna family was built west of the two buttresses, partly incorporating their foundations and extending them. The parts of the rising walls of the chapel that are accessible show that it was built of brickwork with a modulus of 24–25 cm, occasionally dropping to 22 cm, for five rows of bricks and five mortar beds. This type of masonry was used in Rome in the late thirteenth century. It is clear that the chapel was added on to the side of the north aisle, 'breaching the perimeter wall of the church.'[236] It must postdate the building of the transept, buttresses, nave, and aisles.

Bolgia pointed out that the chapel, which is now as high in the interior as the others flanking the left aisle, was originally much higher and covered with a ribbed Gothic vault.[237] This is accessible in a room, about 2.00 m high, directly above the present chapel. Evidently, a new ceiling was inserted to lower the height of the chapel, when it was restructured in the late sixteenth and early seventeenth centuries. The ribbed Gothic vault is similar to those covering the chapels on the southern side of the church. Ribbed vaults of this type are known in Rome from *c.* 1277 onwards. The Colonna chapel was 4.20 m wide and 4.40 m. deep. It was illuminated by two Gothic pointed windows, one in the north and one in the west wall, traces of which have been found. The window on the west was blocked later, when another chapel was built beside the Colonna chapel.

Part of a mosaic panel from this chapel is preserved at Palazzo Colonna in Rome (Plate 8). It is now 2.82 m long and 0.63 m high, but it must formerly have been longer.[238] On the far left (but not included in Plate 8), there is the coat of arms of the Colonna family — a white fluted column, with a base and a Corinthian capital, on a red background.[239] Beyond the coat of arms, some figures are depicted. At the far right is an image of the Mother of God and the Holy Child

233 Carta and Russo, *S. Maria in Aracoeli*, pp. 133–36.
234 Casimiro, *Memorie*, p. 182.
235 Bolgia, 'Ostentation, Power, and Family Competition', pp. 75–84; Bolgia, *Reclaiming the Roman Capitol*, pp. 164–77, 303, 307, 318.
236 Bolgia, *Reclaiming the Roman Capitol*, pp. 177, 317; see also, Bolgia, 'Ostentation, Power, and Family Competition', p. 83.
237 Bolgia, 'Ostentation, Power, and Family Competition', pp. 83–84; Bolgia, *Reclaiming the Roman Capitol*, pp. 164, 176–77.
238 Oliger, 'Due musaici con S. Francesco', pp. 219 and 232, who suggested it was originally 4.20 m long. See also Gardner, *The Roman Crucible*, pp. 254–55. The mosaic was moved to Palazzo Colonna in 1652.
239 An image of this coat of arms, now in S. Silvestro, is given in fig. 155, below.

with an attendant angel on the left and on the right. Mary and Jesus both gesture towards three figures on the left. The first of these, on the far left, is Saint Francis, shown as a half figure in three-quarter view and with the wounds of the stigmata; in his left hand he holds a book, and with his right hand he presents to the Virgin and Child a much smaller image of a kneeling man dressed in senatorial robes. To the right of this figure is Saint John the Evangelist, holding a Gospel book in his left hand, while he takes the praying hands of the small figure in his much larger right hand. He is evidently his patron saint. Archival records indicate that, on the right of the Virgin and Child, there were two more figures, of Saint John the Baptist and Saint Nicholas, which have not survived.[240] Inscriptions identify the people represented in this mosaic. The small kneeling figure is: 'S(an)C(t)E D(e)I GENITRICIS SERVUS D(omi)N(u)S IOH(anne)S DE COLU(m)PNA' (The servant of the Holy Mother of God, Lord Giovanni Colonna). It is most likely that this was Giovanni Colonna of Palestrina, who was Senator of Rome in 1261–1262, 1279–1280, and 1290–1291. He was the brother of Cardinal Giacomo Colonna, who appears as one of the patrons of the apse mosaic by Jacopo Torriti in S. Maria Maggiore. He was also the brother of Margherita Colonna, whose biography he wrote, and in whose honour the Colonna family founded the Roman Franciscan nunnery of 'Sorores minores inclusae' (Enclosed Sisters Minor) at S. Silvestro in Capite in 1285.[241] One of Giovanni's sons, Pietro, became a cardinal. Another, older Cardinal Pietro Colonna, who died in 1290, left money for the construction of a Colonna family chapel in S. Silvestro in Capite. The presence of Saint Nicholas in the mosaic may refer to the reigning Pope, when the chapel at S. Maria in Aracoeli was built — either Nicholas III (1277–1280) or Nicholas IV (1288–1292).[242] Since the patron, Giovanni Colonna, was represented in his robes as Senator of Rome, the date was probably in his years of office: either 1279–1280, or 1290–1291. Hence, the Colonna chapel at S. Maria in Aracoeli was probably built between 1279 and 1291. The style of the mosaic favours a date in 1288–1291, in the pontificate of Nicholas IV. Ugonio saw the mosaic panel high up on the exterior of the chapel.[243] This may not have been its original location. The chapel was certainly built before 1297, when Pope Boniface VIII Caetani (1294–1303) attacked the Colonna family,[244] confiscating or destroying all Colonna property. It is likely that the chapel was finished before that disaster, and probably between 1288 and 1291.

The Tomb of Cardinal Matteo Da Acquasparta

Among those who supported Pope Boniface VIII's reprisals against the Colonna family was Cardinal Matteo da Acquasparta (1240–1302), Minister General of the Franciscan Order, whose monumental tomb is located in the northern arm of the transept of S. Maria in Aracoeli, not far from the former Colonna chapel (Fig. 122).[245] The effigy of the Cardinal lies on a sarcophagus covered with drapes, and angels hold curtains at either end. The arms of Matteo da Acquasparta are shown in four shields across the front of

240 Oliger, 'Due musaici con S. Francesco', p. 235. Ugonio described them, in BAV, Barb. lat. 1994, fols 404[r] and 447[r]. See, Bolgia, 'Ostentation, Power, and Family Competition', pp. 92–93, who also quotes from Ferrara Biblioteca Comunale, MS 161. P. 8, fol. 975[r].
241 See below Chapter 7.
242 Bolgia, *Reclaiming the Roman Capitol*, pp. 303–04.
243 Bolgia, 'Ostentation, Power, and Family Competition', pp. 92–93; Bolgia argues that originally it may have been placed above the altar.
244 See, *Visions of Sainthood in Medieval Rome*, trans. by Field, ed. by Knox and Field, pp. 52–58, 191–98.
245 Gardner, *The Roman Crucible*, pp. 30–31, 134–36; Gardner, *The Tomb and the Tiara*, pp. 52, 83.

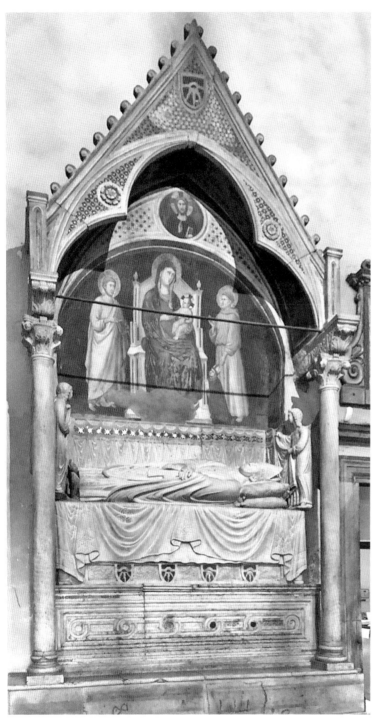

Figure 122. S. Maria in Aracoeli, tomb of Matteo da Acquasparta, c. 1302 (photo: author)

the coffin. Below this is a base decorated with 'Cosmatesque' designs. In a lunette above the sculptural imagery is a painting of the Madonna and Child enthroned, flanked by the Cardinal's patrons, Saint Matthew on the left and Saint Francis on the right. The latter presents a small kneeling figure of the Cardinal to the Madonna and Child. At the top of the surrounding arch there is a half figure of Christ, holding a Gospel book in his left hand and making a gesture of blessing with his right. The paintings have been attributed to Pietro Cavallini and his workshop. Framing the tomb, two columns support a trilobate arch with finials rising to the gable; this is decorated with 'Cosmatesque' *opus sectile*; at the apex of the arch is the Cardinal's coat of arms. The monument to Matteo da Acquasparta was constructed soon after 1302, when he died. His tomb is very similar in design to that of Bishop Guillaume Durand of Mende ('Durandus') in the church of S. Maria sopra Minerva, which dates soon after 1296, and which was made by Giovanni di Cosma.[246] Along with the Savelli tombs in the south arm of the transept, the tomb of Matteo da Acquasparta is one of the most magnificent medieval sepulchral monuments in S. Maria in Aracoeli.

The Conventual Buildings

The conventual buildings at the Aracoeli were demolished when the Victor Emmanuel Monument was built in the late nineteenth and early twentieth centuries. As with the church, the Franciscans took over the monastic buildings of the Benedictines and they rebuilt and extended them for their own community. These structures are known from written documents and some views, drawings, and photographs. Two writers who saw the convent shortly before it was demolished, mentioned that there were two cloisters and they claimed they were both

246 See below, Chapter 6 and (fig. 133).

medieval.[247] Fioravante Martinelli wrote in 1653: 'Est ibi annexum ingens monasterium fratrum de observantia S. Francisci, nobile Sacrarium, et celebris Bibliotheca' (There is a huge monastery there of friars of the Observance of Saint Francis, a noble Sacristy, and a famous Library).[248]

Most early Maps of Rome show S. Maria in Aracoeli from the west, whereas Dupérac and Lafréry's *Map of Rome* of 1577 (Fig. 107, lower right) gives a bird's-eye view of the church and monastery from the east. It shows a quadrangle, with convent buildings around it, to the east of the church. There are also two walled gardens with fruit trees. To the north is the large tower, built by Pope Paul III (1534–1549), which was taken over by later popes, who eventually ceded it in 1585 to the Friars Minor. In the late sixteenth century, the Minister General of the Franciscan Order lived in a part of it.

A more precise image is found in a plan of the church and convent, dating from 1876.[249] Behind the choir of the church, there is a rectangular courtyard, with rooms around three sides. On the eastern side there is a long room, which may have been a refectory. To the north, there is a second, interior courtyard, with a well in the centre, and ambulatories around the open court. These give access to various rooms, one of which, on the east, is rather large and has two columns in the interior — it could be a chapter room.

Old photographs show the inner cloister, with a well in the centre (Fig. 123). A ledge runs around the perimeter of the courtyard and on it stand ancient columns that have been cut short; they support Ionic capitals and large semi-circular arches. Some of the capitals appear to be medieval. Some, but not all, of the columns stand on bases. The colonnades of the cloister are very different from those in the thirteenth-century cloisters at

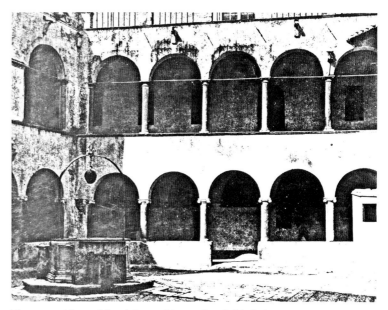

Figure 123. View of the cloister with a well at S. Maria in Aracoeli (photo: ICCD – under licence from MiBACT)

S. Sabina and S. Cosimato. They resemble more closely those at S. Onofrio on the Janiculum Hill, which is usually dated in the first half of the fifteenth century. The Aracoeli cloister also had an upper storey. While the lower ambulatories were vaulted, the upper storey had a wooden ceiling.

Who Designed and Built the Church?

Cellini believed that Arnolfo di Cambio designed the Franciscan church, or the southern addition to it.[250] Although followed by Pietrangeli and Romanini, this attribution is no longer accepted, for lack of evidence.[251] In the eighteenth century, Casimiro reported the following inscription with the date 1313 on a tombstone, which still exists in the floor of the nave: '+ Hic requiescit magister Aldus murator qui fuit fundator et principalis super opus istius ecclesie' (+ Here lies

247 Ojetti, 'Chiostri', pp. 91–92; and Sartorio, 'Dei Chiostri', 453–57.
248 Martinelli, *Roma ex ethnica sacra*, p. 184.
249 Published by Bolgia, *Reclaiming the Roman Capitol*, fig. 1.41.
250 Cellini, 'Di Fra Guglielmo e di Arnolfo'; Cellini, 'L'opera di Arnolfo all'Aracoeli'.
251 See Bolgia, 'Santa Maria in Aracoeli and Santa Croce: The Problem of Arnolfo's Contribution', and Bolgia, *Reclaiming the Roman Capitol*, pp. 257–59.

the master mason Aldus who was the founder and principal of the work of this church).[252] Bolgia considered that the inscription designated this man as the person who directed other masons and supervised the building of the edifice, which is convincing.[253] She went on to suggest that, as 'fundator et principalis', he 'may have been the designer of the church plan', but this seems to be stretching the evidence, for he was clearly a mason, a bricklayer, constructor of walls, and the supervisor of others in his trade, but not an architect.[254] He may have been employed in building S. Maria in Aracoeli from the beginning. When describing the architect or designer of the staircase in front of the church built in 1348, the inscription on the façade uses the term 'fabricator', which was more usual for the architect, designer, or overseer of a building. Apart from these two inscriptions, there are no indications of who designed the church. It seems clear, though, that there was an overall 'master plan', with foundations probably laid at the start, whereas the rising walls may have been constructed in different phases. The medieval family chapels did not belong to the overall plan but appear to have been later additions to the building. It is possible that the main foundations were laid, when the plan was 'set out' on the site by the architect, and then the rising walls were built over a long period of time. 'Aldus' was probably present at the beginning of construction as a young man, and later he supervised the builders, perhaps until he died in 1313. Having been involved from the beginning, he understood how to complete the church according to the master plan and hence could be called a founder of the building.

If the Franciscan church were planned initially in one go, it was in fact built over a long period of time, from the mid-thirteenth to the mid-fourteenth century. Malmstrom suggested building began in the late 1250s and that most of the construction was completed by 1268, the date on a bell given to the friars.[255] Bolgia pointed out that having a bell did not necessarily indicate that the church was finished. (Indeed, at S. Cosimato, a bell dated 1238 was donated to the nuns eight years before their church was consecrated in 1246.[256]) Bolgia gave a date for the building of the Franciscan church from *c.* 1279 to the 1290s,[257] while other scholars thought it was even later, with the façade completed only *c.* 1320.[258]

Given this disagreement about the church's date, one needs a new interpretation, based on the historical evidence and a 'relative chronology' of the successive phases of construction. The staircase in front of the edifice is the only feature that is securely dated: it was begun on 25 October 1348, as the inscription on the façade proclaimed, and it was completed soon after that. Innocent IV's Bull, *Quoniam, ut ait Apostolus*, issued on 20 March 1252, stated that the Friars Minor had begun to rebuild the church and monastery.[259] Even if this statement were only a formula, it shows that as early as 1252, the Friars intended to rebuild the church and they may already have chosen a plan — of a Roman basilica, similar to that at S. Maria in Trastevere, Old St Peter's, and S. Paolo fuori le Mura — and they may have begun setting out the foundations.

252 Casimiro, *Memorie*, p. 251.
253 Bolgia, *Reclaiming the Roman Capitol*, pp. 257–58. She pointed out that the name 'Aldus' was a fragment and could have been longer.
254 Du Cange, *Glossarium mediae et infimae Latinitatis*, 'murator': 'confector murorum' (a maker of walls). See, however, Shelby, 'The Geometrical Knowledge of Medieval Master Masons', with information on the practical understanding of geometry used by masons from the thirteenth to sixteenth centuries.

255 Malmstrom, 'S. Maria Aracoeli at Rome', pp. 53–55; Casimiro, *Memorie*, p. 169, gives the medieval inscription on the bell.
256 See above, Chapter 4.
257 Bolgia, *Reclaiming the Roman Capitol*, pp. 111–16, 192, 202–03.
258 D'Onofrio, *Renovatio Romae*, pp. 105–06; Carta and Russo, *Santa Maria in Aracoeli*, p. 61; and Brancia di Apricena, *Il complesso dell'Aracoeli*, pp. 74–75.
259 *BF*, vol. I, p. 599, no. 397; and see above.

To begin with, they needed an altar at which to celebrate Mass and a choir enclosure for praying the Divine Office. With regard to building materials, the Benedictine church's grey granite columns could be reused, with two in the apse, two at the triumphal arch, two at the eastern end of each side aisle, and twelve in the nave (see Table 1). Beyond that, the papal Bull of 1252 may have helped the Franciscans to acquire the remaining ten assorted columns in the western half of the nave, which were perhaps added in a second building phase. As has been argued above, the chapels on the south of the transept and the Colonna chapel on the north of the church were later additions to the building, perhaps a third building phase. The south-eastern chapel of Saint Rose of Viterbo was formerly dedicated to Saint Nicholas, who also appeared originally in the mosaic from the Colonna Chapel with an image of Giovanni Colonna, who had been a Roman Senator in 1261–1262, 1279–1280, and 1290–1291. Saint Nicholas may have been chosen because the reigning Pope was either Nicholas III or Nicholas IV, which suggests a date for the chapels of c. 1277–1292. The Colonna Chapel breached the existing wall of the north aisle.[260] If this chapel were built between 1277 and 1292, one has to imagine that the eastern part of the nave and aisles were already standing by then. Likewise, the medieval chapels on the southern side of the church seem to have been built in the late thirteenth century, perhaps in the 1280s and 1290s, as additions to the south transept and south aisle. This suggests that the earliest eastern part of the nave and aisles were finished by 1277, and the western half of the nave and aisles, and the façade may have been built shortly afterwards. The family chapels may have followed, and then, finally, the staircase in 1348–1349.

The design of the church follows that of S. Maria in Trastevere in many ways. That was Cardinal Stefano Conti's titular church, built in the twelfth century and consecrated with great pomp and ceremony by his uncle, Pope Innocent III, in 1215. The iconography of the chapel of Saint Helena in the Aracoeli, with its marble plaque carved c. 1252, recalls that in the chapel of S. Silvestro that Cardinal Stefano built in 1246 at SS. Quattro Coronati. One wonders, therefore, whether the rebuilding of S. Maria in Aracoeli (starting with the plan and the foundations) began in 1252–1254, under the patronage of Cardinal Stefano Conti, helped by Cardinal Rainaldo, the Protector of the Franciscan Order, who became Pope Alexander IV (1254–1261) and who may have continued to sponsor the building. The Franciscans were in residence at the Benedictine monastery by July 1252. When the Franciscans held their General Chapter at the friary of the Aracoeli in 1257, Bonaventure was elected Minister General. He ensured that the Order had clear general constitutions; he wrote a new (official) life of Saint Francis; he promoted more fervent devotional perspectives, especially for priests in relation to penance and to the Eucharist and he approved of large churches and convents in which the friars could minister to the urban populace.[261] In 1257, the icon of *Maria Advocata* was said to have been in the church. It seems likely that the whole project of founding S. Maria in Aracoeli, which was first adumbrated in 1248, may well have progressed from its initial phase of planning to the completion of the first phase of building of both church and friary by 1257, closely followed by Cardinals Stefano and Rainaldo (from 1254 to 1261 Pope Alexander IV). Perhaps this was one reason, among others, why the Friars Minor in 1260 at their General Chapter at Narbonne voted to commemorate Cardinal Stefano Conti every year on the anniversary of his death on 8 December 1254.

260 Bolgia, *Reclaiming the Roman Capitol*, pp. 177, 317; see also, Bolgia, 'Ostentation, Power, and Family Competition', p. 83.

261 See, for example, the discussion in Robson, *The Franciscans in the Middle Ages*, pp. 82–94.

By the pontificate of the Franciscan Pope Nicholas IV (1288–1292), the church had been completed, some of the side chapels had been built, a mosaic — perhaps sponsored by the pontiff — decorated part of the cavetto, and there may have been a dedication or consecration in 1291. In 1348–1349, a monumental staircase was added, funded by 5000 golden florins donated by the inhabitants of Rome in thanksgiving to *Maria Advocata* because the plague had ended.

S. Maria in Aracoeli provided the Friars Minor with a sanctuary in an airy and healthy place beside a convent suitable for a large community, which *c.* 1320 numbered fifty. As the most important Franciscan church and friary in Rome, it was their headquarters in the city, it was equipped with a famous library, and it was a parish. Although the church on the Capitol was planned as a medieval Roman basilica, it was also an innovative building with Gothic features — its pointed and rose windows with Gothic tracery, pointed arches at the apse and crossing, and the ribbed vaults and tall lancets in the late thirteenth-century family chapels. It was a fitting forerunner of the only fully Gothic medieval church in Rome, the Dominicans' S. Maria sopra Minerva.

CHAPTER 6

The Friars Preachers at S. Maria Sopra Minerva, founded c. 1266–1276

In 1266, the *Acta* of the Roman Province of the Order of Preachers mentioned a new 'locus' (place) ceded to the Dominicans in Rome.[1] This appears to be one of the first surviving references to their possession of S. Maria sopra Minerva, where the friars built a new church and priory, although they had to wait ten years for their legal rights to the property and the parish to be ratified. By *c.* 1320, this priory was their biggest in Rome, with a community of fifty friars.[2] From 1380 until the late nineteenth century, it became the residence of the Master General of the Order of Preachers. In the late nineteenth century, most of the Minerva buildings were taken over by the new Italian government, but from the 1930s, the church and a much smaller priory became the headquarters of the friars of the Roman Province of Saint Catherine of Siena.

This chapter discusses the history and architecture of the church and priory in the light of recent studies and further research.[3] S. Maria sopra Minerva (Figs 124 and 125) was one of very few Gothic buildings erected in medieval Rome. While thirteenth-century popes and cardinals delighted in the Gothic design of tombs, chalices, vestments, reliquaries, and seals, they seem to have made no attempt to build large Gothic churches in the city.[4] The reason for this is often said to have been the strength of the classical and early Christian traditions in Rome's art and architecture, which resulted in churches being designed along traditional Roman lines.[5] In fact, the large churches that were constructed in Rome in the late thirteenth and fourteenth centuries were built by religious Orders, like the Dominicans and the Franciscans. The Friars Preachers' church of S. Maria sopra Minerva is an example of this phenomenon, having been designed in their preferred style of Gothic architecture.

Location

S. Maria sopra Minerva was situated near the Pantheon, in a neighbourhood that was densely populated in the Middle Ages (Figs 126 and 127).[6] The location reflected a general tendency in the late thirteenth century for Dominican and

1 *Acta Capitulorum Provincialium Provinciae Romanae*, ed. by Kaeppeli and Dondaine, p. 33.
2 See Catalogue of Turin, in Valentini and Zucchetti, *Codice topografico*, vol. III, p. 299.
3 Modern studies on the history and architecture of S. Maria sopra Minerva include Matthiae, 'Gli aspetti diversi di S. Maria sopra Minerva'; Kleefisch, 'Die römische Dominikanerkirche S. Maria sopra Minerva von 1280 bis 1453'; Palmerio and Villetti, *Storia edilizia*; Kleefisch-Jobst, *Die römische Dominikanerkirche Santa Maria sopra Minerva*; Villetti and Palmerio, *Santa Maria sopra Minerva in Roma*; and a new study by Almuth Klein in Claussen and others, ed., *Die Kirchen der Stadt Rom im Mittelalter 1050–1300*, vol. IV, pp. 310–36. Further research was undertaken on site, in various libraries, and at the two Dominican archives in Rome: AGOP at S. Sabina and AM at S. Maria sopra Minerva
4 For the Gothic taste of popes and cardinals, see Gardner, *The Roman Crucible*. Gustafson, 'Roman Versus Gothic' briefly compares Gothic features in S. Maria in Aracoeli and S. Maria sopra Minerva.
5 See, for example, Krautheimer, *Rome*, pp. 211–12.
6 Rome, AGOP, MS XIV, liber C, Parte I, Brandi, *Cronica*, fol. 3; Krautheimer, *Rome*, pp. 271–310.

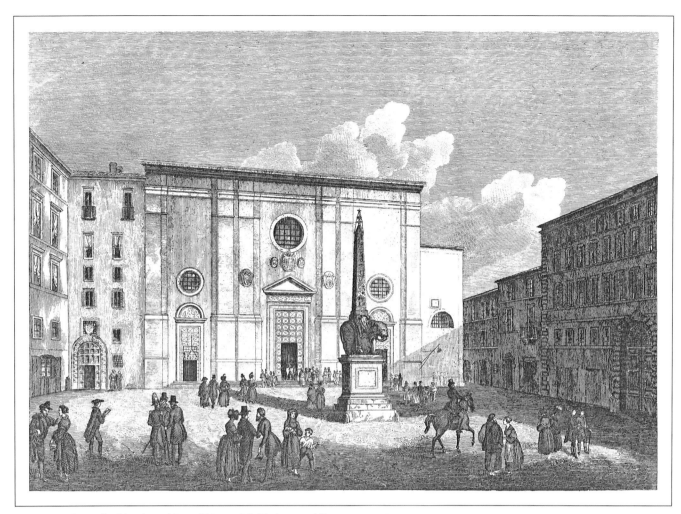

Figure 124. Alessandro Moschetti, View of Piazza di S. Maria sopra Minerva, engraving, 1842 (photo: Bibliotheca Hertziana – Max-Planck-Institut für Kunstgeschichte, Rome)

Franciscan friars to move to the centre of towns, in order to minister to the urban population.[7] In Rome, the Friars Preachers retained S. Sabina, which they associated with Saint Dominic, and added S. Maria sopra Minerva, which was closer to the people. The Franciscans acted in a similar way: they kept S. Francesco a Ripa in Trastevere where Saint Francis had stayed, and they built S. Maria in Aracoeli on the Capitoline Hill.[8] By 1380, S. Maria sopra Minerva had become the headquarters of the Dominican Order, and S. Maria in Aracoeli was the main friary of the Franciscan Order in Rome.

S. Maria sopra Minerva is located in the part of Rome known from Antiquity onwards as the 'Campus Martius' (the Field of Mars).[9] The name was derived from an ancient Roman altar (and a temple associated with it) dedicated to Mars, the Roman god of war. This region was situated within the great bend of the River Tiber, reaching

7 Bruzelius, *Preaching, Building, and Burying*, pp. 121–30.
8 See above, Chapters 3 and 5.

9 Platner and Ashby, *A Topographical Dictionary*, pp. 91–94; *Lexicon Topographicum*, ed. by Steinby, vol. I, pp. 220–24; Claridge, *Rome*, pp. 197–258. For the area in late antiquity and the early Middle Ages, see Spera, 'Trasformazioni e riassetti'.

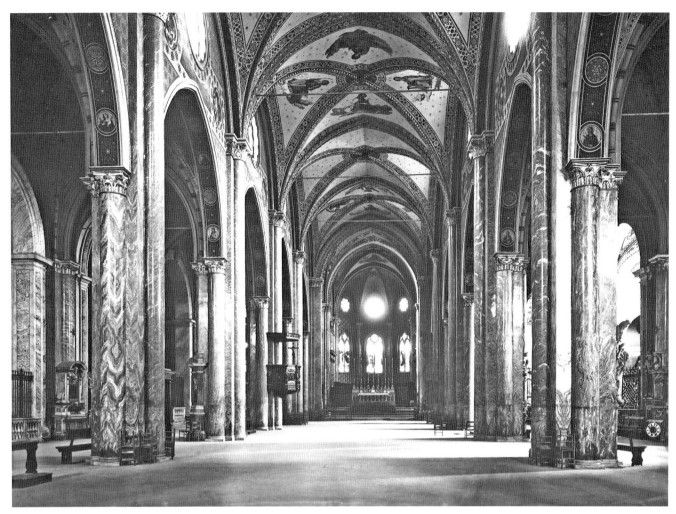

Figure 125. S. Maria sopra Minerva, view of interior (photo: Anderson: Alinari Archives)

from modern Via dei Coronari (which follows the route of the ancient Roman Via Recta) in the north to about as far south as the Theatre of Marcellus, and from the curving bank of the river in the west to beyond the Via del Corso (the medieval Via Lata and ancient Via Flaminia) in the east.[10] It was part of a huge flood plain, which consisted of about 250 hectares of level ground stretching from the River Tiber to the Capitoline and Quirinal Hills. In early times, this plain was a place where sheep and cattle grazed, but by the

10 *Lexicon Topographicum*, ed. by Steinby, vol. I, p. 221.

first century BC, the Campus Martius had become a venue for athletic contests, military exercises, and horse races; it was a place where public meetings were held, and the census was taken every five years. A state farm, the 'Villa Publica', and some gardens were located in this area. In the reign of Augustus (27 BC–AD 14), this district was designated Region IX, 'Circus Flaminius', named after a horse-racing stadium in that part of the city, which was also a gathering place for military triumphal processions. Augustus built his 'Ara Pacis' (the Altar of Augustan Peace) in the area and he also provided an obelisk and solar meridian; when he died, he was buried in a vast mausoleum, overlooking the Campus Martius on the north. Pompey the Great in 55 BC

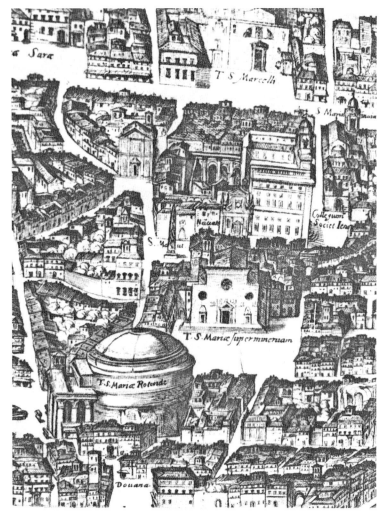

Figure 126. Antonio Tempesta, *Map of Rome* (1593), detail of S. Maria sopra Minerva and the Pantheon (Frutaz, *Piante*, vol. II, 1962, detail of Tav. 265)

built his theatre with its connecting porticoes in the southern part of the district, near modern Campo de' Fiori. Two other theatres were erected not far away: the theatre of L. Cornelius Balbi and the theatre of Marcellus. After a disastrous fire in AD 80, Domitian (81–96) built a new stadium on the site of modern Piazza Navona. The Aqua Virgo aqueduct brought water to the region, where there were the three large Roman Baths of Agrippa, Nero, and Alexander Severus. Over time, numerous temples were erected and dedicated to Roman and foreign cults. There were also shrines and monuments dedicated to former Roman Emperors, such as a temple of the deified Hadrian and the Column of Marcus Aurelius. Of the temples, the Pantheon, first established by Agrippa and then totally rebuilt by Hadrian (117–138), was the most notable. In 608, it was transformed into the church of S. Maria ad Martyres (St Mary of the Martyrs), commonly known as S. Maria Rotunda, on account of its shape.

To the east and south of the Pantheon is the church of S. Maria sopra Minerva, which, as its name implies, reputedly stood on the site of an ancient Roman temple dedicated to Minerva (Fig. 126).[11] Pliny the Elder recorded that Pompey bestowed honour on Rome by building a shrine to Minerva that he dedicated out of the proceeds of war.[12] This may have been the edifice in question, although another tradition attributes to Domitian the building (or rebuilding) of a temple dedicated to Minerva Chalcidica.[13] The Severan Marble Plan of Rome, dating from the early third century, shows a small temple on the site of S. Maria sopra Minerva. A magnificent Roman copy of an ancient Greek statue of Minerva, which may have come from this sanctuary and which was found in the Dominican priory garden near the church, is now in the Vatican Museums.[14] Nearby, there was also a temple of Isis and Serapis, from which may have come the obelisk dug up in the garden at the Minerva in 1665. This now stands in front of the church on the back of a stone elephant, whose design is attributed to

11 Berthier, *L'Église de la Minerve*, p. 1.
12 Pliny, *Natural History*, trans. by Rackham, Jones, and Eichholz, Book VII, 97, vol. II, pp. 568–69.
13 Valentini and Zucchetti, *Codice topografico*, vol. I, pp. 127 and 275.
14 This is the 'Athena Giustiniani' in the Braccio Nuovo, Vatican Museums, Inv. No. 2223. Some modern writers say this second-century AD work came from the Minerva Medica in Rome, but in the seventeenth century, Pietro Santi Bartoli, and in the early twentieth century, Berthier, *L'Église de la Minerve*, p. 2, noted that it was found in the garden of the Dominicans at S. Maria sopra Minerva.

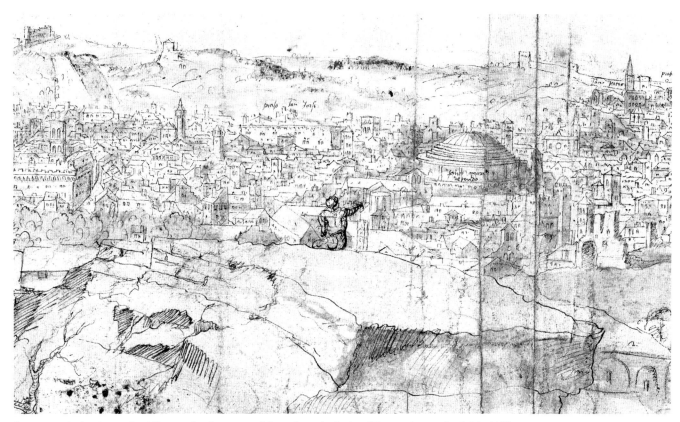

Figure 127. Anthonis van den Wyngaerde, *Panorama of Rome from the Baths of Constantine on the Quirinal Hill*, detail showing the church of S. Maria sopra Minerva to the right of the figure in the middle, with the Pantheon further to the right (Oxford, Ashmolean Museum, WA.C.L.G.IV.96b; photo: Ashmolean Museum)

Gian Lorenzo Bernini and which was carved by Ercole Ferrata in 1667 (Fig. 124).[15] The Saepta Julia and a four-way arch, were located south of the church.[16] Although there were so many important ancient monuments close to S. Maria sopra Minerva, no archaeological excavations have been made directly under the church and priory buildings.

Anthonis van den Wyngaerde (1525–1571) portrayed this area of Rome as built up and thickly populated (Fig. 127). Straight Roman roads — like the Via Lata (now Via del Corso) and the Via Recta (now ending in Via dei Coronari) — were on the edges of the neighbourhood, while new winding thoroughfares, like Via del Papa and Via del Pellegrino, led across the area towards the Tiber and then to Old St Peter's on the other side of the river.[17] S. Maria sopra Minerva was one of several churches in this district, the medieval region of Pigna;[18] other churches — such as S. Marco, S. Marcello, S. Maria in Via Lata, S. Maria in Acquiro, and SS. Apostoli, were located nearby. These were surrounded by medieval aristocratic mansions guarded by towers, and many small dwellings and shops of artisans and others. Some of these buildings

15 Alberto Zucchi claimed, however, that the elephant was designed by Fra Giuseppe Paglia, OP, see Rome, AM, MS cm II. e. 3.4–16, Zucchi, 'La Minerva attraverso i secoli', pp. 51–55.

16 Klein, 'S. Maria sopra Minerva', p. 311.

17 Krautheimer, *Rome*, p. 248.

18 Wickham, *Medieval Rome*, Chapter 5, discusses the region Pigna in the eleventh and twelfth centuries.

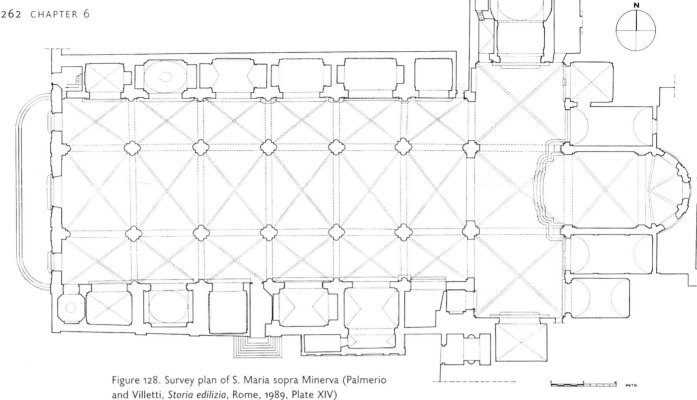

Figure 128. Survey plan of S. Maria sopra Minerva (Palmerio and Villetti, *Storia edilizia*, Rome, 1989, Plate XIV)

nestled in ancient Roman ruins. By the late thirteenth century, when the Friars Preachers took up residence, the area had become a densely populated neighbourhood, but, since the Tiber flooded regularly, most houses were to the east of Piazza Navona.

S. Maria Sopra Minerva Today and Changes Made in the Eighteenth and Nineteenth Centuries

On entering S. Maria sopra Minerva, one sees a six-bay vaulted nave and two aisles separated by multiple piers sustaining pointed Gothic arches (Figs 125 and 128). To the east, there is a tripartite vaulted transept that extends beyond the nave and aisles. The choir and apse are flanked by an entrance passageway and three chapels. North of the transept is the chapel of Saint Dominic, with a small vaulted chamber to the west, which was once part of a bell tower; on the south of the transept is the chapel of Saint Thomas Aquinas, built by Cardinal Oliviero Carafa (1430–1511) and famous for its frescoes painted by Filippino Lippi.[19] North and south of the aisles there are post-medieval side chapels.

There are three entrances in the rectangular façade, which is articulated by pilasters, and formerly rose in a cavetto (compare Figs 124 and 126). A side entrance opens halfway along the south aisle (Fig. 128), while another, at the eastern end of the north aisle, gives access to a narrow corridor leading to the cloister. A door to the east of Saint Dominic's chapel connects the transept to the sacristy and its surrounding area, which includes a seventeenth-century chapel of Saint Catherine of Siena. There is also an entrance to the church located at the east end of a passageway north of the sanctuary.

The way one sees S. Maria sopra Minerva today (Fig. 125) is strongly influenced by changes made to the building in the eighteenth century by the Dominican pope, Benedict XIII Orsini (1724–1730), and by the restoration of the church

19 For the frescoes, see Geiger, *Filippino Lippi's Carafa Chapel*.

in the nineteenth century by a Dominican lay brother, Fra Girolamo Bianchedì, and other artists. Benedict XIII totally renewed the roofs of the church, repaved the building, and cleaned and restored all the chapels, including the chapel of Saint Catherine of Siena near the sacristy; he also whitewashed the interior walls, and the façade.[20] Images of the church made just before the mid-nineteenth century, such as the prints by Luigi Rossini of 1840–1845, show some of these changes, and, in particular, the whitewashed walls and vaults of the interior. When Benedict XIII died, he was buried at the Minerva in the chapel of Saint Dominic, which he had commissioned Filippo Raguzzini to remodel.

The most important architectural changes in the nineteenth century occurred from 1848–1855, when the Dominicans restored the church of S. Maria sopra Minerva in the Neo-Gothic style. After that, nineteenth-century paintings, stained glass, marble, and painted marble inlay were used to decorate the interior, making it colourful but rather dark. This nineteenth-century restoration has obscured rather than clarified the nature of the medieval building, making it necessary to reconstruct the original medieval features of the edifice. When the Dominicans began the nineteenth-century restoration, they believed that the medieval church had been planned and built by two lay brothers of their Order, the master builders Fra Sisto and Fra Ristoro, who had also built S. Maria Novella in Florence c. 1279.[21] Furthermore, it was generally accepted that S. Maria sopra Minerva was a copy of the Dominican church in Florence.[22] These theories are not accepted nowadays, but it is likely that Dominican lay brothers were involved in the planning and building of the medieval church, and that they brought to it the un-Roman style accepted by their Order.[23]

Evidently, the nineteenth-century restoration campaign at the Minerva was inspired by a certain Fra Piel, a French Dominican who had studied architecture in France before entering the Order of Preachers,[24] and it is possible that he was imbued with Neo-Gothic theories, like those of Eugène-Emmanuel Viollet-le-Duc (1814–1879), who was responsible for many restorations of medieval Gothic buildings in France and who sometimes 'corrected' or creatively modified original features of their architecture.[25] Joachim Joseph Berthier, OP characterized the Dominican lay brother, Fra Girolamo Bianchedì, who was entrusted with the nineteenth-century restoration of the Minerva, as an architect, engineer, moulder, and joiner, just like an artist of the Middle Ages — obviously seeing him as a modern Fra Sisto or Fra Ristoro.[26]

Bianchedì concentrated on the Gothic nave, aisles, and transept, as well as the apse of the church, which had been rebuilt in 1614, but he did not restore the later chapels that had been added in Renaissance and Baroque styles.[27]

20 Rome, AGOP, MS XIV, liber C, Parte II, fols 85–88, *Benefici segnalati*; and Rome, AM, MS cm II. e. 3.1–3, p. 40, and Rome, MS cm II. e. 3.4–16, p. 14, Zucchi, 'La Minerva attraverso i secoli'.
21 Masetti, *Memorie istoriche*, p. 9; Marchese, *Memorie*, vol. I, pp. 72–75.
22 Zucchi, 'Roma Domenicana. La costruzione della nuova Chiesa della Minerva', p. 144, believed the lay brothers may have furnished a plan, but he commented that the design of the Minerva was very different from that of S. Maria Novella. For the architecture of S. Maria Novella, see Wood Brown, *The Dominican Church of Santa Maria Novella at Florence*; Bradford-Smith, 'Santa Maria Novella'; and De Marchi, ed., *Santa Maria Novella: La Basilica e il Convento*, vol. I.
23 Davidsohn, *Forschungen zur Geschichte von Florenz*, vol. II, p. 466, doubted the references to Fra Ristoro in the Necrology of S. Maria Novella; see also Spinelli, *S. Maria sopra Minerva*, p. 11; Kleefisch-Jobst, *Die römische Dominikanerkirche Santa Maria sopra Minerva*, p. 93, and Mariotti, 'La Creazione di un mito'. For different views, see, Chiaroni, 'Il Vasari e l'architetto Fra Ristoro da Campi'; and Bradford-Smith, 'Santa Maria Novella', p. 626.
24 Berthier, *L'Église de la Minerva*, p. 12.
25 Viollet-le-Duc, *On Restoration*, pp. 9–71; see also Spurr, *Architecture and Modern Literature*, pp. 142–61.
26 Berthier, *L'Église de la Minerve*, p. 13.
27 Berthier, *L'Église de la Minerve*, pp. 12–13.

264 CHAPTER 6

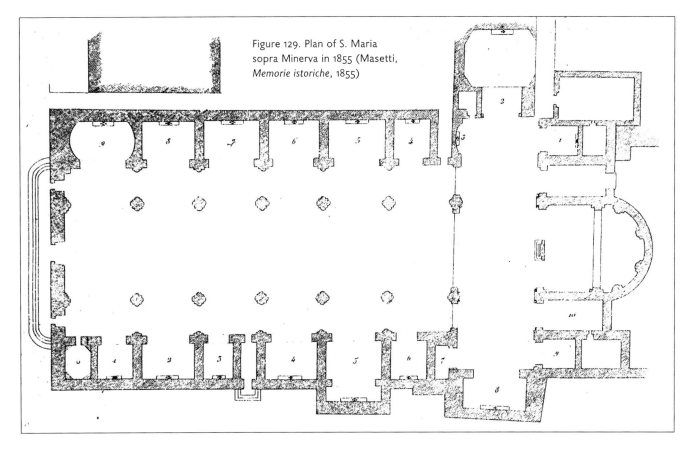

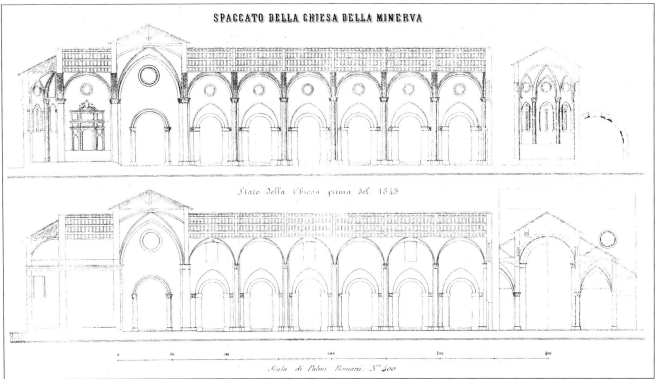

Figure 130. Fra Gieronimo Bianchedi's sections, before (below) and after (above) the nineteenth-century restorations, (Masetti, *Memorie istoriche*, 1855)

According to Pio Tommaso Masetti, OP (a Dominican contemporary of Bianchedì, who wrote a book about the restoration project, which was published in 1855), the lay brother first analysed the building and then drew up plans to 'correct' what he thought were its defects.[28] Contemporary Roman architects, like Virginio Vespignani (1808–1882), who restored many churches in the city, tended to follow the original architectural style of each building, not changing the structure, but sumptuously embellishing the interior.[29] On the contrary, Bianchedì altered several features of the existing structure of S. Maria sopra Minerva.

Masetti's book is illustrated with two plates with architectural drawings labelled 'Pianta dimostrativa della chiesa della Minerva' (a demonstration plan of the church of the Minerva) (Fig. 129) and 'Spaccato della chiesa della Minerva' (Section of the church of the Minerva as restored and 'Stato della Chiesa prima del 1848 [State of the church before 1848]) (Fig. 130). The first is a plan of the church, perhaps a survey drawing, but without a scale. The second includes a longitudinal section of the Church before 1848 and, above it, another showing the same view after the restoration; on the right of the main drawings there are lateral sections of the transept and apse. The drawings in the second plate (Fig. 130) are instructive because they provide a 'before and after' record of the restorations, indicating the main changes made to the church's structure. In the drawing of the church before 1848, one sees three large sixteenth-century rectangular windows in the clerestory wall on the south of the church, a medieval oculus in the transept, and a seventeenth-century rectangular window in the apse. In the section of the restored building above it, there is a nineteenth-century oculus in every bay of the nave, a medieval oculus in the transept, and two nineteenth-century round windows in the sanctuary. In the restored section of the apse, the drawings show nineteenth-century vaults and double-light pointed-arched windows with an oculus above each. (It is interesting to note that, while the interior of the sanctuary today has these 'medieval' features, the exterior of the apse still has the appearance it had in 1614.)

Bianchedì changed the semi-circular arch at the entrance to the sanctuary into a pointed arch; he demolished the upper part of the apse, where he inserted vaulting; he transformed the windows in the apse to double-light pointed openings and inserted oculi above them (Figs 125 and 130). Probably in imitation of S. Maria Novella in Florence, he replaced the six existing rectangular sixteenth-century clerestory windows of the nave with twelve oculi, which he drilled into the church's upper walls (Figs 131 and 132). He made the arches and vaults throughout the building more pointed than they were originally.[30] He managed to transform the structure of the church in the years 1848 and 1849, and then he died, leaving the interior decoration incomplete. Although work stopped altogether amid the political tensions in Italy of 1849–1850, the interior was later embellished with stained glass and frescoes, while real or fake marble covered the piers. In 1855, Pope Pius IX re-dedicated the 'restored' church.[31]

Masetti provided a written description of the layout of the church before the changes of 1848–1855, as shown in his plan (Fig. 129). He noted that the piers in the nave were square, with a half-column attached to each side. The nave was vaulted, quite high and pointed, exceeding the height of the vaults in the side aisles.[32] Masetti suggested that the eastern chapels and transept were completed in 1296, after Pope Boniface VIII

28 Masetti, *Memorie istoriche*, pp. 24–25.
29 Barucci, *Virginio Vespignani*, esp. pp. 17–31 and 133–95.
30 Masetti, *Memorie istoriche*, pp. 25–26; see also Matthiae, 'Gli aspetti diversi di S. Maria sopra Minerva'; Berthier, *L'Église de la Minerve*, pp. 40–43; Palmerio and Villetti, *Storia edilizia*, pp. 195–97.
31 Masetti, *Memorie istoriche*, pp. 67–72.
32 Masetti, *Memorie istoriche*, p. 10.

266 CHAPTER 6

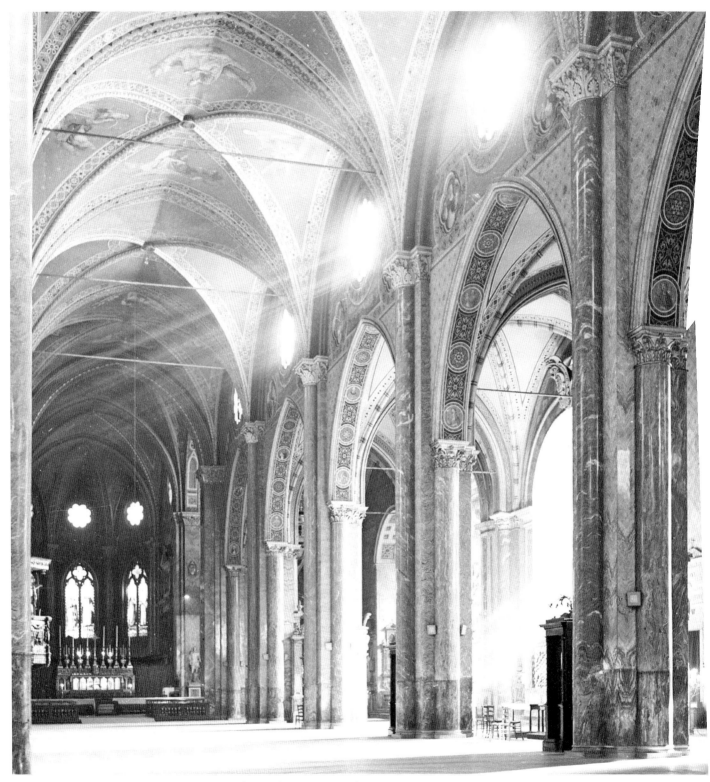

Figure 131. S. Maria sopra Minerva, interior view of nave, showing oculi and side aisle
(photo: Bibliotheca Hertziana – Max-Planck-Institut für Kunstgeschichte, Rome)

donated 2000 pounds Tournois to the Minerva on 18 January 1295.[33] The nave and aisles were covered with a wooden roof until the fifteenth century, when the Dominican Cardinal Juan Torquemada (1388–1468) had the nave vaulted, as shown by his coat of arms.[34] Masetti suggested that the Cardinal's generous donations for this work stimulated other patrons to pay for the vaulting in the side aisles.[35] According to an inscription, Francesco Orsini finished the façade in 1453. In 1598, the floor of the church was raised considerably because of the frequent flooding of the Tiber.[36] On the whole, Masetti deplored the earlier restorations of the church and declared that its true 'risorgimento' was reserved for the mid-nineteenth-century building campaign of Fra Girolamo Bianchedi.[37]

In 1910, Berthier provided further information about the decoration of the restored building.[38] The brothers Achille and Giuseppe Lega from Forlì covered the piers and half-columns with real marble at their base and with fake, painted marble above that. Most of the stained-glass windows were executed by the firm of Bertini in Milan, following designs by Bernardino Riccardi of Parma. Those in the apse portray Saints Dominic and Pius V in the centre, with Saints Vincent Ferrer and Stephen on the left, and Saints Catherine of Alexandria and Catherine of Siena on the right. The same Bernardino Riccardi began painting the vaults of the church, but when this decoration was left unfinished at his death in 1854, it was completed by Carlo Gavardini, Tommaso Oreggia, Filippo Balbi, and other artists, including Fra Serafino of the Minerva community.[39] Giuseppe Fontana designed the Neo-Gothic high altar, which was made by Felice Ceccarini,[40] and the relics of Saint Catherine of Siena were installed beneath it.[41]

Figure 132. Florence, S. Maria Novella, exterior of nave and aisle from the south (photo: author)

The Early Church of S. Maria Sopra Minerva and Its Transfer to the Dominicans

A small church, referred to as 'Minervium' (the Minerva) or 'Minerviam; ibi Sancta Maria in Minerva' (the Minerva; there is Santa Maria in Minerva), is recorded in the *Einsiedeln Itinerary*, written in the late eighth or early ninth century.[42] According to tradition, Pope Zaccharias (741–752) entrusted the monastery of S. Maria in Campo Marzio, north of the Pantheon, to Byzantine nuns who had fled to Rome during iconoclasm in Constantinople (c. 726–843) and the nuns established their residence there.[43] The nunnery

33 Masetti, *Memorie istoriche*, p. 12.
34 Masetti, *Memorie istoriche*, pp. 14–15. Cardinal Juan Torquemada was not the notorious member of the Spanish Inquisition, but his uncle.
35 Masetti, *Memorie istoriche*, p. 15.
36 Masetti, *Memorie istoriche*, p. 17 n. 1. Outside the church there are markers showing how high the flood waters reached at various dates before the embankments were built on either side of the river in the nineteenth century.
37 Masetti, *Memorie istoriche*, p. 19.
38 Berthier, *L'Église de la Minerve*, pp. 39–44.

39 Berthier, *L'Église de la Minerve*, pp. 44 and 139–40.
40 Berthier, *L'Église de la Minerve*, p. 217.
41 Berthier, *L'Église de la Minerve*, pp. 218–28.
42 For the references in the *Einsiedeln Itinerary*, Valentini and Zucchetti, *Codice topografico*, vol. II, pp. 187 and 195; see also, Armellini, rev'd by Cecchelli, *Chiese*, p. 592.
43 Rome, AM, MS III, 327–30, *Campione*, vol. I, p. 1;

had three oratories: the main church of S. Maria in Campo Marzio, the oratory of S. Gregorio Nazianzeno very close by, and the small church of S. Maria sopra Minerva, some way south of the convent and east of the Pantheon.[44] The church and nunnery buildings of S. Maria in Campo Marzio still exist, as remodelled from the sixteenth and seventeenth centuries onwards.[45] The nuns brought with them some relics of Saint Gregory Nazianzen (329–389), which were placed in the oratory dedicated to him.[46] Its early medieval apse survives, with frescoes painted between the eleventh and fourteenth centuries, and there is a bell tower of similar date.[47] In 806, Pope Leo III donated a silver basket to the oratory of S. Gregorio in Campo Marzio, which must have been this sanctuary.[48] A document of 986 refers to the relics of the saint and to 'Anna Abbatissa venerabilis monasterii sanctae Dei genitricis […] et sancti Gregorii Natiantzeni, qui ponitur in Campo Martio' (Anna, Abbess of the venerable monastery of Saint Mary Mother of God […] and Saint Gregory Nazianzen, which is located in the Campus Martius).[49] At an unknown date, Benedictine nuns took the place of the Byzantine Sisters.[50] In the Catalogue of Turin, c. 1320, seventeen nuns were listed.[51] In 1192, the *Liber Censuum* recorded that the church of 'S. Maria in Minerva' received 12 denarii, indicating that it was one of the small churches in Rome.[52] When Pope Celestine III (1191–1198) extended papal protection over the monastery of S. Maria in Campo Marzio in 1194, he confirmed the nunnery's property, including about 150 houses, seventy-four of which were located 'in circuitu monasterii' (around the monastery) and 'Ecclesiam Sancte Marie in Minerva cum omnibus pertinentibus suis' (the church of S. Maria sopra Minerva with all its possessions).[53]

Masetti, *Memorie istoriche*, p. 2, refers to the coming of the Byzantine nuns in 750; for an earlier date c. 741 see Berthier, *L'Église de la Minerve*, p. 2; see also Taurisano, *S. Maria sopra Minerva*, p. 9; Ferrari, *Early Roman Monasteries*, pp. 207–09; Zucchi, 'Roma Domenicana, vol. 1. Fondazione di S. Maria sopra Minerva', p. 99; Bernardino, 'Il convento della Minerva'. Sansterre, *Les Moines grecs et orientaux à Rome*, pp. 34 and 157, prefers a date of 754–60 for the nuns' arrival in Rome; Osborne, *Rome in the Eighth Century*, has a chapter on Pope Zacharias, but does not mention the nunnery of S. Maria in Campo Marzio. S. Maria in sopra Minerva is mentioned in Caracciolo, 'Il monastero', pp. 1–2.

44 It was not uncommon for early medieval monastic institutions in Rome to have more than one church: at Tre Fontane there was the martyrium of Saint Paul at the three fountains, the church of S. Maria (later named S. Maria Scala Coeli), and the monastic church of S. Anastasio, see Barclay Lloyd, *SS. Vincenzo e Anastasio*, pp. 74–75; and at SS. Cosma e Damiano in Mica Aurea c. 1005 there were churches dedicated to Saint Benedict, Saint Nicholas, and Saint Lawrence; see Barclay Lloyd and Bull-Simonsen Einaudi, *SS. Cosma e Damiano in Mica Aurea*, pp. 81, 118–19, and above, Chapter 4.

45 The church is now the centre of the Antiochene Church of Syria in Rome and part of the convent is taken up with offices of the Italian Chamber of Deputies, see Borsi, *Santa Maria in Campo Marzio*. For the post-medieval phases of the church and convent buildings and their decoration, see Coppolaro ed., *S. Maria in Campo Marzio*, from p. 39 onwards.

46 Carusi, *Cartario di S. Maria in Campo Marzio*, pp. xv, citing De Nobili, *Cronaca*, refers to the relics. The crusaders who captured Constantinople in 1204 claimed to have seen the body of Saint Gregory Nazianzen in that city, see Sansterre, *Les Moines grecs et orientaux à Rome*, p. 157, so the relics brought by the nuns may not have been extensive. The relics were translated from the church of S. Gregorio Nazianzeno beside S. Maria in Campo Marzio to St. Peter's on 11 June 1580 and installed in an altar near the tomb of Pope Gregory XIII, see Petrone, 'Vita monastica', pp. 53–56.

47 For the frescoes, see Sgherri, 'Il dipinto frammentario in San Gregrio Nazianzeno', with a date c. 1300–1310. A panel painting of the *Last Judgement* from that church is in the Vatican Pinacoteca.

48 *LP*, vol. II, p. 25; see also Ferrari, *Early Roman Monasteries*, p. 207.

49 Cited by Sansterre, *Les Moines grecs et orientaux à Rome*, p. 157.

50 A Bull of Pope Celestine III, dated 1194, refers to the nuns living according to the Rule of Saint Benedict, see Carusi, *Cartario di S. Maria in Campo Marzio*, p. 115.

51 Valentini and Zucchetti, *Codice Topografico*, vol. III, p. 295.

52 *Liber Censuum*, ed. by Fabre, Duchesne, and Mollat, vol. I, no. 135, p. 302. Among the small churches, there were some that received 18 denarii, others 12, and the smallest of all 6.

53 Carusi, *Cartario di S. Maria in Campo Marzio*, no. 62,

On 24 September 1255, Pope Alexander IV (1254–1261) wrote to the English Cistercian, John of Toledo, Cardinal of S. Lorenzo in Lucina, arranging for some women penitents to have the church of S. Maria sopra Minerva and some accommodation nearby.[54] These 'penitents' may have been a group of 'semi-religious' women and it is likely that they lived in a house next to the church.[55] Very soon afterwards, on 1 December 1255, the Pope wrote another letter to the Cardinal approving the transfer of these women to San Pancrazio, which is located a short distance outside the Aurelian Walls on the Janiculum Hill, because at S. Maria sopra Minerva, 'multa ibi propter ineptiam loci patiantur incommoda sustineant detrimenta' (they are suffering a lot there on account of the unsuitability of the place and they are putting up with inconvenient and detrimental conditions).[56] Alexander IV also noted that, when the penitents moved, they were living 'sub habitu et observantia Cistercensium' (in the habit and according to the observance of the Cistercians),[57] a change for which the Cistercian Cardinal John of Toledo was most likely responsible.

Shortly after this, the Dominican friars, who may have been looking for a church in the more densely populated part of the city, began negotiations to take over S. Maria sopra Minerva.[58] The sources for the Dominican history of the church are to be found in a variety of historical documents, including papal letters and the 'Acta' of the Chapters of the Roman Province.[59] Although the medieval documents in the Minerva Archive were lost in the nineteenth century, some of them had been transcribed, or were referred to in a chronicle written by Ambrosio Brandi, OP in the first half of the seventeenth century and then copied, with annotations, *c.* 1706; a copy of the eighteenth-century version of this manuscript is now in the General Archive of the Order of Preachers at S. Sabina.[60] Besides this, Giacomo Reginaldo Quadri, OP in 1758 compiled a register, known as the 'Campione', of all the items at that time in the Minerva Archive related to the church.[61] This manuscript is in the Minerva Archive, where there is also an important history of the church and priory, the unpublished manuscript of Alberto Zucchi, OP, *La Minerva attraverso i secoli*, and his other notes.[62]

The Chapter of the Roman Province held at Todi in 1266 included the command: 'Inhibemus districte fratribus Romanis ne locum Rome novum acceptum aliquatenus alienent' (we strictly forbid the Roman friars to alienate in any way the new place received in Rome), which must have

pp. 115–20; Berthier, *L'Église de la Minerve*, p. 3; Palmerio and Villetti, *Storia edilizia*, pp. 26–27.

54 The Pope's letter is published in *BOP*, vol. I, p. 287, under the heading '*Mulieribus Repentinae vulgo nuncupates Aedes sacras Sanctae Mariae supra Minervam concedit*' (He concedes the sacred buildings of S. Maria sopra Minerva to women who are commonly called Penitents). See also *Les Régistres d'Alexandre IV*, ed. by Bourel de la Roncière and others, vol. I, no. 821, p. 247. For John of Toledo, see Paravicini Bagliani, *Cardinali di Curia*, vol. I, pp. 228–41.

55 For these groups of 'quasi-religious' or 'semi-religious' women, see Bolton, 'Mulieres Sanctae', and Bolton, 'Daughters of Rome'; Bynum, *Holy Feast and Holy Fast*; and Makowski, 'A Pernicious Sort of Woman'. For this group at the Minerva, see also, Kleefisch-Jobst, *Die römische Dominikanerkirche Santa Maria sopra Minerva*, p. 18.

56 *Les Régistres d'Alexandre IV*, ed. by Bourel de la Roncière and others, vol. I, no. 895, p. 266. See also, Barclay Lloyd, 'The Church and Monastery of S. Pancrazio', pp. 255–57.

57 *Les Régistres d'Alexandre IV*, ed. by Bourel de la Roncière and others, vol. I, no. 895, p. 266.

58 Rome, AGOP, MS XIV, liber C, Parte I, Brandi, *Cronica*, fols 3–4.

59 The papal documents were published in *BOP*; for the Acta of the Roman Province, see *Acta Capitulorum Provincialium Provinciae Romana*, ed. by Kaeppeli and Dondaine.

60 Rome, AGOP, MS XIV, liber C, Parte I, Brandi, *Cronica*.

61 Rome, AM, MS III, 327–30, *Campione*.

62 Rome, AM, MS cm II. e. 3.1, 1–3, Zucchi, 'La Minerva attraverso i secoli (la chiesa e il convento di S. Maria sopra Minerva); Rome, AM, MS cm II. g. 5, Zucchi, *Miscellanea*, 1–8. See also Zucchi, 'Roma Domenicana: La chiesa e il convento di S. Maria sopra Minerva', for the sources on the history of the church and convent.

meant the Minerva.[63] When a new Dominican priory was founded in the Middle Ages, it was often called simply a 'locus' (place), before its official foundation as a priory.[64] While the Dominicans 'received' S. Maria sopra Minerva in 1266, negotiations for its legal transfer to them continued for about ten years.[65] Despite this delay, it is likely that some friars from S. Sabina went to live at S. Maria sopra Minerva, which was at first a dependent of the older Dominican house on the Aventine.[66] Legally, S. Maria sopra Minerva remained the property of the nuns of S. Maria in Campo Marzio until 1275.[67]

The Florentine Dominican, Aldobrandino dei Cavalcanti, Bishop of Orvieto and Vicar of Rome under Gregory X (1271–1276) steered the negotiations regarding S. Maria sopra Minerva through the papal Curia with the help of the Prior of S. Sabina, Latino Malabranca, who later became a cardinal.[68] Cardinal Aldobrandino, acting as Vicar of Rome, in a letter dated 17 November 1275, referred to the church of S. Maria sopra Minerva as having been ceded to the Dominicans by the Abbess and Community of S. Maria in Campo Marzio in Rome, of the Order of Saint Benedict, to whom it belonged.[69] A second document, issued on the same day, gave the Friars Preachers permission to exchange some property near the Tiber for gardens, houses, and other structures close to S. Maria sopra Minerva.[70] This suggests that they were planning to extend the church and convent at the Minerva.

There was another legal problem involved in the takeover: the church came under the jurisdiction of the Parish of S. Marco, near modern Piazza Venezia, and the Dominicans needed to secure its juridical independence from the clergy there. In 1257, Pope Alexander IV wrote a letter ending a lawsuit between the nuns of S. Maria in Campo Marzio and the clergy of S. Marco, some of whom officiated at S. Maria sopra Minerva; the aim was to ensure that the nuns would regain full possession of the church.[71] Another papal letter, addressed to the Senator of Rome, asked him to help the nuns take back possession of the church and its property.[72] After that, a series of legal documents were drawn up to resolve legal questions and to clear up any other problems related to the disputed hegemony of the parish. In the end, Cardinal Uberto of Sant'Eustachio arbitrated in favour of the Dominicans. He issued a document, in which he decreed that the church of S. Maria sopra Minerva, with all its appurtenances and possessions and with its rights and deeds, together with its own parish and with every parochial right, should remain exempt from all servitude and from every burden, and that the Prior and community, and their successors, should remain unhindered and free to have, keep,

63 *Acta Capitulorum provinciae Romanae*, ed. by Kaeppeli and Dondaine, p. 33.

64 Galbraith, *The Constitution*, pp. 51–52. For a similar case at Priverno, see Villetti, 'L'architettura degli ordini mendicanti', p. 23.

65 Taurisano, *S. Maria sopra Minerva*, p. 9; Palmerio and Villetti, *Storia edilizia*, p. 31.

66 Masetti, *Memorie istoriche*, p. 4, suggested that the early friars used to work at the Minerva during the day and then return to S. Sabina in the evening; see also Berthier, *L'Église de la Minerve*, pp. 3–4.

67 Palmerio and Villetti, *Storia edilizia*, p. 32.

68 These two Dominicans also founded S. Maria Novella in Florence. See Taurisano, *S. Maria sopra Minerva*, p. 10; and Palmerio and Villetti, *Storia edilizia*, pp. 32–33; Zucchi, 'Roma Domenicana. 1. La fondazione domenicana di S. Maria sopra Minerva', pp. 102–05.

69 *BOP*, vol. VII, p. 46; Masetti, *Memorie istoriche*, p. 5; Berthier, *L'Église de la Minerve*, p. 6; Kleefisch-Jobst, *Die römische Dominikanerkirche Santa Maria sopra Minerva*, Doc. A2, pp. 175–76, and Palmerio and Villetti, *Storia edilizia*, p. 32.

70 Rome, AGOP, MS XIV, liber C, Parte I, Brandi, *Cronica*, fols 18–20; see also Palmerio and Villetti, *Storia edilizia*, p. 32.

71 The letter itself has been lost, but it was transcribed by Brandi in Rome, AGOP, MS XIV, liber C, Parte I, *Cronica*, fols 6 and 9–10 and it is mentioned in Rome, AM, MS III, 327–30, *Campione*, vol. I, p. 410; see also, Palmerio and Villetti, *Storia edilizia*, p. 30.

72 Palmerio and Villetti, *Storia edilizia*, p. 30.

possess, and arrange, as much with respect to the church as to the parish, whatever would seem to them and to their successors to be profitable.[73] Pope John XXI ratified this judgement in a Brief dated 3 November 1276.[74] Except for baptisms, the church of S. Maria sopra Minerva was then independent of the parish of S. Marco and fully in the hands of the Friars Preachers. (The right to confer baptism at the Minerva was conceded in 1531.)[75] Like the Friars Minor at S. Maria in Aracoeli, the Dominicans had their own church, priory, and parish in the city.

The Dominicans at S. Maria Sopra Minerva

The *Acta* of the Chapter of the Roman Province mentioned a prior of S. Maria sopra Minerva for the first time in 1287, the appointment of a Lector (teacher) in 1288, and a visitation of the community in 1291.[76] This indicates that the Dominican priory must have been fully established by the late 1280s. The community had grown to fifty *c.* 1320.[77] At that time, S. Maria sopra Minerva was the Dominican house in Rome with the most friars, while S. Sabina had thirty, and S. Sisto sixteen. When Raymond of Capua became Master General of the Order of Preachers in 1380, he began the custom of the Master General residing at S. Maria sopra Minerva in Rome, instead of at S. Domenico in Bologna.

Later, Pope Pius V (1566–1572) made the Minerva the head of the Dominican Roman Province.

Funding the New Church: Gifts and Burials

In about 1280, the Dominicans began to build a large new church of S. Maria sopra Minerva. For this, they needed funds, but, as a Mendicant Order, they had no financial reserves and they had to rely on donations from wealthy patrons. Some large gifts came from the Popes, the Senators of Rome, and some members of wealthy Roman families. In 1279, Pope Nicholas III Orsini (1277–1280) instructed the Senators of Rome to contribute money for the construction of the new church.[78] On 24 June 1280, he wrote again to the Senators, Giovanni Colonna and Pandolfo Savelli, demanding that they provide the Dominicans with the money the Roman Senate had agreed to donate for the building.[79] In January 1295, Pope Boniface VIII (1295–1303) provided a large sum (2000 pounds Tournois) to continue its construction.[80]

Smaller donations came from cardinals and other donors. In 1277, Cardinal Guala Bicchieri bequeathed twenty pounds to the Dominican friars in Rome, probably for building the new church.[81] In 1286 Cardinal Hugh of Evesham

73 *BOP*, vol. I, p. 550.
74 *BOP*, vol. I, p. 550; *Les Régistres de Grégoire X et de Jean XXI*, ed. by Guirand and others, no. 16. Masetti, *Memorie istoriche*, p. 7; Berthier, *L'Église de la Minerve*, p. 7; see also, Palmerio and Villetti, *Storia Edilizia*, p. 33.
75 Masetti, *Memorie istoriche*, p. 7; Berthier, *L'Église de la Minerve*, p. 7.
76 *Acta Capitulorum Provincialium Provinciae Romanae*, ed. by Kaeppeli and Dondaine, pp. 77–78, 84–85, and 103.
77 Valentini and Zucchetti, *Codice Topografico*, vol. III, p. 299; Rome, AM, MS cm II. e. 3.1, Zucchi, 'La Minerva attraverso i secoli (la chiesa e il convento si S. Maria sopra Minerva)', p. 28.

78 Rome, AM, MS III, 327–30, *Campione*, vol. I, p. 66.
79 Rome, AGOP, MS XIV, liber C, Parte I, Brandi, *Cronica*, fols 20–21; *BOP*, vol. I, pp. 571–72; Masetti, *Memorie istoriche*, p. 8; Berthier, *L'Église de la Minerve*, p. 9; Taurisano, *S. Maria sopra Minerva*, p. 10; Rome, AM, MS cm II. e. 3.1, Zucchi, 'La Minerva attraverso i secoli (la chiesa e il convento si S. Maria sopra Minerva)', p. 24; Kleefisch-Jobst, *Die römische Dominikanerkirche Santa Maria sopra Minerva*, Doc. A4, p. 177.
80 *BOP*, vol. II, p. 39; Rome, AM, MS III, 327–30, *Campione*, vol. I, p. 411; Masetti, *Memorie istoriche*, p. 12; Berthier, *L'Église de la Minerve*, p. 9; Taurisano, *S. Maria sopra Minerva*, p. 10; Rome, AM, MS cm II. e. 3.1, Zucchi, 'La Minerva attraverso i secoli (la chiesa e il convento si S. Maria sopra Minerva)', p. 28.
81 Paravicini Bagliani, *I testamenti dei Cardinali*, p. 116 [27]:

bequeathed money to both the Franciscan and the Dominican friars in Rome without specifying what they should do with the funds.[82] A certain Pietro de Angelis Seio left 300 solidi Provinois to the Minerva on 4 March 1292.[83] In May of the same year, a merchant named Petrus Saxonis left 10 pounds Provinois 'pro fabrica' (for the building) of the Minerva.[84] On 24 August 1297, Cardinal Ugo Aycelin, OP left 100 golden florins to the Dominican friars at the Minerva 'ponendos in constructione operis dicti loci' (to be used for the construction of the work in that place); and he added a further 20 florins for three pittances for the friars and for celebrating a Requiem Mass for his soul; when all his bequests have been distributed, he stated that 'residuum quod fuerit volumus quod totum sit ad opus fabrice ecclesie fratrum Predicatorum Sancte Marie de Minerva in Urbe' (we wish everything that remains [should go] to the work of building the Friars Preachers' church of S. Maria de Minerva in Rome).[85] On 23 May 1300, Cardinal Tommaso d'Ocre left ten pounds Provinois to the church of S. Maria sopra Minerva 'pro opere ipsius ecclesiae' (for the work of this church).[86] Cardinal Francesco Orsini in 1304 left fifty golden florins each to the Dominicans, the Franciscans, and the Hermits of Saint Augustine.[87] When, on 30 June 1309, Cardinal Giovanni Boccamazza left 200 gold florins to the Dominicans at the Minerva for their needs and for Masses to be celebrated in perpetuity for himself on the anniversary of his death, he did not mention the buildings, perhaps indicating that funds were no longer needed for that purpose.[88] Yet, at the end of the Catalogue of Turin c. 1320, the apse of S. Maria sopra Minerva was said to be in a bad state of repair, requiring work estimated at 200 gold florins.[89]

The friars also earned some income from property they possessed near the Minerva. In 1297, they let a house next to the church.[90] In 1315, they received rent for a house in Regione Pigna next to the convent.[91] At about that time, the friars sold a house in the area.[92] A palazzo and a house were given to them in 1350.[93] Another house was donated in 1360 and then the friars bought a third house next to the convent in 1363.[94] In 1426, a house was bequeathed to the Dominicans.[95] Gradually, the friars received many similar bequests.

Various people wanted to be buried in S. Maria sopra Minerva and such burials provided the friars with income.[96] They also signal when certain parts of the church had been completed. For example, an inscription formerly in the pavement in front of the chapel of All Saints in the south transept referred to the tomb of 'Petrus de Buccamatiis' (Pietro de Boccamazza?) who died in 1290.[97] In 1296 Durandus, Bishop of Mende, was buried in the chapel on the far south-east, opening off the

'Item Fratribus Predicatoribus de Urbe libr. XX.' (Item. To the Friars Preachers in Rome 20 pounds).

82 Paravicini Bagliani, *I testamenti dei Cardinali*, p. 210, [5]: *'Item Minoribus et Predicatoribus de Urbe XL libr.'* (Item. To the Friars Minor and the Preachers of Rome, 40 pounds).

83 Palmerio and Villetti, *Storia edilizia*, p. 44, citing BAV, Vat. lat. 11392, S. Maria in Campo Marzio, n. 60.

84 Palmerio and Villetti, *Storia edilizia*, p. 45, referring to ASV, Celestini, n. 18.

85 Paravicini Bagliani, *I testamenti dei Cardinali*, p. 303 [14], [15]; and p. 312 [74]; also cited in Palmerio and Villetti, *Storia edilizia*, p. 45.

86 Paravicini Bagliani, *I testamenti dei Cardinali*, p. 325 [20].

87 Paravicini Bagliani, *I testamenti dei Cardinali*, p. 349 [51].

88 Paravicini Bagliani, *I testamenti dei Cardinali*, pp. 355 [8], 359–60 [30], 362–63 [47], 367.

89 Valentini and Zucchetti, *Codice Topografico*, vol. III, p. 318; see also Rome, AM, MS cm II. e. 3.1, Zucchi, 'La Minerva attraverso i secoli (la chiesa e il convento si S. Maria sopra Minerva)', p. 28.

90 Rome, AM, MS III, 327–30, *Campione*, vol. I, p. 229.

91 Rome, AM, MS III, 327–30, *Campione*, vol. I, p. 105.

92 Rome, AM, MS III, 327–30, *Campione*, vol. I, p. 229.

93 Rome, AM, MS III, 327–30, *Campione*, vol. I, p. 229.

94 Rome, AM, MS III, 327–30, *Campione*, vol. I, p. 229.

95 Rome, AM, MS III, 327–30, *Campione*, vol. I, p. 230.

96 For burials in mendicant churches, see Bruzelius, 'The Dead Come to Town', pp. 203–24; and Bruzelius, *Preaching, Building, and Burying*, pp. 150–66.

97 Forcella, *Iscrizioni*, vol. XIII, no. 899, p. 378.

transept of S. Maria sopra Minerva, indicating that that part of the building was already standing; later his tomb was moved into the south transept, where it remains today (Fig. 133).[98] Cardinal Giovanni Boccamazza was buried in the church in 1309; Fra Roger, Bishop of Siena, in 1326.[99] In the fifteenth century, Cardinal Antonio Gaetani donated 60,000 gold ducats to restore the church and the apse, where he was buried in 1412 and where his coat of arms is still to be seen.[100]

The Medieval Dominican Church of S. Maria Sopra Minerva

S. Maria sopra Minerva was the largest church erected in Rome in the late thirteenth and early fourteenth centuries (Fig. 128).[101] The interior dimensions are as follows: total length, 95 m; length of the sanctuary and apse, 17.32 m; depth of the transept, 13.90 m; width of the transept, 37.07 m; length of the nave, 62.19 m; width of the nave and aisles, 27.43 m; width of the nave, centre to centre of the piers, 12.68 m; width of the north aisle, 6.82 m; width of the south aisle, 7.31 m.[102] This building was much larger than the

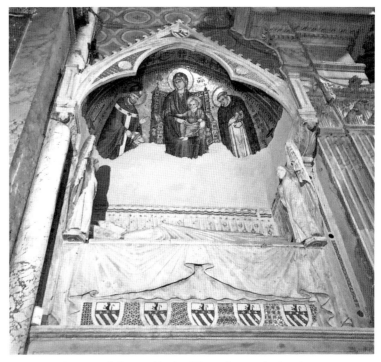

Figure 133. Giovanni di Cosma, Tomb of Durandus, made shortly after 1296, Rome, S. Maria sopra Minerva (photo: author)

Dominican churches at S. Sisto and S. Sabina;[103] and it was comparable in size to the Franciscan church of S. Maria in Aracoeli.[104]

The Dominican church was all constructed in the Gothic style, which was unusual in medieval Rome. In fact, medieval churches in Rome were usually built along the lines of the city's early Christian basilicas — with a nave and side aisles separated by colonnades, a semi-circular apse, and sometimes a transept. The columns often sustained semi-circular arches, as at S. Sabina in the fifth century; S. Clemente in the twelfth century; or S. Maria in Aracoeli in the thirteenth century; or there was a straight entablature, as at S. Maria Maggiore in 432–440 or S. Maria in Trastevere, in 1130–1143.[105] Only occasionally

98 Berthier, *L'Église de la Minerve*, p. 9; Palmerio and Villetti, *Storia Edilizia*, pp. 45–46; Rome, AM, MS cm II. e. 3.1, Zucchi, 'La Minerva attraverso i secoli (la chiesa e il convento si S. Maria sopra Minerva)', p. 29, says the tomb was originally in the Cappella Altieri until it was moved, when the chapel was renovated in 1670.

99 Palmerio and Villetti, *Storia edilizia*, pp. 47–48.

100 Kleefisch-Jobst, *Die römische Dominikanerkirche Santa Maria sopra Minerva*, p. 40.

101 Villetti and Palmerio, *Santa Maria sopra Minerva in Roma*, p. 23. Part of this Section stems from a paper given in the Session 'Rethinking medieval Rome' at the annual conference of the Society of Architectural Historians in Glasgow in June 2017. I thank Alison Perchuk for her invitation to give the paper and for her comments on an original draft of it.

102 These dimensions have been scaled from the survey plan of Palmerio and Villetti, *Storia edilizia*, plate XIV (our fig. 128). Jeremy M. Blake and I checked this plan for its accuracy.

103 See above, Chapters 1 and 2.

104 See above, Chapter 5.

105 Krautheimer, *Rome*, pp. 45–49, 161–64; Barclay Lloyd, 'The Building History [...] of S. Clemente'; Barclay Lloyd, *The Medieval Church and Canonry of S. Clemente*;

was a church built in another style in medieval Rome, and that was because it belonged to a religious Order, which had its own distinctive architecture — as was the case at Tre Fontane outside the city walls, where the Cistercians in the twelfth century built SS. Vincenzo e Anastasio.[106] At S. Maria in Aracoeli, the plan of the church was 'traditional', but there were features in its elevation, such as the clerestory and transept windows and ribbed vaults in some added chapels, which were Gothic.[107] S. Maria sopra Minerva was Gothic in plan and elevation, with features characteristic of Italian Gothic architecture and other medieval Dominican buildings.[108]

Although the Gothic style seems mostly to have by-passed the large churches of the Eternal City, recent restoration campaigns have uncovered a few outstanding examples of Gothic architecture in some smaller buildings in Rome. For instance, in Cardinal Stefano Conti's palace at SS. Quattro Coronati, built c. 1244–1254, there is the impressive 'Aula Gotica', or 'Gothic Hall', located on the floor above the chapel of S. Silvestro.[109] At the 'Sancta Sanctorum' there are Gothic features in the rectangular, vaulted chapel, which Pope Nicholas III built in 1277–1279 as his private oratory within the medieval papal palace at the Lateran.[110] This building combines some distinctive Gothic features, such as a ribbed vault, with elements that are very Roman, such as reused ancient columns and medieval copies of ancient Roman Corinthian capitals. Giovanni Belardi in the 1990s restored a high Gothic structure at Tre Fontane, which probably served as the private chapel of the abbot in the late thirteenth century and is now used as a sacristy.[111] It was covered by a Gothic ribbed vault and decorated with late thirteenth-century frescoes. These buildings show that the Gothic style was not totally rejected in Rome, but the evidence seems to indicate that it was considered appropriate in private contexts — in the Pope's chapel at the Lateran palace; inside a cardinal's palace; or in the reserved space of a monastery. In these places, late medieval prelates could relish a new style that was different from the early Christian architecture of Rome.[112] There is no evidence, however, that the Gothic style was used in the overall planning of any large church in the city, except for S. Maria sopra Minerva.

Begun c. 1280, the east end — with the apse, the eastern chapels, and transept — were in use by c. 1290 (Fig. 128). By 1320, the eastern half of the nave could accommodate the choir for a Dominican community of 50 friars. The western half of the nave and aisles was probably completed shortly after 1340. In the first half of the fifteenth century, Cardinal Juan de Torquemada had the nave vaulted, and Francesco Orsini claimed to have finished the church, when he may have built the aisle vaults and additions to the façade, in 1453.

Kinney, 'S. Maria in Trastevere'; Kinney, 'The Image of a Building'.

106 Barclay Lloyd, *SS. Vincenzo e Anastasio*, with further bibliography.
107 See above, Chapter 5.
108 Some scholars, like Kleefisch-Jobst, deny that there was anything distinctive about the architecture of the Order of Preachers, see Kleefisch-Jobst, *Die römische Dominikanerkirche Santa Maria sopra Minerva*, p. 111. For different points of view, see Schenkluhn, *Architettura*, pp. 45–53, 177–89, and Wagner-Rieger, 'Zur Typologie italienischer Bettelordenskirchen'.
109 Draghi, *Gli affreschi dell'Aula gotica*; Draghi, *Il Palazzo cardinalizio dei Santi Quattro a Roma*, and Barelli, *The Monumental Complex of Santi Quattro Coronati*, pp. 67–90; Hauknes, 'The Painting of Knowledge'.
110 Gardner, 'L'architettura del Sancta Sanctorum', pp. 19–37.

111 Belardi, 'Considerazioni sui restauri'; Belardi, 'Il restauro dell'abbazia delle Tre Fontane, (seconda parte)'; Belardi, 'Il restauro architettonico', pp. 98–160; Belardi, 'Restauri nella Chiesa dei SS. Vincenzo e Anastasio', p. 145; Barclay Lloyd, 'The Medieval Murals in the Cistercian Abbey of SS. Vincenzo e Anastasio', pp. 326–36; Barclay Lloyd, *SS. Vincenzo e Anastasio*, pp. 157–59.
112 For the high clergy's taste for Gothic art of other forms, see Gardner, *The Roman Crucible*.

Reconstructing the Medieval Church

In the twentieth century, several scholars tried to reconstruct the original features of the medieval church of S. Maria sopra Minerva, taking the nineteenth-century changes into account. Richard Krautheimer characterized the building briefly as 'a basic mendicant-friars' Gothic' church, with 'pointed arches, quatrefoil compound piers, shafts on responds against bare walls, small windows, and an open timber roof'.[113] Very early in his career, Krautheimer wrote a book about mendicant architecture in Germany and he knew the type well.[114]

Other more detailed studies have analysed and reconstructed the medieval church.[115] Using these, four main features of the building will be considered here: (a) the east end of the church; (b) the nave and aisles; (c) the division of the nave and aisles into two sections, for the friars in the east and the laity in the west; and (d) the façade. Finally, there is a discussion of the chapels.

(a) The East End of the Church

Following common medieval practice, construction of S. Maria sopra Minerva began at the east end of the building, with the 'cappella maggiore' (literally 'the major chapel', meaning the sanctuary of the church). In the late thirteenth and fourteenth centuries, the Dominicans and Franciscans in Italy often followed the Cistercian custom in the so-called 'Bernardine plan' of having an apse that ended in a straight wall, flanked by two, four, six, or more rectangular

Figure 134. Florence, S. Maria Novella, plan (Wood Brown, *The Dominican Church of Santa Maria Novella*, Edinburgh, 1902)

side-chapels.[116] One can see this disposition at the Dominican church of S. Maria Novella in Florence (Fig. 134), where the sanctuary ends in a straight wall and is flanked by four rectangular chapels.[117] In 1986, Ursula Kleefisch observed, however, that the east end of S. Maria sopra Minerva differed markedly from that of S. Maria Novella in Florence, concluding that

113 Krautheimer, *Rome*, pp. 211–12.
114 Krautheimer, *Die Kirchen der Bettelorden*.
115 The main studies are: Matthiae, 'Gli aspetti diversi di S. Maria sopra Minerva'; Kleefisch, 'Die römische Dominikanerkirche S. Maria sopra Minerva von 1280 bis 1453'; Palmerio and Villetti, *Storia edilizia*; Kleefisch-Jobst, *Die römische Dominikanerkirche Santa Maria sopra Minerva*; and Villetti and Palmerio, *Santa Maria sopra Minerva in Roma*. See also, most recently, in 2020, Klein, 'S. Maria sopra Minerva'.

116 Schenkluhn, *Architettura*, pp. 45–53, 177–89. See also Wagner-Rieger, 'Zur Typologie italienischer Bettelordenskirchen'.
117 Wood Brown, *The Dominican Church of Santa Maria Novella at Florence*; Bradford-Smith, 'Santa Maria Novella'; De Marchi, ed., *Santa Maria Novella: La Basilica e il Convento*, vol. I. As shown in the plan, the chapels on the north were later extended eastwards.

Figure 135. Baldassarre Peruzzi, survey drawing of the apse and a plan to remodel it (Florence Uffizi Gallery, Prints and Drawings, U 527v A – under licence from MiBACT)

the Roman church was not planned as a copy of the Florentine building.[118]

In fact, some sixteenth-century architectural drawings and written documents enable one to reconstruct the medieval east end of the church before the early seventeenth-century rebuilding of the apse. A drawing dated 1519 (Uffizi U 527v A) by Baldassarre Peruzzi (1481–1536), shows the layout of that part of the church (Fig. 135).[119]

Peruzzi's sketch shows the apse as more or less semi-circular, with small columns in the interior, and a larger pilaster on the exterior. Presumably, the interior columns sustained a ribbed vault rather than a normal Roman half dome. To the right of the apse, Peruzzi sketched the chapel on the south. He shows that it has a straight east wall and is covered with two cross vaults. Antonio da Sangallo the Younger and his brother Giovanni Battista da Sangallo (known as 'Battista'), made drawings, now in the Department of Prints and

118 Kleefisch, 'Die römische Dominikanerkirche Santa Maria sopra Minerva von 1280 bis 1453', p. 12.
119 Pasti, 'Documenti', pp. 591–95. For the drawings, see Ferri,

Indice grafico, p. 145; Giovannoni, *Antonio da Sangallo il Giovane*, vol. I, pp. 245–46; vol. II, figs 232–33; and Heikamp, 'Die Entwurfzeichnungen für die Grabmäler der Mediceer-Päpste', pp. 134–52.

Drawings of the Uffizi Gallery in Florence, for a projected rebuilding of the apse of the Minerva *c.* 1539.[120] These drawings also indicate the shape of the medieval apse and the layout of its adjacent chapels. The survey drawing made *c.* 1539 by Battista da Sangallo (Uffizi U 1661v A) (Fig. 136) shows a more clearly polygonal (five-sided) apse with interior columns and exterior pilasters, as well as two chapels on either side of the apse which end in straight east walls and are covered with cross vaults. The chapels closest to the apse are at least twice as deep as the outer chapels — the one on the north is drawn as though it extended further than the one on the south.[121] That means that the chapels on either side of the apse were 'stepped', or placed *en échelon*, a feature not seen anywhere else in medieval Rome. The apse and the adjacent side chapels were vaulted, and they communicated through arched entrances with the transept (partly shown in elevation below Battista's plan). Three drawings by Antonio da Sangallo the Younger, made *c.* 1539 and linked to a project to rebuild the apse as a new choir, reveal a similar layout.[122] One of them (Fig. 137) shows the old apse to the west of its projected replacement, with a clearly polygonal outline on the exterior and in the interior. All the sixteenth-century drawings gave dimensions in Roman palmi, which enabled Palmerio and Villetti to draw a measured reconstruction of the apse and chapels (Fig. 138).[123]

Figure 136. Giovanni Battista da Sangallo, survey drawing of the east end of S. Maria sopra Minerva (Florence Uffizi Gallery, Prints and Drawings, U 1661v A – under licence from MiBACT)

Figure 137. Antonio da Sangallo the Younger, plan showing the old apse in outline and projected new choir (Florence Uffizi Gallery, Prints and Drawings, U 1310 A – under licence from MiBACT)

120 Armellini, rev'd by Cecchelli, *Chiese*, p. 1361. The drawings in the Uffizi are U 178 A, U 1313 A and U 1310 A by Antonio Sangallo, and a survey plan by Giovanni Battista da Sangallo U 1661vA.

121 Although the northern chapel seems longer than that on the south, the dimensions written on the drawing led Palmerio and Villetti to draw the two inner chapels of equal length, see fig. 138.

122 Antonio da Sangallo the Younger's survey and project are in the Uffizi, U 178 A, U 1310 A, and U 1313 A. See also, Kleefisch-Jobst, 'Die Errichtung der Grabmäler'. The project as shown on Antonio's plan was never completed.

123 Pasti, 'Documenti'; Kleefisch-Jobst, 'Die Errichtung der Grabmäler'; Palmerio and Villetti, *Storia edilizia*.

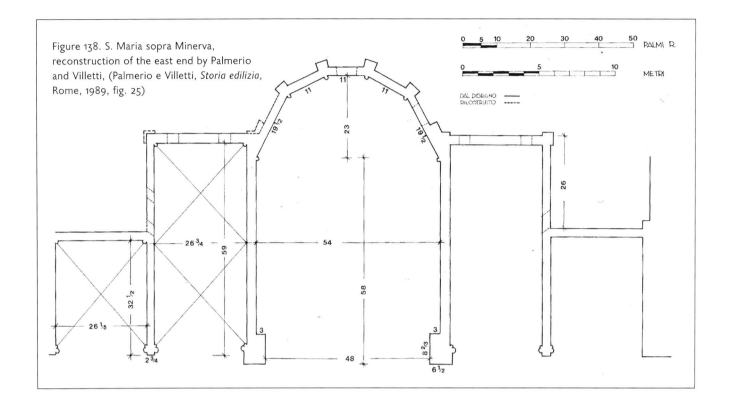

Figure 138. S. Maria sopra Minerva, reconstruction of the east end by Palmerio and Villetti, (Palmerio e Villetti, *Storia edilizia*, Rome, 1989, fig. 25)

In a detail of Anthonis van den Wijngaerde's *Panorama of Rome taken from the Baths of Constantine on the Quirinal* (Fig. 127), just to the right of the image of the artist, the exterior of the apse of the Minerva is indicated as pentagonal, with pilaster buttresses at its exterior angles.[124] In this *Panorama*, van den Wijngaerde shows not only the exterior of the apse of the Minerva, with its distinctive pilasters, but also the eastern wall of the transept, also articulated by pilasters.

The apse and the chapels of the Roman church were clearly different from those of S. Maria Novella in Florence (Fig. 134). As Marina Righetti Tosti-Croce has pointed out, in Rome at S. Maria Maggiore and St John Lateran, new apses were built in the late thirteenth century, which with the apse at S. Maria in Aracoeli were in some ways similar to that of S. Maria sopra Minerva.[125] Claudia Bolgia has drawn attention to the fact that the apse at S. Maria in Aracoeli was semi-circular on the inside and pentagonal on the outside, with pilasters on the exterior.[126] This is clearly shown on a plan of the church drawn *c.* 1480 in the Spada collection (Fig. 114), indicating that the Aracoeli apse differed from that at the Minerva, which was five-sided inside and out.

The transept of the Dominican church was divided into three parts and extended about 5 m beyond the nave and aisles (Fig. 128). It was probably built at the same time as the apse and its flanking chapels. It was 37.07 m long and

Recently, Klein, 'S. Maria sopra Minerva', provided a good reconstruction plan of the building, indicating these features.
124 Pasti, 'Documenti', p. 592. See also, Lanciani, 'Il panorama di Roma delineato da A. van den Wyngaerde', tavv. VI–XXII; Egger, *Römische Veduten*, vol. II, p. 44, tav. 109; and Righetti Tosti-Croce, 'Appunti sull'architettura'.

125 Righetti Tosti-Croce, 'Appunti sull'architettura'.
126 Bolgia, *Reclaiming the Roman Capitol*, p. 178; and see above, Chapter 5.

13.90 m deep, and hence about 3 m shorter and 4.50 m deeper than the transept of S. Maria in Aracoeli, which was 40.38 m long and 9.43 m deep. Unlike the transept at S. Maria in Aracoeli, the Minerva transept was a little higher than the nave and did not resemble the transept of Old St Peter's.[127] Whereas the transept at the Aracoeli was covered originally with a simple timber roof, the transept at the Minerva was vaulted.

To date the eastern end of the church, one must refer to the history of the Dominican foundation and the early tombs in that part of the church. The priory at S. Maria sopra Minerva was functioning by the late 1280s. The earliest tombs in the transept are dated 1290 (Petrus de Buccamatiis),[128] and 1296 (Durandus) (Fig. 133).[129] These burials indicate that the liturgical east end of the church (including the apse, flanking chapels *en échelon*, and transept) was completed by *c*. 1290. (Since the Catalogue of Turin referred to the need to restore the apse at the Minerva *c*. 1320, the apse may have been remodelled or restored shortly after that date.)[130]

(b) The Nave and Aisles

Guglielmo Matthiae's study of S. Maria sopra Minerva concentrated particularly on the nave and aisles and considered early elements that had been overlooked by the nineteenth-century restorers.[131] For example, he observed that the eighteenth-century pavement of Benedict XIII was made of terracotta and strips of stone, perhaps travertine; this was *c*. 12 cm above an earlier paving (possibly of the sixteenth century).

The bases of the piers of the nave had been changed during the nineteenth-century restorations. The vaulting differed from that shown in Rossini's print of the church interior *c*. 1843, which had vaults typical of the fifteenth century.[132] Matthiae removed some plaster from one of the piers in the nave and found that it was faced with brick and then covered in a thick coat of plaster before the nineteenth-century restoration, perhaps indicating that the entire interior had been plastered.[133] (This may date, however, from the time of Benedict XIII, when the interior was whitewashed. The walls and piers of the medieval church interior may originally have been faced only with brickwork.)

Matthiae carefully examined the exterior walls of the church on the sides of the building and in the roof space.[134] The aisle walls were built of brickwork, similar to that on the pier he examined in the nave. The walls retained stretches of a typical Roman medieval cornice of small brackets and bricks laid in a sawtooth pattern. On the north aisle wall there were pilasters 1.75 m wide and 0.30 m deep, which were attached to the upper cornice. In two pilasters of the south aisle, about 0.85 m below the cornice, Matthiae noted stone waterspouts ending in crudely carved heads of lions. In the roof space, there was evidence that the side aisles were originally covered with a simple wooden roof. Matthiae observed that the present roof over the side aisles was made to correspond with the nineteenth-century oculi, whereas the medieval roof must have been less sloping. This indicated that the roof was changed in the nineteenth century.[135]

In the nave interior, Matthiae noted that the distance from one pier to the next is 8.50–9 m,

127 The transept at the Aracoeli was initially lower than the nave, as mentioned in Chapter 5.
128 Forcella, *Iscrizioni*, vol. XIII, no. 899, p. 378; see Kleefisch-Jobst, *Die römische Dominikanerkirche Santa Maria sopra Minerva*, p. 25.
129 His tomb was moved to its present position in the seventeenth century. The signature of Giovanni di Cosma is inscribed on it.
130 Valentini and Zucchetti, *Codice topografico*, vol. III, p. 318.
131 Matthiae, 'Gli aspetti diversi di S. Maria sopra Minerva'.

132 Matthiae, 'Gli aspetti diversi di S. Maria sopra Minerva', p. 21 and p. 26 n. 8.
133 Matthiae, 'Gli aspetti diversi di S. Maria sopra Minerva', p. 21.
134 Matthiae, 'Gli aspetti diversi di S. Maria sopra Minerva', pp. 22–24.
135 It had also been rebuilt in the pontificate of Benedict XIII.

Figure 139. Galuzzi, Reconstruction of the medieval church of S. Maria sopra Minerva (Matthiae, 'Gli aspetti diversi di S. Maria sopra Minerva', *Palladio*, NS 4, 1954)

indicating very wide bays, like those often found in Tuscan Gothic churches.[136] He did not find a cornice, or external pilasters in the nave walls, but he did see traces of medieval clerestory windows in the roof space, with slightly pointed arches outlined with bricks and with no embrasures. He believed that originally there had been one such window in the centre of each bay of the nave, but they were subsequently cut, first by the fifteenth-century vaulting, then by the rectangular sixteenth-century windows, and finally by the nineteenth-century oculi; the two medieval windows that survive in part were 1.44 m. high and 0.62 m. wide, and their sills must have been very close to the original upper roof-line of the side aisles.[137] Therefore, the aisles may have had either a flat terrace roof, or a roof with only a slight incline.

In the roof space, the arch between the nave and the transept was originally pointed and outlined by brick voussoirs. It was changed when the nave was vaulted in the fifteenth century, and again in the nineteenth century. The walls of the transept were a little higher than those of the nave.

A reconstruction drawing of the church illustrates Matthiae's study (Fig. 139).[138] Although it shows an outline of the transept, it concentrates on the nave and aisles. The clerestory wall of the nave opens in a small, slightly pointed arched window in every bay, and the nave is covered with wooden roof beams. Between the nave and aisles, wide pointed arches rise between square piers with pilasters and semi-columns attached. Pilasters and half columns correspond across the aisles. The south aisle roof slopes down at a low angle to the sawtooth frieze of the cornice at the top of the aisle wall, which is articulated by exterior pilasters, from which extend lion-headed waterspouts.

Ursula Kleefisch-Jobst studied the planning, construction, and appearance of the medieval building, as it developed from c. 1275–c. 1453.[139] Apart from investigating historical documents, she made an extensive examination of the building itself, which, she concluded, is medieval in essence, although it is now seen through the lens of a number of later changes. Her architectural analysis attempted to go beyond the remarks made by Matthiae in 1954.[140]

According to Kleefisch-Jobst, the church of S. Maria sopra Minerva was planned as a basilica, with a nave and two aisles, a transept, and a polygonal apse flanked by four stepped chapels.[141] While the plan may have some features of a 'basilica', there are other elements, which make

136 Matthiae, 'Gli aspetti diversi di S. Maria sopra Minerva', p. 24.
137 Matthiae, 'Gli aspetti diversi di S. Maria sopra Minerva', p. 23.
138 Matthiae, 'Gli aspetti diversi di S. Maria sopra Minerva', fig. 11.
139 Kleefisch-Jobst, *Die römische Dominikanerkirche Santa Maria sopra Minerva*, p. 7.
140 Kleefisch-Jobst, *Die römische Dominikanerkirche Santa Maria sopra Minerva*, pp. 7–8.
141 Kleefisch-Jobst, *Die römische Dominikanerkirche Santa Maria sopra Minerva*, p. 9.

the architecture quite unlike the basilicas of early Christian and medieval Rome. At the Minerva, there are wide bays with multiple piers rather than more closely spaced columns separating the nave and aisles, and between the piers there are pointed arches rather than a straight entablature or an arcade with semi-circular arches. In these features, S. Maria sopra Minerva is different from the traditional basilicas of Rome. S. Maria in Aracoeli, with its colonnades and semi-circular arches, is more like a medieval Roman basilica (compare Figs 109 and 125). Although the Franciscan church has some Gothic features, S. Maria sopra Minerva is clearly more Gothic in both plan and elevation.[142]

Kleefisch-Jobst rightly pointed out that, although it differs in many ways from other medieval churches in Rome, S. Maria sopra Minerva was constructed according to medieval Roman building practice. The Roman tradition is apparent in its tufa and brick masonry, brick and marble cornices, and, to a lesser extent, in its capitals of varied design.[143] She analysed the capitals in some detail, distinguishing five major types (Corinthian, Composite, palmette, figured, and leaf capitals) and she was able to differentiate between those that are medieval; those that have been reworked, most probably in the fifteenth century; and those carved in the nineteenth century.[144] She dated some of the capitals in the side aisles and on the corresponding nave piers to the first decade of the fourteenth century;[145] the capitals on the lower half columns connected with the vaulting in the aisles to the fifteenth century, when the aisle vaulting was completed;[146] and a group of capitals with palmette leaves to the nineteenth century, because of their style and because they are located over the main half-columns in the nave, which originally had no capitals at all.[147] A figured capital with animals is also from the nineteenth century.[148]

Kleefisch-Jobst observed that the nave originally had a wooden roof, until Cardinal Torquemada covered it with vaults in the first half of the fifteenth century. She suggested that the lack of vaulting in the nave and aisles revealed that the medieval church was left unfinished. Yet, early Dominican legislation about buildings stipulated that only the sacristy, and perhaps the section of the nave containing the choir enclosure, should be vaulted, as a demonstration of the Order's ideals of poverty.[149] The original wooden covering of the nave and aisles may have expressed the Dominicans' obedience to those rules, in contradiction to Kleefisch-Jobst's assertion that the friars at S. Maria sopra Minerva paid no heed to the Order's legislation.[150]

At more or less the same time as Kleefisch-Jobst's book was published, two major studies of S. Maria sopra Minerva came out in Italian.[151] The authors, Giancarlo Palmerio and Gabriella Villetti, had examined the church in detail, and they paid careful attention to documentary and graphic sources. They also provided accurate architectural survey plans and sections, as well as several reconstruction drawings.[152] Like Matthiae and Kleefisch-Jobst, Palmerio and Villetti examined the nave and transept walls in the roof space

142 See above, Chapter 5.
143 Kleefisch-Jobst, *Die römische Dominikanerkirche Santa Maria sopra Minerva*, pp. 71–86.
144 Kleefisch-Jobst, *Die römische Dominikanerkirche Santa Maria sopra Minerva*, pp. 73–80.
145 Kleefisch-Jobst, *Die römische Dominikanerkirche Santa Maria sopra Minerva*, p. 32.
146 Kleefisch-Jobst, *Die römische Dominikanerkirche Santa Maria sopra Minerva*, p. 43.
147 Kleefisch-Jobst, *Die römische Dominikanerkirche Santa Maria sopra Minerva*, p. 78.
148 Kleefisch-Jobst, *Die römische Dominikanerkirche Santa Maria sopra Minerva*, p. 79.
149 Meersseman, 'L'architecture dominicaine au XIIIe siècle', pp. 147–48.
150 Kleefisch-Jobst, *Die römische Dominikanerkirche Santa Maria sopra Minerva*, pp. 95–111.
151 Palmerio and Villetti, *Storia edilizia* and Villetti and Palmerio, *Santa Maria sopra Minerva in Roma*.
152 Jeremy Blake and the author checked the accuracy of some of the survey drawings.

above the church; they also inspected details in the other parts of the building.

They made a thorough analysis of the structure, which included many details about the masonry of the church.[153] In the roof space over the crossing, there was a pointed arch, which originally opened between the transept and nave of the church.[154] This was partly cut by a semi-circular arch, installed when the nave vaults were built in the fifteenth century.[155] In the nineteenth century a new pointed arch was inserted.[156] The authors observed that the original arch was outlined by voussoirs 60 cm long (ancient Roman 'bipedales'), while the brickwork above it was typical of the late thirteenth century.[157] South of the arch, looking west, there is similar brickwork. In the northern arm of the transept the authors found two types of masonry: the first had alternating rows of brickwork (with a 5 × 5 modulus of 24–25 cm) and *opus saracinescum* (tufelli only); the second was built of *opus saracinescum* on one side, with brickwork on the other. (Both types of masonry can be found in other Roman buildings constructed in the thirteenth and fourteenth centuries.)[158] The south arm of the transept was shored up by two large buttresses in a repair that seems to have been necessary in the early fourteenth century; another buttress was visible from the room above the chapel of Saint Dominic at the northern end of the transept.[159]

The highest stretch of the nave walls, 40 cm below the roof, is built in a kind of rubble masonry, which the authors attributed to the raising of the roof in the nineteenth century, but it is more likely to have been part of the fifteenth-century campaign to vault the nave.[160] The walls of the first bay of the nave from the transept are built of tufelli on the outside and brickwork with a 5 × 5 modulus of 24–25 cm on the inside.[161]

Whereas Matthiae had identified a blocked opening with a pointed arch on either side of the nave as windows, Palmerio and Villetti asserted that these openings were doorways leading into a service passage for inspecting the upper reaches of the building.[162] There is, however, no other evidence for such a passage, so this interpretation is unconvincing.

It was clear from their inspection of the walls that the nave was not vaulted until the fifteenth-century campaign of Cardinal Torquemada.[163] The original roof beams in the nave were 3 m apart.[164] On the exterior of the nave wall there were some pilasters, 10 m apart, but they were obviously not associated with the position of the roof beams.[165]

Palmerio and Villetti found indications that both the nave and the aisle walls were extended westwards in more than one phase. This was particularly noticeable on the south, where one phase went from the first bay west of the transept to the third bay; then, after a clear break, the wall was extended and strengthened from the fourth bay onwards. The masonry in the three westernmost bays of the nave and aisles was an untidy version of *opus saracinescum*. This led

153 Palmerio and Villetti, *Storia edilizia*, pp. 41–65; Villetti and Palmerio, *Santa Maria sopra Minerva in Roma*, pp. 23–62.
154 Palmerio and Villetti, *Storia edilizia*, p. 70.
155 Villetti and Palmerio, *Santa Maria sopra Minerva in Roma*, p. 43.
156 Palmerio and Villetti, *Storia edilizia*, p. 72.
157 It has a 5 x 5 modulus of 24–25 cm, with short brick fragments (3.5 or 4 cm long), mortarbeds 1.5–2 cm high, and mortar of a light colour. This masonry is typical of Roman building of the later thirteenth century, as shown in Barclay Lloyd, 'Masonry Techniques', pp. 231–32, 'L' and 'M'; 238–39; and 272–73.
158 Barclay Lloyd, 'Masonry Techniques', p. 244 and Esposito, Daniela, *Techniche costruttive*.
159 Palmerio and Villetti, *Storia edilizia*, pp. 106–07.

160 Palmerio and Villetti, *Storia edilizia*, p. 69. Rubble masonry of this kind was characteristic of fifteenth-century construction in Rome.
161 Palmerio and Villetti, *Storia edilizia*, p. 80.
162 Palmerio and Villetti, *Storia edilizia*, pp. 80–82; Villetti and Palmerio, *Santa Maria sopra Minerva in Roma*, p. 48.
163 Palmerio and Villetti, *Storia edilizia*, p. 107.
164 Palmerio and Villetti, *Storia edilizia*, p. 107.
165 Palmerio and Villetti, *Storia edilizia*, pp. 110–12.

the authors to suggest that this showed that the builders were in haste to finish the building, but it may also show the slap-dash work of a different team of masons, and hence a separate, later building phase. In this part of the nave wall there are also some vertical lesions.[166] Palmerio and Villetti dated the completion of the last three bays of the nave to the fourteenth century.[167]

There are traces of buttresses along the aisle walls, one of which was clearly visible in the roof space in the first bay from the east.[168] In the first bay of the south aisle wall from the transept there were traces of a pointed arched window.[169] Similar windows may have illuminated the remaining bays of both aisles, but obviously disappeared when the side chapels were built.[170] Palmerio and Villetti reported seeing the remains of the original sawtooth brick and marble frieze of the cornice at the top of the aisle walls, but they found no trace of the two waterspouts with carved heads of lions recorded by Matthiae.[171]

After their detailed analysis of the masonry, buttresses, windows, and roofs of the church, Palmerio and Villetti made a surprising reconstruction of the nave and aisles. They suggested that the building was originally a 'hall church', with the nave and aisles covered by a single roof, and with no clerestory. This would have meant that there were no windows in the nave, and that the interior was illuminated only from windows in the side aisles. When the chapels were added along the side aisles, the windows in the aisles were blocked, making the interior

Figure 140. Giovanni Maggi, *Map of Rome*, 1625, edited by Paolo Maupin and Carlo Losi in 1774 (Frutaz, *Piante*, vol. II, 1962, detail of Tav. 315)

very dark. This reconstruction is unsatisfactory and unconvincing.

The reason why Palmerio and Villetti proposed that there was no clerestory was related to the nature of the aisle roofs. As Matthiae had observed, there could only have been a very slight slope from the clerestory walls, to the cornice of the outer aisle walls. The authors therefore believed that one roof covered both the nave and the aisles, and there was no clerestory at all.[172] Eliminating the clerestory seems too drastic a solution to the

166 Villetti and Palmerio, *Santa Maria sopra Minerva in Roma*, pp. 49–50.
167 Villetti and Palmerio, *Santa Maria sopra Minerva in Roma*, p. 54.
168 Villetti and Palmerio, *Santa Maria sopra Minerva in Roma*, p. 48.
169 Villetti and Palmerio, *Santa Maria sopra Minerva in Roma*, p. 46.
170 Palmerio and Villetti, *Storia edilizia*, pp. 79–80.
171 Palmerio and Villetti, *Storia edilizia*, p. 108; Matthiae, 'Gli aspetti diversi di S. Maria sopra Minerva', p. 22.

172 Palmerio and Villetti, *Storia edilizia*, p. 108.

Figure 141. Waterspout with 'lion head' in the cloister garden of S. Maria sopra Minerva (photo: author)

problem of the aisle roofs, especially since, from the sixteenth century onwards, six rectangular windows in the upper walls of the nave are known to have illuminated the interior. Besides, on Antonio Tempesta's *Map of Rome* of 1593 (Fig. 126), one sees a bird's-eye view of S. Maria sopra Minerva, in which it is clear that, along the south, the roof of the nave is separate from the roof of the aisles, which in turn is above the chapel roofs along that side of the church.[173] A similar depiction on Giovanni Maggi's *Map of Rome*, drawn in 1625 and edited in 1774 by Paolo Maupin and Carlo Losi, seems to confirm the separate nave and aisle roofs (Fig. 140).[174] If there were a clerestory, one could interpret the openings with pointed arches in the nave walls in the roof space as windows, as Matthiae did, and not as doorways leading into an imaginary service passage.

The main problem connected with the existence of a clerestory was linked to the roofing, and, in particular, to how water was drained off the aisle roofs, if they were flat or had only a slight slope. Moreover, Palmerio and Villetti did not accept that Matthiae had found lion-headed waterspouts, which is odd, because one of them is now displayed in the cloister garden of the adjacent convent (Fig. 141). Behind the animal's head, a channel is hollowed out to allow water to pass from the back of the stone to the mouth of the carved head of a lion. In fact, these spouts suggest a solution to the problem of removing water from the aisle roofs. Evidence from another church helps to explain this. In his restoration of the twelfth-century Cistercian church of SS. Vincenzo e Anastasio at Tre Fontane in the 1990s, Giovanni Belardi found that water was removed from the nave and south transept roofs of that building by 'down-pipes' concealed in external brick pilasters, which were not buttresses or supports for roof beams, but part of the Cistercian system of drainage; further, there were the remains of plain marble waterspouts near the top of each pilaster, whose purpose was to remove any excess water that did not go into the 'down-pipes'.[175] Belardi's observations show a constructional technique, which the builders at S. Maria sopra Minerva may have followed. In the Dominican church, there were similar pilasters along the aisle walls, and, if one accepts Matthiae's observation about the presence of lion-headed waterspouts, like the one now in the cloister garden, one may suggest a system of pilasters containing 'down-pipes' and waterspouts very like those at Tre Fontane. This system of taking excess water away from the roof and walls of a church is similar to that employed in Gothic buildings with gargoyles.

173 Frutaz, *Piante*, vol. II, tav. 265.
174 Frutaz, *Piante*, vol. II, tav. 315.

175 Belardi, 'Restauri nella Chiesa dei SS. Vincenzo e Anastasio', pp. 132, 143–44.

(c) The Division of the Nave and Aisles into Two Sections

As explained above, Palmerio and Villetti found that the church was built in different phases.[176] They argued that the first bay of the nave was constructed at the same time as the transept and the apse, with the stepped chapels on either side, all of this being completed by c. 1290. Then, construction continued westwards to the end of the third bay, most probably shortly after Pope Boniface VIII donated a large sum of money for the building programme in 1295. This phase was almost certainly completed by c. 1320. The rest of the nave and aisles was built in very untidy masonry, in a new campaign, possibly after Cardinal Matteo Orsini left money to finish the church and to build a private chapel in 1340.[177] The façade was completed in the fifteenth century.

In the first phase, the Dominicans built the 'cappella maggiore' (the sanctuary in the apse) with the high altar for celebrating the conventual Mass. In the second phase, they extended the nave and aisles up to the third bay to house their choir enclosure for reciting the Divine Office. Both the high altar and the choir enclosure were essential for the liturgical prayers of the community. Later, in the third phase, the friars added the western three bays, for the laity. (It is possible that something similar occurred at S. Maria in Aracoeli, where the Franciscans probably set out the transept within the nave of the former Benedictine church and then constructed the first half of their own nave using columns from that building, perhaps leaving to a later time the erection of the western half of the nave and aisles.[178])

It was typical of Dominican architecture to divide the nave into two parts: an 'interior' part in the east for the friars — the 'ecclesia fratrum'; and a western 'exterior' part for the laity — the 'ecclesia laicorum'.[179] The Catalogue of Turin c. 1320 recorded that there were fifty Dominican friars living at S. Maria sopra Minerva, who would have needed a large choir.[180] The choir enclosure would have stood in the eastern half of the nave by that time, and it seems likely that the lay section of the nave and aisles was built later in the fourteenth century.

At the Minerva, two doorways in the aisle walls mark the division of the nave into two distinct parts (Figs 128 and 129). One door opens off the eastern end of the north aisle, very close to its juncture with the transept. This doorway leads from the church into a fairly long passageway going in the direction of the cloister. This entrance would have been used by the friars, who could have come in and out of their part of the church through it. The second doorway opens between two chapels in the south aisle at the beginning of the fourth bay from the transept. It leads from the adjacent street into the church and would have given access to the part of the building reserved for the laity in the western half of the nave and aisles. (In some ways, this recalls the side entrances to the 'public' part of the churches at S. Sisto and S. Sabina and the south entrance shown in the Spada Plan of S. Maria in Aracoeli [Fig. 114].)

At the eastern end of the church there is also a doorway leading from the north transept to a passageway between the chapel of Saint Dominic and the sacristy. It connected the eastern end of the church to a staircase, leading upstairs to a dormitory in the priory. Hence, one can imagine the Dominican friars coming down the stairs early in the morning to enter the transept, and then their choir in the nave, for the Divine

176 Palmerio and Villetti, *Storia edilizia*, p. 90.
177 Forte, 'Il cardinale Matteo Orsini', pp. 230–31.
178 See above, Chapter 5.
179 See Meersseman, 'L'architecture dominicaine', pp. 139–40; Gilardi, '"Ecclesia laicorum" e "ecclesia fratrum"'; Cannon, *Religious Poverty, Visual Riches*, pp. 25–45; Bruzelius, *Preaching, Building, and Burying*, pp. 19–25.
180 Valentini and Zucchetti, *Codice topografico*, vol. III, p. 299.

Office, followed by the conventual Mass at the high altar in the 'cappella maggiore'. Later, they may have returned to the cloister via the door and passageway at the eastern end of the north aisle.

The medieval choir enclosure was in the centre of the nave. According to Brandi, 'Era anticamente il Coro in mezzo della Chiesa cinto di fuori da alcuni altari ne quali si celebrava' (in early times the choir was in the middle of the church and it was surrounded on the outside by some altars at which [Mass] was celebrated).[181] Changes were planned in 1536–1539, when four cardinals (Ippolito de' Medici, Innocenzo Cibo, Giovanni Salviati, and Nicolo Ridolfi) proposed to set up monumental tombs in the apse of S. Maria sopra Minerva in honour of the Medici Popes, Leo X (1513–1521) and Clement VII (1523–1534).[182] At that time, the choir was to be moved from the centre of the nave to behind the high altar, as was common in Roman churches in the sixteenth century.[183] As Cardinal Ridolfi wrote at the time:

> [...] ho pensato [...] levare el coro di mezzo la chiesa della Minerva ove sta al presente et collocarlo drieto [sic] alla cappella grande in la quale si hanno a mettere le sepolture, di sorte che l'opera viene ad essere più evidente et apparirà meglio assai che non havrebbe fatto non si mutando el coro detto[184]

> ([...] I have thought [...] about removing the choir from the middle of the church of the Minerva where it is at present and placing it in the sanctuary, in which they have to put the tombs, so that the work will be more visible, and will look very much better than it would have, if the said choir were not changed.)

This would also have given lay people an uninterrupted view down the nave to the high altar and the tombs in the apse. This suggests that the medieval choir was a large and high structure, obscuring the view of the sanctuary from the aisles and the lay section of the church in the west.[185]

In 1539, a technical report, which accompanied the Cardinals' proposal, stated that it was necessary to free the piers of the nave from the choir enclosure, so that people could walk through the spaces between them.[186] From this, one may suppose that the choir enclosure was very close to the piers, if not attached to them, as was the case in the eleventh-century abbey church of Saint Benedict at Monte Cassino, as shown in a plan related to a project of Antonio da Sangallo the Younger to relocate the monks' choir from the nave to the apse (Fig. 81). The medieval monks' choir took up five bays of

181 Rome, AGOP, MS XIV, liber C, Parte I, Brandi, *Cronica*, fol. 29; Palmerio and Villetti, *Storia edilizia*, pp. 143–44.

182 Pecchiai, 'I lavori fatti nella chiesa della Minerva'. For further discussion of this project, see Kleefisch-Jobst, 'Die Errichtung der Grabmäler'; and Frommel, *Architettura alla Corte Papale*, pp. 335–57. See also, Palmerio and Villetti, *Storia edilizia*, pp. 100–04, with analytical drawings figs 21–22, 25, 29–31 and 34.

183 For the custom of moving the choir from the centre of the nave to the apse in Dominican and Franciscan churches, see Hall, *Renovation and Counter-Reformation*, pp. 1–32, with respect to S. Maria Novella and S. Croce in Florence in 1565–1566; and Cooper, 'Franciscan Choir Enclosures', pp. 1–5.

184 Pecchiai, 'I lavori fatti nella Chiesa della Minerva', p. 206. Permission for this project was granted in 1536 to Fra Tommaso Strozzi by the Grand Duke of Tuscany,

Alexander I, according to Berthier, *L'Église de la Minerve*, pp. 235–36. The architectural planning was to be done by Antonio da Sangallo the Younger, while the sculpture was entrusted to Lorenzo Lotti and the bas-reliefs to Baccio Bandinelli. For further discussion of this project, see Kleefisch-Jobst, 'Die Errichtung der Grabmäler'; Frommel, *Architettura alla Corte Papale*, pp. 335–57; and Palmerio and Villetti, *Storia edilizia*, pp. 100–04, with analytical drawings figs 21–22, 25, 29–31 and 34. For sixteenth-century choir chapels with tombs, see Frommel, '"Capella Iulia"', especially pp. 50–51, referring to S. Maria sopra Minerva.

185 Berthier, *L'Église de la Minerve*, p. 10, suggested that the choir was large and hence allowed for conclaves to be held in the church in the years 1431 and 1447.

186 'Relazione tecnica', added to a letter from Cardinal Nicola Ridolfi, dated 15 July 1539, published in Pecchiai, 'I lavori fatti nella chiesa della Minerva', pp. 206–07.

the Monte Cassino nave, with the partitions of the enclosure connected to the columns that separated the nave from the aisles. At the east end of the choir there were two exits, and one in the middle of the western end, flanked by two altars. The Benedictine church had a transept, but the choir was in the nave. The disposition at S. Maria sopra Minerva may have been similar. The new choir in the Dominican church was finished in 1544.[187] Around 1600, when the apse was threatening to fall down, Carlo Maderno built a new one, which was completed in 1614, an arrangement that lasted until the changes in 1848–1855.[188]

Kleefisch-Jobst imagined that an intermediary wall ('Lettner') stood between the choir enclosure and the church of the laity, which would have been normal in a Dominican church.[189] This hypothesis is understandable: there had been a 'tramezzo' at S. Sabina since 1238, even before the Dominican General Chapter in 1249 prescribed such a screen in all churches of the Order.[190] Marcia Hall showed that there were complex medieval screens ('ponti') between the choir and the lay area of the Dominican church of S. Maria Novella in Florence and the Franciscan church of S. Croce in Florence.[191] The intermediary wall in S. Sabina was shown on Bufalini's *Map of Rome* in 1551 (Fig. 50) and it was described by Ugonio in 1588.[192] But Bufalini showed no 'tramezzo' at S. Maria sopra Minerva in his *Map of Rome* and the documents pertaining to the proposal to move the choir to the apse of that church did not mention it either, in spite of the cardinals' desire to allow the Medici monuments to be seen from the nave. It was the choir enclosure that was in the way. In addition, research regarding the death and burial of Saint Catherine of Siena also seems to indicate that there was no intermediary wall in the church in the late fourteenth century.[193] When Catherine died on 29 April 1380, one of her disciples, Stefano Maconi, carried her body to S. Maria sopra Minerva, where 'they laid the corpse behind the iron railings of Saint Dominic's chapel in the church', to protect it from the crowds who came to venerate her and who may have hoped to take away small pieces of her clothing, or indeed parts of her body, as relics.[194] This chapel opened off the north transept at the eastern end of the church (Fig. 128). When Raymond of Capua wrote about this in his life of Catherine, he mentioned that protective iron railings closed off the chapel, but he said nothing about a wall or screen preventing people from entering the eastern half of the building. On the contrary, it is clear from his account that hundreds of lay men, women, and children came to venerate Catherine, and they must have had access to the northern arm of the transept. (In the Franciscan church of S. Maria in Aracoeli, there was the famous shrine of the Aracoeli, the Chapel of Saint Helena, at the northern end of the transept, and that, too, was accessible to pilgrims.[195] Bolgia asserts that there was no 'tramezzo' in the Franciscan church from at least 1372, when she shows that the Felici Tabernacle to house the icon of *Maria Advocata* was built directly against the western edge of the choir enclosure.[196]) It seems that, in the

187 Pecchiai, 'I lavori fatti nella Chiesa della Minerva', pp. 207–08.
188 Berthier, *L'Église de la Minerve*, p. 236.
189 Kleefisch-Jobst, *Die römische Dominikanerkirche Santa Maria sopra Minerva*, p. 39.
190 *Acta capitulorum generalium*, ed. by Reichert, vol. I, p. 47; and see above, Chapter 2.
191 Hall, 'The Ponte in S. Maria Novella'; Hall, 'The Tramezzo in Santa Croce'; Hall, 'The Italian Rood Screen'; Hall, 'The "Tramezzo" in the Italian Renaissance'. See also, Bacci, *Lo spazio dell'anima*, pp. 79–85; Cooper, 'Franciscan Choir Enclosures'; Cooper, 'Access all Areas?'; and Cannon, *Religious Poverty, Visual Riches*, Parts I and II, pp. 23–163.
192 Ugonio, *Historia delle Stationi*, pp. 10[r–v].

193 Barclay Lloyd, 'Saint Catherine of Siena's Tomb', pp. 119–20.
194 Raymond of Capua, *Legenda Maior*, ed. by Henschenius and Papebrochius, Part III, para. 376.
195 Bolgia, *Reclaiming the Roman Capito: Santa Maria in Aracoeli*, pp. 116–45.
196 Bolgia, *Reclaiming the Roman Capito: Santa Maria in Aracoeli*, pp. 284–85.

late fourteenth century, mendicant churches in Rome had a high choir enclosure in the eastern part of the nave, but they may have dispensed with the 'tramezzo', which was a feature of earlier mendicant churches, like S. Sabina.[197]

If one considers the proposed chronology of the Minerva, this makes sense. In the first phase (with the 'cappella maggiore' and its flanking chapels, the transept and the first bay of the nave), built by c. 1290, there was no need for a screen across the nave and aisles. In the second phase, constructed c. 1295–c. 1320, in the eastern half of the nave, there was still no need for the screen, since the area for the laity was in the aisles and in a relatively small part of the nave to the west. In the third phase, which has been dated after c. 1340, an intermediary wall may not have been built because it was not deemed necessary almost one hundred years after such a feature had been prescribed; by this time, moreover, the rules regarding the layout and size of Dominican churches were not as strict as before.[198] Perhaps no 'tramezzo' was ever built at S. Maria sopra Minerva, or there was a screen of a different kind, open enough for the many people who came to venerate the body of Catherine of Siena to walk through it to the north transept.

While the body of Catherine of Siena was in Saint Dominic's chapel at S. Maria sopra Minerva, an Augustinian hermit named Giovanni of Siena climbed into the pulpit, in order to speak to the crowd about Catherine's virtues, but he climbed down again because he could not make himself heard over the hubbub.[199] It would be interesting to know where exactly the pulpit was located in this church belonging to the Order of Friars Preachers, but that is not recorded in the sources. It may have been near the western end of the choir enclosure, so that the preacher could address the laity in their part of the church.

The church is very large (95 m long internally). In the late thirteenth and early fourteenth centuries, this was typical of Dominican and Franciscan churches.[200] The reason why mendicant churches were so large was that they included the two distinct parts of the nave and aisles. One can therefore argue that the size of the church was not related to a desire to have a monumental building that would enhance the reputation of the friars, but a practical way of having separate spaces for the community and for the laity. Poverty was expressed not in size, but in the use of simple materials, such as brick facing, and little or no vaulting. At the Minerva, vaulting initially existed in the transept and in the apse and its adjacent chapels, but it was only added to the nave and aisles in the fifteenth century.

(d) The Façade

In the first half of the fifteenth century, an inscription that was formerly on the façade stated that Count Francesco Orsini completed the church.[201] The inscription records:

> Franciscus de Ursinis Gravin. / et Cupersani comes alme Ur / bis prefectus illustris aedes / Marie Virginis supra Minervam / iamdiu medio opera interup / tas propriis sumptibus absolvere / curavit pro eius anime salute / anno Dni MCCCCLIII / pont. d. nri. Nicolai Pape V.
>
> (Francesco Orsini, Count of Gravina and Conversano, and illustrious Prefect of the fair City of Rome, at his own expense and for the salvation of his soul, undertook to

197 See above, Chapter 2.
198 Meersseman, 'L'Architecture dominicaine', pp. 162–77.
199 Raymond, *Life*, trans. by Lamb, III, 5, p. 317; and Tommaso da Siena, *Libellus de Supplemento*, ed. by Cavallini and Foroloso, p. 319.
200 Meersseman, 'L'Architecture dominicaine', p. 142; and Schenkluhn, *Architettura*, pp. 177–89.
201 Quoted by Kleefisch-Jobst, *Die römische Dominikanerkirche Santa Maria sopra Minerva*, p. 42. See also, Pietrangeli, ed., *Guide Rionali di Roma*, vol. IX, part 2, pp. 54–56.

complete the building of S. Maria sopra Minerva, which had been interrupted for a long time in the middle of the work, in the year of the Lord 1453 in the pontificate of our lord Pope Nicholas V.)

His coat of arms appears on the façade and on some of the vaults of the side aisles; therefore, these parts of the buildings have been attributed to him. In the roof space above the aisles, there are some stretches of wall built in the kind of rubble masonry typical of fifteenth-century construction in Rome, which may have been part of that building campaign, a continuation of the vaulting of the church begun by Cardinal Torquemada.[202]

From the roof space, it is also apparent that the central part of the façade wall was built of brickwork with a 5 × 5 modulus of 25–26 cm, and high up near the southern corner of the church, this masonry changes to tufelli with a few rows of bricks.[203] These types of masonry were more common in the thirteenth and fourteenth centuries than in the fifteenth. The rest of the upper part of the façade is built of fifteenth-century rubble masonry. The masonry therefore shows that the central part of the façade was built in the fourteenth century, possibly around 1340, but it was modified on either side in the fifteenth century.[204]

To understand the construction of the façade, one can examine some views of the Minerva, dating from the sixteenth and seventeenth centuries.

Tempesta in 1593 (Fig. 126) indicated in the centre a tall part of the wall rising to a cavetto. (There is a cavetto at S. Maria in Aracoeli and another at S. Maria in Trastevere, where a tympanum was later built above it.[205] In the later Middle Ages, before subsequent rebuilding programmes, there was also a cavetto at Old St Peter's, S. Eustachio, S. Lorenzo fuori le Mura, St John Lateran, and S. Paolo fuori le Mura.) In Tempesta's illustration of S. Maria sopra Minerva, the cavetto is only over the nave, the aisle walls being much lower.

The façade opens in three round windows and three doors. One oculus is located above each of the doors, the one in the centre being higher and larger than the other two.[206] The doors are each flanked by columns that support a triangular pediment, and the central entrance is larger than the other two. Kleefisch-Jobst pointed out that the coat of arms of the Capranica family is carved on the lintel of the central door; hence, she claimed convincingly that Cardinal Domenico Capranica was responsible for the three fifteenth-century doorways, and, since he died in 1458, they must have been executed shortly before that date.[207] Another inscription testifies to a later restoration of the doors by a member of the same family in 1610.[208] Kleefisch-Jobst dated the round windows in the façade to the middle of the fifteenth century, possibly as part of the campaign financed by Cardinal Domenico Capranica.[209] She claimed convincingly that it was Cardinal Domenico Capranica, rather

202 This masonry was observed by the author.
203 Palmerio and Villetti, *Storia edilizia*, pp. 93–94; Villetti and Palmerio, *Santa Maria sopra Minerva in Roma*, p. 50.
204 Bolgia, *Reclaiming the Roman Capitol*, p. 198 n. 15, refers to the fact that Kleefisch-Jobst, *Die römische Dominikanerkirche Santa Maria sopra Minerva*, pp. 66–67 dates the façade to the early fourteenth century, which is too early with respect to the building phases of the church, while Palmerio and Villetti, *Storia edilizia*, p. 247, dated it 1453. As argued here, the central part of the façade, corresponding with the nave, would have been begun c. 1340, and modified c. 1453.
205 Bolgia, *Reclaiming the Roman Capitol*, pp. 198–210, for S. Maria in Aracoeli; and Krautheimer, *Rome*, fig. 119, showing the façade of S. Maria in Trastevere. See also above, Chapter 5.
206 Kleefisch-Jobst, *Die römische Dominikanerkirche Santa Maria sopra Minerva*, pp. 36–37.
207 Kleefisch-Jobst, *Die römische Dominikanerkirche Santa Maria sopra Minerva*, p. 42.
208 Kleefisch-Jobst, *Die römische Dominikanerkirche Santa Maria sopra Minerva*, p. 42.
209 Kleefisch-Jobst, *Die römische Dominikanerkirche Santa Maria sopra Minerva*, pp. 42–43.

than Count Francesco Orsini, who added these features to the façade.

Cardinal Antonio Barberini (1607–1671) had further work done on the façade, which Pope Benedict XIII restructured and painted c. 1725.[210] From his time onwards, the façade was changed into a wide rectangular wall, as it is today (Fig. 124). The cavetto has disappeared, and the façade is divided by pilasters into three sections.

Medieval Chapels

Chapels and altars were added to the church of S. Maria sopra Minerva at various times. The first chapels were those opening off the eastern side of the transept, two on either side of the sanctuary. There were also four altars placed against the medieval choir enclosure. Gradually, chapels were added along the south aisle, and at either end of the transept. There were initially no chapels flanking the north aisle, as that was where the southern ambulatory of the medieval cloister was located. There were, however, a number of altars set against the north aisle wall, until the Dominican Master General Vincenzo Giustiniani (1558–1571) totally rebuilt the cloister, allowing space for a row of chapels along the north of the church.

The chapels were often paid for by patrons who wanted to be buried in them. In addition, these benefactors left money to the parish for Masses to be celebrated for the repose of their souls. A long section of the *Campione* is devoted to the bequests made to the Minerva for this purpose,[211] which is followed by a list of chapels, as they existed in 1758.[212] There is also an earlier list of chapels in Brandi's chronicle.[213]

It is evident that the patronage of chapels changed over time — when, for example, a family died out or could no longer afford to keep up the commitment to maintain the chapel.[214] This was the case when Diego di Coca, an auditor of the Spanish Rota in Rome, built a chapel along the south aisle in 1464, and endowed it with an olive grove in Tivoli to pay for Masses, as stipulated in his contract.[215] In 1519, the Dominicans transferred patronage of the chapel to Paolo Planca Incoronati and his heirs, who were still responsible for it in the late seventeenth century. The dedication of a chapel frequently changed too. For example, the chapel of Saint Antoninus of Florence was re-dedicated to Saint Louis Bertrand.[216] All this makes any discussion of the chapels complicated. They will be grouped together here according to their position in the church: first those opening off the transept; then, the altars around the medieval choir enclosure; the chapels along the south aisle; and, finally, those along the north aisle.[217] Attention will be paid primarily to medieval features of the chapels.

(a) Chapels Opening off the Transept

The four chapels to the east of the transept were the oldest in the church, originally built by 1290. The one on the far north was at first dedicated to Saint Michael the Archangel, but later Saint Mary Magdalene was included in the dedication, when the Maddaleni family took over as patrons. It was mentioned as being close to the sacristy,

210 Palmerio and Villetti, *Storia edilizia*, pp. 249–50.
211 Rome, AM, MS III, 327–30, *Campione*, vol. I, pp. 139–97.
212 Rome, AM, MS III, 327–30, *Campione*, vol. I, p. 198.
213 Rome, AGOP, MS XIV, liber C, Parte I, Brandi, *Cronica*, fols 29–31.

214 The building and maintenance of chapels was similar at S. Maria in Aracoeli, see above, Chapter 5.
215 The history of the patronage of this chapel can be followed in Rome, AM, MS III, 327–30, *Campione*, vol. I, pp. 156–57. See also, Palmerio and Villetti, *Storia edilizia*, pp. 156–57.
216 Rome, AM, MS III, 327–30, *Campione*, vol. I, p. 151. See also, Palmerio and Villetti, *Storia edilizia*, pp. 147–48.
217 Sources for this are mainly Rome, AM, MS III, 327–30, *Campione*, vol. I, pp. 139–97; and Rome, AGOP, MS XIV, liber C, Parte I, Brandi, *Cronica*, fols 29–53. See also, Palmerio and Villetti, *Storia edilizia*, pp. 141–86.

which is beside it, just north of the transept.²¹⁸ In 1607, a small room with a wash basin were added east of the chapel and south of the sacristy (see Fig. 129, 1). Although it was renewed in 1726, this chapel retains its thirteenth-century cross vault, which may have been restored in 1848–1855. The Frangipane and Maddaleni were patrons of the chapel, followed by the Capo di Ferro, and then the de Massimi family.

The next chapel, just north of the apse, was changed in 1600 into a passageway leading to Via Beato Angelico behind the church.²¹⁹ (There was a small doorway in the east wall of the chapel long before this change was made.) In the Middle Ages, there was a chapel in that location with two bays covered with cross vaults, being twice as deep as the chapel of Saints Michael and Mary Magdalene next to it, as indicated by Battista da Sangallo (see Fig. 136). The space is now covered with a barrel vault. Until the fifteenth century, the chapel was dedicated to Saint Thomas Aquinas, and Brandi records that there was 'un Altare con la figura di s. Tommaso Aquino molto antica' (an altar with a very ancient image of Saint Thomas Aquinas).²²⁰ Unfortunately, that representation has not survived.

Among the tombs in the present passageway, there is a composite monument with an inscription naming two Dominican Cardinals — Latino Malabranca, who died in 1294, and Matteo Orsini, who died in 1340.²²¹ Both were important patrons of S. Maria sopra Minerva. The two tombs may have been brought together in the nineteenth century.

Another tomb in the passageway is the monument to the Dominican artist, Beato or

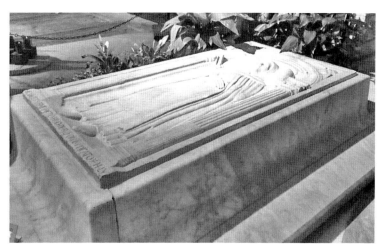

Figure 142. S. Maria sopra Minerva, Tomb of Beato Angelico (photo: Beth Hay)

Fra Angelico (Fra Giovanni da Fiesole), who died at the Minerva in 1455 (Fig. 142).²²² It now has the form of a raised floor tomb, with an image of a Dominican friar carved on the top. (There may originally have been only a floor slab.) The inscription at the edge of the marble slab identifies the deceased as the painter, Fra Giovanni of Florence, of the Order of Preachers.²²³ On 18 February 1455, he died at the Minerva priory and was buried in the church.²²⁴ While in Rome, Fra Angelico painted a chapel in Old St Peter's and two chapels in the papal palace at the Vatican; of these works, only the chapel of Nicholas V remains today. Fra Angelico is known to have painted an altarpiece for the high altar of S. Maria sopra Minerva as well as an image of the *Annunciation*, but these works do not survive.²²⁵

218 Rome, AM, MS III, 327–30, *Campione*, vol. I, p. 161; see also Palmerio and Villetti, *Storia edilizia*, pp. 169–70.
219 Palmerio and Villetti, *Storia edilizia*, pp. 168–69.
220 Rome, AGOP, MS XIV, liber C, Parte I, Brandi, *Cronica*, fol. 29.
221 Gardner, *The Tomb and the Tiara*, pp. 121–23. Matteo Orsini in his will stated he wanted to be buried in the chapel he built in honour of Saint Catherine of Alexandria, discussed below.

222 *La sepoltura del Beato Angelico*, AM, MS cm II. G. 3.13; Berthier, *L'Église de la Minerve*, p. 237.
223 Forcella, *Iscrizioni*, vol. I, no. 1590, p. 418.
224 *La sepoltura del Beato Angelico*, AM, MS cm II. G. 3.13. The grave of the artist was found in 1915 under the floor of the passageway north of the apse, which was the chapel of Saint Thomas Aquinas before Cardinal Carafa built the chapel dedicated to that saint beside the south transept, and the passageway was opened in 1600.
225 Rome, AGOP, MS XIV, liber C, Parte I, Brandi, *Cronica*, fols 34 and 50, refers to the death of Beato Angelico and the fact that he was buried in S. Maria sopra Minerva. Rome, AM, MS III, 327–30, *Campione*, vol. I, p. 188, says

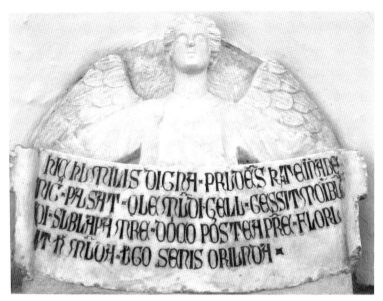

Figure 143. S. Maria sopra Minerva, angel from Raymond's tomb of Catherine of Siena (photo: ICCD – under licence from MiBACT)

To the south of the sanctuary, the first chapel was originally dedicated to the Annunciation to the Virgin Mary; then, from *c.* 1380 onwards, Catherine of Siena was venerated there; and from *c.* 1573, it became an oratory of the Most Holy Rosary. When Catherine of Siena died in Rome on 29 April 1380, her body was brought to the Minerva, where she was buried.[226] The exact place where she was first interred is not recorded, but it was probably in the common burial ground of the convent, which was located in the medieval cloister to the north of the church, where Brandi mentioned ambulatories that were low and dark surrounding the convent cemetery.[227] By 1382,

Raymond of Capua had translated Catherine's remains to a new sepulchre in the first chapel south of the sanctuary of the church.[228] A stone angel holding a scroll, which was found in the remains of the former bell tower of the Minerva in the nineteenth century, is believed to have been part of Raymond's monument for Catherine (Fig. 143).[229] The shape of the figure suggests it was originally placed in a shallow niche above a marble coffin that stood on the floor of the chapel.[230] The angel is a half-length figure, 65.5 cm high and 82 cm wide, with symmetrical wings and a robe carved in a linear style with pointed folds. The scroll bears an inscription in Gothic lettering of the late fourteenth century, which Raymond probably composed:[231]

HIC HUMILIS DIGNA PRUDENS CATHARINA BENIGNA, / PAUSAT, QUAE MUNDI ZELUM GESSIT MORIBUNDI. / SUB LAPA MATRE, DOMINICO POSTEA PATRE, / FLORUIT HAEC MUNDA VIRGO SENIS ORIUNDA.

(Here rests the humble, worthy, prudent, and kindly Catherine. She had zeal for the dying world. She flourished under her mother, Lapa, and then under Dominic, her father. This pure virgin came from Siena.)[232]

he died at the convent of the Minerva and was buried in the church. See also, Rome, AM, MS cm II. e. 3.1, Zucchi, 'La Minerva attraverso i secoli (la chiesa e il convento si S. Maria sopra Minerva)', pp. 47–48.

226 Rome, AGOP, MS XIV, liber C, Parte I, Brandi, *Cronica*, fols 30–31; Palmiero and Villetti, *Storia Edilizia*, pp. 171–74; Barclay Lloyd, 'Saint Catherine of Siena's Tomb' and below, Chapter 8.

227 Rome, AGOP, MS XIV, liber C, Parte I, Brandi, *Cronica*, fol. 40; de Gregori, 'Il chiostro della Minerva', p. 42; Taurisano, *S. Maria sopra Minerva*, pp. 49–50; Masetti, *Memorie istoriche*, p. 55.

228 Tantucci, *De translatione Corporis*, p. 8; Masetti, *Memorie istoriche*, p. 56; Berthier, *L'Eglise de la Minerve*, p. 411; and Taurisano, *S. Maria sopra Minerva*, p. 50.

229 Bianchi, 'Il sepolcro', pp. 21–23.

230 It is now located in a niche near the chapel incorporating parts of the room where Saint Catherine died, which Cardinal Antonio Barberini built near the sacristy of the Minerva in 1637, for which see Taurisano, *S. Maria sopra Minerva*, pp. 53–54. Such 'niche tombs', usually with a canopy as well, were common in Rome from the twelfth century onwards, as pointed out by Gardner, *The Tomb and the Tiara*, pp. 24–31.

231 Berthier, *L'Église de la Minerve*, p. 412; and Bianchi, 'Il sepolcro', pp. 22–23.

232 Bianchi, 'Appendice epigrafica', p. 55.

It is recorded that Raymond, with the help of some of Catherine's followers, notably her sister-in-law, Lisa Colombini, promoted her cult by having paintings made of her.[233] Historical sources record such an image placed close to her tomb, showing Catherine giving some clothes to a beggar, and then having a vision of Christ wearing them.[234] In 1411–1416, when Stefano Maconi mentioned this example of Catherine's generosity, he added, 'actus iste figuratus est Romae iuxta sepulcrum eius' (this deed is represented in Rome near her tomb), a fact also mentioned by Tommaso da Siena.[235] In addition, a marginal note in a fifteenth-century manuscript of this account refers to such an image: 'Questo atto è dipénto a Roma assai adornatamente' ('This deed is painted very ornately in Rome').[236] Although no painting of Catherine giving clothes to a beggar survives at the Minerva, another depiction of the event made in the late fourteenth or early fifteenth century can still be seen in the Dominican nunnery church of S. Sisto (Fig. 33), showing that in Rome Catherine was remembered for her kindness to the poor.[237]

Antonino Pierozzi (1389–1459), better known as Saint Antoninus of Florence, wrote a short biography of Catherine.[238] It was perhaps intended to promote her canonization. Antonino reported that, when he was prior at the Minerva in 1430, he translated her body to a more prominent place in the chapel next to the sanctuary in a marble tomb.[239] The new tomb included a white marble effigy of Catherine, as revealed in a restoration undertaken in the year 2000 (Fig. 144).[240] The figure is carved from a single block of white Carrara marble. Before restoration, however, the face, hands, mantle, feet, and pillow had been coloured in the nineteenth century, so as to make the figure look like a contemporary devotional statue of the Dominican saint (Fig. 145).[241] Chemical analysis of the colouration showed that it all dated from 1855 and later. Catherine is represented with her head on two pillows, on one of which is an inscription in early fifteenth-century letters, 'BEATA KATERINA' (BLESSED CATHERINE), indicating that she had not yet been canonized when the figure was carved.[242] It is not known who made the statue. Since the Florentine Dominican Antonino commissioned it, and the marble came from Carrara, it is likely that it is the work of a Tuscan or Florentine artist.[243]

233 Tommaso da Siena, *Libellus de Supplemento*, ed. by Cavallini and Foroloso, p. 381.

234 This illustrated an incident told by Raymond of Capua, *Legenda Maior*, ed. by Henschenius and Papebrochius, Part II: paras 135–38.

235 For Maconi's comment, *Il Processo Castellano*, ed. by Laurent, pp. 270–71; and see Tommaso da Siena, *Sanctae Catharinae Senensis Legenda Minor*, p. 45: 'Iste actus est figuratus Rome iuxta sepulcrum eius' (This deed is represented in Rome near her tomb).

236 *Leggenda Minore di S. Caterina*, ed. by Grottanelli, p. 203 n. 33. See also Drane, *The History of Saint Catherine of Siena*, p. 70 and n. 1. In the eighteenth century, Tantucci knew such a painting had existed, so he located Catherine's tomb in the floor of the south transept, because there was in his time a faded painting thought to represent Catherine on the south-easternmost pier of the nave. By the mid-nineteenth century no trace of that painting survived, and Tantucci's theory of the tomb's location and his assertion that it was a floor slab are no longer accepted.

237 Barclay Lloyd, 'Paintings for Dominican Nuns', pp. 203, 223–30 and above, Chapter 1.

238 Pierozzi, *Storia breve*, trans. by Sante Centi, ed. by Acariglia. For the original Latin text, *Tertia pars Historiarum Domini Antonini*, Cap. XIV. This biography of Catherine closely follows the account of Raymond of Capua but is much shorter.

239 *Tertia pars Historiarum Domini Antonini*, Titulus XXIII, Cap. XIIII, XIX. See also Pierozzi, *Storia breve*, trans. by Sante Centi, ed. by Acariglia, pp. 121–22; Morçay, *Saint Antonin*, pp. 53–54; Walker, *The 'Chronicles' of Saint Antoninus*, pp. 7, 18, 23–24.

240 Nerger, 'Il Restauro della tomba di santa Caterina', pp. 399–410. For tombs with effigies, see Gardner, *The Tomb and the Tiara*, pp. 36–37.

241 Nerger, 'Il Restauro della tomba di santa Caterina', pp. 405–06.

242 Bianchi, 'Il sepolcro', p. 25, noted that the effigy was tilted so that it could be seen at an angle, suggesting that originally it was placed high up and against a wall of the chapel.

243 S. Maria sopra Minerva is renowned today for works by Florentine artists of the fifteenth and sixteenth centuries,

294 CHAPTER 6

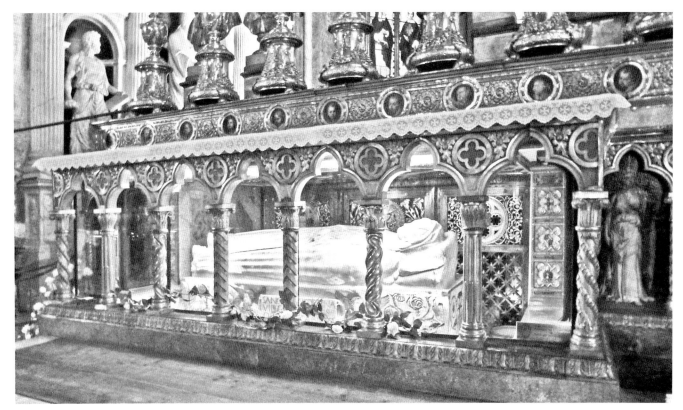

Figure 144. S. Maria sopra Minerva, tomb of Saint Catherine of Siena under the high altar today (photo: author)

A fragmentary bas-relief, showing the Virgin Mary seated and holding two crowns, has also been linked to Antonino's version of Catherine's tomb.[244]

In 1449 patronage of the chapel, where Catherine's tomb was located, was transferred to Cardinal Domenico Capranica (1400–1458), and his heirs.[245] His brother, Cardinal Angelo Capranica (1410–1478) successfully promoted Catherine's canonization, which was proclaimed on 29 June 1461 by the Sienese Pope Pius II Piccolomini (1458–1464), who had begun his ecclesiastical career as Cardinal Domenico Capranica's secretary.[246] Five years after her canonization, in 1466, Saint Catherine's monument was placed upon the altar in the chapel.[247] Beneath her effigy was a sarcophagus, with an inscription in gold letters, which reflected the fact that she had been canonized, referring to her as 'SANCTA CATERINA/ VIRGO DE SENIS/ ORDINIS

the most famous of which are Filippino Lippi's frescoes (1488–1493) in the Carafa chapel and Michelangelo's statue of the risen Christ (1519–1521) just north of the sanctuary.

244 Gentilini, 'La Madonna di Santa Caterina', who attributes it to Donatello; Barclay Lloyd, 'Saint Catherine of Siena's Tomb'; and Caglioti, 'La connoisseurship della scultura rinascimentale', pp. 136–40. See below, Chapter 8.

245 Bianchi, 'Il sepolcro', pp. 32–37; see also, Norman, 'The Chapel of Saint Catherine in San Domenico', pp. 413–19.

246 *The Commentaries of Pius II*, trans. by Gragg, intro. and notes by Gabel, vol. I, p. 375: Book V; Richardson, *Reclaiming Rome*, p. 59.

247 Rome, AGOP, MS XIV, liber C, Parte I, Brandi, *Cronica*, fol. 33. Palmieri and Villetti, *Storia Edilizia*, p. 163, n. 111; Bianchi, 'Il sepolcro', pp. 35–36. When saints are canonized, they are said to be raised to the altar. In Rome, since the time of Pope Boniface VIII (1294–1303) some tombs had been positioned above an altar, see Gardner, *The Tomb and the Tiara*, pp. 57–59; Gardner, *The Roman Crucible*, pp. 128–30.

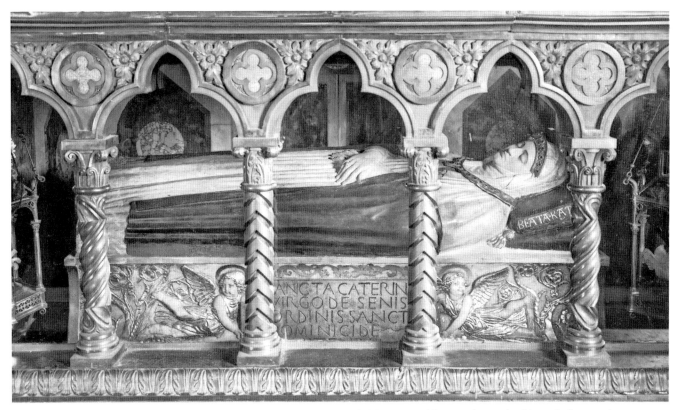

Figure 145. S. Maria sopra Minerva, the tomb of Saint Catherine of Siena from c. 1855 to 2000, under the high altar (photo: Alinari)

SANCTI / DOMINICI DE/ PENITENTIA' (Saint Catherine, Virgin of Siena, of the Order of Penitence of Saint Dominic). The chapel became a place of pilgrimage, and Pius II granted pious visitors an indulgence.[248] At about the same time, in 1466–1469, a reliquary containing Catherine's head was inserted into a marble tabernacle carved by Giovanni di Stefano (1443–1504) in the church of San Domenico in Siena.[249] A Sienese society in Rome, known as the 'Compagnia della Nazione Senese' (the Company of the Sienese Nation) or the 'Compagnia di Santa Caterina presso la tomba' (the Company of Saint Catherine at her tomb), began to meet in the chapel at S. Maria sopra Minerva from c. 1470 onwards.[250]

When, in 1571, papal forces defeated the Ottoman Turks at Lepanto, the Dominican Pope Pius V (1566–1572) attributed this victory to people praying the Rosary. At S. Maria sopra Minerva there was a strong Confraternity of the Most Holy Rosary and in 1573 they obtained permission to hold their meetings in the Capranica chapel, and to re-dedicate it to Our Lady of the Rosary.[251] The agreement allowing this stipulated that some frescoes of the life of Saint Catherine, which had been planned by Camillo Capranica, should still be painted on the walls of the chapel; that the fifteen mysteries of the Holy Rosary should also be depicted; that the members of the Confraternity could not be buried in the chapel; that the sepulchre of the Capranica family should be preserved there; and that the

248 *BOP*, vol. III, p. 412.
249 Bianchi and Giunta, *Iconografia di S. Caterina da Siena*, no. 208, p. 294; Norman, 'The Chapel of Saint Catherine in San Domenico', pp. 405–09.
250 Norman, 'The Chapel of Saint Catherine in San Domenico', pp. 413–14.

251 BAV, Chigi G III 81, fols 1ʳ–8ᵛ; Bianchi, 'Il sepolcro', 37–39.

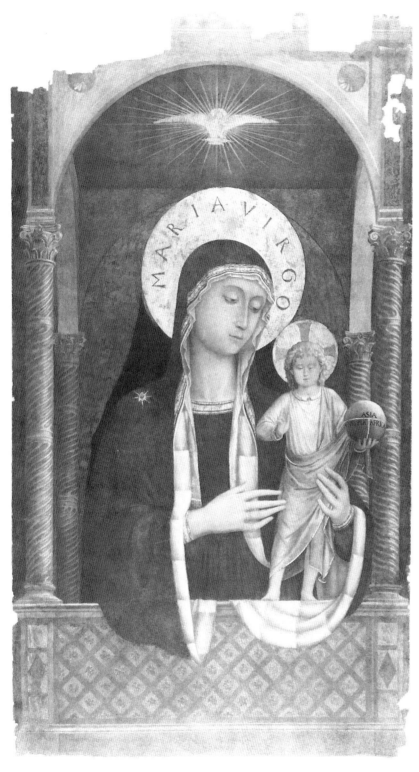

Figure 146. Follower of Fra Angelico (?) *Our Lady of the Rosary* (photo: ICCD – under licence from MiBACT)

tomb of Saint Catherine of Siena should remain in the chapel in perpetuity, but under the altar.[252] On 4 October 1579, a painted banner of the *Madonna and Child* (Fig. 146) was brought in procession to the chapel and placed above the altar, while Catherine's coffin and effigy were placed under it.[253] The position of the banner and the tomb reflect different types of worship and veneration: while worship (latria) is due to God alone, saints are deserving of veneration (dulia), and the greatest veneration (hyperdulia) is reserved for the Mother of God. Therefore, the image of the *Madonna and Child* was placed above the tomb of Saint Catherine. The chapel ceiling was covered with scenes illustrating the fifteen traditional mysteries of the Holy Rosary by Marcello Venusti and Carlo Saraceni, while Giovanni de Vecchi (1536–1614) decorated the side walls with episodes from the life of Saint Catherine in six large scenes.[254]

The Sienese community in Rome was outraged by the changes in the Capranica Chapel. They introduced litigation, which continued until 1639, when statues of Saint Dominic and Saint Catherine were placed in the chapel on either side of the altar with the Marian image.[255] Having Saint Dominic

252 BAV, Chigi G III 81, fol. 8ʳ. For the restructuring, see Bilancia, 'Annibale Lippi, architetto'.

253 Rome, AGOP, MS XIV, liber C, Parte I, Brandi, *Cronica*, fols 34–35. The banner was painted in 1449 in tempera on silk. Today it is attributed to a follower of Beato Angelico, possibly Benozzo Gozzoli. After 1700 it was attached to a wooden panel, and it is now located in the north-eastern chapel of the transept.

254 Heideman, 'Saint Catherine of Siena's Life and Thought'; and Heideman, 'Giovanni De' Vecchi's Fresco Cycle'.

255 *Cappellae Sanctae Catharinae Senensi*, BAV, Chigi G III 81, fol. 1ᵛ; see also, Taurisano, *S. Maria sopra Minerva*, p. 51. The statues are still in the chapel.

and Saint Catherine of Siena flanking the Madonna and Child then became an essential part of the iconography of Our Lady of the Rosary.[256]

Like the passageway to the north of the apse, the first chapel on the south of the sanctuary had two bays. It now has a painted barrel vault, but Peruzzi indicated that it was originally covered with two cross vaults (Fig. 135). Later, a sacristy was added to the south-east of it (Fig. 129). When the church of S. Maria sopra Minerva was restored in 1848–1855, Saint Catherine's effigy and sarcophagus were taken out of the chapel, the effigy was modified and coloured (compare Figs 144 and 145), and the saint's tomb was placed under the new high altar of the church, the focal point of the whole building. At that time, the banner of the *Madonna and Child* was moved to the chapel of Saint Michael the Archangel and Saint Mary Magdalene, which opens off the northern end of the transept. Today, on Saint Catherine's feast day (29 April) visitors can enter the space under the high altar behind the tomb, where there is enough room for two people at a time. This is an imaginative nineteenth-century reconstruction of how a saint's tomb was venerated in the Middle Ages.[257]

The second chapel on the south of the sanctuary was dedicated to All the Saints. From 1426, the Altieri family served as its patrons. The tomb of Petrus de Buccamatiis was located in front of the entrance in 1290 and Bishop Durandus of Mende's monument was installed in this chapel in 1296, but it was later moved to its present position in the transept (Fig. 133). From these burials, it is clear that the chapel existed by 1290–1296 and perhaps sometime before that.

At the northern end of the transept is the chapel of Saint Dominic, built originally *c.* 1350 by Giacomo Alberini who also paid for the nearby staircase connecting the sacristy to the dormitory, as well as for the doors of the sacristy, and the campanile, as noted in Brandi's *Cronica* and in the *Campione*:

> Cappella quae est inter Sacristiam et Campanila in honorem Patriarchae nostri beati Dominici dedicate et construere fecit Dominus Jacobus de Alberinis.
>
> (Signor Giacomo de Alberini had the chapel that is between the Sacristy and the bell tower constructed and dedicated in honour of our Patriarch, Saint Dominic.)[258]
>
> [...] la suddetta Cappella la fece fare fabbricare il Signor Giacomo Alberini Cittadino Romano, ed a sue spese fece fare la scala della Sagrestia per andare nel Dormitorio e le porte della Sagrestia e il campanile'.
>
> ([...] the Roman citizen Signor Giacomo Alberini had the said chapel constructed, and at his own expense he also had the stairs of the Sacristy that go up to the dormitory, the doors of the sacristy, and the campanile built.)[259]

When the Alberini family returned the chapel to the Dominicans in 1633–1634, the friars ceded it to Alessandro Rondanini.[260] Later in the seventeenth century, the chapel was demolished and rebuilt, according to a plan by Martino Longhi, but the project remained unfinished. Another attempt

256 Pointed out by Bianchi, 'Il sepolcro', p. 50 n. 140. For this iconography, see, for example, Sassoferrato's *Madonna del Rosario*, 1643, now in the Museum of S. Sabina and formerly in the Chapel of Saint Catherine of Siena in that church, illustrated in Gianandrea, Annibali, and Bartoni, ed., *Il convento di Santa Sabina*, pp. 191–93.

257 See medieval examples in Lamia, 'The Cross and the Crown, the Tomb and the Shrine', pp. 39–56.

258 Rome, AGOP, MS XIV, liber C, Parte I, Brandi, *Cronica*, fols 30–31; see also, fols 43–44, for further information about the chapel.

259 Rome, AM, MS III, 327-30, *Campione*, vol. I, p. 165. Palmerio and Villetti convincingly suggest a date in the second half of the fourteenth century, Palmerio and Villetti, *Storia edilizia*, p. 171.

260 Rome, AM, MS III, 327-30, *Campione*, vol. I, p. 162.

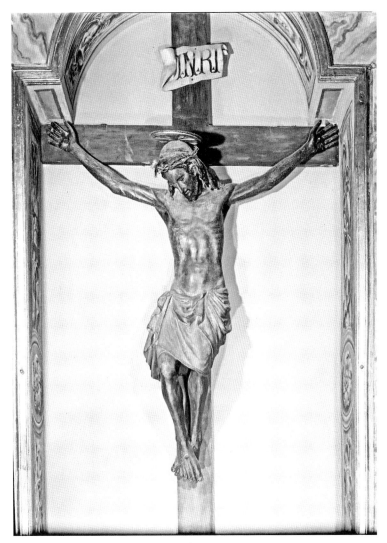

Figure 147. S. Maria sopra Minerva, unknown artist, crucifix (photo: ICCD – under licence from MiBACT)

On the western side of the north arm of the transept there are two monuments. One is a chapel at first dedicated to the Blessed Virgin Mary and then to Saint Hyacinth, the Polish Dominican, who was received into the Order by Saint Dominic at S. Sabina.[262] The other is the tomb of the fifteenth-century sculptor, Andrea Bregno (1418–1506).

Opposite the chapel of Saint Dominic, at the southern end of the transept, Cardinal Oliviero Carafa in 1478–1503 built the chapel of Saint Thomas Aquinas and had it decorated by Filippino Lippi.[263] This replaced the earlier chapel of Saint Thomas Aquinas north of the sanctuary. The altarpiece represents the *Annunciation*, with the added figures of Saint Thomas Aquinas presenting Cardinal Carafa to the Virgin Mary. Behind that is a representation of the *Assumption of the Virgin*. The west wall of the chapel is decorated with an allegorical painting of the *Triumph of Saint Thomas Aquinas*. Later, Pope Paul IV Carafa (1555–1559) was buried in a tomb on the eastern side of the chapel, designed by Pirro Ligorio.[264]

On the western side of the south transept, Antonio di Toscanella, a Roman citizen, built the Chapel of Holy Cross, and in 1429, he left 300 florins to pay for a property to finance a Mass to be said for his soul there three times a week.[265] It was later named the chapel of the Crucifix and Saint Barnabas. Quadri, the author of the *Campione*, claimed unconvincingly that Giotto carved the wooden crucifix (Fig. 147), but the artist is unknown.[266] In front of the chapel there are two columns sustaining a marble trilobate

was made to renew the chapel in 1676, and finally Pope Benedict XIII (1724–1727) commissioned Filippo Raguzzini to rebuild it completely in its present form.[261] The Pope is buried there in a monumental tomb.

261 AGOP, MS XIV, liber C, Parte II, fol. 86, *Benefici segnalati*; Rome, AM, MS cm II. e. 3.1-3, Zucchi, 'La Minerva attraverso i secoli (la chiesa e il convento si S. Maria sopra Minerva)', pp. 38–40; Rome, AM, MS cm II. e. 3.4-16, Zucchi, 'La Minerva attraverso i secoli (dal XVII al XX secolo)', p. 14.

262 Palmerio and Villetti, *Storia edilizia*, pp. 175–76. For Hyacinth, see above, Chapter 2.
263 Rome, AGOP, MS XIV, liber C, Parte I, Brandi, *Cronica*, fols 37–38; Rome, AM, MS III, 327-30, *Campione*, vol. I, p. 152; Geiger, *Filippino Lippi's Carafa Chapel*.
264 Coffin, *Pirro Ligorio*, pp. 74–76.
265 Rome, AGOP, MS XIV, liber C, Parte I, Brandi, *Cronica*, fol. 29; Rome, AM, MS III, 327-30, *Campione*, vol. I, p. 154.
266 Rome, AM, MS III, 327-30, *Campione*, vol. I, p. 155.

arch and tympanum made in the 'Cosmatesque' style. It is often said that they formed part of the medieval altar canopy at S. Maria sopra Minerva, but they may come from a medieval tomb, like that of Durandus.[267]

(b) Chapels around the Choir Enclosure

As often happened in Dominican churches, chapels were attached to the exterior of the medieval choir enclosure. These have not survived, but they are recorded in the *Campione*, as being dedicated to Saints Peter and Paul (or the Blessed Virgin Mary and Saints Peter and Paul);[268] Saint Antony Abbot;[269] Saints Crispin and Crispian;[270] and Saint Vincent the Confessor.[271] The chapels dedicated to Saint Antony Abbot and Saint Vincent were said to have been behind the choir, whereas the altar of Saints Peter and Paul faced the church of the laity. These chapels were all demolished when the choir was moved into the apse in 1544.

(c) Chapels Opening off the South Aisle

To the east of the side entrance of the church, there was the first chapel built on the south, which was funded by Cardinal Matteo Orsini, OP, who made a bequest to pay for it to be built and furnished in 1340.[272] It has changed a great deal, but his will lists his gifts for its decoration and for the religious ceremonies to be held in it. It was originally dedicated to Saint Catherine of Alexandria and contained the Cardinal's tomb.[273] Matteo Orsini bequeathed his best vestments to be used in the chapel, along with three embroidered antependia to hang in front of the altar — one from Toulouse, one made in Rome, and one made of the famous English embroidery, 'opus anglicanam'. Besides these, there were other altar cloths, candles and candelabra, a chalice, a tabernacle, a thurible, and a container for incense. The will lists altarpieces with representations of the Virgin Mary and of Saints Peter and Paul and other paintings depicting Saint Catherine of Alexandria and Saint Peter Martyr, as well as an image of hinds embroidered in gold. An icon of gilded silver of Saint Catherine of Alexandria and two others representing angels were to be placed in the chapel on her feast day. There was a tablet containing relics of the saints and a large and beautifully illuminated Missal. Later, the chapel was re-dedicated to the Blessed Sacrament.[274]

Cardinal Juan de Torquemada endowed a chapel, which was at first dedicated to Saint James the Apostle, on the south of the church.[275] It was where the Cardinal was buried, and he provided the income from two shops in Campo de' Fiori to pay for Masses to be said for the repose of his soul. When he founded the Confraternity of the Annunziata in 1460 to provide dowries for poor girls, he restructured the chapel and dedicated it to the '*Annunziata*' (the Virgin Mary Annunciate). He commissioned Antoniazzo Romano to execute a painting of the *Annunciation*, in which the Cardinal is included, kneeling beside some of the girls, who are shown receiving their dowries from the Virgin.

267 Palmerio and Villetti, *Storia edilizia*, p. 159.
268 Rome, AM, MS III, 327–30, *Campione*, vol. I, p. 147.
269 Rome, AM, MS III, 327–30, *Campione*, vol. I, p. 150.
270 Rome, AM, MS III, 327–30, *Campione*, vol. I, p. 193.
271 This dedication may have been to the Dominican Saint Vincent Ferrer. If so, it was superseded by the chapel of Saint Vincent Ferrer erected by Master General Vincenzo Giustiniani in the sixteenth century.
272 Forte, 'Il cardinale Matteo Orsini', pp. 207–10, 230–32, 258, and notes 83–87. Rome, AM, MS III, 327–30, *Campione*, vol. II, p. 186, erroneously refers this to the later chapel of Saint Catherine of Siena, although doubts are expressed as to this dedication. See Kleefisch-Jobst, *Die römische Dominikanerkirche Santa Maria sopra Minerva*, pp. 21 and 38. The items left by the Cardinal are reminiscent of the patronage of popes and cardinals discussed in Gardner, *The Roman Crucible*, pp. 157–217.

273 Rome, AM, MS III, 327–30, *Campione*, vol. I, pp. 89 and 148–49.
274 Palmerio and Villetti, *Storia edilizia*, pp. 152–56.
275 Rome, AGOP, MS XIV, liber C, Parte I, Brandi, *Cronica*, fols 40, 57–59; Rome, AM, MS III, 327–30, *Campione*, vol. I, p. 158. Palmerio and Villetti, *Storia edilizia*, pp. 151–52.

(d) Altars and Chapels Opening off the North Aisle

At first, because the medieval cloister was adjacent to the north aisle of the church, no chapels were built along that side, but some altars were set up against the wall. Only after Vincenzo Giustiniani, OP demolished the first cloister and built a new one in the middle of the sixteenth century, were chapels erected on that side of the church. Among them was the chapel of the Giustiniani family, dedicated to the Dominican Saint Vincent Ferrer (1350–1419), who was canonized in 1455–1458.[276] This altar may also have replaced that of 'S. Vincenzo Confessore' beside the choir enclosure, which was demolished when the choir was moved into the apse in 1544. Clearly, the new chapel was also meant to commemorate Master General Vincenzo Giustiniani, as indicated in an inscription. The Giustiniani family chapel retained the saint's cult and commemorated their relative. Since 2001, there has been a fragment of a fresco of the *Madonna and Child* in this chapel, which seems stylistically to date from the late thirteenth or very early fourteenth century.[277] The Virgin is depicted as in the *Hodegetria* icon, with her right hand indicating the Child, who leans back, blesses with his right hand, and holds a scroll in his left hand. The Mother of God is seated on a blue cushion; behind the two figures there is a pink mandorla decorated with gold stars within a deep blue border. This painting may have been removed from a wall or a tomb, but its original location is unknown.

In 1393, Bishop Giacomo de Fusignano built an altar dedicated to Saint James the Apostle along the north aisle.[278] In its place Lucrezia Medici Salviati built a chapel, referred to as 'S. Giacomo della famiglia Salviati' (the Salviati family chapel of Saint James). Just west of the doorway leading from the northern aisle to the cloister, there was an altar dedicated to Saint Jerome in 1512. Later, a chapel was built in its place and dedicated to the Dominican Pope Saint Pius V.[279]

The chapels were additions to the medieval church. They were built and then managed by their patrons and they testify to the good relations between the Dominican friars and the people of Rome. As in other churches of the Dominican Order, lay people were welcome. They helped the friars to maintain the church and received spiritual benefits in return from the religious community, who regularly celebrated Mass in their chapels and prayed for the living and the dead members of the patrons' families. As Bruzelius has shown, lay patrons from important families and the friars benefitted from having lateral chapels with secondary altars and extra burial space in mendicant churches.[280] The chapels were also used by a number of lay Confraternities, like that of the Holy Rosary, which were formed for pious and charitable purposes.[281] S. Maria sopra Minerva and S. Maria in Aracoeli had such Confraternities.

The Priory

The accommodation of the Penitent women who preceded the Dominicans at S. Maria sopra Minerva was said to have been unsuitable and incommodious. The friars no doubt decided to rebuild the convent, just as they rebuilt the church, but today almost nothing remains of the medieval priory, as it was all restructured in the fifteenth, sixteenth, and seventeenth centuries.

The Maggi-Maupin-Lozi *Map of Rome*, drawn in 1625 and edited in 1774, clearly shows two cloisters to the north and to the north-west of the church

276 Palmerio and Villetti, *Storia edilizia*, pp. 179–80.
277 Sgherri, 'La Vergine con il Bambino in S. Maria sopra Minerva'.
278 Rome, AM, MS III, 327-30, *Campione*, vol. I, p. 145. See also, Palmerio and Villetti, *Storia edilizia*, pp. 178–79.
279 Palmerio and Villetti, *Storia edilizia*, pp. 176–78.
280 Bruzelius, *Preaching, Building, and Burying*, pp. 166–71.
281 Bruzelius, *Preaching, Building, and Burying*, pp. 173–74.

(Fig. 140).[282] Originally, there was probably only one on the north, later called 'il primo chiostro' (the first cloister), which was surrounded by colonnaded ambulatories leading to the chapter room, refectory, and kitchen on the ground floor, and to one or more dormitories upstairs.[283]

Today, when one leaves the church at the eastern end of the north aisle, one walks through a passageway leading to a large cloister, built in the sixteenth century. The first cloister of the medieval priory was in this location, but notable changes were made in the fifteenth and sixteenth centuries. In the seventeenth century, the early cloister was remembered and described as having been as follows:

> Il primo chiostro ch'è contiguo alla chiesa basso oscuro è noto che cingeva il Cimiterio con alcuni moriccioli attorno e con alcune colonnette di sopra accoppiato a due a due che reggevano le volte.
>
> (The first cloister, which is contiguous with the church, was low and dark, and is known to have surrounded the Cemetery with some low walls around it and with some colonettes above joined in pairs two by two, which supported the vaults.)[284]

The pairs of colonnettes on ledges surrounding the garth suggest a strong resemblance to the thirteenth-century cloisters at S. Sabina and S. Cosimato. Grossi noted that one colonnette was still in situ, in the passageway leading from the north aisle to the present cloister, where it is attached to one corner.[285] The garth was the priory cemetery and was perhaps where Catherine of Siena was first interred.

From 1450–1468, Cardinal Juan de Torquemada remodelled and then decorated the first cloister.[286] He had paintings executed in green monochrome around the ambulatories, illustrating episodes from the Old and New Testaments, as well as some other scenes, that included an image of the genealogy of the Dominican Order and a portrait of Torquemada himself with Saint Sixtus (since he was titular cardinal of S. Sisto in Rome); beneath the frescoes there were Latin epigrams, which he had composed.[287] It is not clear who painted this cycle. The frescoes have been attributed to Antoniazzo Romano, Melozzo da Forlì, or Fra Angelico.[288] In 1467 a book was published in Rome, reputedly the first to be printed in Italy, with the title, '*Meditationes Reverendissimi patris domini Johannis de turre cremata Sacrosancte Romane ecclesiae Cardinalis posite et depicte de ipsius mandato in ecclesie ambitu sancta Marie de Minerva Rome*' (Meditations of the most reverend Father and Lord Juan de Torquemada, Cardinal of the most holy Roman Church, placed and depicted by his own command, in the environs of S. Maria in Minerva in Rome). The book contained over thirty woodcut illustrations.[289] They are believed to have been similar to the depictions in the cloister and a short meditation on each scene was written in Latin by the Cardinal.

282 Frutaz, *Piante*, vol. II, tav. 315.

283 Zucchi and Grossi, 'L'antico convento della Minerva'; Palmerio and Villetti, *Storia edilizia*, pp. 257–65.

284 Rome, AGOP, MS XIV, liber C, Parte I, Brandi, *Cronica*, fol. 40, writing in the early seventeenth century, but presumably basing his account on a much earlier descriptions of the cloister; see also de Gregori, 'Il chiostro della Minerva', esp. p. 42.

285 Zucchi and Grossi, 'L'antico convento della Minerva', p. 148 and note 11.

286 Zucchi and Grossi, 'L'antico convento della Minerva', p. 148 and Palmerio and Villetti, *Storia edilizia*, p. 261 indicate that it is incorrect to say that Torquemada built this cloister from scratch.

287 Rome, AGOP, MS XIV, liber C, Parte I, Brandi, *Cronica*, fol. 79; Rome, AM, MS cm II. e. 3.1, Zucchi, 'La Minerva attraverso i secoli (la chiesa e il convento si S. Maria sopra Minerva)', pp. 48–50. See also Donati, 'L'antico chiostro della Minerva', pp. 156–61, esp. pp. 156–58, who thinks of the cloister as a great and splendid illuminated codex; de Gregori, 'Il chiostro della Minerva'; and Bourgeois, *Reconstructing the Lost Frescoes*.

288 De Gregori, 'Il chiostro della Minerva', pp. 45–46.

289 De Gregori, 'Il chiostro della Minerva'; Bourgeois, *Reconstructing the Lost Frescoes*.

A second cloister at S. Maria sopra Minerva was built or restored in the late fifteenth century by Cardinal Oliviero Carafa.[290] It was called the 'Chiostro della Cisterna' (the cloister with the cistern). There seem to have been commodious rooms on two floors around this cloister that provided additional accommodation for the brethren.[291]

Once the medieval Dominican priory at S. Maria sopra Minerva had been established, it became the venue for Provincial and General Chapters. For example, in 1332, the Provincial Chapter of the Roman Province was held there.[292] The *Acta* recorded that the friars prayed 'pro sororibus nostris sancti Sixti que solemnem pictantiam fecerunt capitulo' (for our sisters of S. Sisto who made the solemn dinner for the chapter).[293] The General Chapter of the Order was later held at the Minerva in 1451, 1468, 1474, 1481, 1484, and then very frequently in the sixteenth century and later, reflecting the importance of this priory.[294]

In the fifteenth century two conclaves to elect a new pope took place at the Minerva. In 1431, the Cardinals elected Pope Eugene IV (1431–1447) there, after which on 23 October 1431, 150 gold florins were paid from the papal treasury to the Dominicans 'pro reparatione dormitorio, quod fuit destructum tempore conclavis' (to repair the dormitory which was destroyed at the time of the conclave).[295] In spite of such hazards, the friars hosted another conclave in 1447, which elected Pope Nicholas V (1447–1455).

The priory at the Minerva became an important Dominican house of studies.[296] The *Acta* of the Roman Province regularly named the professors there, who were appointed to teach the Bible, Theology, Philosophy, and the *Sentences* of Peter Lombard.[297] For example, in 1288, Fra Pagano from Lucca was chosen to read the *Sentences*, as was Fra Latino from Florence in 1291.[298] In 1292, Fra Gentile of Rome was appointed to lecture on Scripture;[299] in the following year, Fra Paolo from Aquila took over from him;[300] and Fra Giordano from Pisa followed in 1295, when S. Maria sopra Minerva was referred to as a 'studium in theologia' (an [advanced] School of Theology).[301] In 1305, Fra Angelo from Orvieto was appointed to teach Aristotle's *Metaphysics* and *De Anima*.[302] Fra Andrea de Gallo began to teach in the 'studium in philosophia' (the [advanced] School of Philosophy) in 1318.[303] Some students were sent to the Minerva to study logic in 1331.[304] The Chapter in 1338 advised the community to provide for the advanced School of Philosophy both a teacher (Fra Stefano of Rieti)

290 Palmerio and Villetti, *Storia edilizia*, p. 262.

291 Palmerio and Villetti, *Storia edilizia*, p. 262.

292 *Acta Capitulorum provinciae Romanae*, ed. by Kaeppeli and Dondaine, pp. 268 (for the announcement of the place) and pp. 269–81 (for the Minutes of the Chapter).

293 *Acta Capitulorum provinciae Romanae*, ed. by Kaeppeli and Dondaine, p. 279.

294 The General Chapter was held at the Minerva in 1501, 1508, 1512, 1518, 1525, 1530, 1532, 1546, 1553, 1558, 1569, 1571, 1580, 1583, 1589, as noted in Rome, AM, MS cm II. e. 3.1–3, Zucchi, 'La Minerva attraverso i secoli (la chiesa e il convento si S. Maria sopra Minerva)', pp. 94–96.

295 Archivio di Stato, *Liber obligationum Eugenii IV*, fol. 30ᵛ; Rome, AM, MS III, 327–30, *Campione*, vol. I, p. 148; and quoted in Rome, AM, MS cm II. e. 3.3, Zucchi, 'La Minerva attraverso i secoli (la chiesa e il convento si S. Maria sopra Minerva)', pp. 44 and 50.

296 For the Dominican system of education, see Mulchahey, 'First the Bow is Bent in Study…' and, related to architecture, Schenkluhn, *Ordines Studentes*.

297 Mulchahey, 'First the Bow is Bent in Study…', pp. 130–41.

298 *Acta Capitulorum provinciae Romanae*, ed. by Kaeppeli and Dondaine, pp. 84–85, 100.

299 *Acta Capitulorum provinciae Romanae*, ed. by Kaeppeli and Dondaine, pp. 106, 107.

300 *Acta Capitulorum provinciae Romanae*, ed. by Kaeppeli and Dondaine, p. 112.

301 *Acta Capitulorum provinciae Romanae*, ed. by Kaeppeli and Dondaine, p. 121.

302 *Acta Capitulorum provinciae Romanae*, ed. by Kaeppeli and Dondaine, pp. 154, 155 and 156.

303 *Acta Capitulorum provinciae Romanae*, ed. by Kaeppeli and Dondaine, pp. 206 and 209.

304 *Acta Capitulorum provinciae Romanae*, ed. by Kaeppeli and Dondaine, pp. 259–62, 264, 'studentes in logicalibus'.

and seven students; and, for the study of logic, 'in logicalibus', they appointed Fra Angelo Patelluti from Viterbo and nine students.[305] In 1341, Fra Jacopo of Rieti became Lector; and Fra Jacopo de Spina from Perugia was appointed 'Bacellarius' (bachelor-teacher).[306] In 1344, Fra Angelo of Piscina was appointed Lector, Fra Jacopo from S. Andrea of Siena became Bacellarius, two students were sent to study theology, Fra Pietro da Bassano was appointed to teach philosophy, seven students were sent to study under him, and Fra Giovanni de Trebis was to teach logic to five students.[307]

In 1577, the Spanish Dominican, Fra Juan Solano (c. 1505–1580), founded the College of Saint Thomas Aquinas at the Minerva.[308] This was separate from the conventual 'studia' and was open to international students: from 1630 to 1640 students came from Austria, Poland, Dalmatia, Bohemia, Lithuania, Prussia, England, Ireland, Malta, and Armenia.[309] There were Faculties of Arts, Philosophy, Theology, and Canon Law. Students who were not Dominicans were accepted at the College. When the Minerva buildings were taken over by the Italian state in the nineteenth century, the College was transferred for a short time to the French Seminary nearby. The College then became the Pontifical University of Saint Thomas Aquinas (the 'Angelicum') in 1910. In the 1930s, it was moved to the former nunnery buildings of SS. Domenico e Sisto and became known as the 'New International Pontifical College, the Angelicum', which is still one of the major ecclesiastical universities in Rome.[310]

The Minerva had an important library, which was located from the mid-sixteenth century above the Master General's apartments. In 1698, Cardinal Domenico Casanate left the Dominicans his private library of c. 20,000 books as well as 160,000 scudi, with which to establish a separate public library, which became known as the Biblioteca Casanatense.[311] It still exists, run by the Italian state rather than by the Dominicans, in a building designed by Antonio Maria Borioni and completed by Carlo Fontana in 1725.

From the sixteenth century onwards, the Minerva became a venue for the Dominican mission against heresy, when in 1542 it was made the centre of the Holy Office (the Roman Inquisition).[312] The inquisitors met every Wednesday afternoon in a special room, now known as the 'Sala Galileiana', named after the famous trial of Galileo Galilei that took place there in 1633, when he formally abjured his theories about the cosmos, although he continued to disagree with the Inquisitors.

In 1557, Pope Paul IV elevated the status of the church of S. Maria sopra Minerva, making it a *titulus*. The first titular cardinal was the Dominican, Michele Ghislieri (1504–1572), who was also Inquisitor General. In 1566, he was elected pope, taking the name Pius V. Before the battle of Lepanto, he urged people to intercede by saying the Rosary, which was one of the devotions promoted at S. Maria sopra Minerva by the formation of a Confraternity of the Holy Rosary. He firmly believed that this prayer contributed to the victory at Lepanto, of which he had an intuition while he was at S. Sabina. Pope Pius V

305 *Acta Capitulorum provinciae Romanae*, ed. by Kaeppeli and Dondaine, pp. 294–300.

306 *Acta Capitulorum provinciae Romanae*, ed. by Kaeppeli and Dondaine, pp. 333–35.

307 *Acta Capitulorum provinciae Romanae*, ed. by Kaeppeli and Dondaine, pp. 353–56.

308 Rome, AGOP, MS XIV, liber C, Parte I, Brandi, *Cronica*, fol. 80; Rome, AM, MS cm II. e. 3.1–3, Zucchi, 'La Minerva attraverso i secoli (la chiesa e il convento si S. Maria sopra Minerva)', p. 99.

309 Information on this College is given in Rome, AM, MS cm II. g. 5.8, Zucchi, *Miscellanea*, 'Il Collegio di S. Tommaso d'Aquino alla Minerva'.

310 At that time, the Dominican nuns went to live at the Madonna del Rosario nunnery on Monte Mario.

311 Masetti, 'La Biblioteca Casanatense'.

312 Rome, AM, MS cm II. e. 3.1–3, Zucchi, 'La Minerva attraverso i secoli (la chiesa e il convento si S. Maria sopra Minerva)', p. 72.

is buried in S. Maria Maggiore, but there is also a chapel dedicated to him at the eastern end of the north aisle of S. Maria sopra Minerva — and another in the priory at S. Sabina.

Significant changes were made to the priory buildings at the Minerva in the sixteenth century. In 1545, a new infirmary was financed by a bequest from Cardinal Paluzzo Altieri.[313] By far the most important sixteenth-century additions were those made by Fra Vincenzo Giustiniani, Master General of the Dominican Order from 1558 to 1571. He demolished the first cloister with the paintings of the *Meditationes* of Cardinal Torquemada. In the space formerly occupied by its southern ambulatory, side chapels could then be erected beside the church, opening off the adjacent north aisle. Giustiniani rebuilt the cloister on a much larger scale, extended the convent buildings, and provided a new refectory.[314] He was said to have transformed the entire convent.[315]

Pope Urban VIII in 1636 sanctioned more new convent buildings, which included restructuring the sacristy and moving to a space behind it the room in Via S. Chiara in which Saint Catherine of Siena had died: Cardinal Antonio Barberini laid the foundation stone and Master General Niccolò Ridolfi oversaw the building of this chapel.[316] Construction was begun under the supervision of a certain Fra Domenico.[317] Two years later, in 1638, Paolo Maruscelli erected noviciate buildings along Via del Seminario.[318] In 1698, the Biblioteca Casanatense was established in new buildings,[319] and the Master General had a residence and offices constructed for the General Curia of the Order.

The history and architecture of S. Maria sopra Minerva illustrate the rise of an important Dominican priory in the densely populated centre of the city, where the friars could reach out to the people of Rome. From 1380 onwards, the Master General lived there. It was a centre of learning, with the normal Dominican convent *studia*, a college of higher education in the arts, theology, philosophy, and canon law, and the University of Saint Thomas Aquinas, open to international students. It had a famous library and also the Biblioteca Casanatense. The Dominican General Chapter was often held at S. Maria sopra Minerva, as were two conclaves to elect popes in the fifteenth century.

On 20 September 1870, Italian troops entered Rome through Porta Pia, thereby completing the unification of Italy by taking over the city, dissolving the Papal States, and proclaiming the new state of Italy. As early as November 1870, government officials moved into some of the Minerva buildings. When the religious Orders in Italy were suppressed in 1873, the government took over the rest of the Dominicans' property. The church became an ordinary parish, with a house in Via Beato Angelico behind the apse reserved for the parish clergy. Only a few parts of the convent, and of the Biblioteca Casanatense, remained in the friars' possession for a few years.[320] The Dominicans from the Minerva went to live in a house in via Piè di Marmo in 1878.[321] In 1884, the Italian Government annexed the College of Saint Thomas, the Biblioteca Casanatense, and the building of the Dominican General Curia. The Master General of the Order, who

313 Palmerio and Villetti, *Storia edilizia*, p. 265.
314 Rome, AGOP, MS XIV, liber C, Parte I, Brandi, *Cronica*, fols 79–80; de Gregori, 'Il chiostro della Minerva', pp. 36–40.
315 Rome, AGOP, MS XIV, liber C, Parte I, Brandi, *Cronica*, p. 13.
316 Rome, AM, MS III, 327-30, *Campione*, vol. I, p. 430; see also, Armellini, rev'd by Cecchelli, *Le Chiese di Roma*, p. 59, and Rome, AM, MS cm II. e. 3.2, Zucchi, 'La Minerva attraverso i secoli', pp. 18–19.
317 Rome, AGOP, MS XIV, liber C, Parte I, Brandi, *Cronica*, fol. 84.
318 Rome, AM, MS III, 327-30, *Campione*, vol. III, pp. 37–39.
319 Masetti, 'La Biblioteca Casanatense'.
320 Rome, AM, MS cm II. e. 3.6, Zucchi, 'La Minerva attraverso i secoli', p. 60.
321 Rome, AM, MS cm II. e. 3.6, Zucchi, 'La Minerva attraverso i secoli', p. 62.

had lived at S. Maria sopra Minerva since the late fourteenth century, went to stay at a house in Via S. Sebastianello. In 1891, the Minerva convent buildings functioned as the offices of the Ministry of Public Instruction.[322] Today the Italian Government still occupies most of the former Minerva priory buildings.

When the 'Lateran Pacts' and the Concordat of 1929 established a new agreement between the Vatican and the Government of Italy, the cloister north of the church and some other rooms were returned to the Order of Preachers.[323] The Master General and the Dominican Curia went to live at S. Sabina,[324] and S. Maria sopra Minerva became the centre of the 'Provincia Romana S. Catharinae Senensis' (the Roman Province of Saint Catherine of Siena), which it still is today. While writing this chapter, the church of S. Maria sopra Minerva has been undergoing restoration. Perhaps the restorers will uncover some unknown features of the building.

322 Armellini, rev'd by Cecchelli, *Chiese di Roma*, p. 488.
323 Rome, AM, MS cm II. e. 3.7, Zucchi, 'La Minerva attraverso i secoli', p. 9.
324 Pointed out in Chapter 2.

CHAPTER 7

The Franciscan Nunnery at S. Silvestro in Capite, founded in 1285

Figure 148. Antonio Tempesta and Giovanni G. de Rossi, *Map of Rome*, 1693. (Frutaz, *Piante*, vol. III, 1962, det. of Tav. 367)

In 1285, Giovanni Colonna, three times Senator of Rome, and his brother, Giacomo Colonna, Cardinal Deacon of S. Maria in Via Lata, founded a Franciscan nunnery at S. Silvestro in Capite. This took place shortly after their sister, Margherita Colonna, had died on 30 December 1280 in the Colonna family home near Palestrina, where for some years she had lived an informal Franciscan lifestyle with a group of companions.[1] In the late sixteenth century, the church of S. Silvestro was restructured in magnificent Baroque style and the monastic buildings beside it were rebuilt in the eighteenth century, only to be turned into the General Post Office of Rome in the late nineteenth century. Some parts of the medieval church survive, however; many documents reveal aspects of the monastery's history; and some drawings indicate features of the nuns' church and later conventual buildings.[2]

Location

S. Silvestro in Capite is located in the northern part of the Campus Martius, a short distance to the east of the present Via del Corso (the medieval 'Via Lata' and ancient 'Via Flaminia').[3] The monastery is shown on Antonio Tempesta's *Map of Rome* (in the upper right corner of Fig. 148).

1 For Margherita Colonna, discussed in greater detail later in this chapter, see Oliger, *B. Margherita Colonna*, with the Latin texts of her biography; Barone, 'Margherita Colonna'; and *Visions of Sainthood in Medieval Rome*, trans. by Field, ed. by Knox and Field, with an English translation of the biographical texts and some papal documents.

2 For this church and convent see Krautheimer, *Corpus*, vol. IV, pp. 148–62; Gaynor and Toesca, *S. Silvestro in Capite*; Buchowiecki, *Handbuch der Kirchen Roms*, vol. III, pp. 842–65; Jäggi, *Frauenklöster*, pp. 26, 191; and Kane, *The Church of San Silvestro*. Federici, 'Regesto', published many medieval documents, while later ones are now in the Archivio di Stato in Rome, where there are also some important architectural drawings. See also the older studies, Giacchetti, *Historia* and Carletti, *Memorie*. For the founding of the nunnery, see Oliger, 'Documenta originis Clarissarum', pp. 99–102; Oliger, *B. Margherita Colonna*; Barone, 'Margherita Colonna'; *Visions of Sainthood in Medieval Rome*, trans. by Field, ed. by Knox and Field, pp. 45–63, 144–54; and Rehberg, 'Nobiltà e monasteri femminili nel Trecento', pp. 407–17.

3 For the Campus Martius in general, see Chapter 6.

The ancient Via Flaminia lies c. 2.60 m below the present road: it began near the Capitoline Hill and continued as one of the major Roman highways, going north from the city through Umbria to the Adriatic Sea, and then along the coast to Rimini.[4] An ancient Roman arch, built by Domitian and known later as the 'Arco di Portogallo', stood across the road to the west of the church and nunnery.

In the later Middle Ages, the district where S. Silvestro is located was called 'Regione Colonna'.[5] The name was derived from the ancient column of Marcus Aurelius (161–180), further south on the west side of the Via Lata. This was obviously a desirable place for Giovanni and Giacomo Colonna to establish a nunnery, which Andreas Rehberg has aptly called a 'Hauskloster' (a family convent), where many of their female relatives became nuns.[6] There was, and still is, a large piazza in front of the church. From the sixteenth century onwards, there was significant urban development to the north, east, and west of S. Silvestro, which must have been rather isolated in a semi-rural setting in the late thirteenth century.

The Earlier Medieval Monastery that Preceded the Franciscan Foundation

Two brothers who were elected to the papacy one after the other, Popes Stephen II (752–757) and Paul I (757–767), founded a monastery for Greek monks in their family home east of Via Lata, the future S. Silvestro in Capite.[7] The monastery was dedicated to two early popes, Saint Stephen (254–257) and Saint Silvester (314–335). Stephen may have been chosen because he had the same name as Pope Stephen II. Silvester was famous because he was Bishop of Rome at the time of the first Christian emperor, Constantine (312–337), whom he was believed to have baptized, and from whom he was said to have received the 'Donation of Constantine', a forged medieval document that justified the papacy's claim to political power in the secular realm. Both these claims were illustrated in the frescoes of Cardinal Stefano Conti's chapel of S. Silvestro at SS. Quattro Coronati in 1246, and a fresco of the baptism of Constantine, painted by Ludovico Gemignani in the seventeenth century, can be seen in the apse of the present church of S. Silvestro in Capite.[8]

A Saint Dionysius (Denis) was also mentioned with regard to S. Silvestro, as the patron of the monastery's major church, as distinct from the monastery itself and an upstairs oratory within it. (These varied dedications are similar to the situation at SS. Cosma e Damiano in Mica Aurea in 1005, where, besides the monastery dedicated to Saints Cosmas and Damian, there were three sanctuaries: the main church of Saint Benedict and the oratories dedicated to Saint Nicholas, and to Saint Lawrence.[9]) Saint Dionysius was another early pope, whose pontificate, from 260 to 268, followed that of Pope Sixtus II (257–258).[10] Pope Dionysius appears in a list of saints venerated at S. Silvestro, in an inscription which is now in the narthex of the church.[11] From the eleventh century onwards, however, Saint Dionysius was sometimes identified as Denis, the patron saint of Paris.[12] This suggestion was made, for example, by the monk Benedict of Soracte c. 1000, who

4 Ashby and Fell, 'The Via Flaminia', pp. 125–90.
5 Hubert, 'Un censier'; Hubert, 'Patrimoines immobiliers'; Hubert, *Espace Urbain*.
6 Rehberg, *Kirche und Macht*, p. 44; Rehberg, 'Nobiltà e monasteri femminili nel Trecento', p. 408.
7 For Stephen II, see *LP*, vol. I, pp. 440–62; and for Paul I, *LP*, vol. I, pp. 463–67. See also, Osborne, *Rome in the Eighth Century*, pp. 158–92.
8 Osborne, *Rome in the Eighth Century*, p. 155, mentions the foundation of the monastery and discusses the 'Donation of Constantine'. The Baroque painting is illustrated in Kane, *The Church of San Silvestro*, pp. 29, 75.
9 See above, Chapter 4.
10 Saint Sixtus II was the patron of the Dominican nunnery of S. Sisto, see above, Chapter 1.
11 See Krautheimer, *Corpus*, vol. IV, p. 150; Kane, *The Church of San Silvestro*, pp. 15, 102.
12 Gaynor and Toesca, *S. Silvestro in Capite*, p. 7.

asserted that the church Pope Stephen II began to build in Rome was dedicated to Saints Denis, Eleutherius, and Rusticus, who were all patron saints of Paris.[13] While this seems a rather fanciful idea, Jean-Marie Sansterre has pointed out that the Latin monastery of S. Andrea at Soracte was a dependent of the early Greek monastery of S. Silvestro in Rome and it was included in the medieval legends concerning Pope Silvester.[14] It is therefore possible that Benedict of Soracte's claim about the French Saint Dionysius (Denis) was based on a tradition stemming from that monastery and S. Silvestro. Indeed, the legendary Parisian connection may reflect the fact that Pope Stephen II went to Paris in 754, where he stayed at the monastery of Saint Denis, while he was negotiating an alliance with the King of the Franks, Pepin, to support Rome against the Lombards, who were then ravaging parts of Italy. In doing this, the Pope was seeking military aid from the Franks, instead of from the papacy's traditional ruler and ally, the Emperor of Byzantium. It was part of a fundamental change of alliance in the eighth century, which reached a climax when Charlemagne was crowned Holy Roman Emperor in Rome in the year 800. Hence, the reference to Saint Denis may have alluded to this new alliance.[15] In spite of this, Richard Krautheimer, Eileen Kane, and John Osborne do not accept the claims of Benedict of Soracte, who was notoriously unreliable, and they stress that it was Pope Saint Dionysius who was the patron of the Roman monastery church.

A reliquary containing some of his remains is today in the sacristy at S. Silvestro, as well as some relics of Saint Silvester. Relics of the early martyrs, Hippolytus, Pigmenius, and Tarcisius, are also at S. Silvestro.

In the twelfth century, the monastery was identified as being 'inter duos hortos' (between two gardens), which would indicate that it was located in a semi-rural, sparsely inhabited part of the city.[16] It was later called S. Silvestro 'in Capite', after a famous relic, believed to be part of the head of Saint John the Baptist, which was brought there at the time of Anaclete II, who was accepted as Pope in Rome from 1130 to 1138, but who was thereafter designated an antipope.[17]

Two documents record that in 761, or in 757–767, Pope Stephen II began the construction of a church on the site and that his brother, Pope Paul I, founded the monastery in their family home, where he had been born and had grown up, dedicating it to the pope and martyr, Saint Stephen, and the pope and confessor, Saint Silvester.[18] (In establishing a monastery in his own home, Paul I followed the example of Pope Gregory the Great [590–604] who had founded the monastery of S. Andrea in Clivo Scauri in his family home on the Caelian Hill.) On the upper floor of the monastery at S. Silvestro, there was an oratory that housed the relics of the papal saints, Stephen and Silvester. Within the monastic enclosure, the *Liber Pontificalis* records that Paul I

13 Ferrari, *Early Roman Monasteries*, 306–07; Gaynor and Toesca, *S. Silvestro in Capite*, p. 7.

14 Pope Saint Silvester was first buried in the Catacomb of Priscilla in Rome and then at Soracte, after which some of his relics were translated to the Roman monastery that bears his name, see, Sansterre, *Les Moines grecs et orientaux à Rome*, pp. 82–83.

15 See Osborne, *Rome in the Eighth Century*, pp. 159–60 for the incursions of the Lombard King Aistulf (749–56) into Italy, the papal alliance with the Franks, and the foundation of the monastery of Saints Stephen and Silvester by Popes Stephen II and Paul I.

16 Ferrari, *Early Roman Monasteries*, p. 312.

17 Ferrari, *Early Roman Monasteries*, p. 310. Giacchetti, *Historia*, p. 27, claimed in the early seventeenth century to have seen a document in the monastery, which stated that the relic, 'Translatum fuit Innocentii Papa non sedente, sed regnante' (was translated when Pope Innocent was not enthroned but reigned), meaning it was brought to S. Silvestro during the disputed pontificate of Innocent II's rival Anaclete II (1130–1138).

18 See the 'Constitution of Paul I' in *Concilia Aevi Karolini*, ed. by Werminghoff, vol. II. 1, pp. 65–71; and in Federici, 'Regesto', 22 (1899), pp. 254–64, excerpts of which are published in Ferrari, *Early Roman Monasteries*, pp. 302–03. See also, *LP*, vol. I, pp. 464–65.

constructed from the foundations a new church of marvellous beauty, decorated with mosaics, marble inlay, gold, and silver.[19] A silver ciborium sheltered the altar, below which was a 'confessio' in a crypt, where the relics of innumerable saints were installed, having been taken from the early Christian cemeteries around Rome, which had recently been decommissioned because of the attacks on them in 756 by the Lombard king Aistulf (749–756).[20] In 1896, galleries of tombs, which may have been connected with this transfer of early Christian remains, were also found under the Piazza in front of S. Silvestro.[21]

The monks of the early monastery were called to praise God by singing the psalms in the Greek mode, indicating that this was at first a Greek community.[22] There were many Greek monks in Rome in the eighth century, when the Pope was often Greek or Syrian, but those who came to S. Silvestro are believed to have fled from Constantinople to Rome from about 754 onwards on account of Iconoclasm.[23] Their first abbot was named Leontius in the 'Constitution' of the monastery drawn up by Paul I, which was signed by twenty-two bishops, seventeen priests, one archpriest, and one archdeacon.[24] Guy Ferrari accepted the authenticity of this document, which referred to the transfer of relics from the Catacombs to the new church, which, Paul I claimed, 'noviter a fundamentis [...] construxi' (I have newly built [...] from the foundations); and it described the monastery as having a separate oratory, in which the monks were to sing the psalms in perpetuity.[25] The Constitution also mentioned some (unspecified) property donated to the monastery, which the abbot was not allowed to lease or sell. This included 'casalia' (farming establishments), 'massae' (lands), 'salinas' (salt pans), 'aquimolas' (watermills), and 'piscarias' (fishponds) in the city of Rome and 'in diversis locis et civitatibus' (in various places and towns).[26]

The property of S. Silvestro was mentioned in more detail in other documents. A twelfth-century copy of a Bull of Pope Sergius II (844–847), accepted as genuine by Paul Fridolin Kehr, stated that that Pope, in order to fund repairs to the monastery, ceded to S. Silvestro the city gate of Saint Valentine (in ancient times called the Porta Flaminia, and now the Porta del Popolo), the dependent monastery of Saint Valentine outside that gate, and the Milvian Bridge over the River Tiber, where the monks would receive a toll from everyone who crossed it.[27] The monastery of Saint Valentine and all its property, including the Milvian Bridge, were confirmed as belonging to

19 *LP*, vol. I, p. 464.
20 Pope Gregory III (731–741) appears to have begun the transfer of early Christian remains from the catacombs to churches in Rome, see de Blaauw, 'Liturgical Features of Roman Churches', pp. 331–32. Osborne, *Rome in the Eighth Century*, pp. 155–92, refers to the transfer of remains from the catacombs to S. Silvestro.
21 Gaynor and Toesca, *S. Silvestro in Capite*, p. 12.
22 For early Greek monasteries in Rome see, Antonelli, 'I primi monastery di monaci orientali'; and Sansterre, *Les Moines grecs et orientaux à Rome*.
23 Sansterre, *Les Moines grecs et orientaux à Rome*, p. 128, gives 754 as the date when many Greek monks came to Rome during Iconoclasm; and see pp. 36–37, 82–83, 91–94, for the foundation of S. Silvestro, which was one of the three most important Greek monasteries in early medieval Rome, the others being S. Saba and S. Anastasio at Tre Fontane. (Iconoclasm started in Byzantium in 726 and ended officially with the Second Council of Nicaea in 787, and effectively in 843.) Osborne, *Rome in the Eighth Century*, p. 180, gives an alternative reason for the choice of Greek monks, suggesting that it was because Popes Stephen II and Paul I came from a Hellenic family and spoke Greek.

24 This is published in full in *Concilia Aevi Karolini*, ed. by Werminghoff, vol. II. 1, pp. 65–71; and in Federici, 'Regesto', 22 (1899), pp. 254–64, while a long quotation is given in Ferrari, *Early Roman Monasteries*, p. 302.
25 *Concilia Aevi Karolini*, ed. by Werminghoff, vol. II. 1, pp. 66–67; and Ferrari, *Early Roman Monasteries*, pp. 302 and 305–06.
26 *Concilia Aevi Karolini*, ed. by Werminghoff, vol. II. 1, p. 67; see also, Sansterre, *Les Moines grecs et orientaux à Rome*, p. 92.
27 Ferrari, *Early Roman Monasteries*, pp. 303–04, 308; Kehr, *Italia Pontificia*, vol. I, Roma, p. 82.

S. Silvestro in a Bull of Pope Agapitus II, dated 955, which also mentioned another monastery of S. Terentianus (in the province of Viterbo) and all its property.[28] A Bull of Pope John XII, dated 962, referred to all the same property and added the ancient Roman Antonine Column (the Column of Marcus Aurelius).[29] (A marble plaque was set up in the narthex of the church of S. Silvestro in 1119, in which Abbot Petrus threatened to excommunicate anyone who attempted to rent or alienate the Column.[30]) The Bull of 962 referred also to a number of churches belonging to S. Silvestro: two, dedicated to the Mother of God, were located in front of the monastery (probably S. Maria in Via, beside today's Via del Tritone, and S. Maria in Xenodochio, now called S. Maria in Trivio, near the much later Trevi Fountain); the church of S. Andrea (not far from the later seventeenth-century church of S. Andrea delle Fratte); as well as churches dedicated to S. Hipolito, S. Anastasio, S. Stefano de Campo, S. Maria de Arciones, and S. Giovanni in Pigna.[31] There were other properties along the Via Salaria and the Via Nomentana, near Porta S. Giovanni, and along the Via Latina.[32] Beyond Rome, the monastery was endowed with possessions in Sutri, Nepi, Gallese, Orte, Bomarzo, and other places in the Sabina.[33] From all this, it appears that S. Silvestro's property was very extensive. In the early fourteenth century, this rich monastery owned 180 houses in the area close by; and, apart from these, sometimes it leased for a small annual rent the ground on which other people built their homes.[34]

Popes Leo III (795–816), Gregory IV (827–844), and Nicholas I (858–867) donated precious liturgical vessels and textiles to S. Silvestro. Leo III gave a silver crown, as well as a Byzantine vestment to the major basilica and another to the oratory, showing that the monks at his time were Greek and there were two sanctuaries — the basilica or major church, and the oratory.[35] Similarly, Gregory IV donated two altar frontals, one for the church and one for the oratory.[36] Pope Nicholas I provided four curtains for the altar, five icons, and four gilded crosses.[37] In 856, there was a devastating flood in Rome, when water came into the church of Saint Dionysius at the monastery and, as a result, the steps leading into the church could not be seen properly.[38] Two years later, Nicholas I was elected Pope in the basilica of Saint Dionysius within the monastery.[39] Like the monasteries of SS. Cosma e Damiano in Mica Aurea and S. Maria in Capitolio, S. Silvestro was one of the twenty most important monasteries in Rome in the twelfth century.[40]

Life at the monastery was not always peaceful. Shortly after Pope Leo III was elected in 795, some family members of his predecessor, Hadrian I, ambushed him, and attacked him violently, as he was walking in procession along the Via Lata near S. Lorenzo in Lucina during one of the penitential Litanies.[41] They pursued him to S. Silvestro (Fig. 148), where they attempted to blind him and cut out his tongue, but he was saved from this fate, and, apparently, miraculously healed of

28 Ferrari, *Early Roman Monasteries*, pp. 304–05; Federici, 'Regesto', 22 (1899), pp. 265–81.
29 Federici, 'Regesto', 22 (1899), pp. 265–81 and Ferrari, *Early Roman Monasteries*, pp. 305 and 309.
30 Forcella, *Iscrizioni*, vol. x, p. 79, no. 149. See also, Gaynor and Toesca, *S. Silvestro in Capite*, p. 25.
31 Ferrari, *Early Roman Monasteries*, p. 309.
32 Sansterre, *Les Moines grecs et orientaux à Rome*, p. 93.
33 Sansterre, *Les Moines grecs et orientaux à Rome*, p. 93.
34 Hubert, 'Patrimoines immobiliers', pp. 133–75.

35 *LP*, vol. II, p. 22 and *LP*, vol. II, p. 11.
36 *LP*, vol. II, p. 79.
37 *LP*, vol. II, p. 153, for the curtains, and Giachetti, *Historia*, p. 44 for the icons and crosses.
38 *LP*, vol. II, p. 145.
39 *LP*, vol. II, p. 151.
40 Valentini and Zucchetti, *Codice topografico*, vol. III, pp. 361–62, 438–39.
41 Osborne, *Rome in the Eighth Century*, pp. 160–62, describes this and other violent struggles in Rome in the second half of the eighth century.

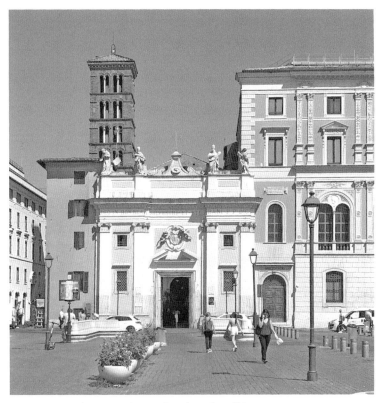

Figure 149. S. Silvestro in Capite, façade and twelfth-century bell tower from south (photo: author)

the effects of the attack.[42] He was held prisoner at S. Silvestro for a time, until he was transferred to the monastery of S. Erasmo on the Caelian Hill, from which he was set free by followers of the King of the Franks. He alluded to this incident in a speech he made just before he crowned Charlemagne Holy Roman Emperor in 800.[43]

During the Investiture Controversy, the Holy Roman Emperor Henry IV, who opposed Pope Gregory VII (1073–1085), came to Rome, marched up the Capitoline Hill, and then installed his alternative antipope Clement III, at the Lateran.[44] Pope Gregory stayed in the Castel Sant'Angelo until Robert Guiscard came to his defence in 1084.

The Norman troops entered the city from the north and came along the Via Lata, where they are reported to have completely destroyed the region around the churches of S. Silvestro and San Lorenzo in Lucina.[45] The monastery church was badly damaged at that time.

Shortly after the Investiture Controversy was settled in the Concordat of Worms in September 1122, Pope Calixtus II (1119–1124) re-consecrated the high altar of the church of S. Silvestro in 1123,[46] which suggests that the church had been repaired by then. His chamberlain, Alphanus, was probably involved in the restoration, for he gave gifts to S. Silvestro, including a new floor.[47]

A tall bell tower was built (Fig. 149) in the twelfth century, to judge by its masonry, in brickwork with a high modulus of 28–32 cm for five courses of brick and mortar, streaked with *falsa cortina* pointing. It has been attributed to Pope Innocent III (1198–1216), which would make it similar in date to that at S. Sisto (Fig. 7).[48] It rises in eight storeys, and a medieval bronze rooster, which once stood at the apex of the tower, has survived and is now in the chapel of the Pietà, where the reliquary of Saint John the Baptist is kept. On 30 October 1267, relics of Saint Dionysius (believed at that time to have been those of Saint Denis of Paris) were taken to the chapel of Saints Paul and Nicholas in the church and placed in the altar; they were later transferred to the altar of Saint John the Baptist.[49]

42 *LP*, vol. II, pp. 4–5.
43 Gaynor and Toesca, *S. Silvestro in Capite*, pp. 15–16.
44 *LP*, vol. II, pp. 282–92. See Kane, *The Church of San Silvestro*, pp. 50–51; Hamilton, 'Memory, Symbol, and Arson', pp. 378–99.

45 *LP*, vol. II, p. 290. They went on to the area near the Lateran, where they destroyed SS. Quattro Coronati and damaged San Clemente. See also, Wickham, *Medieval Rome*, pp. 108–09.
46 Krautheimer, *Corpus*, vol. IV, p. 151.
47 An inscription, cited by Severano, *Memorie sacre delle sette Chiese*, pp. 350–51, records this. For Alphanus and his connection with S. Maria in Cosmedin, which was also re-consecrated in 1123, see Osborne, 'The Tomb of Alfanus'.
48 Kane, *The Church of San Silvestro*, pp. 51–52, gives a date between 1191 and 1216, citing Serafini, *Torri campanarie*, pp. 216–17, but his dates are not always reliable. It was certainly built in the twelfth century.
49 Krautheimer, *Corpus*, vol. IV, p. 151, and Giacchetti,

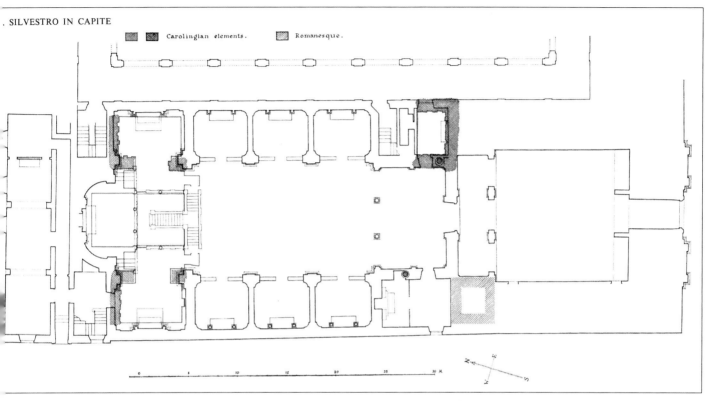

Figure 150. Spencer Corbett and Richard Krautheimer, Plan of S. Silvestro in Capite (Krautheimer, *Corpus*, vol. IV, 1970, Tav. IX)

At an unknown time, Latin monks replaced the Greek community at S. Silvestro. Sources from the late twelfth and thirteenth centuries reflect the change, a document dated 1277 clearly demonstrating that the monks were Benedictine.[50] Robert Brentano has argued that some surviving documents hint at the decline of the monastery in the second half of the thirteenth century.[51] In 1249, the abbey was in debt and its possessions had to be re-ordered by the Vicar of Rome, Cardinal Stefano Conti of S. Maria in Trastevere. Pope Clement IV (1265–1268) moved the abbot of S. Silvestro to the monastery of S. Gregorio in Rome, after which, between 1269 and 1277, there was no abbot at S. Silvestro, the monastery being governed only by a prior. At that time, there seem to have been only five or six monks. In 1277, the monk named Matteo from Subiaco was appointed abbot of S. Silvestro, only to be moved in 1279 to S. Paolo fuori le Mura. From 1283 to 1284, there was again no abbot. The Benedictines stayed at S. Silvestro until 1285. The last abbot, Arnolfo, was transferred to the Roman Benedictine monastery at S. Lorenzo fuori le Mura and the other monks were assigned to other monasteries of their Order.[52]

Historia, pp. 47–49.

50 Ferrari, *Early Roman Monasteries*, p. 309 n. 14, cites a text published in Federici, 'Regesto', 22 (1899), pp. 290–91, which explicitly says, '[...] Mathei abbatis venerabilis S. Silvestris de Capite in Urbe, ordinis s. Benedicti [...] sub anno Domini MCCLXXVII [...]' ([...] of Matteo the venerable abbot of S. Silvestro in Capite in Rome, of the Order of Saint Benedict [...] in the year of the Lord 1277).

51 Brentano, *Rome before Avignon*, pp. 239–41.

52 Gaynor and Toesca, *S. Silvestro in Capite*, p. 26.

The Church of S. Silvestro Today

The church of S. Silvestro today reflects changes made in the late sixteenth century by the architects Francesco da Volterra (1535–1595) and Carlo Maderno (1556–1629). It has its sanctuary slightly north-east and its entrance more or less south-west (Fig. 150). (Here, they will be referred to as in the north and south.) In front of the church there is now a courtyard, which was formerly an atrium. It is entered through an early eighteenth-century doorway with a frame carved in the Middle Ages (Fig. 149). The Baroque façade of the entrance to the courtyard has an attic and is articulated in three sections by pilasters. Above it stand statues of saints associated with the church — Silvester and Stephen; and the Franciscan founders, Francis and Clare.[53] There are also images on the façade in low-relief of the head of John the Baptist and the Holy Face of Christ. The courtyard is surrounded by small rooms on the east, south, and west sides. On the north, a double-storeyed narthex with a Baroque façade stands in front of the church, with the twelfth-century bell tower on the west. The upper storey of the narthex was originally built in the thirteenth century.[54] (At S. Sabina, there was also a double-storeyed narthex.[55]) The ceiling of the upper room at S. Silvestro is modern, and above it there is another room and a passageway to the north, with some frescoes high up on the northern wall of this corridor. This means that the room above the narthex was formerly very high.

When one enters the church of S. Silvestro, which is now magnificently decorated in Baroque style, one first walks under a deep organ loft, supported by two columns in the nave (Fig. 150). To the west is the chapel of the Pietà, where there is the reliquary containing part of the head of Saint John the Baptist and the bronze rooster from the apex of the campanile.[56] A narrow side entrance to the church gives access to this chapel. On the right of the main entrance to the church there is a small chapel dedicated to the Sacred Heart of Jesus (now the parish office), north of which a staircase used to lead up to the organ loft.[57] Beyond this part of the church, the nave is flanked by three rectangular chapels on either side, and then a transept, with a chapel at either end. The side chapels, which were sponsored by Roman families, have Baroque altar pieces and decoration in fresco, stucco, and gilding. At the crossing, there is a crypt, which was rebuilt in the early twentieth century. In the apse, the high altar stands in the centre, raised above the level of the nave, and set against a thick north wall. Stairs lead down into the crypt and, on either side of the sanctuary, steps ascend to the level of the altar. A barrel vault, with a magnificent fresco by Giacinto Brandi (1621–1691) of the *Assumption of the Virgin Mary*, covers the nave;[58] and over the crossing there is an unusual elliptical dome, with a fresco of *God the Father in glory in the heavens* by Cristofano (or Christoforo) Roncalli, called 'Il Pomerancio' (1552–1626).[59]

Behind the sanctuary, a corridor runs from east to west with three doorways leading into a long sacristy. Along the eastern side of the church is a courtyard, one side of which is included on the plan (Fig. 150). This was the western ambulatory

53 For the iconography of this façade, see Kane, *The Church of San Silvestro*, pp. 13–25.

54 In the 1970s and 1980s, one could see that a part of the west wall of the upper floor was built of *opus sarcinescum*, typical of thirteenth-century construction in Rome, but this masonry has now been covered with plaster.

55 See above, Chapter 2.

56 The reliquary of the relic of Saint John the Baptist is discussed in Toesca, 'Il reliquario'. For the rooster, see Kane, *The Church of San Silvestro*, p. 51, who gives a date for it in the twelfth century.

57 Kane, *The Church of San Silvestro*, p. 100, explains that there is an inscription, stating that the organ loft and the organ were installed in 1686, although the present organ was made by Jules Anneessens (1876–1956).

58 Kane, *The Church of San Silvestro*, pp. 82–84.

59 Kane, *The Church of San Silvestro*, p. 76.

of one of the two cloisters of the nunnery, as restructured in the eighteenth century. In 1849, the Poor Clare nuns of S. Silvestro had to leave their convent, but they returned soon afterwards. The law, which suppressed religious Orders in Rome, led to their expulsion in 1876, when they went to live at S. Cecilia in Trastevere. The Italian Government took over the conventual buildings at S. Silvestro and eventually established Rome's General Post Office in the convent. In 1885, the church, with the living quarters and offices around the courtyard in front, were ceded to the priests of Saint Vincent Pallotti, of the Society of the Catholic Apostolate, to serve as the national church for English residents and pilgrims in Rome. It still has a congregation that is bilingual in English and Italian.

Archaeological Evidence

There have been no scientific excavations on this site, but in 1906–1908, Father William Whitmee, SAC (Society of the Catholic Apostolate), who was then rector of S. Silvestro, constructed a deep crypt between the high altar and the nave of the church. In doing so, he revealed some of the foundations of the eighth-century building, which can now be viewed in the crypt. Krautheimer discussed them in his study of the church of S. Silvestro in 1970, which included a survey plan drawn by Spenser Corbett (Fig. 150).[60] Krautheimer's analysis of the archaeological and architectural evidence for the early medieval church is particularly interesting.[61] The foundations of the early medieval north wall to the west and east of the high altar are marked on Corbett's plan. The foundations were made of large blocks of tufa (Fig. 151). This masonry is typical of foundation walls built in the eighth and ninth centuries in Rome. Hence, these walls

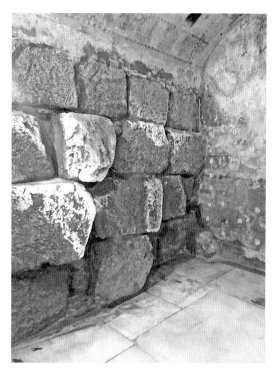

Figure 151. S. Silvestro in Capite, crypt, eighth-century wall built of large blocks of tufa (photo: author)

can be identified as belonging to the church built by Pope Paul I. At right angles to them are similar blocks, on either side of the 'confessio', forming the foundations of two piers. There are also foundations of an arch, parallel to the north wall and in line with the blocks indicating the two piers. Traces of the foundations of two colonnades running in a north–south direction are also visible in the crypt.

At the south-eastern corner of the church, under the parish office, there is a small cellar, where Krautheimer found further signs of the early medieval building on its south, east, and west sides (Fig. 150). The south wall is directly below the present façade wall of the church and the east wall stands below the church's present east wall. The wall on the west of the cellar is aligned with the presumed eastern colonnade of the early church. These discoveries indicate that the perimeter walls of the eighth-century building stand directly below the perimeter

60 Krautheimer, *Corpus*, vol. IV, pp. 148–62, and Plate IX.
61 Krautheimer, *Corpus*, vol. IV, pp. 154–56.

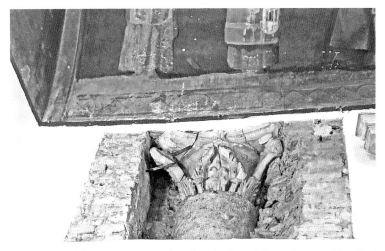

Figure 152. S. Silvestro in Capite, chapel of the Sacred Heart (now parish office), column and capital from the eighth-century church (photo: author)

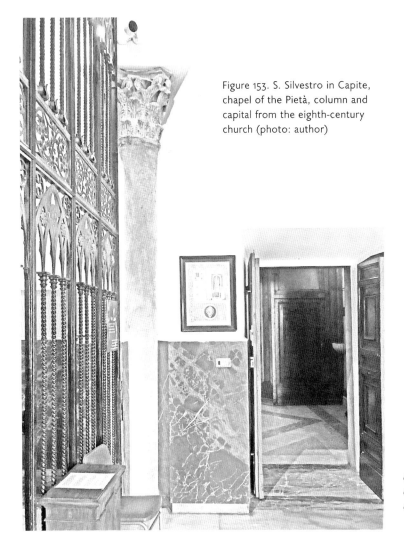

Figure 153. S. Silvestro in Capite, chapel of the Pietà, column and capital from the eighth-century church (photo: author)

walls of the present church. The overall length and width of the two successive buildings are the same. The nave is now flanked by chapels, which fill the space formerly occupied by the aisles of the early medieval church.

There are two columns, one on the east, accessible in the parish office (Fig. 152), and another further to the north on the west, visible in the Chapel of the Pietà (Fig. 153). These columns appear to survive from the earlier basilica in their original positions. Their shafts are of grey granite and they sustain Corinthian capitals. They stand in line with the foundations discovered on either side of the 'confessio' in the crypt. Moreover, in the present church, the two columns which sustain the north wall of the organ loft (Fig. 150) seem also to have come from the early medieval church, but they have been moved to different places, on a higher level.

Krautheimer reconstructed the eighth-century nave and aisles from this evidence.[62] The church was a basilica, with a nave *c.* 33 m long and *c.* 10 m wide, flanked by an aisle on either side, *c.* 5 m wide. Separating the nave and aisles were columns, 4.40–4.50 m high, including bases, columns and Corinthian capitals. From traces of sheets of marble visible in the crypt, the early medieval floor level can be assumed to have been between 0.90 m and 1.00 m below that of today. The location of the campanile in the south-west corner of the narthex shows that the church originally faced south, as it does today. (This is in some ways like the monastic church of S. Maria in Capitolio, as reconstructed by Claudia Bolgia.)[63] On the north, the church of S. Silvestro has been restructured, but it is most likely that there was originally a semi-circular apse — decorated with the mosaics, different kinds of marble inlay, gold, and silver, mentioned in the *Liber Pontificalis*.[64] On the west, in the chamber that gives access

62 Krautheimer, *Corpus*, vol. IV, pp. 157–58.
63 See above, Chapter 5.
64 *LP*, vol. I, p. 464.

to the corridor and sacristy behind the church, there is a curved wall, in which there is a small metal door. This may have been part of the rota, or turn, of the nuns, before the changes made to the church in the sixteenth century.[65]

The Colonna Family founds the Franciscan Nunnery at S. Silvestro in Capite

Giovanni Colonna (Senator of Rome in 1261–1262, 1279–1280, and 1290–1291) and his brother, Giacomo Colonna (appointed Cardinal Deacon of S. Maria in Via Lata in March 1278), transformed S. Silvestro into a nunnery of the Franciscan Order of 'Sorores minores inclusae' (Enclosed Sisters Minor) in 1285, in honour of their sister Margherita Colonna (*c*. 1255–1280), who had established a small private and informal community of Franciscan women at Mount Prenestino, above Palestrina.[66] Probably in order to promote her cause for canonization, two biographies were written of Margherita — one by her older brother, Giovanni, composed between 1281 and 1285; the other by one of the early Sisters of S. Silvestro, Stefania, dated between 1288 and 1292.[67] (Giovanni is represented on the mosaic from the Colonna Chapel at S. Maria in Aracoeli, now at Palazzo Colonna [Plate 8].[68]) It was unusual in the thirteenth century for a layman like Giovanni to author such a work, whereas some nuns did compose short biographical works, such as the *Miracula Beati Dominici* (Miracles of Saint Dominic) by Sister Cecilia of S. Sisto.[69]

Giovanni gives details of his sister's life.[70] Because their father died when she was only an infant, he, as her older brother, became her guardian.[71] When he wanted to arrange for her to marry a prominent Roman nobleman, she was persuaded by her other brother, Cardinal Giacomo Colonna, to consider a life of consecrated virginity. She experienced a vision of the Blessed Virgin Mary, who confirmed this idea and helped her put it into practice in the power of the Holy Spirit. She began to practise rigorous self-denial and to keep long vigils of prayer. She remained deeply devoted to the Mother of God, who appeared to her on other occasions and guided her in her spiritual life.

As part of her penance, she wore a hair shirt under her normal clothes. After some time, she put aside her secular dress and wore clothes that 'conformed in all regards to the habit of the Sisters of the Blessed Clare, except that she wore an exterior cloak'; she also cut off her hair, in this way expressing her commitment to her consecrated state of life. She took Saint Clare as her model.[72] According to Giovanni, she put on the Franciscan habit after a vision in which she heard a sermon based on Christ's words, 'If any man will come after me, let him deny himself, and take up his cross, and follow me' (Matthew

65 Father Rory Hanly, SAC, who is now Rector of S. Silvestro in Capite, pointed out this feature. The rota or turn is discussed more fully below.

66 For the foundation of the nunnery, *Visions of Sainthood in Medieval Rome*, pp. 45–48, 144–54; Rehberg, *Kirche und Macht*, pp. 42–44; Rehberg, 'Nobiltà e monasteri femminili nel Trecento', pp. 407–17.

67 Published in Latin by Oliger, *B. Margherita Colonna († 1280): Le due vite*; translated into English by Sean L. Field in *Visions of Sainthood in Medieval Rom*, ed. by Knox and Field, pp. 65–143 (*Vita* I by Giovanni) and pp. 155–90 (*Vita* II by Stefania). See also, Barone, 'Margherita Colonna e le Clarisse'; Barone, 'Le due vite di Margherita Colonna'; and Lopez, 'Between Court and Cloister'.

68 See above, Chapter 5.

69 Published in Cecilia, *Miracula Beati Dominici*.

70 Lopez, 'Between Court and Cloister', pp. 555–64, suggests that Giovanni placed her in the social context of the baronial families in Rome, stressing her generous almsgiving — from what would have been her dowry — her humility, and her links both to the Roman nobility and to the Franciscan Order.

71 In what follows, information is taken from the translation of his *Vita* of Margherita by Giovanni in *Visions of Sainthood in Medieval Rome*, trans. by Field, ed. by Knox and Field, pp. 65–143.

72 *Visions of Sainthood in Medieval Rome*, trans. by Field, ed. by Knox and Field, pp. 89–90 and notes 131 and 132.

16. 24 and Luke 9. 23); and 'she associated the one preaching this passage with the blessed Francis [since] the image of the likeness of this father showed a similar habit'.[73] After the sermon, the preacher gave Margherita a red stone cross, which she placed near her heart, where it remained fixed to her chest. The authors of *Visions of Sainthood in Medieval Rome* suggest that the image mentioned in this incident referred to the famous fresco of Saint Francis in the medieval monastery at Subiaco.[74] The iconography seems closer, however, to the painting now in the cell of Saint Francis at S. Francesco a Ripa, where Francis carries a book inscribed with the Gospel text that is quoted and holds a red cross close to his chest (Plate 5).[75] Margherita then took Saint Francis as a model as well as Saint Clare. She began to preach, and she made herself poor: 'she, the very least of the *minores*, served the poor of Christ and the servants of Christ just as he [Francis] had'.[76]

Margherita began to do charitable works of mercy — feeding the hungry, clothing the poor, and supporting pilgrims and strangers, as well as offering them a place to stay if they needed it.[77] She looked after the sick and visited them in their homes. She also went to Zagarolo to take care of the Friars Minor there, when they needed help. She assisted a woman who was a leper, whom she kissed, in a work of mercy characteristic of Saint Francis, and after looking after the leper's immediate needs, she arranged for her to be cared for by others in a leprosarium in Campania.[78]

She persuaded her brothers to let her go and live in Vulturella (modern Mentorella), where there was a shrine of the Virgin Mary.[79] By this time, she had been joined by some companions who followed her way of life. Her plan was to live at Vulturella as an oblate. When that project failed, she discerned with the help of the Mother of God that she and her companions should leave that place. She then went to Rome (on her own), where she served an elderly woman named 'Lady Altrude of the Poor', described as 'a poor woman of Christ'.[80] When Margherita arrived in Rome, she went to St Peter's at night to see the icon of the *Veronica*, the Holy Face of Christ.[81] She spent some time with Lady Altrude, who was accustomed to attend the dawn Mass and Office at the church of the Friars Minor. (This could have been either at S. Francesco a Ripa or at S. Maria in Aracoeli.) Margherita worked humbly in Altrude's house, sweeping the floor, washing the dishes, and doing the normal chores of a housemaid. By this she demonstrated both humility and obedience. Giovanni suggests that Margherita advanced in both the contemplative and the active life at this time.[82]

After many days, Margherita returned to the Colonna home at Monte Prenestino, where she began to suffer from an ulcer on her leg, which would lead to her early death at the age of twenty-five.[83] As she prepared to die, Margherita, herself now 'a poor woman of Christ', had no possessions to leave to others; however, she entrusted the companions who had gathered

73 See, *Visions of Sainthood in Medieval Rome*, trans. by Field, ed. by Knox and Field, p. 90.
74 *Visions of Sainthood in Medieval Rome*, trans. by Field, ed. by Knox and Field, pp. 90–91 and n. 135.
75 See above, Chapter 3.
76 *Visions of Sainthood in Medieval Rome*, trans. by Field, ed. by Knox and Field, p. 91.
77 *Visions of Sainthood in Medieval Rome*, trans. by Field, ed. by Knox and Field, pp. 93–97. These are among the corporal works of mercy.
78 *Visions of Sainthood in Medieval Rome*, trans. by Field, ed. by Knox and Field, pp. 96–97.

79 *Visions of Sainthood in Medieval Rome*, trans. by Field, ed. by Knox and Field, pp. 99–106.
80 *Visions of Sainthood in Medieval Rome*, trans. by Field, ed. by Knox and Field, pp. 106–10.
81 *Visions of Sainthood in Medieval Rome*, trans. by Field, ed. by Knox and Field, p. 107. This icon is discussed more fully below.
82 *Visions of Sainthood in Medieval Rome*, trans. by Field, ed. by Knox and Field, p. 110 and n. 211.
83 *Visions of Sainthood in Medieval Rome*, trans. by Field, ed. by Knox and Field, pp. 110–33.

around her to her brother, Cardinal Giacomo.[84] After receiving extreme unction, she blessed each member of her family and each of her companions.[85] She died on 30 December 1280 (the vigil of the feast of Saint Silvester) and was buried in the local church at Monte Prenestino, in her Franciscan habit. Her funeral was attended by members of her family, her companions, many Friars Minor, and many of the poor people she had served. Her tomb was placed opposite an image of the Mother of God in the church. Her holiness was confirmed by the miracles that took place there.

In Giovanni's narrative, Margherita appears to be a woman who did many charitable works for the poor. This aspect of her life was characteristic of certain 'semi-religious' women, who looked after the poor rather than pursuing a life of contemplation in a strictly enclosed nunnery. Although the contemplative life of an enclosed nun was considered superior in the Middle Ages to the active life of these holy women, it seems Margherita preferred serving the poor in humility and obedience to living in an enclosed monastery. In spite of this, it is clear in the *Vita* written by Giovanni that her brothers thought she should either have joined the monastery of Saint Clare in Assisi (they arranged for her to go there, but this proved impossible because she became ill) or she should have founded her own enclosed contemplative nunnery.[86] Her brothers, Giovanni and Giacomo, with the assistance of Pope Honorius IV Savelli (1285–1287) and Jerome of Ascoli — Minister General of the Franciscan Order from 1274 to 1278 and, from 1281 to 1288, Cardinal of Palestrina — then established the monastery at S. Silvestro in Capite, accomplishing what, in their opinion, she had desired but failed to do. They also provided for her companions and for later nuns by setting up the nunnery.

Margherita's companions moved from Palestrina to Rome to become the first nuns at S. Silvestro in Capite five years after her death. The new foundation was ratified by Pope Honorius IV in three Bulls, dated 24 September 1285, 9 October 1285, and 2 November 1285.[87] In the first of these documents, the Pope praised Margherita Colonna because, 'despising riches and the grand rank to which she was born, and scorning the other enticements of the world, [she] prudently chose humbly to serve the poor Christ in poverty'.[88] She had formed her followers into a 'family' whose members wore the Franciscan religious habit although they did not follow a specific religious Rule. The Pope therefore acceded to their request to live in a nunnery, like 'an enclosed fortress', and to follow the Rule of the Order of Enclosed Sisters Minor. The Cardinal Bishop of Palestrina, Jerome of Ascoli, had accepted their religious profession at Monte Prenestino and they had elected Herminia as their abbess. Honorius IV explained to her how the new monastery of S. Silvestro in Capite came to be founded:

> [...] desiring to consider the pressing need for an appropriate location [...] we have decided to grant to you the Monastery of San Silvestro in Capite in the city [of Rome],

84 *Visions of Sainthood in Medieval Rome*, trans. by Field, ed. by Knox and Field, p. 130.

85 Giovanni recounts her last days, funeral, and entombment, in *Visions of Sainthood in Medieval Rome*, trans. by Field, ed. by Knox and Field, pp. 125–36.

86 *Visions of Sainthood in Medieval Rome*, trans. by Field, ed. by Knox and Field, pp. 100–01 (for the plan to go to Assisi and join the monastery of Saint Clare) and pp. 92, 99–100, 106 (for references to a plan to establish a nunnery, which she did not do).

87 The three Bulls, the first, *Ascendit fumus aromatum*, dated 24 September 1285, the second, *In mandatorum suorum*, dated 9 October 1285, and the third *Nuper dilectae in Christo Filiae*, dated 2 November 1285, are published in Latin in *BF*, vol. III, pp. 544–46, 548–49, and 549–50. They are published in English translation in *Visions of Sainthood in Medieval Rome*, trans. by Field, ed. by Knox and Field, pp. 145–54.

88 *Visions of Sainthood in Medieval Rome*, trans. by Field, ed. by Knox and Field, p. 146.

which is in the immediate grant of the Roman Church. Previously [it pertained] to the Order of Saint Benedict, [but it is] now empty because its abbot has been removed to the Monastery of San Lorenzo of the same Order beyond the walls of the city, while the monks of the monastery have been settled elsewhere as we have thought beneficial to their salvation [...] We have decided [...] in a specific benefit, to grant to you the monastery together with its homes, gardens, vineyards, land, farms, chattels, vassals, and all other goods, privileges, immunities, and all else pertaining thereto, and all rights whatever, decreeing that the monastery moreover shall be called the Monastery of San Silvestro in Capite of the Order of the 'Sorores minores inclusae' (Enclosed Sisters Minor), and that your same Order shall be observed there in perpetuity; and you as well as those who will come after you in the same monastery, shall freely be able to use all privileges, indulgences, immunities, and benefits granted to your same Order by the Apostolic See; and that this same Monastery of San Silvester shall remain directly subject to the Roman Church, as it has been.

We desire as well that four Friars of the Order of 'Minores', proven through long service, shall remain continuously at the monastery to perform the solemnities of the divine office for you as well as the sacraments of the Church.[89]

This Bull was signed by the Pope and twelve cardinals, including Jerome of Ascoli, Cardinal Bishop of Palestrina (and former Minister General of the Franciscan Order), Latino Malabranca, Cardinal Bishop of Ostia and Velletri (a Dominican, who helped in the foundation of S. Maria sopra Minerva); Giacomo Colonna (Cardinal Deacon of S. Maria in Via Lata and the brother of Margherita Colonna); and Benedetto Gaetani (future Pope Boniface VIII, who later became a fierce enemy of the Colonna family).

Attached to a second Bull of 9 October 1285, Honorius IV sent the nuns an official, papally approved copy of the 'Rule of the Order of Enclosed Sisters Minor'.[90] This was the Rule of Isabelle of France, written in Paris with help from leading Friars Minor, such as Bonaventure, William of Harcombourg, William of Meliton, Eudes of Rosny, and Geoffrey of Vierson; Popes Alexander IV and Urban IV had approved this Rule in two versions, in 1259 and 1263.[91] Although written with the assistance of eminent friars, the Rule was essentially the work of Isabelle of France, the daughter of King Louis VIII and Blanche of Castille and sister of King Louis IX.[92] Isabelle was not a nun, but she lived at the nunnery she founded at Longchamp near Paris for the last ten years of her life. The version of the Rule copied out for the nuns at S. Silvestro was the second recension of 1263. There were some differences between the two versions.[93] Places in the nunnery mentioned rather vaguely in the first Rule, were specified clearly in the second; the role of serving sisters was clarified; Sisters who went to help establish another monastery were able to return to the original one; the Sisters were to be called 'Sorores minores' (Sisters Minor); and, most importantly, the links between the nuns and the male Franciscan Order were strengthened. Some details were practical but perhaps less important: a statement, which appears in the 1259 Rule, that 'no animal may be kept within the

89 Translation from *Visions of Sainthood in Medieval Rome*, trans. by Field, ed. by Knox and Field, pp. 147–48.

90 *Visions of Sainthood in Medieval Rome*, trans. by Field, ed. by Knox and Field, pp. 150–52.

91 *The Rules of Isabelle of France* gives the history of these Rules and an English translation of them by Sean L. Field.

92 See Sean L. Field's introduction to *The Rules of Isabelle of France*; and, more recently, Field, 'Douceline of Digne and Isabelle of France', esp. 91–98.

93 Summed up in *The Rules of Isabelle of France*, ed. and trans. by Field, pp. 25–27.

enclosure, except for cats', is omitted in the 1263 Rule.[94] The Rule of Isabelle has some interesting general features. Each nun was to 'live always in obedience and chastity and without property and, like the hidden treasure of a glorious king, remain enclosed her entire life'.[95] While the Rule insisted on personal poverty, the nuns were 'permitted to receive in common revenues and possessions, and to retain them'; and a Procurator was to be appointed to manage the possessions of the monastery.[96] This communal property was considered necessary for funding enclosed convents, even though it seems to contradict the Franciscan ideal of poverty. (In the case of S. Silvestro, the earlier monastery had had extensive possessions, only some of which were ceded to the nunnery by Honorius IV.) The Abbess was to be elected and there was provision for an elected 'President' to take her place, when for some serious reason she was unable to fulfil her office.[97] Isabelle, like Margherita, was deeply devoted to the Mother of God and she stressed the Virgin Mary's virtue of humility. In fact, the original name of the nunnery at Longchamp was the 'Monastery of the Humility of Blessed Mary' and in the first version of the Rule, the Sisters were called 'Sorores Ordinis Humilium Ancillarum Beatissimae Mariae Virginis Gloriosae' (Sisters of the Order of Humble Handmaids of the Most Blessed Glorious Virgin Mary).[98] Humility was a key virtue in the Rule, linked to the Franciscan concept of 'minoritas', of seeking to be less important, or minor. In the second version of the Rule, the Sisters were to be called 'Sorores minores', just as the Friars were called 'Fratres minores'.[99] The Franciscan character of the Rule was further stressed in that the Visitor and the priests who celebrated Mass and heard confessions should be Friars Minor, and both nuns and friars should be under obedience to the Minister General and Provincial Minister of the Franciscan Order.[100] (The four friars at S. Silvestro stipulated by Honorius IV also recalled the four required by Saint Dominic to reside at S. Sisto to serve the temporal and spiritual needs of the Dominican nuns.)

In a third Bull issued on 2 November 1285, Honorius IV conceded that a greater number of Friars could be assigned to the monastery, making a total of six or more.[101] (In the Catalogue of Turin, c. 1320, there were two friars at S. Silvestro, as at S. Cosimato.[102]) This third Bull was given at S. Sabina, near which Honorius IV's palace was located.[103]

Cardinal Giacomo Colonna, who was recognized as the founder of the monastery and its first Protector from 1285 to 1297, drew up Constitutions for the nuns of S. Silvestro, probably between 1288 and 1297, setting out how their religious way of life should be carried out in practice.[104] First, the Cardinal stressed the importance of reciting the Divine Office

94 *The Rules of Isabelle of France*, ed. and trans. by Field, [40] pp. 94–95. As a comparison, one may note that at the General Chapter of the Friars Minor at Narbonne in 1260, it was stipulated that no friar and no place could have an animal, except to control mice, which Bihl says means 'such as a cat', see Bihl, 'Documenta', p. 49, no. 23.

95 *The Rules of Isabelle of France*, ed. and trans. by Field, [1] p. 61.

96 *The Rules of Isabelle of France*, ed. and trans. by Field, [58], pp. 104–07.

97 *The Rules of Isabelle of France*, ed. and trans. by Field, [54] and [56], pp. 102–05.

98 *The Rules of Isabelle of France*, ed. and trans. by Field, pp. 32–33.

99 There were earlier groups who took that name, but the Friars at first were not keen that they should.

100 *The Rules of Isabelle of France*, ed. and trans. by Field, [43], pp. 96–97; [51], pp. 100–01; [55], pp. 102–05.

101 *Visions of Sainthood in Medieval Rome*, trans. by Field, ed. by Knox and Field, pp. 152–54.

102 Valentini and Zucchetti, *Codice topografico*, vol. III, p. 293.

103 See above, Chapter 2.

104 Published from a copy in Perugia, Bibliotheca Municipalis, codex E 58, dating to the fifteenth century, in Oliger, 'Documenta originis Clarissarum', pp. 99–102; before the actual text, at pp. 83–86, Oliger introduced the document, saying he believed the Constitutions were composed between 1288 and 1297.

correctly. Then he gave rules about always keeping silence in the dormitory; when the bell rang to get up, no one was to remain in bed or stay in the dormitory, except for those who were sick and those looking after them. In the refectory, there was to be 'summum silentium' (complete silence) during meals. The nuns were to listen to readings as they ate, and 'ut divina lectio diligentius audiatur' (so that the divine reading may be heard more diligently), he ordered 'quam non legi, sed cantari' (that it should not be read but it should be sung).[105] The cellarers were to be in charge of what food was procured and eaten. Communication with those outside the monastery was to be made through a rota or turn, where there was a Sister who kept watch. When speaking with people from outside the monastery, a Sister was obliged to be accompanied by two others who could hear the conversation. No Sister was to linger near the turn and listen to what was said there, except when that was necessary. No objects were to be passed through the rota, from the interior to the exterior, or vice versa. Holy Communion was to be received 'per hostiolum cratium' (through the 'little gate' in the grille).[106] This was to be opened only when the Sisters received Communion and when they needed to hear the word of God — probably a sermon commenting on a biblical text — but otherwise it was to remain closed. A later note was added at the end of the document, which was obviously a copy of the original Constitutions, that mentioned the nuns taking an oath at Our Lady's altar on 11 November 1322 and swearing that the community would receive no more than forty nuns, and refuse to take any more, unless the daughter of an emperor, or king, or other high-ranking noble were to apply.[107]

In 1288–1292, Stefania, who had known Margherita Colonna and who claimed to have presided over a group of Sisters, perhaps either as abbess or as 'President' at S. Silvestro, wrote a new biography of her, with a prefatory letter addressed to Cardinal Giacomo Colonna.[108] Stefania's account confirmed that of Giovanni and sometimes corrected details in that earlier narrative. She highlighted the miracles and the death of Margherita. This gives the impression that the work was commissioned with the intention of seeking Margherita's canonization or at least of promoting her cult. Moreover, in her text, Stefania followed the Bulls of canonization of Saint Elizabeth of Hungary and of Saint Francis in parts of her narrative.[109] In Parts 3–5, Stefania gave her personal recollections of Margherita. She described her as a candle set on a candlestick, which gave light to those around her.[110] For this reason, Stefania stated that she herself 'sought out this modest, pure, and holy woman' and became one of her followers, eventually entering the monastery of S. Silvestro to become a nun. She noted how Margherita ate sparingly because

105 Oliger, 'Documenta originis Clarissarum', p. 100.
106 Oliger, 'Documenta originis Clarissarum', p. 102. This is also described in *The Rules of Isabelle of France*, ed. and trans. by Field, [29], pp. 82–83. See, Jäggi, *Frauenklöster*, pp. 185–89 for different types of grated windows in nuns' churches and convents, and her fig. 199, with an example of a small opening in a larger iron grille. See also, fig. 101, in Chapter 4 above.
107 Oliger, 'Documenta originis Clarissarum', p. 102; Brentano, *Rome before Avignon*, p. 246; Rehberg, 'Nobiltà e monasteri femminili nel Trecento', p. 413, comments that this shows the social pretensions of the nuns.
108 *Visions of Sainthood in Medieval Rome*, trans. by Field, ed. by Knox and Field, pp. 24–31; text: 155–90. The authors showed how Stefania based her narrative on her own recollections, but often also on other sources. Lopez, 'Between Court and Cloister', pp. 568–73, suggested Stefania stressed Margherita's spiritual teaching, preaching and miracles, from a convent perspective. For the idea of having a Sister as a 'President' or 'second in command' see *The Rules of Isabelle of France*, ed. and trans. by Field, [56], pp. 104–05.
109 *Visions of Sainthood in Medieval Rome*, trans. by Field, ed. by Knox and Field, pp. 27–31.
110 *Visions of Sainthood in Medieval Rome*, trans. by Field, ed. by Knox and Field, p. 162.

fasting was a very strong weapon against the temptations of the devil. Margherita was filled with compassion and moderation in dealing with her companions; she was characterized by spiritual joy, and she delighted in charitable works, such as feeding the poor. Armed with spiritual defences against the devil, she was also inspired by the Holy Spirit with wisdom and revelation. Stefania recorded a vision (also reported by Giovanni), in which Margherita saw three roads and then took the most arduous one so as to leave the world and to fly like a pure dove 'to those lands that Christ, the Sun of Justice, looks upon and illuminates, overflowing with the fruits of virtue where none had gone before her and few were following far behind'.[111] After recounting many miracles, Stefania ended with a description of Margherita's death in 1280.

Five years later, Margherita's companions, including Stefania, came from Monte Prenestino to Rome to establish the new monastery of the Order of Enclosed Sisters Minor. Fra Mariano of Florence (c. 1477–1523) in 1518 mentioned Margherita Colonna among the saints buried at S. Silvestro.[112] In another work, published a year later in 1519, he stated that, 'when the holy body [of Margherita] entered the city of Rome, and neared the area called Colonna, all of San Silvestro's bells resounded, although no mortal hand had pulled them, only angelic force'.[113] (Since Fra Mariano took other parts of his account from Stefania's life of Margherita Colonna, it is possible that this story derives from that work, where the final section of the text is now missing.[114]) Ottavio Panciroli repeated the story when he mentioned that the remains of Margherita were brought to Rome and that, as her body came close to the church of S. Silvestro, all the bells began to ring of their own accord; he also noted that, on that occasion, the church and the monastery had been restored.[115] Margherita's brothers, Giovanni and Giacomo Colonna, founded the nunnery and it is most likely they had work done on the buildings before the nuns moved in. It is probable that Margherita's body was translated to a tomb located in a chapel, built c. 1290 by the Colonna family in the east transept of the church.[116] S. Silvestro was close to the Column of Marcus Aurelius, one of the most famous columns in Rome, in the 'Regione Colonna' of the city. Now there was a Colonna 'family' monastery of enclosed nuns, with a Colonna family chapel in the church.

It is clear that the Colonna brothers and young Cardinal Pietro Colonna — Giovanni's son and Giacomo's nephew — were hoping that Margherita would be canonized as a Colonna saint. Several women of their immediate family, and also women of other related baronial families in Rome, became nuns at S. Silvestro. Rehberg has pointed out that, when Cardinal Giacomo died, and Pope John XXII on 13 August 1318 appointed Cardinal Pietro Colonna Protector of the nuns at San Silvestro, he mentioned how Cardinal Giacomo and Giovanni Colonna had wanted the monastery to be conceded to them by apostolic authority for the daughters of the same Giovanni and the nieces of the Cardinal and of Giovanni, as well as other women of the same clan. There were also the daughters and nieces of some other people associated with the family and the descendants of their relatives. Thus far, the Pope noted, there had been more than twelve Colonna Sisters who had served the Lord in the same monastery.[117] For this reason among

111 *Visions of Sainthood in Medieval Rome*, trans. by Field, ed. by Knox and Field, pp. 164–65.
112 Mariano da Firenze, *Itinerarium Urbis Romae*, p. 215.
113 *Visions of Sainthood in Medieval Rome*, trans. by Field, ed. by Knox and Field, p. 204, citing Mariano da Firenze, *Libro delle degnità*, ed. by Boccali, p. 237, translated by Lezlie S. Knox.
114 See comments in *Visions of Sainthood in Medieval Rome*, trans. by Field, ed. by Knox and Field, pp. 202–03.

115 Panciroli, *Tesori nascosti*, 1625 edn, p. 392.
116 This chapel is discussed in more detail below.
117 *BF*, vol. v, pp. 156–57; Rehberg, *Kirche und Macht*, p. 44; Rehberg, 'Nobiltà e monasteri femminili nel Trecento', p. 408.

others, Rehberg thought S. Silvestro in Capite was truly a 'Hauskloster' (a family convent).[118] He also studied the documents pertaining to the convent and found that most of the nuns were in fact of high social rank and many of them were from Roman baronial families, and, in particular, from the Colonna and those who supported them.

Unfortunately, the Colonna family came up against strong opposition from Pope Boniface VIII Gaetani (1294–1303).[119] After Giovanni Colonna died in 1292, tensions between the Colonna and Gaetani families intensified. Matters came to a head when Stefano Colonna — Giovanni's son, Cardinal Giacomo's nephew, and Cardinal Pietro's brother — ambushed a papal mule train and stole a large sum of money. Although the Colonna cardinals condemned this act and returned what had been stolen, the Pope demanded extra funds in restitution, which the Colonna refused to pay. Then the two Colonna cardinals denounced the actions of Boniface VIII and demanded an investigation into the legitimacy of his claims to the papacy. This led to their being stripped of their office as cardinals in May 1297. Boniface declared them enemies of the city of Rome and excommunicated them. He declared a crusade against the Colonna family and his troops destroyed their homes in Rome, around Palestrina, and elsewhere. The two former cardinals were imprisoned in Tivoli.

Boniface VIII also moved against the monastery of S. Silvestro in Capite, where the abbess was then Giovanna Colonna — daughter of Giovanni, niece of Cardinal Giacomo, and sister of Cardinal Pietro Colonna. Boniface removed Giovanna Colonna from office and decreed that the nuns should no longer have Giacomo Colonna as their Protector; he appointed Cardinal Matteo of Aquasparta (formerly Minister General of the Franciscan Order) to make changes in the personnel governing the nunnery.[120] The nuns were no longer to be members of the Order of Enclosed Sisters Minor, following the Rule of Isabelle, but to become members of the Order of Saint Clare and to follow the Rule of Urban IV. When the nuns resisted, they were excommunicated and some of the nunnery's property was expropriated by the Pope.

There was at the same time a political crisis between Pope Boniface VIII and King Philip IV of France. On 7 September 1303, the agents of the French king kidnapped Boniface VIII at Anagni, and during an altercation, Sciarra Colonna, who was assisting the French, struck the Pope. This violent act of aggression is known as 'the outrage of Anagni'. After that, Boniface VIII remained in prison for two days, and, when he was released, he returned to Rome, but he died shortly afterwards, on 11 October 1303.

His successor was Pope Benedict XI (1303–1304), who was a Dominican and is known to have been sympathetic to the nuns of his own Order. At the request of the Franciscan nuns, he rescinded the decrees of Boniface VIII regarding the monastery of S. Silvestro.[121] He lifted the penalty of excommunication and annulled the sentence passed against the Sisters; he allowed them to live according to the Rule of Isabelle; and he returned the property taken from the nunnery. His successor, Clemente V (1305–1314)

118 Rehberg, *Kirche und Macht*, p. 44; Rehberg, 'Nobiltà e monasteri femminili nel Trecento', p. 408.

119 See, *Visions of Sainthood in Medieval Rome*, trans. by Field, ed. by Knox and Field, pp. 52–58, 191–98.

120 Two Bulls of Boniface VIII effected the changes: *Generalis ecclesiae regimini*, 11 December 1297 and *Ad apicem apostolicae*, 5 April 1298, published in Latin in *BF*, vol. IV, pp. 456–57 and 468–69; and in English translation in *Visions of Sainthood in Medieval Rome*, trans. by Field, ed. by Knox and Field, pp. 192–95 and 196–98. The tomb of Cardinal Matteo of Aquasparta is in the transept of S. Maria in Aracoeli, near the Colonna Chapel in that church, as noted above in Chapter 5.

121 See the Bull, *Dudum felicis recordationis*, 23 December 1303, published in Latin in *BF*, vol. v, pp. 8–9; and in English translation in *Visions of Sainthood in Medieval Rome*, trans. by Field, ed. by Knox and Field, pp. 198–201.

re-instated the two Colonna cardinals in 1306. After a short time in Rome, Clement V moved to Avignon with the papal court in 1309. When the Catalogue of Turin was written *c.* 1320, there were thirty-six nuns at S. Silvestro in Capite and two Franciscan friars.

S. Lorenzo in Panisperna

It is interesting briefly to compare the history of S. Silvestro in Capite with that of another Colonna foundation, S. Lorenzo in Panisperna.[122] After Giacomo Colonna was reinstated as cardinal in 1306, he was given the opportunity to establish a second nunnery. Before that, Boniface VIII had entrusted the former Benedictine monastery of S. Lorenzo in Panisperna, which no longer had any monks living in it, to the Lateran Canons. In 1306, Cardinal Giacomo's nephew, Cardinal Pietro Colonna, became Archpriest of the Lateran basilica and began to negotiate a deal between his uncle and the Canons. On 26 April 1308, their Prior, Pietro Capocci, transferred the monastery buildings of S. Lorenzo in Panisperna and its property to Cardinal Giacomo Colonna on condition that he found a monastery there, which was obliged to pay an annual rent in kind to the Chapter.[123] This contract was considered by the nuns of S. Lorenzo as the Instrument of the Foundation of their nunnery. The Cardinal restructured the buildings — not without great expense — and only after he had done that, he admitted a group of nuns. He then went to the papal court at Avignon, where the donation of the monastery was confirmed by a papal Bull of 1 August 1318, shortly before Cardinal Giacomo died on 14 August 1318.[124] Later that year, there were thirteen nuns at S. Lorenzo, probably the abbess and twelve other experienced nuns, who, in the monastic tradition, came to start the new foundation.[125] By *c.* 1320, the Catalogue of Turin recorded eighteen nuns, but, surprisingly, there was no mention of their religious Order. Nor was there any mention of friars in residence, as at S. Cosimato and at S. Silvestro.

Indeed, the new foundation must have had a difficult beginning. The Pope was far away in Avignon. Cardinal Giacomo Colonna had gone there to consult him, and he obtained some initial papal documents for the Sisters, but he died in Avignon two weeks' later, after which Cardinal Pietro Colonna took over until 1326, when he also died. The nuns seem to have received assistance from friars, who resided at S. Maria in Aracoeli and did not live at their nunnery. Only in 1377, when Pope Gregory XI came to Italy from Avignon, were the nuns able to request and receive full papal approval and permission for them to live according to the Rule of Isabelle, as well as papal privileges regarding their property. The foundation of this nunnery was therefore affected by difficult

122 Rehberg, *Die Kanoniker*, p. 115; Rehberg, 'Nobiltà e monasteri femminili nel Trecento', esp. pp. 417–25; Marini, 'Il monastero di San Lorenzo in Panisperna'; and Ait, 'Il Patrimonio delle clarisse di San Lorenzo in Panisperna'. See also Andrea di Rocca di Papa, *Memorie storiche*; Armellini, revd by Cecchelli, *Le chiese di Roma*, vol. II, pp. 249–51; Krautheimer, *Corpus*, vol. II, p. 189; Tomassi, *Chiesa di San Lorenzo in Panisperna*; Lotti, 'S. Lorenzo in Panisperna', pp. 14–17; Panetti, *La chiesa di San Lorenzo in Panisperna*; de Crescenzo and Scaramella, *La Chiesa di San Lorenzo in Panisperna*; Guido, 'Il monastero di S. Lorenzo in Panisperna'; Fallica, 'Intervento di Mauro Fontana nella chiesa di San Lorenzo in Panisperna'; Fallica, 'Sviluppo e trasformazione'; Sturm, Canciani, Pastor Altaba, and d'Angelico, 'Dal monastero di S. Lorenzo in Panisperna al palazzo del Viminale'.

123 According to Fallica, 'Sviluppo e trasformazione', p. 120, it was a quantity of wax.

124 The Bull is published in Wadding, *Annales Minores*, vol. VI, pp. 578–80. See also Rehberg, 'Nobiltà e monasteri femminili nel Trecento', esp. pp. 417–25.

125 Wadding thought they came from S. Cosimato, but it is more likely that they were from S. Silvestro, given the Colonna connection. They are also said to have come from S. Maria ai Monti, which seems unlikely, but see Panetti, *La chiesa di San Lorenzo in Panisperna*, pp. 13–14, and de Crescenzo and Scaramella, *La Chiesa di San Lorenzo in Panisperna*, pp. 25–26.

circumstances, and by the move of the papacy to Avignon.

Despite this, S. Lorenzo in Panisperna became a very important nunnery in Rome, especially in the later fourteenth century. Bridget of Sweden (c. 1303–1373) often visited the nuns, and she died there, after which she was buried for a year in the church, before her remains were translated to her native country. The nuns of S. Lorenzo came from Roman baronial families, including the Colonna, although by the end of the fourteenth century, the influence of the founding family had diminished both at S. Lorenzo in Panisperna and at S. Silvestro.

What survives of the church at S. Lorenzo dates from the sixteenth century, for it was rebuilt from 1564 to 1574, reputedly by Francesco da Volterra, who was later responsible for the sixteenth-century rebuilding of S. Silvestro in Capite, and it was reconsecrated in 1577. There is a medieval crypt, with an inscription recording the dedication of an altar by Pope Boniface VIII in 1300. This site was where Saint Lawrence was believed to have been burned to death. The medieval church had a nave and two aisles separated by columns. The sanctuary was in the north and the entrance to the south. Since the sixteenth-century remodelling, the church has had a single nave, flanked by three chapels on either side, a rectangular sanctuary, and the nuns' choir to the north of that. There is a window between the high altar and the nuns' choir. Above that, a huge Baroque fresco by Pasquale Cati (1550–1620) illustrates *The martyrdom of Saint Lawrence*, on the wall behind the high altar.[126] Today, the nuns' choir can be entered through the sacristy, which is one of three rooms to the east of the sanctuary and the nuns' choir. (Originally there would have been only two rooms – one opening off the east side of the sanctuary, the other to the north, where there is now only a narrow partition between the remaining two spaces.) It is possible that there was formerly a chapel east of the sanctuary and a second choir parallel to the first one to the north of it. If that were so, as at S. Cosimato, the nuns may have been able to see, hear, and receive Holy Communion, through windows in the north wall of the chapel.

In 1873, the Italian government suppressed the nunnery. The church survives, but the monastery was transformed into a building for three science departments of the University of Rome. In 1938, the Regio Istituto di Patologia del Libro took the place of two of these institutions. Later, the Presidente del Consiglio (the Italian Prime Minister), stayed in the buildings, until he took over Palazzo Chigi as his official residence in 1961. Interesting work has been published on the medieval documents of S. Lorenzo in Panisperna, and some studies have been made of the later architecture and art of the church and former monastery. It would be helpful to have further clarification of the medieval phases of the buildings.

The Architecture of the Franciscan Church of S. Silvestro in Capite

Unfortunately, there are only a few clues about how the medieval church of San Silvestro was laid out from the late thirteenth to the early sixteenth century. In the eighth century, it was a basilica with a nave and two aisles, a transept, and an apse decorated with mosaics and precious marble inlay. Beneath the high altar was a 'confessio' or crypt, with the relics of 'innumerable' saints from the Catacombs. It is most likely that significant changes were made in the late thirteenth century, before Margherita Colonna's community moved in, but not much is known about them.

In the early sixteenth century, Pope Julius II (1503–1513) brought a group of nuns from Florence under the guidance of Abbess Angelica Acciaiuoli, to join the community at

126 Maniello Cardone, 'Pasquale Cati'.

THE FRANCISCAN NUNNERY AT S. SILVESTRO IN CAPITE, FOUNDED IN 1285 327

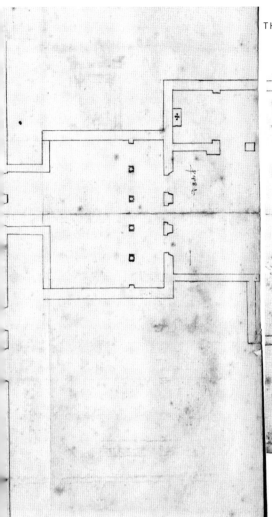
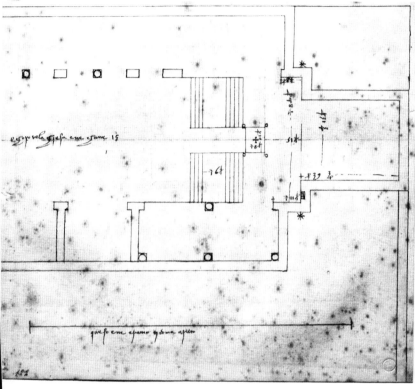

Figure 154. Plan of S. Silvestro in Capite by Antonio Tanghero (Florence, Casa Buonarroti, drawings, nos 114 A and 122 A)

S. Silvestro,[127] and Pope Leo X made S. Silvestro a cardinal's titular church in 1517. Shortly after that, there was a plan to provide a new high altar for the church, and the nuns asked Michelangelo Buonarroti to make it. To this end, in 1518, the 'scalpellino' (stonecutter) Antonio Tanghero drew a plan of the church and sent it with a covering letter written by Piero Rosselli to Michelangelo in Florence (Fig. 154). In fact, the great Florentine sculptor did not carve the altar, but Tanghero's plan remained in Florence, where it is now preserved in two pieces in the Casa Buonarroti.[128]

The plan was analysed and published by Ilaria Toesca.[129] The drawing shows the courtyard in front of the church, entered through a double doorway, rather than the single entrance of today. Instead of Baroque piers in the narthex, there is a row of four columns in front of the church. (This is similar to most other medieval entrance porticoes in Rome, for example, that at SS. Giovanni e Paolo (Fig. 57).) The narthex does not extend all the way across the façade, as there are walls possibly of rooms on the east and west of the courtyard, as there are today. Not one, but three doorways lead from the narthex into the church, which is annotated with dimensions written on the plan: length, 15 canne romani (33.51 m); nave width, 48½ palmi romani (c. 10.80 m).[130]

127 Pietrangeli, *Rione III – Colonna*, p. 14.
128 Casa Buonarroti, nos 114 A and 122 A. Gaynor and Toesca, *S. Silvestro in Capite*, p. 22, fig. 5.

129 Gaynor and Toesca, *S. Silvestro in Capite*, p. 22, fig. 5.
130 These dimensions are very close to those given for the

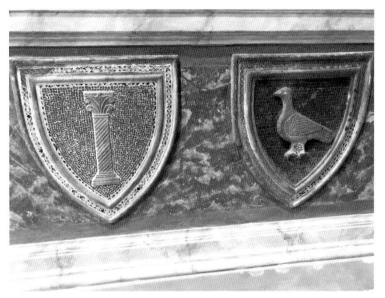

Figure 155. S. Silvestro in Capite, Colonna and Palombara coats of arms (photo: author)

Figure 156. S. Silvestro in Capite, east end of transept, coat of arms of a Colonna cardinal (photo: author)

At the northern end of the nave is the high altar, under a ciborium supported by four columns, which are marked on the plan. In front of the altar there seems to be a passageway from the nave to a crypt, flanked by two flights of steps. Behind the altar and the sanctuary, the plan shows a rectangular choir, 39¾ palmi romani (8.86 m) long and somewhat narrower than the nave.[131] At the entrance to the choir there was an arch, 49 palmi romani (10.91 m) high.[132] It is not known when this choir was constructed, but it could have been built for the nuns in the late thirteenth century.

In the south-western corner of the nave there is a chapel with an altar against the southern (façade) wall of the church. This was probably the chapel of Saint John the Baptist, which is now the chapel of the Pietà, containing the relic of that saint. Beyond the chapel and moving north, there is an aisle, with two columns alternating with piers and then a further row of piers, separating the aisle from the nave. The sequence of columns and piers is reminiscent of the nave colonnades of some early twelfth-century churches in Rome, such as S. Clemente (*c.* 1099–1119) and S. Maria in Cosmedin (1119–1123). This suggests that the arrangement may date from about that time, perhaps just before Pope Calixtus II re-consecrated the high altar of S. Silvestro in 1123. It is possible that his chancellor, Alphanus, was responsible for these changes.[133]

nave in the Krautheimer–Corbett survey: *c.* 33 m long and *c.* 10 m. wide. See Krautheimer, *Corpus*, vol. IV, p. 157.

131 Gaynor and Toesca give a length of 7.30 m, which seems to be a measure from later notes by Carlo Maderno rather than that on the plan.

132 The arch was mentioned, and its dimensions given, in the letter that Piero Rosselli wrote to Michelangelo, dated 2 November 1518, see Gaynor and Toesca, *S. Silvestro in Capite*, p. 40. (The conversion from palmi romani seems to be inaccurate in Gaynor and Toesca's text, so it has been corrected here.)

133 For Alphanus, see above. He was buried in the narthex of S. Maria in Cosmedin, as discussed by Osborne, 'The Tomb of Alfanus'.

On the eastern side of the nave, moving northwards from the narthex, there is first a space blocked off by a wall from the church, then two side chapels, and then a long area of two bays. One of the side chapels was erected by the Palombara family *c.* 1300 and displays the Colonna and the Palombara coats of arms today (Fig. 155);[134] the second chapel was constructed by the Tedallini family *c.* 1380.[135] Toesca argued convincingly that the space with two bays, north of these two chapels, was the medieval chapel of the Colonna family.[136] There is still an altar donated by the Colonna, which is flanked by two reliefs, of unknown date, of the Colonna coat of arms, surmounted by a cardinal's hat (Fig. 156). According to annotations on Tanghero's plan, this chapel was 58 palmi romani (12.91 m) long and 22 palmi romani (4.90 m) wide. Its lay-out, with four columns and two side piers, suggests that it was covered with two cross vaults, although none are drawn on the plan. When Carlo Maderno demolished the medieval Colonna chapel during the late sixteenth-century changes to the church, he gave the same dimensions for the chapel, and he noted that it was covered by pointed arches and rib-vaulting, indicating that it had a Gothic elevation.[137] The upper part of a pointed double-light Gothic window frame, found in the area of the General Post Office in the 1870s, is known from a photograph, and has been associated convincingly with this chapel.[138] This,

then, was a late thirteenth-century Gothic chapel, constructed at about the time of the translation of Margherita Colonna's remains to S. Silvestro and the foundation of the Franciscan nunnery in 1285. Its form is reminiscent of the Colonna and other family chapels in S. Maria in Aracoeli, although this was bigger than most, having two bays. An older Cardinal Pietro Colonna (not Giovanni's son and Cardinal Giacomo's nephew) in his will, dated 18 June 1290, donated funds for the chapel, where he wanted there to be an altar where a priest would regularly celebrate Mass for the repose of his soul.[139] It is likely that this was the chapel he wanted to have built, and that the tomb of Margherita Colonna was located there, *c.* 1285–1290. In 1629, Giovanni Giacchetti described a reliquary in the shape of a fifteenth-century gilded bust, which contained her relics.[140]

Shortly before 1588, Pompeo Ugonio visited S. Silvestro, and commented on the church's history and appearance.[141] He noted that the building had previously been divided into a nave and two aisles, as was common in Rome's ancient basilicas, but in his time, chapels filled the right aisle. They had been built by prominent Roman families, such as the 'Thedelini' [*sic*] and the Colonna, as was shown by their coats of arms. Indeed, he noted that the Colonna coat of arms was to be seen in several places in the building.

134 The coats of arms, made in mosaic, look medieval, but the décor of the chapel is predominantly Baroque. They may have been transferred from an earlier position to the new chapel.
135 The Tedallini Chapel may formerly have been where the present chapel dedicated to SS. Stefano, Dionisio, and Silvestro is, according to Gaynor and Toesca, *S. Silvestro in Capite*, pp. 40–41.
136 Gaynor and Toesca, *S. Silvestro in Capite*, p. 40.
137 Information from Gaynor and Toesca, *S. Silvestro in Capite*, p. 40. Carlo Maderno's notes are in the Archivio di Stato di Roma. See below for further information on his work at S. Silvestro.
138 Gaynor and Toesca, *S. Silvestro in Capite*, fig. 3. See also

Bolgia, 'An Engraved Architectural Drawing', p. 441 and fig. 9.
139 Gaynor and Toesca, *S. Silvestro in Capite*, p. 40 and n. 9, referring to Federici, 'Regesto del monastero di S. Silvestro de Capite', 23 (1900), pp. 426–28, with the will of Pietro Colonna.
140 Giacchetti, *Historia*, p. 40. In 1627, an Apostolic Visitation to the church and nunnery of S. Lorenzo in Panisperna recorded that the body of Blessed Margherita was in a chapel — most likely the nuns' choir — near the high altar 'senza il capo quale è nel Monastero di S. Silvestro' (without the head which is in the Monastery of S. Silvestro); see Fallica, 'Sviluppo e trasformazione', p. 119.
141 Ugonio, *Historia delle Stationi*, pp. 241–47.

Along the left side of the church, he saw two very old altars and in the centre of the nave there was an old stone pulpit carved with various figures and other ornament.[142] Between the steps going up to the high altar, Ugonio noted that there was the 'confessio'. The high altar was quite modern in Ugonio's opinion, as it stood against a wall, and it was elaborately decorated.

In many ways, Ugonio's description of S. Silvestro confirms the evidence in Tanghero's plan. One item not shown on that plan concerns the organ loft at the southern end of the church (Fig. 150).[143] Near the entrance, Ugonio noted a 'portico', by which he meant a wall sustained by columns, 'sopra il quale è fabbricato il coro delle Monache' (over which is built the choir of the nuns).[144] The letter of Piero Rosselli to Michelangelo in 1518 referred to the nuns' intention to build a new choir in that location.[145] The new choir was most likely constructed around 1520. The high altar seen by Ugonio was consecrated in 1522.

Later, the architects Francesco da Volterra, and Carlo Maderno transformed the rest of the church from 1591 to 1597, and the German titular Cardinal Franz Seraph von Dietrichstain reconsecrated it in 1601.[146] Decoration of the interior then continued into the early nineteenth century. Two architectural drawings by Francesco da Volterra — a plan of the church and a longitudinal section — survive from the 1591–1597 building campaign (Figs 157 and 158).[147] It is clear that the chapels of the side aisles were changed

142 Giacchetti, *Historia*, p. 43, wrote that this pulpit was transferred to SS. Nereo ed Achilleo on the Via Appia, but, according to Krautheimer, *Corpus*, vol. IV, pp. 159–60, it is more likely that it is the one now in S. Cesareo on the Via Appia, which is decorated with carvings of sphinxes, lions, and griffins.
143 Krautheimer, *Corpus*, vol. IV, p. 154.
144 Ugonio, *Historia delle Stationi*, p. 246.
145 Gaynor and Toesca, *S. Silvestro in Capite*, p. 41.
146 Kane, *The Church of San Silvestro*, pp. 58–64, 73–96.
147 They are in ASR, Collezione Mappe, cart. 86. no. 531, 1 and 3. The plan is 65 by 43.8 cm, drawn in ink, with pink and faded yellow wash; the section is 45 cm long and 30 cm

Figure 157 (opposite). Francesco da Volterra, plan of S. Silvestro in Capite, 1591 (ASR, Collezione Mappe, cart. 86. no. 531, fol. 1 – under licence from MiBACT)

after the plan and section were drawn, for the architect drew only two south of the transept on either side, followed by a narrow entrance and a chapel beside the campanile on the west, and a staircase and a room beside the narthex on the east, whereas there are now three chapels of equal size south of the transept on both east and west; beyond them, on the west, there is the side entrance and the larger chapel of the Pietà; and on the east, a blocked off staircase and the Chapel of the Sacred Heart (now the parish office) (compare Fig. 150). Otherwise, the drawings show the lay-out of the church more or less as it is today.

Of great interest are the three choirs that Francesco da Volterra indicated for the nuns (Figs 157 and 158). One was where the 'organ loft' and the room over the narthex are today; another was behind the sanctuary of the church; and a third was directly above the second one, as shown in the section. On his plan (Fig. 157), Francesco da Volterra indicated existing features in pink, with changes to be made marked in yellow, which has now turned brown. He added copious notes to his plan, which help the viewer understand the former layout of the church as well as his intended changes. The two columns supporting the organ loft / choir at the southern end of the church were marked in pink on the plan, showing that the choir was in place before 1591, a point confirmed by Ugonio.[148] In Francesco da Volterra's Section (Fig. 158), an altar and a crucifix stand at the northern end of this choir and the seating of the nuns is sketched against the eastern wall. (There was no organ at that time.) In his plan, the architect shows stairs next to what

high, also drawn in ink and wash. See also, Gaynor and Toesca, *S. Silvestro in Capite*, pp. 42, 44.
148 See above, and Gaynor and Toesca, *S. Silvestro in Capite*, p. 44.

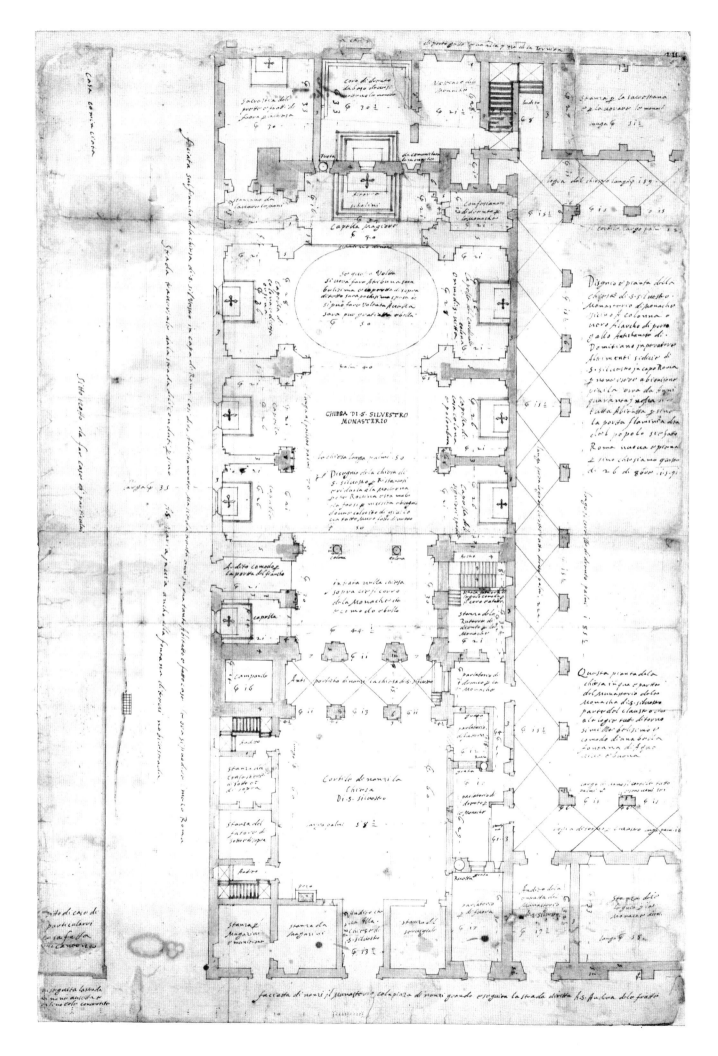

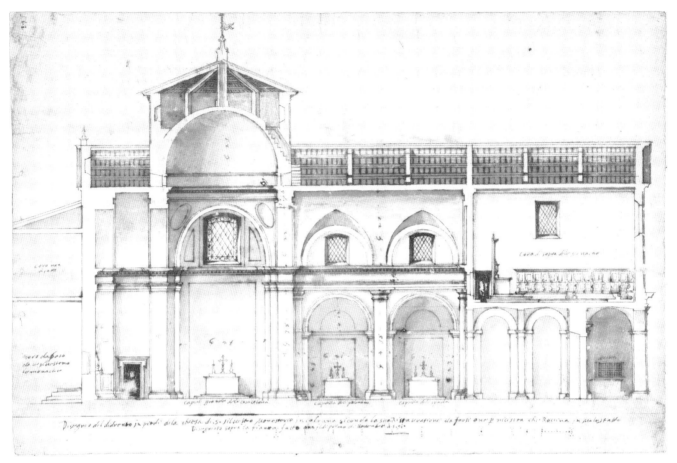

Figure 158. Francesco da Volterra, Longitudinal Section of proposed remodelling of the church of S. Silvestro in Capite, 1591 (ASR, Collezione Mappe, cart. 86. no. 531, fol. 3 – under licence from MiBACT)

is now the parish office, leading up to the choir, while the door at the top of the stairs is shown on the far left of the choir in the Section. (It is now blocked up.) From the cloister, the nuns would have entered a room at the eastern end of the narthex, and from there gone into what is now the parish office, to begin ascending the stairs beyond that. It is clear, from the Section, that the choir extended over the narthex and over a little more than one third of the nave.[149]

(This disposition is reminiscent of Francesco Borromini's project for S. Sabina, to build a new choir supported on two columns and jutting into the nave, and perhaps attached to the upper room of the double-storeyed narthex, which had been at the church when the Dominicans arrived (see Fig. 65).) It was common for medieval nuns to have a raised choir at the liturgical 'west end' of their churches, although this was not the case in Rome. In Naples, the Poor Clare church of Donna

149 In fact, this room is still in existence and is called 'the Chapter Room' by the incumbent Pallottine priests. Some wooden seating there is obviously taken from the former nuns' choir. The ceiling of the room is modern and there is another room above it, showing that the

choir was much higher than the present 'Chapter Room'. Beside the upper room, there is a corridor and high up on the upper part of the north wall, which would have been the north wall of the choir, there are some paintings — of the *Trinity*, *Saint Michael*, a *Guardian angel and a youth*, and *Christ meeting his Mother on the Way of the Cross*. The style of the paintings suggests they were executed in the early sixteenth century.

Regina, built between 1313 and 1316–1320, had a raised choir in that position.[150] At S. Silvestro, the raised choir to the south of the church was not medieval but seems to have been added in the early sixteenth century. In 1686, a new organ was provided for the church, and hence some changes were made to the raised choir.[151] The present layout upstairs seems to date from the twentieth century.

Carola Jäggi has noted that sometimes medieval nuns of the Mendicant Orders had more than one choir.[152] At the northern end of S. Silvestro, Francesco da Volterra shows on his plan a large rectangular room behind the high altar, which he labelled as the interior choir of the nuns. This is the same place as that shown in Tanghero's plan, except that Volterra indicated the early sixteenth-century altar in the sanctuary standing against the northern wall of the church. (It is pink and therefore existed before his rebuilding.) In the centre of this wall, behind the altar, there was a window (Figs 157 and 158) that opened into the choir, which has seating along the other three walls. The architect also drew and labelled a 'Ruota' (turn) to the west of the high altar. (This is where there is now a small metal door today, within what survives of a cylindrical wall.) To the east of the high altar, the architect drew another window, which is labelled 'da communicarsi le Monache' (where the Nuns can take Communion). Jäggi has described such Communion windows in other nuns' churches.[153] They were closed with a grate, with a small door that could be opened for the priest to give communion to the nuns. (This seems also to be the case in the large eighteenth-century window with a grille at S. Cosimato, Fig. 101.)

The position of the northern choir at S. Silvestro, behind the high altar and with three openings communicating with the church, is reminiscent of the choir in the church of S. Chiara in Naples, built between 1310 and 1318 and consecrated in 1348.[154] (It is also reminiscent of what is known of the arrangements in S. Sisto and S. Cosimato in Rome, where there was a straight wall with more than one opening.) On his plan, Francesco da Volterra has also added a chapel on the west of this choir and a room on the east. (The architect has labelled the one on the west, as a sacristy for the priests or friars who had come from outside the convent. The room on the east is called a vestry for the nuns.) To the east of the Communion window, there is a small room in pink, and hence pre-existing Francesco da Volterra's projected changes. It is accessible from the nuns' area and has a small window to the south. It may have functioned as a confessional.

In the north-eastern corner of the plan, at the junction of the church and the nunnery, there is a staircase, which can be accessed only from the cloister, and which leads up to a third choir, which is directly above the one behind the high altar. This choir is marked in the Section (Fig. 158), and it seems to be a rather plain room. It would have been a private space, where the nuns could have prayed, close to the sanctuary, but without being in communication with what was happening in the church.

At the eastern end of the narthex and in the eastern wing of the atrium, there were two parlours, which only the nuns could enter from the convent (Figs 157 and 158). People from outside the monastery could communicate with them through windows filled with iron grilles and turns.

150 See Bruzelius, 'Hearing is Believing', pp. 86–87; Jäggi, *Frauenklöster*, pp. 154–55, 198–202; Fleck, '"Blessed Are the Eyes That See Those Things You See"', which concentrates on the fresco decoration.
151 Kane, *The Church of San Silvestro*, p. 100.
152 Jäggi, 'Eastern Choir or Western Gallery?', pp. 79–93.
153 Jäggi, *Frauenklöster*, pp. 185–89.

154 Bruzelius, 'Queen Sancia of Mallorca and the Convent Church of Sta. Chiara in Naples', esp. pp. 78–81; Jäggi, *Frauenklöster*, pp. 154–58, and figs 198–99. See also, Andenna, 'Sancia Queen of Naples and *Soror Clara*', pp. 115–32; and Gaglione, 'Dai primordi del Francescanesimo femminile a Napoli fino agli statute per il Monastero di S. Chiara', esp. pp. 53–118.

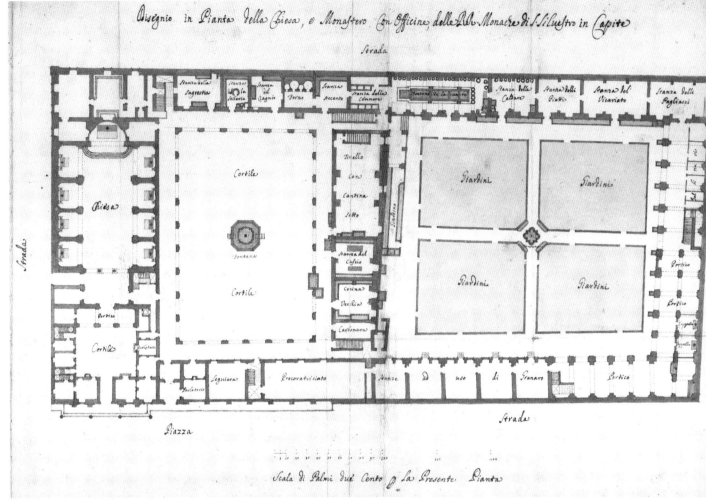

Figure 159. Plan of the church, monastery, and workshops of the nuns of S. Silvestro in Capite, eighteenth century (ASR, Collezione Mappe, 86, no. 531, fol. 2 – under licence from MiBACT).

There was a window with a 'grata' at the east end of the narthex; two more opened on either side of a room between the two nuns' parlours; and there was a room at the south-east that could be accessed by outsiders from the atrium, or from the piazza. Next to two of the grates, there was also a turn for passing objects from the convent to the exterior, or vice versa. These arrangements were all projected by Francesco da Volterra in 1591.

The Conventual Buildings

The medieval convent does not survive, but there is some information about its structures from the sixteenth to the eighteenth century. In 1588, a dormitory was added to the nunnery. In the late seventeenth and early eighteenth centuries, the church and monastery were renewed by Abbess Maria Archangela de Mutii. An inscription in the courtyard referred to work sponsored by the same abbess to improve the convent buildings by adding vaulting, loggias, and balconies in 1693.[155] She also provided a grotto in the garden.

155 Carletti, *Memorie*, p. 50.

An eighteenth-century ground plan survives of the church and the convent buildings of S. Silvestro (Fig. 159).[156] Beside the church, there are two courtyards, the one furthest east with a formal garden. At the centre of each there is a fountain. The function of each room around the courtyards is written on the plan. On the northern side of the courtyard next to the church, one finds a staircase (which would have ascended to the upper choir behind the sanctuary), the sacristy storeroom, a place for keeping wood, a room with an oven, an unidentified room next to that, and a room containing ash. Continuing on the northern side of the second courtyard, one finds a place for washing, with a fountain in a long tub and several round receptacles; a room for plates; a room for the Vicariate; and a room for storing hay. On the eastern side of the second courtyard, there is a space for keeping straw, a staircase, a porticoed entrance, and a chapel. On the southern side of the eastern courtyard stands another portico, more stairs, and a granary. To the south beside the church, there is a large office for the Procurator, a storeroom for wood, and a parlour. Between the two courtyards, moving from north to south, one finds a staircase, a pantry with a cellar underneath it, the 'old kitchen', and a room for storing charcoal. Presumably the dormitories of the nuns and of the novices, the infirmary, and other rooms were upstairs. This plan also indicates three parlours — one to the east of the narthex, one on the eastern side of the courtyard in front of the church, and one in the southern wing of the monastery near the church.

The *Mandylion*

Besides the famous relic of the head of John the Baptist, the monastery possessed an early copy of the icon called the *Mandylion* of Edessa (Plate 9).[157] It is not known when the image came to S. Silvestro and in 1870 it was moved to the Vatican for safe-keeping before Rome was taken by the Italian troops.[158] According to Carlo Bertelli and Hans Belting, who examined it carefully, this icon was painted on cloth and fixed to a wooden panel.[159] The image is now in a metal case, fashioned in 1623 by the silversmith Francesco Comi, and donated by one of the nuns of S. Silvestro, Sister Dionora Chiarucci.[160] Bertelli noted that beneath the seventeenth-century cover there was an older metal frame.[161] One sees only the face of Christ, outlined by the inner metal frame, which opens in three points at the base to reveal his beard. Bertelli was convinced that the work was of 'eastern' origin, made in smooth layers of colour with sparing stylistic elaboration, and he was especially struck by Christ's gaze, which seemed to have an inexpressible psychological complexity.[162] Belting dated the image in the sixth century, but he also noted that it was difficult to

156 ASR, Collezione Mappe, 86, no. 531, 2. This is 42.3 by 67.5 cm, drawn in ink and wash.

157 For this icon, see Giacchetti, *Iconologia Salvatoris*, esp. pp. 1–84; Carletti, *Memorie*, pp. 94–108; Bertelli, 'Storia e vicende dell'immagine edessina a S. Silvestro in Capite', pp. 3–33; Belting, *Likeness and Presence*, pp. 53, 208–24; Barclay Lloyd, '"Chiamansi Romei"', pp. 232–38; Kessler and Wolf, ed., *The Holy Face and the Paradox of Representation*; Kessler, 'Il Mandylion'; Leone, *Icone di Roma e del Lazio*, no. 2, p. 55; and Kane, *The Church of San Silvestro*, pp. 21–25.

158 Belting, *Likeness and Presence*, p. 53 and fig. 15. It is now in the Sala del Pianto, where part of the Pope's Treasury is housed, behind the Sistine Chapel.

159 Bertelli, 'Storia e vicende dell'immagine edessina', pp. 11–12, 15, and n. 41, where he gives dimensions of 25 cm by 15 cm., within a case measuring 30 by 20 cm. Belting, *Likeness and Presence*, p. 210, says it is 'painted on canvas fixed to a wooden panel' and is 40 by 29 cm in size.

160 Toesca, 'La cornice dell'immaggine edessina', pp. 33–37.

161 Bertelli, 'Storia e vicende dell'immagine edessina', p. 11. In Plate 9, one sees the early frame within the elaborate seventeenth-century case; another sheet of metal since 1623 has covered the original frame and it was attached to the earlier one with small metal 'nails', as can be seen today at the Vatican.

162 Bertelli, 'Storia e vicende dell'immagine edessina', pp. 12–13.

see the work properly because of layers of later varnish, and he suggested that, if it were cleaned, one would 'regain what may well be the oldest surviving icon of Christ'.[163]

The Holy Face of Edessa, known as the *Mandylion*, was a very significant icon in the Byzantine Empire, and there was also an image of the Holy Face in Rome, known as the *Veronica*, which was one of the most important icons in the West.[164] The S. Silvestro icon represented a strong eastern tradition, while the icon of the *Veronica* at Old St Peter's was in a different western tradition. In the East, the icon of the Holy Face was associated with the legend of Agbar, King of Edessa (now Urfa in Turkey), while in the West, the image was at first associated with the Emperor Tiberius and Pontius Pilate, and eventually with a woman named Veronica. Both icons represented only the face of Christ; in both, his features were believed to have been impressed on a cloth, which was used to dry his face — during a visit to the Saviour by a delegation from King Agbar in the eastern tradition and during his Passion according to the western tradition. The two images were different in style: medieval copies of the *Veronica* tend to show a rounded face and a low forehead, while copies of the icon of Edessa have an elongated countenance, fine features, and a rather intense expression.

The *Veronica* at St Peter's was first mentioned by Benedict of Soracte in the eleventh century.[165] Petrus Diaconus, *c.* 1140, identified it as the 'sudarium', the cloth with which Christ wiped his holy face, which was called the 'Veronica', and which was brought to Rome at the time of Tiberius Caesar;[166] in 1143, the *Ordo Romanus* of Benedictus Canonicus also referred to a sudarium, which was called the Veronica; and the twelfth-century canon of St Peter's, Peter Mallius, in his description of the Vatican basilica, located it in a chapel in St Peter's; in 1197, Pope Celestine III (1191–1198) placed the Veronica image in a tabernacle above an altar.[167] From the twelfth century onwards, the *Veronica* was frequently shown to the crowds of pilgrims at Old St Peter's. Pope Innocent III (1198–1216) arranged for the image to be taken on an annual procession from St Peter's to the Hospital of Santo Spirito, which he had founded, on the Sunday following the Octave of the Epiphany. The Pope wrote a prayer to be said before the image and granted indulgences to people who took part in the procession and said the prayer.[168] Pilgrims to Rome often obtained small lead reliefs of the *Veronica* as souvenirs, which they sewed on to their clothes to show they had been to the Eternal City, as pilgrims wore a cockle shell to demonstrate that they had been to Compostela. In his *Vita* of Margherita Colonna, her brother Giovanni mentioned that she went one night to see the *Veronica* at St Peter's.[169]

In the Byzantine world, the legend and history of the icon of Edessa was very different.[170] Eusebius

163 Belting, *Likeness and Presence*, pp. 53 and 210. For the rather dark and indistinct appearance of the icon, see Kessler, 'Christ's Dazzling Dark Face', pp. 231-246.

164 See Wolf, 'La Veronica e la tradizione romana di icone', pp. 9–35; Wolf, 'From Mandylion to Veronica', esp. 166–70; Morello and Wolf, ed., *Il Volto di Cristo*, pp. 100–211; and Murphy and others, ed., *The European Fortune of the Roman Veronica*.

165 *Il 'Chronicon' di Benedetto, monaco di S. Andrea del Soratte'*, ed. by Zucchetti, p. 41.

166 The word 'sudarium' is connected with 'sudor' (sweat) or 'sudare' (to sweat) in Latin; 'Veronica' refers to 'vera' (true) 'icon' (image); it was later associated with a woman, called Veronica, who wiped Christ's face with her veil on the Way of the Cross.

167 Belting, *Likeness and Presence*, pp. 541–42; Wolf, 'From Mandylion to Veronica', p. 167. For the reference in the *Ordo Romanus* of Benedictus Canonicus, see *Le Liber Censuum*, ed. by Fabre, Duchesne, and Mollat, vol. II, p. 143; and for the description of Peter Mallius, Valentini and Zucchetti, *Codice topografico*, vol. III, p. 420.

168 The prayer could also be said outside of Rome and, indeed, it is found in some medieval English manuscripts, see Morgan, '"Veronica" Images and the Office of the Holy Face', pp. 85–99.

169 *Visions of Sainthood in Medieval Rome*, trans. by Field, ed. by Knox and Field, p. 107.

170 For the way the tradition of the *Mandylion* evolved in the

c. 300 related how Agbar, King of Edessa, wrote a letter to Jesus, who dictated a reply to the King, but the historian did not mention an image.[171] The earliest reference to the icon seems to be in a Syriac work, entitled the *Doctrina Addai*, known from a recension dated c. 400.[172] In this, there is the story of King Agbar's letter and Jesus's reply, and also an account of how Hannan, a member of the delegation, who was an archivist and also a painter, made an image of Jesus. King Agbar received this portrait joyfully and kept it in a place of honour in his palace. The Greek *Acts of Thaddaeus* (Addai), of the sixth or seventh century, gave a variation of the story, stating that during the delegates' visit, Christ moistened his face with water and, when he dried it, an image of his countenance miraculously remained on the cloth he used as a towel.[173] This image of the Saviour was considered an authentic likeness and 'acheiropoietos' (not made by human hands). It was called the '*Mandylion*', after 'mandil', the Arabic word for a small cloth, kerchief, napkin, or towel.[174] The icon was kept in Edessa, but it seems to have disappeared in the early sixth century, only to reappear during a siege by the Persians in 544. The Greek historian Evagrius believed this 'God-made image' had saved the city.[175] In the sixth century, an identical image also appeared on a ceramic tile, which had been pressed against the original. As an important protector of Edessa, the icon was placed in the city's Orthodox cathedral, when it was rebuilt after 553, and many painted copies were made of the original.[176]

The icon was very famous in the East, and it became an important proof that God approved of religious images at the time of Iconoclasm.[177] Iconodule writers recounted the story of its miraculous origin. For example, John Damascene (676–749) wrote:

> An esteemed tradition has been handed down to us from the beginning that Abgar, the King of Edessa, was set on fire with divine love by hearing of the Lord and sent messengers asking him to visit him. But if this request were declined, they were to have his likeness painted. Then he, who is all-knowing and omnipotent, is said to have taken a piece of cloth and pressed it to his face, impressing upon it the image of his countenance, which it retains to this day.[178]

People who supported the veneration of icons in Byzantium argued that these circumstances showed divine approval for holy images. Andrew of Crete (650–740) used the story to justify the veneration of icons; and it was mentioned at the Second Council of Nicaea in 787 to show their importance.[179] As Averil Cameron commented, the *Mandylion* became 'a major Byzantine iconodule symbol'.[180] The image was thus famous throughout the Byzantine Empire in the eighth and ninth centuries.

In 944, the original icon and the tile with the same image from the sixth century were brought from Edessa to Constantinople amid great pomp and ceremony and they were placed in the palace chapel of the Theotokos of Pharos (the Mother

Byzantine Empire, see Drijvers, 'The Image of Edessa in the Syriac Tradition'; and Cameron, 'The History of the Image of Edessa', pp. 80–94.

171 Eusebius, *Historia Ecclesiastica*, 1.13.
172 Drijvers, 'The image of Edessa in the Syriac Tradition', p. 15; Cameron, 'The History of the Image of Edessa', pp. 81–82.
173 Cameron, 'The History of the Image of Edessa', pp. 82–83.
174 Cameron, 'The History of the Image of Edessa', pp. 82–83; Kessler, 'Configuring the Invisible by Copying the Holy Face', esp. pp. 136–150.
175 Drijvers, 'The Image of Edessa in the Syriac Tradition', pp. 18–19; Cameron, 'The History of the Image of Edessa', p. 85.

176 Cameron, 'The History of the Image of Edessa', pp. 84–87.
177 Cameron, 'The Mandylion and Byzantine Iconoclasm'.
178 John of Damascus, *On the Divine Images*, p. 35.
179 Cameron, 'The Mandylion and Byzantine Iconoclasm', pp. 40–43.
180 Cameron, 'The Mandylion and Byzantine Iconoclasm', p. 43.

of God near the lighthouse), with the great relics of Christ — the crown of thorns, the lance, and the Saviour's tunic.[181] The icon remained there until the crusaders took the city in 1204, when Robert de Clari recorded having seen both the icon and the tile in two gold reliquaries hanging in the palace chapel.[182] In 1247 these precious relics were sent to the King of France to be kept at the Sainte Chapelle in Paris; and they remained there until the French Revolution. Other copies of the *Mandylion* appeared in the West in the thirteenth and fourteenth centuries. For example, a Slavic copy of the icon of Edessa made *c.* 1200 was sent to Laon cathedral in 1249,[183] and in 1384, the Byzantine Emperor John V gave the Genoese captain, Lionardo Montaldo, a copy of the icon, which is now in the church of S. Barbara degli Armeni in Genoa.[184] This image is similar in size and style to the Holy Face from S. Silvestro in Capite, but the latter was until recently considered an earlier version of the original icon.[185] In 1996, however, a group of scholars at a conference in Rome decided that because the original metal frame of the Vatican image was the same in size and form as that which formerly surrounded the icon in Genoa, the *Mandylion* from S. Silvestro was almost certainly painted to substitute the image in Genoa, or as a veil to be placed over it.[186]

Giuseppe Carletti in 1795 noted that a Byzantine tradition related how, when the icon came to Constantinople, a holy hermit called Paul placed a veil over it on which the image was miraculously reproduced.[187] Perhaps this accounts for the theory about it being a veil.

There is no evidence, however, regarding how or when the icon of the *Mandylion* came to S. Silvestro. In 1518, Fra Mariano of Florence reported that the nuns were prohibited from showing their icon to the public, 'ob confusionem vitandam et ut maiori reverentia adhibeatur illi sancti Petri' (in order to avoid confusion and so that greater reverence should be shown to that of Saint Peter's).[188] Evidently, the authorities in Rome at that time valued the western *Veronica* more highly than the nuns' eastern *Mandylion*. For this reason, the icon at S. Silvestro remained relatively unknown, and it was normally kept in the nuns' choir, except on two days a year, 6 January and 6 August, the feasts of the Epiphany and Transfiguration, when it was shown to the public. The nuns' chaplain in the early seventeenth century, Giovanni Giacchetti, noted that those were the feasts of this icon in a liturgical calendar at S. Silvestro, which included feasts that had been celebrated by the Greek monks, as well as those of the Benedictines, and Franciscans. In the early seventeenth century the nuns processed through the cloister with the icon after Vespers on 15 August, which was the vigil of the commemoration of the day when the icon arrived from Edessa on 16 August 944 in Constantinople and hence it was a Byzantine festival.[189] Ironically, it is this icon that has survived, whereas the *Veronica*

181 Belting, *Likeness and Presence*, p. 213.
182 Belting, *Likeness and Presence*, p. 218 and n. 27.
183 Grabar, *La Sainte Face*; see also, Belting, *Likeness and Presence*, p. 218.
184 Belting, *Likeness and Presence*, p. 210.
185 Giacchetti, *Iconologia Salvatoris*, pp. 44–45; Belting, *Likeness and Presence*, pp. 210–11, and Bertelli, 'Storia e vicende dell'immagine edessina', pp. 7, 13, 19–20, 22.
186 Bozzo Dufour, 'Il "Sacro Volto" di Genoa', p. 66 and note 38, who says that she, Belting, and Wolf came to this conclusion. Kessler noted, however, that this theory was accepted, 'benché quest'opera non sia ancora stata sottoposta a un'estesa analisi scientifica' (although this work had not yet been subjected to an extensive scientific analysis) see Kessler, 'Il Mandylion', p. 91, Schede III. In the absence of supporting historical documentation and scientific evidence, this hypothesis therefore seems unconvincing.

187 Carletti, *Memorie*, pp. 98–99.
188 Mariano da Firenze, *Itinerarium Urbis Romae*, p. 215; see also, Bertelli, 'Storia e vicende dell'immagine edessina', p. 9.
189 Giacchetti, *Historia*, pp. 71–76, for the liturgical calendar of S. Silvestro; Giacchetti, *Iconologia Salvatoris*, p. 31, for the procession of the nuns on the evening of 15 August; and see also, Ragusa, 'Mandylion-Sudarium'; and Ragusa, 'The Edessan Image'. This feast at S. Silvestro may have gone back to the tenth century.

was reputedly stolen by Charles V's Protestant troops during the Sack of Rome in 1527 when it disappeared and it is now known from a few copies of the original and from numerous manuscript illuminations.[190]

One wonders when the icon of Edessa came to S. Silvestro.[191] Three dates seem plausible in the Middle Ages. Given the icon's importance at the time of Iconoclasm, the first possible date would have been in the eighth century, when the Greek monks came to Rome and took up residence at S. Silvestro.[192] They could have brought it with them. Or, it could have been one of the five new icons presented to the church in the pontificate of Nicholas I (855–867), as noted above. Giovanni Giacchetti published an inscription in 1629, which he saw over the entrance to the church, and which called the icon, 'imago redemptoris Iesu Christi quam ipsemet Abagaro Edessenorum regi […] misisse traditur' (an image of the Redeemer Jesus Christ which he himself […] is said to have sent to King Abgar, king of the people of Edessa).[193] Giachetti recorded another inscription, on a pier in the nave of the church stating that the icon was: 'A Graecis profugis pro S. Fide tuenda / Romam asportata […]' (brought to Rome for safe-keeping by Greeks who were refugees because of the holy faith […]), referring to the fact that the first Greek monks at S. Silvestro were believed to have fled to Rome from Iconoclasm in Byzantium.[194] The date of these inscriptions is not known, but Giachetti and his contemporaries evidently believed that the icon was brought to S. Silvestro by the first Greek monastic community, just as the monks from Asia Minor brought an icon and a relic of Saint Anastasius of Persia to Tre Fontane, in the seventh century.[195] That icon and relic were also used in arguments in favour of icons by the Roman delegates at the Second Council of Nicaea in 787.

A second possibility is that the image at Silvestro was brought to Rome shortly after the original icon arrived in Constantinople in 944. This may have been why its arrival in the Byzantine capital was commemorated at S. Silvestro. The Greek monastery was the recipient of extensive property in 955 and 962, showing its importance in the second half of the tenth century. Presumably, there was some communication between the monks and Byzantium at that time, which preceded the break between Rome and Constantinople in 1054. The icon may have arrived at S. Silvestro then.

It is also possible that it came to the monastery after 1204, perhaps as a gift of the Colonna family, when the nunnery was founded in 1285. Giovanni Colonna mentioned that Margherita Colonna had seen the *Veronica* at St Peter's, which may have been mentioned as a forerunner of her community's possessing their own version of the Holy Face.[196] In that case, it would have

190 Chastel, 'La Veronique', pp. 74–82, for the disappearance of the Veronica; and for its importance, see, Wolf, 'La Veronica e la tradizione romana di icone'; Wolf, 'From Mandylion to Veronica', esp. pp. 166–170. See also, Morello and Wolf, ed., *Il Volto di Cristo*, pp. 100–211; and Murphy and others, ed., *The European Fortune of the Roman Veronica*. In recent years the Franciscan friars at Manoppello have claimed that their version of the Holy Face is the original Veronica, see, for example, Badde, *The Holy Veil of Manoppello*.

191 According to Wolf, 'Given the lack of sources, the early history of the cult of images in early Christian and mediaeval Rome remains a field of conjecture and speculation', Wolf, 'Icon and Sites: Cult Images of the Virgin', p. 41.

192 Giacchetti, *Historia*, p. 23.

193 Giacchetti, *Historia*, p. 62; Kane, *The Church of S. Silvestro in Capite*, pp. 104–05.

194 Giacchetti, *Historia*, p. 54; the translation is from Kane, *The Church of S. Silvestro in Capite*, p. 105. This inscription is also recorded in ASR, *Congregazioni religiose femminili, Clarisse di S. Silvestro in Capite*, Busta 4993 / 2. See Cameron, 'The Mandylion and Byzantine Iconoclasm', for the importance of this icon to those who opposed Iconoclasm.

195 Giacchetti, *Iconologia Salvatoris*, p. 23. For the icon and relic at Tre Fontane, see Barclay Lloyd, *SS. Vincenzo e Anastasio at Tre Fontane*, pp. 10–11, 244–46.

196 In a similar way, it was stressed that Margherita died on the vigil of the feast of Saint Silvester in 1280, another

been like the various relics and icons that were sent from Constantinople to Italy and France in the thirteenth and fourteenth centuries. Unfortunately, there is no written evidence regarding the date it arrived at S. Silvestro and these theories are only conjectural, especially since Fra Mariano first mentioned the icon only in the sixteenth century.[197] The nuns' icon was an early image of the *Mandylion*, just as the icon of the Dominican nuns of S. Sisto was an early copy of the Byzantine *Hagiosoritissa* in Constantinople, whereas the *Hodegetria* icon at S. Cosimato was, like the *Maria Advocata* at S. Maria in Aracoeli, painted in medieval Rome.

The church of S. Silvestro is now a magnificent Baroque building served by Pallottine priests of the Society of the Catholic Apostolate, while the nunnery has become the General Post Office of Rome. Yet historical documents, architectural drawings, and traces of earlier features of the buildings hint at how the medieval church was structured. The buildings ultimately go back to the Greek monastery founded by Popes Stephen II and Paul I in their family home in the eighth century; to the time when Benedictine monks resided there; and to the Franciscan nunnery established for women of the Colonna family and their associates in 1285. For nearly 600 years the nuns of San Silvestro followed the Rule of Isabelle, praising the Lord and living humbly as Enclosed Sisters Minor, until they were forced to move to other quarters in the late nineteenth century.

presage of what was to come. Carletti refers to an account of the nuns' arrival in Rome by a lawyer, Pietro Antonio Petrini, from Palestrina, who wrote c.1703, that some elderly residents remembered a painting of the Holy Face in the church of S. Biagio at Palestrina, which the nuns had taken to Rome, see Carletti, *Memorie*, p. 99, but this is not very convincing, even though Carletti refers to a Cardinal Colonna who was papal legate in 'Asia' in 1223, who obtained the icon there.

197 Fra Mariano does not mention the arrival of the icon at S. Silvestro, but the nuns' custom of showing it to the public.

CHAPTER 8

Medieval Dominican Penitents from c. 1286 and Catherine of Siena (1347–1380)

Saint Francis had many lay followers, like Jacopa of Settesoli and Count Pandolfo of Anguillara, who were members of the Franciscan Third Order, or Tertiaries.[1] These women and men, who were married, widowed, or single, were inspired to follow the Gospel in a radical way with the help of the Friars Minor. Among the Franciscans in the thirteenth century, there were women, such as Saints Elizabeth of Hungary (1207–1231), Umiliana de Cerchi of Florence (1219–1246), Rosa of Viterbo (1233–1251), and Margherita of Cortona (1247–1297), as well as Lady Altrude of the Poor in Rome, with whom Margherita Colonna stayed shortly before 30 December 1280, who were outstanding in caring for the poor, and doing corporal works of mercy.[2] Many of these women lived a 'semi-religious' way of life. They did not reside in convents or nunneries, but they often stayed at home with members of their family, or with a few like-minded women. The vocation of such women was recognized by Pope Nicholas IV with his Bull *Supra montem* in 1289, which included a Rule of life for them.[3]

One finds lay people in the Dominican Order, too. Sister Domenica Salomonia, who wrote in the seventeenth century, using medieval sources no longer available today, referred to lay men and women who offered themselves to the nunnery of S. Sisto.[4] Among these people, there seem to have been two different categories: the first were identified as servants, working at the nunnery or on its property; and the second were called 'penitents'. According to Fr. Marie-Hyacinthe Laurent, the terms 'Third Order' and 'Tertiary' were not used among the Dominicans in the thirteenth and fourteenth centuries.[5] Female penitents were sometimes named 'mantellate' (wearing a mantle), 'vestitae s. Dominici' (in the habit of Saint Dominic), 'beatae' (blessed), 'devotae' (devoted), 'pinzocherae' (lay people wearing religious habits), or 'beghinae' (beguines). The first category of lay people associated with the Order included bakers, shoemakers, weavers, and those who did the daily shopping, all devout men and women, who offered their services and all their means to the community at S. Sisto, without asking for anything specific in return; they relied on the nuns, however, to give them practical assistance and to pray for them. Some lay people worked the land and looked after

1 For Jacopa of Settesoli and Count Pandolfo of Anguillara, see above, Chapter 3.
2 For the splendid stained-glass windows showing the life and works of mercy of Elizabeth of Hungary in the Elizabeth Church, Marburg, see Burke, 'As Told by Women'; and for Franciscan semi-religious women in Italy, see Kilgallon, 'Female Sites of Devotion'. For Lady Altrude of the Poor in Rome, see *Visions of Sainthood in Medieval Rome*, trans. by Field, ed. by Knox and Field, pp. 106–10 and above, Chapter 7. Her dates are unknown.
3 See Pazzelli and Temperini, ed., *La 'Supra Montem' di Niccolo IV*; Stewart, '*De illis qui faciunt penitentiam*'. *The Rule of the Secular Franciscan Order* (his chapter 'Analysis

of the Rule of 1289'); and Bartoli, 'Women and the Franciscan legacy', esp. p. 16.
4 Spiazzi, *Cronache e Fioretti*, p. 119. See also, Creytens, 'Les convers des Moniales dominicaines au moyen âge'; and Koudelka, 'Il convento di S. Sisto a Roma negli anni 1369–1381', pp. 21–22.
5 Laurent says this in his Introduction to Tommaso da Siena's *Tractatus*, p. vi, n. 6.

the sheep, cows, horses, and domestic animals. Others transported wood, coal, and the crops gathered at the harvest. Lay men of exemplary life maintained the nunnery buildings, church, and the tower. Some names of these people are known from the extant economic records of the nunnery: Pietro de Crongeto was mentioned in 1227; Giovanni, in 1233; Nicolò, in 1244; Benedetto Caninus, in 1264; a married couple, Thedallo de Piscionibus and his wife, Costanza, in 1272; and Trasmundo Taska, in 1278.[6] Sister Domenica says some of them wore the Dominican habit, which identified them as dependants of the nunnery.

There were other lay men and women, who did not live at a nunnery or priory, but in their own homes, where they followed a form of consecrated life, guided in their spiritual journey by the Friars Preachers. Many in this second category were widows, who continued to live at home, whereas those who were unmarried often lived with their parents, while that was possible. Sometimes there were groups of men, or of women, who lived in a communal house. On 7 December 1286, Munio of Zamora (1237–1300), the seventh Master General of the Order of Preachers from 1285 to 1291, approved the 'Ordinationes' (arrangements) for the women 'vestitae' in Orvieto.[7] Evidently, the women requested the Master General to ratify and attach his seal to a document recording their 'religio' (religious way of life), which they presented to him.[8] Maiju Lehmijoki-Gardner recently found a fourteenth-century copy of this text in the Biblioteca Comunale degli Intronati, Siena (MS T.II.8.a, fols 1[r]–8[v]), which she has translated and published in English.[9] It consists of a fairly simple Rule, or way of life, for consecrated lay women associated with the Order of Preachers, who in some ways were similar to the beguines in Northern Europe.[10] The Sienese document is fascinating because it provides concrete instructions about the religious way of life of these early Italian Dominican 'vestitae' or 'mantellate'. The location and date of this surviving exemplar of the 'Ordinationes' also point to Catherine of Siena, who was a Dominican consecrated lay woman, called a 'mantellata', the name in Siena corresponding to 'vestita' in Orvieto. She would have been expected to live according to the 'Ordinationes'.

After outlining who could be received into their association, the 'Ordinationes' described the habit of these sisters (which consisted of two white tunics, one worn over the other and fastened with a belt; a black mantle; and a white veil), and it gave details of the clothing ceremony of the sisters. The women came under the jurisdiction of the local Dominican friars, who assigned one of their community as a Prior to be responsible for the women and appointed a Prioress from among the group. At the canonical hours, the sisters were to recite the Lord's Prayer a prescribed number of times. (It is likely that they were not asked to pray the Psalms and other readings of the Divine Office because they were illiterate.) Some women, however, could read, as Tommaso da Siena, also known as Caffarini (1350–c. 1434), relates in the 'Legend of Maria of Venice':

6 *Le più antiche carte del convento di San Sisto*, ed. by Carbonetti Vendittelli, p. ix; and documents 151 and 152, 14 January 1272, pp. 305–09.
7 *Dominican Penitent Women*, ed. and trans. by Lehmijoki-Gardner, pp. 40–45, for a translation of the text. This is also mentioned in Meersseman, *Dossier*, but see the critique of this in Lehmijoki-Gardner, 'Writing Religious Rules' and Lehmijoki-Gardner, 'Le Penitenti domenicane tra Duecento e Trecento'. See also, Hinnebusch, *History of the Dominican Order*, vol. I, pp. 400–04.
8 *Dominican Penitent Women, Ordinationes*, ed. and trans. by Lehmijoki-Gardner, [18], p. 45.

9 *Dominican Penitent Women*, ed. and trans. by Lehmijoki-Gardner, pp. 40–45.
10 McDonnell, *Beguines and Beghards*; and Makowski, *'A Pernicious Sort of Woman'*, pp. xxi–xxx; and 57–67; Sensi, 'The Women's Recluse Movement'. There were similar groups among the Franciscans, such as the sisters founded in Provence by Douceline of Digne, see Field, 'Douceline of Digne and Isabelle of France', pp. 83–98, esp. 85–91; and see Kilgallon, 'Female Sites of Devotion'.

she knew how to read somewhat and kept learning to do so even better for as long as she remained in this world; not only did she read the Divine Office [...] but she also devoted herself to other devout and holy lessons.[11]

These women did not have a convent or a chapel of their own, but they lived in their own homes or in groups.[12] For the night office, they were advised to pray in their room at home and to attend services at the church, only if they could walk there with companions and without danger. They were to go to confession once a month and to receive Holy Communion together ten times a year at the Dominican church. It is implied that they did manual and other types of work, because they were told to refrain from it on Sundays and other holy days. They were to visit frequently the members of their group who were sick. They were not to wander around the town or 'attend wedding banquets, dances, or any mundane or indecent feast'.[13] There were rules about fasting and abstaining from meat. On the death of a sister, everyone in the group was to be informed, go to the funeral, and pray for the deceased. After advising them to keep silent in church, the 'Ordinationes' required them to meet at the Dominican church on the first Friday of every month for Mass and a sermon, after which part of the 'Ordinationes' was to be read to them. Faults and corresponding punishments were listed. Except for their Dominican services and meetings, the sisters were to attend their parish church, and they were advised to reverence their parish priest.

Some other Italian women in this state of life are known, such as a penitent woman called Stefania from Tiber Island, who was buried in S. Sabina in 1313, and whose tomb slab shows her holding an open book against her chest.[14] Not far from Rome, at Città di Castello, lived Margaret of Castello (1287–1320), who was born blind and who was nevertheless outstanding in holiness, teaching, and helping the poor.[15] Some documents in the Archivio di Stato in Florence refer to Dominican 'mantellate' in Tuscany, the first one dated 21 November 1313.[16] In Lucca, Donna Caruccia, widow of Vitale Caccialupi, asked in her will, dated 27 July 1315, to be buried in the cemetery of the Dominican friars in Lucca, dressed in the habit of a 'vestita' of the Order of Preachers.[17] A donation made to the Dominicans of Arezzo by Donna Balduccia, mentioned in a document dated 29 May 1336, indicates the presence of these women in that town.[18] A wealthy lady on 2 August 1391 left a house to the association of 'vestitae' of the Order of Saint Dominic at San Geminiano.[19]

Catherine of Siena

Catherine of Siena (1347–1380) was not a cloistered nun but lived as a 'mantellata', as the Dominican penitents were called in Siena. At first, she stayed quietly at home with her family; later, she went out to serve the sick and the poor; and in the latter part of her life, she travelled frequently to places like Florence, Pisa, Avignon, and Rome to fulfil a very public ministry, which she backed up

11 *Dominican Penitent Women*, ed. and trans. by Lehmijoki-Gardner, p. 128.
12 See Kilgallon, 'Female Sites of Devotion', for a similar phenomenon among Franciscan penitents.
13 *Ordinationes* 11, *Dominican Penitent Women*, ed. and trans. by Lehmijoki-Gardner, p. 43.
14 Garms and others, ed., *Die mittelalterlichen Grabmäler in Rom*, vol. I, LVII, 8, pp. 282–83; Darsy, *Santa Sabina*, fig. 40; and see above, Chapter 2. That she was portrayed with a book implies that she could read.
15 She was canonized by Pope Francis on 24 April 2021. Laurent, 'La Plus Ancienne légende de la b. Marguerite de Città di Castello'; and <https://www.op.org/st-margaret-of-citta-di-castello/> [accessed 12 December 2021].
16 Tommaso da Siena, *Tractatus*, ed. by Laurent, pp. v–vi.
17 Tommaso da Siena, *Tractatus*, ed. by Laurent, p. vi, n. 2.
18 Tommaso da Siena, *Tractatus*, ed. by Laurent, p. vi, n. 3.
19 Tommaso da Siena, *Tractatus*, ed. by Laurent, p. vi, n. 4.

with numerous letters to people in high places, such as the Pope, the King of France, and the Queen of Naples.[20] She was also one of the great mystics of the later Middle Ages. She went to Rome in November 1378 and died there on 29 April 1380.[21] She did not stay with the Dominican nuns at S. Sisto, but she lived in a house close to S. Maria sopra Minerva, the Dominican church where she was buried.[22] Immediately after her death, many people recognized her as 'beata' (blessed), and after her canonization in 1461, she was officially declared 'sancta' (a saint).[23]

After Catherine died, her former spiritual director, Raymond of Capua (1330–1399), wrote her 'official' biography, the *Legenda Maior*, which was completed in 1395.[24] He mentioned that the information for his book came from Catherine herself, from her mother Lapa, from her sister-in-law Lisa, and many other people who had known Catherine personally, such as two Dominican friars from the priory of San Domenico in Siena, Fra Tommaso della Fonte and Fra Bartolomeo di Domenico.[25] In the early fifteenth century, Tommaso Caffarini, who had known Catherine personally, composed an abbreviated version of Raymond's biography, to which he added new information of his own; his book was entitled the *Legenda Minor* in Latin, or the *Leggenda Minore* in Italian.[26] Between 1401 and 1418, he wrote another work on Catherine, his *Libellus de Supplemento*.[27] An anonymous account of her life, which concentrates on her miracles before c. 1374, also survives in Florence.[28] It seems to have been a source used by Caffarini, who included Catherine's miracles; and he also wrote about how she received the stigmata, which was illustrated in some versions of his work.[29] In addition, he and some other Dominicans referred to how they venerated Catherine each year on the Sunday after the feast of Saint Peter Martyr, at the *Processo Castellano*, a diocesan enquiry held in 1411–1416 into how the Dominicans in Venice were honouring Catherine before she was canonized.[30] Saint Antonino Pierozzi (1389–1459), who was Prior at S. Maria sopra Minerva in 1430 and became Archbishop of Florence in 1446, wrote a short life of Catherine based on the work of Raymond of Capua, her official biography.[31]

20 See the four volumes of *The Letters of St Catherine of Siena*, ed. by Noffke.
21 For Saint Catherine's sojourn in Rome, see Esch, 'Tre sante ed il loro ambiente sociale a Roma', esp. pp. 112–119; and Cavallini and Giunta, *Luoghi cateriniani di Roma*.
22 Bianchi, 'Il sepolcro'; Barclay Lloyd, 'Saint Catherine of Siena's Tomb'; Caglioti, 'La connoisseurship della scultura rinascimentale'.
23 For the distinction between 'blessed' and 'saint' in the late Middle Ages, see Vauchez, *Sainthood in the Later Middle Ages*, pp. 85–103; for the early cult of Saint Catherine, see Hamburger and Signori, ed., *Catherine of Siena: The Creation of a Cult*; and for later veneration of her, Parsons, *The Cult of Saint Catherine of Siena*. There are many books on Catherine, such as Drane, *The History of Saint Catherine of Siena*; Jørgensen, *Saint Catherine of Siena*; Luongo, *The Saintly Politics of Catherine of Siena*; Muessig, Ferzoco, and Kienzle, ed., *A Companion to Catherine of Siena*; Vauchez, *Catherine of Siena*; Murray, *Saint Catherine of Siena*; and see Zangari, 'Sulle ultime ricerche', pp. 436–40 for some of the latest research in this field.
24 Raymond of Capua, *Legenda Maior*, ed. by Henschenius and Papebrochius, pp. 851–978; for the English translation, see Raymond of Capua, *Life*, trans. by Lamb; for the Italian translation, see Raimondo da Capua, *Legenda maior cioè Vita di S. Caterina da Siena*, trans. by Tinaglio.

25 Raymond of Capua, *Legenda Maior*, ed. by Henschenius and Papebrochius, Part I, paras 24–34.
26 Tommaso da Siena, *Sanctae Catharinae Senensis Legenda Minor*, ed. by Francheschini, and *Leggenda Minore*, ed. by Grottanelli.
27 Tommaso da Siena, *Libellus de Supplemento*, ed. by Cavallini and Foroloso, of which there is a translation into English of Part I in *Dominican Penitent Women*, ed. and trans. by Lehmijoki-Gardner, pp. 177–91.
28 Anonymous, *I miracoli di Caterina [...] da Siena*, ed. and trans. by Lehmijoki-Gardner.
29 See, Vauchez, *Catherine of Siena*, Chapter 3: 'Catherine as viewed by her medieval biographers' and Moerer, 'The Visual Hagiography of a Stigmatic Saint'.
30 *Il Processo Castellano*, ed. by Laurent.
31 Pierozzi, *Storia breve*, trans. by Sante Centi. See above, Chapter 6.

Catherine's Life According to Raymond of Capua

Raymond of Capua, who knew Catherine well because he had been her spiritual director from 1374 to 1378, divided her life into three phases.[32] The first went from her early childhood until she became a Dominican 'mantellata' and experienced a 'mystical marriage' with Christ; the second described how she related to other people, especially the poor, in Siena; and the third discussed her more public role in Florence, Avignon, and Rome.[33] At various points in the early narrative, Raymond stressed how Catherine was drawn to the Order of Preachers. At the age of six, she saw above the roof of the church of S. Domenico in Siena an apparition of Christ enthroned, wearing priestly vestments and the papal tiara; he was accompanied by Saints Peter, Paul, and John the Evangelist; in this vision, Christ blessed her.[34] A year later, at the age of seven, she felt a great desire to give herself entirely to Christ, and with the help of the Virgin Mary, she made a private vow to remain a virgin; shortly after that, she began to feel great esteem for the Dominicans of Siena.[35] When she turned twelve, her family wanted to arrange a marriage for her, which she resisted. This led to harsh persecution from her parents and siblings. Amid the noisiness of the house, she retreated into the interior 'cell' of her heart, where she could pray.[36] When her father saw a white dove hovering over her head as she knelt in prayer, he realized by the power of the Holy Spirit that she had a vocation to a life consecrated to God.[37] Eventually, Catherine's family began to understand her calling.

According to Raymond, Catherine began to desire more and more to be clothed in the Dominican habit. This began when she saw in a vision the founders of several religious Orders, including Saint Dominic, whom she recognized because he was holding a beautiful white lily.[38] (It is of interest that depictions of Saint Dominic at this time, such as the one at S. Sisto, showed him holding a lily [see Saint Dominic, the second saint from the left, in Fig. 32].) All the other founders gave her advice, whereas Saint Dominic showed her the habit of the 'mantellate' of his Order, who were numerous in Siena; he told her to take courage because she would certainly put on that habit, as she desired. She reacted with great happiness and tears of joy, thanking God and Saint Dominic for having consoled her in such a sublime way. She was then able to tell her family firmly that Christ was her bridegroom and they realized she would not marry anyone else. She also managed to persuade her parents to give her a bedroom of her own, where she could retire to pray and live in solitude.[39] For the next three or four years, she lived an ascetic life at home in her room, learning about the spiritual life directly from Christ. She began to fast and abstain from food and drink,[40] and in some of her ascetic practices she imitated Saint Dominic.

32 See also, Vauchez, *Catherine of Siena*, Chapter 3: 'Catherine as viewed by her medieval biographers'.

33 Raymond's treatment of this third part is comparatively short, according to Luongo, *The Saintly Politics of Catherine of Siena*, and Vauchez, *Catherine of Siena*, perhaps because it was so unusual for a medieval woman to travel so much and be so involved in political and high-level Church affairs.

34 Raymond of Capua, *Legenda Maior*, ed. by Henschenius and Papebrochius, Part I, para. 29, p. 860.

35 Raymond of Capua, *Legenda Maior*, ed. by Henschenius and Papebrochius, Part I, paras 35 and 38, pp. 862–63.

36 Raymond of Capua, *Legenda Maior*, ed. by Henschenius and Papebrochius, Part I, para. 49, p. 865.

37 Raymond of Capua, *Legenda Maior*, ed. by Henschenius and Papebrochius, Part I, paras 52–56, pp. 866–67.

38 Raymond of Capua, *Legenda Maior*, ed. by Henschenius and Papebrochius, Part I, para. 53, p. 866.

39 Raymond of Capua, *Legenda Maior*, ed. by Henschenius and Papebrochius, Part I, para. 57, p. 867. Kilgallon, 'Female Sites of Devotion', p. 71, points out that Franciscan medieval penitent women often had to share a bedroom with other family members.

40 Raymond of Capua, *Legenda Maior*, ed. by Henschenius and Papebrochius, Part I, paras. 57–58, p. 867; see also, Bynum, *Holy Feast and Holy Fast*, Chapter 5.

While she was living this life of penance, the devil began to attack her in many ways,[41] but through this spiritual warfare, she grew in the virtues of faith and fortitude.

Catherine wanted to take the Dominican habit but in Siena the 'mantellate' were almost all widows, who did not want to admit an attractive, young girl like Catherine, who might cause scandal.[42] Eventually, however, they were won over. Lapa and Catherine went to the Dominican church and, in the presence of the other sisters and the friar who was appointed to guide the 'mantellate' spiritually, she was clothed in the habit.[43] Among other things, one of the sisters taught Catherine the alphabet, and she began to practise reading the letters she had learned, in the Psalms. She said that Christ came to help her read the Divine Office — although Raymond claimed that she began reading the words in Latin without understanding their meaning.[44] Later, she often repeated in Italian the opening antiphon, 'O God come to my aid; O Lord, make haste to help me'.[45]

Although Catherine had no formal education, she authored many letters, a book known as *The Dialogue*, and numerous prayers.[46] She did this by dictating to various scribes: Raymond gave the names of Stefano di Corrado de' Maconi, Barduccio di Pietro Canigiani, and Neri di Landuccio dei Paglieri, and there were others who remained anonymous.[47] Catherine ascribed her ability to author her works to divine intervention.[48]

As she grew in holiness, Catherine came closer to Christ, and he told her he would 'marry her in faith'.[49] Raymond describes her 'mystical marriage' to Jesus in the presence of the Virgin Mary, Saint John the Baptist, Saint Paul, and Saint Dominic, with King David providing musical accompaniment on his harp.[50] She always referred to Jesus as her spouse and other people, like Raymond, called her the spouse of Christ.

In the second part of his book, Raymond related how Catherine took care of the poor, the sick, and prisoners in Siena, while having other, profound spiritual experiences. After the 'mystical marriage', Christ called Catherine to leave the solitude of her room and to serve others. She first did this at home, helping members of her family in great humility. Later, she went out to look after the poor and the sick in Siena. One instance of this service was to give her under-tunic and some other clothes to a poor beggar, as was illustrated at the nunnery of S. Sisto in a fresco that survives (Fig. 33) and in a painting near her tomb known only from written sources.[51] After this act of generosity, Christ appeared to her, praised her, and gave her an invisible garment in return. On other occasions, she tended the sick in their homes or at the 'Ospedale della Misericordia' in Siena, where the poor were given medical assistance.[52]

41 Raymond of Capua, *Legenda Maior*, ed. by Henschenius and Papebrochius, Part I, paras 67–68, p. 869.

42 Raymond of Capua, *Legenda Maior*, ed. by Henschenius and Papebrochius, Part I, para. 70, p. 870.

43 Raymond of Capua, *Legenda Maior*, ed. by Henschenius and Papebrochius, Part I, para. 75, p. 871.

44 Raymond of Capua, *Legenda Maior*, ed. by Henschenius and Papebrochius, Part I, para. 113, p. 881.

45 Psalm 69 (70), 1; see Raymond of Capua, *Legenda Maior*, ed. by Henschenius and Papebrochius, Part I, para. 113, p. 881.

46 See, in English translation, *The Letters of St Catherine of Siena*, trans. by Noffke; *Catherine of Siena: The Dialogue*, trans. by Noffke; *The Prayers of Catherine of Siena*, trans. by Noffke.

47 Raymond of Capua, *Legenda Maior*, ed. by Henschenius and Papebrochius, Part II, para. 261, p. 918 and Part III, para. 343, p. 939, for those named, Part III, para. 332, pp. 936–37 for unnamed scribes.

48 Tylus, 'Mystical Literacy', pp. 155–83, esp. 156–60.

49 Raymond of Capua, *Legenda Maior*, ed. by Henschenius and Papebrochius, Part I, para. 114, p. 881.

50 Raymond of Capua, *Legenda Maior*, ed. by Henschenius and Papebrochius, Part I, para. 115, p. 881.

51 Raymond of Capua, *Legenda Maior*, ed. by Henschenius and Papebrochius, Part II, paras 135 and 138, pp. 887–88; see above, Chapters 1 and 6.

52 Raymond of Capua, *Legenda Maior*, ed. by Henschenius and Papebrochius, Part II, paras 147–64, pp. 889–94.

Among those she cared for was a female leper, called Tecca, whom nobody else wanted to help.[53] In fact, the leprous woman was not only physically sick, but she was also difficult to deal with, and she accused Catherine rudely of many misdemeanours. Although Catherine discovered signs of leprosy on her own hands after assisting Tecca for some time, she persevered in caring for her, and, when Tecca died, she washed her body and prepared it for burial. After the funeral, Catherine found that the marks of leprosy had disappeared from her own hands. Another person she helped was one of the 'mantellate' in Siena, called Palmerina, who was envious of Catherine and often criticised her, spreading false rumours about her.[54] When Palmerina fell ill, Catherine visited her in her home, but was not graciously received. Catherine began to pray fervently for Palmerina, and in the end, when the Sister was dying, she went to see her again, and there was a reconciliation, after which Palmerina took the Sacraments and died in peace. Another Sister among the 'mantellate', called Andrea, suffered from an ulcerous cancer of the breast, which was particularly foul-smelling.[55] Catherine went to help her, by washing away the liquid secreted from her wound and putting new dressings on it. Instead of being grateful, Andrea began to spread rumours that Catherine was not a virgin, seeking to destroy her reputation among the other sisters and anyone else who would listen. This troubled Catherine, to whom the Lord appeared, and he offered to crown her, either with a crown of gold or a crown of thorns. She chose the latter, so as to be conformed to Christ's sufferings. In spite of Andrea's calumny, she continued to look after her. On one occasion, as Catherine was dressing her wound, she removed a quantity of pus, which she then drank as a penance. The following night, Christ appeared to her and showed her his wounds; he told her to come closer to him and drink some of the water and blood from the wound in his side, as a reward for her courageous action of drinking the pus from Andrea's wound.

There were many other people Catherine helped; not all were grateful, and some spread untrue gossip about her, which she bore patiently. In the end, she attracted around her a group of disciples, both men and women. At this time, Catherine continued to have strong mystical experiences, such as giving her heart to Jesus, and then receiving his in exchange.[56] She desired to receive Holy Communion frequently, since it brought her great joy and often resulted in her going into ecstasy or deep prayer with floods of tears as she contemplated the Passion of Christ.[57]

Raymond claimed that Catherine was responsible, through her prayers, for the conversion of sinners.[58] For example, there were two prisoners, who, on their way to their execution, were blaspheming God, but they stopped after Catherine prayed for them, and the Lord appeared to them. Another man, called Giacomo, who fomented quarrels and fights in Siena, became more peaceful as a result of meeting her; and a certain Nanni gave up his enmity and violence through her intercession and counsel. When her mother, Lapa, died in a state of unconfessed sin, Catherine prayed for her and she returned to life and she was able to repent.[59] When the plague came to Siena, Catherine through her prayers healed a

53 Raymond of Capua, *Legenda Maior*, ed. by Henschenius and Papebrochius, Part II, paras 143–46, pp. 889–90.
54 Raymond of Capua, *Legenda Maior*, ed. by Henschenius and Papebrochius, Part II, paras 147–49, pp. 890–91.
55 Raymond of Capua, *Legenda Maior*, ed. by Henschenius and Papebrochius, Part II, paras 154–64, pp. 892–94.
56 Raymond of Capua, *Legenda Maior*, ed. by Henschenius and Papebrochius, Part II, paras 179–80 and 186, pp. 895–900.
57 Raymond of Capua, *Legenda Maior*, ed. by Henschenius and Papebrochius, Part II, paras 187–201, 312–30, pp. 900–03, 930–35.
58 Raymond of Capua, *Legenda Maior*, ed. by Henschenius and Papebrochius, Part II, paras 228–40, pp. 909–13..
59 Raymond of Capua, *Legenda Maior*, ed. by Henschenius and Papebrochius, Part II, paras 243–44, pp. 914.

number of people, including Raymond, who had caught the disease while ministering to many people who were ill.[60]

In the third part of his book, Raymond described Catherine's public role as an ambassadress and peace-maker in Florence, Avignon, and other places, ending with her final years in Rome. He described her death and burial, although he was not present; and he ended his work by recounting her miracles, and her extraordinary virtues. She attended the Dominican General Chapter of 1374 in Florence. In 1377, she acted as an ambassadress of Pope Gregory XI in that city in an attempt to bring peace between the Florentines and the papacy.[61] She stayed in Florence until a peace treaty had been published. She began to write her book, *The Dialogue*, in Florence and continued writing it when she returned to Siena. She travelled to the papal court at Avignon in France to speak to Pope Gregory XI and tried to persuade him to return permanently to Rome. In the last years of her life, she fulfilled a very public and political mission in the Church and in the world, and she wrote letters to important people.[62] She went to other places in Italy: when she was in Pisa in 1375, she had a strong mystical experience, culminating in the stigmata.

Raymond explained that Pope Urban VI commanded him to order her, under holy obedience, to move to Rome in 1378, which she did, accompanied by a large number of men and women disciples.[63] The Pope asked her to address the cardinals and himself, quite an unusual thing for a woman to do at that time; she encouraged them when the Church was experiencing many difficulties.[64] In November 1378, the election of a rival pope, Clement VII, plunged the Church into the Great Schism, which lasted until 1417. When the Pope wanted Catherine to go and speak to the King of Sicily on his behalf, she refused, but she encouraged Raymond to go to France and confer with King Charles V, which was another request made by Pope Urban VI.[65] At the end of his mission in France, Raymond remained in Genoa. Catherine stayed in Rome with her numerous disciples, both men and women, who formed her spiritual 'family' and referred to her as 'Mamma'.

Raymond states that she and her followers lived in 'Via del Papa, between the Minerva and Campo de' Fiori'.[66] The house is believed to have been at today's Piazza S. Chiara, 14, where there is now a chapel, 'la Cappella del Transito', which commemorates her death; it was decorated in the seventeenth century and restored in 1989.[67] During the last two years of her life, Catherine remained in Rome, walking almost every day to St Peter's to attend Mass and pray for long hours for the Church, while waging an intense spiritual battle against evil, which Raymond considered a form of martyrdom.[68]

André Vauchez comments that Raymond in his biography gave an image of Catherine which minimized in some ways her extraordinary interventions in politics, justice, reconciliation,

60 Raymond of Capua, *Legenda Maior*, ed. by Henschenius and Papebrochius, Part II, paras 252–56, pp. 916–17.
61 Raymond of Capua, *Legenda Maior*, ed. by Henschenius and Papebrochius, Part III, para. 332, p. 936.
62 See, Luongo, *The Saintly Politics of Catherine of Siena* and *The Letters of St Catherine*, trans. by Noffke.
63 Raymond of Capua, *Legenda Maior*, ed. by Henschenius and Papebrochius, Part III, para. 333, p. 937.
64 Raymond of Capua, *Legenda Maior*, ed. by Henschenius and Papebrochius, Part III, para. 334, p. 937.
65 Raymond of Capua, *Legenda Maior*, ed. by Henschenius and Papebrochius, Part III, paras 335–37, pp. 927–38.
66 Raymond of Capua, *Legenda Maior*, ed. by Henschenius and Papebrochius, Part III, para. 348, pp. 940–41.
67 Cavallini and Giunta, *Luoghi cateriniani di Roma*, pp. 45–46. The actual room in which Catherine died was transferred stone by stone to S. Maria sopra Minerva in the seventeenth century, where it was re-erected behind the sacristy.
68 Raymond of Capua, *Legenda Maior*, ed. by Henschenius and Papebrochius, Part III, paras 344–48, pp. 939–41. For the route taken by Catherine to go to St Peter's, see, Giunta, 'Santa Caterina da Siena pellegrina a "Santo Pietro"'.

and public life, as well as in the highest levels of Church affairs.[69] It was very unusual for women at her time to be so active in these spheres — although Saint Bridget of Sweden (*c.* 1303–1373), who was canonized in 1391 while Raymond was writing his biography of Catherine, and who had also been a mystic, had insisted forcefully that the Pope should return to Rome. Catherine frequently travelled from one place to another, in a manner not considered appropriate for a consecrated virgin in the late Middle Ages. This was a fact that Raymond did not emphasize. Nor did he stress the importance of her writings, whereas Tommaso da Siena Caffarini focused on this aspect of her life, making a collection of her letters and having her *Dialogue* copied. Caffarini also emphasized the importance of her experience of the stigmata, seeing her as a female Dominican equivalent of Saint Francis of Assisi (which was not very acceptable to the Friars Minor).

Catherine's Death, Burial, and Cult

Catherine died in Rome on 29 April 1380, in the house near S. Maria sopra Minerva. Immediately afterwards, one of her disciples, Barduccio Canigiani, wrote a letter describing her death.[70] As Catherine neared the end of her life, her followers in Rome came to her deathbed and she prayed for each of them in turn, and gave them advice. Then, she interceded for the Church and for the Pope. She was very conscious of her sins, and twice received absolution. During an intense struggle with the devil, she cried out for mercy through the precious blood of Jesus. Finally, having pronounced the words, 'Father, into Thy Hands I commend my spirit', she bowed her head, and expired.

Raymond was in northern Italy, so he was not present at her death, although he said he had a presentiment that she had passed away. Several eyewitnesses among Catherine's followers informed him afterwards about what had happened.[71] There was also a Roman woman called Semia, who had a vision of Catherine as a young girl surrounded by saints and angels in heaven; there were three crowns on her head, one on top of the other — the lowest of silver, the middle one of gold mixed with silver, and the highest of pure gold set with jewels.[72] The mention of three crowns is interesting because in the Middle Ages it was believed that at the hour of death certain holy people — virgins, martyrs, and doctors of theology — were awarded such crowns ('aureolae') as a mark of special distinction.[73] The crowns were different from the halo, which was depicted only after canonization, and which was not shown in visual representations of Catherine of Siena before she was canonized in 1461.[74] Some images, however, represented Catherine with three 'aureolae', concentrating on her heroic virtues as a virgin dedicated to Christ, as a person who suffered grievously for the Church of her day, and as a woman who taught and wrote Christian doctrine.[75]

69 Vauchez, *Catherine of Siena*, Chapter 3: 'Catherine as viewed by her medieval biographers'. In this he follows a similar line of argument in Luongo, *The Saintly Politics of Catherine of Siena*.

70 In Latin in *AA SS*, ed. by Henschenius and Papebrochius, aprilis III, pp. 959–61, and parts in English translation in Drane, *The History of Saint Catherine of Siena*, pp. 564–68.

71 Raymond of Capua, *Legenda Maior*, ed. by Henschenius and Papebrochius, Part III, para. 367, p. 945.

72 Raymond of Capua, *Legenda Maior*, ed. by Henschenius and Papebrochius, Part III, paras 370–77, pp. 946–48.

73 Thomas Aquinas, *Commentum in quattuor libros Sententiarum*, 2, 1233–1244, says that every human being has to contend with the flesh, the world, and the devil, and some saints do this in an exemplary manner, hence deserving the 'aureolae' given to virgins, martyrs, and doctors (of theology).

74 This point was made at *Il Processo Castellano*, ed. by Laurent, pp. 8 and 28. Catherine, before her canonization was shown with golden rays around her head, rather than a halo. In the frescoes at S. Sisto, she is shown with these rays, instead of a halo.

75 Donati, 'Santa Caterina da Siena nelle stampe del '400';

In 1430, when Antonino Pierozzi was the Dominican prior of S. Maria Sopra Minerva — before he became Archbishop of Florence — he translated Catherine's remains to a new tomb, for which he provided a marble effigy of her, lying on two pillows, one of which was inscribed 'BEATA KATERINA' (BLESSED CATHERINE), indicating that she was beatified but not yet canonized.[76] It seems Antonino may have provided other embellishments to the tomb. In 2003, Professor Francesco Caglioti discovered a letter written in 1592 by the art dealer, Marco Antonio Dovizi, to a prospective collector and buyer in Florence, Baccio Valori, which mentioned that some pieces of sculpture were for sale on the art market in Rome.[77] Dovizio claimed that all the pieces had been carved by the Florentine sculptor Donatello (1386–1466). The carvings were listed as a lunette in bas-relief, showing Christ and the Virgin Mary about to crown Catherine of Siena; three rectangular plaques with figures almost in the round of Saints Catherine, Dominic, and Michael; and two large, and two smaller angels, the latter holding lights, or candles.[78] Caglioti and Giancarlo Gentilini have both connected the description of the bas-relief with a fragmentary scene showing the *Madonna holding two crowns*, which seems to be part of the lunette described in Dovizio's letter.[79] The relief, which is now in a private collection in Rome, was clearly part of a lunette, since a curve begins in the upper section on the left. The Virgin Mary is shown in profile, seated and looking down towards the viewer's right, to what must have been the centre of the relief — perhaps where Catherine would have been represented; with her left hand the Virgin Mary holds up a gothic crown and she has another in her right hand on her lap. Several small cherubs surround her. The presumed figures of Christ and Saint Catherine have not survived.[80] The style of carving is typical of the Florentine sculptor Donatello, to whom Gentilini attributed the relief, but Caglioti believed it was made not by the master himself but by a follower of Donatello and according to his design. It could have been carved in Rome in 1430, when Donatello is known to have been in the city, as attested by a letter dated 23 September 1430 from Poggio Bracciolini to Niccolo Niccoli.[81]

Perhaps referring to Catherine, Antonino wrote that many people who had not yet been canonized by the Church might have been superior in virtue to others inscribed in the catalogue of saints.[82] This could be shown visually *c.* 1430 by crowns ('aureolae'), if not yet by a halo. An inscription, which mentioned an 'aureola' and Catherine's virtues, was to be seen near her tomb in the sixteenth century. It began,

> Virginitas doctrina fides sanctissima vita aureolam capiti dant caterina tuo [...]
>
> (Virginity, doctrine, faith, and a most holy life / give to your head, O Catherine, a crown [...])[83]

Hall and Uhr, 'Aureola super Auream', 578–83; Bianchi and Giunta, *Iconografia di S. Caterina da Siena*, pp. 172, 175, 176, 225, 232, catalogue nos 20, 23, 25, 101, 111.

76 See above, Chapter 6.
77 Caglioti, 'La connoisseurship della scultura rinascimentale', p. 139. The letter from Marco Antonio Dovizio to Baccio Valori, Rome, 28 April 1592, is in Bottari, *Raccolta di lettere sulla pittura, scultura ed architettura*, vol. II, pp. 41–44, n. III.
78 This letter was published in Gentilini, 'La Madonna di Santa Caterina'.
79 Gentilini, 'La Madonna di Santa Caterina'; Caglioti, 'La connoisseurship della scultura rinascimentale', pp. 136–40.

80 A theory that Christ was giving a palm to Saint Catherine as a symbol of martyrdom, although she was not actually a martyr, in Barclay Lloyd, 'Saint Catherine of Siena's Tomb', pp. 129–32, has rightly been refuted by Caglioti, who has pointed out that Dovizio says that Christ was extending the open palm of his right hand to Catherine, and not a palm branch; Caglioti, 'La connoisseurship della scultura rinascimentale', p. 152 n. 20.
81 Pfisterer, *Donatello*, p. 489 n. 3.
82 Pierozzi, *Storia breve*, p. 31.
83 The text is recorded by Chacón, '*Inscriptiones e epitaphia*', BAV Chigi I. V. 167, fol. 168ʳ, who says it was on a

Antonino's tomb included the effigy of Catherine and probably the carved lunette above it. It is possible that the other figures mentioned by Dovizio were also part of Catherine's tomb decoration *c.* 1430, or they may have been added after her canonization, when her tomb was placed upon the altar in the chapel in 1466.[84] In fact, three figures in the round of Saints Catherine, Dominic, and Michael have been linked to the post-1466 version of her tomb by Gentilini and Caglioti, the latter seeing a connection between the latter two with the two patrons of the chapel, the Capranica Cardinals Domenico and Angelo, for whom Dominic and Michael were the patron saints. The statue of Saint Catherine is now in a niche in the Via del Corso entrance of the Palazzo Odescalchi in Rome. She clearly has a halo to mark her sainthood in this representation, not a crown, nor rays of light.[85] If it formed part of her tomb, it is most likely that it was added after her canonization in 1466.

When Catherine died, her disciples were not sure what to do. In the end, they decided to take her body to S. Maria sopra Minerva, and request she be buried there.[86] Her tomb in the Dominican church became a place of pilgrimage, where people left ex-votos to give thanks for miracles that happened when they prayed there.[87] When she was canonized in June 1461, Pope Pius II Piccolomini (1458–1464) praised her in an oration, a papal Bull, and in three hymns — for her vocation to virginity; the austerity of her life expressed in fasting and penance; her service of the poor, the sick, and the imprisoned; her prudent speech and writings, filled with wisdom and doctrine, which were infused rather than learned; her efforts to make peace between Florence and the papacy; her dedication to the Church in Rome; and the many miracles ascribed to her intercession.[88] Possibly one of his hymns was sung for the monks at the monastery of S. Maria de Oliveto on 2 May 1462, when he recorded that in the refectory, 'he introduced musicians who sang to them, while they ate, a new song about Saint Catherine of Siena so sweetly that they brought tears of joy to the eyes of all the monks'.[89]

After her canonization, the words 'SANCTA CATERINA/ VIRGO DE SENIS/ ORDINIS SANCTI / DOMINICI DE/ PENITENTIA' (Saint Catherine, Virgin of Siena, of the Order of Penitence of Saint Dominic) were inscribed on her sarcophagus, which in 1466 was placed on the altar in the chapel at S. Maria sopra Minerva south of the sanctuary, where she was buried.[90] The inscription appropriately calls her a saint. Instead of describing her as a 'mantellata', it anachronistically identifies her as a member of the 'Order of Penitence of Saint Dominic', which through the efforts of Tommaso Caffarini had been approved by Pope Innocent VII in 1405.[91] This meant she was a member of the Dominican Third Order, as opposed to the Second Order of cloistered nuns, and the First Order of Friars Preachers.[92]

After Catherine of Siena's death in 1380, her disciple, the Dominican friar, Tommaso da Siena Caffarini, became the spiritual guide of a group

plaque in the chapel which contained the tomb of Saint Catherine. The last inscriptions in his manuscript are dated 1576, on fols 106r and 116r, so he must have seen this one before the chapel was transformed in 1579, as described above, Chapter 6. See also, Bianchi, 'Appendice epigraphica', p. 56.

84 See Barclay Lloyd, 'Saint Catherine of Siena's Tomb', pp. 133–43, and above, Chapter 6.
85 Barclay Lloyd, 'Saint Catherine of Siena's Tomb', pp. 142–43.
86 Raymond of Capua, *Legenda Maior*, ed. by Henschenius and Papebrochius, Part III, para. 376, p. 947.
87 For the various phases of her tomb, Barclay Lloyd, 'Saint Catherine of Siena's Tomb' and above, Chapter 6.

88 *BOP*, vol. III, pp. 140–43; Mansi, *Pii II olim Aeneas Sylvii Piccolominei Senensis Orationes*, vol. 2, pp. 411–12.
89 Mansi, *Pii II olim Aeneas Sylvii Piccolominei Senensis Orationes*, vol. II, p. 673, Book X.
90 See above Chapter 6, and Barclay Lloyd, 'Saint Catherine of Siena's Tomb', pp. 133–35.
91 See above, Chapter 6.
92 For Dominican penitents, see above.

of Dominican consecrated lay men and women in Venice with a view to securing papal approval of their way of life.[93] He formed the group into the 'Order of Penitence of Saint Dominic' and he wrote a treatise extolling the virtues of some exemplary penitent lay women, such as Vanna of Orvieto and Maria of Venice.[94] In his treatise, Tommaso da Siena claimed, erroneously, that the lay Order had been started by Saint Dominic himself as a 'Militia Ihesu Christi' (Militia of Jesus Christ), that would help him defeat the heretics by defending the faith.[95] Tommaso completely revised the simple 'Ordinationes' ratified by Master General Munio, changing it into the 'Dominican Penitent Rule'. This clarified and strengthened the links between the lay penitents and the friars by defining more clearly the role of the Prior. It also instituted a year's formation for candidates who aspired to their way of life. Pope Innocent VII in his Bull, *Sedis apostolicae*, issued on 26 June 1405, gave this Rule papal approval.[96]

Catherine of Siena was not a cloistered nun, but a 'semi-religious' woman, a 'mantellata', later called a member of the 'Order of Penitence of Saint Dominic'. Catherine was celebrated as an outstanding example of sanctity, even though the medieval popes, from Innocent III to Boniface VIII, wanted religious women to live in strict enclosure, and most medieval clergymen, like Benedict of Montefiascone, the Dominican prior of S. Sisto from 1316 to 1318, did not approve of religious women 'per diversa vagantes' (wandering around in various places) but wanted them to live 'sub arcta clausura' (in strict enclosure).[97] At first, she stayed in her parents' home. She served the poor and the sick; and, finally, she travelled frequently to other parts of Italy and to France as an ambassadress in the service of the Church at a very difficult time. When Pope Urban VI demanded she should come to Rome, she obediently did so. She was asked to address the Pope and the Cardinals and to pray for the Church. Although she was not taught to read and write as a child, she managed to author a book, many letters, and prayers. She was a mystic, who had strong spiritual experiences. Guided by her Dominican spiritual directors, such as Raymond of Capua, she remained true to Church teaching. She died in Rome and is now buried under the high altar of S. Maria sopra Minerva, where her tomb, which has been transformed and moved several times, can still be visited (Fig. 144).

Through her disciples, such as Giovanni Dominici, Raymond of Capua, Tommaso da Siena Caffarini, and Chiara Gambacorta, Catherine contributed to the 'reform' of the Dominican Order in the fifteenth century.[98] Giovanni Dominici, who had helped her in Siena, and Raymond of Capua, her spiritual director, spearheaded the Observant Reform of the Order between 1390 and 1420. Dominici founded strictly enclosed nunneries, such as Corpus Christi in Venice in 1394, and reformed houses for the friars in Tuscany, such as that of San Domenico in Fiesole, where

93 He is also famous for having written a biography of Saint Catherine and a supplementary book about her: Tommaso da Siena, *Sanctae Catharinae Senensis Legenda Minor*, ed. by Francheschini; Tommaso da Siena, *Libellus de Supplemento*, ed. by Cavallini and Foroloso.

94 Tommaso da Siena, *Tractatus*, ed. by Laurent. Some of his biographies of 'vestitae/mantellate', such as Vanna of Orvieto and Maria of Venice, have been translated into English and published in *Dominican Penitent Women*, ed. and trans. by Lehmijoki-Gardner, pp. 59–86, 105–76.

95 Tommaso da Siena, *Tractatus*, ed. by Laurent, pp. 2 and 4.

96 BOP, vol. II, pp. 473–77. Lehmijoki-Gardner has shown convincingly that this Rule was what Meersseman mistakenly believed was the original document that Munio approved, see Lehmijoki-Gardner, 'Writing Religious Rules'; Lehmijoki-Gardner, 'Le Penitenti domenicane tra Duecento e Trecento'; and *Dominican Penitent Women*, ed. and trans. by Lehmijoki-Gardner, Introduction, pp. 5–8.

97 See Chapter 1, and Benedict of Montefiascone, *Historical Introduction*, 1, p. 69.

98 Vauchez, *Catherine of Siena*, Chapter 4; Gagliardi, 'Caterina Madre dell'Osservanza domenicana'; Duval, 'Chiara Gambacorta'; and Duval, '*Comme les anges sur la terre*'.

Antonino Pierozzi and Fra Angelico entered the Order, while Tommaso da Siena Caffarini in Venice directed the male and female penitents leading up to their recognition as a Third Order in 1405. Tommaso also collected Catherine's letters, had her book copied, and promoted images made of her to further her cult. Chiara Gambacorta founded the 'Observant' nunnery of S. Domenico in Pisa, which influenced other reformed monasteries of Dominican nuns.

While Catherine was an outstanding example of a 'semi-religious' woman in medieval Italy, there were many others in the Dominican and Franciscan Orders. They did not live in conventual buildings next to a church, like those that have been the subject of this book. Whereas one can follow the evolution of the Dominican and Franciscan friars and nuns in Rome through the location and history of their places of residence, first on the periphery or in Trastevere, and then in the more densely populated parts of the city, it is not possible in most cases to know where the 'semi-religious' penitents stayed. Their homes were part of the domestic architecture of the city — its small houses, or palaces with family towers. Art connected with them is very scarce, confined to a few tombs and paintings. Yet, through their prayer and works of mercy they contributed to the overall mission of the Mendicant Orders in serving the poor in Rome and renewing the Church in the Middle Ages.

Conclusion

From the beginning of the thirteenth century, Pope Innocent III was aware of the need to reform the medieval Church and he took steps to achieve this. In 1213, he sent a letter, *Vineam domini Sabaoth*, to prelates and other religious leaders, inviting them to come to Rome for the Fourth Lateran Council and expressing his desire for ecclesiastical reform, an end to heresy, and peace and freedom for the Church.[1] The Council met in Rome in November 1215. It was attended by 71 patriarchs, 412 bishops, and 900 abbots and priors. These dignitaries were accompanied by their assistants, including Dominic, who came with Bishop Foulques of Toulouse. The first Canon of the Council clearly proclaimed the teachings of the Church, the next two dealt with false teachings, and then heresy. There followed decrees on many other matters, such as the responsibilities of bishops; improvements of the clergy; Church justice; religious Orders; and relations with Jews and Saracens. All this was aimed at reforming the Church and sorting out some of the most pressing moral problems of the time.

While the Fourth Lateran Council reformed the Church juridically and institutionally through its decrees, Dominic and Francis ushered in a new era of spiritual renewal and religious revival. Their zeal for the Gospel, their enthusiastic acceptance of voluntary poverty, their humility, their assiduous prayer, their preaching, their care for the poor and the sick, their obedience to the ecclesiastical hierarchy, and their overflowing joy brought a new springtime to the Latin Church as a whole. They founded the Dominican and Franciscan Orders — in spite of the fact that Canon 13 of the Fourth Lateran Council forbade the establishment of new religious Orders and insisted that people who wanted to set up new religious houses should follow an approved and existing Rule.

When Pope Gregory IX canonized Dominic on 3 July 1234, he issued a Bull, *Fons sapientiae*, in which he likened the history of the Church to Zecharia's vision of four chariots, pulled by horses of red, black, white, and variegated colour (Zecharia 6. 1–2). Gregory interpreted these different coloured horses as signifying the successive groups that had formed or reformed the Church: the early martyrs (red), the Benedictines (black), the Cistercians (white), and then, in his day, the Dominicans and Franciscans (variegated).[2] It was clear that the Dominicans and the Franciscans proved to be the largest and most significant new Orders of their time, including both women and men, nuns and friars.[3] The nuns were contemplatives living in enclosed monasteries, while the friars followed an active 'Apostolic life', going two by two into the world to preach, taking nothing with them except a walking stick and a book, and performing miracles of healing and exorcism (as the apostles were instructed to do in Mark 6. 7–13). The Dominican friars were trained in theological disputation to promote the truth, hence their motto 'Veritas'. The Franciscan

1 Pennington, 'The Fourth Lateran Council', pp. 41–42.

2 BOP, i, no 108, pp. 67–68. See also Lippini, *San Domenico*, pp. 513–20.

3 For other Mendicant Orders, such as the Carmelites, Augustinians, and the Servites, see, for example, Andrews, *The Other Friars*.

friars wished people 'Pax et Bonum' (peace and goodness) and preached penance, conversion, and reconciliation. The ministry of the friars of both Orders was predominantly to lay people in towns and cities, such as medieval Rome. As the two Orders evolved, lay people joined the Franciscans as tertiaries and they assisted the Dominicans in various ways. Among the Dominicans and Franciscans there were also 'semi-religious' penitents, like Margherita Colonna and Catherine of Siena.[4]

The earliest Dominican houses in Rome — S. Sisto and S. Sabina — were on the edge of the city and the first Franciscan foundations of S. Francesco a Ripa and S. Cosimato, were in Trastevere, which was on the west bank of the River Tiber. About the middle of the thirteenth century, as the two Orders became more institutionalized, the friars moved into more densely populated parts of Rome. The Franciscan church and friary of S. Maria in Aracoeli were situated prominently on the Capitoline Hill, a site rich in ancient tradition, and where the medieval Roman Commune was located. The Dominican friars at S. Maria sopra Minerva were near the Pantheon (from 608 consecrated as the church of S. Maria ad Martyres), in the middle of the 'Regione Pigna', a densely populated part of the Campus Martius. In this way, in the mid-thirteenth century, the friars of both orders, who had previously been itinerant preachers, speaking to people in open squares and living on the edges of the city, began to establish large churches with parochial rights in the midst of the local population. When Catherine of Siena came to Rome, she chose to live not at the nunnery of S. Sisto, but in a house close to S. Maria sopra Minerva, where she was buried in 1380. In 1285, Cardinal Giacomo Colonna and his brother Giovanni established a new Franciscan nunnery on the northern edge of the Campus Martius, in an area known in the Middle Ages as 'Regione Colonna'. This was a convent for nuns from the extended Colonna family and their associates, as was a second nunnery, which Cardinal Giacomo Colonna established early in the fourteenth century at S. Lorenzo in Panisperna.

As the Dominicans and Franciscans brought spiritual renewal to the Church in the Eternal City, they also renewed the buildings on each site where they settled. While these locations were important in antiquity, they had also been places previously occupied by other ecclesiastical establishments. At S. Sisto and S. Sabina, there had been ancient 'tituli', and they were among Rome's stational churches. In the ninth century, there had been a nunnery at S. Sisto. The Friars Preachers at S. Sabina at first shared the buildings with diocesan clergy. The church and friary at S. Francesco a Ripa took the place of the medieval pilgrims' hostel of S. Biagio, run by the Benedictine monks of SS. Cosma e Damiano in Mica Aurea, whose monastery was replaced by the Franciscan nunnery of S. Cosimato. At S. Maria in Aracoeli a new church and friary were constructed over the earlier buildings of the Benedictine monastery of S. Maria in Capitolio. The Dominicans rebuilt the small convent and church of S. Maria sopra Minerva, which had belonged to the Byzantine and then the Benedictine nuns of S. Maria in Campo Marzio. Just before the arrival of the Dominicans, the site had been occupied for a short time by a group of penitent women, who then moved to S. Pancrazio, where a new Cistercian nunnery was established for them. The Colonna family provided new buildings at S. Silvestro, where there had previously been Greek and then Latin monks. At S. Lorenzo in Panisperna the Colonna did something similar at a Latin Benedictine monastery, thus founding two Franciscan nunneries. The Franciscans replaced former Benedictine monasteries at each of their foundations in Rome.

The rebuilding activity of both Mendicant Orders was a form of architectural renewal of some of Rome's churches and conventual buildings. Whereas the fifth-century basilica of

4 See Chapters 7 and 8.

S. Sabina remained, all the other Dominican and Franciscan foundations were provided with new churches. Where there were existing convent buildings, these were extended and replaced.

Buildings cost a lot of money, but the Dominicans and Franciscans were vowed to poverty. It is therefore interesting to note how they relied on patrons — who were popes, cardinals, medieval Roman nobles, or other lay people — to provide for the construction of their churches and convents. From the late thirteenth century onwards, the churches were flanked by chapels, which were often sponsored by members of wealthy families, who paid for Masses to be said in them for the repose of their souls, and who also undertook to maintain the chapels and thereby the church.[5] Some people who were not members of the Mendicant Orders were buried in the churches or adjacent cemeteries of the friars, paying for that privilege. They also donated or bequeathed property to the Dominicans and Franciscans.

Sometimes, it is said that the early Christian and medieval churches of Rome are architecturally all very similar — they are basilicas, with a nave, two or more aisles separated by colonnades, sometimes a transept, and a semi-circular apse.[6] In this group of early Dominican and Franciscan churches, however, there is remarkable variety in architectural planning, and it is sometimes clear that the buildings were constructed in successive phases. To be sure, S. Sabina is a magnificent fifth-century basilica with the traditional plan, without a transept, but the Dominican friars adapted it internally to suit their needs — to have private space for their choir, for example, they erected an intermediary choir-screen, or 'tramezzo', across the nave and aisles within the fifth-century building. The Franciscan church of S. Francesco a Ripa seems to have been built in two phases, with a new transept similar in plan to that in the upper church of S. Francesco and that of S. Chiara in Assisi, which was attached to a nave flanked by colonnades and two aisles laid out in the Roman manner. S. Maria in Aracoeli had a 'Roman' plan — in many ways like that of S. Maria in Trastevere — with a nave and two aisles, separated by eleven columns on either side, and a transept that seemed to copy that at Old St Peter's, with columns at the triumphal arch, like those at S. Paolo fuori le Mura; to this was added a Franciscan-style apse, semi-circular on the inside and polygonal on the outside. In elevation, the Capitoline church had elements in the Gothic style, such as rose windows in the transept, large pointed windows filled with marble tracery in the clerestory of the nave, not to mention later private chapels, with tall Gothic ribbed vaulting and lancet windows, some filled with stained glass. The plan and elevation of S. Maria sopra Minerva were totally Gothic in style. The apse was polygonal inside and out, and it was flanked by stepped chapels, *en échelon*, on either side, in a plan that was very unusual in Rome. Instead of columns, multiple piers connected by pointed arches separated the nave and aisles. The nave was clearly completed in more than one phase of construction and vaulting was added only in the fifteenth century. The Gothic character of the building was later 'enhanced' or 'corrected' in the nineteenth-century Neo-Gothic restoration.

Nuns' churches were different again. This was so that the Sisters could worship in a very private space, not seen by the public, to whom only a part of the church was accessible. S. Sisto had a single nave, with a wall built across it, pierced by a large grated window and a 'turn', as can be deduced from written sources.[7]

5 For patronage of Mendicant buildings, see Bruzelius, *Preaching, Building, and Burying*; and for patronage by thirteenth-century popes and cardinals, see Gardner, *The Roman Crucible*.

6 See, for example, Krautheimer, *Rome*, pp. 167–68, 173–76. Occasionally, reference has been made to Gothic features in medieval Roman churches, as in Gustafson, 'Roman Versus Gothic'.

7 These features were described by Cecilia, *Miracula Beati Dominici*, see Chapter 1.

This divided the nuns' choir from the public part of the church. A similar arrangement appears to have pertained at S. Cosimato, where a second choir, parallel to the first, was added at a much later date. At S. Silvestro, there seems to have been a different layout. At first, the nuns' choir was located behind the apse of the church, with three windows — one directly behind the altar, another with a turn, and a third with a small opening through which the nuns received Holy Communion. In the sixteenth century, two more choirs were added — a raised choir at the liturgical 'west' end of the building, and a choir upstairs, above the one behind the apse. These features recall the layout of the medieval Franciscan nunneries at S. Maria Donnaregina and at S. Chiara in Naples.

Both the Dominican and Franciscan Orders had rules about how their architecture should express their ideal of voluntary poverty. Their later churches were large, not to show their importance, but in order to accommodate crowds of followers, and also because they needed to contain the friars' choir as well as a separate space for the laity. In the Orders' legislation, churches were to be plain, and free from curiosities and superfluities; there was to be very little vaulting, and there were to be no bell towers. The early Dominicans limited the height of various parts of the buildings. One sees that there was no vaulting in the nave and aisles at S. Maria sopra Minerva until the fifteenth century, and there was none at first at S. Maria in Aracoeli. Both the Friars Preachers and the Friars Minor inherited unfinished twelfth-century bell towers at S. Sabina and S. Maria in Aracoeli. These were not completed, but a bell wall was attached to the one at S. Sabina, while the tower at S. Maria in Aracoeli was incorporated into a row of chapels added in the late thirteenth century and in 1564 it became the side entrance to the church. Bells were installed on the other side of the church on a bell wall. There are remains of a bell tower at S. Maria sopra Minerva, but it was small, and it was later demolished, in the remodelling of the chapel of Saint Dominic. At the nuns' churches, medieval campanili were built by Pope Innocent III at S. Sisto and in the twelfth century at S. Silvestro in Capite. These were retained, and a bell tower in medieval style was added to S. Cosimato in the fifteenth century. (The fact that the nuns there were given a bell dated 1238 suggests, however, that there may have been a predecessor to this campanile.)

The conventual buildings of the friars and nuns had the usual monastic elements: a chapter room, refectory, kitchen, cellar, dormitories, and cloister. They were built in traditional Roman styles, but with some interesting new features, such as the colonnaded loggia at S. Sabina, overlooking the Tiber. The chapter rooms of S. Sisto and S. Sabina survive, if changed in later times. The refectory at S. Sisto — famous for a miracle of Saint Dominic — also survives, as refurbished in the seventeenth and in the twentieth century. While some conventual structures have been demolished, there are still two remarkable thirteenth-century cloisters — one at S. Sabina and the other at S. Cosimato. The Trastevere nunnery also has a cloister of a different style, built in the late fifteenth century by Pope Sixtus IV. Both S. Sisto and S. Sabina had a defensive tower to protect the entrance to the convent, perhaps because they were on the periphery of the city. Medieval nuns had a series of parlours, equipped with grilles and turns, for their restricted communication with the outside world.[8]

The medieval Dominican and Franciscan architecture in Rome shows how the settlement of the two Mendicant Orders enriched the urban fabric and the ecclesiastical buildings of the city. The Dominican and Franciscan structures were arguably the most significant newly built churches and convents in thirteenth-century Rome. Besides,

8 At SS. Quattro Coronati, one can see a turn of this kind in the space opposite the entrance to the thirteenth-century chapel of S. Silvestro.

the large churches of S. Maria in Aracoeli and S. Maria sopra Minerva demonstrated in varied ways, how the Gothic style was introduced in Rome by the Mendicant Orders.

In terms of religious paintings, it has been noted that each community of nuns in Rome possessed an icon. The Dominicans took over the *Maria Advocata* of S. Maria in Tempulo (later called the *Maria Advocata* of S. Sisto), an example of the Byzantine *Hagiosoritissa*, painted in encaustic, probably in the sixth or early seventh century, and brought to Rome from the Byzantine East (Plates 1 and 2). The friars at S. Maria in Aracoeli possessed a famous icon of *Maria Advocata*, (Plate 7) which was clearly a Roman copy, made in the late eleventh century, of the earlier icon at S. Sisto. An icon of the *Hodegetria*, most likely painted in Rome, was at S. Cosimato (Plate 6). At S. Silvestro, there was an image of the *Mandylion* or Holy Face of Christ, an early work perhaps of the sixth century, which may have been brought from Constantinople by Greek monks fleeing from Iconoclasm in the eighth century (Plate 9). These icons and other paintings, such as the Crucifix at S. Sisto (Fig. 25), the altarpiece from Sant'Aurea, and the early panel of Saint Francis at S. Francesco a Ripa (Plate 5), are examples of the devotional images in the Mendicant churches.

Works by two famous medieval artists, the Roman painter Pietro Cavallini and the Franciscan mosaicist Jacopo Torriti, were made for the Franciscans in Rome, but they now survive only in fragments in the churches under discussion. At S. Francesco a Ripa and S. Maria in Aracoeli, written sources report that there were frescoes by Cavallini showing the life and miracles of Saint Francis, which unfortunately have not survived. Giorgio Vasari believed that Cavallini's image of the *Madonna and Child of the Aracoeli* in the apse of the Capitoline church was his masterpiece, but it no longer exists.[9] Some fragments of paintings by Cavallini, or by his assistants, have been found in the roof space of S. Maria in Aracoeli and in some of the side chapels. A cycle of rather damaged frescoes in S. Sisto has been attributed to the workshop of Cavallini, while an unknown artist added a band of paintings above them at the end of the fourteenth or early in the fifteenth century (Figs 26–34). When Pope Sixtus IV restored the church of S. Cosimato, an anonymous painter executed works in the refurbished nuns' choir, possibly over earlier images, while Antonio del Massaro painted *Saints Francis and Clare beside the Virgin and Child in a landscape* in the public part of the church (Fig. 99).

Mosaicists added images in S. Maria in Aracoeli, depicting the patrons of private chapels with the Madonna and Child, angels, Saint Francis, and other saints (see, for example, Plate 8). Some of these images have been attributed to one of the greatest late medieval mosaic artists in Rome, Jacopo Torriti, who was a Franciscan friar, and who made the magnificent late thirteenth-century apse mosaics at St John Lateran (destroyed and replaced by a copy in the nineteenth century) and at S. Maria Maggiore, where the patrons — the Franciscan Pope Nicholas IV and Cardinal Giacomo Colonna — are depicted, kneeling below Christ crowning the Virgin.

A few medieval liturgical furnishings, such as choir stalls, altars, tabernacles, and pulpits survive, for example, in S. Maria in Aracoeli.[10] The medieval marble workers of Rome also made monumental tombs, such as that of Durandus in S. Maria sopra Minerva, on which the name of the artist, Giovanni di Cosma, is mentioned in an inscription. This tomb is similar to that of Matteo di Acquasparta in S. Maria in Aracoeli,

9 It disappeared in the sixteenth century, when the apse was demolished to make way for a new choir.

10 See the detailed discussions of these works in Bolgia, 'An Engraved Architectural Drawing'; Bolgia, 'The Felici Icon Tabernacle (1372)'; Bolgia, 'Ostentation, Power, and Family Competition'; Bolgia, *Reclaiming the Roman Capitol*.

where there are also two monumental sepulchral monuments of the Savelli family. There are many floor slab tombs at S. Sabina, while the later tombs of Saint Catherine of Siena and Beato Angelo are to be found in S. Maria sopra Minerva.

Saints Dominic and Francis are depicted in other works of art in Rome. For instance, Cardinal Stefano Conti included both of these saints in the décor of his new palace at SS. Quattro Coronati near the Lateran region *c.* 1246 and in doing so illustrated their virtues and their ideals. In a vaulted reception room on the first floor, now called the 'Aula Gotica' (Gothic Hall), frescoes came to light in restorations undertaken between 1996 and 2006.[11] They include early depictions of Saints Francis and Dominic, on the east wall in the northern bay of the hall, where a series of gigantic female figures, personifying virtues, are painted in the lunettes below the vaulting (Plate 10). Each large figure carries on her shoulders a smaller male figure of someone who exemplified the virtue she personifies. Under one foot of the virtue there is another much smaller figure that is a personification of the opposite vice, and on the other side there is a small figure of a person notorious for that vice. Inscriptions help to explain this unusual iconography. The figure of Saint Francis is identified as an outstanding example of the virtue, 'AMOR CELESTIS' (Heavenly Love).[12] On a scroll held by the virtue, there is a quotation from an eleventh-century work, the *Proverbia Wipponis*, which contrasts life in the world with a life dedicated to God.[13] The personification of the virtue has her foot on the figure of a man, who is identified by a fragmentary inscription as Julian the Apostate with the words '… LIAN APOSTATA', who sought worldly power, wealth, and fame. By contrast, to seek heavenly love, Francis left the world. His radical way of living the Gospel in poverty and his imitation of Christ then made him an example of heavenly love, which his followers continued to spread to all people.

The figure of Saint Dominic is raised up on the shoulders of the virtue called 'EMULATIO SANCTA' (Holy Emulation) of which he is to be seen as an outstanding example, since he radically imitated Christ and the apostles.[14] At the feet of the virtue is a small figure personifying the opposite vice, 'EMULATIO PERVERSA' (Emulation Perverted) and the image of a man notorious for that vice, identified by an inscription as 'SIMON MAGUS', who was reported to have offered the apostles money in an attempt to buy the miraculous power they exercised, wanting to act as they did, but without obtaining true power from the Holy Spirit (Acts 8. 9–24).[15] From this, Simon Magus came to be identified with the sin of simony, the paying of money to obtain ecclesiastical offices, an object of special

11 Draghi, *Gli affreschi dell'Aula Gotica*; Draghi, *Il Palazzo cardinalizio dei Santi Quattro a Roma*, esp. p. 26; Romano, ed., *Il Duecento e la cultura gotica 1198–1287*, no. 30, pp. 136–79, esp. pp. 157–58 (written by Andreina Draghi) and pp. 172–73 (by Claudio Noviello). For the date, which is deduced from an inscription in the Cardinal's private chapel below this hall, see Barelli, *The Monumental Complex of Santi Quattro Coronati*, p. 73; Forcella, *Iscrizioni*, vol. VIII, p. 290, no. 719. See also, Hauknes, 'The painting of knowledge', especially pp. 22–23 and 30–38. The style of the paintings is similar to that of some of the murals in the crypt of Anagni cathedral, which were completed between *c.* 1231 and *c.* 1255 by the so-called 'third master' of Anagni.

12 For the figure of Saint Francis, see Bolgia, *Reclaiming the Roman Capitol*, pp. 103–04 and Plate 6.

13 See Draghi, *Gli affreschi dell'Aula Gotica*, pp. 298–99, who explains, p. 82, that Wippo, chaplain to Emperor Conrad II wrote his *Proverbia* in 1027–1028. The text on the scroll is published in PL 142, col. 1263A.

14 The Latin word '*aemulatio*' means 'to strive to do [something] like or better than another', including the sense of imitation, but possibly with an overtone of rivalry and even jealousy, see Du Cange, *Glossarium*, vol. I, p. 115, which adds the meaning, 'donner de la jalousie' (to give rise to jealousy).

15 Ferreiro, *Simon Magus*; Ferreiro, 'Simon Magus and Simon Peter'; Grassi, 'Simon Magus', NCE, 13, pp. 130–31. See also Dante, *Inferno*, XIX, 1–6.

condemnation in the later Middle Ages.[16] Saint Dominic's love of poverty and his refusal to accept a bishopric obviously ran counter to such corrupt scheming. Moreover, Simon Magus was the archetypal heretic, who spread false teachings. Irenaeus described him in AD 174–180 as 'Simon of Samaria, from whom all sorts of heresies derive their origin' (Irenaeus, *Against Heresies*, Book 1, Chap. 23, para. 2). Medieval legends recounted how Simon Magus came to Rome, where he taught false doctrine, and where he died in a contest with Saint Peter, in which they were called upon to work miracles in the presence of the Emperor Nero.[17] In the thirteenth-century fresco, the presence of this apostate and notorious early heretic reminds the viewer of Dominic's work in trying to counteract heresy by teaching the truth about Christ and the Church, and his Order's continued efforts in that regard.[18]

The Dominican and Franciscan foundations of medieval Rome bear witness to their Orders' spiritual renewal of the Church, and they reveal the material renewal of architecture and art in the ancient city. With Saint Francis's example of leaving all for the heavenly love of God, of the Cross, of the Eucharist, of the poor, and of all God's creatures, and Saint Dominic's emulation of Christ and the apostles, in poverty, fervent prayer, preaching, and saving souls by insisting on the truth, the Franciscans and Dominicans strongly supported the reform and renewal of the late medieval Church in Rome and around the world.

16 Lynch, 'Simony', *Dictionary of the Middle Ages*, 11, pp. 300–02; Ferreiro, *Simon Magus*, pp. 23–24.
17 Ferreiro, *Simon Magus*; Ferreiro, 'Simon Magus and Simon Peter', pp. 112–14, and 132; Grassi, 'Simon Magus', pp. 130–31. Bolgia, *Reclaiming the Roman Capitol*, p. 320, notes that the contest was believed to have taken place on the Capitoline Hill.
18 See, Ames, *Righteous Persecution*.

Glossary

A cassettone	A ceiling constructed of wood, having regular recessed coffers, which are usually square, rectangular, or octagonal in shape
Acheiropoietos	Not made by human hands, referring to a miraculously produced icon
Aisle	Lateral divisions of a church flanking the nave
Apse	A semi-circular or polygonal area at the liturgical east end of a church, usually covered with a semi-dome
Arcade	A series of arches supported by columns or piers
Architrave	A lintel of stone (the lowest part of an entablature) carried from one column to another
Atrium	A courtyard, preceding a church
Barrel vault	A half-cylindrical vault
Basilica	A rectangular church, with a central nave, flanked by two or more aisles, leading to an apse, which is sometimes preceded by a transept
Bay	An area or compartment between columns, pilaster, or piers
Bipedales	Ancient Roman bricks two Roman feet long (29.56 cm × 2 = 59.12 cm or *c.* 60 cm)
Campanile	A bell tower
Capital	Top portion of a column or pilaster, in various styles such as Doric, Ionic, Corinthian, Composite, or more varied
Cappella Maggiore	The sanctuary of a church
Cavetto	The concave crown on top of a façade, which swings out from the façade, and which is usually flat at the top
Chancel	The sanctuary of a church
Chapter Room	A room used for daily meetings in a monastery or priory
Choir	The place where monks, nuns, or friars celebrate the Divine Office; also called the 'choir enclosure'
Ciborium	A freestanding canopy over an altar, supported by four columns
Cipollino	A type of greenish-grey marble with dark green streaks, making it look like an onion
Clerestory	High walls with windows on either side of the nave of a church, above the roof level of the aisles

Cloister	A quandrangle surrounded by colonnaded covered walkways in a monastery or friary
Colonnade	A row of evenly spaced columns supporting arches or an entablature
Column	An upright stone shaft
Colonnette	A small column used in cloister arcades, bell towers, and windows
Confessio	A crypt-like shrine under an altar, where relics are preserved
Corbel	A block or bracket projecting from a wall, often used to support a beam or vault
Cornice	A moulded projection which often crowns or finishes the entablature of a building
'Cosmatesque'	The style of marble floors, tombs, and liturgical furniture made by medieval Roman marble workers, some of whom were members of the Cosmati family
Crossing	The space at the intersection of the nave and transept of a church
Cross vaults	A vault formed by the intersection at right angles of two barrel vaults
Enceinte	A boundary wall enclosing a fortified place
Entablature	The superstructure supported by columns, usually in three parts: the architrave, frieze, and cornice
Exedra	A recessed space added to the main part of a building
Falsa cortina	A finishing of the mortar, with a thin line made by a trowel (also called 'stilatura')
Fenestella	A small niche-like window opening under an altar and often in a crypt to enable pilgrims to see and / or touch with a cloth the relics of a saint or martyr
Frieze	A decorated band between the architrave and cornice, or any ornamented band or strip on a wall
Hygumenarch	The head, or abbot, of a Byzantine monastery
Icon	An image in Byzantine style of Christ, the Virgin Mary, an angel, or a saint
Loggia	A gallery which is open on one or more sides, also a covered balcony
Lunette	A semi-circular area, over a window or enclosed by an arch of a vault, often decorated with mosaic or painting
Mandorla	An almond-shaped design enclosing a figure of God the Father, Christ, or the Virgin Mary
Modulus	A constant proportion or measurement, for example, in masonry, of five rows of bricks and the mortar laid horizontally between them
Mortarbeds	The mortar between courses of bricks or stone
Mosaic	A picture or design made of small pieces of stone or glass set in cement or plaster
Narthex	The transverse vestibule of a church usually in front of the nave

Nave	The main area of a church, from narthex to apse
Nimbus	A halo of light surrounding the head of Christ, the Virgin Mary, an angel, or a saint
Oculus	A circular window
Opus incertum	Masonry in Ancient Roman architecture composed of small blocks of tufa in an irregular sequence
Opus listatum	Masonry composed of one or more courses of bricks alternating with courses of stone
Opus reticulatum	Ancient Roman masonry composed of small blocks of tufa in a decorative pattern that resembles a net
Opus saracinescum	Masonry composed of regular rows of small blocks of volcanic tufa stone
Opus sectile	Surface decoration made with marble cut into pieces and set in cement or plaster
Order	A combination of base, column, and capital in Classical architecture
Pavonazzetto	A type of marble, in colour creamy white streaked with purple
Pediment	A gable, often triangular, usually over a façade, door, or window
Pergola	A screen on posts or columns
Pier	A support built of stone or brick used to sustain arches
Pilaster	A rectangular, shallow pier attached to the face of a wall
Plinth	A rectangular block at the base of a column or colonnade
Pointing	A way of finishing mortar
Portico	A colonnaded entrance
Presbytery	The area of a church reserved for the clergy, and where the high altar is usually located; the chancel, or sanctuary
Prothyron	A small monumental entrance porch in front of a medieval church or monastery
Pulvin	An impost block, which is placed between a capital or a column and an arch
Quadriporticus	A four-sided colonnaded atrium
Quatrefoil	Tracery divided in a four-lobed pattern
Relief	Sculpted figures and designs that project from a background so that they are partly or almost entirely free of it
Relieving arch	An arch built into a wall to discharge the load on the wall
Reliquary	A receptacle for the relics of the saints
Revetment	A facing of marble, stone, or stucco, which covers the surface of a wall

Ribbed vault	A vaulted ceiling supported by a framework of diagonal and arched stone ribs
Roundel	A circular medallion or panel
Rubble masonry	Masonry made up of irregular pieces of stone and brick
Sawtooth frieze	A frieze with bricks laid at an angle, similar to the cutting edge of a saw
Sesquipedales	Ancient Roman bricks one-and-a-half Roman feet long (29.56 cm × 1.5 = 44.34 cm. or *c.* 45 cm)
Shaft	A column which stands between a base and capital
Soffit	The underside of an arch
Spandrel	The triangular areas between the curve of an arch and the wall or between two arches
Splayed windows	Windows with a narrow, arched opening, surrounded by an arch with a larger radius on the exterior on both sides
Spoils / spolia	Reused architectural material, such as capitals, columns, bases, and bricks
Springing	The point where an arch rises from its supports
Stilatura	A finishing of the mortar, with a thin line made by a trowel (also called 'falsa cortina')
Stucco	Plaster reinforced with powdered marble and used for decoration
Tesserae	Small pieces of coloured stone or glass used in mosaics
Tondo	A circular painting or carving
Trabeation	Horizontal beams resting on columns, as opposed to arches
Tramezzo	An intermediary wall built between the private and public sections of a Mendicant church
Transenna	A marble plaque, often used to enclose a shrine or altar, or to separate one part of a church from another
Transept	The transverse part of a church, crossing the main axis of the nave at a right angle
Travertine	Porous rock from the district around Tivoli
Tufa	The local volcanic stone around Rome
Tufelli	Small blocks of tufa
Tympanum	The area enclosed within a pediment
Vault	A curved ceiling
Volute	A scroll or twisting form
Voussoir	A brick or wedge-shaped stone used in an arch

Bibliography

Manuscripts and Archival Sources, and Other Unedited Material

Rome, ACSR, fondo *Ministero dei Lavori Pubblici, Segretariato Generale, Trasferimento della Capitale da Firenze a Roma*, busta 16, fasc. D/21
——, fondo *Ministero della Pubblica Istruzione, Direzione Generale Antichità e Belle Arti*, II, I, busta 225, fasc. 3879
——, fondo *Ministero della Pubblica Istruzione, Direzione Generale Antichità e Belle Arti*, II, II, busta 402, fasc. 4488, pianta allegato, busta 13, fasc. 600
Rome, AGOP, MS XIII, *Memorie riguardanti il Nostro Convento di S. Sabina dal 1412 al 1678*
——, MS XIV, liber C, Parte I, fols 1–84, Brandi, Ambrosio, *Cronica breve […] della Chiesa e Convento della Minerva a Roma, dell'Ordine dei Predicatori*
——, MS XIV, liber C, Parte II, fols 85–88, *Benefici segnalati fatti a questa nostra chiesa di S. Maria sopra Minerva dal Sommo Pontifice regnante Benedetto XIII*
Rome, ASC, Busta 59
——, *Commissione Archeologica Comunale*, fasc. 1160, anno 1892
——, *Contratti, Atti Privati 1875*
Rome, AM, MS III, 327–30, *Campione, o sia generale Descrizione di tutte le scritture spettanti al Venerabile Convento di Santa Maria dell'Annunziata o sopra Minerva di Roma* (compiled by Fra Giacomo Reginaldo Quadri, OP, 1758), 4 vols
——, MS cm II. e. 3. 1–3, Zucchi, Alberto, OP, 'La Minerva attraverso i secoli (la chiesa e il convento di S. Maria sopra Miinerva dalle origini)'
——, MS cm. II. e. 3. 4–16, Zucchi, Alberto, OP, 'La Minerva attraverso i secoli (dal XVII al XX secolo)'
——, MS cm II. g. 5. 1–8, Zucchi, Alberto, OP, *Miscellanea per il volume 'Roma Domenicana'*
——, MS cm II. g. 3. 13, *La sepoltura del Beato Angelico identificata e riordinata*, from *Il Nuovo Giornale*, no date
Rome, Archivum S. Francisci a Ripa, MS 12 (formerly MSS 98 and 99) Ludovico da Modena (1637–1722), *Cronaca della Riforma e Fondazione dei conventi dal 1519 al 1722*
Rome, ASR, *Collezione Mappe*, 86, no. 531
——, *Fondo Clarisse in SS. Cosma e Damiano in Mica Aurea*
——, *Congregazioni religiose femminili, Clarisse di S. Silvestro in Capite*, buste 4988–5226; Registri 5610–5631
Rome, Biblioteca Casanatense, MS 3209, Anonymous, *Notizie del Convento e Chiesa di Santa Sabina di Roma*
Rome, Biblioteca Nazzionale Centrale 'Vittorio Emmanuele', *Fondi minori, Varia*, 5, O. Formicini, *Liber monialium Sancti Cosmati de urbe in Regione Transtiberim …*
——, *Fondi minori, Varia*, 6, O. Formicini, *Liber monialium Sancti Cosmati de urbe in Regione Transtiberim …*
Siena, Biblioteca comunale degli Intronati, MS T.II. 8.a., fols 1r–8v., Munio of Zamora, *Ordinationes*
Vatican City, ASV, AA.ARM. B 15, *Libro di tutta la Spesa da N.S. Papa Sisto V. a Santa Sabina, 1587*
Vatican City, BAV, MS Barb. lat. 1993, Ugonio, Pompeo, *Schedario*
——, MS Barb. lat. 1994, Ugonio, Pompeo, *Theatrum Urbis Romae*
——, MS Barb. lat. 2160, Ugonio Pompeo, *Schedario*
——, MS Chigi I. V. 167, Chacón, Alonso, OP (c. 1530–1599), 'Inscriptiones e epitaphia'
——, MS Chigi G III 81, *Cappellae Sanctae Catharinae Senensi in Ecclesia Sanctae Mariae super Minervam de Urbe […]*
——, MS Codex Rossianus 3, *Modi Orandi Sancti Dominici*, fols 5r–13r

——, MS Vat. Lat. 7847, Orsola Formicini, *Istoria del monastero di S. Cosimato*

——, MS Vat. lat. 11257 and 11258, Spada, Virgilio, Architectural drawings, 2 vols

——, MS Vat. lat. 11871, Bruzio, Giovanni Antonio, *Opera*

——, MS Vat. lat. 11904, De Rossi, 'Descriptio aliquot ecclesiarum'

Primary Sources

Acta Canonizationis S. Dominici, in *Monumenta Historica Sancti Patris Nostri Dominici*, fasc. 2, MOPH, 16, ed. by Angelo Walz, Heribert C. Scheeben, and Marie-Hyacinthe Laurent (Rome: Institutum Historicum Fratrum Praedicatorum, 1935), pp. 89–19

Acta capitulorum generalium ordinis praedicatorum, ed. by Benedictus Maria Reichert, OP, MOPH, 1 (Rome: in domo generalis [Stuttgart: Jos Roth], 1898)

Acta Capitulorum Provincialium Provinciae Romanae (1243–1344), ed. by Thomas Kaeppeli, OP and Antonio Dondaine, OP, MOPH, 20 (Rome: Istituto Storico Domenicano, Santa Sabina, 1941)

Acta Sanctorum [*AASS*], ed. by Godefrido Henschenius, Daniel Papebrochius, SJ, and others, 69 vols, (Antwerp: Apud Michaelem Cnobarum, 1643–1940)

Alberti, Leandro, *De viris illustribus Ordinis Praedicatoribus* (Bologna: in aedibus Hieronymi Platonis, 1517)

Alveri, Gasparo, *Della Roma in ogni stato* (Rome: Mascardi, 1664)

Anonymous, *The Miracoli of Catherine of Siena* (English translation of *I miracoli di Caterina di Iacopo da Siena di Anonimo Fiorentino*, ed. by Francesco Valli, Fontes Vitae S. Caterinae Senensis Histoirici, 4 [Siena: Università di Siena, 1936]) in *Dominican Penitent Women*, ed. trans. and introduced by Maiju Lehmijoki-Gardner, with contributions from Daniel E. Bornstein and E. Ann Matter (New York: Paulist Press, 2005), pp. 87–104

The Apocryphal New Testament, trans. and ed. by Montague Rhodes James (Oxford: Clarendon Press, 1924)

Baglione, Giovanni, *Le nove chiese di Roma*, ed. by L. Barroero (Rome: Archivio Guido Izzi, 1990)

BAV, Codex Rossianus 3 (1). Modi Orandi Sancti Dominici facsimile edn: *Die Gebets- und Andachtsgesten des Heiligen Dominikus. Einer Bilderhandschrift*, Kommentarband von Leonard E. Boyle, OP und Jean-Claude Schmitt, Codices e Vaticanis selecti quam simillime expressis iussu Iohannis Pauli Vonsilio et Opera Curatorum Bibliothecae Vaticanis, 82 (Zürich: Belser, 1995)

Beati Iordani de Saxonia Epistulae, ed. by Angelo Walz, OP, MOPH, 23 (Rome: ad S. Sabinae, apud historicum Fratrum praedicatorum, 1951)

Benedict of Montefiascone, OP, *Notice historique servant d'Introduction au Registre du chartes du monastère (Historical Introduction to the Register of Charters of the Monastery of S. Sisto)* (AGOP, MS XII, 3g, fols 1ᵛ–11ᵛ and AGOP, MS XII, 3 f. 2–3ᵛ), published in Vladimir J. Koudelka, OP, 'Le "Monasterium Tempuli" et la fondation dominicaine de San Sisto', *AFP*, 31 (1961), 69–81

Benedicti Regula, Corpus Scriptorum Ecclesiasticorum Latinorum, 75, ed. by Rudolph Hanslik, (Vienna: Hoelder-Pichler-Tempsky, 1960)

Bihl, Michael, 'Documenta. Statuta Generalia Ordinis edita in capitulis generalibus celebratis Narbonae an. 1260, Assisi an. 1279 atque parisiis an. 1292 (editio critica et synoptica)', *AFH*, 34 (1941), 13–36, 37–94, 284–358

The Book of St Gilbert, ed. and trans. by Raymonde Foreville and Gillian Keir, Oxford Medieval Texts (Oxford: Clarendon Press, 1987)

Bullarium Franciscanum [*BF*], 5 vols, ed. by Joannis Baptistae Constantii and Ioannis Hyacinthus Sbaralea (Rome: Typis Sacrae Congregationis de Propaganda Fide, 1759)

Bullarium Ordinis FF. Praedicatorum [*BOP*], ed. by A. Brémond, 8 vols (Rome: Mainardi, 1729–1740)

Capgrave, John, *Ye Solace of Pilgrimes, A description of Rome c. AD 1450*, ed. by C. A. Mills (London: Oxford University Press, 1911)

Carletti, Giuseppe, *Memorie istorico-critiche della Chiesa e Monastero di S. Silvestro in Capite in Roma* (Rome: Nella Stamperia Pilucchi Cracas, 1795)

Carusi, Enrico, *Cartario di S. Maria in Campo Marzio (986–1199)*, Miscellanea della Società Romana di Storia Patria, 17 (Rome: Società Romana di Storia Patria, 1948)

Casimiro, Romano, *Memorie istoriche della Chiesa e Convento di S. Maria in Aracoeli di Roma* (Rome: Rocco Bernabò, 1736)

Cassiodorus Senatoris Variae, ed. by Theodore Mommsen, MGH, AA (Berlin: Weidmann, 1894)

Catalogue of Turin, c. 1320, Biblioteca Nazionale di Torino, MS lat. A 381, fols 1–16, in *Codice Topografico della Città di Roma*, ed. by Roberto Valentini and Giuseppe Zucchetti, 4 vols, Fonti per la Storia d'Italia (Rome: Reale Istituto Storico Italiano per il Medio Evo, 1940, 1942, 1946, 1953), vol. III, pp. 205–318

Catalogus Pontificum et Imperatorum Romanorum ex Casinensi, ut videtur, sumptus, a pluribus continuatus, MGH, Scriptores, vol. XXII (Hanover: Hahn, 1872)

Catherine of Siena: The Dialogue, trans. by Suzanne Noffke, OP (New York: Paulist Press, 1980)

Cecilia, *Miracula Beati Dominici*, in Angelus Walz, 'Die "Miracula Beati Dominici" der Schwester Cäcilia. Einleitung und Text', in *Miscellanea Pio Paschini*, in *Lateranum*, 1 (1948), pp. 293–326

Chronica Romanorum pontificum et imperatorum ac de rebus in Apulia gestis (781–1228) auctore ignoto monacho Cisterciensi, in *Ignoti monachi cistercensis s. Mariae de Ferraria Chronica [...]*, ed. by Augusto Gaudenzi, Società Napoletana di Sancta Patria, Monumenti Storici, Series 1, Cronache (Naples: Francesco Giannini et Fil., 1888)

The Chronicle of John Malalas, ed. by Elizabeth Jeffreys, Michael Jeffreys and Roger Scott, Byzantina Australiensa, 4 (Leiden: Brill, 1986)

Il 'Chronicon' di Benedetto, monaco di S. Andrea del Soratte, ed. by G. Zucchetti, Fonti per la Storia d'Italia (Rome: Tipografia del Senato, 1920)

Chronicon Farfense, ed. by Ugo Balzani, Fonti per la Storia d'Italia, 33 and 34, 2 vols (Rome: tip. del Senato, 1903)

Ciacconius, Alphonsus, *Vitae et Gesta Summorum Pontificum Romanoruma Christo Domini usque Clementem VIII necnon SRE Cardinalium cum eorundem insignibus*, 2 vols (Rome: Apud Stephanum Paulinum, 1601)

——, *Vitae et res gestae et Pontificum Romanorum et S. R. E. Cardinalium, ab initio nascentis Ecclesiae ad Clementem IX. P.O.M. ab Augustino Oldoino… recognitae*, 4 vols (Rome: Antonio de Rubeis, 1677)

Ciampini, Giovanni Battista, *Vetera Monimenta*, 2 vols (Rome: ex typographia Joannis Jacobi Komarek Bohemi, 1690, and Rome: ex typographia Bernabò, 1699)

The Commentaries of Pius II, trans. by F. A. Gragg, with an historical introduction and notes by Leona C. Gabel, Smith College Studies in History, 22, nos 1–2, 2 vols (Northampton, MA: Department of History of Smith College, 1937 and 1951)

Concilia Aevi Karolini, ed. by Albertus Werminghoff, vol. II. 1, MGH Concilia (Hanover: Hahn, 1906)

Constantine of Orvieto, *Legenda Sancti Dominici*, 21, in *Monumenta Historica Sancti Patris Nostri Dominici*, fasc. 2, MOPH, 16, ed. by Angelo Walz, Heribert C. Scheeben, and Marie-Hyacinthe Laurent (Rome: Institutum Historicum Fratrum Praedicatorum, 1935), pp. 261–352

Le cose maravigliose dell'alma città di Roma [...] E si tratta delle Chiese, rappresentante in disegno da Gieronimo Francino … Nuovamente corretti et purgati da molti errori et ampliato dal Rev. Padre Fra Santi de Sant'Agostino, edited and corrected by Fra Santi, with illustrations by Gieronimo Francino (Venice: Per Gieronimo Francino, 1588)

Una Cronaca di Santa Sabina sull'Aventino, publicazione della Biblioteca Comunale di Macerata, MS 5, 3, B, 7, ed. by E. Rodocanachi (Turin: Bocca, 1898)

De Nobili, Giacinto, *Cronaca del venerabile monastero di S. Maria in Campo Marzio di Roma*, ed. by Fioravente Martinelli, in Martinelli, *Roma ex ethnica sacra sanctorum Petri et Pauli apostolica praedicatione profuse sanguine …* (Rome: typis romanis Ignatij de Lazaris, 1653), pp. 187–208

Die Annalen des Tholomeus von Lucca, ed. by Bernhard Schmeidler, MGH, Scriptores, n.s. vol. 8, (Berlin: Weidmann, 1930)

Domenica Salomonia, *Cronache del Monastero di San Sisto (1221–1575)*, in Raimondo Spiazzi, OP, *Cronache e Fioretti del monastero di San Sisto all'Appia* (Bologna: Edizioni Studio Domenicano, 1993), pp. 23–370

Dominican Penitent Women, ed., trans. and introduced by Maiju Lehmijoki-Gardner, with contributions from Daniel E. Bornstein and E. Ann Matter (New York: Paulist Press, 2005)

Durandus, Guillielmus, *Rationale Divinorum Officiorum* (Lyon: apud haeredes Guillelmi Rouillij, 1612)

Early Dominicans, Selected Writings, ed., trans. and with an Introduction by Simon Tugwell, OP, *The Classics of Western Spirituality*, ed. by Richard J. Payne (Mahwah, NJ: Paulist Press, 1982)

Fedele, Pietro, 'Carte del monastero dei SS. Cosma e Damiano in Mica Aurea', *Archivio della R. Società romana di Storia Patria* 21 (1898), 459–534; and 22 (1899), 25–107 and 383–447

——, 'Tabularium S. Praxedis', *Archivio della R. Società di Storia Patria* 27 (1904), 27–78 and 28 (1905) 41–114

Federici, Vincenzo, 'Regesto del monastero di S. Silvestro de Capite', *Archivio della R. Società romana di Storia Patria* 22 (1899), pp. 213–300, 489–538; and 23 (1900), pp. 67–128, 411–47

Ferrando, Pedro, *Legenda Sancti Dominici*, ed. by Angelo Walz, Heribert C. Scheeben, and Marie-Hyacinthe Laurent, OP, in *Monumenta Historica Sancti Patris Nostri Dominici*, fasc. 2, MOPH, 16 (Rome: Institutum Historicum Fratrum Praedicatorum, 1935), pp. 195–259

Forcella, Vincenzo, *Iscrizioni delle Chiese e d'altri Edifici di Roma, dal secolo XI fino ai giorni nostri*, 14 vols (Rome: Tipografia delle scienze matematiche e fisiche, 1869–1884)

Fracheto, Gerardus de, *Vitae Fratrum Ordinis Praedicatorum necnon Cronica ordinis ab anno MCCIII usque ad MCCLIV*, ed. by Benedict Maria Reichert, OP, MOPH, 1 (Louvain: E. Charpentier et J. Schoomans, 1896)

Francis of Assisi: Early Documents (FAED), 4 vols: I. *The Saint*; II. *The Founder*; III. *The Prophet*; IV. *Index*, ed. by Regis Armstrong, J. A. Wayne Hellman, and William J. Short (New York: New City Press, 1999–2001)

Fratris Galvagni de la Flamma (Galvagno della Fiamma), *Chronica Ordinis Praedicatorum, ab anno 1170 usque ad 1333*, ed. by Benedictus Maria Reichert, OP, MOPH, 2, fasc. 1 (Rome: in domo generalitia, 1897)

Frontinus, Julius Sextus, *The Stratagems and The Aquedects of Rome*, trans. by Charles E. Bennett, ed. by Mary B. McElwain, Loeb Classical Library (London: William Heinemann Ltd, 1980)

Gallonio, Antonio, *Historia delle sante vergini romane* (Rome: Presso Ascania, e Girolamo Donangeli, 1591)

Gesta Episcoporum Cameracensium, Bk 1, MGH, *Scriptores*, vol. VII (Hanover: Hahn, 1846)

Giacchetti, Giovanni, *Historia della venerabile chiesa et monastero di S. Silvestro de Capite di Roma* (Rome: Giacomo Mascardi, 1629)

Giacchetti, Ioannis (i.e. Giovanni), *Iconologia Salvatoris et Karologia Praecursoris, sive De Imagine Salvatoris ad Regem Abagarum missa: et de Capite S. Ioannis Baptistae Praecursoris Romae in Ecclesia Monialium S. Silvestri dicta (de Capite) mirifica omnium devotione asservatis et cultis, Tractatus* (Rome: Apud Iacobum Mascardum, 1628)

Ghiberti, Lorenzo, *I Commentarii (1452–1455)*, ed. by Julius von Schlosser, 2 vols (Berlin: Julius Bard, 1912)

Gilberti Chronicon Pontificum et imperatorum Romanorum, MGH, *Scriptores*, vol. XXIV (Hanover: Hahn, 1846)

Gregorius I, Papa, Registrum, Epistolae, 2 vols, ed. by Paul Ewald and Ludovicus Hartman, MGH, *Epistolarum* (Berlin: Weidmann, 1890 and 1891)

Gui, Bernard, *De fundatione et prioribus conventuum provinciarum Tolosanae et Provinciae ordinis Praedicatorum*, ed. by P. A. Amergier, MOPH, 24 (Rome: Institutum historicum Fratrum praedicatorum, 1961)

Guillaume de Tudela, *The Song of the Cathar Wars: A History of the Albigensian Crusade*, trans. by Janet Shirley (Aldershot: Ashgate, 2000)

Historia diplomatica S. Dominici, Monumenta Historica, Sancti Patris Nostri Dominici, Fasc. I, MOPH, 15, ed. by Marie-Hyacinthe Laurent, OP (Paris: Vrin, 1933)

Monumenta Historica Sancti Patris nostri Dominici, fasc. 2, MOPH, 16, ed. by Angelo Walz, Heribert C. Scheeben, and Marie-Hyacinthe Laurent (Rome: Institutum Historicum Fratrum Praedicatorum, 1935)

Humbert of Romans, *Legenda S. Dominici*, in *Monumenta Historica Sancti Patris nostri Dominici*, fasc. 2, MOPH, 16, ed. by Angelo Walz, Heribert C. Scheeben, and Marie-Hyacinth Laurent (Rome: Institutum Historicum Fratrum Praedicatorum 1935), pp. 355–433

——, *Opera de vita regulari*, ed. by Joachim Joseph Berthier, OP, 2 vols (Rome: Befani, 1888, 1889)

Innocentii III Papae Gesta, J. P. Migne, PL, vol. CCXIV, cols xvii–ccxxviii

Irenaeus of Lyons, *Against the Heresies*, trans. and annotated by Dominic J. Unger, OFM Cap., with revisions by John J. Dillon, Ancient Christian Writers, 3 vols (Mahwah: Paulist, 1992–2012)

John of Damascus, *On the Divine Images*, trans. by D. Anderson (Crestwood, NY: St Vladimir's Seminary, 1980)

Jordan of Saxony, *Libellus de principiis Ordinis Praedicatorum*, in *Monumenta Historica Sancti Patris Nostri Dominici*, fasc. 2, MOPH, 16, ed. by Angelo Walz, Heribert C. Scheeben, and Marie-Hyacinthe Laurent (Rome: Institutum Historicum Fratrum Praedicatorum, 1935), pp. 25–88

The Lady, Clare of Assisi: Early Documents, revised edn and trans. by Regis J. Armstrong, OFM Cap (New York: New City Press, 2006)

Lanciani, Rodolfo A., *L'itinerario di Einsiedeln e l'ordine di Benedetto Canonico* (Rome: Tipografia della R. Accademica dei Lincei, 1891)

Leggenda Minore di S. Caterina da Siena e Lettere dei suoi discepoli, scritture inedite, ed. by Francesco Grottanelli (Bologna: Presso Gaetano Romagnoli, 1868)

Leggenda per la Consacrazione di Santa Maria in Trastevere (BAV Vat. Lat. 10999), ed. and transcribed by Marco Bartoli, Italian translation by Maria Rosaria Mallo (Rome: S. Maria in Trastevere, 2015)

The Letters of St Catherine of Siena, trans. by Suzanne Noffke, OP, 2nd edn, 4 vols, Medieval and Renaissance Texts and Studies, 202, 203, 329, 355) (Tempe, AZ: Arizona Center for Medieval and Renaissance Studies, 2000, 2001, 2007, and 2009)

Le Liber Censuum de l'Église romaine, ed. by Paul Fabre, Louis Duchesne and G. Mollat, Bibliothèque des Écoles Françaises d'Athènes et de Rome, 2nd series, 3 vols (Paris: Du Boccard, 1889–1932)

Le Liber Pontificalis: Texte, Introduction et Commentaire [*LP*], ed. by Louis Duchesne, 3 vols, Bibliothèque des Écoles Francaises d'Athènes et de Rome (Paris: Du Boccard, repr. 1981)

Liber Constitutionum Sororum Ordinis Praedicatorum (ex exemplari codicis Ruthenensis in AGOP, text *c.* 1256) ed. by an Anonymous Dominican Friar, *Analecta Sacris Ordinis Fratrum Praedicatorum*, 3 (1897), 337–348

Lippini, Pietro, OP, *San Domenico visto dai suoi contemporanei: I più antichi documenti relative al Santo e alle origini dell'Ordine Domenicano* (Bologna: Edizioni Studio Domenicano, 1998)

Litterae Encyclicae Magistrorum Generalium Ordinis Praedicatorum, ed. by Benedictus Maria Reichert, OP, in MOPH, 5 (Romae: in domo generalitia, 1900)

Livy, Books I and II, trans. by B. O. Foster, The Loeb Classical Library (Cambridge, MA: Harvard Univesity Press, 1976)

Mansi, Johannes Dominicus, *Pii II olim Aeneas Sylvii Piccolominei Senensis Orationes […]*, 2 vols (Lucca: Ph. M. Benedini, 1755–1757)

Mansi, Johannes Dominicus, *Sacrorum Conciliorum Nova et amplissima Collectio*, 31 vols (Venice: Apud Antonium Zatta, 1759–1767), vol. 22 (1767)

Mariano da Firenze, *Itinerarium Urbis Romae [1518]*, ed. by Enrico Bulletti, OFM, Studi di Antichità Cristiana, 2 (Rome: Pontificio Istituto di Archeologia Cristiana, 1931)

Mariano da Firenze, *Libro delle degnità et excellentie del Ordine della serafica madre delle povere donne Sancta Clara da Assisi*, ed. by Giovanni Boccali (Florence: Edizioni Studi Francescani, 1986)

Martinelli, Fioravante, *Imago B. Mariae Virginis quae apud ven. SS. Sixti et Dominici moniales […] asservatur* (Rome: apud Ludovicum Grignanum, 1635)

——, *Roma ex ethnica sacra sanctorum Petri et Pauli apostolica praedicatione profuse sanguine …* (Roma: typis romanis Ignatij de Lazaris, 1653)

Martini Chronicon. Pontificum et imperatorum, ed. by Ludwig Wieland, *MGH, Scriptores*, XXII, (Hanover: Hahn, 1872)

Master Gregorius the Marvels of Rome, trans. with introduction and commentary by John Osborne, Medieval Sources in Translation, 31 (Toronto: Pontifical Institute of Mediaeval Studies, 1987)

Meditations on the Life of Christ, trans. and ed. by Isa Ragusa and Rosalie B. Green (Princeton: Princeton University Press, 1961)

Monumenta Diplomatica S. Dominici, ed. by Vladimir J. Koudelka, OP, with Raymond J. Loenertz, OP, MOPH, 25 (Rome: Apud Institutum Historicum Fratrum Praedicatorum, 1966)

Monumenta Historica Sancti Patris Nostri Dominici, fasc. 1, ed. by Marie-Hyacinthe Laurent, MOPH, 15 (Paris: Vrin, 1933)

Monumenta Historica Sancti Patris Nostri Dominici, fasc. 2, ed. by Angelo Walz, Heribert C. Scheeben, and Marie-Hyacinthe Laurent, MOPH, 16 (Rome: Institutum Historicum FF. Praedicatorum, 1935)

The Nine Ways of Prayer of St Dominic, ed. and trans. by Simon Tugwell, OP (Rome: Ufficio Libri Liturgici, 1996)

Odetto, Gundisalvo, OP, 'La Cronaca Maggiore dell'Ordine domenicano di Galvano della Fiamma: Frammenti', *AFP* 10 (1940), 297–373

Oliger, Livarius, 'Documenta originis Clarissarum', *AFH*, 15 (1922), 71–102

——, *B. Margherita Colonna († 1280): Le due vite scritte dal fratello Giovanni Colonna senatore di Roma e da Stefania monaca di S. Silvestro in Capite*, Lateranum. Nova Series. Annus 1, no. 2 (Rome: Facultas Theologica Pontificii Athenaei Seminarii Romani, 1935)

Panciroli, Ottavio, *Tesori nascosti dell'alma città di Roma* (Rome: Heredi d'Alessandro Zannetti, 1600, 2nd edn 1625)

Panvinio, Onofrio, *Epitome pontificum Romanorum* (Rome: impendis Iacobi Stradae, 1557)

——, *De praecipuis Urbis Romae sanctioribusque Basilicis, quas Septem Ecclesiae vulgo vocantur* (Rome: Apud Haeredes Antonii Bladii, 1570)

Peter of les Vaux-de-Cernay (Petrus Sarnensis), *The History of the Albigensian Crusades*, trans. by W. A. Sibly and M. D. Sibly (Woodbridge: Boydell, 1998)

Pflugk-Harttung, J. von, *Acta Pontificum Romanorum inedita*, 3 vols (Tübingen: Fues, 1881–1883)

Pierozzi, Antonino, *Storia breve di S. Caterina da Siena, Terziaria Domenicana*, trans. by Tito Sante Centi, OP, ed. by Alfredo Scariglia, OP (Siena: Cantagalli Edizioni, 2002)

Le più antiche Carte del Convento di San Sisto in Roma (905–1300), ed. by Cristina Carbonetti Vendittelli, Codice diplomatico di Roma e della regione romana, 4 (Rome: Società Romana si Storia Patria, 1987)

Pliny the Elder (Gaius Plinius Secundus), *Natural History (Naturalis Historia)*, 10 vols, trans. by H. Rackham, W. H. Jones, and D. E. Eichholz, Loeb Classical Library (London: Heinemann, 1969–1971)

Posterla, Francesco, *Roma Sacra e Moderna* (Rome: Mainardi, 1725)

The Prayers of Catherine of Siena, 2nd edn, trans. by Suzanne Noffke, OP (San José: Authors' Choice Press, 2001)

Il Processo Castellano, ed. by Marie-Hyacinthe Laurent, OP, Fontes Vitae S. Catharinae Senensis Historici, 9 (Milan: Fratelli Bocca Editori, 1942)

Prudentius (Aurelius Clemens Prudentius), 2 vols, *Peristephanon Liber*, trans. by H. J. Thomson, vol. II, Loeb Classical Library, 398 (London: Heinemann, 1953)

Raimondo da Capua, *Legenda Maior, cioè Vita di S. Caterina da Siena (1347–1380)*, trans. by G. Tinaglio OP (Siena: Basilica Cateriniana and S. Sisto Vecchio Roma, 1969)

Raymond of Capua, *De Sanctae Catharinae Senensis (Legenda Maior)*, ed. by G. Henschenius and D. Papebrochius, in I. Bollandus and others, *AA SS*, 69 vols (Antwerp: Apud Michaelem Cnobarum, 1643–1940), aprilis III (Antwerp, Apud Michaelem Cnobarum, 1675), pp. 851–978

——, *The Life of St Catherine of Siena*, trans. by George Lamb (Rockford, IL: TAN, 2009)

Les Régistres d'Alexandre IV, ed. by Charles de Bourel de la Roncière and others, 3 vols, Bibliothèque des Écoles Francaises d'Athènes et de Rome, 2nd series, 15 (Paris: A. Fontemoing, 1895–1959)

Les Régistres de Grégoire X et de Jean XXI, ed. by Jean Guirand, and others, Bibliothèque des Écoles Francaises d'Athènes et de Rome, 2nd series, 12 (Paris: Du Boccard, 1892–1960)

Les Régistres d'Honorius IV, ed. by Maurice Prou, Bibliothèque des Écoles Francaises d'Athènes et de Rome, 2nd series, 7 (Paris: Thorin, 1888)

Il Regesto di Farfa compilato da Gregorio da Catino, ed. by I. Giorgi and Ugo Balzani, 5 vols, Biblioteca della Società Romana di Storia Patria I, 1–5 (Rome: Reale Società Romana di Storia Patria, 1879–1914)

Il Regesto Sublacense, ed. by Leone Allodi and Guido Levi (Rome: Reale Società Romana di Storia Patria, 1885)

Rule of Saint Augustine, Masculine and Feminine Versions, with Introduction and Commentary by Tarcisius J. Van Bavel, OSA, trans. by Raymond Canning, OSA (London: Darton, Longman and Todd, 1984)

The Rules of Isabelle of France: An English Translation with Introductory Study, ed. and trans. by Sean L. Field (St Bonaventure, NY: Franciscan Institute Publications, 2013)

Severano, Giovanni, *Memorie sacre delle sette Chiese di Roma* (Rome: Per Giacomo Mascardi, 1630)

St Jerome, Select Letters, trans. by F. A. Wright, Loeb Classical Library (Cambridge, MA: Harvard University Press, 1980)

Tanner, Norman, *Decrees of the Ecumenical Councils*, 2 vols (London: Sheed and Ward and Georgetown University Press, 1990)

Tertia pars Historiarum Domini Antonini Archipraesulis Florentii (Lyon: Industria Iacobus Myt, 1543)

Theodore d'Apolda, *Liber de vita et obitu et miraculis sancti Dominici et de ordine quem instituit*, in *AASS, Augusti*, vol. I (Antwerp: Apud Jacobum Antonium van Gherwen, 1733), pp. 562–632

Thomas Aquinas, *Commentum in quattuor libros Sententiarum Magistri Petri Lombardi*, 2 vols, (Parma: Fiaccadori, 1856–1858)

Tolomeo da Lucca, *Historia Ecclesiastica Nova*, Ludovicus Antonius Muratori, *Rerum Italicarum scriptores*, 11 (Milan: Ex Typographia Societatis Palatinae in Regia Curia, 1727)

Tommaso da Siena (Caffarini), *Sanctae Catharinae Senensis Legenda Minor*, Fontes Vitae S. Catharinae Senensis Historici 10, ed. by E. Francheschini (Milan: R. Università Filli Bocca, 1942)

——, *Libellus de Supplemento*, ed. by Giuliana Cavallini and Imelda Foroloso (Rome: Edizioni Cateriniane, 1974)

Tractatus de Ordine ff. de Paenitentia S. Dominici di f. Tommaso da Siena 'Caffarini', ed. by Marie-Hyacinthe Laurent, OP, Fontes Vitae S. Catherinae Senensis Historica, 21 (Siena: University of Siena, 1938)

Ugonio, Pompeo, *Historia delle Stationi di Roma che si celebrano la Quaresima* (Rome: Appresso Bartolomeo Bonfadino, 1588)

Vasari, Giorgio, *Le Vite de' più excellenti architettori, pittori, et scultori Italiani (1550–1568)*, ed. by Gaetano Milanesi, 9 vols (Florence: Sansoni, 1878–1885)

Vasi, Giuseppe, *Delle Magnificenze di Roma antica e moderna* (Rome: Niccolò e Marco Pagliarini, 1756)

Visions of Sainthood in Medieval Rome: The Lives of Margherita Colonna by Giovanni Colonna and Stefania, trans. by Larry F. Field, ed. by Lezlie S. Knox and Sean L. Field (Notre Dame, IN: University of Notre Dame Press, 2017)

Vita … Gregorii Papae IX, from *Vitae nonnullorum Pontificum Romanorum a Nicolao Aragoniae SRE Cardinali consriptae*, in *Rerum Italicarum Scriptores …* , ed. by Ludovicus Antonius Muratori, 3 (Milan: Ex Tipographica Societatis Palatinae in Regia Curia, 1723), pp. 575–87

Wadding, Luke (and continued by various later authors), *Annales Minorum seu Trium Ordinum a S. Francisci institutorum*, 3rd edn, 30 vols (Quaracchi-Florence: Ad Claras Aquas, 1931–1951)

William of Puylaurens, *The Chronicle of William of Puylaurens*, trans with an introduction, notes and appendices by W. A. Sibly and M. D. Sibly (Woodbridge: Boydell, 2003)

Secondary Works

Accrocca, Felice, 'Quo elongati: il tentative di una doppia fedeltà', *Frate Francesco*, 81 (2015), 133–66

——, 'Francesco, il Cardinale Ugo di Ostia e la conferma papale della regola', *Collectanea Francescana*, 86 (2016), 433–60

Ait, Ivana, 'Il Patrimonio delle clarisse di San Lorenzo in Panisperna tra XIV e XV secolo: prime indagini', *Reti Medievali*, 19.1 (2018), 453–72; see also <http://www.retimedievali.it> [accessed 27 Sept. 2021]

Alberzoni, Maria Pia, 'Papato e nuovi Ordini religiosi femminili', in *Il papato duecentesco e gli Ordini mendicanti*, Atti dei Convegni della Società internazionale di studi francescani, 25, Assisi, 13–14 febbraio 1998 (Spoleto: Centro Italiano di Studi sull'alto Medioevo, 1998), pp. 205–61

——, *Clare of Assisi and the Poor Sisters in the Thirteenth Century*, ed. by Jean François Godet-Calogeras, trans. by William Short and Nancy Celaschi (Saint Bonaventure, NY: Franciscan Institute Publications, 2004)

——, 'I nuovi Ordini, il IV concilio lateranense e i Mendicanti', in *Domenico di Caleruega e la Nascita dell'Ordine dei Frati Predicatori*, ed. by Enrico Menesto, Atti del XLI Convegno Internazionale di Studi sull'Alto Medioevo, Nuova Serie, 18 (Spoleto: Fondazione Centro Italiano di Studi sull'Alto Medioevo, 2005), pp. 39–89

——, '"Intra in gaudium Domini, Domini tui videlicet". Diana d'Andalò e Chiara d'Assisi: da "sorores" a "moniales"', *Francescana: Bollettino della Societa internazionale di studi francescani*, 12 (2010), 1–42

Alce, Venurino, OP, 'Documenti sul convento di San Domenico in Bologna dal 1221 al 1251', *AFP*, 42 (1972), 5–45

——, *The Basilica of Saint-Dominic in Bologna* (Bologna: Edizioni Studio Domenicano, 1997)

——, *La basilica di San Domenico* (Bologna: Edizioni Studio Domenicano, 2015)

Amato, Pietro, ed., *De vera effigie Mariae. Antiche Icone di Roma*, Catalogo della mostra (Milan: Mondadori, 1988)

Ames, Christine Caldwell, *Righteous Persecution: Inquisition, Dominicans, and Christianity in the Middle Ages* (Philadelphia: University of Pennsylvania Press, 2010)

Andaloro, Maria, 'Note sui temi iconografici della Deesis e Haghiosoritissa', *Rivista dell'Istituto di Archeologia e Storia dell'Arte*, 17 (1970), 85–153

——, 'Il sogno di Innocenzio III all'Aracoeli, Niccolò IV e la basilica di San Giovanni in Laterano', in *Studi in onore di Giulio Argan*, 3 vols (Rome: Multigrafica, 1984), vol. I, pp. 29–37

——, 'Le icone a Roma in età preiconoclasta', in *Roma tra Oriente e Occidente*, Atti della 49 Settimana di Studio del Centro Italiano di Studi sull'Alto Medioevo, 49 (Spoleto, 2001), 2 vols (Spoleto: Centro Italiano di Studi sull'Alto Medioevo, 2002), vol. II, pp. 719–54

Andaloro, Maria, and Carla D'Angelo, ed., *Mosaici medievali di Roma attraverso il Restauro dell'ICR 1991–2004* (Rome: Gangemi Editore Internazional, 2017)

Andaloro, Maria, and Serena Romano, ed., *Arte e Iconografia a Roma dal Tardoantico alla fine del Medioevo* (Milan: Jaca, 2002)

Andenna, Cristina, 'Dalla Religio pauperum Dominarum de Valle Spoliti all'Ordo Sancti Damiani', in *Die Bettelorden im Aufbau*, ed. by Gert Melville and Jörg Oberste (Eichstätt: LIT, 1999) pp. 429–92

——, 'Sancia, Queen of Naples and *Soror Clara*: A Life Lived Between Secular Responsibilities and Religious Desire', in *Franciscan Women: Female Identities and Religious Culture Medieval and Beyond*, ed. by Lezlie Knox and David B. Couturier (Saint Bonaventure, NY: Franciscan Institute, Bonaventure University, 2020), pp. 115–32

Andrews, Frances, *The Other Friars: The Carmelite, Augustinian, Sack and Pied Friars in the Middle Ages* (Woodbridge: Boydell, 2006)

Annibali, Manuela, 'Il museo domenicano: storia dell'allestimento del patrimonio artistico domenicano e il percorso di arte e fede nel convento di Santa Sabina', in *Il convento di Santa Sabina all'Aventino e il suo patrimonio storico-artistico e architettonico*, ed. by Manuela Gianandrea, Manuela Annibali, and Laura Bartoni (Rome: Campisano Editore, 2016), pp. 145–52

——, 'Il Rinascimento privato del convento di Santa Sabina: Bandinello Sauli, Vincenzo Giustiniani, Pio V', in *Il convento di Santa Sabina all'Aventino e il suo patrimonio storico-artistico e architettonico*, ed. by Manuela Gianandrea, Manuela Annibali, and Laura Bartoni (Rome: Campisano Editore, 2016), pp. 43–54

Anonimo (i.e. Fr Giuseppe Sanità, OFM), *S. Francesco a Ripa: Guida storico-artistico della chiesa* (Roma: 'Il Sagittario, no date [1960s or 1970s])

Anonymous, *Saint Dominique, son esprit, ses vertus, d'apres les temoins oculaires* (Saint-Maximin [Var]: Librairie Saint-Thomas-d'Aquin, 1923)

Anonymous, *San Sisto all'Appia* (Rome: San Sisto, 1991)

Antonelli, Ferdinando, OFM, 'I primi monasteri orientali in Roma', *Rivista di Archeologia Cristiana*, 5 (1928), 105–22

Armellini, Mariano, revised by Carlo Cecchelli, *Le Chiese di Roma dal Secolo IV al XIX* (Rome: Edizioni R.O.R.E. di Nicola Ruffolo, 1942)

Ascheri, M., G. Mazzoni, and F. Nevola, ed., *L'ultimo secolo della Repubblica di Siena: arte, cultura e società*, Atti del congresso internazionale, Siena, 28–30 settembre 2003 – 16–18 ottobre 2004 (Siena: 2008)

Ashby, Thomas, ed., *Topographical Study in Rome in 1581: A Series of Views with a Fragmentary Text by Etienne Du Pérac*, Roxburghe Club, 171 (London: J. B. Nichols and Sons, 1916)

Ashby, Thomas, and R. A. L. Fell, 'The Via Flaminia', *Journal of Roman Studies*, 11 (1921), 125–90

Aubert, Marcel, *L'Architecture cistercienne en France*, 2 vols (Paris: Éditions d'art et d'histoire, 1947)

Bacci, Michele, *Lo spazio dell'anima: vita di una Chiesa medievale* (Rome: Editori Laterza, 2005)

Bacci, Peleo, *La cappella delle Suore della Penitenza detta la 'Cappella delle Volte'*, in *San Domenico di Siena. Ricerche sulle sue fasi costruttive* (Siena: Lazzeri, 1942–1944)

Badde, Paul, *The Holy Veil of Manoppello: The Human Face of God* (Nashua, NH: Sophia Institute Press, 2018)

Barclay Lloyd, Joan, 'Masonry Techniques in Medieval Rome', *PBSR*, 53 (1985), 225–77

——, 'The Building History of the Medieval Church of S. Clemente in Rome', *Journal of the Society of Architectural Historians*, 45 (1986), 197–223

——, 'The Medieval Benedictine Monastery of SS. Cosma e Damiano in Mica Aurea in Rome, c. 936–1234', *tjurunga – An Australasian Benedictine Review*, 34 (May 1988), 25–35

——, *The Medieval Church and Canonry of S. Clemente in Rome*, San Clemente Miscellany 3, (Rome: San Clemente, 1989)

——, '"Chiamansi Romei in quanto vanno a Rome" (V.N., XL, 7): Pilgrimage to Rome in the Late Duecento', in *La gloriosa donna della mente: A commentary on the 'Vita Nuova'*, ed. by Vincent Moleta (Florence: Olschki, and Department of Italian, The University of Western Australia Perth, 1994), pp. 225–47

——, 'The Architecture of the Medieval Monastery at S. Lorenzo fuori le Mura, Rome', in *Architectural Studies in Memory of Richard Krautheimer*, ed. by Cecil L. Striker (Mainz: Philipp von Zabern, 1996), pp. 99–102

——, 'The Medieval Murals in the Cistercian Abbey of SS. Vincenzo e Anastasio ad *Aquas Salvias* at Tre Fontane in their Architectural Settings', *PBSR*, 65 (1997), 287–348

——, 'L'architettura medievale di S. Cosimato', in Joan Barclay Lloyd and Karin Bull-Simonsen Einaudi, *SS. Cosma e Damiano in Mica Aurea: Architettura, Storia e Storiografia di un Monastero romano soppresso*, Miscellanea della Società Romana di Storia Patria, 38 (Rome: Società Romana di Storia Patria, 1998), pp. 77–126

——, 'The Architectural Planning of Pope Innocent III's Nunnery of S. Sisto in Rome', in *Innocenzo III: Urbs et Orbis*, ed. by Andrea Sommerlechner, Atti del Congresso Internazionale, Roma, 9–15 settembre 1998, 2 vols (Rome: Società Romana di Storia Patria and Istituto Storico Italiano per il Medio Evo, 2003) vol. II, pp. 1292–1311

——, 'The Church and Monastery of S. Pancrazio, Rome', in *Pope, Church and City: Essays in Honour of Brenda M. Bolton*, ed. by Frances Andrews, C. Egger and C. M. Rousseau (Leiden: Brill, 2004), pp. 245–66

——, 'Medieval Dominican Architecture at Santa Sabina in Rome, c. 1219 – c. 1320', *PBSR*, 72 (2004), 231–92

——, *SS. Vincenzo e Anastasio at Tre Fontane near Rome: History and Architecture of a medieval Cistercian Abbey*, Cistercian Studies Series, 198 (Kalamazoo: Cistercian Publications, 2006)

——, 'Paintings for Dominican Nuns: A New Look at the Images of Saints, Scenes from the New Testament and Apocrypha, and Episodes from the Life of Saint Catherine of Siena in the Apse of San Sisto Vecchio in Rome', *PBSR*, 80 (2012), 189–232

——, 'San Cosimato: da monastero benedettino a monastero delle Clarisse. Gli edifici e le loro funzioni', in *'San Chosm'e Damiano e 'l suo bel monasterio…': il complesso monumentale si San Cosimato ieri, oggi, domani*, ed. by Gemma Guerrini Ferri, Joan Barclay Lloyd, and Anna Maria Velli, Quaderni di TestoeSenso 1/2013 (Rome: Università degli Studi 'Tor Vergata', 2013), pp. 33–51

——, 'Memory, Myth and Meaning in the Via Appia from Piazza di Porta Capena to Porta San Sebastiano', in *The Site of Rome: Studies in the Art and Topography of Rome 1400–1750*, ed. by David R. Marshall (Rome: 'L'Erma di Bretschneider, 2014) pp. 28–51

——, 'Saint Catherine of Siena's Tomb and its Place in Santa Maria sopra Minerva, Rome: Narration, Translation, and Veneration', *PBSR*, 83 (2015), 111–48

——, 'Il protiro medievale a Roma', in *Nuovi Studi su San Cosimato e Trastevere*, ed. by Anna Maria Velli (Rome: Graphofeel Edizioni, 2017), pp. 79–104

Barclay Lloyd, Joan, and Bull-Simonsen Einaudi, Karin, 'Cronologia. Fonti documentarier sul monastero dei SS. Cosma e Damiano in Mica Aurea,' in Joan Barclay Lloyd and Karin Bull-Simonsen Einaudi, *SS. Cosma e Damiano in Mica Aurea: Architettura, Storia e Storiografia di un Monastero romano soppresso*, Miscellanea della Società Romana di Storia Patria, 38 (Rome: Società Romana di Storia Patria, 1998), pp. 127–144

Barclay Lloyd, Joan, and Karin Bull-Simonsen Einaudi, *SS. Cosma e Damiano in Mica Aurea: Architettura, Storia e Storiografia di un Monastero romano soppresso*, Miscellanea della Società Romana di Storia Patria, 38 (Rome: Società Romana di Storia Patria, 1998)

Barelli, Lia, *The Monumental Complex of Santi Quattro Coronati in Rome* (Rome: Viella, 2009)

Barresi, Paolo, Patrizio Pensabene, and Daniela Trucchi, 'Materiali di reimpiego e progettazione nell'architettura delle chiese paleocristiane di Roma', in *Ecclesiae Urbis*. Atti del Convegno internazionale di studi sulle chiese di Roma, Roma 4–10 settembre 2000 ed. by Federico Guidobaldi and Alessandra Guiglia Guidobaldi (Vatican City: Pontificio Istituto di Archeologia Cristiana, 2002), vol. II, pp. 799–842

Barone, Giulia, 'I Francescani a Roma', *Storia della Città*, 9 (1978), 33–35

——, 'Margherita Colonna e le Clarisse di S. Silvestro in Capite', in *Roma anno 1300*, Atti del Congresso internazionale di storia dell'arte medievale, Rome 19–24 maggio 1980, ed. by Angiola Maria Romanini (Rome: L'Erma di Bretschneider, 1983), pp. 799–805

——, 'Le due vite di Margherita Colonna', in *Esperienza religiosa e scritture femminili tra medioevo ed età moderna*, ed. by Marilena Modica (Acrireale: Bonnano, 1992), pp. 25–32

——, 'La regola di Urbano IV', *Convivium assisiense*, n.s. 6 (2004), 83–96

——, 'Alle origini del Secondo Ordine Domenicano: Esperienze religiose femminili nei Secoli XII–XIII', in *Il Velo, la Penna e la Parola. Le Domenicane: storia, istituzioni e scritture*, ed. by Gabriella Zara and Gianni Festa, Biblioteca di Memorie Domenicane (Florence: Nerbini, 2009), pp. 21–30

Barone, Giulia, and Umberto Longo, ed., 'Roma religiosa: monasteri e città (secoli VI–XVI'), *Reti medievali*, 19.1 (2018) See also <http://www.retimedievali.it> [accessed 12 October 2021]

Bartoli, Marco, 'Women and the Franciscan Legacy (XIII–XV Centuries)', *Franciscan Women: Female Identities and Religious Culture, Medieval and Beyond*, ed. by Lezlie Knox and David B. Couturier (Saint Bonaventure, NY: Franciscan Institute, Bonaventure University, 2020), pp. 9–20

Bartolomei Romagnoli, Alessandra, 'La vita religiosa femminile alla fine del medio evo: temi e problemi', in *Litterae ex quibus nomen Dei componitur: Studi per l'ottantesimo compleanno di Giuseppe Avarucci*, ed. by Alexander Horowski (Rome: Bibliotheca Seraphica-Capuccina, 2016), pp. 291–311

Bartoni, Laura, 'Dalle "delitie" del cardinal Bernerio alle opera "necessarie" del primo Settecento. Le alterne vicende del convento di Santa Sabina in età moderna', in *Il convento di Santa Sabina all'Aventino e il suo patrimonio storico-artistico e architettonico*, ed. by Manuela Gianandrea, Manuela Annibali, and Laura Bartoni (Rome: Campisano Editore, 2016), pp. 55–72

Barucci, Clementina, *Virginio Vespignani, architetto tra Stato Pontificio e Regno d'Italia* (Rome: Argos, 2006)

Baynes, Norman, *Byzantine Studies and other Essays* (London: Athlone, 1955)

Bedouelle, Guy, OP, *Saint Dominic: The Grace of the Word*, trans. by Sister Mary Thomas Noble, OP, rev. edn (San Francisco: Ignatius Press, 1995)

Belardi, Giovanni, 'Considerazioni sui restauri in atto nell'abbazia delle Tre Fontane a Roma', *Arte Medievale*, 2.7 (1993), 229–30

——, 'Il restauro dell'abbazia delle Tre Fontane, (seconda parte)', *Arte Medievale*, 2.8 (1994), 79–91

——, 'Il restauro architettonico', in Fra Jacques Brière, Liliana Pozzi and others, *Abbazia delle Tre Fontane: il complesso, la storia, il restauro* (Rome: Edilerica, 1995), pp. 98–160

——, 'Restauri nella Chiesa dei SS. Vincenzo e Anastasio nel complesso delle Tre Fontane', *M di R monumentidiroma*, 1–2 (2005/2006), 129–46

Bellanca, Calogero, *La Basilica di Santa Sabina e gli Interventi di Antonio Muñoz* (Rome: In Conventu Santa Sabina, 1999)

Belluzzi, Amadeo, ed., *Giuliano da Sangallo* (Milan: Officina Libraria, 2017)

Belting, Hans, *Likeness and Presence: A History of the Image before the Era of Art* (Chicago: Chicago University Press, 1994)

Benson, R. I., G. Constable, and Carol D. Lanham, ed., *Renaissance and Renewal in the Twelfth Century* (Cambridge, MA: Harvard University Press, 1982)

Berman, Constance, *The Cistercian Evolution: The Invention of a Religious Order in Twelfth-Century Europe* (Philadelphia: University of Pennsylvania Press, 2010)

Bernardini, Virginia, Andreina Draghi, and Guia Verdesi, *SS. Domenico e Sisto*, Le Chiese di Roma Illustrate, NS 26 (Roma: Istituto Nazionale di Studi Romani, Fratelli Palombi Editori, 1991)

Bernardino, Franco, 'Il convento della Minerva a Roma', *L'Urbe* NS, 32.3 (1969), 12–17

Bernetti, G., 'S. Caterina negli scritti di Pio II', *Caterina da Siena*, 18.1 (1967), 16–20

Bertelli, Carlo, 'L'immagine del "Monasterium Tempuli" dopo il restauro', *AFP*, 31 (1961), 82–111

——, 'La Madonna del Pantheon', *Bollettino d'Arte*, 46 (1964), 24–32

——, 'Storia e vicende dell'immagine edessina a S. Silvestro in Capite a Roma', *Paragone-Arte*, 217/37 (1968), 3–33

——, 'Caput Sancti Anastasii', *Paragone-Arte*, 247/21 (1970), 12–25

Berthier, Joachim J., OP, *L'Église de la Minerve à Rome* (Rome: Tipografia Manuzio, 1910)

——, *L'Église de Sainte-Sabine à Rome* (Rome: Tipografia 'Roma', 1910)

——, *Le Couvent de Sainte-Sabine à Rome* (Rome: Coopérative typographique 'Manuce', 1912)

——, 'La Restauration de l'église de Sainte-Sabine à Rome', *Analecta Sacri Ordinis Fratrum Praedicatorum*, 13 (1918), 406–14

——, *Chroniques du monastère de San Sisto et de San Domenico e Sisto à Rome*, 2 vols (Levanto: Imprimérie de l'Immaculée, 1919–1920)

Betti, Fabio, 'L'arredo liturgico della basilica di S. Sabina al tempo di papa Eugenio II: dalla scoperta ai restauri storici (1894, 1918, 1936)', *Arte Medievale*, Series 4, 7 (2017), pp. 31–52

Bianchi, Alessandro, 'Affreschi duecenteschi nel S. Pietro in Vineis in Anagni', in *Roma Anno 1300*, pp. 379–84

Bianchi, Lidia, 'Il sepolcro di S. Caterina da Siena nella basilica di S. Maria sopra Minerva', in Lidia Bianchi and Diega Giunta, *Iconografia di S. Caterina da Siena* (Rome: Città Nuova Editrice, 1988), pp. 15–62

—— , 'Appendice epigrafica', in Lidia Bianchi and Diega Giunta, *Iconografia di S. Caterina da Siena* (Rome: Città Nuova Editrice, 1988), pp. 55–62

Bianchi, Lidia, and Diega Giunta, *Iconografia di S. Caterina da Siena* (Rome: Città Nuova Editrice, 1988)

Bianco, Maria Grazia, ed., *La Roma di santa Caterina da Siena*, Quaderni della Libera Università 'Maria SS. Assunta', 18 (Rome: Edizioni Studium, 2001)

Bigaroni, Marino, 'San Damiano – Assisi. The First Church of Saint Francis', *Franciscan Studies*, 47.25 (1987), 45–97

Bigaroni, Marino, Hans-Rudolf Meier, and Elvio Lunghi, *La Basilica di S. Chiara in Assisi* (Perugia: Quattroemme, 1994)

Bilancia, Fernando, 'Annibale Lippi, architetto della Cappella del SS. Rosario di S. Maria sopra Minerva', *Palladio*, 20.39 (2007), 101–10

Binski, Paul, and Patrick Zutshi, with Stella Panayotova, *Western Illuminated Manuscripts: A Catalogue of the Collection in Cambridge University Library* (Cambridge: Cambridge University Press, 2011)

Bisogni, Fabio, 'Gli inizi dell'iconografia domenicana', in *Domenico di Caleruega e la Nascita dell'Ordine dei Frati Predicatori*, Atti del 41 Convegno Internazionale di Studi sull'Alto Medioevo, Nuova Serie diretta da Enrico Menesto', 18 (Spoleto: Fondazione Centro Italiano di Studi sull'Alto Medioevo 2005), pp. 613–38

Bloch, Herbert, 'Monte Cassino, Byzantium and the West in the Earlier Middle Ages', *Dumbarton Oaks Papers*, 3 (1946), 166–224

—— , 'The New Fascination with Ancient Rome', in *Renaissance and Renewal in the Twelfth Century*, ed. by Robert L. Benson, Giles Constable, and Carol D. Lanham (Cambridge, MA: Harvard University Press, 1982), pp. 615–36

—— , *Monte Cassino in the Middle Ages* (Cambridge, MA: Harvard University Press, 1986)

Bober, Phyllis Pray, and Ruth O. Rubinstein, with Susan Woodford, *Renaissance Artists and Antique Sculpture: A Handbook of Sources*, 2nd edn (London: H. Miller, 2010)

Böhm, Margret, *Wandmalerei des 13. Jahrhunderts im Klarissenkloster S. Pietro in Vineis zu Anagni. Bilder für die Andacht* (Münster: LIT, 1999)

Bolgia, Claudia, 'Il coro medievale della chiesa di S. Maria in Aracoeli a Roma', in *Studi in Onore di Angiola Maria Romanini*, ed. by Antonio Cadei and others (Rome: Sintesi informazione, 1999), pp. 233–42

—— , 'The So-Called Tribunal of Arnolfo di Cambio at Santa Maria in Aracoeli', *Burlington Magazine*, 143 (2001), 753–56

—— , 'An Engraved Architectural Drawing at S. Maria in Aracoeli, Rome', *Journal of the Society of Architectural Historians*, 62.4 (2003), 436–47

—— , 'The Felici Icon Tabernacle (1372) at S. Maria in Aracoeli, Reconstructed: Lay Patronage, Sculpture, and Marian Devotion in Trecento Rome', *Journal of the Warburg and Courtauld Institutes*, 68 (2007), 27–72

—— , 'Ostentation, Power, and Family Competition in Late Medieval Rome: The Earliest Chapels at S. Maria in Aracoeli', in *Aspects of Power and Authority in the Middle Ages*, ed. by Brenda Bolton and Christine Meek, International Medieval Research, 14 (Turnhout: Brepols, 2007), pp. 73–106

—— , 'Santa Maria in Aracoeli and Santa Croce: The Problem of Arnolfo's Contribution', in *Arnolfo's Moment*, ed. by David Friedman, Julian Gardner, and Margaret Haines, Acts of an International Conference, Florence, Villa I Tatti, May 26–27, 2005 (Florence: Olschki, 2009), pp. 91–106

—— , *Reclaiming the Roman Capitol: Santa Maria in Aracoeli from the Altar of Augustus to the Franciscans, c. 500–1450* (London: Routledge, 2017)

—— , 'Patrons and Artists on the Move: New Light on Matteo Giovannetti between Avignon and Rome', *PBSR*, 88 (2020), 185–213

Bolton, Brenda, '*Mulieres Sanctae*', in *Sanctity and Secularity: The Church and the World*, ed. by D. Baker (Oxford: Blackwell, 1973), pp. 77–95

——, 'Daughters of Rome: All One in Christ Jesus!' in Brenda Bolton, *Innocent III: Studies on Papal Authority and Pastoral Care* (Aldershot: Ashgate, 1995), pp. 101–15

Bonifacio VIII e il suo tempo, Anno 1300: il primo Giubileo, Catalogue of the exhibition at Rome, Palazzo Venezia, ed. by Marina Righetti Tosti-Croce (Milan: Electa, 2000)

Bonniwell, William R., *A History of the Dominican Liturgy*, 2nd edn (New York: Wagner, 1945)

Bordi, Giulia, and others, ed., *L'officina dello sguardo. Scritti in onore di Maria Andaloro. I luoghi dell'arte. Immane, memoria, materia*, 2 vols (Rome: Gangemi, 2014)

Bourdua, Louise, *The Franciscans and Art Patronage in Late Medieval Italy* (Cambridge: Cambridge University Press, 2004)

Borsi, Franco, *S. Maria in Campo Marzio. La sede della Camera dei Deputati* (Rome: Editalia, 1987)

Borsi, Franco, and others, *S. Maria sopra Minerva. La sede della Camera dei Deputati* (Rome: Editalia, 1990)

Borsoi, Maria Barbara Guerrieri, 'La Cappella di San Pio V', in *Il convento di Santa Sabina all'Aventino e il suo patrimonio storico-artistico e architettonico*, ed. by Manuela Gianandrea, Manuela Annibali, and Laura Bartoni (Rome: Campisano Editore, 2016), pp. 119–26

Borsook, Eve, *Mural Painters of Tuscany*, 2nd edn (Oxford: Clarendon Press, 1980)

Boskovits, Miklos, 'Su Niccolò di Buonaccorso, Benedetto di Bindo e la pittura senese del primo Quattrocento', *Paragone*, 31 (1980), 3–22

Bottari, Giovanni Gaetano, *Raccolta di lettere sulla pittura, scultura ed architettura (1754–1773)*, ed. by Stefano Ticozzi, 8 vols (Milan: Silvestri, 1822–1825)

Bourgeois, Angi Elsea, *Reconstructing the Lost Frescoes of S. Maria sopra Minerva in Rome from the 'Meditationes' of Cardinal Juan de Torquemada: A Case Study in the History of Art* (Lewiston: The Edwin Mellen Press, 2009)

Bowes, Kimberly Diane, *Private Worship, Public Values and Religious Change in Late Antiquity* (Cambridge: Cambridge University Press, 2008)

Boyle, Leonard E., OP, *The Community of SS. Sisto e Clemente in Rome, 1677–1977*, with a chapter by Hugh Fenning, OP, San Clemente Miscellany, 1 (Rome: Apud S. Clemente, 1977)

——, 'The Ways of Prayer of Saint Dominic. Notes on Manuscript Rossi 3 in the Vatican Library', *AFP*, 64 (1994), 5–17

——, 'A Material Consideration of Santa Sabina Ms XIV L 1', in *Aux Origines de la 'Liturgie dominicaine'*, ed. by Leonard Boyle and Pierre-Marie Gy (Rome: Ecole française de Rome, 2004), pp. 19–42

Boyle, Leonard E., OP, and Pierre-Marie Gy, OP, ed., *Aux Origines de la 'Liturgie dominicaine': Le manuscript Santa Sabina XIV L 1*, with the collaboration of Pawels Krupta, OP, Collection de l'École Française de Rome, 327: Documents, Études et Répertoires Publiées par l'Institut de Récherche et d'Histoire des Textes, 67 (Rome: École Française de Rome, 2004)

Bozzo Dufour, Colette, 'Il "Sacro Volto" di Genova. Problemi e aggiornamenti' in *The Holy Face and the Paradox of Representation*, ed. by Herbert L. Kessler and Gerhard Wolf, Villa Spelman Colloquia, vol. VI (Bologna: Buova Alfa Editoriale, 1998), pp. 55–67

Bradford-Smith, Elizabeth, 'Santa Maria Novella and the Problem of Historicism/ Modernism/ Eclecticism in Italian Gothic Architecture', in *Medioevo: il Tempo degli Antichi*, ed. by Arturo Carlo Quintavalle, Atti del Convegno internazionale di studi, Parma, 24–28 settembre 2003, I convegni di Parma, 6 (Milan: Electa, 2006), pp. 621–30

Brancia di Apricena, Mariana, *Il complesso dell'Aracoeli sul colle Capitolino, sec. IX–XIX* (Rome: Edizioni Qasar, 2000)

Brandenburg, Hugo, *Le Prime Chiese di Roma IV–VII Secolo: L'Inizio dell'Architettura ecclesiastica occidentale* (Milan: Jaca, 2004)

——, *The Ancient Churches of Rome from the Fourth to the Seventh Century: The Dawn of Christian Architecture in the West* (Turnhout: Brepols, 2005)

Brandt, Olof, 'Sul battistero paleocristiano di S. Lorenzo in Lucina', *Archeologia Laziale*, 12 (1995), 145–50

——, 'The Excavations in the Baptistery of S. Lorenzo in Lucina in 1993, 1995 and 1998', in *San Loreno in Lucina: The Transformation of a Roman Quarter*, ed. by Olof Brandt (Stockholm: Svenska Institutet i Rom, 2012), pp. 49–77

Breccia Fradocchi, Margherita Maria, *S. Agostino in Roma: arte, storia, documenti* (Rome: Editrice del Carretto, 1979)

Brenk, Beat, 'L'anno 410 e il suo effetto sull'arte chiesiastica a Roma', in *Ecclesiae Urbis*. Atti del Convegno internazionale di studi sulle chiese di Roma, Roma 4–10 settembre 2000 ed. by Federico Guidobaldi and Alessandra Guiglia Guidobaldi (Vatican City: Pontificio Istituto di Archeologia Cristiana, 2002), vol. II, pp. 1001–18

Brentano, Robert, *Rome before Avignon: A Social History of Thirteenth-Century Rome* (London: British Museum, 1991)

Brett, Edward Tracy, 'Humbert of Romans and the Dominican Second Order', *Memorie Domenicane*, NS 12 (1981), 1–25

——, *Humbert of Romans: His Life and Views of Thirteenth-Century Society* (Toronto: Pontifical Institute of Mediaeval Studies, 1984)

Brühl, Carlrichard, 'Die Kaiserpfalz bei St Peter und die Pfalz Ottos III. Auf dem Palatin', *Quellen und Forschungen aus italienischen Archiven und Bibliotheken*, 34 (1954), 1–30

Bruzelius, Caroline, 'Hearing is Believing: Clarissan Architecture, ca. 1213–1340', *Gesta*, 31 (1992), 83–91

——, 'Queen Sancia of Mallorca and the Convent Church of Sta. Chiara in Naples', *Memoirs of the American Academy in Rome*, 40 (1995), 69–100

——, 'The Dead Come to Town: Preaching, Burying and Building in the Mendicant Orders', in *The Year 1300 and the Creation of a New European Architecture*, ed. by A. Gajewski and Z. Opacic (Turnhout: Brepols, 2007), pp. 203–24

——, 'The Architecture of the Mendicant Orders in the Middle Ages: An Overview of Recent Literature', *Perspective: Le Journal de l'INHA*, 2 (2012), 95–116

——, *Preaching, Building, and Burying: Friars in the Medieval City* (New Haven: Yale University Press, 2014)

Bruzelius, Caroline, and Caroline J. Goodson, 'The Buildings', in *Walls and Memory: The Abbey of San Sebastiano at Alatri (Lazio) from Late Roman Monastery to Renaissance Villa and Beyond*, ed. by Elizabeth Fentress, Caroline J. Goodson, Margaret L. Laid, and Stephanie C. Leonie, Disciplina Monastica. Studies on Medieval Monastic Life (Turnhout: Brepols, 2005), pp. 73–113

Bruzelius, Caroline, Andres Giordano, Lucas Giles, Leopoldo Repola, Emanuela de Feo, Andrea Basso, and Elisa Castagna, 'L'Eco delle Pietre: History, Modeling, and GPR as Tools in Reconstructing the Choir Screen at Sta. Chiara in Naples', *Archeologia e Calcolatori*, Supplemento 10, (2018), 81–103

Bruzelius, Caroline, and Leopolda Repola, 'Monuments and Methods in the Age of Digital Technology: A Case-Study and its Implications', in *Cultura in transito: Ricerca e technologie per il patrimonio culturale*, ed. by Antonio Bertini, Immacolata Caruso, Gemma Teresa Colesanti, and Tiziana Vitolo (Roma: L'Erma di Bretschneider, 2020), pp. 15–24

Buchowiecki, Walter, *Handbuch der Kirchen Roms*, 4 vols (Vienna: Hollinek, 1967, 1970, 1974, and 1997)

Bule, Steven, Alan Phipps Darr, and Fiorella Superbi Goffredi, ed., *Verrocchio and Late Quattrocento Italian Sculpture* (Florence: Le Lettere, 1992)

Bull-Simonsen Einaudi, Karin, 'Il monastero di S. Cosimato in Mica Aurea. Appunti di storia e di topografia', in Joan Barclay Lloyd and Karin Bull-Simonsen Einaudi, *SS. Cosma e Damiano in Mica Aurea: Architettura, Storia e Storiografia di un Monastero romano soppresso*, Miscellanea della Società Romana di Storia Patria, 38 (Rome: Società Romana di Storia Patria, 1998), pp. 11–76

Bull-Simonsen Einaudi, Karin, 'Perché studiare San Cosimato?' in *'San Chosm' e Damiano e 'l suo bel monasterio … ': o il complesso monumentale di San Cosimato ieri, oggi, domani*, ed. by Gemma Guerrini Ferri and Joan Barclay Lloyd with Anna Maria Velli, Quaderni di TestoeSenso, 1/2013 (Rome: TestoeSenso Università Tor Vergata, 2013), pp. 13–22

Burke, Linda, 'As Told By Women: St Elizabeth of Hungary, Her Four Handmaids, and the Iconography of the Elizabeth Medallion Window (Elizabeth Church, Marburg, Germany)', in *Franciscan Women: Female Identities and Religious Culture Medieval and Beyond*, ed. by Lezlie Knox and David B. Couturier (Saint Bonaventure, NY: Franciscan Institute, Bonaventure University, 2020), pp. 21–61

Burton, Janet, and Karen Stöber, ed., *Women in the Medieval Monastic World* (Turnhout: Brepols, 2015)

Bynum, Caroline Walker, *Holy Feast and Holy Fast: The Religious Significance of Food to Medieval Women* (Berkeley: University of California Press, 1987)

Caglioti, Francesco, 'Su Isaia da Pisa. Due "Angeli reggicandelabro" in Santa Sabina all'Aventino e l'altare eucaristico del Cardinale d'Estouteville per S. Maria Maggiore', *Prospettiva*, 89–92 (1998), 125–60

——, 'La connoisseurship della scultura rinascimentale: esperienze e considerazioni di un "romanista" mancato', in *Il metodo del Conoscitore: Approcci, limiti, prospettive*, ed. by Stefan Albl with Alina Aggujaro (Rome: Artemide, 2016), pp. 125–52

Cameron, Averil, 'The Theotokos in Sixth-Century Constantinople', *Journal of Theological Studies*, NS 29 (1978), 79–108

——, 'The Virgin's Robe: An Episode in the History of Early Seventh-Century Constantinople', *Byzantion*, 49 (1979), 42–56

——, 'The History of the Image of Edessa: The Telling of a Story', in *Okeanos: Essays Presented to IHOR Sevchenko on his Sixtieth Birthday by his Colleagues and Students*, ed. by Cyril Mango and Omeljan Pritsak with the assistance of Uliana M. Pasicznyk, Harvard Ukrainian Studies, vol. VII (Cambridge, MA: Ukrainian Research Institute, Harvard University, 1983), pp. 80–94

——, 'The Mandylion and Byzantine Iconoclasm', in *The Holy Face and the Paradox of Representation*, ed. by Herbert L. Kessler and Gerhard Wolf, Villa Spelman Colloquia, vol. VI (Bologna: Buova Alfa Editoriale, 1998), pp. 33–54

Cannizzaro, Giovanna, 'La Chiesa di S. Sisto Vecchio', *Alma Roma*, 18 (1977), 34–38

Cannon, Joanna, 'Dominican Patronage of the Arts in Central Italy: The Provincia Romana, *c.* 1220–*c.* 1320' (unpublished doctoral thesis, University of London, 1980).

——, 'Simone Martini, the Dominicans and the Early Sienese Polyptych', *Journal of the Warburg and Courtauld Institutes*, 45 (1982), 69–93

——, 'Dominic "Alter Christus"? Representations of the Founder in and after the "Arca di San Domenico"', in *Christ among the Medieval Dominicans*, ed. by Kent Emery, Jr. and Joseph P. Wawrykow (Notre Dame: University of Notre Dame Press, 1998), pp. 26–48

——, *Religious Poverty, Visual Riches: Art in the Dominican Churches of Central Italy in the Thirteenth and Fourteenth Centuries* (New Haven: Yale University Press, 2013)

Caperna, Maurizio, *La basilica di S. Prassede: il significato della vicenda architettonica*, 3rd edn (Rome: Quasar, 2014)

Caracciolo, Irene, 'Il monastero di Sant Maria e San Gregorio: documenti e testimonianze artistiche dalle origini alla fine del Medioevo', in *Santa Maria in Campo Marzio dalle origini orientali alla Procura del Patriarchato di Antiochia dei Siri*, ed. by Marco Coppolaro (Rome: L'Erma di Bretschneider, 2021), pp. 1–37

Caraffa, Filippo, and Luigi Lotti, *S. Cosimato. L'Abbazia e la chiesa di Mica Aurea in Trastevere*, Monografie Romane, *Alma Roma*, 5 (Rome: Nardini 1971)

Carbonara, Giovanni, *Iussu Desiderii. Montecassino e l'architettura campano-Abbruzzese nell'XI secolo* (Rome: Bentivoglio, 2014)

Carbonetti Vendittelli, Cristina, 'Il registro di entrate e uscite del convento domenicano di San Sisto degli anni 1369–1381', in *Economia e Societa a Roma tra Medioevo e Rinascimento*, ed. by Anna Esposito and Luciano Palermo, Studi dedicati ad Arnold Esch (Rome: Viella, 2005), pp. 83–121

——, 'Il monastero romano di San Sisto nella seconda metà del XIV secolo: la comunità femminile e la gestione del suo patrimonio', *Reti Medievali Rivista*, 19.1 (2018), 371–401 <http://rivista.retimedievali.it> [accessed 27 Sept. 2021]

Cariboni, Guido, 'Domenico e la vita religiosa femminile. Tra realtà e finzione istituzionale' in *Domenico di Caleruega e la Nascita dell'Ordine dei Frati Predicatori*, ed. by Enrico Menesto, Atti del XLI Convegno Internazionale di Studi sull'Alto Medioevo, NS 18 (Spoleto: Fondazione Centro Italiano di Studi sull'Alto Medioevo, 2005), pp. 327–60

Carlotti, Paolo, 'Ripensare Trastevere disegnando San Cosimato', in *Nuovi Studi su San Cosimato*, ed. by Anna Maria Velli (Rome: Graphofeel Edizioni, 2017), pp. 117–39

Carocci, Sandro, *Baroni di Roma: Dominazioni Signorili e Lignaggi aristocratici nel Duecento e nel primo Trecento*, Istituto Storico per il Medio Evo, NS 23 and Collection École Française de Rome, 181 (Roma: Istituto Storico per il Medio Evo, 1993)

Carta, Marina, and Laura Russo, *Santa Maria in Aracoeli*, Le Chiese di Roma Illustrate, NS 22 (Rome: Istituto Nazionale di Studi Romani, Fratelli Palombi Editori, 1988)

Caruso, Antonio, *Santa Marcella* (Rome: Edizioni Vivere In, 2003)

Castagnoli, Ferdinando, *Topografia di Roma Antica* (Turin: Editrice Internazionale: 1980)

Catalogo delle opera principali, in *Il convento di Santa Sabina all'Aventino e il suo patrimonio storico-artistico e architettonico*, ed. by Manuela Gianandrea, Manuela Annibali, and Bartoni Laura (Rome: Campisano Editore, 2016), pp. 157–251

Cavallini, Giuliana, and Diega Giunta, *Luoghi cateriniani di Roma* (Rome: Centro Nazionale di Studi Cateriniani, 2000)

Cecchelli, Carlo, *I Crescenzi, i Savelli, i Cenci* (Rome: Reale Istituto di Studi Romani, 1942)

——, 'Note e documenti su chiese romane. San Cosimato', *Roma*, 21.2 (1943), 81–82

Cellini, Pico, 'Di Fra Guglielmo e di Arnolfo', series 4, 40 *Bollettino d'Arte*, 4.40 (1955), 215–29

——, 'Ricordi Normanni e Federiciani a Roma', *Paragone*, 81 (1956), 3–7

——, 'L'opera di Arnolfo all'Aracoeli', *Bollettino d'Arte*, 4.47 (1962), 180–95

——, *Tra Roma e Umbria: Studi e Ricerche sull'Arte* (Rome: Archivio Guido Izzi, 1996)

Centi, Timoteo, OP, 'Il culto di S. Caterina da Siena prima della canonizzazione', *S. Caterina da Siena*, 16.3 (1965), 17–22

Chastel, André, 'La Veronique', *Revue de l'Art*, 40/41 (1978), 71–82

Chenu, Marie Dominique, 'Monks, Canons, and Laymen in Search of the Apostolic Life', in *Nature, Man and Society in the Twelfth Century* (Chicago: University of Chicago Press, 1968), pp. 202–38

Chiabò, Myriam, Maurizio Gargano, and Rocco Ronzani, ed., *Santa Monica nell'Urbe, dalla tarda antichità al rinascimento. Storia, agiografia, arte*, Atti del convegno Ostia Antica-Roma, 27–30 settembre 2010 (Rome: Centro Culturale Agostiniano, 2011)

Chiaroni, Vincenzo, OP, 'Il Vasari e l'architetto Fra Ristoro da Campi costruttore della Chiesa di Santa Maria Novella in Firenze', *Studi Vasariani*, Atti del Convegno internazionale per il VI Centenario della prima edizione delle 'Vite' del Vasari, Firenze – Palazzo Strozzi, 16–19 settembre 1950 (Florence: Sansoni, 1950), pp. 140–43

Ciancio Rossetto, Paola, 'La "Passeggiata archeologica"', in *L'Archeologia in Roma Capitale tra sterro e Scavo* (Venice: Marsilio, 1983), pp. 75–88

Cirulli, Beatrice, 'Lippo Vanni: il trittico di Santa Aurea per i Santi Domenico e Sisto', in Serena Romano, *Apogeo e fine del Medioevo, 1288–1431*, Corpus, 6 (Milan: Jaca, 2017), pp. 329–30

——, 'Gli affreschi nella navata di San Sisto Vecchio', in *Apogeo e fine del Medioevo, 1288–1431*, ed. by Serena Romano, Corpus, 6 (Milan: Jaca, 2017), pp. 347–49

Claridge, Amanda, *Rome*, Oxford Archaeological Guides (Oxford: Oxford University Press, 1998)

Claussen, Peter Cornelius, *Magistri doctissimi romani: die römischen Marmorkünstler des Mittelalters*, Forschungen zur Kunstgeschichte und christlichen Archäologie, 14; Corpus Cosmatorum, I (Stuttgart: Steiner, 1987)

——, 'Renovatio Romae: Erneuerungsphasen römischer Architektur im 11. und 12. Jahrhundert', in *Rom in hohen Mittelalter*, ed. by Reinhard Elze (Sigmaringen: Thorbecke, 1992), pp. 87–125

Claussen, Peter Cornelius, Daniela Modini, and others, ed., *Die Kirchen der Stadt Rom im Mittelalter 1050–1300*, 4 vols, Forschungen zur Kunstgeschichte und christlichen Archäologie, 23, Corpus Cosmatorum, II (Stuttgart: Franz Steiner, 2002–2020)

Coarelli, Filippo, *Rome and Environs: An Archaeological Guide* (Los Angeles: University of California Press, 2007)

Coates-Stephens, Robert, *Immagini e Memoria: Rome in the Photographs of Father Peter Paul Mackey 1890–1901*, The British School at Rome Archive, 8 (London: The British School at Rome, 2009)

Coffin, David R., *Pirro Ligorio. The Renaissance Artist, Architect, and Antiquarian* (University Park: Pennsylvania State University Press, 2004)

Cooper, Donal, 'Franciscan Choir Enclosures and the Function of Double-Sided Altarpieces in Pre-Tridentine Umbria', *Journal of the Warburg and Courtauld Institutes*, 64 (2001), 1–54

——, 'Access All Areas? Spatial Divides in the Mendicant Churches of Late Medieval Tuscany', in *Ritual and Space in the Middle Ages: Proceedings of the 2009 Harlaxton Symposium*, ed. by Frances Andrews, Harlaxton Medieval Studies, 21 (Donington: Shaun Tyas, 2011), pp. 90–107

Cooper, Donal, and Janet Robson, *The Making of Assisi: The Pope, the Franciscans and the Painting of the Basilica* (New Haven: Yale University Press, 2013)

Coppolaro, Marco, ed., *Santa Maria in Campo Marzio dalle origini orientali alla Procura del Patriarchato di Antiochia dei Siri* (Rome: L'Erma di Bretschneider, 2021)

Cosentino, Augusto, 'Il battesimo a Roma: edifice e liturgia', in *Ecclesiae Urbis*. Atti del Convegno internazionale di studi sulle chiese di Roma, Roma 4–10 settembre 2000 ed. by Federico Guidobaldi and Alessandra Guiglia Guidobaldi (Vatican City: Pontificio Istituto di Archeologia Cristiana, 2002), pp. 109–42

Costen, Michael, *The Cathars and the Albigensian Crusade* (Manchester: Manchester University Press, 1997)

Creytens, Raymond, OP, 'Les Constitutions Primitives des Soeurs Dominicaines de Montargis (1250)', *AFP*, 17 (1947), 41–84

——, 'Les constitutions des Frères Prêcheurs dans la rédaction de S. Raymond de Peñafort (1241)' *AFP*, 18 (1948), 29–68

——, 'Les convers des Moniales dominicaines au moyen âge', *AFP*, 19 (1949), 5–48

Cristofaro, Alessio, Marzia Di Mento, and Daniela Rossi, 'Coraria Septimiana et Campus Iudeorum', *Thiasos*, 6 (2017), pp. 3–39

Crowe, Joseph A., and G. B. Cavalcaselle, *A History of Painting in Italy*, 6 vols (London: Murray, 1903)

Cutarelli, Silvia, *Il complesso di San Saba sell'Aventino: Architettura e sedimentazioni di un monumento medievale*, Percorsi Città e Architettura nel tempo (Rome: Edizioni Quasar, 2019)

D'Amato, Alfonso, and others, *Le reliquie di S. Domenico. Storia e leggenda, ricerche scientifiche, ricostruzione fisica* (Bologna: Tipografia L. Parma, 1946)

Darsy, Felix, OP, 'Zone di sepolture dall'alto Medioevo in Santa Sabina', *Rivista di Archeologia Cristiana*, 25 (1948), 198–99

——, 'Sabine (Basilique de Sainte)', in *Dictionnaire d'Archéologie Chrétienne et de Liturgie*, ed. by Henri Irénée Marrou, vol. XV (Paris: Letouzey, 1950), pp. 218–38

——, 'Stratigraphie générale de la Zone archéologique de Sainte Sabine sur l'Aventin', in *Mélanges en honneur de Monseigneur Michel Andrieu* (Strasbourg: Palais Universitaire, 1956), pp. 113–26

——, 'Les Portes de Sainte Sabine dans l'archéologie et l'iconographie générale du monument', in *Actes du Ve Congrès Internationale d'Archeologie Chrétienne*, Aix-en-Provence, 13–19 septembre 1954 (Paris: Société d'Éditions 'Les Belles-Lettres', 1957), pp. 471–85

——, *Santa Sabina*, Le Chiese di Roma Illustrate, 63–64 (Rome: Edizioni 'Roma' – Marietti, 1961)

——, *Recherches archéologiques à Sainte-Sabine*, Monumenti dell'antichità cristiana, series II, 9 (Vatican City: Pontificio Istituto di Archeologia Crstiana, 1968)

Davidsohn, Robert, *Forschungen zur Geschichte von Florenz*, 2 vols (Berlin: Mittler, 1901 and 1908)

de Blaauw, Sible, 'A Mediaeval Portico at San Giovanni in Laterano: The Basilica and its Ancient Conventual Building', *PBSR*, 58 (1990), 299–316

——, 'Klokken supra Urbem. Over klokgelui in middeleeuws Rome', in *Terugstrevend naar ginds: de wereld van Helene Nolthenius*, ed. by E. Melder (Nijmegen: Sun, 1990), pp. 111–42 [Italian translation: 'Campane supra Urbem: Sull'uso delle campane nella Roma medievale', *Rivista di storia della Chiesa in Italia*, 47 (1993), 367–414]

——, 'The Lateran and Vatican Altar Dispositions in Medieval Roman Church Interiors: A Case of Models in Church Planning', in *Cinquante années d'études médiévales: à la confluence de nos disciplines*, Actes du Colloque organisé à l'occasion du cinquantenaire du CESM, Poitiers, 1–4 septembre 2003, ed. by Claude Arrignon, Marie-Hélène Debiès, Claude Galderisi, and Eric Palazzo (Turnhout: Brepols, 2005), pp. 201–17

——, 'Arnolfo's High Altar Ciboria and Roman Liturgical Traditions', in *Arnolfo's Moment: Acts of an International Conference*, ed. by David Freedman, Julian Gardner, and Margaret Haines, Villa I Tatti Studies, 23 (Florence: Olschki, 2009), pp. 123–41

——, 'Origins and Early Developments of the Choir', in *La Place du choeur: architecture et liturgie du Moyen Age au temps modern*, ed. by Sabine Frommel and Laurent Lecomte, Actes du colloque de l'EPHE, Insitut National de l'Histoire de l'Art, les 10 et 11 décembre 2007 (Paris: Picard, 2012), pp. 25–32

——, 'Liturgical Features of Roman Churches: Manifestations of the Church of Rome', in *Chiese locali e chiese regionali nell'alto medioevo*, Settimane di Studio della Fondazione Centro Italiano di studi sull'alto medioevo, LXI (Spoleto: Fondazione Centro Italiano di studi sull'alto medioevo, 2014), pp. 321–37

de Castris, Pierluigi Leone, 'Montano d'Arezzo a S. Lorenzo', in *Le chiese di San Lorenzo e San Domenico: Gli ordini mendicanti a Napoli*. Atti della Giornata di Studi su Napoli, Losanna, 13 dicembre 2001, ed. by Serena Romano and Nicholas Bock, Études lausannoises d'histoire de l'art, 3 (Naples: Electa, 2005), pp. 95–125

de Crescenzo, Patrizia, and Antonio Scaramella, *La Chiesa di San Lorenzo in Panisperna sul colle Viminale* (Rome: Istituto Poligrafico e Zecca dello Stato, 1998)

de Gregori, Luigi, 'Il chiostro della Minerva e le "*Meditationes*" del Card. Turrecremata', in *Le onoranze a S. Caterina da Siena nella R. Biblioteca Casanatense* (Rome: Cuggiani, 1940), pp. 29–54

Degni, Paola, and Pier Luigi Porzio, ed., *La Fabbrica del Convento: Memorie storiche, Trasformazioni e recupero del complesso di San Francesco a Ripa in Trastevere* (Rome: Donzelli Editore, 2011)

Delaney, John J., *Dictionary of Saints*, 2nd edn (New York: Doubleday, 2005)

Dell'Adolorata, Stanislao, *La Cappella papale di Sancta Sanctorum ed i suoi sacri tesori, l'imagine acheropita e la Scala Santa* (Grottaferrata: Tipografia Italo-Orientale 'S. Nilo', 1919)

Del Vasto, Antonio, OFM, *Church of S. Francis of Assisi a Ripa Grande and its Saints, Historical Artistic Guide*, Supplement of *Frattini di S. Antonio* (Genoa: Marconi, 2009)

de Marchi, Andrea, ed., *Santa Maria Novella: La Basilica e il Convento*, 3 vols, Banca Cassa di Risparmio Firenze (Florence: Mandragora, 2015–2016)

Demus, Otto, *The Mosaics of San Marco*, 4 vols (Chicago: University of Chicago Press, 1984)

Dereine, Charles, SJ, 'Le premier Ordo de Prémontré', *Revue Benedictine*, 58 (1948), 84–92

Descemet, Charles, *Mémoire sur les fouilles exécutées à Santa Sabina (1855–1857) par M. Descemet, correspondant de l'Institut archéologique de Rome* (Rome: Institut archéologique, 1857)

Di Bello, Cinzia, 'Item n. 154', in *Bonifacio VIII e il suo tempo, Anno 1300: il primo Giubileo*, Catalogue of the exhibition at Rome, Palazzo Venezia, ed. by Marina Righetti Tosti-Croce (Milan: Electa, 2000), pp. 199–200

Dieck, Margarete, *Die Spanische Kapelle in Florenz. Das trecenteske Bildprogramm des Kapitelsaals der Dominikaner von S. Maria Novella*, Europäische Hochschulschriften, Kunstgeschichte, 298 (Frankfurt-am-Main: Lang, 1997)

Diez, Ernst, and Otto Demus, *Byzantine Mosaics in Greece* (Cambridge, MA: Harvard University Press, 1931)

Di Gioia, Vincenzo, 'Il quartiere moderno dell'Aventino. Dal primo insediamento all'assetto attuale', *Studi Romani*, 43 (1995), 297–319

——, *L'Aventino: un colle classico tra antico e moderno* (Rome: Istituto poligrafico e Zecca dello Stato, Libreria dello Stato, 2004)

Dimier, Anselme, *Receuil de plans d'églises cisterciennes*, 4 vols (Paris: Vincent, Fréal et Cie, 1949)

di Rocca di Papa, Andrea, *Memorie storiche della chiesa e monastero di S. Lorenzo in Panisperna*, (Rome: Editrice Romana, 1893)

Dizionario degli Istituti di Perfezione, ed. by Guerrino Peliccia and Giancarlo Rocca, 10 vols, vol. IV (Rome: Ed. Paoline, 1977)

Dodsworth, Barbara W., 'Dominican patronage and the Arca di S. Domenico', in *Verrocchio and Late Quattrocento Italian Sculpture*, ed. by S. Bule, A. Phipps Darr, and F. Superbi Goffredi (Florence: Casa Editrice Le Lettere, 1992), pp. 283–90

——, *The Arca of S. Domenico*, Intercultural Studies, 2 (New York: Lang, 1995)

Domenico di Caleruega e la Nascita dell'Ordine dei Frati Predicatori, ed. by Enrico Menesto, Atti del XLI Convegno Internazionale di Studi sull'Alto Medioevo, Nuova Serie, 18 (Spoleto: Fondazione Centro Italiano di Studi sull'Alto Medioevo, 2005)

Donati, Lamberto, 'Santa Caterina da Siena nelle stampe del'400. Appunti iconografici', *Studi Cateriniani*, 1 (1924), 1–27

——, 'L'antico chiostro della Minerva ed il primo libro illustrato italiano', *Strenna deo Romanisti*, 30 (1969), 156–61

Donin, Richard Kurt, *Die Bettelordenskirchen in Österreich* (Baden bei Wien: Rohrer, 1935)

D'Onofrio, Cesare, *Renovatio Romae. Storia e urbanistica dal Campidoglio all'EUR* (Rome: Edizioni Mediterranee, 1973)

Draghi, Andreina, *Gli affreschi dell'Aula Gotica nel Monastero dei Santi Quattro Coronati. Una storia ritrovata* (Milan: Skira, 2006)

——, *Il Palazzo cardinalizio dei Santi Quattro a Roma: I dipinti duecenteschi* (Milan: Skira, 2012)

Drane, Augusta Theodosia, *The History of Saint Catherine of Siena and her Companions* (London: Burns and Oates, 1880)

Drijvers, Han J. W., 'The Image of Edessa in the Syriac Tradition', in *The Holy Face and the Paradox of Representation*, ed. by Herbert L. Kessler and Gerhard Wolf, Villa Spelman Colloquia, vol. VI (Bologna: Nuova Alfa Editoriale, 1998), pp. 13–31

Droandi, Isabella, 'Per la pittura del Duecento nell'Aretino', in *Arte in Terra d'Arezzo: Il Medioevo*, ed. by Marco Collareta and Paola Refice (Florence: SISMEL, 2010), pp. 195–97

Du Cange, Charles du Fresne, Sieur de, *Glossarium mediae et infimae Latinitatis*, 5 vols (repr. Graz: Akademische Druck und Verlagsanstalt, 1954)

Duchesne, Louis, 'Notes sur la topographie de Rome au moyen-age', *Mélanges d'Archéologie et d'Histoire de l'Ecole Francaise de Rome*, 10 (1890), 225–50

Dunlop, Anne, '*Advocata Nostra*: Central Italian Paintings of Mary as the Second Eve' (unpublished doctoral thesis, University of Warwick, 1997)

——, 'Flesh and the Feminine: Early Renaissance Images of the Madonna with Eve at her Feet', *Oxford Art Journal*, 25.2 (2002), 127–48

——, 'The Dominicans and Cloistered Women: The Convent of Sant'Aurea in Rome', *Early Modern Women*, 2 (2007), 43–71

Duval, Sylvie, 'Chiara Gambacorta e le prime Monache del monastero di San Domenico di Pisa: l'Osservanza domenicana al femminile', in *Il Velo, la Penna e la Parola. Le Domenicane: storia, istituzioni e scritture*, ed. by Gabriella Zara and Gianni Festa, Biblioteca di Memorie Domenicane (Florence: Nerbini, 2009), pp. 93–112

——, 'Comme les anges sur la terre'. Les moniales dominicaines et les débuts de la réforme observante (1385–1461), Bibliothèque des écoles françaises d'Athènes et de Rome, 366 (Rome: École Française de Rome, 2015)

Egger, Hermann, *Römische Veduten: Handzeichnungen aus dem XV.–XVIII. Jahrhundert zur Topographie der Stadt Rom*, 2 vols (Vienna: Schroll, 1931–1932)

Elkins, Sharon K., *Holy Women in Twelfth-Century England* (Chapel Hill: University of North Carolina Press, 1988)

Encyclopedia dei Papi, ed. by M. Bray, vol. II (Rome: Istituto Enciclopedi Italiana, 2000)

Episcopo, Silvana, 'Il battistero della basilica di S. Marcello a Roma fra tarda Antichità e Medioevo', in *Tardo Antichità e alto Medioevo. Filologia, Storia, Archeologia, Arte*, Atti delle giornate sull'età romanobarbarica, Napoli, 17–18 novembre 2000 e 29 settembre–1 ottobre 2003, ed. by Marcello Rotili (Naples: Arte Tipografia, 2009), pp. 235–306

Ermini Pani, Letizia, and Carlo Travaglini, ed., *Trastevere: un'analisi di lungo periodo*, Convegno di Studi, Roma, 13–14 marzo, 2008, Miscellanea della Società Romana Storia Patria, 55 (Rome: Società Romana Storia Patria alla Biblioteca Vallicelliana, 2010)

Esch, Arnold, 'Tre sante ed il loro ambiente sociale a Roma: S. Francesca Romana, S. Brigida di Svezia e S. Caterina da Siena', in *Atti del simposiio internazionale Cateriniano-Bernardiniano*, Siena, 17–20 Aprile 1980, ed. by Domenico Maffei and Paolo Nardi, Accademia Senese degli Intronati (Siena: Mori, 1982), pp. 89–120

Esposito, Anna, 'I gruppi bizzocali a Roma nel '400 e le *sorores de poenitentia* agostiniane', in *S. Monica nell'Urbe: dalla tarda Antichità al Rinascimento*, Atti del convegno Ostia Antica-Roma, 29–30 Settembre 2010, ed. by Maria Chiabò (Rome: Roma nel Rinascimento, 2011), pp. 157–188

Esposito, Daniela, *Techniche costruttive murarie medievali: murature 'a tufello' in area romana*, Storia della tecnica edilizia e restauro dei monumenti, 2 (Rome: L'Erma' di Bretschneider, 1998)

Eubel, Konrad, *Hierarchia catholica medii aevii*, 4 vols (Regensburg: Monasterii, 1913)

Falco, Giorgio, 'Il catalogo di Torino delle chiese, degli ospedali, dei monasteri di Roma nel secolo XIV', *Archivio della Società Romana di Storia Patria*, 32 (1909), pp. 411–43

Falcucci, Claudio, Giorgio Leone, and Flavia Scarperia, 'Sulla tavola medievale di San Francesco a Ripa Grande in Roma: fonti, critica, diagnostica e la scoperta di una nuova "firma" di Margarito d'Arezzo', *Collectanea Francescana*, 84 (2014), 277–342

Fallica, Salvatore, 'Intervento di Mauro Fontana nella chiesa di San Lorenzo in Panisperna a Roma', *Studi Romani*, 56 (2008), 262–75

——, 'Sviluppo e trasformazione della chiesa e del monastero di S. Lorenzo in Panisperna a Roma', *Studi Romani*, 62 (2014), 117–48

Farmer, David Hugh, *Oxford Dictionary of Saints* (Oxford: Oxford University Press, 2004)

Fenning, Hugh, 'SS. Sisto and Clemente: 1677–1797', in Leonard E. Boyle, OP, *The Community of SS. Sisto e Clemente in Rome 1677–1977* (Rome: Apud S. Clemente, 1977), pp. 27–58

Fentress, Elizabeth, Caroline J. Goodson, Margaret L. Laid, and Stephanie C. Leonie, ed., *Walls and Memory: The Abbey of San Sebastiano at Alatri (Lazio) from Late Roman Monastery to Renaissance Villa and Beyond*, Disciplina Monastica. Studies on Medieval Monastic Life (Turnhout: Brepols, 2005)

Feret, Henri-Marie, OP, 'Les armoiries en blason de l'Ordre des Frères Prêcheurs', *Memorie Domenicane*, 29 (2012), 33–45

Ferrari, Guy, *Early Roman Monasteries: Notes for the History of the Monasteries and Convents at Rome from the V through the X Century*, Studi di Antichità Cristiana, 23 (Vatican City: Pontificia Istituto di Archeologia Cristiana, 1957)

Ferreiro, Alberto, 'Simon Magus and Simon Peter in Medieval Irish and English Legends', in *La figurar di San Pietro nelle Fonti del Medioevo*, ed. by Loredana Lazzari and Anna Valenti Bacci, Atti del Convegno tenutosi in occasione della Studiosum universitatum docentium congressus, Textes et études du Moyen Age, 17 (Louvain-la-neuve: Féderation Internationale des Instituts d'Études, 2001), pp. 112–32

——, *Simon Magus in Patristic, Medieval, and Early Modern Traditions*, Studies in the History of Christian Traditions, 125 (Leiden: Brill, 2005)

Ferri, Pasquale Nerino, *Indice grafico ed analitico dei disegni di architettura civile e militare esistenti nella R. Galleria degli Uffizi*, Ministero della Publica Istruzione, 3 (Rome: Press i principali Librai, 1885)

Field, Sean L., 'Douceline of Digne and Isabelle of France', in *Franciscan Women: Female Identities and Religious Culture Medieval and Beyond*, ed. by Lezlie Knox and David B. Couturier (Saint Bonaventure, NY: Franciscan Institute, Bonaventure University, 2020), pp. 83–98

Fleck, Cathleen A., '"Blessed Are the Eyes That See Those Things You See": The Trecento Choir Frescoes at Santa Maria Donnaregina in Naples', *Zeitschrift für Kunstgeschichte*, 67.2 (2004), 201–24

Foletti, Ivan, 'La porta di Santa Sabina, un'immagine in dialogo con il culto', in *Zona liminare: Il nartece di Santa Sabina a Roma, la sua porta e L'Iniziazzione cristiana*, ed. by Ivan Foletti and Manuela Gianandrea, Studia Artium Medievalium Brunensia, 3 (Rome: Viella e Masaryk University, 2015), pp. 95–199

——, 'The Doors of S. Sabina: Between Stational Liturgy and Initiation', in *The Fifth Century in Rome: Art, Liturgy, and Patronage*, ed. by Ivan Folletti and Manuela Gianandrea, Studia Artium Medievalium Brunensia, 4 (Rome: Viella, 2017), pp. 121–32

Foletti, Ivan, and Manuela Gianandrea, 'Il nartece, la sua funzione e le sue decorazioni', in *Zona liminare: Il nartece di Santa Sabina a Roma, la sua porta e L'Iniziazzione cristiana*, Studia Artium Medievalium Brunensia, 3 (Rome: Viella e Masaryk University, 2015), pp. 33–93

Foletti, Ivan, and Manuela Gianandrea, *Zona liminare: Il nartece di Santa Sabina a Roma, la sua porta e L'Iniziazione cristiana*, Studia Artium Medievalium Brunensia, 3 (Rome: Viella e Masaryk University, 2015)

Foletti, Ivan, and Manuela Gianandrea, ed., *The Fifth Century in Rome: Art, Liturgy, and Patronage*, Studia Artium Medievalium Brunensia, 4 (Rome: Viella, 2017)

Fontana, Giacomo, *Raccolta delle migliori chiese di Roma e Suburbane*, 4 vols (Rome: Tip. di Giovanni Battista Marini, 1838)

Fontana, Vincenzo Maria, OP, *De romana provincia Ordinis Praedicatorum* (Rome: N. A. Tinassij, 1670)

Forte, Stefano L., 'Il cardinale Matteo Orsini e il suo testamento', *AFP*, 37 (1967), 228–62

Freuler, Gaudenz, 'Andrea di Bartolo, Fra Tommaso d'Antonio Caffarini, and Sienese Dominicans in Venice', *Art Bulletin*, 69 (1987), 570–86

Freedman, David, Julian Gardner, and Margaret Haines, ed., *Arnolfo's Moment: Acts of an International Conference* (Florence: Olschki, 2009)

Frommel, Christoph Luitpold, '"Capella Iulia": Die Grabkapelle Papst Julius II in Neu-St Peter', *Zeitschrift für Kunstgeschichte*, 40 (1977), 26–62

——, 'Jacobo Gallo als Förderer der Künste…', in *Kotinos*, ed. by Heide Froning, Tonio Hölscher, and Harald Mielsch (Mainz: von Zabern, 1992), pp. 450–60

——, *Architettura alla Corte Papale nel Rinascimento* (Milan: Electa, 2003)

Frommel, Christoph Luitpold, and Nicholas Adams, ed., *Drawings of Antonio Sangallo the Younger and his Circle*, with coordination by Christoph Jobst, 2 vols, The Architectural History Foundation New York (Cambridge, MA: MIT, 1994 and 2000)

Frutaz, Amato P., *Le Piante di Roma*, 3 vols (Rome: Istituto di Studi Romani, 1962)

Gagliardi, Isabella, 'Caterina Madre dell'Osservanza domenicana e prima diffusione del movimento riformatore', in *Università, teologia e studium domenicano, dal 1360 alla fine del Medioevo*, ed. by Roberto Lambertini, Atti del Convegno di studi, 21–23 ottobre 2011 (Bologna: Nerbini, 2014), pp. 123–35

Gaglione, Mario, 'Sancia d'Aragone-Maiorca tra impegno di governo e "attivismo" francescano', *Studi storici: rivista trimestrale dell'Istituto Gramsci*, 4 (2008), 931–85

——, 'Dai primordi del Francescanesimo femminile a Napoli fino agli statute per il Monastero di S. Chiara', in *La Chiesa e il Convento di Santa Chiara: Committenza artistica, vita religiosa e progettualità politica nella Napoli di Roberto d'Angiò e Sancia di Maiorca*, Centro Interuniversitario per la Storia delle Città Campane nel medioevo – Quaderni, 6 (Battipaglia: Vegliacarlone, 2014), pp. 27–118

Galbraith, Georgina R., *The Constitution of the Dominican Order, 1216–1360*, Publications of the University of Manchester, 170 (Manchester: Manchester University Press, 1925)

Gallavotti Cavallero, Daniela, *Rione XXI, San Saba*, Guide Rionale di Roma (Rome: Palombi, 1989)

Gardner, Julian, 'Pope Nicholas IV and the Decoration of Santa Maria Maggiore', *Zeitschrift für Kunstgeschichte*, 36 (1973), 1–50

——, 'Andrea di Bonaiuto and the Chapterhouse Frescoes in S. Maria Novella', *Art History*, 2 (1979), 107–38

——, 'The Louvre Stigmatization and the Problem of the Narrative Altarpiece', *Zeitschrift für Kunstgeschichte*, 45 (1982), 217–47

——, 'Päpstliche Träume und Palastmalereien', in *Träume im Mittelalter: Ikonologische Studien*, ed. by Agostino Paravicini Bagliani and Giorgio Stabile (Stuttgart: Belser, 1989), pp. 113–24

——, 'Patterns of Papal Patronage *circa* 1260–*circa* 1300', in *The Religious Roles of the Papacy: Ideals and Realities, 1130–1300*, ed. by Christopher Ryan, Papers in Mediaeval Studies, 8 (Toronto: Pontifical Institute of Mediaeval Studies, 1989), pp. 439–56

——, *The Tomb and the Tiara: Curial Tomb Sculpture in Rome and Avignon in the Later Middle Ages*, Clarendon Studies in the History of Art (Oxford: Clarendon Press, 1992)

——, 'L'architettura del Sancta Sanctorum', in *Sancta Sanctorum*, ed. by Carlo Pietrangeli (Milan: Electa, 1995), pp. 19–37

——, 'Nuns and Altarpieces: Agendas for Research', *Römisches Jahrbuch der Bibliotheca Hertziana*, 30 (1995), 27–57

——, 'Arnolfo di Cambio: From Rome to Florence', in *Arnolfo's Moment: Acts of an International Conference*, ed. by David Freedman, Julian Gardner, and Margaret Haines (Florence: Olschki, 2009), pp. 141–57

——, *The Roman Crucible: The Artistic Patronage of the Papacy, 1198–1304*, Römische Forschungen der Bibliotheca Hertziana, 33 (Munich: Hirmer, 2013)

Gardner von Teuffel, Christa, 'Ikonographie und Archäologie: das Pfingsttriptychon in der Florentiner Akademie an seinem ursprünglichen Aufstellungsort', *Zeitschrift für Kunstgeschichte*, 41 (1978), 16–40

Garms, Jörg, and others, ed., *Die mittelalterlichen Grabmäler in Rom und Latium vom 13. bis zum 15. Jahrhundert. 1. Band: Die Monumentalengräber*, Publikationen des Oesterreichischen Kulturinstituts in Rom, 5 (Vienna: Österreichische Akademie der Wissenschaften, 1994)

Gatti, G., 'Della Mica Aurea in Trastevere', *Bullettino della Commissione archeologica comunale di Roma*, serie 3 (1889), pp. 367–99

——, Report in *Notizie degli Scavi*, 1892, pp. 265–66, 315–16, 348

——, Report in *Notizie degli Scavi*, 1894, pp. p. 279

Gatto, Ludovico, 'La Roma di Caterina', in *La Roma di Caterina da Siena*, ed. by Maria Grazia Bianco, Quaderni della Libera Università 'Maria Assunta' LUMSA – Roma, 18 (Rome: Edizioni Studium, 2001), pp. 13–48

Gaynor, Juan Santos, and Toesca, Ilaria, *S. Silvestro in Capite*, Le Chiese di Roma Illustrate (Rome: Marietti, 1964)

Geertman, Hermann, 'Ricerche sopra la prima fase di San Sisto Vecchio in Roma', *Rendiconti della Pontificia Accademia Romana di Archeologia*, 41 (1968–1969), 219–28

——, *More Veterum*, Archeologica Traectina edita AB – Academiae Rheno-Traectinae Instituto Archeologico, 10 (Groningen: H. D. Tjeenk Willink, 1975)

——, 'Titulus Sancti Sixti', in Herman Geertman, *Hic fecit Basilicam: studi sul Liber Pontificalis e gli edifice ecclesiastici di Roma da Silvestro a Silverio*, ed. by Sible de Blaauw (Leuven: Peeters, 2004), pp. 127–32

Geertman, Herman, and M. Beatrice Annis, 'San Sisto Vecchio: Indagini topografiche e archeologiche', in *Roma dall'Antichità al medioevo II: contesti tardoantichi e altomedioevali*, ed. by Lidia Paroli and Laura Vendittelli (Milan: Electa, 2004), pp. 517–41

Geiger, Gail, *Filippino Lippi's Carafa Chapel: Renaissance Art in Rome* (Kirksville, MO: Sixteenth Century Journal Publishers, Inc., 1986)

Genovesi, Franco, 'La zona di Porta Capena sull'Appia', in *San Domenico e il monastero di San Sisto all'Appia*, ed. by Raimondo Spiazzi, OP (Bologna: Edizioni Studio Domenicano, 1993), pp. 11–48

——, 'Un nuovo capitolo nella storia di San Sisto', in *San Domenico e il monastero di San Sisto all'Appia*, ed. by Raimondo Spiazzi, OP (Bologna: Edizioni Studio Domenicano, 1993), pp. 661–79

Gentilini, Giancarlo, 'La Madonna di Santa Caterina. Il contributo di Donatello al sepolcro cateriniano della Minerva', in *Siena e Roma: Raffaello, Caravaggio e i protagonist di un legame antico* (Siena: Protagon Editori, 2005), pp. 472–93

Ghilardi, Massimiliano, 'L'area meridionale della Regio XIV Transtiberim in età romana: storia degli scavi e cenni di inquadramento topografico', in *S. Maria dell'Orto: Il complesso architettonico trasteverino. Studi. Progetti. Restauri*, ed. by Michele Funghi and Williams Troiano (Rome: dei Merangoli Editrice, 2015), pp. 3–14

Gianandrea, Manuela, 'Note sul perduto arredo liturgico di Santa Sabina all'Aventino nel corso del medioevo', *Rivista dell'Istituto nazionale d'archeologia e storia dell'arte*, 66 (2011), 151–64

——, 'Un'inedita committenza nella Chiesa romana di Santa Sabina all'Aventino: il dipinto altomedioevale con la *Vergine e il Bambino, santi e donatori*', in *Medioevo: I committenti*, Atti del Congresso internazionale di studi, Parma, 21–26 settembre 2010, ed. by Arturo Carlo Quintavalle (Milan: Electa, 2011), pp. 399–410

——, 'Nel lusso della tradizione. L'inedita decorazione del nartece di Santa Sabina all'Aventino (Il nartece di Santa Sabina, 1), *Hortus Artium Medievalium*, 20.2 (2014), 700–08

——, 'Politica delle immagini al tempo di Papa Costantino (708–15): Roma *versus* Bisanzio?' in *L'officina dello sguardo. Scritti in onore di Maria Andaloro. I luoghi dell'arte. Immane, memoria, materia*, ed. by Giulia Bordi and others, 2 vols (Roma: Gangemi, 2014), vol. I, pp. 335–42

——, 'Il nartece e il cortile dell'arancio tra passato e presente: lettura di un palinsesto complesso', in *Zona liminare: Il nartece di Santa Sabina a Roma, la sua porta e L'Iniziazzione cristiana*, ed. by Ivan Foletti and Manuela Gianandrea, Studia Artium Medievalium Brunensia, 3 (Rome: Viella and Masaryk University, 2015), pp. 39–85

——, 'Archeologia del monumento, fonti testuali e immagini storiche. Per una rilettura della fase medievale del convento domenicano di Santa Sabina all'Aventino', in *Il convento di Santa Sabina all'Aventino e il suo patrimonio storico-artistico e architettonico*, ed. by Manuela Gianandrea, Manuela Annibali, and Bartoni Laura (Rome: Campisano Editore, 2016), pp. 21–42

——, 'Il giardino dell'Arancio di san Domenico, Vicende di un complesso palinsesto archeologico, storico-artistico e semantico', in *Il convento di Santa Sabina all'Aventino e il suo patrimonio storico-artistico e architettonico*, ed. by Manuela Gianandrea, Manuela Annibali, and Bartoni Laura (Rome: Campisano Editore, 2016), pp. 95–106

——, 'Un'apparente arcaicità: il chiostro medievale di Santa Sabina all'Aventino', in *Il convento di Santa Sabina all'Aventino e il suo patrimonio storico-artistico e architettonico*, ed. by Manuela Gianandrea, Manuela Annibali, and Bartoni Laura (Rome: Campisano Editore, 2016), pp. 75–88

——, 'Real and Fake Marble on the Antique Façade of S. Sabina all'Acentino, Rome', in *The Fifth Century in Rome: Art, Liturgy, and Patronage*, ed. by Ivan Foletti and Manuela Gianandrea, Studia Artium Medievalium Brunensia, 4 (Rome: Viella, 2017), pp. 31–37

Gianandrea, Manuela, Manuela Annibali, and Laura Bartoni, ed., *Il convento di Santa Sabina all'Aventino e il suo patrimonio storico-artistico e architettonico* (Rome: Campisano Editore, 2016)

Giesser, Valentine, 'Il mosaic del monumento di Guillaume Durand in Santa Maria sopra Minerva', in Serena Romano, *Apogeo e fine del Medioevo, 1288–1431*, Corpus, 6 (Milan: Jaca, 2017), pp. 198–99

Gigli, Laura, *Rione XII. Trastevere*, parte quinta, Guide Rionali di Roma, 12 (Rome: Fratelli Palombi Editori, 1987)

——, *San Marcello al Corso*, Le Chiese di Roma Illustrate, n. s., 29 (Rome: Istituto Nazionale di Studi Romani-Palombi, 1996)

Gigli, Laura, and Marco Setti, 'Il restauro del portale di San Cosimato', in *'San Chosm' e Damiano e 'l suo bel monasterio …': o; complesso mounmentale di San Cosimato ieri, oggi domani*, ed. by Gemma Guerrini Ferri and Joan Barclay Lloyd with Anna Maria Velli, Quaderni di TestoeSenso, 1/2013 (Rome: TestoeSenso Università Tor Vergata, 2013), pp. 187–97

Gigli, Laura, and Marco Setti, 'Il restauro della fontana nel giardino del Monastero di San Cosimato in Mica Aurea e le basi per un primo repertorio delle fonti idriche', in *'San Chosm' e Damiano e 'l suo bel monasterio …': il; complesso mounmentale di San Cosimato ieri, oggi domani*, ed. by Gemma Guerrini Ferri and Joan Barclay Lloyd with Anna Maria Velli, Quaderni di TestoeSenso, 1/2013 (Rome: TestoeSenso Università Tor Vergata, 2013), pp. 199–208

Gilardi, Costantino G., OP, '"Ecclesia laicorum" e "ecclesia fratrum": luoghi e oggetti per il culto e la predicazione secondo "l'ecclesiasticum officium" dei fratri predicatori', in *Aux Origines de la 'Liturgie dominicaine'*, ed. by Leonard Boyle and Pierre-Marie Gy (Rome: Ecole française de Rome, 2004), pp. 379–443

Gilchrist, Roberta, *Gender and Material Culture: The Archaeology of Religious Houses* (London: Routledge, 1994)

Gill, Meredith, '"Remember Me at the Altar of the Lord": Saint Monica's Gift to Rome', in *Augustine in Iconography, History, and Legend*, ed. by J. C. Schnaubelt and F. van Fleteren, Collectanea Augustiniana, 4 (New York: P. Lang, 1999), pp. 549–76

Giovannoni, Gustavo, *Antonio da Sangallo il Giovane*, 2 vols (Rome: Tipografia regionale, 1959)

Giunta, Diega, 'La prima processione con la reliquia della testa di S. Caterina: tradizione, storia, iconografia', *Quaderni del Centro nazionale di Studi Cateriniani*, 1 (1986), 119–38

——, 'Santa Caterina da Siena pellegrina a "Santo Pietro"', in *Luoghi cateriniani di Roma*, ed. by Giuliana Cavallini and Diega Giunta (Rome: Centro Nazionale di Studi Cateriniani, 2000), pp. 43–64

Gleeson, Philip, OP, 'Dominican Liturgical Manuscripts from before 1259', *AFP*, 42 (1972), 81–135

Goergen, Donald J., OP, *St Dominic. The Story of a Preaching Friar* (New York: Paulist, 2016)

Golding, Brian, 'St Bernard and St Gilbert', in *The Influence of Saint Bernard: Anglican Essays*, ed. by Benedicta Ward (Oxford: SLG, 1976), pp. 41–52

——, *Gilbert of Sempringham and the Gilbertine Order* (Oxford: Clarendon Press, 1995)

Golzio, Vincenzo, and Giuseppe Zander, *Le chiese di Roma dall'XI al XVI secolo* (Bologna: Cappelli Editore, 1963)

Gomez-Moreno, Carmen, Arthur K. Wheelock Jr., Elizabeth H. Jones, and Millard Meiss, 'A Sienese St Dominic Modernized Twice in the Thirteenth Century' *Art Bulletin*, 51 (1969), 363–73

Gordon, Dillian, 'A Dossal by Giotto and His Workshop: Some Problems of Attribution, Provenance and Patronage', *Burlington Magazine*, 131.1037 (August 1989), 524–31

Grabar, André, *La Sainte Face de Laon. Le mandylion dans l'art orthodoxe* (Prague: Seminarium Kondakovianum, 1931)

Graef, Hilda, *Mary: A History of Doctrine and Devotion*, with a new chapter by Thomas A. Thompson, SM (Notre Dame, IN: Ave Maria Press, 2009)

Graham, Rose, *St Gilbert of Sempringham and the Gilbertines* (London: E. Stock, 1903)

——, 'Excavations on the Site of Sempringham Priory', *Journal of the British Archaeological Association*, NS 5 (1940), 73–101

Graham-Leigh, Elaine, *The Southern French Nobility and the Albigensian Crusade* (Woodbridge: Boydell, 2005)

Grassi, J. A., 'Simon Magus', *New Catholic Encyclopedia*, 2nd edn, 15 vols (New York: Thomson/Gale, 2003), vol. XIII, pp. 130–31

Grassi, Luigi, 'La Madonna dell'Aracoeli e le tradizioni romane del suo tema iconografico', *Rivista di Archeologia Cristiana*, 19 (1941), 65–94

Grig, Lucy, 'Deconstructing the Symbolic City: Jerome as Guide to Late Antique Rome' *PBSR*, 80 (2012), 125–43

Grundmann, Herbert, *Religious Movements in the Middle Ages*, trans. by Steven Rowan, with an introduction by Robert E. Lerner (Notre Dame, IN: Notre Dame University Press, 1995)

Guerrieri Borsoi, Maria Barbara, 'La Cappella di San Pio V', in *Il convento di Santa Sabina all'Aventino e il suo patrimonio storico-artistico e architettonico*, ed. by Manuela Gianandrea, Manuela Annibali, and Laura Bartoni (Rome: Campisano Editore, 2016), pp. 119–26

Guerrini, Paola, 'Trastevere nella tarda antichità e nell'alto medioevo: continuità e trasformazioni dal IV all'VIII secolo', in *Trastevere: un'analisi di lungo periodo*, ed. by Letizia Ermini Pani and Carlo Travaglini, Convegno di Studi, Roma, 13–14 marzo, 2008, Miscellanea della Società Romana Storia Patria, 55 (Roma: Società Romana Storia Patria alla Biblioteca Vallicelliana, 2010), pp. 35–96

Guerrini Ferri, Gemma, 'Il *Liber monialium* ed il *Libro de l'antiquità* di suor Orsola Formicini. Le Clarisse e la storia del venerabile monastero romano dei Santi Cosma e Damiano in Mica Aurea detto di San Cosimato in Trastevere', *Scrineum Rivista*, 8.8 (2013), 81–111

——, 'I libri di suor Orsola Formicini (Roma Biblioteca Nazionale Centrale), mss. Varia 5 e Varia 6', in *'San Chosm' e Damiano e 'l suo bel monasterio …': complesso mounmentale di San Cosimato ieri, oggi domani*, ed. by Gemma Guerrini Ferri and Joan Barclay Lloyd with Anna Maria Velli, Quaderni di TestoeSenso, 1/2013 (Rome: TestoeSenso Università Tor Vergata, 2013), pp. 89–99

——, 'La "Madonna del coro": la storia dell'icona di San Cosimato nei manoscritti di suor Orsola Formicini (Roma, Biblioteca Nazionale Centrale, mss. Varia 5 e Varia 6)', in *'San Chosm' e Damiano e 'l suo bel monasterio …': complesso mounmentale di San Cosimato ieri, oggi domani*, ed. by Gemma Guerrini Ferri and Joan Barclay Lloyd with Anna Maria Velli, Quaderni di TestoeSenso, 1/2013 (Rome: TestoeSenso Università Tor Vergata, 2013), pp. 225–39

——, 'Storia, contabilita ed approvvigionamenti nel monastero di San Cosimato dalla cronaca manoscritto della badessa suor Orsola Formicini (MS BNCRoma, Varia 5, sec. XVI ex. – XVII in.)', in *Nuovi Studi su San Cosimato e Trastevere*, ed. by Anna Maria Velli (Rome: Graphofeel Edizioni, 2017), pp. 19–61

Guerrini Ferri, Gemma, and Joan Barclay Lloyd, ed., *'San Chosm' e Damiano e 'l suo bel monasterio …': il complesso mounmentale di San Cosimato ieri, oggi domani*, with Anna Maria Velli, Quaderni di TestoeSenso, 1/2013 (Rome: TestoeSenso Università Tor Vergata, 2013)

Guido, Simone, 'Il monastero di S. Lorenzo in Panisperna', *Frate Francesco*, NS 81 (2015), 185–95

Guidobaldi, Federico, 'Gli scavi del 1993–1995 nella basilica di S. Clemente a Roma e la scoperta del Battistero paleocristiano. Nota preliminare', *Rivista di Archeologia Cristiana*, 73.2 (1997), 459–91

——, 'L'organizzazione dei *tituli* nello spazio urbano' in *CHRISTIANA LOCA: Lo spazio Cristiano nella Roma del primo millennio*, ed. by Letizia Pani Ermini, 2 vols (Rome: Fratelli Palombi, 2000), vol. I, pp. 123–29

——, 'Un estesissimo intervento urbanistico nella Roma dell'inizio del XII secolo e la parziale Perdita della "memoria topografica" della città antica', *Mélanges de l'École française de Rome médiévale*, 126.2 (2014), 575–614

Guidobaldi, Federico, and Alessandra Guiglia Guidobaldi, ed., *Ecclesiae Urbis*. Atti del Convegno internazionale di studi sulle chiese di Roma, Roma 4–10 settembre 2000, 2 vols (Vatican City: Pontificio Istituto di Archeologia Cristiana, 2002)

Gustafson, Erik, 'Roman Versus Gothic in Trecento Architecture', in *Art and Experience in Trecento Italy*, Proceedings of the Andrew Ladis Trecento Conference, New Orleans, November 10-12, 2016, ed. by Holly Flora and Sarah S. Wilkins (Turnhout: Brepols, 2018), pp. 113–21'

Gy, Pierre-Marie, OP, 'Documentation concernant le Ms Santa Sabina XIV L 1', in *Aux Origines de la 'Liturgie dominicaine'*, ed. by Leonard Boyle and Pierre-Marie Gy (Rome and Paris: Ecole française de Rome and CNRS, 2004), pp. 5–16

Hall, Edward, and Horst Uhr, 'Aureola and Fructus: Distinctions of Beatitude in Scholastic Thought and the Meaning of Some Crowns in Early Flemish Painting', *Art Bulletin*, 60 (1978), 249–70

Hall, Edward, and Horst Uhr, '*Aureola super Auream*: Crowns and Related Symbols of Special Distinction for Saints in Late Gothic and Renaissance Iconography', *Art Bulletin*, 67 (1985), 567–603

Hall, Marcia B., 'The Ponte in S. Maria Novella: The Problem of the Rood Screen in Italy', *Journal of the Warburg and Courtauld Institutes*, 37 (1974), 157–73

——, 'The Tramezzo in Santa Croce, Florence, Reconstructed', *The Art Bulletin*, 56 (1974), 325–41

——, 'The Italian Rood Screen: Some Implications for Liturgy and Function', in *Essays Presented to Myron P. Gilmore*, ed. by Sergio Bertelli and Gloria Mamakus, 2 vols (Florence: La Nuova Italia Ed, 1978), vol. II, pp. 213–18

——, *Renovation and Counter-Reformation: Vasari and Duke Cosimo in Santa Maria Novella and Santa Croce* (Oxford: Clarendon Press, 1979)

——, 'The "Tramezzo" in the Italian Renaissance', in *The Thresholds of the Sacred: Architectural, Liturgical, and Theological Perspectives on Religious Screens, East and West*, ed. by Sharon E. J. Gerstel (Washington, DC: Dumbarton Oaks Papers, 2006), pp. 214–32

Hamburger, Jeffrey F., 'The Use of Images in the Pastoral Care of Nuns: The Case of Heinrich Suso and the Dominicans', *The Art Bulletin*, 71.1 (1989), 20–46

——, 'Art, Enclosure and the Cura Monialium: Prologomena in the Guise of a Postscript', *Gesta*, 31.2 (1992), 108–34

——, *Nuns as Artists: The Visual Culture of a Medieval Convent* (Berkeley: University of California Press, 1997)

Hamburger, Jeffrey F., and Susan Marti, ed., *Crown and Veil: Female Monasticism from the Fifth to the Fifteenth Centuries*, trans. by Dietlinde Hamburger (New York: Columbia University Press, 2008)

Hamburger, Jeffrey F., and Gabriela Signori, ed., *Catherine of Siena: The Creation of a Cult* (Turnhout: Brepols, 2013)

Hamburger, Jeffrey F., Eva Schlotheuber, Susan Marti, and Margaret Fassler, *Liturgical Life and Latin Learning at Paradies bei Soest, 1300–1425: Inscription and Illumination in the Choir Books of a North German Dominican Convent*, 2 vols (Münster: National Museum of Women and the Arts and Aschendorff Verlag, 2016)

——, 'The House of Theophylact and the Promotion of Religious Life among Women in Tenth Century Rome', in Hamilton, *Monastic Reform, Catharism and the Crusades*, pp. 195–215

——, 'The Monastery of S. Alessio and the Religious and Intellectual Renaissance in Tenth-Century Rome', in Hamilton, *Monastic Reform, Catharism and the Crusades*, pp. 265–310

——, 'The Monastic Revival in Tenth Century Rome', *Studia Monastica*, 4 (1962), pp. 55–68 and reprinted in Hamilton, Monastic Reform, Catharism and the Crusades, pp. 35–68'

Hamilton, Bernard, *Monastic Reform, Catharism and the Crusades (900–1300)* (London: Variorum Reprints, 1979)

Hamilton, Louis I., 'Memory, Symbol, and Arson: Was Rome "Sacked" in 1084?', *Speculum*, 78.2 (2003), 378–99

——, 'The Rituals of Renaissance: Liturgy and Mythic History in The Marvels of Rome', *Rome Re-imagined: Twelfth-century Jews, Christians, and Muslims Encounter the Eternal City*, ed. by Louis I. Hamilton and Stefano Riccione, Special Offprint of Medieval Encounters, vol. 17 / 4–5 (2011) (Leiden: Brill, 2011), pp. [5] 417 – [26] 438

Hamilton, Louis I., and Stefano Riccione, ed., *Rome Re-imagined: Twelfth-Century Jews, Christians, and Muslims Encounter the Eternal City*, Special Offprint of Medieval Encounters, vol. 17 / 4–5 (2011), (Leiden: Brill, 2011)

Hauknes, Marius, 'The Painting of Knowledge in Thirteenth-Century Rome', *Gesta*, 55.1 (2016), 19–47

Heideman, Johanna, *The Cinquecento Chapel Decorations in S. Maria in Aracoeli in Rome* (Amsterdam: Academische Pers, 1982)

——, 'Saint Catherine of Siena's Life and Thought: A Fresco-Cycle by Giovanni De' Vecchi in the Rosary Chapel of S. Maria sopra Minerva in Rome', *Arte Cristiana*, 77.735 (1989), 451–64

——, 'Giovanni De' Vecchi's Fresco Cycle and its Commissioners in the Rosary Chapel of S. Maria sopra Minerva', in *The Power of Imagery: Essays on Rome, Italy and the Imagination*, ed. by Peter J. van Kessel (Rome: Apeiron, 1993) pp. 149–62

Heikamp, Detlef, 'Die Entwurfzeichnungen für die Grabmäler der Mediceer-Päpste Leo X und Clemens VII', *Albertina Studien*, 4 (1966), 134–54

Herklotz, Ingo, 'I Savelli e le loro cappelle di famiglia', in *Roma anno 1300*, Atti del Congresso internazionale di storia dell'arte medievale, Rome 19–24 maggio 1980, ed. by Angiola Maria Romanini (Rome: L'Erma di Bretschneider, 1983), pp. 567–78

Hetherington, Paul, 'The Mosaics of Pietro Cavallini in Santa Maria in Trastevere', *Journal of the Warburg and Courtauld Institutes*, 33 (1970), 84–106

——, *Pietro Cavallini: A Study in the Art of Late Medieval Rome* (London: Sagittarius, 1979)

Hill, Bennett D., 'St Dominic (*c.* 1171–1221)', in *Dictionary of the Middles Ages*, vol. IV, ed. by J. R. Strayer (New York: Scribner, 1984), pp. 239–40

Hillner, Julia, 'Families, Patronage, and the Titular Churches of Rome, *c.* 300–*c.* 600', in *Religion, Dynasty, and Patronage in Early Christian Rome, 300–900*, ed. by Kate Cooper and Julia Hillner (Cambridge: Cambridge University Press, 2007)

Hinnebusch, William A., OP, *The History of the Dominican Order*, 2 vols (New York: Alba House, 1966 and 1973)

——, *The Dominicans: A Short History* (New York: Alba House, 1975)

——, 'Dominicans', in *The Dictionary of the Middles Ages*, vol. IV, ed. by J. R. Strayer (New York: Scribner, 1984), pp. 242–55

Hodel, Paul Bernard, 'Les Sources de la Vie de Saint Dominique, in *Saint Dominique et l'Ordre des Prêcheurs dans l'Aude*, ed. by Jean Claude Guerre and Norbert Ferrasse, Cahier No 101, (Montréal d'Aud: Association Culturelle du Razès, 2015), pp. 9–15

Hohlstein, Michael, '"Sacra Lipsana": The Relics of Catherine of Siena in the Context of Propagation, Piety, and Community', in *Catherine of Siena: The Creation of a Cult*, ed. by Jeffrey F. Hamburger and Gabriela Signori (Turnhout: Brepols, 2013), pp. 47–67

Holgate, Ian, 'The Cult of Saint Monica in Quattrocento Italy: Her Place in Augustinian Iconography, Devotion, and Legend', *PBSR*, 71 (2003), 181–206

Hood, William, 'Saint Dominic's Manner of Praying: Gestures in Fra Angelico's Cell Frescoes at S. Marco', *The Art Bulletin*, 68 (1986), 195–206

——, *Fra Angelico at San Marco* (New Haven: Yale University Press, 1993)

Horn, Walter W., and Ernest Born, *The Plan of San Gall: A Study of the Architecture and Economy of, and Life in a Paradigmatic Carolingian Monastery*, California Studies in the History of Art, 19 (Berkeley: University of California Press, 1979)

Horowski, Aleksander, 'La legislazione per le Clarisse del 1263: la Regola di Urbano IV, le lettere di Giovanni Gaetano Orsini e di San Bonaventura', *Collectanea Franciscana*, 87 (2017), 65–157

Huber, Raphael M., OFM Conv., *A Documented History of the Franciscan Order (1182–1517)*, (Milwaukee, WI: Nowiny, 1944)

Hubert, Etienne, 'Un censier des biens romains du monastère S. Silvestro in Capite (1333–1334)', *Archivio della Società romana di storia patria*, 111 (1988), 93–140

——, 'Patrimoines immobiliers et habitat à Rome au moyen âge: la *Regio Columnae* du XIe siècle au XIVe siècle', *Mélanges de l'École Française de Rome, Moyen Âge*, 101 (1989), 133–75

——, *Espace urbain et habitat à Rome du Xe siècle à la fin du XIIIe siècle*, Collection de l'École Française de Rome, 135 (Rome: École Française de Rome, 1990)

Huelsen, Christian F., *Le Chiese di Roma nel medioevo* (Florence: Olschki, 1927)

Iazeolla, Tiziana, 'Gli affreschi di S. Sebastiano ad Alatri', in *Roma anno 1300*, Atti del Congresso internazionale di storia dell'arte medievale, Rome 19–24 maggio 1980, ed. by Angiola Maria Romanini (Rome: L'Erma di Bretschneider, 1983), pp. 469–72

Jäggi, Carola, 'Eastern Choir or Western Gallery? The Problem of the Place of the Nuns' Choir in Königsfelden and Other Early Mendicant Nunneries', *Gesta*, 40.1 (2001), 79–93

——, *Frauenklöster im Spätmittelalter: Die Kirchen der Klarissen und Dominikanerinnen im 13. und 14. Jahrhundert* (Petersberg: Michael Imhof, 2006)

Jäggi, Carola, and Uwe Lobbedey, 'Church and Cloister: The Architecture of Female Monasticism in the Middle Ages', trans. by Dietlinde Hamburger, in *Crown and Veil: Female Monasticism from the Fifth to the Fifteenth Centuries*, ed. by Jeffrey F. Hamburger and Susan Marti (New York: Columbia University Press, 2008), pp. 109–31

James, Liz, *Mosaics in the Medieval World, from Late Antiquity to the Fifteenth Century* (Cambridge: Cambridge University Press, 2017)

Jarrett, Bede, *Life of Saint Dominic* (Washington: Burns Oates and Washbourne, 1924)

Jeremias, Gisela, *Die Holztür der Basilika S. Sabina in Rom* (Tübingen: E. Wasmuth, 1980)

Jørgensen, Johannes, *Saint Catherine of Siena*, transl. by Ingeborg Lund (New York: Longmans, Green and Co, 1938)

Josi, Enrico, 'Relazione', *Atti della Pontificia Accademia Romana di Archeologia (Ser. III) Rendiconti*, 12 (1937), 174

Jung, Jacqueline E., 'Beyond the Barrier: The Unifying Role of the Choir Screen in Gothic Churches', *The Art Bulletin*, 82 (2000), 622–57

——, 'Peasant Meal or Lord's Feast? The Social Iconography of the Naumburg Last Supper', *Gesta*, 42.1 (2003), 39–61

Kaftal, George, *St Dominic in Early Tuscan Painting* (Oxford: Blackfriars, 1948)

——, *Saint Catherine of Siena in Tuscan Painting* (Oxford: Blackfriars, 1949)

——, *Iconography of the Saints in Tuscan Painting*, Saints in Italian Art, 1 (Florence: Sansoni, 1952)

——, *Iconography of the Saints in Central and South Italian Painting*, Saints in Italian Art, 2, (Florence: Sansoni, 1965)

Kaftal, George, and Fabio Bisogni, *Iconography of the Saints in the Painting of North East Italy*, Saints in Italian Art, 3 (Florence: Sansoni, 1978)

Kaftal, George, and Fabio Bisogni, *Iconography of the Saints in the Painting of North West Italy*, Saints in Italian Art, 4 (Florence: Le Lettere, 1985)

Kane, Eileen, *The Church of San Silvestro in Capite in Rome*, 2nd edn (Genoa: Stampa B. N. Marconi, 2015)

Kehr, Paul Fridolin, *Italia Pontificia*, vol. I, *Roma* (Berlin: Weidmann, 1906)

Kennedy, Trinita, ed., *Sanctity Pictured: The Art of the Dominican and Franciscan Orders in Renaissance Italy* (London: Philip Wilson Publishers, 2014)

Kessler, Herbert L., 'Configuring the Invisible by Copying the Holy Face', in *The Holy Face and the Paradox of Representation*, ed. by Herbert L. Kessler and Gerhard Wolf, Villa Spelman Colloquia, vol. VI (Bologna: Buova Alfa Editoriale, 1998), pp. 129–51

——, 'Il Mandylion', in *Il Volto di Cristo*, Exhibition Catalogue of Exhibition at Palazzo delle Esposizioni, ed. by Giovanni Morello and Gerhard Wolf, with Bibliotheca Apostolica Vaticana (Milan: Electa, 2000), pp. 64–99

——, 'Christ's Dazzling Dark Face', in *Intorno al Sacro Volto. Genova, Bisanzio e il Mediterraneo (secoli XI–XIV)*, ed. by Anna Rosa Calderoni Masetti, Colette Dufour Bozzo, and Gerhard Wolf, Collana del Kunsthistorisches Institut in Florenz, Max-Planck-Institut, XI (Venice: Marsilio, 2007), pp. 231–246

Kessler, Herbert, and Gerhard Wolf, ed., *The Holy Face and the Paradise of Representation*, Villa Spelman Colloquia, vol. VI (Bologna: Nuova Alfa Editore, 1998)

Kilgallon, Ella, 'Female Sites of Devotion in the Medieval Italian City: The Domestic "Cell"', in *Franciscan Women: Female Identities and Religious Culture Medieval and Beyond*, ed. by Lezlie Knox and David B. Couturier (Saint Bonaventure, NY: Franciscan Institute, Bonaventure University, 2020), pp. 63–82

Kinder, Terryl N., *L'Europe cistercienne* (Paris: Zodiaque, 1997)

King, Archdale A., *The Dominican Rite: History and Liturgy*, ed. by Ryan Grant, excerpted from King, Archdale A., *Liturgies of the Religious Orders* (London: Longman and Green and Mediatrix Press, 2015)

Kinney, Dale, 'S. Maria in Trastevere from its Founding to 1215' (unpublished doctoral dissertation, New York University, 1975)

——, 'Making Mute Stones Speak: Reading Columns in S. Nicola in Carcere and S. Maria in Aracoeli', in *Architectural Studies in Memory of Richard Krautheimer*, ed. by Cecil L. Striker (Mainz: Zabern, 1996), pp. 83–86

——, 'Fact and Fiction in the Mirabilia Urbis Romae', in *Roma felix: Formation and Reflections of Medieval Rome*, ed. by E. O'Caragain and C. Neuman de Vegvar (Aldershot: Ashgate, 2007), pp. 235–52

——, 'Patronage of Art and Architecture', in *Pope Innocent II (1130-1143): The World vs the City*, ed. by John Doran and Damian J. Smith, Church, Faith and Culture in the Medieval West (Abingdon: Routledge, 2016), pp. 352–88

——, 'The Image of a Building: Santa Maria in Trastevere', *California Italian Studies*, 6.1 (2016) <http://escholarship.org/uc/item/3fp5z3gz> [accessed 12 October 2021]

Kirsch, Johann Peter, *Die römischen Titelkirchen im Altertum*, Studien zur Geschichte und Kultur des Altertums, 9.1–2 (Paderborn: Schöningh, 1918)

——, 'Anzeiger für christliche Archäologie, Nr LII, Ausgrabungen und Funde', *Römische Quartalschrift für christliche Altertumskunde und für Kirchengeschichte*, 44 (1936), 295–99

——, 'Anzeige', *Jahrbuch des deutschen Archäologischen Instituts mit dem Beiblatt Archäologischer Anzeiger*, 52 (1937), col. 405

Kitzinger, Ernst, 'The Arts as Aspects of Renaissance: Rome and Italy', in *Renaissance and Renewal in the Twelfth Century*, ed. by R. I. Benson, G. Constable, and Carol D. Lanham (Cambridge, MA: Harvard University Press, 1982), pp. 637–70

Kleefisch-Jobst, Ursula, 'Die Errichtung der Grabmäler für Leo X. und Clemens VII. und die Projekte für die Neugestaltung der Hauptchorkapelle von S. Maria sopra Minerva', *Zeitschrift für Kunstgeschichte*, 51.4 (1988), 524–41

——, *Die römische Dominikanerkirche Santa Maria sopra Minerva: ein Beitrag zur Architektur der Bettelorden in Mittelitalien* (Minster: Nodus, 1991)

Kleefisch, Ursula, 'Die römische Dominikanerkirche S. Maria sopra Minerva von 1280 bis 1453. Eine Baumonographische Untersuchung' (unpublished PhD thesis, Rheinischen Friedrich-Wilhelm-Universität zu Bonn, 1986)

Klein, Almuth, 'S. Maria sopra Minerva', in *Die Kirchen der Stadt Rom im Mittelalter 1050–1300*, vol. IV, ed. by Daniela Modini, Carola Jäggi, and Peter Cornelius Claussen, Forschungen zur Geschichte und christlichen Archäologie, 23, Corpus Cosmatorum II, 4 (Stuttgart: Steiner, 2020), pp. 310–36

Knipping, Detlef, 'Die Chorschranke der Kathedrale von Amiens und ihre Rolle in Liturgie und Reliquienkult', *Gesta*, 38.2 (1999), 171–88

Knowles, David, *Monastic Sites from the Air* (Cambridge: Cambridge University Press, 1952)

——, 'Gilbertini e Gilbertine', in *Dizionario degli Istituti di Perfezione*, ed. by G. Peliccia and G. Rocca, IV (Rome: Edizione Paoline, 1977), cols 1178–1182

Knox, Lezlie, *Creating Clare of Assisi: Female Franciscan Identities in Later Medieval Italy* (Leiden: Brill, 2008)

Knox, Lezlie, and David B. Couturier, ed., *Franciscan Women: Female Identities and Religious Culture Medieval and Beyond* (Saint Bonaventure, NY: Franciscan Institute, Bonaventure University, 2020)

Kollwitz, Johannes, *Oströmische Plastik der theodosianischen Zeit* (Berlin: De Gruyter, 1941)

Koudelka, Vladimir J., OP, 'Notes sur le Cartulaire du S. Dominique', *AFP*, 28 (1958), 92–114

——, 'Le "Monasterium Tempuli" et la fondation dominicaine de San Sisto', *AFP*, 31 (1961), 1–81

——, 'Domenico Fondatore dell'Ordine dei Frati Predicatori', *Biblioteca Sanctorum*, 16 vols (Rome: Istituto Giovanni XXIII della Pontificia Università Lateranense, 1961–2013), vol. IV (1964), cols 692–727

―――, 'Les Dépositions des témoins au procès de canonization de saint Dominique', *AFP*, 42 (1972), 47–67

―――, 'Il convento di S. Sisto a Roma negli anni 1369–1381', *AFP*, 46 (1976), 5–24

―――, *Dominic*, trans. by Consuelo Fissler (London: Darton, Longman, and Todd, 1997)

Krautheimer, Richard, *Die Kirchen der Bettelorden in Deutschland*, Deutsche Beiträge zur Kunstwissenschaft, 2 (Cologne: Marcan, 1925)

―――, *Corpus Basilicarum Christianarum Romae*, 5 vols (Vatican City: Pontificia Istituto di Archeologia Cristiana and Institute of Fine Arts, New York University, 1937–1977)

―――, 'Some Drawings of Early Christian Basilicas in Rome: St Peter's and S. Maria Maggiore', *The Art Bulletin*, 31.3 (1949), 211–15

―――, 'The Architecture of Sixtus III. A Fifth Century Renascence?' in *Essays in Honor of Erwin Panofsky*, ed. by Millard Meiss, De artibus opuscula, 40, 1 (New York: New York University Press, 1961) pp. 291–302

―――, 'Fra Angelico and – Perhaps – Alberti', in *Studies in Late Medieval and Renaissance Painting in Honor of Millard Meiss*, ed. by Irwin Lavin and John Plummer (New York: New York University Press, 1977), pp. 290–96

―――, *Rome: Profile of a City, 312–1308* (Princeton: Princeton University Press, 1980)

―――, *Lorenzo Ghiberti* (Princeton: Princeton University Press, 1982)

―――, *Three Christian Capitals: Topography and Politics* (Berkeley: University of California Press, 1983)

―――, *Early Christian and Byzantine Architecture*, revised edn by Richard Krautheimer with Slobodan Ćurčić, Pelican History of Art (New Haven: Yale University Press, 1986)

―――, 'Congetture sui mosaici scomparsi di S. Sabina a Roma', *Rendiconti della Pontificia Accademia Romana di Archeologia*, 60 (1987–1988), 171–87

Kuhn-Forte, B., 'S. Francesco a Ripa', in Buchowiecki, *Handbuch der Kirchen Roms*, vol. IV (Vienna: Hollinek, 1997)

La Bella, C., 'Scultori nella Roma di Pio II (1458-64). Considerazioni su Isaia da Pisa, Mino da Fiesole e Paolo Romano', *Studi Romani*, 43.1–2 (1995), 26–43

Lainati, Chiara Augusta, 'La Cloture de Sainte Claire et des premières Clarisses dans la legislation canonique et dans la pratique', *Laurentianum*, 14 (1973), 223–50

Lambert, Elie, 'L'Église et le couvent des Jacobins de Toulouse et l'architecture dominicaine en France', *Bulletin Monumental*, 104 (1946), 141–86

Lambert, Malcolm, *Medieval Heresy: Popular Movements from the Gregorian Reform to the Reformation*, 3rd edn (Oxford: Blackwell, 2002)

Lambertini, Roberto, *Apologia e Crescita dell'Identità Francescana (1255–1279)*, Nuovi Studi Storici, 4 (Rome: Istituto Storico Italiano per il Medio Evo, 1990)

Lamia, Stephen, 'The Cross and the Crown, the Tomb and the Shrine: Decoration and Accommodation for England's Premier Saints', in *Decorations for the Holy Dead: Visual Embellishments on Tombs and Shrines of Saints*, ed. by Stephen Lamia and Elizabeth Valdez del Álamo (Turnhout: Brepols, 2002), pp. 39–59

Lamia, Stephen, and Elizabeth Valdez del Álamo, ed., *Decorations for the Holy Dead: Visual Embellishments on Tombs and Shrines of Saints* (Turnhout: Brepols, 2002)

Lanciani, Rodolfo, 'Il panorama di Roma delineato da Antonio van den Wyngaerde', *Bullettino della Commissione archeologica comunale di Roma*, 23.2 (1895), 81–109

―――, *The Destruction of Ancient Rome: A Sketch of the History of the Monuments* (New York: Macmillan, 1899)

―――, *Notes from Rome*, ed. by Anthony L. Cubberly (London: British School at Rome, 1988)

Lansford, Tyler, *The Latin Inscriptions of Rome: A Walking Guide* (Baltimore: Johns Hopkins University Press, 2009)

Laurent, Marie-Hyacinthe, 'La Plus Ancienne légende de la b. Marguerite de Città di Castello', *AFP* 10 (1940), 109–31

Lawrence, Clifford H., *Medieval Monasticism: Forms of Religious life in Western Europe in the Middle Ages* (London: Longman, 1984)

——, *The Friars: The Impact of the Mendicant Orders on Medieval Society*, revised edn (London: I. S. Tauris, 2013)
Le Pogam, Pierre-Yves, 'Cantieri e residenza dei papi nella seconda metà del XIII secolo. Il caso del "Castello Savelli" sull'Aventino', in *Domus et splendida palatia: Residenze papali e cardinalizie a Roma fra XII e XV secolo*, ed. by Alessio Moncatti, Atti della giornata di Studio, Pisa, Scuola Normale superiore, 14 novembre 2002 (Pisa: Edizioni della Normale, 2004), pp. 77–87
——, 'Otton III sur le Palatin ou sur l'Aventin? Note sur les Résidences aristocratiques de l'Aventin au xe siècle, notamment celle de Sainte-Sabine', *Mélanges de l'Ecole Française de Rome (Moyen Âge)*, 116.2 (2004), 595–609
——, *De la 'Cité de Dieu' au 'Palais de Pape': Les Résidences pontificales dans la séconde moitié du XIIIe siécle*, Rome, Fascicule, 326 (Rome: École Française de Rome, 2005)
Lehmijoki-Gardner, Maiju, 'Writing Religious Rules as an Interactive Process: Dominican Penitent Women and the Making of their *Regula*', *Speculum*, 79 (2004), 640–87
——, 'Le Penitenti domenicane tra Duecento e Trecento', in *Il Velo, la Penna e la Parola. Le Domenicane: storia, istituzioni e scritture*, ed. by Gabriella Zara and Gianni Festa, Biblioteca di Memorie Domenicane (Florence: Nerbini, 2009), pp. 113–23
Leone, Giorgio, *Icone di Roma e del Lazio*, Repertorii dell'Arte del Lazio, 5/6, 2 vols (Roma: L'Erma di Bretschneider, 2012)
Lexicon Topographicum Urbis Rome, ed. by Eva Margareta Steinby, 6 vols (Rome: Edizioni Quasar, 1993–2000)
Linehan, Peter, *The Ladies of Zamora* (Manchester: Manchester University Press, 1997)
Little, Lester K., *Religious Poverty and the Profit Economy in Medieval Europe* (London: Paul Elek, 1974)
Lopez, Bianca, 'Between Court and Cloister: The Life and Lives of Margherita Colonna', *Church History*, 82 (2013), 554–75
Lotti, Luigi, 'S. Lorenzo in Panisperna', *Alma Roma*, 14.5/6 (1973), 14–17
Lowe, Kate J. P., 'Franciscan and Papal Patronage at the Clarissan Convent of S. Cosimato in Trastevere, 1440–1560', *PBSR*, 68 (2000), 217–39
——, 'Artistic Patronage at the Clarissan Convent of San Cosimato in Trastevere', *PBSR*, 69 (2001), 273–97
——, *Nuns' Chronicles and Convent Culture in Renaissance and Counter-Reformation Italy* (Cambridge: Cambridge University Press, 2003)
Lunghi, Elvio, *La Passione degli umbri: Crocifissi di legno in Valle Umbra tra Medioevo e Rinascimento* (Foligno: Orfini Numeister, 2000)
Luongo, F. Thomas, *The Saintly Politics of Catherine of Siena* (Ithaca: Cornell University Press, 2006)
Lynch, Joseph H., 'Simony', in *The Dictionary of the Middle Ages*, ed. by Joseph R. Strayer, 13 vols (New York: Charles Scribner's Sons, 1982–1989), vol. XI, pp. 300–02
Maccarrone, Michele, 'Il progetto per un "universale coenobium" per le monache di Roma', in *Studi su Innocenzo III*, Italia Sacra, Studi e documenti di storia ecclesiastica, 17 (Padua: E. Antenore, 1972), pp. 272–78
Maguire, Brian Patrick, 'Cistercian Nuns in Twelfth and Thirteenth-Century Denmark and Sweden: Far from the Madding Crowd', in *Women in the Medieval Monastic World*, ed. by Janet Burton and Karen Stöber (Turnhout: Brepols, 2015), pp. 167–84
Maguire, Henry, 'The Iconography of Symeon with the Christ Child in Byzantine Art', *Dumbarton Oaks Papers*, 34/35 (1980/1981), 261–69
Makowski, Elizabeth, *Canon Law and Cloistered Women: Periculoso and its Commentators, 1298–1545*, Studies in Medieval and Early Modern Canon Law, 5 (Washington, DC: The Catholic University of America Press, 1997)
——, *'A Pernicious Sort of Woman': Quasi-Religious Women and Canon Lawyers in the Later Middle Ages*, Studies in Medieval and Early Modern Canon Law, 6 (Washington, DC: The Catholic University of America Press, 2005)
Maleczek, W., 'Conti, Stefano', *DBI*, vol. XXVIII, 1983, pp. 475–78
Malmstrom, Ronald, 'S. Maria in Aracoeli at Rome' (unpublished PhD thesis, University of New York, 1973)

——, 'The Colonnades of High Medieval Churches at Rome', *Gesta*, 14 (1975), 37–45

Mandonnet, Pierre, OP, 'Note de symbolique médiévale: Domini canes', *Mémoire Dominicaine*, 29 (2012), 17–29

Maniello Cardone, Sabina, 'Pasquale Cati: un document relative al *Martirio di san Lorenzo* in San Lorenzo in Panisperna e notizie sulla vita artistica del pittore', *Alma Roma*, NS 5, 39 (1998–1999), 93–108

Mantegna, Cristina, 'Le carte dei SS. Cosma e Damiano in Mica Aurea come documentazione diplomatica', in *'San Chosm' e Damiano e 'l suo bel monasterio ...': complesso mounmentale di San Cosimato ieri, oggi domani*, ed. by Gemma Guerrini Ferri and Joan Barclay Lloyd with Anna Maria Velli, Quaderni di TestoeSenso, 1/2013 (Rome: TestoeSenso Università Tor Vergata, 2013), pp. 53–67

Marchese, Vincenzo Fortunato, OP, *Memorie dei più insigne pittori, scultori, architetti domenicani*, 2 vols, 4th edn (Bologna: Romagnoli, 1878–1879)

Marchetti Longhi, Giuseppe, *L'Aventino nel medio evo*, I colli di Roma. L'Aventino (Rome: Istituto di Studi Romani, 1947)

Marini, Alfonso, 'Monasteri femminili a Roma nei secoli XIII–XV', *Archivio della Società romana di Storia Patria*, 132 (2010), 81–108

——, 'Il monastero di San Lorenzo in Panisperna nel tessuto urbano di Romanei secoli XIV–XV', *Reti Medievali*, 19.1 (2018), 437–52

Marini, Piero, *Il Terz'Ordine francescano nella storia di S. Maria in Aracoeli* (Rome: Tip. Via Germanico, 168.8, 1973)

Mariotti, I., 'La creazione di un mito: fra Sisto e Ristoro architetti della chiesa di S. Maria Novella', *Annali della Scuola Normale Superiore di Pisa, Classe di Lettere e Filosofia*, serie IV.1, 1996 (1998), 249–78

Martinelli, Valentino, 'Su una statua di San Domenico a Roma, opera giovanile di Arnolfo', in *Scritti di storia dell'arte in onore di Ugo Procacci*, vol. I (Milan: Electa, 1977), pp. 73–81

Marvin, Lawrence W., *The Occitan War: A Military and Political History of the Albigensian Crusade*, (Cambridge: Cambridge University Press, 2008)

Masetti, Pio-Tommaso, OP, *Memorie istoriche della Chiesa di S. Maria sopra Minerva* (Rome: Dalla tipografia di Bernardo Morini, 1855)

Masetti, Tommaso, 'La Biblioteca Casanatense', *Memorie Domenicane*, 50 (1933), 347–62

Matthiae, Guglielmo, 'Gli aspetti diversi di S. Maria sopra Minerva', *Palladio*, NS 4 (1954), 19–26

——, 'Basiliche paleocristiane con ingresso a polifora', *Bollettino d'Arte*, 42 (1957), 107–21

——, *Pittura romana del medioevo*, 2 vols (Rome: Palombi, 1965–1966)

——, *Mosaici medioevali delle chiese di Roma*, 2 vols (Rome: Istituto Poligrafico, 1967)

——, 'Tre chiese all'inizio dell'Appia', *Capitolium*, 44 (1969), 149–62

——, *Pittura romana del medioevo*, 2 vols, updated by Maria Andaloro, vol. I, and Francesco Gandolfo, vol. II (Rome: Fratelli Palombi, 1988)

Mazzei, Paola, 'Mica Aurea in Trastevere', *Archeologia Classica*, 59 (2008), 183–204

——, '"*Aquae in Transtiberim*": gli acquedotti e le utenze idriche della XIV regione', in *'San Chosm' e Damiano e 'l suo bel monasterio ...': il complesso mounmentale di San Cosimato ieri, oggi domani*, ed. by Gemma Guerrini Ferri and Joan Barclay Lloyd, with Anna Maria Velli, Quaderni di TestoeSenso, 1/2013 (Rome: TestoeSenso Università Tor Vergata, 2013), pp. 115–55

McClendon, Charles B., *The Imperial Abbey of Farfa* (New Haven: Yale University Press, 1987)

McDonnell, Ernest W, *Beguines and Beghards in Medieval Culture, with Special Emphasis on the Belgian Scene* (New Brunswick: Rutgers University Press, 1954)

McGregor, Neil, *Seeing Salvation: Images of Christ in Art* (New Haven: Yale University Press, 2000)

McNamara, Jo Ann Kay, *Sisters in Arms: Catholic Nuns through Two Millennia* (Cambridge, MA: Harvard University Press, 1996)

Meiss, Millard, 'The Problem of Francesco Traini', *The Art Bulletin*, 15 (1933), 97–173

——, *Painting in Florence and Siena after the Black Death* (Princeton: Princeton University Press, 1951)
Menichella, Anna, *San Francesco a Ripa. Vicende costruttive della prima chiesa Francescana di Roma*, Collana di studi di Storia dell'Arte diretta da Mario d'Onofrio, 3 (Rome: Edizioni Rari Nantes, 1981)
Merlin, Alfred, *L'Aventin dans l'Antiquité*, Bibliothèque des écoles françaises d'Athènes et de Rome, 97 (Paris: Albert Fontemoing Editeur, 1906)
Meersseman, Gilles Gérard, 'L'Architecture dominicaine au XIIIe siècle: Legislation et pratique', *AFP*, 16 (1946), 136–90
——, *Dossier de l'ordre de la penitence au XIIIe siècle*, Spicilegium Friburgense, 7 (Friburg: Editions universitaires, 1961)
Meersseman, Gilles Gérard, with Gian Piero Pacini, *Ordo Fraternitatis: Confraternite e pietà dei laici nel medioevo*, 3 vols, Italia Sacra, 24–26 (Rome: Herder, 1977)
Milazzi, Maria, 'Un dipinto di Antonio del Massaro a S. Cosimato: la Madonna in trono tra i santi Francesco e Chiara', in *'San Chosm' e Damiano e 'l suo bel monasterio …': il complesso mounmentale di San Cosimato ieri, oggi domani*, ed. by Gemma Guerrini Ferri and Joan Barclay Lloyd, with Anna Maria Velli, Quaderni di TestoeSenso, 1/2013 (Rome: TestoeSenso Università Tor Vergata, 2013), pp. 209–23
Moerer, Emily A., 'The Visual Hagiography of a Stigmatic Saint: Drawings of Catherine of Siena in the *Libellus de Supplemento*', *Gesta*, 44.2 (2005), 89–102
Mondini, Daniela, *San Lorenzo fuori le Mura: storia del complesso monumentale nel medioevo* (Rome: Viella, 2016)
Monti, Giovanni, 'Restauro dei Monumenti Cateriniani nella basilica di S. Maria sopra Minerva', in *La Roma di santa Caterina da Siena*, ed. by Maria Grazia Bianco, Quaderni della Libera Università 'Maria SS. Assunta', 18 (Rome: Edizioni Studium, 2001), pp. 395–98
Mooney, Catherine M., *Clare of Assisi and the Thirteenth-Century Church: Religious Women, Rules, and Resistance* (Philadelphia: Philadelphia University Press, 2016)
Moore, R. I., 'Saint Bernard's Mission in Languedoc', *Bulletin of the Institute of Historical Research*, 47 (1974), 1–14
——, *The Formation of a Persecuting Society: Authority and Deviance in Western Europe 950–1250*, 2nd edn (Oxford: Blackwell, 2007)
——, *War on Heresy: Faith and Power in Medieval Europe* (London: Profile, 2012)
Moorman, John, *A History of the Franciscan Order, from its Origins to the Year 1517* (Oxford: Clarendon Press, 1968)
Morçay, Raoul, *Saint Antonin, Fondateur du couvent de Saint-Marc, Archevêque de Florence, 1389–1459* (Tours: Maison à Marne, 1914)
Morello, Giovanni, and Gerhard Wolf, ed., *Il Volto di Cristo*, Exhibition Catalogue of Exhibition at Palazzo delle Esposizioni, with Bibliotheca Apostolica Vaticana (Milan: Electa, 2000)
Morgan, Nigel J., '"Veronica" Images and the Office of the Holy Face in Thirteenth-Century England', in *The European Fortune of the Roman Veronica in the Middle Ages*, ed. by Amanda Murphy, Herbert L. Kessler, Marco Petoletti, Eamon Duffy, and Guido Milanese, with the collaboration of Veronika Tvrznikova, Convivium Supplementum (Brno: Université de Lausanne and the Academy of Sciences of the Czech Republic and Masaryk University, 2017), pp. 85–99
Mortari, Luisa, 'L'antica Croce dipinta della Chiesa romana dei Ss. Domenico e Sisto', in *Studi in Onore di Giulio Carlo Argan*, I, ed. by Maurizio Calvesi, Silvana Macchioni, and Bianca Tavassi La Greca (Rome: Multigrafica Editrice, 1984), pp. 11–28
Moskowitz, Anita Fiderer, 'On the Sources and Meaning of Nicola Pisano's Arca di San Domenico in Bologna', in *Verrocchio and Late Quattrocento Italian Sculpture*, ed. by S. Bule, A. Phipps Darr and F. Superbi Goffredi (Firenze: Casa Editrice Le Lettere, 1992), pp. 271–81
——, *Nicola Pisano's Arca di San Domenico and its legacy* (University Park: Pennsylvania State University Press, 1994)
Muessig, C., G. Ferzoco, and B. Kienzle, ed., *A Companion to Catherine of Siena* (Leiden: Brill, 2011)

Mulchahey, M. Michèle, *'First the Bow is Bent in Study…' Dominican Education before 1350*, Studies and Texts 132 (Toronto: Pontifical Institute of Medieval Studies, 1998)

Müller, Anne, 'Symbolic Meanings of Space in Female Monastic Traditions', in *Women in the Medieval Monastic World*, ed. by Janet Burton and Karen Stöber (Turnhout: Brepols, 2015), pp. 299–325

Mundy, John H., *Society and Government at Toulouse in the Ages of the Cathars*, Studies and Texts 129 (Toronto: Pontifical Institute of Medieval Studies, 1997)

Muñoz, Antonio, 'La cappella di S. Silvestro ai Ss. Quattro Coronati e le recenti scoperti', *Rivista di Archeologia Cristiana* 19 (1913), pp. 175–80

——, *Il restauro della Chiesa e del chiostro dei Ss. Quattro Coronati* (Rome: Danesi, 1914)

——, 'Indagini sulla Chiesa di Santa Sabina sull'Aventino', *Studi Romani. Rivista di Archeologia e Storia*, 2.4 (1914), 329–42

——, 'Studi sulle basiliche romane di Santa Sabina e di Santa Prassede', *Dissertazione della Pontificia Accademia Romana di Archeologia*, 2.13 (1918), 119–28

——, *La basilica di Santa Sabina in Roma — descrizione storico-artistica dopo I recenti restauri* (Milan: Alfieri e Lacroix, 1919)

——, *L'Église de Sainte Sabine à Rome*, Monumenti di Roma e del Lazio, 1 (Rome: tipografia Cuggiani, 1924)

——, *Il restauro della basilica di Santa Sabina* (Rome: Palombi, 1938)

Murphy, Amanda, Herbert L. Kessler, Marco Petoletti, Eamon Duffy, and Guido Milanese, ed., with the collaboration of Veronika Tvrznikova, *The European Fortune of the Roman Veronica in the Middle Ages*, Convivium Supplementum (Brno: Université de Lausanne and the Academy of Sciences of the Czech Republic and Masaryk University, 2017)

Murray, Paul, OP, *The New Wine of Dominican Spirituality: A Drink called Happiness* (London: Burns and Oates, 2006)

——, *Saint Catherine of Siena: Mystic of Fire, Preacher of Freedom* (Des Plaines, IL: Word of Fire Institute, 2020)

Nerger, Sybille, 'Il Restauro della tomba di santa Caterina nella basilica di S. Maria sopra Minerva a Roma', in *La Roma di santa Caterina da Siena*, ed. by Maria Grazia Bianco, Quaderni della Libera Università 'Maria SS. Assunta', 18 (Rome: Edizioni Studium, 2001), pp. 399–410

Nicoletti, Lina, *The Church of Saints Dominic and Sixtus and the Pontifical University 'Angelicum' in Rome*, ed. by Daniel Cara, OP (Rome: Angelicum University Press, 2003)

Noreen, Kirstin, 'The High Altar of S. Maria in Aracoeli: Recontextualizing a Medieval Icon in Post-Tridentine Rome', *Memoirs of the American Academy in Rome*, 53 (2008), 99–128

Norman, Diana, 'The Chapel of Saint Catherine in San Domenico: A Study of Cultural Relations between Renaissance Siena and Rome', in *L'ultimo sacolo della Repubblica di Siena: arte, cultura e società*, ed. by M. Ascheri, G. Mazzoni, and F. Nevola, Atti del congresso internazionale, Siena 28–30 settembre, 2003 – 16–18 ottobre 2004 (Siena, 2008), pp. 405–19

Oakeshott, Walter, *The Mosaics of Rome* (London: Thames and Hudson, 1967)

O'Daly, Irene A., 'An Assessment of the Political Symbolism of the City of Rome in the Writings of John of Salisbury', *Rome Re-imagined: Twelfth-Century Jews, Christians, and Muslims Encounter the Eternal City*, ed. by Louis I. Hamilton and Stefano Riccione, Special Offprint of Medieval Encounters, vol. 17 / 4–5 (2011), (Leiden: Brill, 2011) pp. [100] 512 – [121] 533

Offner, Richard, and Steinweg, Klara, *A Critical and Historical Corpus of Florentine Painting*, The Fourteenth Century, 7 vols (New York: Institute of Fine Arts, New York University, 1930–1981), *Andrea Bonaiuti*, vol. VI (1979)

Ojetti, Baldassare, 'I chiostri dell'Aracoeli', in *Mostra della città di Roma alla Esposizione di Torino dell'anno 1884* (Roma: Fratelli Centenari, 1884)

Oliger, Livarius, 'Due musaici con S. Francesco della chiesa di Aracoeli in Roma', *AFH*, 4 (Florence: Quaracch, 1911), 213–51

——, 'De origine Regularium Ordinis S. Clarae', *AFH*, 5 (1912), 181–209 and 413–47

——, 'De fratribus minoribus apud S. Mariam Populi Romani a. 1250 habitantibus', *AFH*, 18 (1925), 293–95

——, 'S. Francesco a Roma e nella Provincia Romana', *L'Italia Francescana nel settimo Centenario della morte di S. Francesco* (Assisi: S. Maria degli Angeli, 1927), pp. 65–112

Osborne, John, 'The Tomb of Alfanus in S. Maria in Cosmedin, Rome, and its Place in the Tradition of Roman Funerary Monuments', *PBSR*, 51 (1983), 240–47

——, 'Rome and Constantinople about the Year 700: The Significance of the Recently Uncovered Mural in the Narthex of S. Sabina', in *L'officina dello sguardo. Scritti in onore di Maria Andaloro. I luoghi dell'arte. Immane, memoria, materia*, ed. by Giulia Bordi and others, 2 vols (Roma: Gangemi, 2014), vol. I, pp. 329–34

——, *Rome in the Eighth Century: A History in Art*, British School at Rome Studies (Cambridge: Cambridge University Press, 2020)

Pace, Valentino, 'Pittura del Duecento e del Trecento in Roma e nel Lazio', in *La Pittura in Italia. Il Duecento e il Trecento*, ed. by Enrico Castelnuovo, 2 vols (Milan: Electa, 1985), pp. 423–42

——, *Arte a Roma nel medioevo: committenza, ideologia e cultura figurativa in monumenti e libri* (Naples: Liguori, 2000)

Palagi, A. G., 'La sacra testa di S. Caterina da Siena e le sue urne', *Rassegna Cateriniana*, (1931), 1–11

Palmerio, Giancarlo, and Gabriela Villetti, *Storia edilizia di S. Maria sopra Minerva in Roma, 1275–1870*, Università degli Studi di Roma 'la Sapianza', Dipartimento di Storia dell'Architettura, Restauro e Conservazione dei Beni Architettonici Studi e Documenti, 1 (Rome: Viella, 1989)

Palumbo, Pier Fausto, *Lo Scismo del MCXXX*, Miscellanea della R. Deputazione Romana di Storia Patria, 13 (Rome: Presso la Deputazione alla Biblioteca Vallicelliana, 1942)

Panetti, Viviana, *La chiesa di San Lorenzo in Panisperna a Roma* (Rome: Tipografia Trullo, 1997)

Pani Ermini, Letizia, and Roberto Giordano, 'Recenti ritrovamenti archeologici a S. Sabina', *Studi Romani*, 31 (1983), 49–53

Pantoni, Angelo, 'La basilica di Montecassino e quella di Salerno ai tempi di San Gregorio VII', *Benedictina*, 10 (1956), 23–47

——, 'Descrizioni della basilica di Montecassino attraverso i secoli', *Benedictina*, 19 (1972), 539–86

——, *Le vicende della basilica di Montecassino attraverso la documentazione archeologica*, Miscellanea Cassinense, 36 (Montecassino: Monaci de Montecassino, 1973)

Paravicini Bagliani, Agostino, *Cardinali di Curia e 'Familiae' cardinalizie dal 1227–1254*, 2 vols (Rome: Editore Antenore, 1972)

——, *I testamenti dei cardinali del Duecento*, Miscellanea della Società Romana di Storia Patria, 25 (Rome: Presso Società Romana di Storia Patria alla Biblioteca Vallicelliana, 1980)

Parmegiani, Nedda, and Alberto Pronti, 'Il battistero di S. Cecilia in Trastevere a Roma', in *1983–1993: dieci anni di Archeologia Cristiana in Italia* (Cassino: Edizioni dell'Università degli Studi di Cassino, 2003), vol. I, pp. 391–98

Parsons, Gerald, *The Cult of Saint Catherine of Siena: A Study in Civil Religion* (Aldershot: Ashgate, 2008)

——, 'A Neglected Sculpture: The Monument to Catherine of Siena at Castel Sant'Angelo', *PBSR*, 76 (2008), 257–76

Pasti, Stefania, 'Documenti cinquecenteschi per l'abside della Minerva', in *Roma anno 1300*, Atti del Congresso internazionale di storia dell'arte medievale, Rome 19–24 maggio 1980, ed. by Angiola Maria Romanini (Rome: L'Erma di Bretschneider, 1983), pp. 591–95

Patroni, Giuseppe, *Serie cronologica dei cardinali diaconim [...]della perinsigne basilica di S. Maria in Cosmedin, già pubblicata dall'Arcipr. Giovanni Maria Crescimbeni* (Naples: A. E. S. Festa, 1899)

Pazzelli, Raffaele, and Lino Temperini, ed., *La 'Supra Montem' di Niccolo IV (1289): genesi e diffusione di una regola*, Atti del V Convegno di Studi Francescani, Ascoli Piceno, 16–27 Ottobre 1987 (Rome: Franciscanum, 1988)

Pecchiai, Pio, 'I lavori fatti nella chiesa della Minerva per collocarvi le sepulture di Leone X e Clemente VII', *Archivi d'Italia e Rassegna Internazionale degli Archivi*, ser. II, 17 (1950), 199–208

—— , *La Chiesa dello Spirito Santo dei Napolitani e l'antica chiesa di S. Aurea in via Giulia* (Rome: Ugo Pinnarò, 1953)

Pegg, Mark Gregory, *The Corruption of the Angels: The Great Inquisition of 1245–1246* (Princeton: Princeton University Press, 2001)

—— , 'Questions about questions: Toulouse 609 and the Great Inquisition of 1245–6', in *Texts and the Repression of medieval Heresy*, ed. by Caterina Bruschi and Peter Biller, York Studies in Medieval Theology, 4 (York: York Medieval Press, 2003), pp. 111–25

—— , *A Most Holy War: The Albigensian Crusade and the Battle for Christendom* (Oxford: Oxford University Press, 2008)

Pennington, Kenneth, 'The Fourth Lateran Council. Its Legislation and the Development of Legal Procedure', in *The Fourth Lateran Council: Institutional Reform and Spiritual Renewal*, ed. by Gert Melville and Johannes Helmrath, Proceedings of the Conference Marking the Eight Hundredth Anniversary of the Council, organized by the Comitato di Scienze Sroriche (Rome, 15–17 October 2015) (Affalterbach: Dydymos, 2017), pp. 41–54

Pesci, Benedetto, 'Il problema cronologico della Madonna di Aracoeli alla luce delle fonti', *Rivista di Archeologia Cristiana*, 18 (1941), 51–64

—— , *San Francesco a Ripa*, Chiese di Roma Illustrate, 49 (Rome: Edizioni Marietti, 1959)

Petrone, Gianluca, 'Vita monastica, committenze artistiche e trasformazioni architettoniche nel Cinquecento e Seicento' in *Santa Maria in Campo Marzio. Dalle origini orientali alla procura del Patriarcato di Antiochia dei Siri*, ed. by Marco Coppolaro (Rome: L'Erma di Bretschneider, 2021), pp. 39–70

Petrucci, Armando, *Writing the Dead: Death and Writing Strategies in the Western Tradition* (Stanford: Stanford University Press, 1998)

Pfisterer, Ulrich, *Donatello und die Entdeckung der Stile 1430–1445*, Römische Studien der Bibliotheca Hertziana, 17 (Munich: Hirmer, 2002)

Piazza, Carlo Bartolomeo, *La Gerarchia Cardinalizia* (Rome: Bernabò, 1703)

Pietrangeli, Carlo, 'Recenti restauri nella chiesa di S. Maria in Aracoeli', *Capitolium*, 30 (1955), 166–70

—— , 'Il palazzo del Senatore nel Medioevo', *Capitolium*, 35 (1960), 3–19

—— , 'Storia e architettura dell'Aracoeli', *Capitolium*, 40 (1965), 187–95

—— , 'Storia e istituzioni capitoline dal Medioevo all'età moderna', in *Il Campidoglio. Storia e illustrazioni del colle capitolino, dei monumenti, degli edifice e delle raccolte storiche e artistiche*, ed. by Carlo Pietrangeli (Rome: Capitolinum, 1965), pp. 13–28

—— , ed., *Guide Rionali di Roma*, 22 vols (Rome: Palombi, 1977–2000)

—— , *Rione III — Colonna*, Guide Rionali di Roma (Rome: Fratelli Palombi Editori, 1980)

Pisano, Giulio, 'L'ospizio-ospedale di San Sisto e la Compagna dei Mendicanti di S. Elisabetta', *Roma*, 6 (1928), 241–58

Pistilli, Pio F., 'Considerazioni sulla storia architettonica dell'abbazia romana delle Tre Fontane nel duecento', *Arte Medievale*, 2 serie, 6.1 (1992), 163–92

Platner, Samuel B., and Thomas Ashby, *A Topographical Dictionary of Ancient Rome* (London: Oxford University Press, 1929)

Polzer, Joseph, 'Andrea di Bonaiuto's "Via Veritatis" and Dominican Thought in Late Medieval Italy', *The Art Bulletin*, 77 (1995), 262–89

Pond, Kathleen, trans. and ed., *Love among the Saints: The Letters of Blessed Jordan of Saxony to Blessed Diana of Andalò* (London: Bloomsbury, 1958)

Poós, Ádám, *San Lorenzo in Damaso* (Rome: Parocchia di S. Lorenzo in Damaso, 2013)

Porzio, Pier Luigi, 'Il convento di San Francesco a Ripa e il quartiere di Trastevere', in *La Fabbrica del Convento: Memorie storiche, Trasformazioni e recupero del complesso di San Francesco a Ripa in Trastevere*, ed. by Paola Degni and Pier Luigi Porzio (Rome: Donzelli, 2011), pp. 3–19

Prandi, Adriano, 'Per Santa Sabina', *Strenna dei Romanisti*, 38 (1977), 307–14

Precorini, Arianna, 'Fondazioni femminili nella Provincia Tusciae del XIII secolo', *Collectanea Franciscana*, 8 (2010), 181–206

Priester, Ann Edith, 'The Belltowers of Medieval Rome and the Architecture of Renovatio' (unpublished doctoral dissertation, Princeton University, 1990)

——, 'The Bell Towers and Building Workshops in Medieval Rome', *Journal of the Society of Architectural Historians*, 52 (1993), 199–220

Quadri, Irene, 'La croce dipinta ai Santi Domenico e Sisto', in *Il Duecento e la cultura gotica 1198–1287*, ed. by Serena Romano (Milan: Jaca Book, 2012), pp. 274–77

Quaranta, Paola, Roberta Pardi, Barbara Ciarrocchi, and Alessandra Capodiferro, 'Il "giorno dopo" all'Aventino. Dati preliminari dai contesti di scavo', in *The Sack of Rome in 410 AD: The Event, its Context, and its Impact*, ed. by Johannes Lipps, Carlos Machado, and Philipp von Rummel, Deutsches Archäologisches Institut Rom, Palilia, 28 (Wiesbaden: Dr Ludwig Reichert, 2013), pp. 185–213

Quondam, Amadeo, 'Lanzichenecchi in convento. Suor Orsola Formicini e la storia tra archivio e devozione', *Schifanoia*, 6 (1988), 37–125

Ragusa, Isa, 'Mandylion-Sudarium: The Translation of a Byzantine Relic to Rome', *Arte Medievale*, 2 (1991), 97–106

——, 'The Edessan Image in S. Silvestro in Capite in the Seventeenth Century', in *Arte d'Occisente, Studi in onore di Angiola Maria Romanini*, vol. III, ed. by Antonio Cadei, Marina Righetti Tosti-Croce, Anna Segagni Malacart, and Alessandro Tomei (Rome: Edizioni Sintesi Informazioni, 1999), pp. 939–46

Rainini, Marco, 'La Fondazione e i primi anni del monastero di San Sisto: Ugolino di Ostia e Domenico di Caleruega', in *Il Velo, la Penna e la Parola. Le Domenicane: storia, istituzioni e scritture*, ed. by Gabriella Zara and Gianni Festa, Biblioteca di Memorie Domenicane (Florence: Nerbini, 2009), pp. 49–70

Rehberg, Andreas, *Die Kanoniker von S. Giovanni in Laterano und S. Maria Maggiore im 14. Jahrhundert. Ein Prosopographie*, Bibliothek des Deutschen Historischen Instituts in Rom, 89 (Tübingen: Max Niemeyer, 1999)

——, *Kirche und Macht im römischen Trecento: Die Colonna und ihre Klientelauf dem Kurialen Pfründenmarkt (1278–1378)*, Bibliothek des Deutschen Historischen Instituts in Rom, 88 (Tübingen: Max Niemeyer, 1999)

——, 'Nobiltà e monasteri femminili nel Trecento romano: il caso di San Sivestro in Capite e di San Lorenzo in Panisperna', *Retimedievali*, 19.1 (2018), 403–35

Riccioni, Stefano, 'Rewriting Antiquity, Renewing Rome. The Identity of the Eternal City through Visual Art, Monumental Inscriptions and the *Mirabilia*', in *Rome Re-imagined: Twelfth-Century Jews, Christians, and Muslims Encounter the Eternal City*, ed. by Louis I. Hamilton and Stefano Riccione, Special Offprint of Medieval Encounters, vol. 17 / 4–5 (Leiden: Brill, 2011)

——, 'From Shadow to Light: Inscriptions in Liminal Spaces of Roman Sacred Architecture (11th–12th century)', in *Sacred Scripture / Sacred Space*, ed. by Tobias Frese, Wilfried E. Keil, and Kristina Krüger (Berlin: De Gruyter, 2019). pp. 217–44

Richardson, Carol M., *Reclaiming Rome: Cardinals in the Fifteenth Century* (Leiden: Brill, 2009)

Righetti Tosti-Croce, Marina, 'Gli esordi dell'architettura Francescana a Roma', *Storia della Città* 9 (1978), 28–32

——, 'Appunti sull'architettura a Roma tra Due e Trecento', *Arte Medievale*, 2 (1984), 183–94

——, 'La Basilica tra due e trecento', in *Santa Maria Maggiore a Roma*, ed. by Carlo Pietrangeli (Florence: Nardini Editore, 1988), 129–69

——, 'L'architettura tra il 1254 e il 1308', in *Roma nel Duecento: l'arte nella città dei papi da Innocenzo III a Bonifacio VIII*, ed. by Angiola Maria Romanini (Turin: Ed. Seat, 1991), pp. 75–143

Robbins, D. K., 'A Case Study of Medieval Urban Process: Rome's Trastevere (1250–1450)' (unpublished doctoral dissertation, University of California, 1989)

Roberto, Sebastiano, 'I "teatri sacri" del Barocco nel cenobio dei Domenicani di Santa Sabina', in *L'Aventino dal Rinascimento a Oggi. Arte e Architettura*, ed. by Mario Bevilacqua and Daniela Gavallotti Cavallero (Rome: Editoriale Artemide, 2010), pp. 78–111

Roberto, Sebastiano, and Laura Bartoni, 'La Cappella di San Domenico', in *Il convento di Santa Sabina all'Aventino e il suo patrimonio storico-artistico e architettonico*, ed. by Manuela Gianandrea, Manuela Annibali, and Laura Bartoni (Rome: Campisano Editore, 2016), pp. 107–17

Robson, Michael, *The Franciscans in the Middle Ages* (Woodbridge: Boydell, 2006)

Romanini, Angiola Maria, 'L'architettura degli ordini mendicanti: Nuove prospettive di interpretazione', *Storia della città*, 9 (1978), 5–15

——, *Arnolfo di Cambio e lo 'stil nuovo' del Gotivo italiano* (Firenze: Sansoni, 1980)

——, ed., *Roma anno 1300*, Atti del Congresso internazionale di storia dell'arte medievale, Rome 19–24 maggio 1980 (Rome: L'Erma di Bretschneider, 1983)

——, 'Arnolfo e gli "Arnolfo" apocrifi', in *Roma anno 1300*, Atti del Congresso internazionale di storia dell'arte medievale, Rome 19–24 maggio 1980, ed. by Angiola Maria Romanini (Rome: L'Erma di Bretschneider, 1983), pp. 48–52

——, 'L'architettura dei primi insediamenti francescani', *Storia della Città*, 26/27 (1983), 9–14

——, ed., *Roma nel Duecento: l'arte nella città dei papi da Innocenzo III a Bonifacio VIII* (Turin: Ed. Seat, 1991)

——, 'Arnolfo architectus', in *Studi in onore di Giulio Carlo Argan* (Scandicci: Nuova Italia, 1994), pp. 71–94

Romano, Serena, 'Due affreschi del Cappellone degli Spagnoli: problemi iconologici', *Storia dell'Arte*, 26–28 (1976), 181–213

——, *Eclissi di Roma. Pittura murale a Roma e nel Lazio da Bonifacio VIII a Martino V (1295–1431)* (Rome: Argos, 1992)

——, 'Domenico di Guzmàn, Santo', in *Enciclopedia dell'Arte medievale*, 12 vols (Rome: Istituto dell'Enciclopedia Italiana fondato da Giovanni Treccani, 1994), vol. v, pp. 701–05

——, 'Gli affreschi di San Pietro in Vineis', in *Il collegio Principe di Piemonte e la Chiesa di S. Pietro in Vineis in Anagni*, ed. by Michele Rak (Rome: INPDAP, 1997), pp. 101–16

——, 'The Arca of St Dominic at Bologna', in *Memory and Oblivion*, Proceedings of the XXIX Congress of the History of Art held in Amsterdam, 1–7 September 1996, ed. by Reinink, A. W. and Stumpel, Jeroen (Amsterdam: Springer, 1999), pp. 499–513

——, ed., *Il Duecento e la cultura gotica 1198–1287*, La Pittura medievale a Roma, 312–1431, Corpus, 5 (Milan: Jaca Book, 2012)

——, *Apogeo e fine del Medioevo, 1288–1431*, Corpus, 6 (Milan: Jaca Book, 2017)

Romano, Serena, and Nicholas Bock, ed., *Le chiese di San Lorenzo e San Domenico: Gli ordini mendicanti a Napoli*. Atti della Giornata di Studi su Napoli, Losanna, 13 dicembre 2001, Études lausannoises d'histoire de l'art, 3 (Naples: Electa, 2005)

Roncelli, Angelita, 'Domenico, Diana, Giordano: la nascita del monastero di Sant'Agnese in Bologna', in *Il Velo, la Penna e la Parola. Le Domenicane: storia, istituzioni e scritture*, ed. by Gabriella Zara and Gianni Festa, Biblioteca di Memorie Domenicane (Florence: Nerbini, 2009), pp. 71–91

Ronci, Gilberto, 'Antichi affreschi in S. Sisto Vecchio a Roma', *Bollettino d'arte*, 36 (1951), 15–26

Rossini, Luigi, *Le Antichità Romane*, 2 vols (Rome: Scudellari, 1819–1823)

Rusconi, Roberto, 'The Spread of Women's Franciscanism in the Thirteenth Century', *Greyfriars Review*, 12.1 (1998), 35–75

——, *Francis of Assisi in the Sources and Writings*, trans. by Nancy Celaschi, OSF (Saint Bonaventure, New York: Franciscan Institute Publications, 2008)

Russell, Susan, 'A Drawing by Herman van Swanevelt for a Lost Fresco in S. Maria sopra Minerva, Rome', *The Burlington Magazine*, 143 (2001), 132–37

Russo, Daniel, 'Allégorie, analogie, paradigme. Étude sur la peinture de l'Église dominicaine par Andrea di Bonaiuto, à Florence, 1365–67', in *L'Allégorie dans l'art du Moyen Âge, Formes et fonctions. Héritages creations, mutations*, ed. by Christian Heck (Turnhout: Brepols, 2011), pp. 79–93

Russo, Laura, *Santa Maria in Aracoeli* (Rome: Elio de Rosa Editore, 2007)

Sacchi, Giuliano, 'Santi Cosma e Damiano in Mica Aurea (S. Cosimato): restauri nel protiro', *Cantieri e ricerche*, 2 (1997), 83–100

Sand, Alexa, *Vision, Devotion, and Self-Representation in Late Medieval Art* (Cambridge: Cambridge University Press, 2014)

Sansterre, Jean-Marie, *Les Moines grecs et orientaux à Rome aux époques byzantine et carolingienne: milieu du VIe — fin de IXe siècles*, 2 vols, Académie Royale de Belgique Mémoires de la Classe des Lettres, Collection 8, 2e série, T. 66 – Fascicule 1 (Brussels: Palais des Académies, 1983)

Sartorio, Aristide, 'Dei Chiostri benedettini distrutti sul Campidoglio', *Capitolium*, 4 (1928), 453–57

Scheeben, Heribert-Christian, 'Die Anfänge des zweiten Ordens des Hl. Dominikus', *AFP*, 2 (1932), 284–315

Schenkluhn, Wolfgang, *Ordines Studentes. Aspekte zur Kirchenarchitektur der Dominikaner und Franziskaner im 13. Jahrhundert* (Berlin: Mann, 1985)

——, *Architektur der Bettelorden. Die Baukunst der Dominikaner und Franziskaner in Europa* (Darmstadt: Wissenschaftlicher Buchgesellschaft, 2000) [Italian translation: *Architettura degli Ordini Mendicanti: Lo stile architettonico dei Domenicani e dei Francescani in Europa* (Padua: Editrici Francescane, 2003)]

Schiller, Gertrud, *Ikonographie der christlichen Kunst*, 4 vols (Gütersloh: Mohn, 1976)

Schmitt, Jean-Claude, 'Between Text and Image: The Prayer Gestures of Saint Dominic', *History and Anthropology*, 1 (1984), 127–62

——, *La Raison des gestes dans l'Occident medieval* (Paris: Gallimard, 1990)

——, 'Die Gebets – und Andachtsgesten des Heiligen Dominikus', in BAV, Codex Rossianus 3 (1). Modi Orandi Sancti Dominici facsimile edn: Die Gebets- und Andachtsgesten des Heiligen Dominikus. Einer Bilderhandschrift, Kommentarband von Leonard E. Boyle, OP und Jean-Claude Schmitt, Codices e Vaticanis selecti quam simillime expressis iussu Iohannis Pauli Vonsilio et Opera Curatorum Bibliothecae Vaticanis, 82 (Zürich: Belser, 1995), pp. 7–29

Schnaubelt, J. C., and F. van Fleteren, ed., *Augustine in Iconography, History and Legend*, Collectanea Augustiniana, 4 (New York: Lang, 1999)

Schreiner, Klaus, 'Pastoral Care in Female Monasteries: Sacramental Services, Spiritual Edification, Ethical Discipline', in *Crown and Veil: Female Monasticism from the Fifth to the Fifteenth Centuries*, ed. by Jeffrey F. Hamburger and Susan Marti (New York: Columbia University Press, 2008), pp. 225–44

Schuster, Ildefonso, *L'imperiale abbazia di Farfa: badia benedettina di Farfa*, Studi farfensi, 1 (Rome: Istituto Poligrafico dello Stato, 1987)

Schwarz, Frithjof, *Il bel cimiterio: Santa Maria Novella in Florence, 1279–1348. Grabmäler: Architektur und Gesellschaft* (Berlin: Deutscher Kunstverlag, 2009)

Serafini, Alberto, *Torri campanarie di Roma e del Lazio nel medioevo* (Rome: Presso la Società Romana di Storia Patria, 1927)

Sensi, Mario, 'The Women's Recluse Movement in Umbria during the 13th and 14th Centuries', *Greyfriars' Review*, 8.3 (1994), 319–45 [trans. by Edward Hagman, OFM Cap]

——, *'Mulieres in Ecclesia'. Storie di monache e bizzoche* (Spoleto: Fondazione CISAM, 2010)

Setti, Marco, and Angelo Broggi, 'Dal Lazzaretto all'insediamento della Curia dell'Ordine in Santa Sabina: l'ala Passarelli e il convento nuovo', in *Il convento di Santa Sabina all'Aventino e il suo patrimonio storico-artistico e architettonico*, ed. by Manuela Gianandrea, Manuela Annibali, and Laura Bartoni (Rome: Campisano Editore, 2016), pp. 135–44

Sgherri, Daniela, 'La Vergine con il Bambino in Santa Maria sopra Minerva', in *Apogeo e fine del Medioevo, 1288–1431*, ed. by Serena Romano, Corpus, 6 (Milan: Jaca, 2017), pp. 193–94

——, 'Il dipinto frammentario in San Gregorio Nazianzeno', in *Apogeo e fine del Medioevo, 1288–1431*, ed. by Serena Romano, Corpus, 6 (Milan: Jaca, 2017), pp. 241–42

——, 'La decorazione ad alfresco nell'antica abside e nella navata di San Sisto Vecchio', in *Apogeo e fine del Medioevo, 1288–1431*, ed. by Serena Romano, Corpus, 6 (Milan: Jaca, 2017), pp. 264–69

Shelby, Lon R., 'The Geometrical Knowledge of Medieval Master Masons', *Speculum*, 47.3 (1972), 395–421

Shorr, Dorothy C., 'The Iconographic Development of the Presentation in the Temple', *The Art Bulletin*, 28 (1946), 17–32

Sicari, Giovanni, 'Monastero dei Santi Cosma e Damiano in Mica Aurea: sue proprietà in Roma', *Alma Roma*, 23.3–4 (1983), 30–44

Sigismondi, Fabio, 'La Questione dell'iscrizione medievale di S. Sisto', in *La chiesa e il monastero di San Sisto all'Appia*, ed. by Raimondo Spiazzi, OP (Bologna: Edizioni Studio Domenicano, 1992), pp. 239–60

Simon, André, *L'Ordre des Pénitentes de Ste Marie Madeleine en Allemagne au XIIIe siècle* (Fribourg: Imprimerie et Librairie de L'Oeuvre de Saint-Paul, 1918)

Smith, Julie Ann, 'Prouille, Madrid, Rome. The Evolution of the Earliest Dominican *Instituta* for Nuns', *Journal of Medieval History*, 35 (2009), 340–52

——, '*Clausura Districta*: Conceiving Space and Community for Dominican Nuns in the Thirteenth Century' *Parergon*, 27 (2010), 13–36

——, '"The Hour That They Ought to Direct to the Study of Letters": Literate Practices in the Constitutions and Rule for the Dominican Sisters', *Parergon*, 31.1 (2014), 73–94

——, 'Shaping Authority in the Female Franciscan Rules and *formae vitae*', *Parergon*, 33.1 (2016), 23–48

Snow, Robert J., 'Dominican Chant', in *The Dictionary of the Middles Ages*, vol. IV, ed. by J. R. Strayer (New York: Scribner, 1984), pp. 240–41

Spera, Lucrezia, 'Trasformazioni e riassetti del tessuto urbano nel Campo Marzio centrale tra tardo antichità e medioevo', *Mélanges de l'Ecole Française de Rome Medioevale*, 126.1 (2014), 47–74

Spiazzi, Raimondo, OP, *Madre M. Antonia Lalìa fondatrice delle Suore Domenicane di S. Sisto*, 3 vols (Rome: Ed. S. Sisto, 1989, 1991 and 1992)

——, *La chiesa e il monastero di San Sisto all'Appia* (Bologna: Edizioni Studio Domenicano, 1992)

——, *Cronache e Fioretti del monastero di San Sisto all'Appia* (Bologna: Edizioni Studio Domenicano, 1993)

——, *San Domenico e il monastero di San Sisto all'Appia* (Bologna: Edizioni Studio Domenicano, 1993)

Spinelli, Raffaele, *S. Maria sopra Minerva*, Le Chiese di Roma Illustrate, 19 (Rome: Treves, 1928)

Spurr, David, *Architecture and Modern Literature* (Ann Arbor: University of Michigan Press, 2012)

St John Hope, W. H., 'The Gilbertine Priory of Watton, in the East Riding of Yorkshire', *Archaeological Journal*, 58 (1901), 1–34

Staccioli, Romolo Augusto, 'Trastevere nell'antichità e le testimonianze archeologiche nell'area di San Cosimato', in *'San Chosm' e Damiano e 'l suo bel monastero …': il complesso mounmentale di San Cosimato ieri, oggi, domani*, ed. by Gemma Guerrini Ferri and Joan Barclay Lloyd with Anna Maria Velli, Quaderni di TestoeSenso, 1/2013 (Rome: TestoeSenso Università Tor Vergata, 2013), pp. 113–14

Stein-Kecks, Heidrun, *Der Kapitelsaal in der mittelalterlichen Klosterbaukunst: Studien zu den Bildprogrammen*, Italiensiche Forschungen des Kunsthistorischen Instituts in Florenz, 4 (Munich: Deutscher Kunstverlag, 2004), pp. 255–67

Sterpi, Claudio, Vladimir Koudelka, and Maria Elena Crociani, *San Sisto Vecchio a Porta Capena* (Rome: Edizioni S. Sisto Vecchio, 1975)

Stewart, Robert M., '*De illis qui faciunt penitentiam*'. *The Rule of the Secular Franciscan Order: Origins, Development, Interpretation* (Rome: Biblitheca Seraphico-Capuccina, 1991)

Strinati, Claudio, 'Espressione figurative e committenza confraternale nella cappella Capranica alla Minerva', *Ricerche per la Storia di Roma*, 5 (1984), 395–428

Strinati, Tommaso, *Aracoeli: gli affreschi ritrovati* (Milan: Skira, 2004)

——, 'Il Medioevo "nascosto": una ricognizione di conservazione', *Monumenti di Roma*, 1–2 (2005/6), 169–76

Sturm, Saverio, Marco Canciani, Maria Pastor Altaba, and Marco d'Angelico, 'Dal monastero di S. Lorenzo in Panisperna al palazzo del Viminale: nuove metodologie d'indagine strumentale', in *Monasteri di Clausura a Roma*, ed. by Mario Bevilacqua, Marina Caffiero, and Saverio Sturm (Perugia: Quattroemme, 2018), pp. 305–21

Sundt, Richard A., '*Mediocres domos et humiles habeant fratres nostri*: Dominican Legislation on Architecture and Architectural Decoration in the Thirteenth Century', *Journal of the Society of Architectural Historians*, 46 (1987), 394–407

——, 'The Jacobin Church of Toulouse and the Origin of its Double-Nave Plan', *The Art Bulletin*, 71 (1989), 185–207

Sykes, Katharine, *Inventing Sempringham: Gilbert of Sempringham and the Origin of the Role of the Master* (Münster: LIT, 2011)

Tantucci, Ambrogio Ansano, OP, *De translatione Corporis et delatione Senis sacri capitis seraphicae virginis Catharinae Senensis …*, (Rome: ex typographio Paleariniano, 1742)

Taurisano, Innocenzo, OP, '*Quomodo Sanctus Patriarchus Dominicus orabat*', in *Analecta Sacri Ordinis Praedicatorum*, 15 (1922), 95–106

——, *Santa Sabina*, Le Chiese di Roma Illustrate, 11 (Rome: Palombi, 1925)

——, *S. Maria sopra Minerva e le Reliquie di S. Caterina da Siena* (Rome: Palombi, 1955)

Tempesta, Claudia, ed., *L'icona murale di Santa Sabina all'Aventino* (Rome: Gangemi Editore, 2010)

Terzi, Arduino, *San Francesco d'Assisi a Roma* (Rome: A. Nardini, 1956)

Thomas, Antoninus Hendrik, OP, *Die oudste Constituties van de Dominicanen: Voorgeschiedenis, Tekst, Bronnen, Onstaan en Ontwikkeling (1215–1237)* [with a summary in French] Bibliothèque de la Revue d'Histoire ecclésiastique, 42 (Leuven: Universiteitbibliotheek, 1965)

Thomas, Annabel, *Art and Piety in the Female Religious Communities of Renaissance Italy: Iconography, Space and the Religious Women's Perspective* (Cambridge: Cambridge University Press, 2003)

Thompson, Sally, *Women Religious: The Founding of English Nunneries after the Norman Conquest*, (Oxford: Oxford University Press, 1990)

Thumser, M., 'Die ältesten Statuten des Kapitels von S. Maria Maggiore in Rom (1262/1271, 1265)', *Quellen und Forschungen aus Italienischen Archiven*, 74 (1994), 294–334

——, *Rom und der römische Adel in der späten Stauferzeit* (Tübingen: Niemeyer, 1995)

Tiberia, Vitaliano, *I mosaici del XII secolo e di Pietro Cavallini in Santa Maria in Trastevere: restauri e nuove ipotesi* (Todi: Ediart 1996)

Tillman, Hélène, 'Ricerche sull'origine dei membri del collegio cardinalizio nel XII secolo', *Rivista di Storia della Chiesa*, 29 (1975), 363–402

Toesca, Ilaria, 'Il reliquario della Testa di San Giovanni Battista nella chiesa di S. Silvestro in Capite a Roma', *Bollettino d'Arte* (1961), 307–14

——, 'La cornice dell'immaggine edessina di San Silvestro in Capite a Roma', *Paragone. Arte*, 217 (n.s. 37), 19 (1968), pp. 33–37

Toesca, Pietro, *Il trecento* (Turin: UTET, 1951)

Tomassetti, Giuseppe, *Della Campagna Romana*, 7 vols (Rome: Reale Società di Storia Patria, 1848–1911)

Tomassi, Pietro, *Chiesa di San Lorenzo in Panisperna: breve guida storica-artistica* (Frascati: Tipografia Grammarioli, 1967)

Tomei, Alessandro, *Iacobus Torriti Pictor: una vicenda figurativa del tardo duecento romano* (Rome: Argos, 1990)

——, *Pietro Cavallini* (Milan: Silvana, 2000)

Tomei, Piero, *L'architettura a Roma nel Quattrocento* (Rome: Palombi, 1942)

Torrigio, Francesco Maria, *Historia della veneranda Immagine de Maria Vergine posta nella Chiesa del Monastero delle RR. Monache di Santi Sisto e Domenico di Roma* (Rome: Manelfi, 1641)

Tosini, Patrizia, 'New Documents for the Chronology and Patronage of the Cappella del Rosario in S. Maria sopra Minerva, Rome', *Burlington Magazine*, 152.1289 (2010), 517–22

Travani, Lucia, *Monete e storia nell'Italia medievale* (Rome: Libreria dello Stato, Istituto Poligrafico e Zecca della Stato, 2007)

Trinci Cecchelli, Margherita, *Corpus della Scultura altomedioevale, VII: La Diocesi di Roma*, Tomo quarto. La I. Regione Ecclesiastica (Spoleto: Centro Italiano sull'Alto Medioevo, 1978)

Tugwell, Simon, OP, 'The Nine Ways of Prayer of St Dominic. A Textual Study and Critical Edition', *Medieval Studies*, 47 (1985), 1–124

——, 'St Dominic's Letter to the Nuns in Madrid', *AFP*, 56 (1986), 5–13

——, 'Notes on the Life of St Dominic', *AFP*, 65 (1995), 5–169

——, 'Notes on the Life of St Dominic', *AFP*, 66 (1996), 5–200

——, 'Notes on the life of St Dominic', *AFP*, 67 (1997), 27–59

——, 'Notes on the Life of St Dominic', *AFP*, 68 (1998), 5–116

——, *Saint Dominic and the Order of Preachers* (Dublin: Dominican Publications, 2001)

——, 'Notes on the Life of St Dominic', *AFP*, 73 (2003), 5–141

——, 'For whom was Prouille founded?', *AFP*, 74 (2004), 5–125

——, 'Schema chronologique de la vie de Saint Dominique', in *Domenico di Caleruega e la Nascita dell'Ordine dei Frati Predicatori*, Atti del XLI Convegno Internazionale di Studi sull'Alto Medioevo, Nuova Serie diretta da Enrico Menesto, 18 (Spoleto: Fondazione Centro Italiano di Studi sull'Alto Medioevo, 2005), pp. 1–24

Tylus, Jane, 'Mystical Literacy: Writing and Religious Women in Medieval Italy', in *A Companion to Catherine of Siena*, ed. by C. Muessig, G. Ferzoco and B. Kienzle (Leiden: Brill, 2011), pp. 155–83

Udina, Cristina, 'Dallo xenodocchio benedettino al convento francescano', in *La Fabbrica del Convento: Memorie storiche, Trasformazioni e recupero del complesso di San Francesco a Ripa in Trastevere*, ed. by Paola Degni and Pier Luigi Porzio (Rome: Donzelli, 2011), pp. 21–53

Underwood, Paul Atkins, *The Kariye Djami*, Bollingen Series, 70, 4 vols (New York: Pantheon, 1966)

Untermann, Matthias, 'The Place of the Choir in Churches of Female Convents in the Medieval German Kingdom', in *Women in the Medieval Monastic World*, ed. by Janet Burton and Karen Stöber (Turnhout: Brepols, 2015), pp. 327–35

Urban, Gunther, 'Die Kirchenbaukunst des Quattrocento in Rom', *Römisches Jahrbuch für Kunstgeschichte*, 9/10 (1961–1962), 73–287

Urbani, Giovanni, 'Anonimo fine secolo XIII: *Madonna col Bambino*, tav. m. (A) 0,81 × 0,61, m., Roma, S. Cosimato', *Bollettino dell'Istituto Centrale del Restauro*, 7/8 (1951), 55–58

Valentini, Roberto, and Giuseppe Zucchetti, *Codice Topografico della Città di Roma*, 4 vols, Fonti per la Storia d'Italia (Rome: Reale Istituto Storico Italiano per il Medio Evo, 1940, 1942, 1946, 1953)

van Marle, Raimond, *The Development of the Italian Schools of Painting*, 18 vols (The Hague: Martinus Nijhoff, 1923–1938)

Vann, Gerald, *To Heaven with Diana* (London: Collins, 1960)

Vasari, Giorgio, *Le Vite de' più eccellenti Pittori, Scultori ed Architettori, nelle redazioni del 1550 e 1568*, Text ed. by Rosanna Bettarini and Commentary ed. by Paolo Barocchi (Florence: Sansoni Edtori, 1967)

Vauchez, André, *Sainthood in the Later Middle Ages*, trans. by Jean Birrell (Cambridge: Cambridge University Press, 2005)

——, *Francis of Assisi: The Life and Afterlife of a Medieval Saint*, trans. by Michael F. Cusato, OFM (New Haven: Yale University Press, 2013)

——, *Catherine of Siena: Life of Passion and Purpose*, trans. by Michael F. Cusato, OFM (New York: Paulist, 2018)

Velli, Anna Maria, ed., *Nuovi Studi su San Cosimato e Trastevere* (Rome: Graphofeel Edizioni, 2017)

Venanzi, Corrado, 'Il Campanile Romanico di Santa Maria in Aracoeli', *Bollettino del Centro Nazionale di Studi di Storia dell'Architettura*, 4 (1945), 6–7

Venanzi, Corrado, *Caratteri costruttivi dei Monumenti, 1: Strutture murarie a Roma e nel Lazio* (Spoleto: Panetto e Petrelli, 1953)

Vicaire, Marie-Humbert, OP, *Saint Dominique de Caleruega d'après les documents du XIII siècle* (Paris: Editions du Cerf, 1955)

——, *Histoire de Saint Dominique: au Coeur de l'Église*, 2 vols (Paris: Les Editions du Cerf, 1957)

——, 'Dominique (Saint)', in *Dictionnaire d'histoire et de géographie ecclésiastiques* ed. by R. Aubert and E. van Cauvenbergh, XIV (Paris: Letouzey et Ané, 1960), cols 592–608

——, *L'imitation des Apôtres. Moines, chanoines, mendicants (IVe – XIIIe siècles)* (Paris: Cerf, 1963)

——, *Saint Dominic and his Times* (London: Darton, Longman, and Todd, 1964)

——, *Dominique et ses prêcheurs* (Fribourg: Editions Universitaires, 1977)

——, '"Vesperus" (L'étoile du soir) ou l'image de Saint Dominique pour ses Frères au XIIIe Siècle', *Mémoire Dominicaine* 29 (2012), pp. 83–115

Villetti, Gabriella, 'L'architettura degli Ordini mendicanti a Priverno nel Due- Trecento', *Palladio*, 11 (1993), pp. 23–36

Villetti, Gabriella, and Giancarlo Palmerio, *Santa Maria sopra Minerva in Roma: notizie dal cantiere* (Rome: Bonsignori Editori, 1994)

Viollet-Le-Duc, Eugène-Emmanuel, *On Restoration*, ed. and trans. by Charles Wethered (London: Sampson Low, Marston Low and Crown Buildings in Fleet Street, 1875)

Visser, Margaret, *The Geometry of Love: Time, Space, and Meaning in an Ordinary Church* (New York: New Point Press, 2001)

Vitali, Federica, 'Gli affreschi medioevali di S. Sisto Vecchio in Roma', in *Roma anno 1300*, Atti del Congresso internazionale di storia dell'arte medievale, Rome 19–24 maggio 1980, ed. by Angiola Maria Romanini (Rome: L'Erma di Bretschneider, 1983), pp. 433–41

Voci, Federica, 'Donne a Roma nei secoli centrali del medioevo' (unpublished PhD thesis, Università Tor Vergata, 2011)

Voltaggio, Mattia, '… et stavan confusamente'. La Storia delle carte del monastero di San Cosimato di Roma', in *'San Chosm' e Damiano e 'l suo bel monasterio …': il complesso mounmentale di San Cosimato ieri, oggi, domani*, ed. by Gemma Guerrini Ferri and Joan Barclay Lloyd with Anna Maria Velli, Quaderni di TestoeSenso, 1/2013 (Rome: TestoeSenso Università Tor Vergata, 2013), pp. 61–87

Vout, Caroline, *The Hills of Rome: Signature of an Eternal City* (Cambridge: Cambridge University Press, 2012)

Wagner-Rieger, Renate, 'Zur Typologie italienischer Bettelordenskirchen', *Römische Historische Mitteilungen*, 2 (1957/58), 266–98

Wakefield, Walter L., *Heresy, Crusade, and Inquisition in Southern France, 1100–1250* (Berkeley: California University Press, 1974)

Walker, James Bernard, *The 'Chronicles' of Saint Antoninus: A Study in Historiography*, Studies in Medieval History, 6 (Washington, DC: The Catholic University of America, 1933)

Wickham, Chris, *Medieval Rome: Stability and Crisis of a City, 900–1150* (Oxford: Oxford University Press, 2015)

Wilson, A., 'The Water Mills on the Janiculum', *Memoirs of the American Academy in Rome*, 45 (2000), 219–46

Wolf, Gerhard, *Salus populi romani: Die Geschichte römischer Kultbilder im Mittelalter* (Weinheim: VCH, Acta Humaniora, 1990)

——, 'La Veronica e la tradizione romana di icone', in *Il Ritratto e la Memoria*, ed. by Augusto Gentili, Philippe Morel, and Claudio Cieri, Materiali 2, 'Europa delle Corti', Centro Studi sulle società di antico regime, Biblioteca del Cinquecento, 55 (Roma: Bulzoni, 1993), pp. 9–35

——, 'From Mandylion to Veronica: Picturing the "Disembodied" Face, Disseminating the True Image of Christ in the Latin West', in *The Holy Face and the Paradox of Representation*, ed. by Herbert L. Kessler and Gerhard Wolf, Villa Spelman Colloquia, 6 (Bologna: Buova Alfa Editoriale, 1998), pp. 153–79

——, 'Icon and Sites. Cult Images of the Virgin in Mediaeval Rome', in *Images of the Mother of God. Perceptions of the Theotokos in Byzantium*, ed. by Maria Vassilaki (Aldershot: Ashgate, 2005)

Wood, Jeryldene, 'Perceptions of Holiness in Thirteenth-Century Italian Painting: Clare of Assisi', *Art History*, 14.3 (1991), 301–22

——, 'Breaking the Silence: The Poor Clares and the Visual Arts in Fifteenth-Century Italy', *Renaissance Quarterly*, 48.2 (1995), 262–86

——, *Women, Art and Spirituality: The Poor Clares of early Modern Italy* (Cambridge: Cambridge University Press, 1996)

Wood Brown, James, *The Dominican Church of Santa Maria Novella at Florence: A Historical, Architectural, and Artistic Study* (Edinburgh: Otto Schulze, 1902)

Zangari, Mattia, 'Sulle ultime ricerche in merito alla santità femminile dell'età medievale e della prima età moderna', *Annali della Scuola Normale Superiore di Pisa, Classe di Letter e Folosofia*, 5.2 (2018), 435–65

Zara, Gabriella, and Gianni Festa, ed., *Il Velo, la Penna e la Parola. Le Domenicane: storia, istituzioni e scritture*, Biblioteca di Memorie Domenicane (Florence: Nerbini, 2009)

Zarri, Gabriella, 'Introduzione', in *Il Velo, la Penna e la Parola. Le Domenicane: storia, istituzioni e scritture*, ed. by Gabriella Zara and Gianni Festa, Biblioteca di Memorie Domenicane (Florence: Nerbini, 2009), pp. 11–20

Zawilla, Ronald J., OP, 'Dominican Rite', in *The Dictionary of the Middle Ages*, vol. IV, ed. by J. R. Strayer (New York: Scribner, 1984), pp. 241–42

Zucchi, Alberto, OP, *Roma domenicana: note storiche*, 4 vols (Florence: Memorie Domenicane, 1938)

——, 'Roma Domenicana: La chiesa e il convento di S. Maria sopra Minerva', *Memorie Domenicane*, 60 (1943), 52–55

——, 'Roma Domenicana. La costruzione della nuova Chiesa della Minerva', *Memorie Domenicane*, 60 (1943), 141–48

——, 'Roma Domenicana. 1. La fondazione domenicana di S. Maria sopra Minerva', *Memorie Domenicane*, 60 (1943), 97–105

——, 'La chiesa dei Santi Domenico e Sisto a Magnapoli', in *La chiesa e il monastero di San Sisto all'Appia*, ed. by Raimondo Spiazzi, OP (Bologna: Edizioni Studio Domenicano, 1992), pp. 459–77

Zucchi, Alberto, and Isnardo Pio Grossi, 'L'antico convento della Minerva', *Memorie Domenicane*, 84 (1967), 143–61

Zuraw, S. E., 'The Public Commemorative Monument: Mino da Fiesole's Tombs in the Florentine Badia', *The Art Bulletin*, 80 (1998), 452–77

Index

Academy of the Arcadians: 151
Accaiuoli, Angelica, Abbess: 326
acheiropoietos (not made by human hands): 73, 204, 337
Acquaroni, Ermingilda, Abbess: 203
Acts of Thaddaeus (*Addai*): 337
Advocata. *See*: Icons: Maria Advocata
aediles M. Aemilius Lepidus and M. Aemilius Paulus: 101
Agapitus II, Pope: 220
Agbar, King of Edessa: 336, 337
Aistulf, King of the Lombards: 309 n. 15, 310
Alaric: 102
Alatri, S. Sebastiano. *See*: Franciscan nunneries in places other than Rome
Alberic: 136, 147, 190
Alberini, Giacomo: 297
Albert, OP priest at S. Sisto: 70
Albert the Great, OP, St: 222
Albertoni, Ludovica, Blessed: 166, 171
Alberzoni, Maria Pia: 35 n. 48, 70 n. 162, 87–88, 193 nn. 55–57; 194 nn. 63, 69; 195 nn. 74, 78
Alexander II, Pope: 159, 169, 185, 191, 199
Alexander III, Pope: 159 n. 30
Alexander IV, Pope: 32, 83, 195, 220 n. 40, 222–23, 226, 255, 269, 270, 320
Alexander, St: 118, 135
Alfani, Emmanuele: 51
Alessio, St: 97, 101, 147, 166, 241
Almo River. *See*: Mariana River
Alphanus, papal Chamberlain: 312, 328
altar of Augustan Peace (Ara Pacis): 259
altar of heaven (Ara Coeli): 218, 227, 233–34, 239
altar of Mars: 258
altar of the son of God: 213, 233
Altemps, Mark Sittich von Hohenems, Cardinal: 231
alter Christi (another Christ): 37
Altrude of the Poor: 318, 341
Ambrose, St: 81
Ambrosian Friars ad Nemus: 201

Amicie, daughter of Simon de Montfort: 90
Anaclete II /Anacletus II, Pope, later declared Antipope: 218, 220, 226, 234, 309
Anacletus I, Pope: 234
Anagni: 32, 210, 223, 324
 cathedral crypt, painters: 223, 360 n. 11
 S. Pietro in Vineis: *See*: Franciscan nunneries in places other than Rome
Anastasius I, Pope: 45, 57, 59
Anastasius of Persia, St: 339
Andrew of Crete: 337
Andrews, Francis: 18, 222 n. 53, 355 n. 3
'Angelicum' (Pontifical University of Saint Thomas Aquinas): 31, 73, 93, 303
Aniene River: 45
Anna, Abbess: 268
Anthony of Padua, St, 174, 175
Antoniazzo Romano: 299, 301
Antonine Baths (Thermae Antonianae). *See*: baths: Baths of Caracalla
Antonine Column (Column of Marcus Aurelius): 311
Antonino Pierozzi, OP, St. (*also known as* Antoninus): 344, 350–53
Antonio del Massaro: 200, 359, Fig. 99
Apostolic life (*Vita apostolica*) 96, 355
Appian Gate. *See*: Porta San Sebastiano
Appius Claudius Caecus: 101
aqueducts: 31
 Aqua Alsietina: 155
 Aqua Appia: 101, 104
 Aqua Iulia: 45 n. 23
 Aqua Marcia: 101
 Aqua Traiana: 155
 Aqua Virgo: 260
 aqueduct in ruins at SS. Cosma e Damiano in Mica Aurea: 178
 aqueduct underground at S. Sabina: 101, 104
Ara Coeli. *See*: altar of Heaven
Arca di S. Domenico (St Dominic's tomb): 128

Arch of Domitian (*also known as* Arco di
 Portogallo): 308
Archpriest of the Lateran: 325
Archpriest of S. Sebastiano: 205
Archpriest Theodore: 117
Armilustri Square: 100
Arnolfo, Abbot: 313
'*Arx*' (citadel): 213–15
Asia Minor: 158, 339
Assisi: 17, 18, 27 n. 9, 28, 32, 35–38, 48, 49 n. 38,
 74, 153, 158 n. 21, 160–64, 168–70, 172, 176,
 193 nn. 55–57; 194, 195 nn. 73, 74, 78; 221, 224, 229,
 242–43, 319, 349, 357
Assisi, churches
 Portiuncula: 36, 153
 S. Chiara: 168, 357
 S. Damiano: 29, 36, 49 n. 38, 153 n. 3, 194
 S. Francesco: 35, 36, 74, 164, 229
 S. Maria degli Angeli: 36, 37, 160, 161
 S. Pietro: 37
Associazione Mica Aurea: 18, 186
Auguraculum (place of augury): 215
Augustus, Emperor: 31, 45, 100, 155, 213, 215, 216,
 233–34, 259
Aula Gotica (Gothic Hall): 33 n. 35, 197 n. 82, 223,
 274, 360 n. 11
Aurelian Walls: 31, 48, 155–56, 269
Aventine Hill. *See*: hills of Rome: traditional seven
 hills
aureolae (crowns): 349 n. 75, 350
Avignon: 17, 29, 31 n. 26, 87 n. 252, 313 n. 51,
 322 n. 107, 325–26, 343

Balbi, Filippo: 267
Balbi: L. Cornelius, 260
Bandinelli, Baccio: 286
Barberini, Antonio, Cardinal: 132 n. 176, 241 n. 169,
 290, 292 n. 230, 304
Barresi, Paolo: 58
basilica Crescentiana: 45, 59
basilica of St John Lateran. *See*: churches in Rome:
 S. Giovanni Laterano
basilica of St Peter's. *See*: churches in Rome: Old
 St Peter's / St Peter's basilica
Baths (Thermae): 155
 Baths of Agrippa: 260

Baths of Alexander Severus: 260
Baths of Caracalla (*also known as* Antonine
 Baths [Thermae Antonianae]): 44, 45, 48,
 Figs 2, 3
Baths of Constantine: 278, Fig. 127
Baths of Decius: 101
Baths of Mamertinus: 45
Baths of Nero: 260
Baths of Surae: 101
Beato Angelico (*also known as* Fra Angelico or
 Fra Giovanni da Fiesole), OP: 291, 296 n. 253
 tomb (in S. Maria sopra Minerva): Fig. 142
Belardi, Giovanni: 274, 284
Beaven, Lisa: 18, 241 n. 175
Bedouelle, Guy, OP: 35, 36 n. 54, 38 n. 66, 43 nn. 1,
 2, 7; 44 n. 10, 143 n. 233, 145, 146 n. 241
Belting, Hans: 71 nn. 173, 177; 335, 336 nn. 163, 167;
 338 nn. 181–86
Benedict of Soracte: 308, 309, 336
Benedict XI, Pope: 33, 324
Benedict XIII, Pope: 49, 136, 146, 240, 262, 263, 279,
 290, 298
Benedict of Montefiascone, OP: 61, 70, 88 n. 260,
 97 n. 13, 122, 352
Benedictine monasteries
 at Farfa: 159, 180, 190, 191
 at Monte Cassino: 159, 160 n. 31, 169, 191, 221,
 231, 239, 286–87, Fig. 81
 at Soracte: 309
 at Subiaco: 220, 313
 fresco of St Francis: 318
 in Rome
 S. Andrea in Clivo Scauri: 221, 309
 S. Anselmo: 97, 102, 111 (n. 67)
 SS. Cosma e Damiano in Mica Aurea
 (*see also*: Franciscan church and nunnery
 of S. Cosimato; and Franciscan church
 and friary of S. Francesco a Ripa): 18,
 27, 30 n. 20, 153, 155–56, 158–60, 169, 172,
 177–80, 183–88, 190–92, 193 nn. 55, 61; 195,
 196 n. 82, 199 nn. 89, 96; 204, 205, 220,
 268 n. 44, 308, 311, 356
 S. Lorenzo fuori le Mura: 27, 52, 54 n. 57, 66,
 81 n. 219, 170, 171 n. 85, 237, 289, 313
 S. Lorenzo in Panisperna: 325

S. Maria in Capitolio (*see also*: Franciscan church and friary of S. Maria in Aracoeli): 28, 169, 178, 213, 219–27, 311, 316, 356
 bell tower / campanile: 120, 358
 'hegoumenos' inscription: 220
 hypothetical reconstructions of the Benedictine church: 226–27
 possessions, 220–21, 225
 Privilege of Ancletus II, Pope (*see also*: Anaclete II): 220–21
S. Paolo fuori le Mura: 27, 59, 79 n. 212, 102, 120, 169, 231, 233, 254, 289, 313, 357
S. Silvestro in Capite (*see also*: Franciscan church and nunnery of S. Silvestro in Capite): 307 n. 2, 313 n. 50
S. Valentine: 310
near Viterbo, S. Terentianus: 311
Benedictine nunneries in Rome
 S. Agnese fuori le Mura: 34
 S. Bibiana: 70
 S. Ciriaco, 34, 73
 S. Maria in Campo Marzio (after Byzantine nuns): 73, 267, 268, 270, 272 n. 83, 356
 S. Maria in Iulia: 34
 S. Maria in Tempulo: 48, 70–73, 359, Fig. 6
 SS. Cosma e Damiano in Regione S. Eustachio: 93
Benedictine revival of architecture in the eleventh century: 191
Benedictus Campaninus: 190
Bernardine plan: 127, 275
Bernerio, Girolamo, OP, Cardinal: 136, 143
Bernini, Gian Lorenzo: 166, 171
Bersaglieri barracks: 158, 172
Bertelli, Carlo: 71 nn. 173, 176, 177; 72, 335, 338 nn. 185, 188
Berthier, Joachim Joseph, OP: 44 n. 12, 61 n. 108, 82 nn. 226–28; 83 nn. 229–30, 233; 88 nn. 261–62; 89 nn. 263, 270; 91 n. 284, 93 n. 301, 96 n. 12, 103 n. 44, 113 n. 74, 118 n. 101, 122 n. 116, 123 n. 119, 124 nn. 125, 134; 126 nn. 137, 138; 127 n. 149, 129 nn. 160–62; 131, 137–38, 146, 260 nn. 11, 14; 263, 265 n. 30, 267, 268 n. 43, 269 n. 53, 270 nn. 66, 69; 271 nn. 74–75, 79–80; 273 n. 98, 286 nn. 184–85; 287 n. 188, 291 n. 222, 292 nn. 228, 231
Bertini, Milan, makers of Neo-Gothic stained-glass: 267

Besson, Hyacinthe, OP: 53, 104
Bianchedì, Girolamo, OP: 263, 265, 267, Fig. 130
Biblioteca Casanatense: 118 n. 97, 147 n. 250, 303–04
Biblioteca Comunale degli Intronati, Siena: 342
Bicchieri, Guala, Cardinal: 271
'bizoke' (semi-religious women): 61
Black Death: 241
Blake, Jeremy M.: 17, 35, 104, 182, 183 n. 20, 273 n. 102, 281 n. 152, Figs 4, 10, 13, 38, 41–46, 68, 71, 82, 89–92, 94
Blanche, Sr, OP: 70
Blanche of Castille: 320
Boccamazza family
 Pietro (?): 272
 Sr Angelica, OP: 82, 83, 149
 Sr Catherine, OP: 93
 Giovanni, Cardinal: 68, 82, 83, 90, 93, 149, 202, 225, 272, 273
 Sisters from the family at S. Sisto: 82
Boccasini, Niccolò, Cardinal (later, Benedict XI, Pope): 33, 324
Bolgia, Claudia: 18, 28 n. 11, 34 n. 41, 38 n. 65, 73 n. 187, 158 n. 20, 169–71, 174 n. 11), 175 n. 117, 213 nn. 1, 2, 4; 215 nn. 11, 12, 15; 218, 219 nn. 25–27, 29; 220 n. 41, 223 n. 54, 224–35, 237, 238 nn. 150, 151; 239, 240 nn. 165, 167; 241 n. 175, 242, 244–51, 253 nn. 249, 251; 254–55 n. 260, 278, 287, 289 nn. 204–05; 316, 329 n. 138, 359 n. 10, 360 n. 12, 361 n. 17
Bologna: 18, 36, 46, 74, 122, 127, 143, 150
 S. Maria della Mascarella: 69 n. 157
 S. Domenico (before 1251, S. Nicolò): 74, 86, 127 n. 146, 271
 S. Nicolò delle Vigne (after 1251, Domenico): 36, 127, 128 n. 151
Bolton, Brenda: 18, 27 n. 7, 44 n. 12, 61 n. 107, 62 n. 108, 114; 69, 269 n. 55
Bomarzo: 311
Bonaventure, St: 161, 174, 221, 22, 240, 255, 311, 320
Bonfanti, Giuseppe: 185
Boniface VIII, Pope: 33, 34, 88, 222, 251, 265, 271, 285, 294 n. 147, 320, 324–26, 352
Borioni, Antonio Maria: 303
Borromini, Francesco: 134, 135, 332, Fig. 65
Bracciolini, Poggio: 350

Bradford-Smith, Elizabeth: 18, 263 nn. 22, 23; 275 n. 117
Brandi, Ambrosio, OP: 257 n. 6, 269, 270 nn. 70, 71; 271 n. 79, 286, 290–92, 294 n. 247, 296 n. 253, 297–99, 301 nn. 284, 287; 303 n. 308, 304 nn. 314–17
Brandi, Giacinto: 314
Brentano, Robert: 31 n. 26, 87, 313, 322 n. 107
bridges over the Tiber
 pons Aemilius (*also known as* Ponte S. Maria or Pons S. Maria Palatinus): 92, 156, 180, 204
 pons Cestius: 155, 156
 pons Fabritius (*also known as* pons Quattuor Capitum Fabritius): 155, 156
 Ponte Garibaldi: 181
 Ponte Sant'Angelo: 241
Bridget of Sweden, St: 326, 349
Brühl, Carlrichard: 148
Brusati Arcucci, Giuseppe: 171
Bruzelius, Caroline: 18, 27 n. 6, 32 n. 30
Bufalini, Leonardo: 114, 124, 138, 165, 287
Bull-Simonsen Einaudi, Karin: 18, 27 n. 10, 155 n. 12, 158, n. 13, 159 nn. 25–28; 177 nn. 2, 4, 5; 183, 185 nn. 21, 22, 26; 186 nn. 27–32; 188 nn. 34, 36, 37; 190 nn. 38, 40; 191 nn. 51–53; 193 n. 55, 196 n. 82, 198 n. 84, 201 nn. 103, 105; 203 nn. 112, 115; 207 n. 128, 209 n. 131, 268 n. 44
burials in Mendicant churches: 222, 271, 272, 279, 297
Buoncompagni, Filippo, Cardinal: 49, 51, 57, 59
Byzantine Emperor: 72, 338
Byzantine Empire: 240, 336
Byzantine festival, 338
Byzantine gesture of blessing: 204
Byzantine iconoclasm: 310 n. 23, 337 nn. 177, 179, 180; 339 n. 194
Byzantine mosaics: 80
Byzantine nuns in Rome: 267, 268, 356
Byzantine vestments: 311
Byzantine world: 336
Byzantium (*see also*: Constantinople): 159 n. 31, 309, 310 n. 23, 337, 339

Caccialupi, Vitale, 343
Caelian Hill. *See*: hills of Rome: traditional seven hills

Caetani (*also known as* Gaetani) family: 33, 324
 Antonio, Cardinal: 273
 Benedetto, Cardinal (later, Pope Boniface VIII) 251, 320, 324
 Sr Maria Belardina; 209
Cagliari, church of San Francesco: 168
Caglioti, Francesco: 294 n. 244, 344 n. 22, 350, 351
Caleruega, Castile: 36
Calixtus II, Pope: 45, 47, 52, 312, 328
Camaldolese community: 177
'Camellaria': 219
Cameron, Averil: 72 n. 179, 337, 339 n. 194
Campania: 318
Campo, Abbot of Farfa: 190
Campo de' Fiori: 92, 241, 260, 299, 348
Campo Marzio: 31, 73, 258, 267–68, 270, 272 n. 83, 307, 356
Campus Martius. *See*: Campo Marzio
Canigiani, Barduccio di Pietro: 346, 349
Caninus, Benedetto: 342
Cannesio, Michele: 239
Cannon, Joanna: 27 n. 6, 35, 38 nn. 62, 64; 74, 84 n. 239, 124, 126–28, 143 n. 234, 285 n. 179, 287 n. 191
canonization
 of St Catherine of Siena: 29, 75, 85, 293, 294, 344, 349, 351
 of St Dominic: 37 n. 68, 159
 of St Francis: 39 n. 70, 160
 of St Hyacinth Odrowitz: 136
 of St Margaret of Castello: 343 n. 15
 of St Peter Martyr: 129
 of St Pius V: 146
 of St Rose of Lima: 146
Canons: 30, 95
 Gilbertine Canons: 62, 63, 69
 Lateran Canons: 46, 325
 Regular Canons: 36
Capitoline Hill. *See*: hills of Rome: traditional seven hills
Capitolium (Capitol): 213 n. 5, 214, 215, 218, 220, 224, 229, 230, 234, 240, 244, 256
Capocci family: 244, 246, 247
 Angelo, Captain of the People: 247
 Giacomo di Giovanni, Senator of Rome: 247
 Giovanni: 247
 Luciana: 247
 Pietro, Prior of the Lateran Canons: 325

Capodiferro family's chapel in S. Maria in Aracoeli: 245, 248 n. 222

Capranica chapel in S. Maria sopra Minerva: 294, 296

Capranica coat of arms: 289

Capranica family: 294
 Angelo, Cardinal: 351
 Camillo: 294
 Domenico, Cardinal: 289, 294, 351

Carafa, Oliviero, Cardinal: 238, 262, 291 n. 224, 294 n. 243, 298, 302

Carbonetti Vendittelli, Cristina: 44 n. 12, 46 nn. 25, 26; 47 n. 29, 82 n. 228, 83 n. 234, 87 n. 251, 92 nn. 288–96; 342 n. 6

Cardinal Protector of the Franciscan Order: 33, 153, 222, 255

Cariboni, Guido: 35 n. 48, 70 n. 170, 87, 90, 194 nn. 63–64

Carletti, Giuseppe: 307 n. 2, 334 nn. 155, 157; 338, 340 n. 196

Cartaro, Mario: 44, 154, 156, 178, Figs 2, 75

Casali, Andrea: 55

Casanate, Domenico, Cardinal: 303

Casimiro, Romano: 215 n. 16, 220 n. 40, 224 n. 67, 228 n. 8), 230 n. 95, 233, 235 n. 136, 238, 239 nn. 152, 156; 240 n. 163, 241 nn. 170, 172, 174, 177; 243 n. 186, 244 nn. 188, 190; 247, 248–49 n. 231, 250 n. 234, 253, 254 nn. 252, 255

Castel Sant' Angelo (*also known as* the Mausoleum of Hadrian): 241, 312

Catacomb at S. Lorenzo fuori le Mura: 52

Catacomb of Calixtus: 52

Catacombs: 53, 310, 326

Catalogue of Turin: 29–31, 34, 44 n. 13, 66 n. 131, 67, 129, 172, 195, 201 n. 99, 224 n. 65, 257 n. 2, 268, 272, 279, 285, 321, 325

Catherine of Alexandria, St: 51 n. 46, 267, 291 n. 221, 299

Catherine of Siena, St: 29, 35, 51 n. 46, 76, 84, 87, 132 n. 177, 136. 257, 262–63, 267, 287–88, 292, 293 n. 236, 296–97, 299 n. 272, 301, 304, 305, 341–44, 352–53, 356, 360, Figs 33, 144–45, 245
 death and burial, 349–51

Cavalcanti, Aldobrandino, OP: 270

Cavallini, Pietro: 75, 80, 81 n. 218, 87 n. 253, 164, 172, 176, 230, 248–49, 252, 288 n. 199, 293 n. 233, 344 nn. 21, 27; 348 n. 67, 352 n. 93, 359, Fig. 121

Cecilia, Sr. OP, Bl, author of *Miracula Beati Dominici*: 47, 63–66, 69–71, 123, 134, 317, 357

Ceccarini, Felice: 267

Celestine I, Pope: 109, 110, 114

Celestine III, Pope: 268, 336

Cenci chapel in S. Maria in Aracoeli: 245, 249

Cenci family: 83 n. 230, 245, 249

Cenci, Jacopa: Abbess, 196

Cencius Camerarius (later Pope Honorius III): 60, 147

Cesarini, Giuliano, Cardinal: 131, 132, 137

Ceslaus, OP, St: 123, 124, 136, 146

Charlemagne, 309, 312

Charles V, Holy Roman Emperor: 339

Charles V, King of France: 348

Chiarucci, Sr Dionora, 335

choir enclosures: 128 (n. 156)
 in Rome
 at S. Maria in Aracoeli: 235, 239, 240, 255
 at S. Maria sopra Minerva: 281, 285–90, 299–300
 at S. Sabina: 118, 125

choir screen (*see also*: intermediary wall or 'tramezzo'): 36, 66 n. 130, 124–29, 357

churches in Rome
 Old St Peter's / St Peter's basilica: 27, 31, 78 n. 204, 87, 96, 103, 104, 204, 227, 231, 233, 237, 238, 254, 261, 268 n. 46, 279, 289, 318, 336, 339, 348, 357, Fig. 115
 S. Agata in Torre, later called S. Maria in Torre: 73
 S. Anastasia: 111, 135
 S. Anastasio (*see also*: SS. Vincenzo e Anstasio): 266 n. 44, 310 n. 23, 311
 S. Andrea: 311
 S. Andrea delle Fratte: 311
 S. Aurea *See*: Dominican church and nunnery of S. Aurea
 S. Balbina: 48
 S. Biagio (later S. Francesco a Ripa): 27, 153, 158, 160–61, 169, 172–73, 176–78, 221, 234 n. 65, 339–40, 356
 S. Callisto: 181
 S. Cecilia: 79 n. 212, 137, 155, 164, 178
 S. Clemente: 44 n. 12, 50, 54 n. 57, 55, 58, 59, 62, 67 n. 141, 69 n. 155, 82, 119 n. 105, 137, 146, 170, 181, 230, 237, 239, 273, 312 n. 45, 324, 328

S. Cosimato. *See*: Franciscan church and nunnery of S. Cosimato
S. Crisogono: 151, 164, 237
S. Croce in Gerusalemme: 27
S. Eustachio: 87, 223, 289
S. Francesco a Ripa. *See*: Franciscan church and friary of S. Francesco a Ripa
S. Giovanni in Laterano (*also known as* St John Lateran or the Lateran basilica): 27, 37, 38, 242, 278, 284, 325, 339, 278, 289, 369
S. Giovanni in Pigna: 311
S. Hipolito: 311: 27, 52, 54 n. 57, 66, 81 n. 219, 170, 171 n. 85, 237, 289, 313
S. Lorenzo in Damaso: 241
S. Lorenzo in Lucina: 59, 137, 200, 269, 311, 312
S. Lorenzo in Panisperna, *See*: Franciscan church and nunnery of S. Lorenzo in Panisperna
S. Marcello: 261
S. Marco: 261
S. Maria ad (or de) Gradellis: 161, n. 42
S. Maria ad Martyres (*also known as* the Pantheon or S. Maria Rotunda): 260, 356
S. Maria de Arciones: 311
S. Maria Annunziata: 27
S. Maria del Popolo: 203, 224
S. Maria del Priorato: 97, 147
S. Maria in Acquiro: 261
S. Maria in Aracoeli. *See*: Franciscan church and friary of S. Maria in Aracoeli)
S. Maria in Aventino: 147, 190
S. Maria in Campo Marzio: 73, 267–68, 270, 272 n. 83, 356
S. Maria in Capitolio. *See*: Benedictine monasteries in Rome: S. Maria in Capitolio; and Franciscan church and friary of S. Maria in Aracoeli
S. Maria in Cosmedin: 47, 54 n. 57, 79 n. 212, 122, 148, 161 n. 42, 170, 181, 224 n. 65, 312 n. 47, 328
S. Maria in Domnica: 169, 231, 233
S. Maria in Tempulo: 48, 70, 72 n. 180, 73, 359
S. Maria in Trastevere: 33, 80, 155–56, 164, 223, 224 n. 63, 226–31, 233, 237, 254–55, 273, 274 n. 105, 289, 313, 357, Fig. 112
S. Maria in Trivio: 311
S. Maria in Via: 311
S. Maria in Via Lata: 34, 241, 261, 307, 317, 320

S. Maria in Xenodochio: 311
S. Maria Maggiore: 27, 80, 81 n. 218, 147, 232, 241–48, 249, 251, 273, 278, 304, 359
S. Maria Nova: 31 n. 28, 161 n. 42
S. Maria sopra Minerva. *See*: Dominican church and priory of S. Maria sopra Minerva
S. Pancrazio: 34, 62, 200, 201, 269, 356
S. Paolo fuori le Mura: 27, 59, 79 n. 212, 102, 120, 169, 231, 233, 254, 289, 313, 357
St Peter's. *See*: Old St Peter's / St Peter's basilica
S. Pietro in Montorio: 155, 201
S. Pietro in Vincoli: 58
S. Prassede: 120, 237
S. Prisca: 97, 101
S. Pudenziana: 58
S. Saba: 121, 122, 166, 319 n. 23, Fig. 58
S. Sabina. *See*: Dominican church and priory of S. Sabina
S. Sebastiano: 27
S. Sebastiano near the Tiber: 205
S. Silvestro in Capite. *See*: Franciscan church and nunnery of S. Silvestro in Capite
S. Sisto (now S. Sisto Vecchio). *See*: Dominican church and nunnery of S. Sisto
S. Spirito in Sassia: 206
S. Stefano de Campo: 311
S. Stefano Rotondo: 120
S. Susanna: 241
S. Teodoro: 221
S. Vitale: 58, 59
SS. Apostoli: 261
SS. Bonifacio ed Alessio: 97, 101, 147, 166, 241
SS. Cosma e Damiano in Mica Aurea. *See*: Benedictine monasteries in Rome; Franciscan church and friary of S. Francesco a Ripa; and Franciscan church and nunnery of S. Cosimato
SS. Giovanni e Paolo, 58, 122, 327, Fig. 57
SS. Quattro Coronati: 33, 62, 65 n. 123, 137, 197 n. 82, 223, 235, 255, 312 n. 45, 358, n. 8, 360 cardinal's chapel and palace: 255, 274, 308, 360, Plate 10
SS. Vincenzo ed Anastasio at Tre Fontane: 27, 120, 146 n. 246, 170–71, 181, 191, 230, 246, 268 n. 44, 274, 284, 310 n. 23, 339
St John Lateran. *See*: S. Giovanni in Laterano

Ciampini, Giovanni Battista: 113, 136 n. 199, Fig. 48
Cibo, Innocenzo, Cardinal: 286
Cicchonetti, Filippo: 47, Fig. 5
Circus Maximus: 46–48, 103, 161 n. 42
Cistercian architecture: 127
Cistercian nuns at S. Pancrazio: 34, 62, 200, 201, 269 n. 56, 356
Cistercians: 31, 43, 70 n. 170, 121, 146, 195, 269, 274, 355
Città di Castello: 343
Clare, St: 29, 48, 90, 195, 200, 203, 317–19
Claudius, Emperor: 100, 101
Claussen, Cornelius: 29 n. 13, 62 n. 109, 171 n. 86, 206 n. 127, 227 n. 87, 257 n. 3
Clement III, Antipope: 312
Clement VII, Antipope: 348
Clement III, Pope: 147
Clement IV, Pope: 91, 313
Clement V, Pope: 324, 325
Clement VII, Pope: 286
Clement IX, Pope: 114, 146
Clivo di Rocca Savelli: 100
Clivus Argentarius: 221
Cloaca Maxima: 46
Coates-Stephens, Robert: 18
Cola da Rienzo: 244
Colalucci, Gianluigi: 73
Colonna cardinal's coat of arms: 328, 329, Fig.156
Colonna Chapel in S. Maria in Aracoeli: 226, 249–51, 255, 317, 324 n. 120, 329
Colonna Chapel in S. Silvestro in Capite: 171, 251, 329
Colonna family: 29, 33, 83, 233, 249–51, 317–20, 323, 324, 329, 339, 340, 356
 Agapito: 248
 Giacomo, Cardinal: 29, 251, 307, 308, 317, 320–25, 329, 356, 359
 Giovanna, Abbess: 129
 Giovanni, OP: 129
 Giovanni, Senator of Rome: 6, 25, 251, 255, 307, 317, 323, 324, 329, Plate 8
 Margherita, Blessed: 174, 251, 307, 317, 319–23, 326, 329, 336, 339, 341, 356
 biography (*Vita*) of Margherita Colonna by Giovanni Colonna: 317–18
 biography (*Vita*) of Margherita Colonna by Sr Stefania: 322–23

 Matteo: 82
 Pietro, Cardinal, died shortly after 1290: 82
 Pietro, Cardinal, died 1326: 251, 323–25, 329
 Sciarra: 324
 Stefano: 324
Colonna home at Monte Prenestino: 318
Colonna Region (*see also*: Regions): 31 n. 28, 87, 243, 308, 323, 326 n. 127, 356
Colonna nuns: 83 n. 229, 308, 323, 326
Colosseum: 31, 45, 161 n. 42
Column of Marcus Aurelius. *See*: Antonine Column
Comi, Francesco: 335
Compagnia della Nazione Senese: 295
Compagnia di Santa Caterina presso la tomba: 295
Conca, Sebastiano: 55
Conclaves at S. Maria sopra Minerva: 286 n. 185, 302, 304
Concordat of Worms: 312
Confraternity of the Most Holy Rosary: 295, 300, 303
Conrad II, Holy Roman Emperor: 360 n. 13
Constantine of Orvieto, OP: 37 n. 58, 38 n. 66, 67, 96
Constantine, Pope: 117
Constantine, Emperor: 308
 Baths of Constantine: 276
 'Donation of Constantine', 235, 308
Constantinople (*see also*: Byzantium): 72, 117, 240, 267, 268 n. 46, 310, 337–40, 359
 Chalkopratia: 72
 nunnery church of the Chora: 80
Constitutions: 88
 Constitutions of Prémontré: 95
 Constitutions of the nuns of S. Silvestro: 321, 322
 Constitutions / Institutiones of the nuns at S. Sisto (*see also*: Institutiones of Dominican nuns; and Institutiones of Humbert of Romans): 88–91,194
 Constitutions of the Order of Friars Preachers: 37, 91, 95 n. 1, 127
 Constitutions of the Friars Minor: 255
Conti family
 Fillipo, OFM, son of Stefano: 223
 Stefano (*also known as* 'Stefano de Normandis'), Cardinal: 33, 196–97, 223–24, 235, 255, 274. 308, 313, 360

Palace at SS. Quattro Coronati, with Aula Gotica and chapel of S. Silvestro: 26, 224, 235, 308, 360, Plate 10
Conti de Segni family
 Andrea da Anagni, OFM, nephew of Rainaldo: 223
 anonymous sister of Rainaldo, Poor Clare nun: 223
 Filippo, brother of Ugolino and father of Rainaldo: 223
 Rainaldo (later, Alexander IV, Pope): 129, 222, 223
 Ugolino, Cardinal (later Gregory IX, Pope): 29, 37, 70, 88, 153, 193, 194, 223
Contini, Gianbattista: 151
Cooper, Donal: 35, 38 nn.63, 65; 128 n. 156, 160 n, 35, 164 n. 62, 239 n. 158, 242, 243 n. 154, 286 n. 183, 287 n. 191
Corbett, Spencer: 130, 315, 328, Figs 37, 150
Corleone, Guido: 66
Cortona, church of S. Francesco: 168
Cosmas and Damian, martyr Sts: 178, 191, 198, 200, 208, 308
'Cosmatesque' decoration: 166, 230, 235 n. 137, 239, 247, 252, 299
Council of Chalcedon: 117
Council of Ephesus: 114, 117
Crabro, River. *See*: Mariana River
Cracow: 123, 136 n. 195
Crociani, Maria Elena: 44 n. 12, 51 n. 46, 62 n. 108, 68, 70 n. 170, 71 n. 174
Cumani: 43
Cybo, Alderano, Cardinal: 203
Cybo, Lorenzo Cardinal: 203, Fig. 100

Daphni, Byzantine church: 80
Darsy, Felix, OP : 96 n. 12, 100, 101 n. 30, 104, 108 n. 53, 109, 113 n. 69, 74, 114, 115 n. 82, 118 n. 101, 119 n. 103, 121, 122 n. 116, 123 nn. 119, 121; 129 nn. 160, 165, 166, 168; 130 n. 169, 132 nn. 176–77; 133, n. 182, 135 n. 187, 136–37, 138, n. 214, 142 n. 224, 146 n. 245, 147, 151, 343 n. 14
da Sangallo, Antonio the Younger: 169, 276–77, 286, Figs 81, 137
da Sangallo, Giovanni Battista (*also known as* Battista): 169, 276–77, 291, Figs 81, 136
da Volterra, Francesco, 314, 326, 330, 333–34, Figs 157, 158
d'Auxio de Podio, Valentino, Cardinal: 132

David, Biblical King: 346
Davidsohn, Robert, 263 n. 23
de Clari, Robert: 338
de Maconi, Corrado: 346
de Medici, Ippolito, Cardinal: 266
de Mutii, Maria Archangela, Abbess: 334
de' Rossi, Matthia: 167 n. 73, 171–72
Descemet, Charles: 101 n. 26, 29; 104, 151
Desiderius, Abbot of Monte Cassino: 159, 169, 231
de Vecchi, Giovanni: 296
Diego d'Acabès, Bishop of Osma, Castile: 36, 43
digital technology in archaeology: 35, 36 n. 53, 66 n. 130
diocesan clergy and the Mendicant Orders: 32, 126, 222, 356
Dionysius (Denis), St, patron of Paris: 308, 309
Dionysius, St and Pope : 308, 309, 311
'disabitato': 156
Divine Office: 69, 124, 125, 255, 285, 320, 321, 342, 343, 346
Domenica Salomonia, OP: 46 n. 25, 66, 68, 70, 82, 83 n. 229, 159, 341
Dominic, St : 19, 27, 29, 32, 33, 35–38, 43–44, 47 n. 30, 48, 51 n. 46, 53, 55, 61–66, 68–71, 73 n. 185, 188; 84, 87–97, 104, 116, 122–23, 126–28, 133–36, 143 n. 233, 146–47, 150, 193, 196, 240, 258, 262–63, 267, 282, 285, 287–88, 292, 295–98, 317, 321, 341, 343, 345–46, 350–52, 355, 357 n. 7, 358, 360–61
 a star seen at his baptism: 38
 Canon of the cathedral of Osma: 95
 death in Bologna: 97, 122
 divides time between S. Sisto and S. Sabina: 123, 134
 Dream of Innocent III: 37–38, left Fig. on cover of book
 his mother's dream of a torch-bearing dog: 38
 'Lumen ecclesiae' (Light of the Church): 39
 miracle in the refectory at S. Sisto: 69
 Pope Gregory IX refers to him as a star: 38
 prays at S. Sabina: 123
 raising of Napoleone at S. Sisto: 53–54, 70–71
 tomb: 38, 128
 virtue of Holy Emulation: 360, 361, Plate 10
 vision of the Apostles Peter and Paul in Old St Peter's: 96

Dominican architecture: 34, 127, 128, 144, 145, 281
Dominican church and nunnery of S. Aurea: 29, 30–32, 64 n. 121, 73, 93, 359
Dominican church and nunnery of S. Sisto: 18, 27, 30, 35, 43, 96, 110, 112–13, 125, 132, 159, 193, 195, 210, 271, 273, 302, 308 n. 10, 344, 356, Figs 1, 24
 ancient Roman mosaic: 56, Fig. 18
 archaeological excavations: 55–60
 architectural survey: 18, 27, 35, Figs 4, 10, 13
 atrium and façade of church: 57, Fig. 20
 bell tower (campanile): 49, 57, 66, 206, 312, 358, Fig. 7
 choir and choir wall: 63–66
 church and nunnery buildings' layout: 44, 45–47, 51, 225, Figs 2–5, 10
 church interior: 50, 51, 357, Figs 8, 9
 church rebuilt in the thirteenth century: 61–62, 193, 196–97, 299–01, 333
 church today: 49–53
 Crucifix: 72–74, 359, Fig. 25
 Dominican foundation (28 February 1221): 17, 27, 33, 43, 44, 69–71
 early Christian basilica: 45, 55, 57–60, Figs 17, 19, 21
 earlier nunnery: 60
 friars at S. Sisto: 30, 70, 90, 92
 icon of *Maria Advocata*, 19, 71–73, 204–05, 240-41, 340, 359, Plate 1
 with gold attachments: Plate 2
 Innocent III's new nunnery: 61–63
 lay tenants: 341
 location: 44–49, Figs 1–3
 medieval frescoes in the church: 74–87
 first phase: 76–81, 83, Figs 26–31
 second phase: 84–87, 293, 345–46, 349 n. 74, Figs 32–34, Plate 3
 miracle of St Dominic in the refectory: 69
 municipal garden centre: 47
 nunnery: 66–69
 chapter room: 52–54, 67–69, 133, 139, 358, Figs 12–15
 cloister: 53
 defensive tower: 68, 133, 358
 kitchen: 54, 170–71
 refectory: 54–55, 69, 209, 358, Fig. 16
 refectory vestibule: 54, 69
 nuns come from S. Maria in Tempuli, S. Bibiana, and Prouilhe: 70
 nuns from S. Aurea move to S. Sisto: 30–31
 nuns move from S. Sisto to SS. Domenico e Sisto (1576): 49 n. 40, 53
 property and income of the nunnery: 92–93
 raising of Napoleone: 53–54, 70–71
 relics from the Catacombs: 52–53
 side doorway of the church: 51–52, 57, 192, 285, Fig. 11
 Station church: 60, 356
 titulus: 59–60, 356
 triptych from Sant'Aurea by Lippo Vanni: 31
Dominican church and priory of S. Maria sopra Minerva: 257–305
 a new Dominican 'locus' in Rome recorded: 257, 270
 architectural drawings of the church: 264–67, 276–79
 by Antonio da Sangallo the Younger: 276–77, Fig. 137
 by Baldassarre Peruzzi: 276, Fig. 135
 by Giovanni Battista (or Battista) da Sangallo: 276–77, Fig. 136
 plan and sections related to the Neo-Gothic 'restoration': 264–67, Fig. 129, 130
 architectural survey: 262, Fig. 128
 banner of the *Madonna and Child, Our Lady of the Rosary*: 296, Fig. 146
 Biblioteca Casanatense: 303–04
 buildings taken over by the Italian Government in the nineteenth century: 304–05
 cappella maggiore: 275, 285–86, 288
 cavetto: 262, 289–90
 cemetery: 292, 301
 chapels (medieval): 290–300
 of All Saints (Altieri): 297–99
 of St Catherine of Alexandria: 299
 of St Catherine of Siena (previously of the Annunciation, later of the Holy Rosary): 292–97, 300
 of St Dominic: 297–98
 of St Hyacinth: 298
 of St Thomas Aquinas: 291, 298
 of St Vincent: 299. 300
 of the Holy Cross: 298–99

of the Virgin Mary Annunciate: 299
other chapels: 299–300
choir enclosure in the Middle Ages: 286–88
choir moved to the apse in 1544: 286–88
church: 262–300
 changes made in eighteenth and nineteenth centuries: 262–67
 division of the church into two sections - for the friars and the laity: 285–88
 east end of church: 275–79, Fig. 138
 façade: 288–90
 nave and aisles: 279–84
cloisters: 300–02
 the medieval first cloister: 301
 the first cloister rebuilt in 1450–1468: 300–01, 304
 the second cloister ('il chiostro della Cisterna'): 302
Conclaves at the Minerva: 286 n. 185, 302, 304
Crucifix: 298, Fig. 147
dimensions of the church: 273
Dominican Centre of the Holy Office (the Roman Inquisition): 303
Dominican College of St Thomas Aquinas at the Minerva: 303–04
Dominican foundation ratified in 1275–1276
Dominican General and Provincial Chapters at the Minerva: 302
Dominican house of studies: teachers and subjects taught: 302–03
earlier church: 267–68
Fra Juan Solan, OP at the Minerva: 303
Fra Sisto, OP and Fra Ristoro, OP: 263
fresco of the *Madonna and Child* (now in Giustiniani chapel): 300
frescoes by Filippino Lippi: 262, 294 n. 243, 298
Gothic style of architecture: 273–74
headquarters of the Dominican Order in Rome from 1380: 304
headquarters of the Roman Province of Saint Catherine of Siena: 305
interior: 259, 266, Figs 125, 131
intermediary wall ('Lettner' or tramezzo): 287–88
juridical independence from the parish of S. Marco ratified in 1276: 270–71
library of the Minerva: 303

location: 257–58, 260 n. 14, 261 n. 16, Figs 126, 148
medieval image of St Thomas Aquinas (no longer extant): 291
medieval painting of St Catherine of Siena (no longer extant): 293
modifications of the church made by Pope Benedict XIII: 262–63, 279, 290, 298
Neo-Gothic 'restoration' of 1848–1855: 263–67, Figs 150, 151
oculi in the clerestory: 265, 279, 280, Fig. 151
patronage (funding): 271–73
plan: 128, Fig. 129
priory: 300–05
reconstructions of the building in modern scholarship: 275–98
 by Giancarlo Palmerio and Gabriella Villetti: 275–78, Fig. 138
 by Gugielmo Matthiae: 279–80, Fig. 139
 by Ursula Kleefisch (*also known as* Ursula Kleefisch-Jobst): 275–78, 280–81
remains of bell tower: 262, 292, 297
Sala Galileiana: 303
statue of the *Risen Christ,* by Michelangelo: 294 n. 243
statues of St Catherine and St Dominic
stepped chapels, 'en échelon': 277, 279, 357, Fig. 138
titulus from 1557: 303
tombs
 in the apse of Medici Popes Leo X and Clement VII: 286–87
 other tombs and burials
 Andrea Bregno: 298
 Beato Angelico (Fra Giovanni ad Fiesole) OP: 291, Fig. 142
 Benedict XIII, Pope: 298
 Boccamazza, Giovanni, Cardinal: 272–73
 Catherine of Siena, St: 292–97, Figs 143, 144, 145
 de Buccamatiis, Petrus (Pietro Boccamazzo?): 272
 Durandus, Bishop of Mende: 273, Fig. 133
 Fra Roger, OP, Bishop of Siena: 273
 Gaetani, Antonio, Cardinal: 273
 Malabranca, Latino, Cardinal, OP: 291
 Orsini, Matteo, Cardinal, OP: 291

transfer of S. Maria sopra Minerva to the
Dominicans: 269–71
views of exterior: 258, 261, Figs 124, 127
waterspouts: 284, Fig. 141
Dominican church and priory at S. Sabina: 18,
27, 30, 32–33, 61, 93, 96, 160, 165–66, 173–74, 191,
201–08, 210, 239, 253, 257 n. 3, 258, 269–70, 273,
285, 287–88, 297 n. 236, 298, 303–05, 3214, 320,
332, 356–57
archaeological evidence: 101, 104, 109
architectural survey: 35, 104–08, Figs 41–46
baptistery: 106–07
bell tower (campanile): 118–19, 358, Figs 54, 55
bell wall: 119, 359, Fig. 56
Borromini plan of the church: 134, Fig. 65
cell/chapel of St Dominic: 145–46
chapel in the priory of St Pius V: 116, 146, 166
chapels in the church: 135–36
choir enclosure: 118, 125
choir loft: 136, 143, 332
choir screen (*also known as* intermediary wall,
or 'tramezzo'): 124–29, Fig. 50
comparison with the 'tramezzo' at
S. Eustorgio, Milan: 126
church
eleventh- and twelfth-century additions: 118–22
exterior and interior views, Figs 39, 40
fifth-century basilica: 102–04, 109–14, 357
in the eighth and ninth centuries: 117–18
in the fifteenth century: 131–36
in the thirteenth century: 124–29
renewed by Sixtus V: 135–36
defensive tower : 133, 358
Dominicans return to S. Sabina *c*. 1930: 17
excavations: 104, 109
extension to the priory by Tullio Passarelli: 103,
115
fifteenth-century changes made by Cardinal
Giuliano Cesarini: 131–32, 137
fifth-century wooden doors with early
Christian reliefs: 112–13, Fig. 49
gardens: 124, 133,136–37, 141, 151, Fig. 56
General Curia of the Dominican Order (the
Dominican Family): 97
hermitage: 137

Hyacinth Odrowatz, Ceslaus, and Hermann
received into the Order by St Dominic:
123–24
installation of the Dominicans at S. Sabina:
122–25
Italian Government expropriates priory
buildings in 1874: 97
Italian Government turns the priory buildings
into a 'lazzaretto': 97, 103 nn. 44, 45
library: 139, 143, 150, 151
location: 97–103, Figs 35–38
medieval house near the apse: 103, 151
mosaics: 113–14, 136
mosaic inscription in the fifth-century basilica:
110–11, Figs 47, 48
narthex: 114–17, 119, 121–22, 134–35, 314,
Figs 51–53, 56
fresco of *Madonna and Child with Saints
and patrons*: 117, Plate 4
painting above the entrance to the narthex:
133–34, Fig. 62
Pope Honorius III ratifies the Dominicans'
residence at S. Sabina: 96, 97, 122–24
Pope Sixtus V remodells the liturgical layout of
the church
priory buildings: 124, 137, 146
block PW: 143–45, Figs 72, 73
chapter room: 139, 140, 174, 358
cloister: 138–40, Fig. 66, 67, 69
loggia overlooking the Tiber: 141–43, 358,
Figs 70, 71
refectory: 139–40
reconstruction drawings: 140–41, Figs 68, 71
remodelling of the church interior
commissioned by Pope Eugene II
side entrance to church: 131–34, Figs 61, 62
stairs from cloister to cell of St Dominic: 146
Station church (Station on Ash Wednesday):
110–11
Thomas Aquinas, OP, St teaches at S. Sabina: 146
titulus: 60 n. 89, 110, 356
tombs: 129–31, 360
of Munio of Zamora: 130, Fig. 60
of Perna, wife of Luca Savelli: 130, Fig. 59
of Stefania from Tiber Island, a Dominican
penitent: 343

vineyard of S. Sabina: 137
windows: 131, 132, Fig. 63
Dominican First Order of Friars: 29, 351
Dominican lay brothers: 89, 92, 127, 263
Dominican nunneries outside of Rome
 at Bologna, S. Agnese: 43 n. 9, 48, 49 n. 38, 66, 70, 78
 at Madrid, Spain: 35 n. 48, 43, 44, 70, 88, 90, 91, 194 n. 83
 at Montargis, France: 36 n. 48, 43, 44, 70, 88, 90, 91, 194 n. 83
 at Pisa, S. Domenico: 353
 at Prouilhe (*also known as* Prouille), France: 19, 69, 70, 88, 90, 91
 at Venice, Corpus Christi: 352
 at Zamora, S. Maria, Spain: 130, 131 n.170
Dominican nunnery of S. Maria del Rosario, Monte Mario 71, 93, 240, 303 n. 310
Dominican penitents (*also known as* 'beatae', beghinae', 'devotae', 'mantellate', 'vestitae'; Order of Penitence of St Dominic, from 1405): 86, 341–53
Dominican Second Order of nuns (officially approved in 1267): 29, 88 n. 261, 90 nn. 275, 276, 280, 281; 91, 92, 351–52
Dominican Sisters of S. Sisto: 18, 50, 53
Dominici, Giovanni: 352
Domitian, Roman Emperor: 260, 308
Donatello: 294, 350
'Donation of Constantine': 235, 308
Donna Balduccia: 343
Donna Caruccia, widow of Vitale Caccialupi: 343
D'Onofrio, Cesare: 213 nn. 1, 3; 218 n. 20, 219, 228 n. 74, 242 n. 179, 259 n. 250
Dosio, Giovanni Antonio: 229
double-storeyed narthex: 113 n. 71, 122, 139, 232, 314, 332
Dovizio, Marco Antonio: 350, 351
Dream of Innocent III: cover, 37, 242
Dunlop, Anne: 18, 29 n. 14, 31 nn. 13, 14; 64 n. 121

early Christian architecture: 27, 96 n. 12, 274, 357
early Franciscan architecture: 168, 169
'ecclesia fratrum' (the part of the church for the friars): 128, n. 153, 285

'ecclesia laicorum' (the part of the church for the laity: 128, n. 153, 285
Edessa: 241
 icon of the *Mandylion*: 335–39, Plate 9
 icon of *Haghiosoritissa (Virgin of Edessa)*: 241
Einsiedeln Itinerary: 60, 101, 159, 267
Eleutherius, St: 309
Elia, OFM: 74
Elizabeth of Hungary, St: 322, 341
Emporium: 101
Enclosed Sisters Minor (Sorores minores inclusae): 251, 317, 319–20, 323–24, 340
equestrian statue of Marcus Aurelius: 214
Eudes of Rosny, OFM: 320
Eugenius II, Pope: 118, 136
Eugenius III, Pope: 121
Eugenius IV, Pope: 172
Eusebius: 336, 337, n. 171
Eustachio (Eustace), St: 84, 85, 87, Fig. 33
Evagrius: 337

Fabian, Pope: 45
Fabriczy, Anonymous, view: 243, Fig. 119
Fanjeaux: 19, 43, 70
Ferdinand, the King of Spain's son: 43
Ferrari, Guy: 31, n. 25, 48 n. 35, 60 nn. 96–99; 158 n. 23, 190 n. 44, 219 nn. 25, 28; 220, nn. 30–36; 266 n. 43, 268 n.48, 309 nn. 13, 16–18; 310, 311, nn. 28–29; 31; 313 n. 30
Ferrari, Tommaso Maria OP, Cardinal of San Clemente: 146
Ferrata, Ercole: 261
Ferrici y Comentano, Pietro, Cardinal of S. Sisto: 51, 57, 132, Fig. 11
Filippo Rusuti: 249
Florence, Dominican church of S. Maria Novella: 78, 128 n. 156, 263, 265, 267, 275, 278, 290 n. 68, 286 n. 183, 287, Figs 132, 134
Florence, Franciscan church of S. Croce: 128 n.156, 230, 249, 286 n. 183, 287
Fontana, Carlo: 151, 98–99, 303, Fig. 36
Fontana, Domenico: 135
Fontana, Giacomo: 115, 214, Figs 52, 108
Fontana, Giuseppe: 267
Fontana, Lavinia: 136

Formicini, Orsola, Abbess and author of a history of S. Cosimato: 159, 185 n. 24, 188, 190 n. 37, 195–96, 198–99, 204, 205 n. 122, 208 n. 130
formula of life: 37, 161, 194, 195
Forum (*also known as* Forum Romanum or Roman Forum): 103, 158, 213, 215, 227, 229, 243
Forum Boarium: 100, 156
Foulques, Bishop of Toulouse: 95, 355
Fourth Lateran Council: 37, 88, 95, 194, 234, 355
Fra Bartolomeo di Domenico: 344
Fra Domenico, OP: 304
Fra Mariano da Firenze: 161, 174, 234, 241, 323, 338, 340
Francesco da Volterra: 314, 326, 330, 333, 334, Figs 157, 158
Francheta della Rovere, sister of Pope Sixtus IV: 185, 202
Francis of Assisi, St: 29, 32, 35–39, 53, 90, 153, 158, 160–66, 169, 173, 176, 194–95, 200, 203, 221–24, 234–35, 242, 247–48, 252, 255, 258, 314, 318, 322, 349, 355, 359. 360
 'alter Christus' (another Christ): 37
 canonization: 32, 160
 Canticle of the Creatures: 37
 Christmas crib: 37
 death: 161
 Dream of Innocent III: 37, 38, 242
 fresco with the virtue of Heavenly Love, in the Aula Gotica: 360–66, Plate 10
 painting attributed to Margaritone of Arezzo at S. Francesco a Ripa: 158, 174–75, Plate 5
 repairing churches of San Damiano, S. Pietro and S. Maria degli Angeli: 37
 shining star: 39
 stigmata: 37
 Testament: 37
 visits to Rome: 36, 160, 161
Franciscans and property: 153, 193–95, 221–22, 225, 321, 324, 325
Franciscan church and friary of S. Francesco a Ripa: 17, 18, 27, 30, 32, 153, 155, 156, 158, 162–63, 169–72, 176–78, 181, 221, 224, 227, 231, 258, 318, 356–57, 359, Figs 76, 77, 78, 80
 archaeological evidence: 158–60
 architectural survey: 157, Fig. 76
 Cavallini frescoes (known from written sources): 164
 cell of St Francis: 173–75
 church from 1229 onwards: 160–72
 columns at the triumphal arch of 'Numidian' granite: 169
 façade: 166, Fig. 78
 friary: 172–73
 originally the Benedictine pilgrims' hospice of S. Biagio. *See*: churches in Rome: S. Biagio
 painting of *St Francis*, *c.* 1250–1272, attributed to Margaritone of Arezzo: 174–75, 318, Plate 5
 plan of church by Baldassarre Peruzzi: 166–68, Fig. 79
 reconstruction of the medieval church by Giuseppe Sanità, OFM, 168, Fig. 80
 vaulted transept, 169
Franciscan church and friary of S. Maria in Aracoeli: 17, 18, 28, 30, 32, 35 n. 51, 38, 153, 166, 167 n. 72, 172 n. 97, 196 n. 82, 199, 213, 216–17, 221 n. 45, 225 n. 71, 227–58, 271, 273–74, 278–79, 281, 285, 287, 289, 290 n. 214, 300, 317–18, 324 n. 120, 325, 329, 340, 356–59
 apse (rebuilt in the sixteenth century): 228–29, Figs 113, 114
 'ara coeli' (altar of heaven), legend: 213, 233–34
 archaeological evidence: 217–18
 bell-tower: 120, 358
 Cavallini frescoes: 230, 248, 249, 252, Fig. 121
 cavetto: 38, 217, Fig. 110
 chapels sponsored by medieval patrons: 171, 215, 217–18, 219, 226–28, 235, 244–51, 254–56, 290 n. 214, 329, 358–59
 chapels beside the choir: 244, 290
 chapels added to the south transept: 244–46, Fig. 111
 Capocci Chapel of St Nicholas, now of St Rose of Viterbo: 246–47
 chapel of St Paschal Baylon (formerly the Capodiferro chapel of St John the Evangelist: 248, Fig. 121
 former Cenci chapel of St Lawrence, later, of Sts Lawrence and Diego: 249
 former chapel of Sts Peter and Paul, part of the earlier bell tower, now side entrance to the church: 246, 249, Figs 111, 120
 chapels in the transept
 chapel / shrine of St Helena and of the ara coeli: 217–18, 233–35

chapel of St Francis, later the Savelli chapel: 235, 246–47
chapels west of the north transept
 Colonna chapel formerly dedicated to St Sebastian: 249–51, Plate 8
choir enclosure, medieval: 238–39
church: 169, 215–17, 227–39, 242
 colonnades: 236–39, Table on p. 236
consecration in 1291: 230–31, 256
'Cosmatesque' opus sectile pavement: 229, Fig 113
date(s) of construction: 254–56
demolition of the friary in 1892: 220
dimensions of church: 217
entrances: 218–19, Figs 110, 111, 119
fabricator Lorenzo Simeone Andreozzo: 243, 254–56
façade: 242–44, Figs 110, 118, 119
fresco fragments: 359
fresco of *Madonna and Child between Sts John the Baptist and John the Evangelist* and other fragments, 248–49, Fig. 121
friary: 252–53
 chapter room (?): 253
 cloisters: 253, Fig. 123
Gothic features: 226, 228, 233, 238, 246, 257 n. 4, 274, 281, 357 n. 6
icon of *Maria Advocata*: 73, 240–42, 359, Plate 7
liturgical furniture: 235, 239, 359
location: 213–15
Master Builder / principal designer of the church 'magister Aldus' (?): 253–54
mosaic of the *Dream of Innocent III*: 38, 242
mosaics in chapel of St Rose of Viterbo: 247
mosaics in the Colonna chapel: 250–51, Plate 8
orientation of church, looking west: 227
parish: 222, 226
pavement: 217, 229, Fig. 113
phases of construction: 254–56
pilgrim pathway: 239–41
plan drawn by Giacomo Fontana (1838): 214, Fig. 108
plan from Spada volume, the 'Spada plan': 229, 233–35, 239, 244–45, 248, 285, Fig. 114
plan compared with that of S. Maria in Trastevere: 214, 227–28, Figs 108, 112

ribbed vaults: 33, 171, 228, 246, 250, 256, 274, Fig. 120
staircase / steps in front of the church: 217, 143–44
tomb of Matteo da Acquasparta, Minister General, Cardinal: 251–52, 359, Fig. 127
transept: 231–35
 comparison with transept of Old St Peter's: 230–31, 233, Fig. 115
transfer of S. Maria in Capitolio to the Franciscans: 221–26
triumphal arch: 217
 columns at junction of transept and aisles: 231
 columns flanking the triumphal arch and the apsidal arch: 231
windows
 in the clerestory: 238, Figs 116, 117
 pointed windows with Gothic tracery: 233
 rose windows: 233
Franciscan church and nunnery of S. Cosimato (*also known as* SS. Cosma e Damiano in Mica Aurea): 17, 18, 27, 29, 30, 32, 35, 62, 155 n. 12, 156, 159 n. 27, 177 nn. 3, 4, 5; 180–83, 185 nn. 21, 26; 186 nn. 28–32; 188, 190–211, 253–54, 301, 321, 325–26, 333, 340, 356, 358–59
 altar in the apse of the church: 201
 archaeological evidence: 183–92
 apse and nuns' choir demolished in 1892: 183, 186
 architectural survey: 179, 184–87, Figs 82, 89, 90, 91, 92
 bell made by Bartolomeo Pisano, dated 1238: 193
 bell tower (campanile): 205–06, Fig. 102
 church divided by a wall into two parts: the nuns' choir and the public part: 183, 200
 church today: 197–98, Fig. 97, 98
 comparisons with other medieval nuns' churches and nunneries: 209–10
 consecration of the Benedictine church in 1066 by Pope Alexander II: 185, 191, 199, 201
 consecration of the nuns' church in 1247 by Bishop Teodino of Ascoli: 196
 consecration of the remodelled nuns' church in 1476 by Pope Sixtus IV: 199, 201
 façade of Pope Sixtus IV: 199, Fig. 84
 fifteenth-century frescoes: 199, 200

Icon: '*Hodegetria*': 204–05, Plate 6
location: 155–58, 177–80
Madonna and Child enthroned, with Saint Francis and Saint Clare, attributed to Antonio del Massaro in 1478–1494: 200, Fig. 99
nunnery becomes a hospice for the elderly ('Ospizio Umberto I'): 177, 183–89, Figs 94, 95
nunnery buildings:
 chapter room (?) later refectory, now Conference Room: 183, 188, 193, 208–09, Fig. 88
 cloister (medieval): 181, 206–09, 358, Figs 85,103, 104, 105
 cloister (courtyard) fifteenth century): 177, 181, 191 n. 53, 202, 208–09, 211, 358, Fig. 86
 conventual buildings: 206–09
 dormitories: 208
 reading desk in refectory: 209
nuns' window with a grille: 198, 203–04, Fig 101
Ospedale Nuovo Regina Margherita: 18, 177, 181–82
plan (disposition) of the church: 182 n. 20, 196, 198–201, 203, 210; Figs 82, 93, 94, 95
Pope Gregory IX and St Clare and other Franciscan nuns: 194–96
 he founds the Damianite nunnery of 'S. Cosme' (i.e. S. Cosimato): 193
 he builds or rebuilds convent buildings: 193
 he appoints Fra Giacomo as bursar of the nunnery in 1234: 193
Pope Sixtus IV remodels the nuns' church: 198–201
reform of nunnery of S. Cosimato by the Poor Clares of S. Lucia of Foligno and S. Maria di Monteluce in 1447–1457: 195
second nuns' choir adjacent to the side chapel with a grille: 203–04, Fig. 101
side chapel: 202–03, Fig. 100
transfer of the Benedictine monastery to the 'Recluses of San Damiano': 192–95
Franciscan church and nunnery of S. Lorenzo in Panisperna: 17, 29, 30–31, 36 n. 53, 83 n. 229, 325–26, 329 n. 140, 356
 Baroque fresco by Pasquali Cati of *The martyrdom of Saint Lawrence*: 326

founded by Cardinal Giacomo Colonna (died 14 August 1318): 29, 325, 356
nuns' choir: 326, 329 n. 140
rebuilt by Francesco da Volterra: 326
relics of Blessed Margherita Colonna: 329 n. 140
Franciscan church and nunnery of S. Silvestro in Capite: 17, 29, 30, 83 n. 229, 112, 135, 171, 206, 220, 251, 307, 356
archaeological evidence: 315–17
architectural survey of church: 315–17, Fig. 150
architecture of Franciscan church: 328–54
bell tower: 312, 214, 358, Fig. 149
church
 chapels
 of the Colonna family, *c.* 1285: 171, 329
 of the Palombara family, *c.* 1300: 329
 of the Pietà: 312, 314, 316, 328, 330, Fig. 153
 of the Sacred Heart: 314, 316, 330, Fig. 152
 of the Tedallini family: 329 *c.* 1380
 coats of arms of the Colonna and of the Palombara: 328, Figs 155, 156
 Communion window: 322, 333, 358
 confessio: 310, 315–16, 326, 330
 courtyard, atrium: 314, 315, 327, 334
 crypt: 310, 314–16, 326, 328, Fig. 151
 dimensions: 316, 327
 façade: 312, 314–15, 327–28, Fig. 149
 grille: 308, 311, 314, 316, 327, 329–30, 332–34
 narthex: 311, 314, 316, 327, 329–30, 332–34
 nuns' choirs: 330, 332–33, 338, Figs 157, 158
 organ loft: 314, 316, 330
 turn / rota: 317, 322, 333–34, 357, 358
earlier monastery and church for Greek monks, followed by Benedictines: 308–13
foundation of the nunnery in 1285: 317–25
Franciscan nuns follow the Rule of Isabelle: 320–21, 324–25, 340
Franciscan nuns follow the Constitutions of Cardinal Colonna: 321–22
icon: the *Mandylion* (Holy Face of Christ): 335–40, Plate 9
location: 307–08, Fig. 148
nunnery buildings: 324–35, Fig. 159

plans
> drawn by Francesco da Volterra, 1591–1597: 314, 326, 330–34 Figs 157, 158
> drawn by Spenser Corbett: 313, Fig. 150
> drawn by Tanghero, 1518: 327–28, Fig. 154
> of the church and nunnery in the eighteenth century: 334–35, Fig. 159

priests of St Vincent Pallotti (Pallottines) take over in 1885

reconsecration of the church in 1123: 328

relics
> from the Catacombs: 309, 326
> head of St John the Baptist: 309, 312, 314, 335
> of Pope St Dionysius and/ or St Denis of Paris: 312, 328
> of Margherita Colonna, Blessed. *See*: Colonna family: Margherita, Blessed
> of Sts Hippolytus, Pigmenius, and Tarcisius: 309
> of Popes Sts Stephen and Silvester

restoration of church after the Norman incursion of 1084: 312

Franciscan friars of the Observance: 253

Franciscan hospice of S. Croce degli Infermi, Verona: 153

Franciscan hospice of S. Maria, Bergamo: 153

Franciscan Hospital of the Maddalena, Siena: 153

Franciscan nunneries: 33, 34, 83 n. 229, 193 n. 57, 194–95, 202 n. 108, 356, 358

Franciscan nunneries in places other than Rome
> S. Chiara, Assisi: 48, 49 n. 38, 168, 357
> S. Chiara, Naples: 36, 66 n. 130, 333, 358
> S. Damiano, Assisi: 29, 36, 48, 49 n. 38, 153, 194
> S. Lucia, Foligno: 195
> S. Maria della Porta Camollia, Siena: 194
> S. Maria di Gattaiola near Lucca: 193 n. 57, 194
> S. Maria di Monteluce in Perugia: 195
> S. Maria di Monticelli, Florence: 194
> S. Pietro in Vineis, Anagni, 210
> S. Sebastiano, Alatri, 209, 210 (n. 135)

Franciscan nuns (*see also*: Clarissan nuns; Damianites; Order of Saint Clare; Poor Clares): 30, 32, 68, 81, 88, 90, 192–95, 204, 210, 324

Franciscan Rule(s): 37, 162

Franciscan Third Order (Tertiaries): 17, 29, 34, 341

Frangipane family: 156 n.18, 162–63, 170–72, 175, 196, 291
> Graziano: 160–61
> 'Fra' Jacopa de Settesoli, wife of Graziano: 160–62, 341
> Frangipane della Tolfa, Vittoria: 172

Fra Bartolomeo di Domenico, OP: 344

Fra Piel, OP: 263

Fra Serafino, OP: 267

Fra Tommaso da Siena (Caffarini), OP: 268 n. 199, 293, 341 n. 5, 342, 343 nn. 16–19; 344 nn. 26, 27; 349, 351, 352

Fra Tommaso della Fonte, OP: 344

Frachet, Gerard: 37, 96

Fratres Minores. *See*: Friars Minor

Frederick II, Holy Roman Emperor: 33, 164, 224, 235, 246 n. 104

Friars Minor: 22, 30, 32, 36, 37 n. 56, 153, 162, 176–77, 195–97, 213, 221, 223–26, 234, 239–41, 253–56, 271–72, 318–21, 341, 349, 358

Friars Preachers: 29, 30, 48, 61, 69, 91, 96, 123–24, 126–28, 130, 136, 150, 257–58, 262, 270–72, 286, 342, 351, 356

Gaetani (*also known as* Caetani) family. *See*: Caetani (*also known as* Gaetani) family

Galileo Galilei: 303

Gallese: 311

Galvano Fiamma, OP: 126

Gambacorta, Sr Chiara, OP: 352–53

Gardner, Julian: 17, 29 n. 14, 30, 31 nn. 23, 24; 32 nn. 31, 32; 35, 38 n. 65, 64 n. 121, 74 nn. 191–93; 78 nn. 203, 207; 80–81, 83 n. 231, 86 n. 244, 129, 130 n. 169, 160 n. 35, 168 n. 77, 171 n. 88, 242–43, 250 n. 238, 251 n. 245, 257 n. 4, 274 nn. 110, 112; 291 n. 221, 292 n. 230, 293 n. 240, 294 n. 247, 299 n. 272, 357 n. 5

gargoyles: 245, 284

gate of the city. *See*: Porta

Gauls: 215

Gavardi, Carlo: 267

Geertman, Herman: 45, 56–60, 113 nn. 68, 69

geese on the Capitol: 215

General Chapter (Dominican): 39, 78, 84, 88, 91–92, 128, 143, 287, 302, 304

General Chapter (Friars Minor)

at Naples, 1316: 195
at Narbonne, 1260: 221, 245, 248 n. 218, 255, 321 n. 94
at Rome, at S. Maria in Aracoeli, 1257: 240, 255
Genoa, church of S. Barbara degli Armeni: 338
Gentilini, Giancarlo: 294 n. 244, 350, 351
Geoffrey of Vierson, OFM: 320
George, Abbot of Subiaco: 320
Ghiberti, Lorenzo: 164
Ghislieri, Michele, OP, Cardinal (later Pius V, Pope): 303
Giacchetti, Giovanni (Ioannes): 307, 309 n. 17, 312 n. 49, 329, 330 n. 142, 355 n. 157, 338–39
Giacomo de Fusignano, Bishop: 300
Gianandrea, Manuela: 18, 27 n. 8, 34 n. 41, 96 n. 12, 108, 114, 115 n. 83, 116–17, 118 n. 102, 122, 132 n. 177, 133 n. 182, 134, 137, 138 n. 214, 141, n. 220, 142, 297 n. 256
Gilbert of Sempringham, St: 62, 63
Gilbertine Order (*also known as* Gilbertine Canons, Gilbertines, or the Order of Sempringham): 44, 62, 63, 69, 87, Figs 22, 23
Gigli, Laura: 18, 137 n. 211, 155 n. 12, 186, 199 n. 95, 202 n. 107
Giordano, Roberto: 109 n. 58, 114
Giotto di Bondone: 37, 38, 78 n. 206, 242 n. 183, 249, 298
Giovanni di Cosma: 252, 279n. 129, 359, Fig. 133
Giovanni di Stefano: 295
Giovanni of Siena, Augustinian hermit: 288
Girolamo (Jerome) of Ascoli, Cardinal (later Pope Nicholas IV): 33, 248 n. 218, 319, 320
Giunta Pisano: 74
Giustiniani, Vincenzo, OP, Cardinal: 141, 143, 290, 299 n. 271, 300, 304
Goergen, Donald J., OP: 35, 36 n. 54, 43 n. 1
Gothic architecture: 33, 257, 274
GPR (Ground Penetrating Radar): 36, 66 n. 130, 124 n. 128
Greccio: 37
Great Schism (1378–1417): 348
Greek monastery of S. Erasmo: 312
Greek monks: 77, 308, 310, 338–39, 359
Gregorio Nazianzeno, St : 268
Gregory I (*alias* Gregory the Great), Pope and St: 60, 110, 178, 215, 221, 241, 309
penitential procession during the plague: 241

Gregory III, Pope: 219, 310 n. 20
Gregory IV, Pope: 311
Gregory VII, Pope: 312
Gregory IX, Pope (*formerly*, Ugolino, Cardinal): 29, 32, 36–39, 88–90, 125, 153, 160–62, 171, 177, 192–96, 201, 206, 221, 223, 355
Gregory X, Pope: 270
Gregory XI, Pope: 325, 348
Gregory XIII, Pope: 44, 49, 93, 268 n. 46
Grottaferrata: 45, 77
Gualdi, Francesco: 162
Guerrini Ferri, Gemma: 18, 27 n. 10, 158 n. 23, 159 nn, 27, 28; 183, n. 18, 190 n. 37, 204, nn. 118, 120; 205 n. 122
Guiscard, Robert: 312

Hadrian, Roman Emperor: 87, 103, 218, 233 n. 122, 241 260
Hadrian I, Pope: 58, 60, 311
Hagiosoritissa, Byzantine name for 'Maria Advocata'. *See*: Icons
Hall, Marcia: 128 n. 156, 286 n. 183, 287
Hamilton, Bernard: 73, 147 n. 256, 190 n. 43
Hannan: 337
Hay, Beth: 18
Heavenly Love (Amor celestis): 360, 361
Helena, St, mother of Emperor Constantine: 167, 218, 227, 233–35, 239, 246, 255, 287
Henry IV, Holy Roman Emperor: 312
heresies: 43 n. 4, 117, 303, 355, 361
heretics: 32, 35, 37, 43, 352
heretic women converted by St Dominic: 44
Hermann, German Dominican friar: 123, 124, 136
Herminia, Abbess: 319
Hermits of Saint Augustine: 224n. 65, 272
hills of Rome
Janiculum Hill: 155–56, 159, 177–78, 180, 253, 269
Monte Mario: 71, 93, 240, 303 n. 310
traditional seven hills: 31
Aventine Hill: 31, 32, 46, 48, 97–104, 111, 135, 137, 147–50, 159, 177, 203, 205, 210, 270, Figs 35–37
Caelian Hill: 32, 44–46, 221, 309, 312
Capitoline Hill: 17, 28, 32, 45, 213–15, 220–21, 224–25, 227, 243, 258, 308, 312, 356, 361 n. 17 Figs 106, 107

 Palatine Hill: 97, 100, 103, 111, 135, 148, 156, 161 n. 42
 Quirinal Hill: 44, 93, 259, 278, Fig. 127
 Viminal Hill: 29 n. 14, 36 n. 53, 325 n. 122

Hodegetria. See: Icons: *Hodegetria* at S. Cosimato
Holy Emulation (Emulatio Sancta): 360–61
Holy Roman Emperor: 33, 164, 224, 235, 309, 312
Honorius III, Pope: 32, 37, 44, 61, 69, 70, 87, 95–96, 122–25, 136–37, 147, 150
Honorius IV Savelli, Pope: 33, 83, 147, 149–50, 164 n. 61, 247–48, 319–21
Hospital of Santo Spirito: 61, 206, 336
Hubert, Etienne: 31 nn. 26, 27; 308 n. 5, 311 n. 34
Huelsen, Christian: 29 n. 16, 30 n. 17, 34 n. 36, 48
Hugh of Evesham, Cardinal: 271
Hugh of St Cher, Cardinal: 90
Humbert of Romans, Master General OP: 32 n. 34, 38 nn. 66, 67; 88, 90–91
Hyacinth, OP, St: 51 n. 46, 123–24, 136, 146, 298

iconoclasm (*c.* 726–843): 267, 310, 337, 339, 359
iconodule: 337
Icons
 Hagiosoritissa (Byzantine neame for *Maria Advocata*): 72, 240, 340, 359
 Hodegetria at S. Cosimato: 204, 249, 300, 359, Plate 6
 Mandylion (Holy Face of Christ) at S. Silvestro in Capite: 335–40, 359, Plate 9
 Maria Advocata: 72, 73, 240
 Maria Advocata at S. Lorenzo in Damaso
 Maria Advocata at S. Maria in Aracoeli: 19, 73, 166, 239–40, 255–56, 287, 340, 359, Plate 7
 Maria Advocata at S. Maria in Campo Marzio: 241
 Maria Advocata at S. Maria in Tempulo: 359
 Maria Advocata at S. Maria in Via Lata: 241
 Maria Advocata at S. Sisto: 19, 73, 74, 82, 93, 355, Plates 1 and 2
 Maria Advocata at S. Susanna: 241
 Maria Advocata ('Virgin of Edessa') at SS. Bonifacio ed Alessio: 241
 Veronica, (Holy Face of Christ) formerly at St Peter's: 318, 336, 338, 339
Il Pomerancio (Cristofano [or Cristoforo] Roncalli): 314
Inglis, Alison: 18

Innocent II, Pope: 120–21, 234, 309 n. 17
Innocent III, Pope: 32–33, 37–38, 43–44, 61–62, 69, 87, 95–96, 104, 124, 193, 196, 197 n. 82, 201, 223, 231, 242, 255, 312, 336, 352, 355, 358
Innocent IV, Pope: 32–33, 90, 127, 129, 194–96, 220 n. 40, 221 n. 48, 222–26, 235, 246 n.204, 254
Innocent VII, Pope: 351–52
Inquisition, Roman: 303
Inquisition, Spanish: 267 n. 34
Inquisitor General: 303
'Institutiones' (Constitutions) of Dominican nuns: 88–91, 194
'Institutiones' of Humbert of Romans (1259): 90–92
'Institutiones' of Montargis: 91
intermediary wall (*see also*: choir screen or tramezzo): 63, 93, 125, 128, 135, 287, 288
Investiture Controversy: 312
Irenaeus, St: 361
Irish Dominican Friars: 50

Jacopa (Jacoba) de' Settesoli, Franciscan Tertiary. *See*: Frangipane family: 'Fra' Jacopa (Jacoba) de' Settesoli, wife of Graziano
Jäggi, Carola: 18, 160–63, 170, 172, 196, 341
Janiculum Hill. *See*: hills of Rome
Jerome of Ascoli. *See*: Girolamo (Jerome) of Ascoli, Cardinal (later Pope Nicholas IV)
Jerome, St: 102, 300
Jerusalem: 72, 78–79, 113, 241 n. 175
Jewish Cemetery ('Campus Judaeorum'): 156
John, Abbot of S. Maria in Capitolio: 220 n. 40
John Damascene, St: 337
John, King of England: 63
John of Calabria, OP, appointed to S. Sisto by St Dominic: 70
John of Toledo, OCist, Cardinal of S. Lorenzo in Lucina: 200, 269
John Peckham, OFM: 222
John V, Byzantine Emperor: 338
John XII, Pope: 220, 311
John XVIII, Pope: 159 n. 30, 177, 190–91, 220
John XXI, Pope: 271
John XXII, Pope: 222, 323
Jordan of Saxony, OP: 38 n. 66, 43, 78, 90, 123, 143 n. 233
Josi, Enrico: 55. 56

Julian the Apostate, Emperor: 360
Julius II, Pope: 326
Justin II, Byzantine Emperor: 72

Kane, Eileen: 29 n. 2, 308 nn. 8, 11; 309, 312 nn. 44, 48; 314 nn. 53–59; 330 n. 146, 333 n. 151, 335 n. 157, 339 n. 193, 194
Kinney, Dale: 18, 213 n. 2; 228 n. 87, 231 nn.101, 105; 237 nn.143, 147; 240 n. 162, 274 n. 105
Kirsch, Johann Peter: 52 n. 56, 56, 60
Kleefisch, Ursula (*also known as* Kleefisch-Jobst, Ursula): 257 n. 3, 263 n. 23, 269 n. 55, 270 n. 69, 271 n. 79, 273 n. 100, 274 n. 108, 275, 276 n. 118, 277 nn. 122–23; 279 n. 128, 280–81, 286 nn. 182, 184; 287, 288 n. 202, 289, 299 n. 272
Knights of Malta: 97, 147, 190
Knox, Lezlie: 18, 29 n. 13, 35 nn. 48, 51; 251 n. 244, 307 nn. 1, 2; 312 nn. 67, 71, 72; 318 nn. 73, 74, 77–83; 319 nn. 84–88; 320 nn. 89–90; 321 n. 101, 322 nn. 108–10; 323 nn. 111, 113–14; 324 nn. 119–21; 335 n. 169, 341 n. 2
Kobold, Sonja: 18
Koudelka, Vladimir: 34 n. 49, 36 n. 54, 43 nn. 1, 8; 44 n.12, 45 n. 23, 46 n. 24, 47 nn. 27, 28; 48, 51 n. 46, 60 n. 93, 61 n. 101, 62 n. 108, 63 n. 116, 68, 70 nn. 165, 170; 71 n. 172, 72 nn. 180–82; 92 n. 288, 93 n. 301, 95 nn. 4, 6; 96 nn. 6, 7; 97 n. 13, 122 n. 117
Krautheimer, Richard: 17, 27 n. 4, 31 n. 26, 45, 46 n. 23, 48 n. 36, 51 n. 47, 53 n. 53, 57 nn. 66, 67; 58 n. 71, 59, 60, 62 nn. 109–10; 66 n. 133, 67, 78 n. 204, 87 n. 252, 96 n. 12, 103 n. 42, 109, 110 nn. 62, 64, 65; 111 n. 68, 113–15, 117 n. 96, 118 n. 101, 120 n. 109, 122 n. 113, 127 n. 148, 131 nn. 172–73; 138 n. 214, 147 nn. 255–56; 215 n. 13–16; 273 n. 105, 275, 289 n. 205, 307 n. 2, 308 n. 11, 309, 312 n. 46, 49; 315–16, 325 n. 122, 328 n. 130, 330 nn. 142–43; 357 n. 6, Figs 37, 115, 150

Lamb of God: 84, 161, 231, 234, 248
Lanciani, Rodolfo: 45, 60 n. 95, 102, 278 n. 124
Laon cathedral: 338
Lateran, 31–32, 44–45, 47–48, 73, 103, 171, 312, 360
 cathedral of Rome: 31, 32, 242
 Lateran basilica. *See*: churches in Rome: S. Giovanni in Laterano (*also known as* St John Lateran)

Lateran Canons: 46, 325
Lateran cloister (1227–1237): 171
Lateran Council IV (1215) (*also known as*: Fourth Lateran Council): 37, 88, 95, 194, 234, 355
Lateran Pacts and Concordat of 1929: 97, 305
Lateran papal palace: 45, 48, 73, 274
Latino Malabranca, OP, Cardinal: 270, 291, 320
La Verna: 37
Lawrence (Lorenzo), St: 52, 53, 178, 245, 249, 268 n. 44, 308, 326
Lapa, Catherine of Siena's mother: 292, 344, 346–47
lay brothers: 62–63, 89, 92, 127, 263
lay sisters: 62–63
Lazio: 34, 71 nn. 173, 179; 73 n. 187, 204 n. 118, 209, 210, 335 n. 157
Lega, Achille and Giuseppe: 267
Legenda Maior by Raymond of Capua: 86, 287 n. 194, 293 n. 234, 344, 345 nn. 34–40; 346 nn. 41–45, 47, 49–52; 347 nn. 53–59; 348 nn. 60–61, 63–66, 68; 349 nn. 71–72; 351 n. 86
Legenda Minor (Leggenda Minore) by Tommaso da Siena 'Caffarini': 239 n. 235, 344, 352 n. 93
Lehmijoki-Gardner, Maiju: 29 n. 15, 35 n. 48, 86 n. 244, 342, 343 nn. 11, 13, 27, 28; 352 nn. 94, 96
Leo I, Pope: 169
Leo III, Pope: 73, 117, 220, 268, 311
Leo IV, Pope: 60
Leo X, Pope: 286, 327
Leonine City: 31
Lepanto, victory in 1571: 146, 231, 295, 303
Le Pogam, Pierre-Yves: 96 n. 12, 103, 104 n. 46, 137, 143 n. 230, 147 nn. 257–58; 148 nn. 150–51
Letter of St Dominic to the nuns of Madrid: 44, 88
Libellus de Supplemento, by Tommaso da Siena 'Caffarini': 288 n. 199, 293 n. 233, 344, 352 n. 93
Liber Censuum: 60, 147, 268, 336 n. 167
library
 at S. Maria in Ara Coeli: 253, 256
 at S. Maria sopra Minerva: 303, 304
 at S. Sabina: 139, 143, 150, 151
 Casanatense Library at the Minerva: 303
Liénart, Achille, Cardinal: 51, 55
Ligorio, Pirro: 298
Lippi, Filippino: 262, 296 n. 252
Lippo Vani, *Altarpiece of Sant' Aurea*: 31, 64 n. 121, 73

Lisa Colombini, Catherine of Siena's sister-in-law: 293, 344
'locus' (place) of a new Dominican priory: 257, 270
Lombards: 309
Longchamp: 202 n. 108, 320, 321
Longhi, Martino: 297
Longhi, Onorio: 1665, 173
Louis of Toulouse, St: 174, 175
Louis VIII, King of France: 320
Louis IX, King of France, Franciscan Tertiary and St: 320
Lowe, Kate: 18, 202, 203 nn. 111, 113; 204 n. 118
Ludovico da Modena, OFM: 162, 163 nn. 52–53; 164, 173
Luke, St. Evangelist and presumed painter of the original icon of *Madonna Advocata*: 72, 80, 240, 318
Lyon, France: 33, 222–25, 246 n. 204

Maconi, Stefano: 287, 293
Maderno, Carlo: 287, 314, 328 n. 131, 329, 330
Malmstrom, Ronald: 213 n. 1, 217–18, 219 n. 28l, 221, 225 n. 71, 226–27, 230 n. 98, 231–33, 35, 237 nn. 141–42, 145; 238 nn. 149–50; 239, 240 n. 164, 242 nn. 179, 181–82; 243 n. 185, 245, 254
Manion, Margaret, 18
'mantellata': 29, 86, 342–43, 345, 351–52
Maps of Rome
 Bufalini, Leonardo (1551): 114, 124, 138, 164, 165, 287, Figs 50, 77
 Cartaro, Mario (1576): 44, 154, 156, 178, Figs. 2, 75
 Dupérac, Stefano and Lafréry, Antonio (1577): 212, 253, Fig. 107
 Greuter, Matthäus (1618): 64
 Maggi, Giovanni, Maupin, Paolo, and Losi, Carlo (1774): 283, 284, 300, Fig. 140
 Nolli, Giambattista (1748): 45, 69, 97, 137, 151, Figs 3, 35
 Pietro Ruga 1824: 27 n. 6, 28, Fig. 1
 Tempesta, Antonio (1593): 204, 212, 260, 284, 289, Figs 106, 126
 Tempesta, Antonio and de Rossi, Giovanni G. (1693): 47 n. 32, 307, Fig. 148
Marcella, St: 102
Marcus Aurelius, Emperor: 214, 260, 308, 311, 323

Margaret of Castello, St: 343
Margaritone of Arezzo: 158, 174–75, Plate 5
Margherita of Cortona, St: 341
Maria Antonia Lalìa, OP, foundress of the Dominican Sisters of S. Sisto: 50, 54, 67
Maria Advocata. *See*: Icons
Maria Cecilia Fichera, OP: 54
Maria of Venice: 342, 352
Mariana / Marrana River (*see also*: Crabro River): 45–48
market on the Capitoline Hill: 215, 220, 221
Marmorata: 100, 102, 137, 148, 149
Marshall, David R.: 18, 28, 49, Figs 1, 7
Martin, Abbot of SS. Cosma e Damiano in Mica Aurea: 220
Martin of Poland (*also known as* Martinus Polonus): 61
Martinelli, Fioravante: 72 n. 180, 253
Maruscelli, Paolo: 304
Masetti, Pio Tommaso, OP: 263 n. 21, 265, 267, 268 n. 43, 270nn/ 66, 69; 271 nn. 74–75, 79–80; 292 nn. 227–28; 303 n. 311, 304 n. 319
Master General of the Dominican Order: 32, 78, 88, 91, 97, 130, 131, 141, 143, 151, 257, 271, 290, 299 n. 271, 300, 303–05, 342, 352
 Humbert of Romans: 88, 90, 91
 Jordan of Saxony: 38 n. 66, 43, 78, 90, 123, 143 n. 233
 Munio of Zamora: 130–31, 342, 352
 Niccolò Ridolfi: 304
 Raymond of Capua: 86, 271, 287, 292, 293 n. 238, 344, 346–49, 352
 Vincenzo Giustiniani: 141, 143, 290, 299, 300, 304
Matteo of Acquasparta, Minister General OFM, then Cardinal: 251–52, 324, 359, Fig. 122
Matteo Orsini, OP, Cardinal. *See*: Orsini family
Matthiae, Guglielmo: 78 n. 34, 58 n.71, 74 n. 195, 81 n. 218, 113 n. 72, 257 n. 3, 265 n. 30, 275 n. 115, 275, 279–83, Fig. 139
Mausoleum of Augustus: 259
Mausoleum of Hadrian (*also known as* Castel Sant'Angelo): 241
medieval Roman commune: 32, 177, 215, 226, 356
Meditationes Reverendissimi patris domini Johannis de turre cremate...: 301, 304
Meditations on the Life of Christ: 81

Melozzo da Forlì: 301

Mendicant Orders: 17, 27, 29, 30, 32–34, 39, 62 n. 111, 123 n. 122, 126, 129 n. 158, 210, 222–23, 244, 333, 353

Menichella, Anna: 27 n. 9, 158, 160, 162–64, 165 nn. 64–65, 67; 167, 171

Mentorella. *See*: Vulturella

Mersseman, Gilles, OP, phases of Dominican architecture: 126–27

Michael the Archangel, St: 241, 290, 297

Michelangelo Buonarroti: 214, 294 n. 143, 327, 328 n. 132, 330

Midi, France: 36, 43

mills
 along the Mariana River: 47
 'Antinian' mill: 48
 belonging to SS. Cosma e Damian in Mica Aurea: 178
 of S. Maria in Capitolio: 220
 of S. Silvestro: 220, 310
 of S. Sisto: 92
 on the Janiculum Hill: 155, 159

Milvian Bridge: 310

Minelli, Giovanni Pietro: 186

Minister General of the Franciscan Order: 32, 221, 226, 240, 248 n. 216, 251, 253, 255, 319–21, 324
 Bonaventure: 221, 240, 255
 Jerome (Girolamo) of Ascoli: 248 n. 218, 319–20
 Matteo of Acquasparta: 251, 324

Mirabilia Urbis Romae (*The Marvels of the City of Rome*): 213, 219

miracle of raising Napoleone from the dead at S. Sisto: 70–71

miracle in the refectory of S. Sisto: 69, 358

Modini, Danieal: 35 n. 52, 171 n. 86

Monasterium Corsarum (the Monastery of the Corsicans): 60

monastery of S. Anselmo: 97, 102, 111 n. 67

monastery of S. Maria de Oliveto: 351

monastery of S. Simetrius and Caesarius: 60

monastery of the Humility of Blessed Mary, Longchamp, France

Montaldo, Lionardo, Genoese captain: 338

Monte Cassino, church of St Benedict. *See*: Benedictine monasteries
 plan drawn by Antonio da Sangallo the Younger, Fig. 81

Monte Mario. *See*: hills of Rome

Moschetti, A.: 258, Fig. 124

Mount (Monte) Prenestino: 317–19, 323

Mortari, Luisa: 73–74

mosaics: 17
 ancient mosaic floors: 56, 102, 104, 108, 109, 186, Fig. 18
 Byzantine mosaics: 78 n. 205, 80 n. 216
 early Christian mosaics
 at S. Sabina,: 109, 111, 113, 114, 129, 136, Figs 47, 48
 medieval mosaic floors: 199
 other medieval mosaics
 at Grottaferrata: 77
 at S. Cosimato: 185, 186, 188
 at S. Maria in Ara Coeli: 80, 81 n. 218, 235, 242, 245, 246 n. 204, 249, 250–51, 255–56, 317, Plate 8
 at S. Maria in Trastevere: 80, 81 n. 218, 164, 233
 at S. Maria Maggiore: 249, 251, 359
 at S. Silvestro in Capite, early medieval church: 310, 216. 326, 329 n. 134
 at St John Lateran: 359

Mullooly, Joseph, OP, Prior of SS. Sisto and Clemente: 55, 68

municipal garden centre: 7

Muratori, Domenico Maria: 146, 177 n. 2, 193 n. 55

Naples: 18, 34, 195, 344
 S. Chiara church and nunnery: 34, 48, 49 n. 38, 66 n. 139, 333, 358
 S. Maria Donnaregina church and nunnery: 201, 202 n. 108, 332

Ndalianis, Angela: 18

Neo-Gothic architecture: 46, 263–67, 357

Neri di Landuccio dei Paglieri: 346

Nepi: 311

Niccoli, Niccolo: 350

Nicola, Cardinal Priest of Dodici Apostoli: 70

Nicola Pisano: 38, 71, 128

Nicholas I, Pope: 311, 339

Nicholas II, Pope: 159, 191

Nicholas III, Pope: 33, 171 n. 88, 246, 247, 251, 255, 271, 274

Nicholas IV, Pope: 33, 80–81, 89, 90, 149, 172 n. 96, 230, 242, 247, 248 n. 218, 251, 255, 256, 341, 359
Nicholas V: Pope: 289, 291, 302
Nicolò: 342
Nolli, Giovanni Battista: 69, 97, 137, 151, Figs 3, 35
Norman troops: 312
Normanni family: 162, 223 n. 80, 226 nn. 79, 80
 Jacopa de Settecoli (*see also*: Frangipane family): 162
nunneries: 17, 29, 30, 31, 33, 34, 48, 49 n. 38, 62 n. 111, 63, 73, 341
nunneries in Rome that were not Dominican or Franciscan
 S. Agnese fuori le Mura: 34
 S. Bibiana: 70
 S. Ciriaco: 34, 73
 S. Maria in Campo Marzio: 73, 267, 268, 270, 272 (n. 83), 356
 S. Maria in Iulia: 34
 S. Maria in Tempulo: 48, 70–73, 359, Fig. 6
 S. Pancrazio (Cistercian nuns): 34, 62, 200, 201, 269, 356
 SS. Cosma e Damiano in Regione S. Eustachio (Benedictine nuns): 93
 SS. Simetrius and Caesarius: 60
Nymphea tria, fountain on the Aventine: 101

obelisk: 215, 259, 260
Observant Reform of the Dominican Order: 352
Observant Reform of Franciscan nuns at S. Cosimato: 195
Odazzi, Giovanni: 136
Odemundus, Abbot of SS. Cosma e Damiano in Mica Aurea: 159, 190, 191 n. 49, 200 n. 97
Odo of Cluny, Abbot: 190
Oliger, Livarius, OFM: 153 n. 7, 160 nn. 32–33; 161 n. 44, 162, 193 n. 55, 194 nn. 65, 68; 195 n. 76, 224 n. 66, 225 n. 71, 247, 250 n. 238, 251 n. 240, 307 nn. 1, 2; 317 n. 67, 321 n. 104, 322 nn. 105, 107
Oliviero Carafa, Cardinal: 238, 262, 298, 302
Order of Friars Minor: 32, 226
Order of Friars Preachers: 28, 32, 36, 38, 50, 78, 88, 90–93, 96, 110, 117, 123–24, 128, 136, 143, 151, 194, 257, 263, 269, 271, 274 n. 108, 291, 342–43, 345
Order of Penitents of St Dominic: 29, 295, 341, 351–52

Order of Penitents of Saint Mary Magdalene, Germany: 90
Order of San Damiano (*also known as* Damianites): 90, 195, 209
Order of St Clare (*also known as* Poor Clares): 30, 33, 195, 324
Order of Sempringham (*also known as* Gilbertines, or Gilbertine Order): 63
Order of S. Sisto in Rome: 90, 194, 195, 324
'Ordinationes' of the Dominican 'vestitae' of Orvieto: 342, 343, 352
Oreggia, Tommaso: 267
Orsini family: 23, 71 n. 171, 163 n, 52
 Francesco, Cardinal: 272, 274, 288, 290
 Francesco, Count of Gravina and Conversano, Prefect of Rome: 267, 288, 290
 Giovanna, 129
 Giovanni Gaetanno, Cardinal (later Pope Nicholas III). *See*: Nicholas III, Pope
 Latino Malabranca, OP, Cardinal, died 1294: 291
 Matteo, OP, Cardinal, died 1340: 285, 291
 Matteo Rosso, 129
 Pardo: 172
 Pietro Francesco OP, Cardinal (later Pope Benedict XIII). *See*: Benedict XIII, Pope
 Vittoria, 172
Orte: 311
Osborne, John: 18, 31 n. 26, 117, 266 n. 43, 308 nn. 7, 8; 309–12, 328
Osma, Spain: 36, 43, 95
Otto Truchses, Cardinal: 113
Our Lady of the Rosary: 132 n. 176, 295, 297, Fig. 146
outrage of Anagni: 324

Palace of Emperor Otto III: 148
Palace of Euphimianus: 147
Palace of Pope Honorius IV Savelli (*see also*: Savelli Palace): 104, 147–51, 319, Figs 35, 36, 74
palaces on the Aventine hill: 147
Palatine Hill. *See*: hills of Rome: traditional seven hills
Palazzo Chigi: 326
Palazzo Colonna: 250, 317
Palazzo del Senatore: 215, 227
Palazzo Odescalchi: 351

INDEX 433

Palencia University: 36
Palestrina: 125, 251, 307, 317, 319–20, 324, 340 n. 196
Pallavicini, Lazzaro, Cardinal: 172
Pallavicini, Ranuccio, Cardinal: 174
Pallottine Order (*also known as* Society of the Catholic Apostolate, or Pallottines): 18, 332 n. 149, 340
Palmerio, Giancarlo: 29 n. 12, 257 n. 3, 265 n. 30, 269 n. 53, 270 nn. 65–72; 271 n. 74, 272 nn. 83–85; 273 nn. 98–99, 101–02; 275 n. 115, 277–78, 281–86, 289 nn. 203–04; 290 nn. 210, 215–17; 291 nn. 218–19; 297 n. 259, 298 n. 262, 299 nn. 267, 274–75; 300 n. 276, 278–79; 301 nn. 283, 286; 302 nn. 290–91; 304 n. 313
Palombi, Guglielmo and the restoration of S. Sisto: 55
Panciroli, Ottavio: 123 n. 121, 147, 163 n. 52, 204, 241 n. 175, 323
Pancratius (*also known as* Pancrazio, St): 34, 62, 155, 156, 178, 180, 200, 201, 269, 356
Pandolfo, Count of Anguillara: 162–64, 172, 341
Pani Ermini, Letizia: 109 n. 58, 114
Pantheon: 17, 31, 32, 71 n. 176, 87, 93, 257, 260, 267–68, 356
Panciroli, Ottavio: 123 n. 121, 147, 163 n. 52, 204, 241 n. 175, 323
Panvinio, Onofrio: 27 n. 3, 147
papal approval of the Dominican Order (1216): 43, 96
papal approval of the Franciscan nuns at S. Lorenzo in Panisperna: 325
papal approval of the Order of Penitence of St Dominic: 29, 352
Papal Bulls: 89, 95, 104, 122–24, 136, 137, 268 n. 50, 311, 325, 351
 by title of Bull:
 Ad apicem apostolicae (1298): 324 n. 120
 Ad conditorem canonum (1322): 222
 Ascendit fumus aromatum (1285): 319–20
 Cum deceat vos (1229): 180, 161, 163, 172
 Cum divinis deputati (1250): 225
 Dilecti filii Fratres Minores Urbis (1249): 224
 Dudum felicis recordationis (1303): 324 n. 121
 Etsi animarum (1254): 222
 Evangelice predicationis officium (1252): 190
 Fons sapientiae (1234): 355
 Generalis ecclesiae regimini (1297): 324 n. 120
 Gratiarum omnium (1217): 95
 Iis, quae auctoritate (1252): 226, 255
 In mandatorum suorum semitasis (1285): 319 n. 87, 320–21
 Inter ceteros (1472): 172
 Lampas insignis caelestium (1250): 225
 Mira circa nos (1228): 39 n. 70, 160
 Nuper dilectae in Christo Filiae, 1285
 Periculoso (1298): 34, 88
 Ordinem vestrum (1245): 221 n. 48
 Quanto dilecti filii Fratres Ordinis Minorum (1248): 223–24
 Quasi lignum vitae (1255): 222
 Quo elongati (1230): 221
 Quoniam, ut ait Apostolus (1252): 225, 254
 Religiosam Vitam (1216): 95
 Sedis apostolicae (1405): 352
 Super Cathedra (1300): 222
 Supra montem (1289): 341
 Una perennis gloria (1290): 172 n. 96
 Vitae perennis gloria (1291): 230 n. 98
 of Pope Agapitus II: 220, 311
 of Pope Anacletus II (later Antipope): 220
 of Pope Celestine III: 268 n. 50
 of Pope John XII: 220, 311
 of Pope John XVIII: 159 n. 30, 190, 191, 220
 of Pope Sergius II: 310
Papal Curia: 32, 37, 96, 270
Papal palace at the Lateran: 45, 48, 274
Papal States: 304
Paris: 19, 96, 128, 202 n. 108, 222, 303, 309, 312, 320, 338
parish / parishes: 30, 32, 123–26, 129, 136, 151, 158, 172, 221–22, 226, 256–57, 270–71, 290, 304, 314–16, 330, 332, 343
Paschal I, Pope: 169
Passarelli, Tullio: 103, 115
pastoral care of nuns and the Dominicans
Passeggiata Archeologica: 45 n. 17, 47
Paul I, Pope: 308–10, 315, 340
Paul II, Pope: 238
Paul III, Pope: 253
Paul IV, Pope: 239, 298, 302
Paul V, Pope: 53
Pax et Bonum: 19, 356
penitent women: 29 n. 15, 35, 86 n. 244, 300, 342 nn. 7–9; 343 nn. 11, 13, 27; 345 n.39, 352 nn. 94, 96; 356

penitential procession (*also known as* 'penitential Litany'): 241
Pensabene, Patrizio: 58
Pentecost: 72, 75 n. 196, 76–79, 82, 84
Pepin, King of the Franks: 309
Peretti Montalto, Cardinal Alessandro: 165, 173
periphery of the city: 32, 48, 103, 353, 358
Persia: 339
Persians: 337
Perugia: 32, 36, 160, 168, 193 n. 57, 194, 195, 225, 226, 303, 321 n. 104
Perugia, church of S. Francesco al Prato: 168
Peruzzi, Baldassarre: 166–68, 171, 276, 297, Figs 79, 135
Peter, Abbot of S. Maria in Capitolio: 220
Peter and Paul, Sts and Apostles of Rome: 96, 113, 117, 246, 249, 299
Peter Mallius: 336
Peter of Illyria, priest and then bishop, founder of the early church of S. Sabina: 109, 110, 136
Petrus Diaconus: 336
Petrus Saxonis: 272
Philip IV, King of France: 324
Piazzale Numa Pompilio: 45
Piazza del Campidoglio: 214, 227, 244
Piazza dei Cavalieri di Malta: 100
Piazza Navona: 215, 260, 262
Piazza S. Chiara: 348
Piazza San Cosimato: 181
Piazza Pietro d'Illiria: 137
Piazza S. Silvestro: 308, 310, 344
Pietro de Angelis Seio: 272
pilgrim path: 146, 166, 239
Pinelli, Bartolomeo: 209
Pisa: 38, 302, 343, 348, 353
Pius II, Pope: 294, 295, 351
Pius IV, Pope: 228
Pius V, Pope and St : 51 n. 46, 93, 116, 135, 143, 146, 166, 267, 271, 295, 300, 303
Pius IX, Pope: 198, 265, 271
Pius XI, Pope: 51
plague: 93, 241, 256, 347
 in 1348 (*also known as* the Black Death): 241, 256
Plan of St Gall: 175: 18, 177, 181
Pomerium: 100
Pompey the Great: 259, 260
Pontius Pilate: 336

Pontifical Athenaeum and Collegio di Sant' Anselmo: 97
Pontifical University of Saint Thomas Aquinas (*also known as* the 'Angelicum'): 31, 72, 73, 93, 303
Poor Clares: 33, 177, 195, 198 n. 88, 204, 205
Porta (*also known as* Gate of the city)
 Porta Appia (*also known as* Porta S. Sebastiano): 52, 180
 Porta Asinaria: 47
 Porta Aurelia (*also known as* Porta S. Pancrazio): 155
 Porta Capena: 44, 45, 50 n. 43
 Porta del Popolo (*also known as* Porta Flaminia and Porta S. Valentino): 310
 Porta Flaminia (*also known as* Porta del Popolo and Porta S. Valentino): 44
 Porta Pia: 304
 Porta Portese: 155
 Porta Portuensis: 155, 156, 160, 178, 180
 Porta S. Giovanni: 311
 Porta S. Pancrazio (*also known as* Porta Aurelia): 155, 178. 180
 Porta S. Paolo: 97
 Porta San Sebastiano (*also known as* Appian Gate): 44, 52
 Porta Trigemina: 100, 104
 Porta S. Valentino (*also known as* Porta Flaminia and Porta del Popolo): 310
poverty, voluntary: 36, 92, 355, 358
Prandi, Adriano: 55, 56, 101, 115, 116, Fig. 53
prayer: 36, 64, 72, 78–80, 82, 86, 89, 91, 126, 303, 317, 336, 342, 345, 347, 353, 355, 361
preaching: 27 n. 6, 32 n. 30, 35 n. 44, 38, 43, 63, 78, 95, 96, 124, 126, 127, 202 n. 109, 222, 244 n. 189, 258 n. 7, 272 n. 96, 285 n. 179, 300 nn. 281–82; 3218, 322 n. 108, 355, 357 n. 5, 361
President (of Sisters Minor): 321–22
Principia: 102
Privilege of Anaclete II: 226
Privilege of Pope John XVIII (1005): 159 n. 30, 190, 191, 220
Processo Castellano: 85 n. 242, 293 n. 235, 344, 349 n. 74
Procurator: 89, 92, 128 n. 153, 321, 335
Protestant troops: 339
Protoevangelium of James: 76, 80

Prouille (*also known as* Prouilhe): 19, 35 n. 48, 43, 69, 70, 88, 90, 91, 194 n. 63
Proverbia Wipponis: 360, quoted in Plate 10
Prudentius (*also known as* Aurelius Prudentius Clemens): 53
Ptolemy of Lucca, OP: 148
Public park with orange trees on the Aventine Hill: 149, 150
Puglia: 126
pulpit / pulpits: 135, 201, 236, 239, 288, 330, 359
 pulpit at S. Eustorgio in Milan, *c.* 1340: 126

Quadri, Giacomo Reginaldo, OP: 269, 298
quasi-religious women (*see also*: semi-religious women, penitent women, or 'bizoke'): 61, 269 n. 55
Quirinal Hill. *See*: hills of Rome: the traditional seven hills

Rabbi Yehiel in Trastevere: 155
Raguzzini, Filippo: 49, 51, 59, 248, 263, 298
Rainaldo dei Conti di Segni, Cardinal of Ostia and Velletri, Protector of the Franciscan Order. *See*: Conti di Segni, family: Rainaldo; and Alexander IV, Pope)
Raymond of Capua, OP: 271, 287, 292, 293 nn. 234, 238; 344–49, 351 n. 86, 352–86
Raymond of Peñafort, OP, St: 146
Recluses of San Damiano: 192, 195
Regionary Catalogues: 101
regions of Rome: 31
 Augustan Regions of Rome (XIV): 31, 45
 Region I Porta Capena: 45
 Region II Caelimontium (the Caeian Hill): 45
 Region VIII Forum Romanum et Capitolium (the Roman Forum and the Capitoline Hill): 215
 Region IX Circus Flaminius (the Campus Martius): 258–60, 312
 Region XII Piscina Publica: 100
 Region XIII Aventinus (the Aventine Hill): 100
 Region XIV Transtiberim (Trasteere): 155, 178
 Ecclesiastical Regions of Rome (VII): 31, 45
 Medieval Regions / Rioni of Rome: 31
 Campitelli Region: 249
 Colonna Region ('Regione Columna'): 31 n. 28, 87, 243, 308, 312, 356
 Pigna Region: 261
 Ripa Region: 148
 Sant' Eustachio Region: 87, 93
Rehberg, Andrea: 18, 29 n. 14, 30 n. 21, 162 n. 48, 307 n. 2, 308, 317 n. 66, 322 n. 107, 323–24, 325 nn. 122, 124
'religio' (religious way of life): 32, 88, 193 n. 54, 342
Remus: 308
renewal ('renovatio') of Rome: 62, 213 nn. 1, 3; 218 n. 20, 219 n. 29, 225 n. 74, 242 n. 179, 254 n. 258
Resurrection of Christ: 117, 234
Riccardi, Bernardino: 267
Riccardo Annibaldi, Cardinal Deacon of S. Angelo in Pescheria: 223, 224
Ridolfi, Nicola or Niccolò, Cardinal: 286, 304
Rieti: 32, 302, 303
Righetti Tosti-Croce, Marina: 81 n. 218, 165 n. 67, 169, 173, 174 n. 110, 278
Rimini: 308
Ripa Grande: 27, 155, 158 nn. 20, 21; 160, 169 n. 80, 174 nn. 111, 113; 175 nn. 115, 117, 119–22
Roberto, Sebastiano: 115 nn. 82, 86; 145 n. 245, 146
Robson, Janet: 35, 38 nn. 63, 65; 160 n. 35, 164 n. 62, 242–43, 255 n. 261
Robson, Michael: 32 n. 33
Rocca Savelli (also called Savelli fortress or Savelli Palace): 100, 104, Figs 35, 36, 74
Roger, Spanish Dominican lay brother appointed to S. Sisto by St Dominic: 70
Roman Commune: 32, 177, 215, 226, 356
Roman families: 17, 33, 244, 271, 314, 329
Roman Forum: 158, 213, 216
Roman mint: 215
Roman Province of St Catherine of Siena: 257, 300
Roman Senate, medieval: 31, 32 n. 29, 249, 271
Roman synods, in 499 and 595: 60, 110
Rome as 'Caput mundi': 31
Romulus and Remus and the foundation of Rome: 97
Ronci, Gilberto: 74 n. 195, 75 n. 197, 76 n. 200, 77 n. 201, 80 n. 213, 84 n. 240
Rondanini, Alessandro: 297
Rosary: 51 n. 46, 132, 292, 295–97, 300, 303
Rose of Lima, OP, St: 51 n. 46, 114, 146, 166
Rose of Viterbo, St: 215, 244, 246–47, 255

Rosselli, Pietro: 327, 328 n. 132, 330
Rossini, Luigi: 218, 263, 279, Fig. 110
rota, a turnstyle for passing things through a nunnery wall: 65, 70, 317, 322
Rule for Franciscan semi-religious women: 341
Rule of Dominican Penitents: 352
Rule of Saint Augustine: 62, 88, 90, 95, 194
Rule of Saint Benedict: 62, 192, 194, 268 n. 50
Rule of St Francis, first version: 37
Rule of St Francis, second version: 37, 153, 162
Rules for Franciscan nuns
 Rule of Cardinal Ugolino, 1219: 194
 Rule of Isabelle of France, 1259, revised 1263 (*also known as* Rule of the Order of Enclosed Sisters Minor): 195, 319–21, 322 nn. 106, 108; 324–25, 340
 Rule of Pope Gregory IX (formerly Cardinal Ugolino), 1228: 90, 195
 Rule of Pope Innocent IV, 1247: 195
 Rule of Pope Urban IV, 1263: 195, 324
 Rule of St Clare, 1253: 194–95
Ruga, Pietro: 27, 28, Fig. 1
Russell, Susan: 18
Rusticus, St, patron of Paris: 309

Sabina, St and martyr: 103, 117
Sabine women: 214
sack of Rome in 410: 102, 109, 150
sack of Rome in 1527: 339
Saepta Julia: 261
Salviati Giovanni, Cardinal: 266
Salviati Lucrezia Medici: 300
Salve Regina: 19
Sanchez, Marga: 18
Sancta Sanctorum chapel: 246, 300
San Damiano. *See*: Assisi, churches: S. Damiano
San Geminiano: 343
Sanità, Giuseppe, OFM: 163, 168–69, Fig. 80
Sansterre, Jean-Marie: 31 n. 25, 268, nn. 43, 45, 49; 309, 310 nn. 22, 23. 26; 311 nn. 32, 33
Sant' Aurea altarpiece by Lippo Vanni: 31, 64 n. 121, 73
Sant' Eustachio family: 87
 Andrea di Sant' Eustachio, two Dominican nuns: 87
 'Sopphia de Sancto Heustachio' (Eustachio), Dominican nun: 87

Saraceni, Carlo: 296
Saracens: 190, 355
Sauli, Bandinello, Cardinal: 142–43
S. Aurea *See*: Dominican church and nunnery of S. Aurea
Savelli Chapel. *See*: Franciscan church and friary of S. Maria in Aracoeli, chapels in the transept
Savelli family: 33, 147, 150, 235, 244–48, 252, 360
 Andrea, daughter of Luca and Vanna: 248
 Antonio: 248
 Jacopo, Cardinal (later, Honorius IV, Pope): 33, 83, 147–49, 164 n. 61, 318–19
 Giovanni: 247
 Luca: 129, 247–48
 Mabilia: 248
 Pandolfo, son of Luca and Vanna: 248, 271, 247–48
 Perna: 129, 130, Fig. 130
 Vanna, née Aldobrandeschi, wife of Luca: 247
Savelli palace (*also known as* Rocca Savelli and Savelli fortress): 97, 99, 100, 147–51, 321, Figs 35, 36, 74
Scale Cassi (stairs to the Aventine Hill): 101
Schola Cantorum of Rome: 225
S. Cosimato. *See*: Franciscan church and nunnery of S. Cosimato
Second Council of Lyon: 222
Second Council of Nicaea: 310 n.23, 337, 339
Semia's vision of St Catherine of Siena: 349
semi-religious women (*see also*: quasi-religious women, penitent women, 'bizoke'): 61 n. 107, 194, 269, 319, 341 n. 2
Sempringham: 62–64, Fig. 22
Senator of Rome, president of the medieval Senate: 215, 247, 251, 270, 307, 317
Senators of Rome: 271
Septimius Severus, Emperor: 161
Septizonium (*see also*: 'Settesoli'): 161 n. 42
Seraphia, St: 103, 117
Sergius II, Pope: 310
Sergius III, Pope: 73
Servian Wall: 44, 100, 104
Settesoli: 160–63, 170, 172, 175, 341
Setti, Marco: 186, 199 n. 95 103 nn. 44, 45
Severan capitals (spoglia): 191, 236
Severan Marble Plan of Rome: 260

S. Francesco a Ripa. *See*: Franciscan church and friary of S. Francesco a Ripa
Siena (*see also*: Catherina of Siena, St): 86, 153, 193 n. 57, 194, 273, 288, 292–93, 295, 303, 341 n. 5, 342–49, 351–53
Silvester, Pope and St: 224 n. 63, 235, 308, 309, 314, 319, 320, 339 n. 196
Simon Magus: 249 n. 229, 360–61
simony: 360, 361 n. 16
Sixtus II, Pope and St: 52, 53, 71 n. 175, 73 n. 188, 79, 301, 308
Sixtus III, Pope: 109–10, 137
Sixtus IV, Pope: 51, 150, 172, 177, 185–86, 198–02, 206, 209–10, 358–59
Sixtus V, Pope: 111, 125, 129, 135, 173
S. Lorenzo in Panisperna, *See*: Franciscan church and nunnery of S. Lorenzo in Panisperna
S. Maria in Aracoeli. *See*: Franciscan church and friary of S. Maria in Aracoeli)
S. Maria sopra Minerva. *See*: Dominican church and priory of S. Maria sopra Minerva
Smith, Julie Ann: 35 n. 48, 43 n. 9, 70 nn.162, 167; 88, 89 n. 267, 91 n. 287, 194 n. 63, 263 n. 23
Society of the Catholic Apostolate (Pallottine Order): 315, 340
Sorores minores inclusae (Enclosed Sisters Minor): 251, 317, 320, 321
Spada plans: 132 n. 175, 229, 233–35, 239, 244–45, 248, 278, 285, Figs 64, 114
Sperelli, Sperello, Cardinal: 172
Spinelli, Fabiana: 18
Sprange, Bartolomeo: 51, 52
S. Sabina. *See*: Dominican church and priory of S. Sabina
S. Silvestro in Capite. *See*: Franciscan church and nunnery of S. Silvestro in Capite
S. Sisto (now S. Sisto Vecchio). *See*: Dominican church and nunnery of S. Sisto
Stadium of Domitian. *See*: Piazza Navona
stational churches: 60, 110, 135, 356
statue of Minerva (*also known as* 'Athena Giustiniani'): 260
statue of an elephant carrying an obelisk: 260, 261 n. 15
Stefania, author of *Vita* of Margherita Colonna: 317, 322, 323

Stefania from Tiber Island, died 1313: 129, 343
Stefano of Fossanova, Cardinal Bishop of Tuscolo: 53 n. 55, 70
Stephen, St: 78 n. 204, 267
Stephen I, Pope and St: 308–09, 314
Stephen II, Pope: 308–09, 310 n. 23, 340
Sterpi, Claudio: 44 n. 12, 57 n. 46, 62 n. 108, 68, 70 n. 170, 71 n. 172
stigmata of St Catherine of Siena: 344, 348–49
stigmata of St Francis of Assisi: 37, 174–75, 223, 235, 251
Strinati, Tommaso: 213 n. 1, 248 n. 223, 249
Sulla, Lucius Cornelius: 215
Synod of Hatfield, England: 117

Tabularium (Archive): 215, 219, 220 n. 17
Tancredi, OP, first prior of S Sisto: 70
Tanghero, Antonio: 327, 329–30, 333, Fig. 154
Tarpeia, Vestal Virgin: 214
Tarpeian Rock: 215
Tempesta Antonio: 16, 212, 260, 307, Figs 106, 126, 148
temples, ancient Roman: 31, 52 n. 50, 101–02, 214–15, 219, 258, 260
Tempulus, Servulus, and Cervulus, and the icon of *Maria Advocata*: 72, Plate 1
Terzi, Arduino: 160 n. 33, 173
Theatre of L. Cornelius Balbi: 260
Theatre of Marcellus (*also known as* 'mons Fabiorum' *or* 'Monte Sasso'): 148–49, 221 n. 43, 259, 260
Theatre of Pompey: 260
Thedallo de Piscionibus and his wife Costanza: 342
Theodora, Abbess of S. Cosimato: 206
Theodora, wife of Theophylact and grandmother of Alberic: 147
Theodore, Archbishop of Canterbury (668–690): 117
Theophylact, House or family: 73, 147
Theotokos (the Mother of God): 72 n. 179, 117, 337
Thermae Antonianae. *See*: baths: Baths of Caracalla: Figs 2, 3
Thomas Aquinas, OP and St : 31, 51 n. 46, 73, 93, 146, 222, 262, 291, 298, 303–04, 349 n. 73
Thomas of Celano, OFM: 39, 153, 161, 162 nn. 46, 47; 174
Thomas Howard of Norfolk, Cardinal of S. Sabina: 136
Tiber bend: 31, 32, 227

Tiber Island: 104, 129, 155–56, 178, 343
Tiber, River: 17, 31, 46, 97, 100, 137, 141, 148, 155, 221, 258, 259, 310, 356
Tiberius, Emperor: 336
Tiburtine Sybil: 213, 230
Tillman, Hélène: 147
titulus / tituli: 45 n. 20, 60, 110, 117, 118, 303
Todi: 269
Toesca, Ilaria: 171 n. 88, 307 n. 2, 308 n. 12, 309 n. 13, 310 n. 21, 311 n. 30, 312 n. 43, 313 n. 52, 314 n. 56, 327, 328 nn 131–32; 329, 330 nn. 145, 147–48
Tomassetti, Giuseppe: 47
tomb (arca) of St Dominic: 38, 128
Tommaso da Siena 'Caffarini': 288 n. 199, 293, 342, 343 nn. 16–19; 344, 349, 351–53
Tommaso d'Ocre, Cardinal: 272
Torquemada, Juan, Cardinal: 301
Torriti, Jacopo: 359
Toulouse: 19, 34 n. 43, 37, 43, 95, 96, 128, 129 n. 157, 143, 174–75, 299, 355
Traini, Francesco: 37, 38
tramezzo (*see also*: choir screen, intermediary wall): 36, 63–66, 79, 93, 124–29, 135, 165, 235, 239, 287, 288, 357
Trasmundo Taska: 342
Trastevere: 17, 31–33, 62, 92, 93 n. 297, 104, 153–56, 158–60, 162, 164, 166, 169–70, 173 n. 102, 176–78, 181, 183 n. 18, 186 n. 27, 188, 190, 193, 195, 198 n. 88, 199 n. 95, 202 n. 107, 205, 210, 220, 223, 224 n. 83, 226–31, 233, 237, 254–55, 258, 273, 289, 313, 315, 353, 356–58, Fig. 75
treasure trove: 102, 150
Tre Fontane. *See*: churches in Rome: SS. Vincenzo e Anastasio at Tre Fontane
Trevi Fountain: 311
tribunal on the Capitoline Hill: 32, 215, 226
Trinci Cecchelli, Margherita: 97 nn. 14, 16; 100 nn. 19, 22; 101 nn. 23, 24, 27, 30; 137
triumphal arches (Roman): 31, 216
triumphal arches in church buildings between the nave and transept: 165, 168–69, 217, 227–28, 231, 238, 255
triumphal processions in Ancient Rome: 259
Trucchi, Daniela: 58
Tudela, Benjamin: 155

Tugwell, Simon, OP: 35, 36 n. 54, 37 n. 58, 43 nn. 1, 3, 8; 44 n. 11, 49 n 38, 65 n. 127, 70 n. 167, 88 n. 258, 96 nn. 6, 7
Tuscan Gothic architecture: 280

Udine, church of San Francesco: 168
Ugo Aycelin, OP, Cardinal: 272
Ugolino Conti di Segni, Cardinal, later Pope Gregory IX (*see also*: Conti di Segni, family): 29, 37, 70, 88, 153, 162 n.45, 193, 194
Ugonio, Pompeo: 49, 57 n. 69, 71 n. 174, 113, 116–18, 124–25, 131, 133 nn.179–80, 134, 135 nn. 185, 189, 191–92; 147, 151, 164–65, 168–69, 201, 234, 251 n. 240, 251
Umberto I, King of Italy: 177, 183
Umbria: 169, 213 n. 1, 308
Umiliana de Cerchi of Florence, St: 341
universal mission of the Dominican Order: 96
Urban IV, Pope: 32, 46 n. 25, 129, 195, 320, 324
Urban VI, Pope: 348, 352
Urban VIII, Pope: 155, 304
Urfa, Turkey: 336

Valerian, Emperor: 52
Valori, Baccio: 350
van den Wyngaerde, Anthonis, *Panorama of Rome...*: 261, 278 n. 124, Fig. 127
van Heemskerck, Marten, View of S. Maria in Aracoeli: 229, 232, 233, 238, 244, Fig. 116
Vanna of Orvieto: 352
Vasari, Giorgio: 164, 230, 263 n. 23, 359
Varetti, C.: 57, 58, Figs 19, 21
Vasi, Giuseppe: 133
Vassalletti, 171
Vatican: 78 n. 204, 155, 204, 227, 233 n. 120, 248, 291, 305, 335, 336, 338
Vauchez, André: 35, 36 n. 53, 344 nn. 23, 29; 345 nn. 32, 33; 348, 349 n. 69, 352 n. 95
Velli, Anna Maria: 19
Vendittelli, Marco: 18
Venerandus, Abbot: 95
Venusti, Marcello: 296
Veritas: 19, 355
Verona: 153, 230
Vespignani, Virginio: 265

Via Anicia: 156, 160, 162
Via Appia: 32, 44, 45, 47, 52, 67, 82, 101, 161, 330 n. 142
Via Aurelia: 156
Via Beato Angelico: 291, 304
Via Campana (*also known as* 'Via Portuensis'): 156
Via dei Coronari: 254, 261
Via del Circo Massimo: 100
Via della Lungaretta: 56
Via del Papa: 87, 261, 348
Via del Pellegrino: 261
Via del Corso: 259, 261, 307, 351
Via del Re: 181
Via del Seminario: 304
Via del Tritone: 311
Via di S. Francesco a Ripa: 181
Via di Valle delle Camene: 45, 49
Via Druso: 44, 45, 49, 56
Via Emillio Morosini: 181
Via Flaminia: 259, 307, 308 n. 4
Via Frangipana: 156, 160, 162
Via Lata: 39, 241, 259, 261, 307, 308, 311, 312, 317, 320
Via Latina: 44, 311
Viale Aventino (formerly called 'Viale di Porta S. Paolo'): 97
Viale Trastevere (*also known as* Viale di Trastevere): 181
Via Mamurtini: 45
Via Nomentana: 118, 311
Via Piè di Marmo: 304
Via Portuensis: 156
Via Recta: 259
Via Roma Libera: 181
Via Salaria: 311
Via Santa Sabina: 100, 104, 108, 114–16, Fig. 51
Via S. Chiara: 304
Via S. Sebastianello: 305
Via Tiburtina: 52
Via Transtiberina (*also known as* Via della Lungaretta): 156
Victor Emmanuel Monument: 213, 252
Vicus Altus: 100, 104–05, 116
Vicus Armilustri: 100, 114
Vicus Portae (later called Strada Marmorata): 97, 100

Vicus Portae Raudusculanae: 97
Villa Publica: 259
Villetti, Gabriella: 265 n. 30, 269 n. 33, 270 nn. 64–65, 67–72; 271 n. 74, 272 nn. 83–85; 273 nn. 98–99, 101–02; 275 n. 115, 277, 281–83, 285, 286 nn. 181–82, 184; 289 nn. 203–04; 290 nn. 110, 115–17; 291 nn. 218–19; 274–75, 300 nn. 276, 278–79; 301 nn. 283, 286; 302 nn. 290–91; 304 n. 313, Figs 128, 138
Vincent Ferrer, OP and St: 51 n. 46, 267, 299n. 271, 300
Vincent Pallotti, St: 315
Viollet-Le-Duc, Eugène-Emmanuel: 263
Vitali, Federica: 74 n. 195, 76 n. 200, 79 nn. 210, 212; 82
Viterbo: 29, 193 n. 56, 200, 215, 239, 244, 246, 247, 255, 303, 311, 341
von Dietrichstain, Franz Seraph, Cardinal: 330
Vulturella (*also known as* Mentorella): 315

Wadding, Luke, OFM: 155 n. 8, 175, 177 n. 2, 192, 193 nn. 54, 59; 220 n. 40, 224 nn. 64, 67; 325 nn. 124–25
Watton Priory: 63, 65, Fig. 23
Whitmee, William, SAC: 315
Wickham, Chris: 31 nn. 26, 28; 32 n. 29, 87 nn. 249, 252; 155 nn. 10, 12; 161 n. 42, 162 n. 50, 177 nn. 3, 6; 190 nn. 41, 42; 215 n. 13, 261 n. 18, 312 n. 45
William of Harcombourg, OFM: 320
William of Meliton, OFM: 320
William of Saint-Amour : 222

York diocese, church of St Oswald of Nostle: 63

Zaccharias, Pope: 267
Zagarolo: 318
Zecharia, prophet: 355
Zuccari, Federico: 52 n. 49, 136
Zuccari, Taddeo: 113
Zucchi, Alberto, OP: 44 nn. 12, 14; 62 n. 108, 75 n. 196, 82 n. 217, 261 n. 15, 263 nn. 20, 22; 268 n. 43, 269, 270 n. 68, 277 nn. 77, 79, 80; 272 n. 89, 273 n. 98, 292 n. 225, 298 n. 261, 301 nn. 283, 285–87; 302 nn. 294–95; 303 nn. 308–09, 312; 304 nn. 316, 320–21; 305 n. 323

Medieval Monastic Studies

All volumes in this series are evaluated by an Editorial Board, strictly on academic grounds, based on reports prepared by referees who have been commissioned by virtue of their specialism in the appropriate field. The Board ensures that the screening is done independently and without conflicts of interest. The definitive texts supplied by authors are also subject to review by the Board before being approved for publication. Further, the volumes are copyedited to conform to the publisher's stylebook and to the best international academic standards in the field.

Titles in Series

Women in the Medieval Monastic World, ed. by Janet Burton and Karen Stöber (2015)

Kathryn E. Salzer, *Vaucelles Abbey: Social, Political, and Ecclesiastical Relationships in the Borderland Region of the Cambrésis, 1131–1300* (2017)

Michael Carter, *The Art and Architecture of the Cistercians in Northern England, c. 1300–1540* (2019)

Monastic Europe: Medieval Communities, Landscapes, and Settlement, ed. by Edel Bhreathnach, Małgorzata Krasnodębska-D'Aughton, and Keith Smith (2019)

Michael Spence, *The Late Medieval Cistercian Monastery of Fountains Abbey, Yorkshire: Monastic Administration, Economy, and Archival Memory* (2020)

The Medieval Dominicans: Books, Buildings, Music, and Liturgy, ed. by Eleanor J. Giraud and Christian T. Leitmeir (2021)

In Preparation

Monastic Communities and Canonical Clergy in the Carolingian World (780–840): Categorizing the Church, ed. by Rutger Kramer, Graeme Ward, and Emilie Kurdziel